1,000 PLACES TO SEE BEFORE YOU DIE

1,000 PLACES TO SEE BEFORE YOU DIE®

The World as You've
Never Seen It Before

Patricia Schultz

ARTISAN I NEW YORK

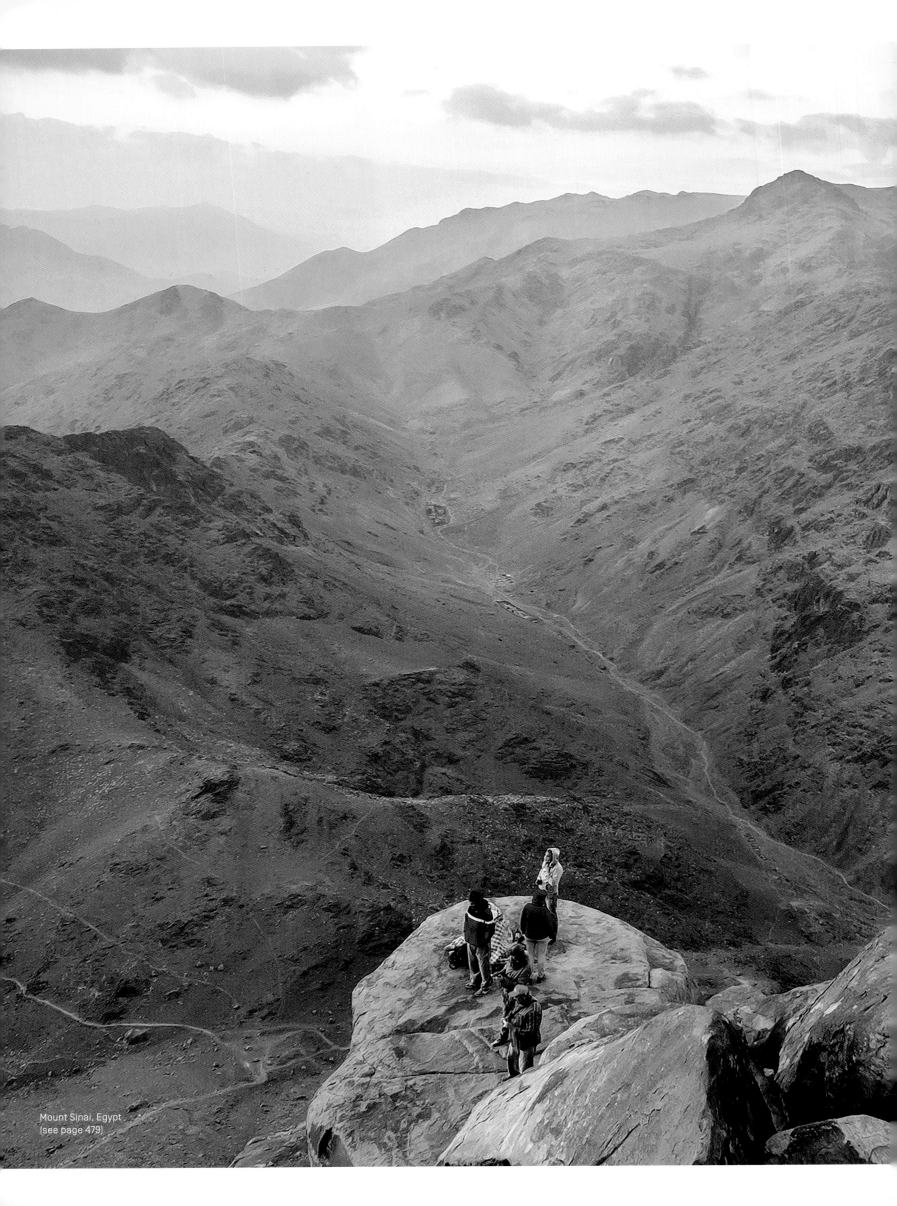

Mount Sinai, Egypt
(see page 479)

To Nick, my travel partner in life and on the road, and to my sister, Rosalyn, my brother-in-law, Ed, and their gorgeous family—together they are the reason that home is always my favorite place of all

Contents

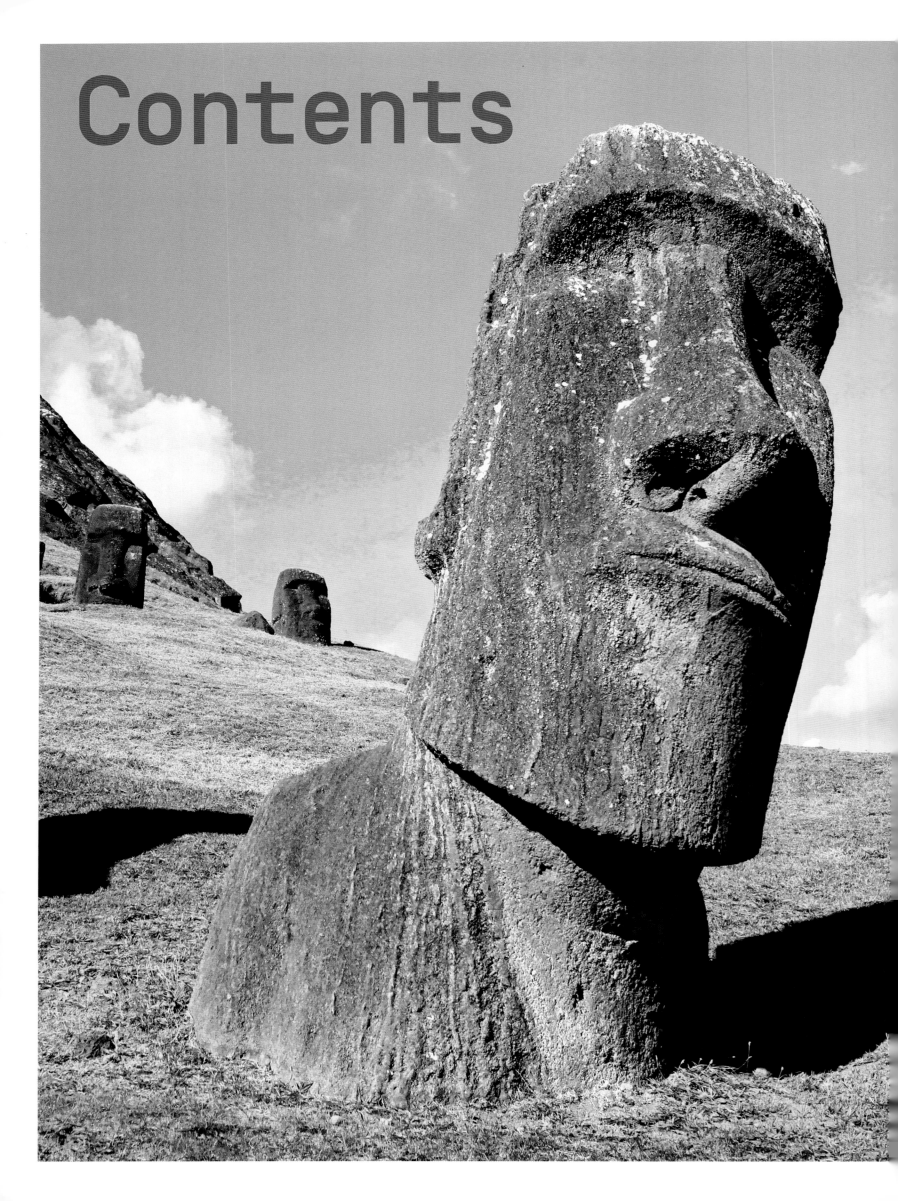

The *moai* of Chile's far-flung Easter Island were created to memorialize important chieftains and prominent ancestors (see page 479).

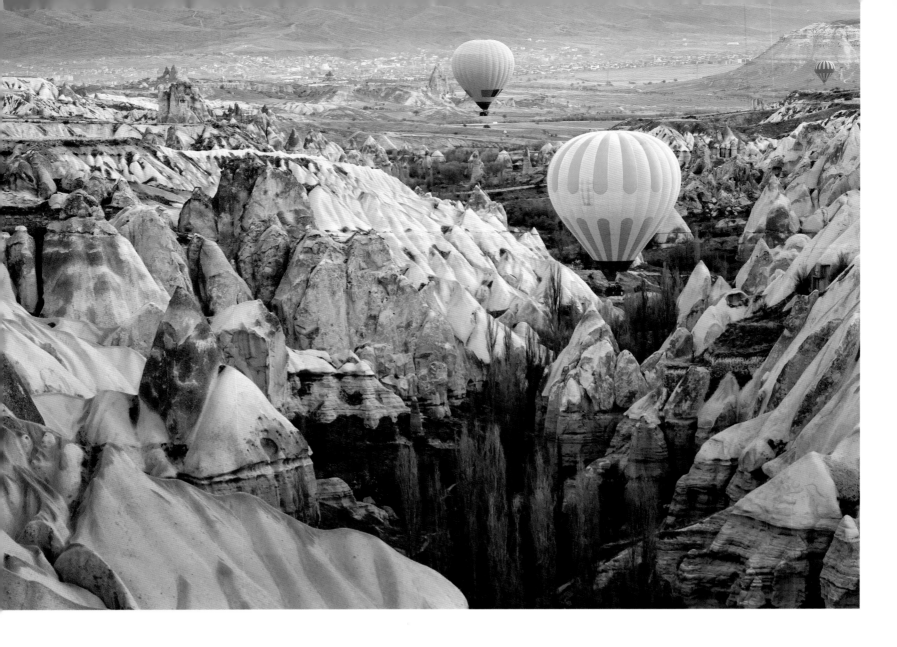

INTRODUCTION

Life is ours to be spent,
not to be saved.

—D. H. Lawrence

By the time *1,000 Places to See Before You Die* was published in 2003, I had spent eight years tirelessly researching and traveling—preceded by decades vagabonding around the globe—to discover and compile my own personal list of the world's wonders. It was a daunting challenge but exciting and rewarding beyond description and an unimaginable endeavor that would change my life. I still smile when I'm asked how many people make up my team. I am the team, and this is my voice, and while some may not agree with all my choices, no one has ever questioned the spirit of the book: The world is large, and life is short. And whatever sparks your joy, do as much of that as possible.

1,000 Places has proved to be an enduring dream book for those new to travel, as well as for veteran travelers curious to expand their bucket lists. Its longevity and global popularity have made every canceled flight, every bleary-eyed 9 a.m. deadline, and every unpaid credit card bill worth the effort, energy, and occasional angst.

But does the world need another *1,000 Places* book? My answer is a resounding yes! Every year, a new wave of adventurers—including the newly graduated, the newly retired, and everyone in between—comes on board with newfound determination to make their lives one of continued curiosity and discovery. And in this moment of insta-everything, this new tome guarantees a wealth of inspiration, thanks to more than a thousand color photographs that bring to life what my words strove to convey in the original. These vibrant images effortlessly capture a time and place—from the animal migration in the Serengeti to the 12th-century golden mosaics in the Cathedral of Monreale outside Palermo.

OPPOSITE PAGE // The surreal landscape of Cappadocia in Anatolia, Turkey (see pages 270–271)

LEFT // The Neue Palais, one of the impressive buildings on Sanssouci's grounds, in Potsdam, Brandenburg, Germany (see page 71)

BELOW // The gentle and mysterious mountain gorilla, Bwindi Impenetrable National Park, Uganda, Africa (see page 204)

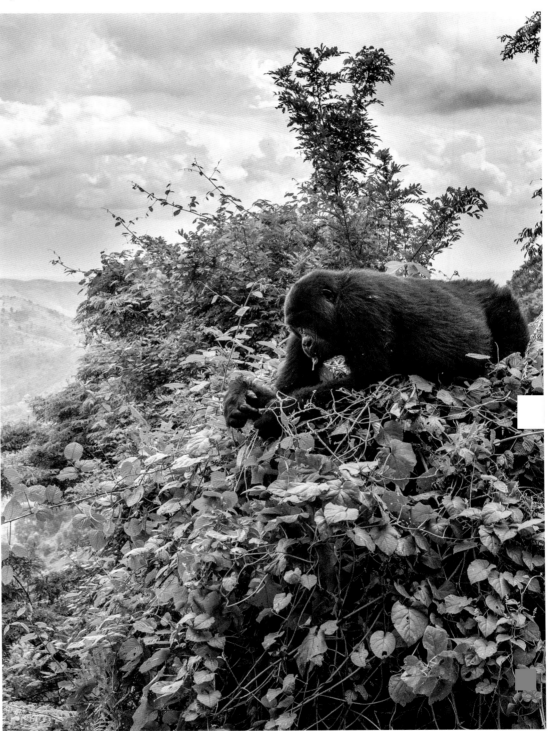

I admit, I teared up just a little when I pored over the final galleys before sitting down to write this introduction: This reimagined *1,000 Places* is like a veritable scrapbook of my life, as if when I stopped in my travels to turn around and enjoy the view, this is just what I saw. With every turn of the page, I am reminded of how full and deeply rewarding my experiences have been, ranging from the iconic must-dos, such as the Taj Mahal and Iguazú Falls, to the unexpected and unsung, such as the kindness of one lovely gentleman in Casablanca when I simply could not find my hotel (I blamed it on jet lag). Here is proof that travel is the only thing you can buy that makes you richer.

While the original book will forever remain my life-changing firstborn child, this deluxe photo-driven edition is its sophisticated offspring—a companion piece, guaranteed to make us fall in love with travel all over again, encouraging us to be born-again explorers, whether from the comfort of our armchairs or on the road to the airport. And at every turn, on every page, another addition for your wish list that commands your attention and hopefully fuels your call to action: Adventure is out there, and it has your name on it.

Of all the books in the world, the most exciting adventures are found between the pages of your passport. I hope this new edition of *1,000 Places* might be your next best choice.

—Patricia Schultz

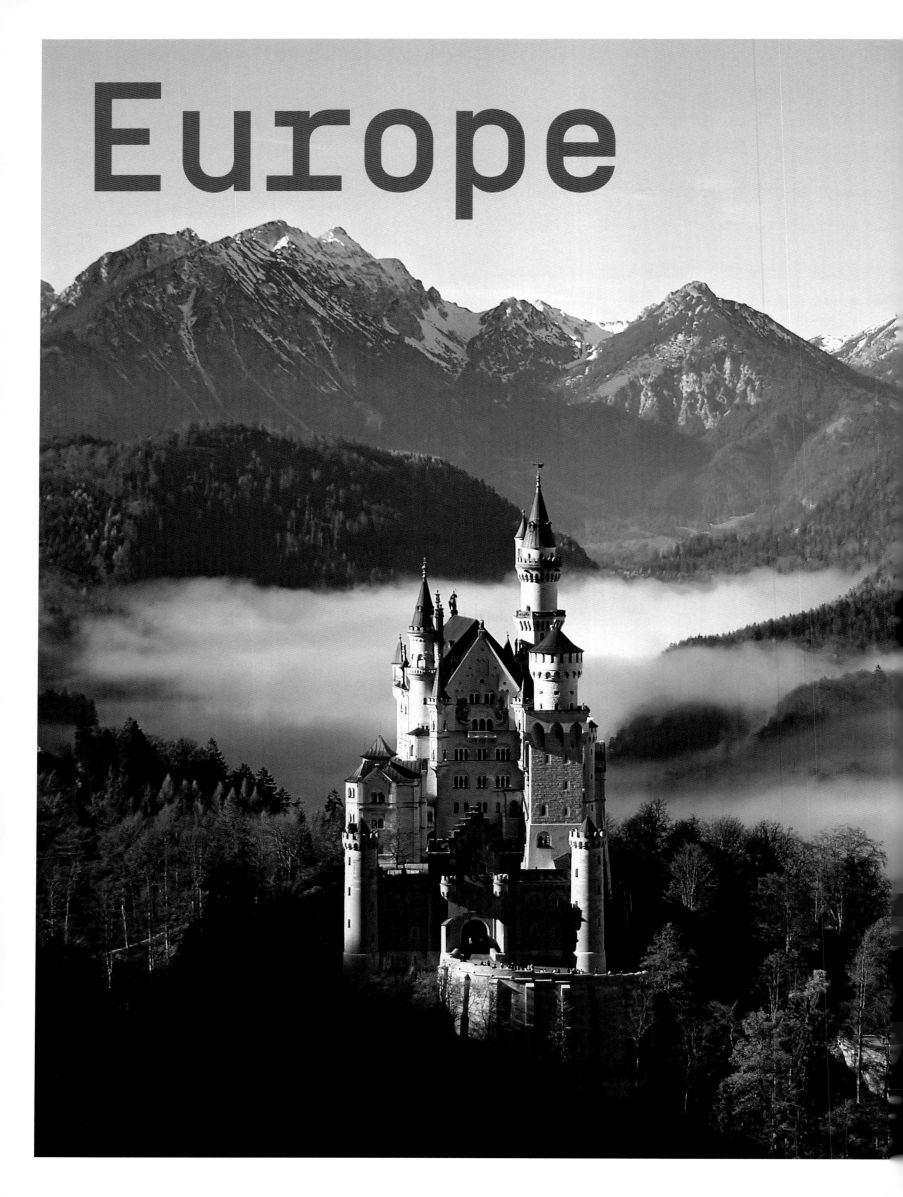

Europe

Neuschwanstein Castle in Bavaria, Germany, the inspiration for the castle in Disney's *Sleeping Beauty* (see page 69).

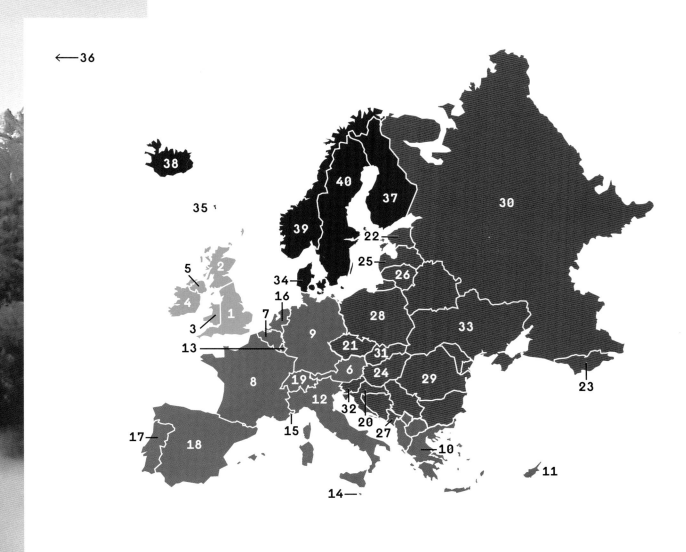

Great Britain and Ireland

1 England
2 Scotland
3 Wales
4 Ireland
5 Northern Ireland

Western Europe

6 Austria
7 Belgium
8 France
9 Germany
10 Greece
11 Cyprus
12 Italy
13 Luxembourg
14 Malta
15 Monaco
16 Netherlands
17 Portugal
18 Spain
19 Switzerland

Eastern Europe

20 Croatia
21 Czech Republic
22 Estonia
23 Georgia
24 Hungary
25 Latvia
26 Lithuania
27 Montenegro
28 Poland
29 Romania
30 Russia
31 Slovakia
32 Slovenia
33 Ukraine

Scandinavia

34 Denmark
35 Faroe Islands
36 Greenland
37 Finland
38 Iceland
39 Norway
40 Sweden

Great Britain and Ireland

CAMBRIDGE UNIVERSITY
Cambridgeshire, England

// Hallowed Seat of Academia

The 31 colleges of Cambridge, one of Europe's oldest centers of learning, have produced alumni as varied as John Milton, Stephen Hawking, Iris Murdoch, Isaac Newton, Charles Darwin, and Oliver Cromwell. The town's narrow lanes are lined with cluttered bookstores, historic inns, and pubs; and the scenic River Cam flows through the heart of the university.

Must Do // Visit Cambridge's King's College Chapel, with Rubens's 17th-century *Adoration of the Magi* hanging behind the main altar, and the Fitzwilliam Museum to see masterpieces by Titian, Michelangelo, and the French Impressionists // "Punt"— float on a wooden, flat-bottomed boat maneuvered by a pole—down the River Cam (*right*) for a view of the chapel from the Backs, the mile-long strip of lawns along the banks of the river // On Christmas Eve, attend the Festival of Nine Carols and Lessons sung by a student choir, a tradition since 1918.

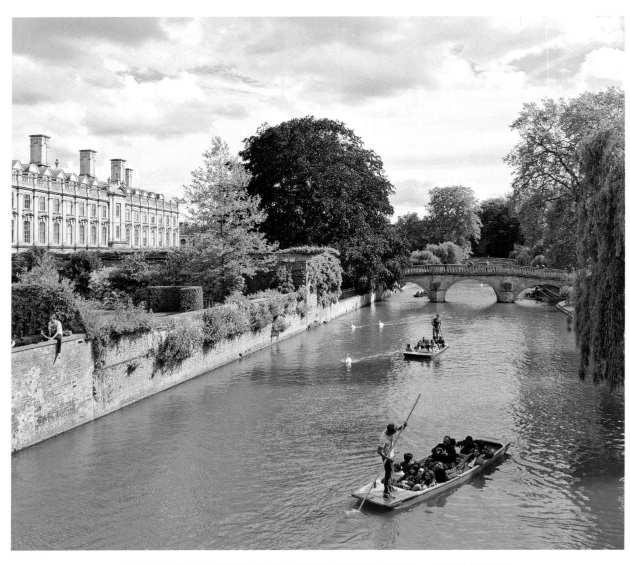

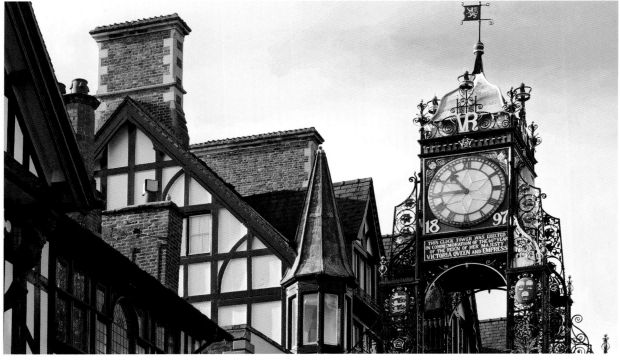

CHESTER
Cheshire, England

// A Walled City and Architectural Feast

Chester boasts a broad and intriguing cross section of English history that stretches back more than 2,000 years. A well-preserved Roman wall surrounds much of the city. Its ramparts are topped by a 2-mile footpath that provides a lovely vantage point to view the medieval cathedral and Chester's famous wrought-iron clock tower (*left*).

Must Visit // The Rows, highly decorated half-timbered buildings with connecting walkways above street level

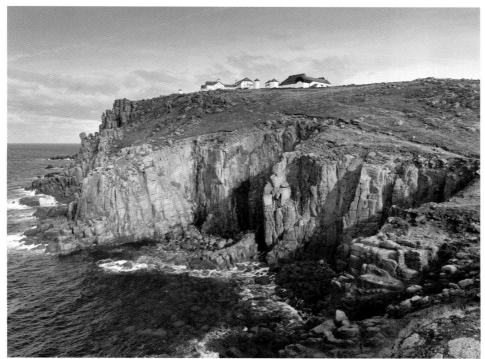

LAND'S END
Cornwall, England

// Treasures at
the End of the Earth

Land's End is the far southwestern tip of
the English mainland, where the country
plunges over sheer cliffs into the Atlantic,
creating an awe-inspiring landscape rich
in history and atmosphere.

Must Visit // St. Michael's Mount, originally
created in 1135 as a sister abbey to Mont
St-Michel in Normandy, France, is attached
to the mainland by a cobbled causeway
// Penzance, a port famous as the home
of Gilbert and Sullivan's singing pirates
// The Isles of Scilly, which feature
unspoiled beaches, exotic palms, flocks
of rare sea birds, and world-famous
subtropical gardens on the island of
Tresco // The harbor town of St. Ives and
its offshoot of London's Tate Gallery, and
the nearby Barbara Hepworth Museum
and Sculpture Garden

PADSTOW AND
ST. MAWES
Cornwall, England

// Tropical Air and
Mediterranean Flavors

The port of Padstow (*right*) on the ruggedly
beautiful north coast of Cornwall is one
of the region's oldest towns. While the
scenery is beautiful, most visitors come
to this quaint village to enjoy excellent
seafood, some of which is handpicked off
the trawlers bobbing in the harbor. A short
drive along the Cornish Riviera leads to the
picturesque village of St. Mawes.

Must Visit // The Eden Project's two giant
greenhouses that form a unique oasis of
exotic plants and trees. The larger is the
tropical biome, where you'll find palms
and giant bamboo, as well as commercial
crops such as bananas, coffee, and rubber.
Next door is the Mediterranean biome, with
plants including olive trees and grapevines.

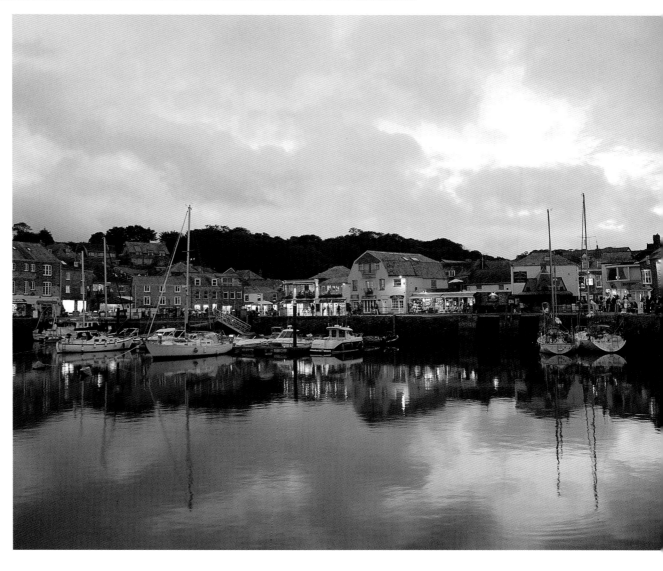

CHATSWORTH HOUSE
Bakewell, Derbyshire, England

// The "Palace of the Peak" in the Heart of England

Chatsworth is one of the most impressive examples of the stately homes enriching England's countryside. Lavish state apartments are decorated with a wealth of treasures, including a prodigious art collection.

Must Visit // The house's 100-acre garden, one of the most celebrated in all of Europe, and its stepped Cascade waterfall along with the seasonally changing display of contemporary sculptures // The craggy moors and limestone dales of the Peak District, England's oldest national park // The market town of Bakewell and the Old Original Bakewell Pudding Shop, the birthplace of the famous dessert

DARTMOOR
Devon, England

// A Romantic Countryside

England's Southwest Peninsula is renowned as a green and lush destination. Fertile conditions and a long farming heritage make visiting Devon a bucolic idyll. At its center are the high hills and rocky outcrops of Dartmoor, with 368 square miles of countryside, including the idyllic village of Sheepstor [*right*], protected as one of England's many national parks.

Must Do // Hike the dramatic moors and wooded valleys of Dartmoor National Park // Sit down to a Devonshire tea.

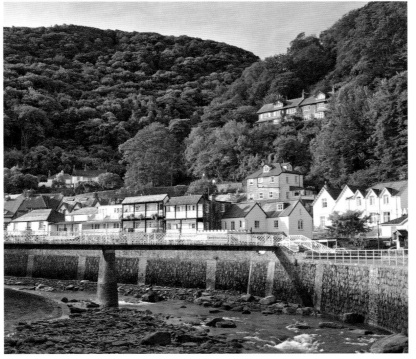

EXMOOR
Devon and Somerset, England

// Where the Moors Meet the Sea

In a beautiful corner of the West Country sits the dramatic and romantic landscape of Exmoor National Park. Its high treeless hills contain the remains of Bronze Age settlements, and streams and rivers cut steep-sided valleys down to the sea, creating breathtaking scenery. Tucked into a bay of the park are twin Victorian towns, Lynmouth [*left*] and Lynton.

Must Do // Visit Exmoor National Park's most famous scenic spot, Valley of the Rocks // Ride on the century-old funicular railway that connects Lynmouth and Lynton // Walk the coastal path to the Countisbury Cliffs, the highest in England.

GLYNDEBOURNE FESTIVAL
Lewes, East Sussex, England

// The European Circuit's Summertime Standout

For true opera fans, there is no lovelier setting than at the renowned Glyndebourne Festival, on the grounds of a graceful neo-Elizabethan manor, amid the green hills of the Sussex Downs. The festival's repertoire is performed by international artists in the estate's modern theater.

Must Do // Participate in the festival's highlight: the ritual evening picnic on the lawn that stretches in front of the manor.

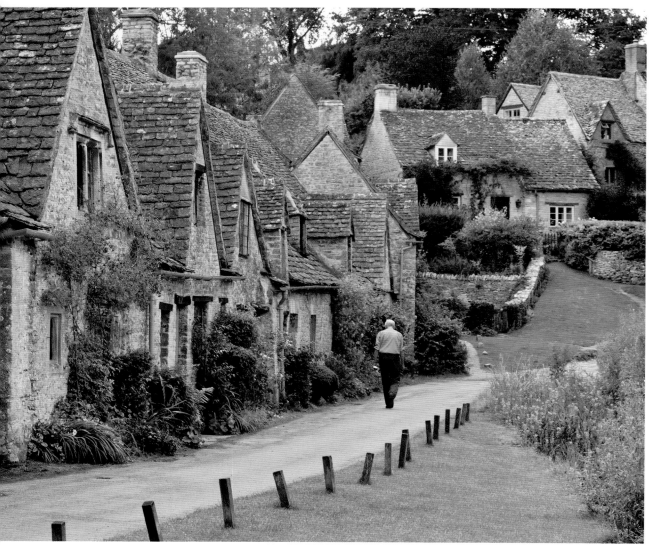

THE COTSWOLDS
Gloucestershire, Worcestershire, and Oxfordshire, England

// Timeless Tableau of the English Countryside

A perfect example of the beauty of rural England, the Cotswolds provide a prime area for walkers, whether they seek gentle riverside strolls or more serious hikes on long-distance trails. Sheep graze in the fields, and almost every town in the region has an impressive church or cathedral built with the wool industry's profits.

Must Visit // The village of Bibury (*left*) near Stow and Bourton, chosen by William Morris, father of the Arts and Crafts Movement, as the most beautiful in England // At the northern end of the hills, the village of Chipping Campden and its famous 10-acre Hidcote Gardens // The Cotswold Way, a popular long-distance trail along the crest of the Cotswold Edge from Bath to Chipping Campden // The nearby village of Broadway and its architecturally striking High Street lined with antiques stores // Broadway Tower, a 3-mile hike to the highest point around and a favorite picnic spot

WINCHESTER CATHEDRAL
Winchester, Hampshire, England

// A Medieval Wonder That Still Surprises

Although slightly austere on the outside, Winchester Cathedral has a grand and awe-inspiring interior, which also contains the tomb of novelist Jane Austen. Construction began in 1079 when Winchester was a major religious, political, and commercial center of Saxon England.

Must Do // In town, see the Great Hall, where King Arthur's iconic Round Table is displayed // Visit Jane Austen's House Museum in Chawton Cottage, the writer's pleasant country home 15 miles west of town, where many of her greatest works were penned // From Winchester, walk the scenic South Downs Way toward Beacon Hill or the village of Exton. For more of a challenge, follow this national trail 107 miles to the famous white cliffs of the Seven Sisters.

OSBORNE HOUSE
Isle of Wight, England

// A Retreat for Royal R&R

With its sandy beaches and dramatic cliffs, the Isle of Wight was a favorite summertime destination for Queen Victoria and Prince Albert and their nine children, who built Osborne House (*left*) in 1845. Family mementos fill the bedroom where the queen died in 1901.

Must Do // Tour the island's capital, Newport, and its 11th-century Carisbrooke Castle, the best-preserved Norman castle in England // Hike the section of the island's 67-mile Coastal Path that crosses Tennyson Down on the way to the Needles, three offshore rock pinnacles battered by the waves of the English Channel.

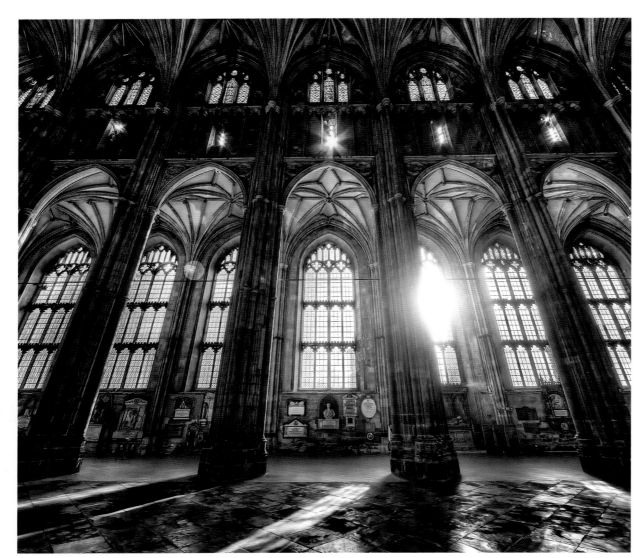

CANTERBURY CATHEDRAL
Canterbury, Kent, England

// The Mother Church of the Anglican World

The seat of the Anglican Church, Canterbury Cathedral is among the country's most beautiful and holiest pilgrimage sites. Archbishop Thomas Becket was murdered in the cathedral in 1170 by four knights allegedly following the orders of King Henry II. Becket was canonized 3 years later, while a repentant Henry established the cathedral as the center of English Christianity.

Must Visit // The cathedral's outstanding 12th- and 13th-century stained-glass windows, including the Great West Window, the Bible Windows, and the Miracle Windows // The spot where Becket died, now marked by a solitary candle

LEEDS CASTLE
Maidstone, Kent, England

// A Magnificent Pile of Medieval Origin

Leeds Castle's buff-colored stone and crenellated towers are reflected in an ornamental pond and lakelike moat, unlike any other castle setting in England, making it among the loveliest castles in the world. It has been much loved as a royal residence from 1278, when it was given to Edward I by a wealthy courtier seeking a favor. Henry VIII spent time here, and six queens called it their favorite residence.

Must Do // Enjoy a perfect country walk through the gardens and parkland surrounding the castle // Visit the castle's aviary and the unlikely Dog Collar Museum, a highlight for many visitors.

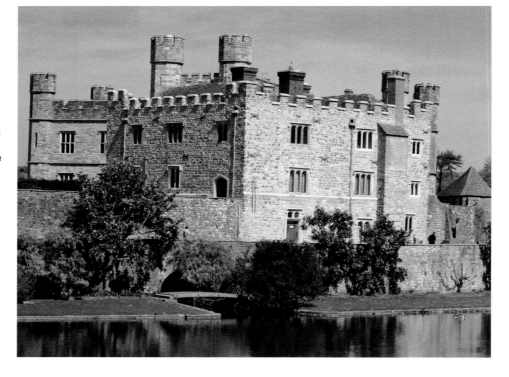

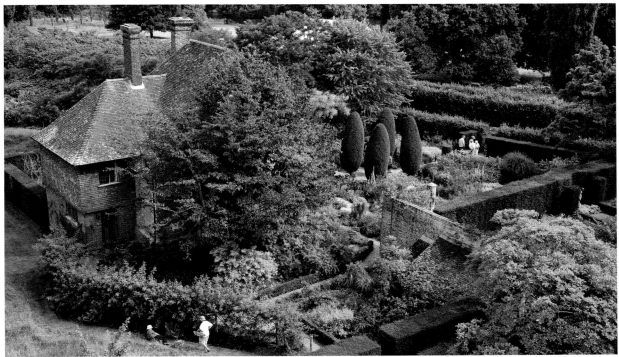

SISSINGHURST CASTLE GARDEN
Sissinghurst, Kent, England

// Eden on London's Doorstep

Some of the most renowned and beloved gardens in England are found at Sissinghurst, in the county of Kent, affectionately called "the Garden of England." An oasis of serenity and beauty, the grounds, transformed by Vita Sackville-West, where she lived with her diplomat husband Harold Nicolson, are filled with a series of gardens within gardens, each one based on a family of plants or a single color.

Must Visit // The White Garden, the Rose Garden, and the Cottage Garden (*left*) // Knole House, 10 miles south of Kent, a castellated stately home dating from 1456. A highlight is the wing of the 365-room house that served as the residence for the Sackville family and where decorations, furniture, and works of art still remain.

THE LAKE DISTRICT
Lancashire and Cumbria, England

// Glorious Walks and Delicious Repasts

The poet William Wordsworth described England's Lake District as "the loveliest spot that man has ever known." At once pastoral and wild, graced with some 15 principal lakes and dozens of lesser ones, the 880-square-mile Lake District is a national park perfect for lakeside strolls or hardy hilltop hikes. Immortalized on canvas and in literature, the land was the birthplace of English Romanticism.

Must Do // Tour Windermere, the best-known and largest lake in England, and the town of Bowness-on-Windermere, a popular destination since Victorian times // Climb Walla Crag from Keswick for beautiful views of Derwentwater (*right*) // Stroll along or hike the 70-mile Cumbria Way, which unfurls across the heart of the district // Visit the village of Grasmere and Dove Cottage, where the poet William Wordsworth lived with his wife and sister, now a museum. Wordsworth is buried in the graveyard of the village church // In summer, ride the restored 19th-century steamer that plies Ullswater, the second largest lake in the district.

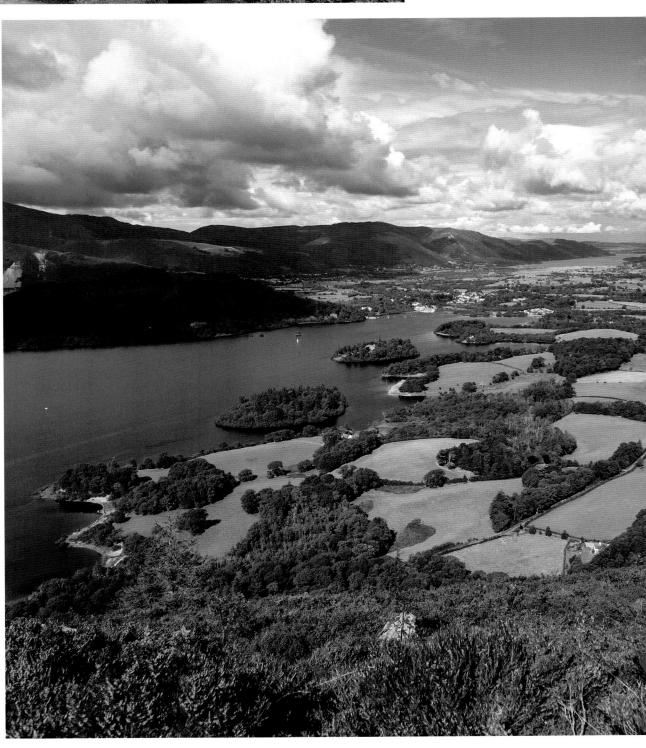

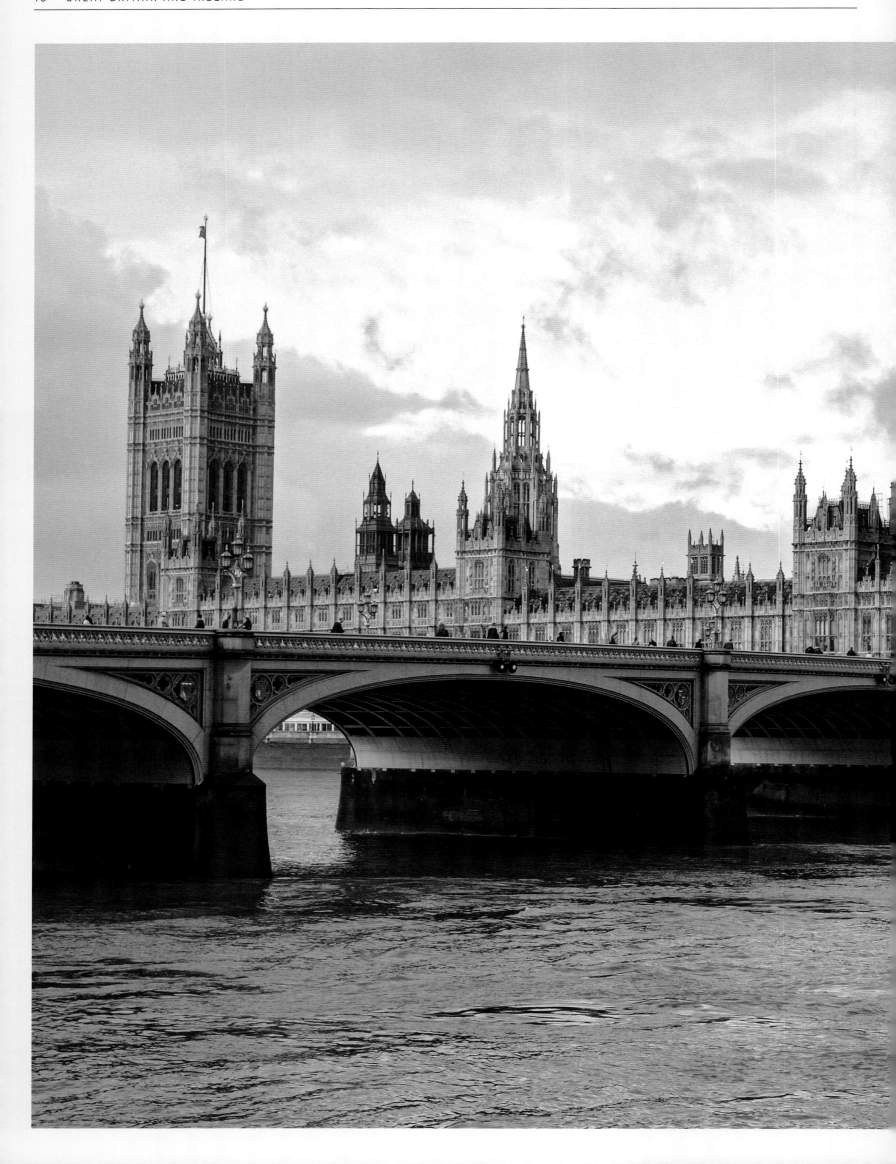

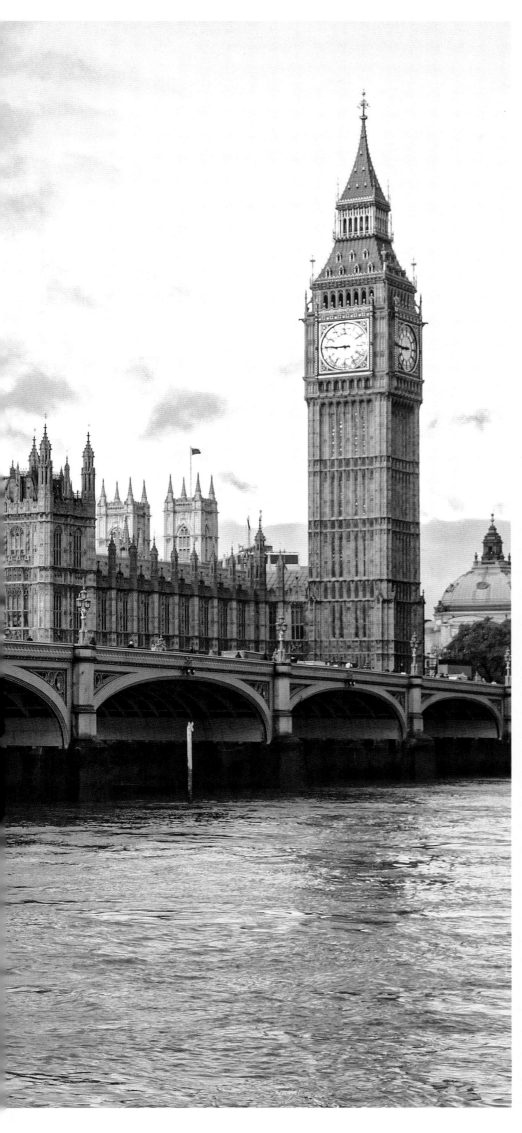

LONDON
England

London can feel like the center of the modern world, but it remains very much a city where history and tradition are integrated into daily life.

Today's London offers something for every visitor—from evenings of performances at the West End and the National Theatre to live music at St. Martin-in-the-Fields and the Royal Albert Hall. Shoppers can peruse the posh offerings of Fortnum & Mason and enjoy tea at Harrods or visit one of London's unique street markets. Museumgoers can enjoy the decorative arts at the Victoria and Albert Museum, see the original Magna Carta and handwritten Beatles lyrics at the British Library, or visit the National Portrait Gallery, which houses portraits of famous English men and women from Henry VIII to Mick Jagger.

Regent's Park, Hyde Park, and Kew Gardens provide serene settings to relax and enjoy manicured lawns, the world's largest orchid collection, and hundreds of flower gardens. Beginning in June and early July, visitors can celebrate the queen's birthday during the Trooping of the Colour or attend the Royal Ascot Races, the Wimbledon Lawn Tennis Championship, or the Chelsea Flower Show, the Olympics of gardening.

Oxford, Windsor Castle, and the Royal Pavilion in Brighton are lovely day trips for those who can bear to take themselves away from the city that entertains, enthralls, and excites everyone who visits.

LEFT // A classic London snapshot, **Westminster Bridge** spans the River Thames, with the Houses of Parliament and Big Ben in the background.

RIGHT // There are 7 million objects on display at the **British Museum**. Unless you have a week to walk the 2 miles of corridors, head for the Elgin Marbles, the Rosetta Stone, the Egyptian mummies, the Samurai armor, the Portland Vase, and the Nereid Monument (*right*).

BELOW // Containing one of the world's largest and best art collections, the **National Gallery** exhibits more than 2,000 works representing every major European school from the mid-13th through the 19th centuries.

BELOW // When the queen is away from late July to September, parts of **Buckingham Palace** are open to the public. The Changing of the Guard takes place daily or on alternate days depending on the month.

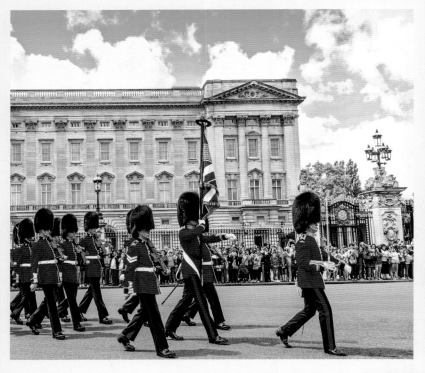

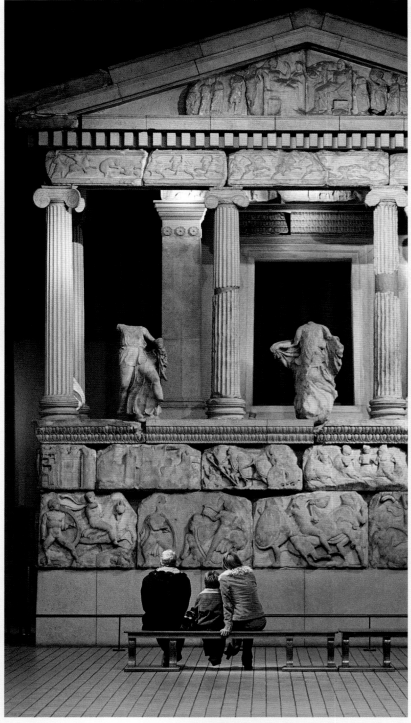

RIGHT // At 350 acres, **Hyde Park** is London's largest royal park, including many statues and fountains, such as the Princess Diana Memorial Fountain and the Huntress Fountain (*right*), and it hosts open-air concerts and royal events. The Serpentine, an L-shaped lake, separates it from Kensington Gardens, with Kensington Palace.

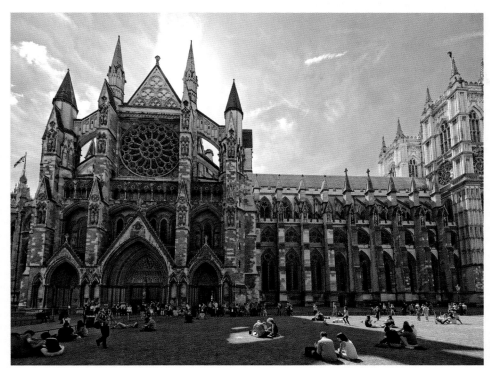

LEFT // **Westminster Abbey** has been the site of all but two British coronations since 1066. Poets' Corner has monuments to, and/or the tombs of, Chaucer, Tennyson, Browning, and Dickens, among many others.

BELOW // **St. Paul's Cathedral**, Sir Christopher Wren's 17th-century masterpiece, is located in the heart of the financial district. The great dome offers a 360-degree view of London while its interior contains the Whispering Gallery.

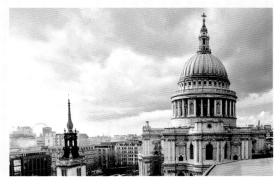

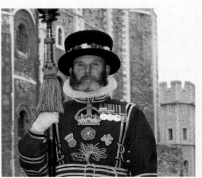

ABOVE // Begun in the 11th century by William the Conqueror, the **Tower of London** contains the Crown Jewels and the macabre Scaffold Site (where Anne Boleyn was beheaded). Tours are given by the tower's Yeoman Warders.

LEFT // The **London Eye**, one of the world's tallest observation wheels, offers views on a clear day some 25 miles in every direction from its 32 glass-enclosed gondolas.

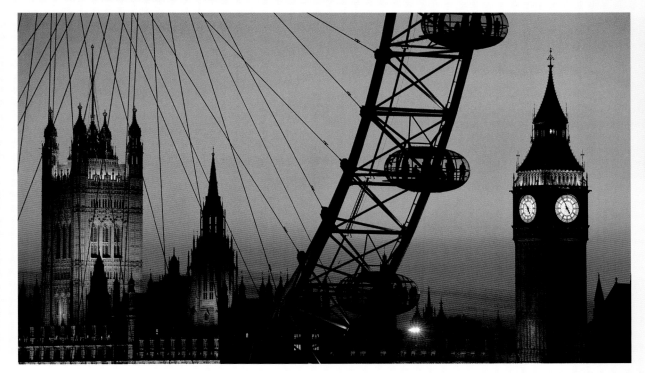

LEFT // London's largest repository of modern art, the **Tate Modern** houses British and foreign works from 1900 to the present (*pictured*, Untitled [Bacchus] by Cy Twombly) in a converted power station. Its sister gallery, the Tate Britain, displays British classics dating back to the 16th century.

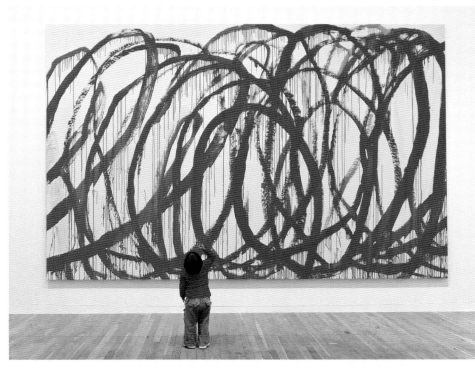

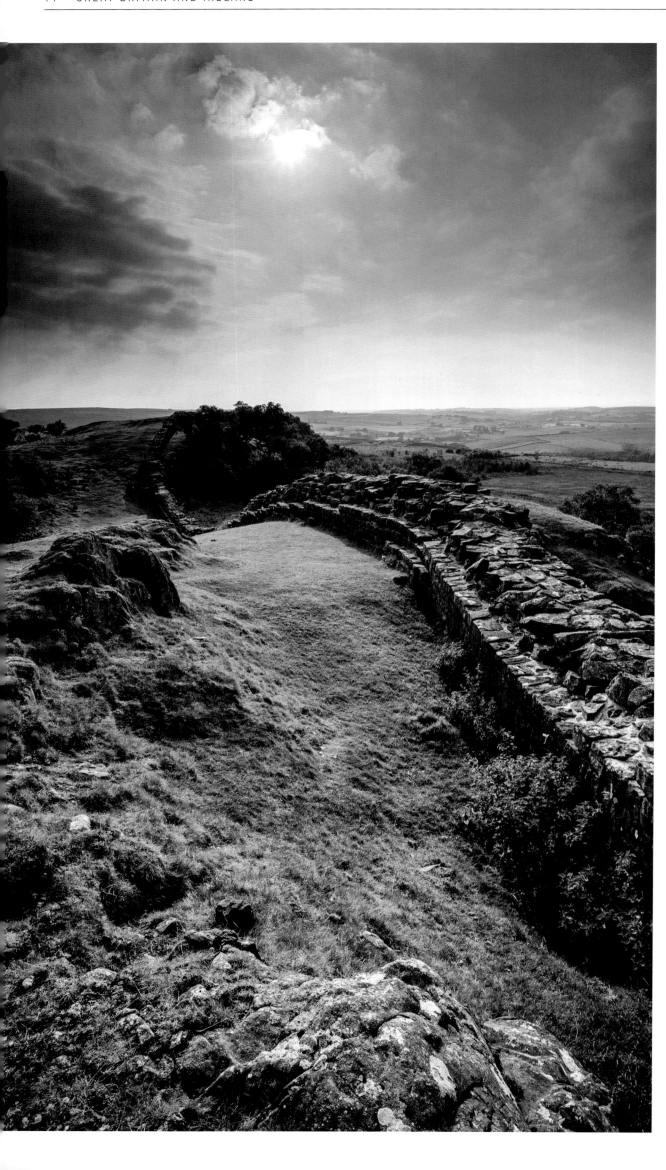

HADRIAN'S WALL
Hexham, Northumberland, England

// Ancient Rome's Line in the Sand

A few sections are all that remain of this wall constructed some 1,800 years ago as the northwesternmost border of Rome's empire. Named after Emperor Hadrian, the wall spanned 73 miles across England and is one of northern Europe's most impressive and important Roman sites.

Must Do // See the best-preserved chunk, the 10-mile stretch in Northumberland [*left*] // Visit the Roman forts Birdoswald, Vindolanda, and Housesteads, whose museums give insights into the daily lives of Roman soldiers // Walk beside the wall for a mile or two or hike its entire length on Hadrian's Wall Path // Bike the popular Hadrian's Cycleway.

THE INTERNATIONAL ANTIQUES AND COLLECTORS FAIR
Newark-on-Trent, Nottinghamshire, England

// The Thrill of the Hunt

Newark's 2-day International Antiques and Collectors Fair fills an 86-acre showground six times a year with up to 4,000 stands and stalls that attract vendors and buyers from all over the globe.

Must Do // Enjoy a unique cultural outing while shopping the world.

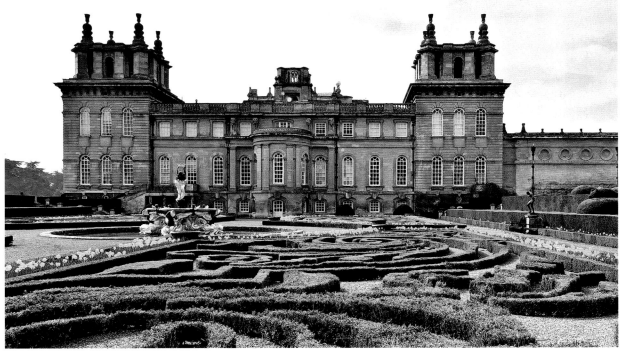

BLENHEIM PALACE
Woodstock, Oxfordshire, England

// England's Most Perfect Baroque Palace

Blenheim is the most celebrated of England's countless stately homes. Regarded as England's answer to Versailles, this Baroque palace is also the birthplace of Sir Winston Churchill.

Must Do // Explore 2,000 acres of park and gardens and try to navigate the famous Marlborough Maze, the world's largest hedge maze.

LUDLOW
Shropshire, England

// Gastronomic Getaway

Considered to be one of England's prettiest little towns, Ludlow is surrounded by the pastoral scenery of the Welsh border. The River Teme is spanned by medieval bridges that were a frequent subject of J.M.W. Turner's paintings, while Ludlow Castle looms over elegant Georgian and Jacobean houses.

Must Do // Sample the offerings of this epicurean center that is at the forefront of the UK's Slow Food movement // Attend the annual Food and Drink Festival.

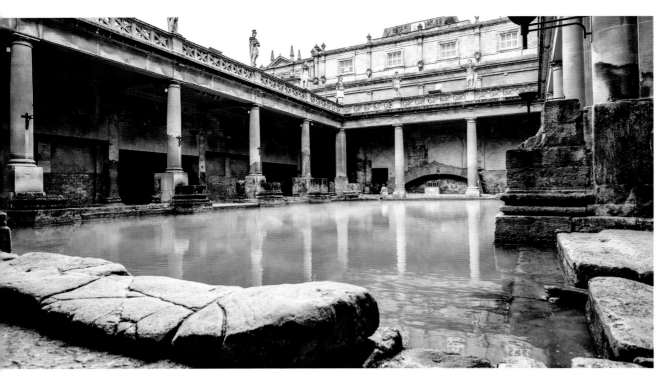

BATH
Somerset, England

// Britain's Most
Historic Spa Town

People have been enjoying the thermal hot springs of Britain's most beautifully preserved Georgian city since Celtic times, and Queen Anne's visit in 1702 launched Bath's rebirth as the country's premier spa town.

Must Visit // The Roman baths (*left*), among Britain's finest classical ruins // The 16th-century Bath Abbey // The Circus, 33 perfectly matching yet subtly differentiated houses that form a Colosseum-inspired circle // The Royal Crescent, a semiellipse of 30 identical stone houses overlooking Royal Victoria Park

WELLS CATHEDRAL
Wells, Somerset, England

// A Standout in
England's Smallest City

Wells reached its pinnacle of prestige when the magnificent Cathedral Church of St. Andrew was built in the 12th century. Over the following years, Wells gradually fell into a centuries-long slumber that preserved its character and heritage.

Must Do // Check the time using the world's second oldest clock, which announces the hour with a fanfare of tilting knights on armored steeds // Admire the cathedral's west front (*right*), heavily ornamented with six tiers of 365 carved life-size figures, completed in the early 13th century, to illustrate biblical stories for the illiterate masses // Travel 6 miles from Wells to Glastonbury Tor, thought to be the mythical Isle of Avalon or the last resting place of King Arthur or a meeting place for fairies or a beacon for UFOs // Attend the Glastonbury Festival, an annual celebration of rock and folk music held in the nearby village of Piton.

STRATFORD-UPON-AVON
Warwickshire, England

// Drama and Ghosts at Shakespeare's Birthplace

The timeless appeal of William Shakespeare's literary work has long made his hometown a point of pilgrimage. But Stratford-upon-Avon's streets of historic half-timbered houses would likely draw visitors even without the fame of the town's native son.

Must Do // Visit the house where Shakespeare was born, Anne Hathaway's cottage, and the 13th-century Trinity Church [*left*], where Shakespeare and his family are buried // Enjoy a performance by the Royal Shakespeare Company, one of the finest repertory troupes in the world // Stop for a pint at the Windmill, which is old enough to have been freqented by Shakespeare himself, or the Black Swan, known as the "Dirty Duck," a favorite spot for actors.

WARWICK CASTLE
Warwick, Warwickshire, England

// England's Finest Feudal Castle

Built in 1068 by William the Conqueror, Warwick occupies a commanding position on an escarpment above the River Avon. Peacocks preen on the grounds of this Norman fortress where visitors are entertained by the Pageant Playground and Castle Dungeon.

Must Do // View the castle's collection of medieval armor and weaponry, and paintings by Rubens and Van Dyck // Travel 5 miles north to visit Kenilworth Castle, once owned by Robert Dudley, rumored to have been a secret lover of Elizabeth I.

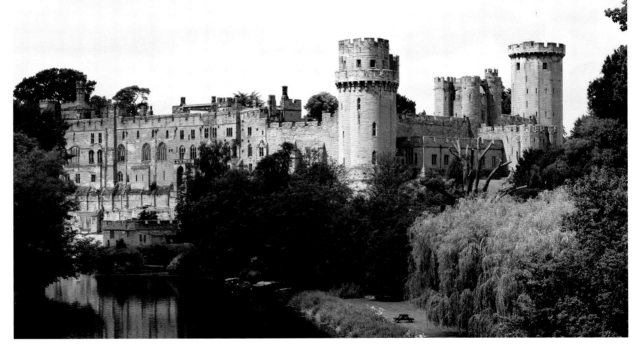

SALISBURY CATHEDRAL
Salisbury, Wiltshire, England

// A Masterpiece of Medieval Technology

The subject of paintings by J.M.W. Turner and John Constable, Salisbury Cathedral with its remarkable 404-foot spire, the tallest in the country, is the pinnacle of the Early English or pointed Gothic style of architecture. The cathedral contains an original Magna Carta and the oldest working clock in the world, a strange mechanical contraption with no dial.

Must Do // Climb up the spire's internal steps for a striking view in the direction of Salisbury Plain and Stonehenge // Drive about 20 miles south from Salisbury through the New Forest—once the private hunting ground of medieval kings and now one of England's newest national parks.

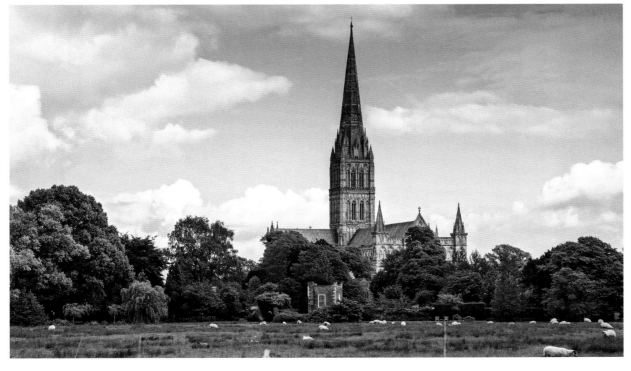

STONEHENGE
Wiltshire, England

// One of the World's Great Mysteries

Britain's best-known prehistoric site, Stonehenge retains an air of magic and mystery to this day. Neolithic and Bronze Age peoples built this collection of artfully placed rocks, then used the site for ceremonies pertaining to the sun and perhaps also as a calendar. Scholars disagree about where the stones came from and how they got to the windswept Salisbury Plain.

Must Do // Celebrate the summer and winter solstices with other visitors, including many modern-day druids // Drive 20 miles north to see the Avebury Stone Circles, which were erected 500 years before Stonehenge was completed.

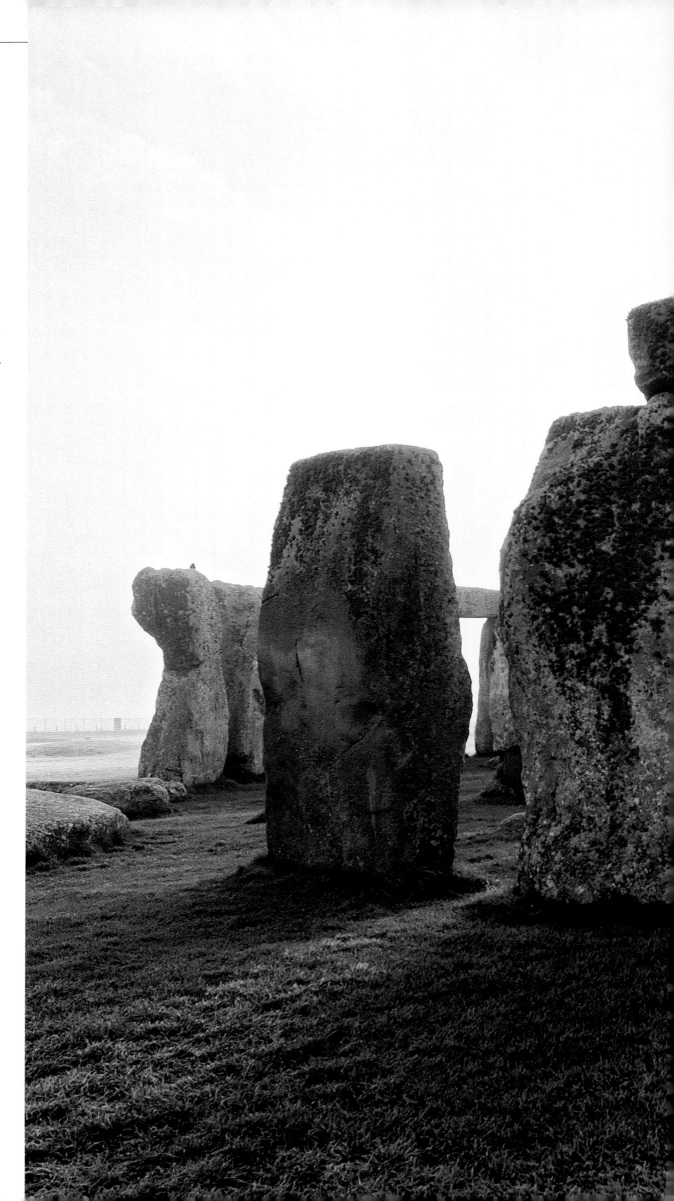

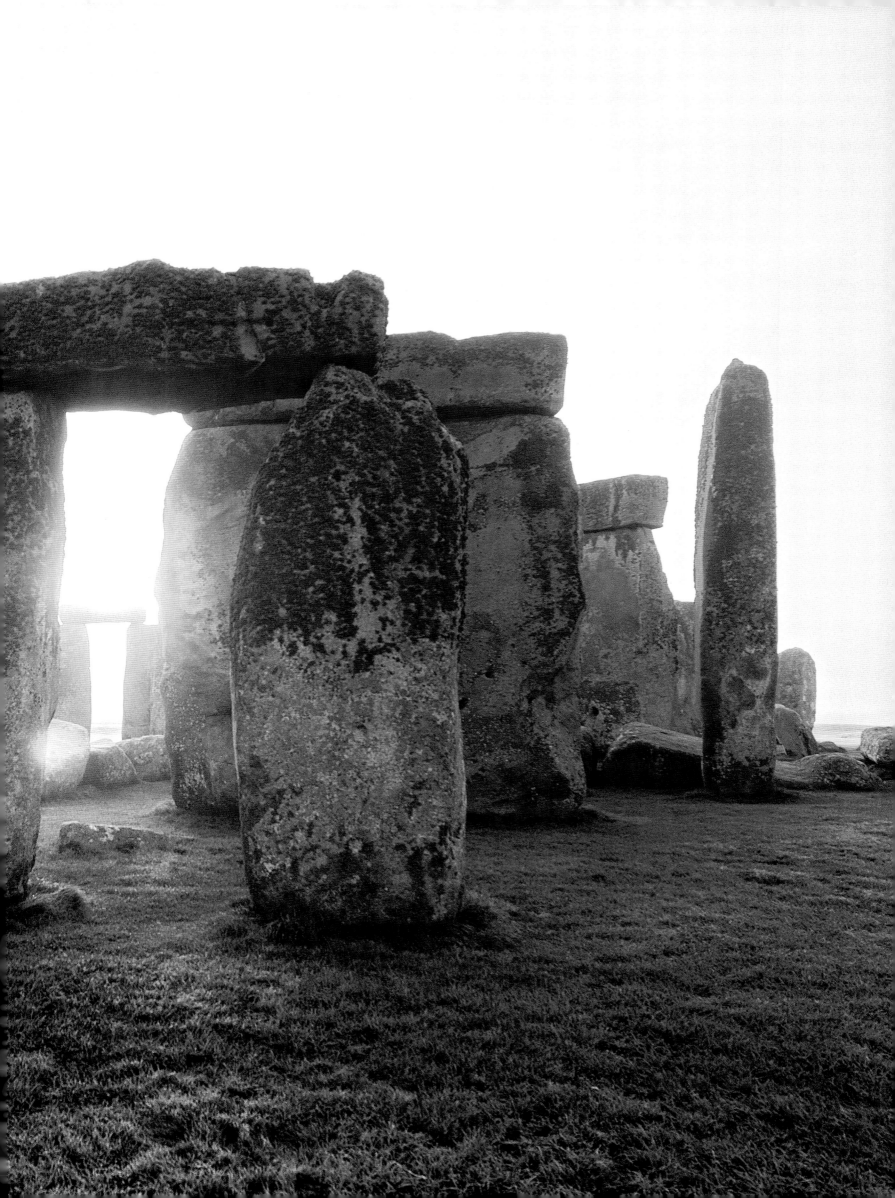

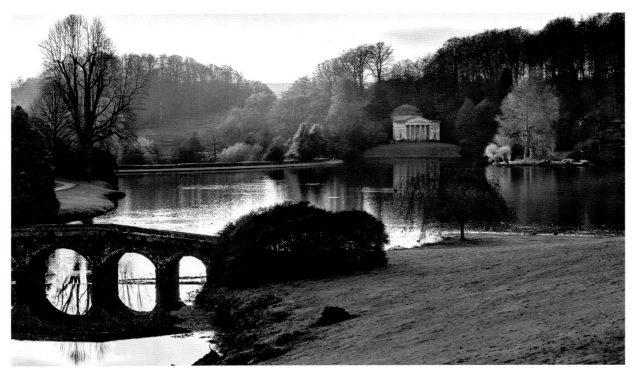

STOURHEAD GARDEN
Stourton, Wiltshire, England

// A Stroll Through a
Classical Painting

Stourhead is arguably England's finest example of 18th-century English landscape gardening. The grounds of Stourhead estate, owned by the Hoare family, were inspired by the paintings of Claude Lorrain and Gaspard Poussin, and are punctuated with a Neoclassical Pantheon (*left*), a grotto, and temples built to Flora and Apollo.

Must Do // Romantic walks in early fall along the footpaths that wind around a chain of small man-made lakes // In summer, delight in the garden's famous dells of rhododendrons and camellias in full bloom // Visit Stourhead House, a beautiful 18th-century Palladian-style mansion, where many rooms are open to the public.

CASTLE HOWARD
York, Yorkshire, England

// Grand, Stately, Elegant

Used as the location for the BBC's adaptation of Evelyn Waugh's *Brideshead Revisited*, Castle Howard sits amid 1,000 acres of parkland and gardens and has been the home of the Howard family for more than 300 years.

Must Visit // The Great Hall, which rises 70 feet from floor to dome // The 160-foot Long Gallery lined with portraits of Howard ancestors by Holbein and other artists

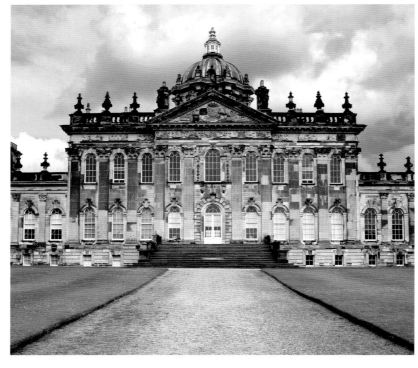

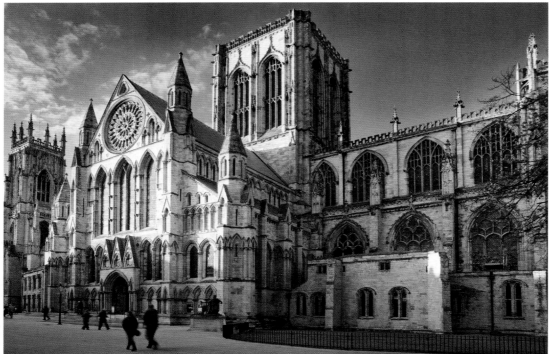

YORK MINSTER
York, Yorkshire, England

// An Ancient City's
Crowning Glory

Strolling on top of York's centuries-old defensive walls is one of England's finest pleasures, and all paths lead to its showpiece Gothic cathedral, York Minster— the largest medieval cathedral, in Great Britain. Climbing up the 275-step spiral staircase of its central tower gives the visitor an appreciation of the scale and the sophisticated engineering of this massive building and the buttresses holding it up.

Must Visit // The Rose Window, which commemorates the end of the War of the Roses // The Great East Window, the largest single medieval stained-glass window in the world // The Jorvik Center, which transports visitors back to the Viking era and the year 975

THE ROYAL SCOTSMAN
Edinburgh, Scotland

// Reliving the Grand
Days of Travel

Choose from 1- to 7-night itineraries through the Highlands and beyond on *The Royal Scotsman* (*below*). Journey through glens and mountain passes on remote and little-used railway lines with frequent stops to visit castles, distilleries, and scenic harbor towns in the relaxed and romantic ambience of the Edwardian era for which Belmond (formerly Orient Express) trains are known. From the kilted piper who greets you on the station platform to the restored grandeur of the mahogany-paneled parlor car and richly refurbished private compartments. the attention to detail is everywhere.

Must Do // Sample the local bounty in the elegant dining car and enjoy a dram or two on board from the excellent selection of Scotland's best whiskies // Explore the train itineraries across the UK.

EDINBURGH CASTLE AND FESTIVALS
Edinburgh, Scotland

// Heart and Soul of Historic
and Cultural Scotland

Scotland's capital owes much of its character to Edinburgh Castle, which overlooks the city from atop the remains of an ancient volcano. The castle displays the Scottish crown jewels and contains the royal chambers where Mary, Queen of Scots, gave birth to James VI of Scotland, who would rule England as James I.

Must Do // Walk the Royal Mile from the castle to Holyrood Palace, the official residence of the British monarch in Scotland // Admire the well-ordered display of August's Edinburgh Military Tattoo (*left*), possibly the world's most outstanding military spectacle // Attend the Edinburgh International Festival—a world-class extravaganza of music, drama, and dance held in August—and its amateur offshoot, the Edinburgh Festival Fringe.

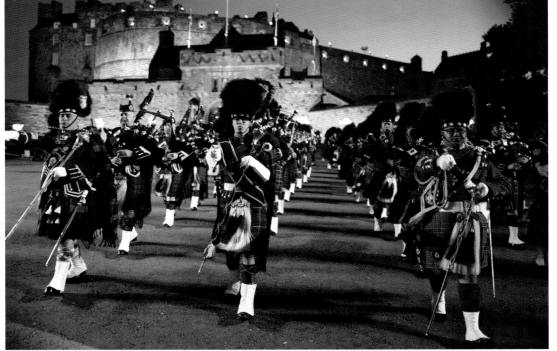

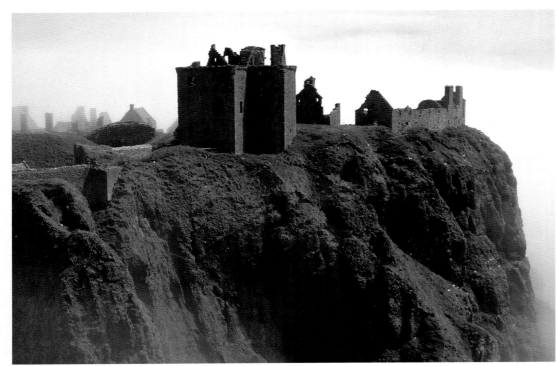

THE CASTLE TRAIL
Grampian Mountains, Scotland

**// Mountains and Monuments
in Scotland's Northeast**

One of the greatest concentrations of castles in Scotland can be found in the eastern foothills of the Grampian Mountains. Nineteen of the finest examples have been linked to form the Castle Trail, a signposted route for drivers that includes Delgatie Castle, one of the oldest in Scotland, and the ruins of the 13th-century Kildrummy Castle as well as the stately homes of Castle Fraser, Crathes Castle, and Fyvie Castle. All the castles are open to the public.

Must Do // Detour from the formal Castle Trail to view the dramatic ruins of Slains Castle, said to have inspired Bram Stoker to write *Dracula* // Perhaps the most dramatic location of all, visit the cliff-top towers and battlements of Dunnottar (*left*), where Franco Zeffirelli chose to film *Hamlet*.

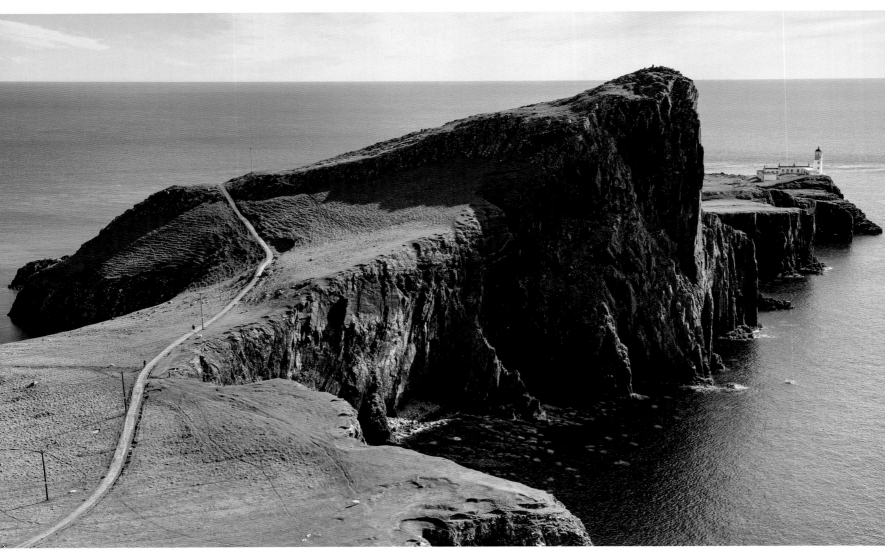

THE HEBRIDES
Scotland

**// Islands at
the Edge of the Sea**

Off the crenellated northwest coast of Scotland lie the islands of the Hebrides. Divided neatly into two areas—Inner and Outer—the Hebrides feature impressive and complex landscapes, with high mountains dropping precipitously to rocky shores and narrow sea-lochs cutting deep inland to create a wild and often remote region where land and sea become intertwined.

Must Do // Drive the Carrich Viaduct and the bridge over Loch Alsh to the Isle of Skye (*above*), the most famous of all the Inner Hebrides // Explore the rocky peak of Ben Mor and the scenic port of Tobermory on the island of Mull, also part of the Inner Hebrides // For those travelers with a taste for adventure, take an end-to-end road and ferry tour of the island chain.

ARGYLL HIGHLANDS
Highlands, Scotland

// A Warm Welcome Among
the Lochs and Glens

Argyll runs along Scotland's western coastline from the remote Ardnamurchan Peninsula to the Mull of Kintyre Lighthouse. Hills, glens, forests, and mountains combine to create dramatic and awe-inspiring scenery throughout the region. If driving to Oban (the region's main town) from Edinburgh or Glasgow, be sure to take the scenic route that cuts across the heart of the Argyll Highlands, through Glen Aray and past Loch Awe.

Must Do // Near Loch Awe, admire the dramatic ruins of Kilchurn Castle (*right*) // Take one of the ferries from Oban to the Inner or Outer Hebrides // Visit Inveraray Castle, the impressive home of the Duke and Duchess of Argyll // Detour down the western shore of Loch Fyne to Crarae Gardens.

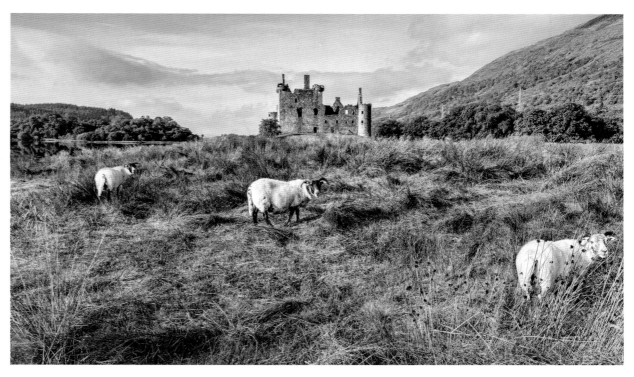

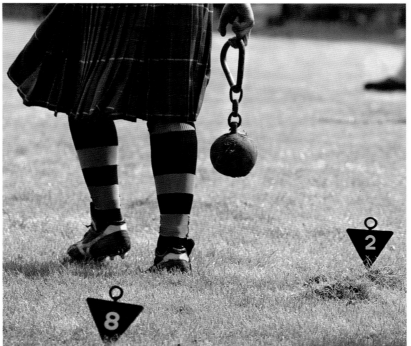

HIGHLAND GAMES
Braemar, Highlands, Scotland

// Hammers, Heavies, and
Ancient Traditions

Brightly colored tartans and the sound of bagpipes enhance these sporting and cultural events that celebrate all things Scottish. Held in towns throughout the Highlands every summer, the Highland Games test the physical prowess of the contestants (known as "Heavies") as they "throw the weight" (*left*), "throw the hammer," "put the stone," and "toss the caber."

Must Do // Visit Braemar and attend one of the most renowned of the 40-plus annual gatherings in the region.

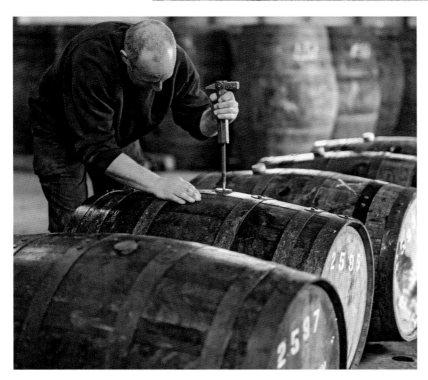

THE MALT WHISKY TRAIL
Speyside, Highlands, Scotland

// Water of Life

Authentic Scotch malt whisky must be made on its native soil, and the use of pure water, quality of the barley, and the amount of peat used to stoke the fire used in the production are all key. There are distilleries all over Scotland, but the epicenter of Scotland's amber spirits is Speyside—the valley of the River Spey. The Malt Whisky Trail starts at Grantown-on-Spey and leads to some of the most memorable spots for exploring the mystery of the malt.

Must Visit // Be sure to stop at the Glenfiddich Distillery in Dufftown; the Glenlivet Distillery in Glenlivet; and Cardhu and Glen Grant, both near the town of Aberlour // Detours worth considering are visits to Glen Moray, in Elgin; Benromach, near Forres; and Tomatin (*left*) when Inverness is your base.

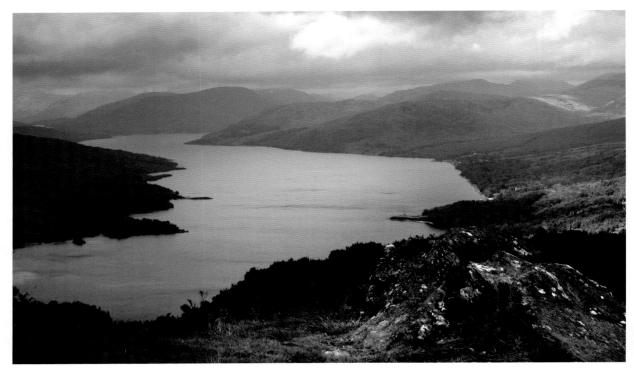

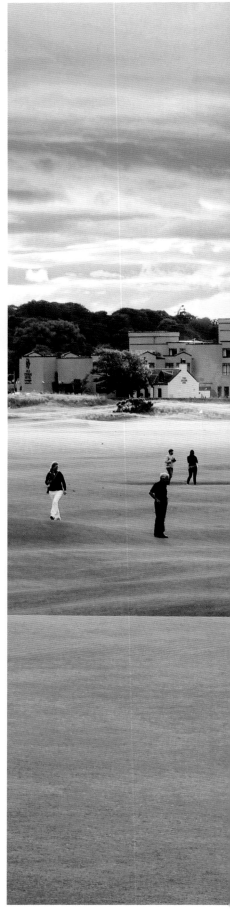

THE TROSSACHS NATIONAL PARK
Scotland

// In the Footsteps of Rob Roy and Braveheart

The Trossachs is where the Highlands meet the heather-clad Lowlands, whose centerpiece is Loch Lomond, the largest and most famous of Scotland's fjordlike lakes. Inspiring both writers and warriors, Rob Roy ("Red Robert") MacGregor became a Scottish folk hero akin to England's Robin Hood here, in part because of the popular book about the real-life Highlander outlaw by Sir Walter Scott, who had used nearby Loch Katrine (*above*) as the setting for "The Lady of the Lake."

Must Do // Hike or bike in Trossachs National Park, Scotland's first national park // Ply the waters of Loch Katrine on the SS *Sir Walter Scott* // Visit Stirling Castle and the nearby National Wallace Monument, overlooking the battlefield where William Wallace fought the English in the 13th century.

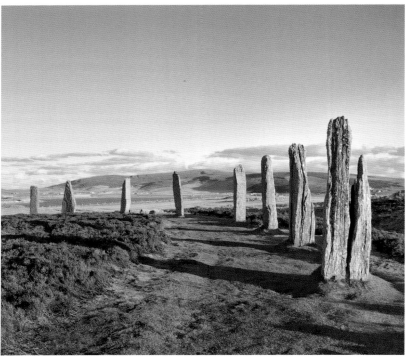

ORKNEY ISLANDS
Scotland

// Scotland's Rocky Northern Outpost

The 67 islands of the Orkney archipelago are a world apart from the Scottish mainland. Ruled by Norway until the 1470s, the Orkneys were used by the Vikings as a base for raids. Secluded beaches provide excellent seal- and bird-watching, and the Orkney capital Kirkwall on the island of Mainland can be reached by ferry from Aberdeen.

Must Do // Visit the semiunderground stone houses at Skara Brae and the mysterious stones known as the Ring of Brodgar (*above*), some of the best-preserved Neolithic sites in Europe.

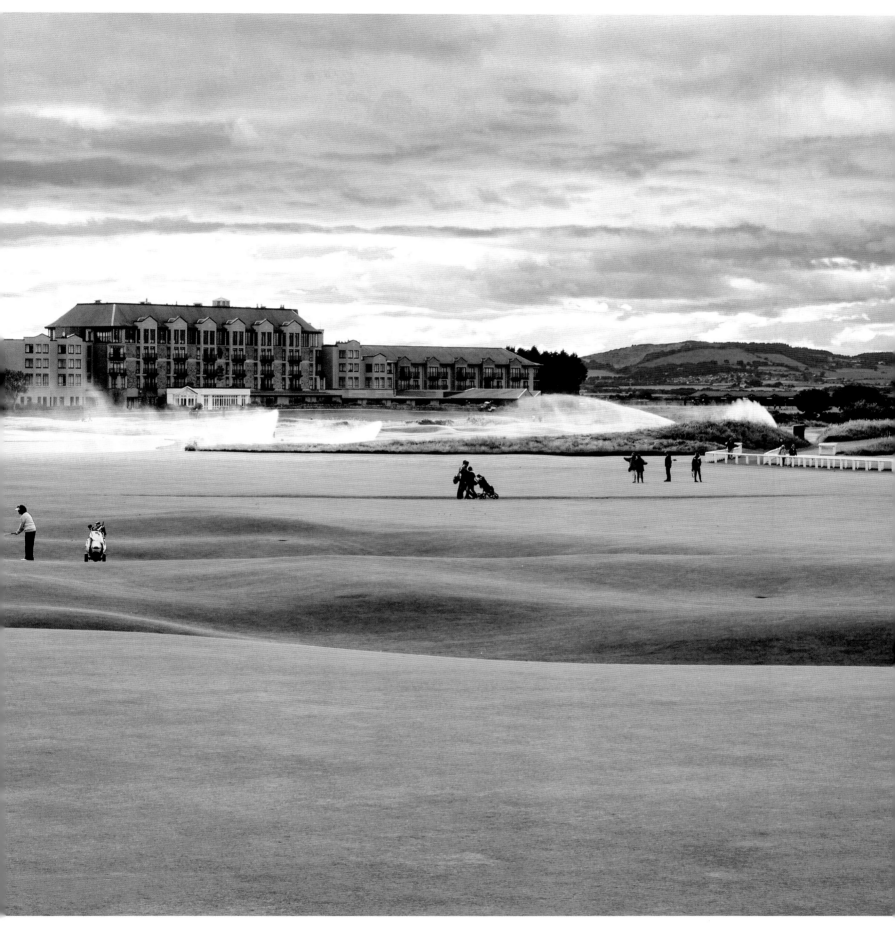

SCOTTISH GOLF
Scotland

// Birthplace of the Royal
and Ancient Game

Scotland is where historians believe golf originated as early as the 14th century. The country's more than 550 courses are considered among the world's finest, and many are true "links," a term derived from the old Scottish word for coastal dunes and scrubby undergrowth where trees are rare, bunkers are frequent, and unpredictable winds pose an additional hazard.

Must Visit // The Old Course at St. Andrews (*above*), the world's temple of golf // Muirfield, near Edinburgh, where many top-level tournaments have been played // The Royal Dornoch Golf Club north of Inverness, just 6 degrees short of the Arctic Circle // Turnberry, the coastal club that has its own lighthouse // Carnoustie, which world champions call the best in Britain despite its reputation for being treacherous

THE CASTLES OF NORTH WALES
North Wales, Wales

// Stalwart Symbols of the Past

From Roman garrisons and Norman strongholds to medieval forts and fanciful Victorian follies, the history of Wales is reflected in its many castles, the finest of which are in northern Wales. Most of them were constructed at the end of the 13th century by England's Edward I to impress and subdue the Welsh.

Must Visit // Beaumaris Castle (*right*) on the island of Anglesey // Conwy Castle and the perfectly preserved walls that surround the medieval town // The dramatic ruin of Harlech Castle // Caernarfon Castle, the site of the investiture of Prince Charles, the current Prince of Wales // Bodnant Garden, a few miles south of Conwy and one of the country's most luxuriant gardens

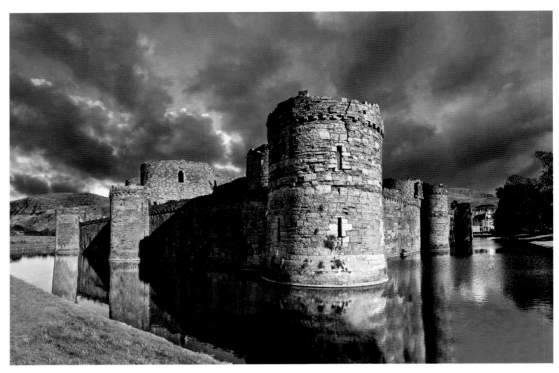

INTERNATIONAL MUSICAL EISTEDDFOD
Llangollen, North Wales, Wales

// Olympics of Welsh Culture

The Welsh tradition of poetry and music stretches back to the Celtic era and is symbolized by the harp, the country's best-known instrument. In more recent times, male choirs have become a major attraction at any festival of Welsh music and language (*eisteddfod*). Llangollen's International Musical Eisteddfod (*left*) is recognized as one of the world's greatest music and cultural festivals, with more than 4,000 performers of instrumental music, song, and dance from around the world.

Must Do // Enjoy Welsh-language-only performances at the annual weeklong National Eisteddfod of Wales, the largest poetry and song competition in Europe, held in a different town every year.

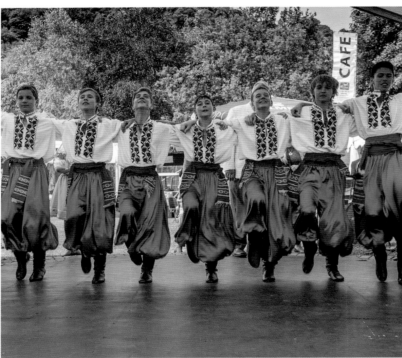

LLŶN PENINSULA
North Wales, Wales

// Nature's Beauty and One Man's Legacy

The Llŷn Peninsula is a popular holiday destination, thanks to its unspoiled rural landscape and sandy, picturesque coastline. Much of the peninsula is designated as an Area of Outstanding Natural Beauty, a protection given to locations in England and Wales, second in importance only to national parks.

Must Visit // Beaches such as Trefor and Nefyn Bay (*right*) in the north // The historic town of Criccieth and its 13th-century castle // The village of Portmeirion, with its Italianate campanile and piazzas built by Sir Bertram Clough Williams-Ellis, who was reportedly inspired by the architecture of Portofino in Italy

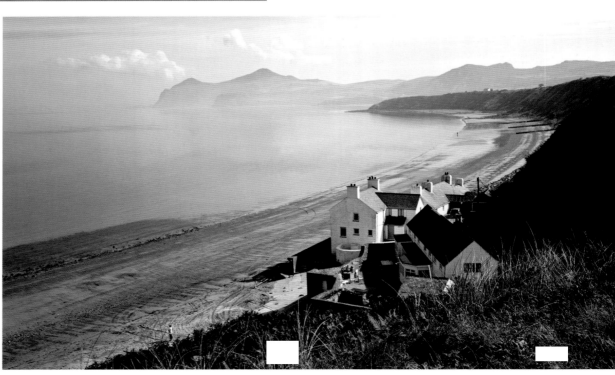

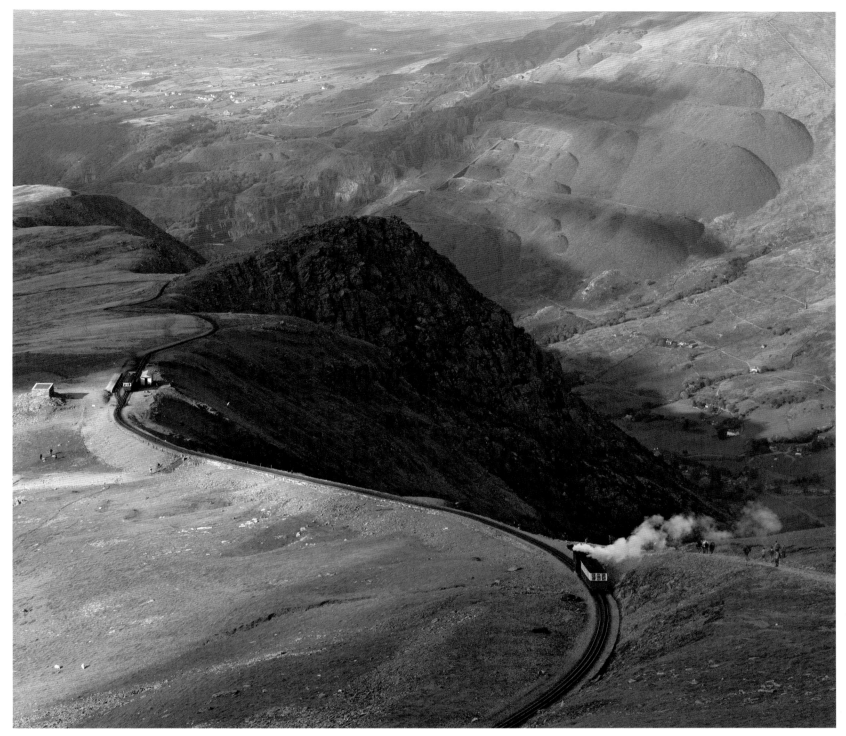

SNOWDONIA NATIONAL PARK
North Wales, Wales

// Arthurian Mountains and Victorian Railways

The mountains of Snowdonia National Park offer unparalleled grandeur and beauty and take their name from Snowdon, at 3,560 feet, the highest point in Wales and England. According to myth, this rugged peak is watched over by the spirit of King Arthur, while his Knights of the Round Table lie sleeping underneath.

Must Do // Ride one of the steam-powered locomotives (*above*) that stop just 70 feet below the peak, leaving an easy climb to the top // Depart from the village of Llanberis for a 3-hour trek to the summit of Snowdon // Hike and bike amid spectacular scenery and wildlife in the park // Take one of the other narrow-gauge steam railways to tiny villages and remote stations.

DYLAN THOMAS COUNTRY
South Wales, Wales

// Poetic Landscapes

The Welsh coastal town of Laugharne is best known as the home of Dylan Thomas, the nation's favorite poet, and there are still a few old-timers in town who remember him enjoying a pint in the bar at Brown's Hotel.

Must Do // Tour the Dylan Thomas Boathouse museum (*right*), where the poet lived. Nearby is his writing shed, where he wrote some of his most famous works, including part of his landmark play, *Under Milk Wood*, which was adapted into the classic 1972 film, shot close by, starring Elizabeth Taylor, Peter O'Toole, and the Welsh-born Richard Burton // In Swansea, where Thomas was born and educated, celebrate his life and work at the Dylan Thomas Centre in the revitalized Maritime Quarter, and attend the annual 2-week-long Dylan Thomas Festival that starts on October 27, his birthday.

WYE VALLEY
Southeast Wales, Wales

// In the Footsteps
of Wordsworth

For much of its southern extent, the border between England and Wales is marked by the River Wye. On a bend in the River Wye, the ruins of the 13th-century Tintern Abbey (right) were rediscovered in the 18th century by artists and poets. Enchanted by the abbey's sylvan setting, William Wordsworth penned a much-loved sonnet celebrating the greatness of God in nature.

Must Visit // The historic border town of Monmouth and its castle built in 1067 // One of the oldest surviving stone castles in Britain, built where the River Wye meets the River Severn near the town of Chepstow

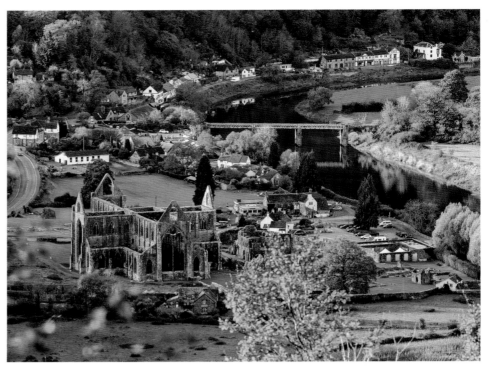

ST. DAVIDS CATHEDRAL
Pembrokeshire, West Wales, Wales

// Sacred Site on
a Scenic Coastline

Flanked by the glorious ruin of the once magnificent Bishop's Palace, the cathedral dedicated to the patron saint of Wales is hidden (a reminder of the days when it needed to be secluded from Viking raiders and marauding pirates) in a valley a short walk from the tiny town of St. Davids. St. David is buried here, making it Wales's most sacred site.

Must Do // Hike Pembrokeshire Coast National Park's cliff-top and seaside footpaths or surf the big waves off the park's sandy beaches // Walk part or all of the Wales Coast Path, an 870-mile route along the country's entire coastline.

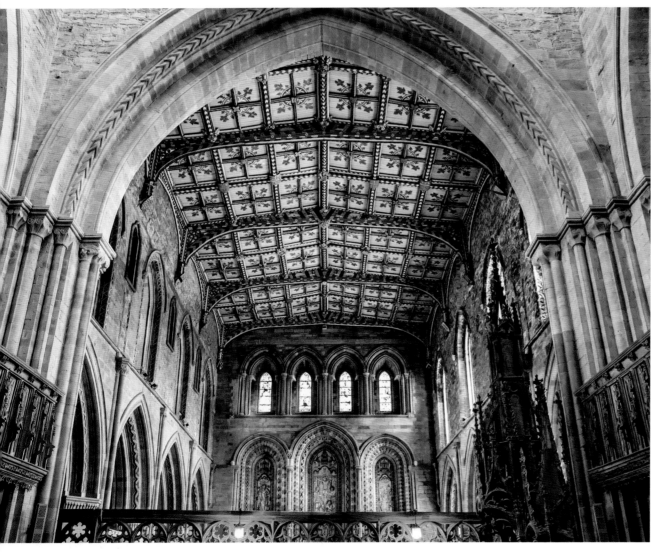

THE COAST OF CLARE
County Clare, Ireland

// Moody Moonscapes
to Stone Castles

The coast of County Clare runs the gamut from stone pastures and towering cliffs to a cluster of romantic castles. It may seem barren at first, but you'll see some of the nearly 1,000 species of plants in the only place in Europe where Mediterranean and Alpine flowers grow side by side.

Must Do // The Cliffs of Moher (*right*), Ireland's most recognizable landmark, are the highlights of a well-signposted hiking trail, the 28-mile Burren Way // Enjoy traditional music in Doolin, a one-street town with more than its share of pubs // Feast at a raucous medieval banquet at the 15th-century Bunratty Castle, an Irish-village theme park.

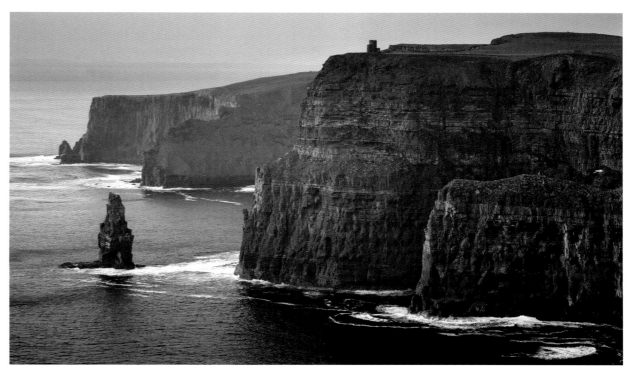

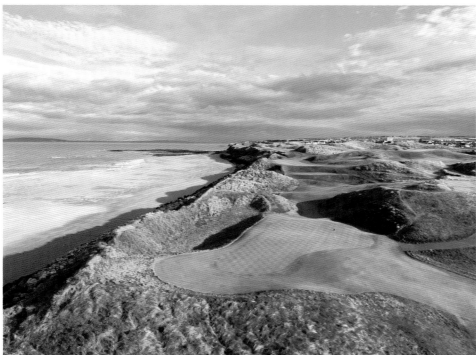

IRELAND'S TEMPLES OF GOLF
Counties Clare and Kerry, Ireland

// Heaven on the Green

Many of Ireland's more than 400 courses surround idyllic castle hotels and ramble across emerald pastures, but the outstanding links of Ireland's southwest remain the most visited. Topping the list is the Ballybunion Golf Club (*left*) that graces the blustery gray coast of County Kerry.

Must Visit // Lahinch Golf Club in nearby County Clare, where the Old Course undulates along the rugged coastline of Liscannor Bay // Waterville Links, which offers inspiring views along Ballinskelligs Bay // Killarney National Park's three courses, one of which runs along the largest freshwater lake in the region, an enchanting backdrop and an obstacle to avoid

CORK JAZZ FESTIVAL AND BLARNEY CASTLE
County Cork, Ireland

// Vibrant Music
and Divine Inspiration

Cork hosts the country's number one jazz festival, which provides a long weekend of fun in late October before the chill of winter settles in. Beer plays a vital role in keeping the beat (Guinness is the sponsor) but is overshadowed by the power, quality, and diversity of the music.

Must Do // Catch spontaneous performances by up-and-coming talents on street corners or in pubs as well as the poetry readings, gallery shows, and film screenings held during the festival // Kiss the Blarney Stone, believed to have special powers, after climbing the narrow steel steps of the 500-year-old Blarney Castle, 5 miles northwest of Cork.

CULINARY CORK
County Cork, Ireland

// From Famine to
Food Revolution

County Cork, where in the 19th century emigrants fled from famine, is today the epicenter of Ireland's modern culinary reawakening. Its reputation as a food capital was launched in 1964 when Myrtle Allen opened the restaurant Ballymaloe House (*left*), and has grown with the establishment of its now famous cooking school and a farmers market in Midleton. Local butchers, fishmongers, produce growers, bakers, and cheese purveyors provide fresh, impeccable ingredients for the area's many fine restaurants.

Must Visit // The seaside town of Kinsale, south of Cork City, called Ireland's Culinary Capital for its October International Gourmet Festival and year-round dining featuring seafood

WILD DONEGAL
County Donegal, Ireland

// The Island's
Northernmost Fringe

Donegal's breathtaking coastline in Ireland's northwest corner offers boundless opportunities for sea kayaking, scuba diving, hiking, surfing, or watching whales, basking sharks, and a variety of birds from puffins to peregrine falcons.

Must Do // Hike the heart-stopping One Man's Pass, a narrow trail along the top of Donegal's dramatic highlight, the 30-mile-long Slieve League peninsula, or walk Slí Cholmcille's Way, a long-distance route to the graceful Assarancagh Waterfall and stunning Glengesh Pass // Visit Glenveagh National Park, an essential wilderness excursion with a neo-Gothic castle at its heart // Explore Lough Swilly (Lake of Shadows) and the pre-Celtic fort Grianan Ailligh for magnificent views // Drive the Inis Eoghain 100, a scenic 100-mile loop, and stop at Malin Head's rocky promontory.

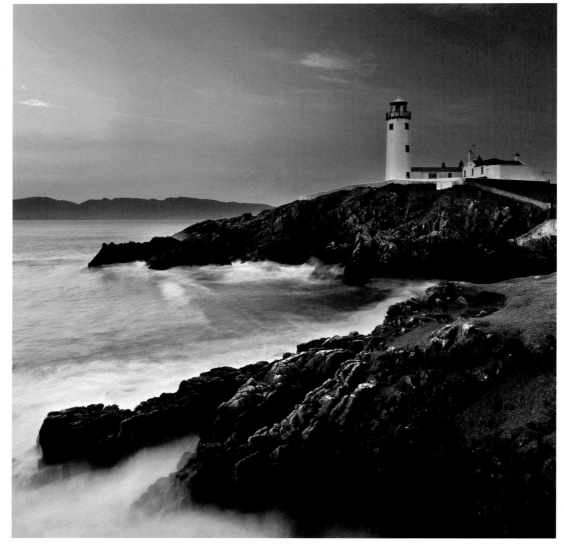

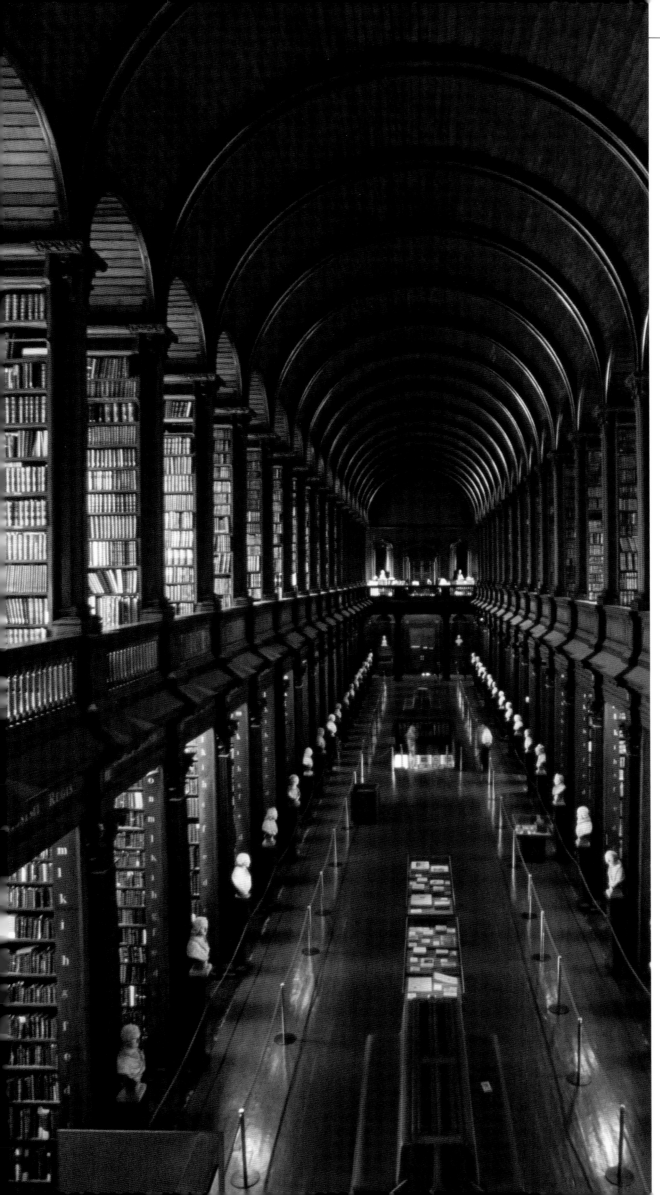

HISTORICAL, CULINARY, AND LITERARY DUBLIN
Dublin, Ireland

// Flavors, Books, and
Landmarks Along the Liffey

Dublin's political history culminated with the 1916 Rising, when 1,200 armed citizens who wanted to free Ireland from British occupation took over Dublin's General Post Office (G.P.O.) and made it their headquarters. Eventually, the rebel leaders surrendered and the G.P.O. was burned to a shell, but today it stands renovated, a landmark that launched the free Irish Republic, with portico columns still bearing bullet pockmarks.

Over the past few decades, Dublin has evolved from its pub-grub reputation to a gastronomic contender. In 1981, Patrick Guilbaud opened his restaurant here, underpinning an elegant French menu with Irish ingredients and paving the way for a citywide culinary awakening.

Ireland's deep love of words stretches back to Druidic oral poetry, Celtic myth, and Ogham-alphabet writing inscribed on stone. Dublin names bridges and streets after writers, erects memorials to commemorate them, designates historical houses in their honor, and awards the world's largest literary prize every year. Dublin boasts such famous literary sons as James Joyce, George Bernard Shaw, W. B. Yeats, Samuel Beckett, and Seamus Heaney. Trinity College's roster of alumni includes writers Jonathan Swift, Bram Stoker, Oscar Wilde, and Samuel Beckett.

Must Do // Visit Trinity College's Old Library's Long Room (*pictured*), which houses the Book of Kells; the James Joyce Centre; the Dublin Writers Museum (sit at the chef's table in its basement); and the Irish Writers Centre // Dine at the Winding Stair restaurant, named after a W. B. Yeats poem, and peruse its adjacent bookshop // Enjoy an "enhanced" afternoon tea at Temple Bar's Clarence Hotel, owned by U2's Bono and the Edge // Visit Kilmainham Gaol, where most of the rebel leaders were executed; Arbour Hill military cemetery; the Decorative Arts and History branch of the National Museum of Ireland; and Dublin's Garden of Remembrance.

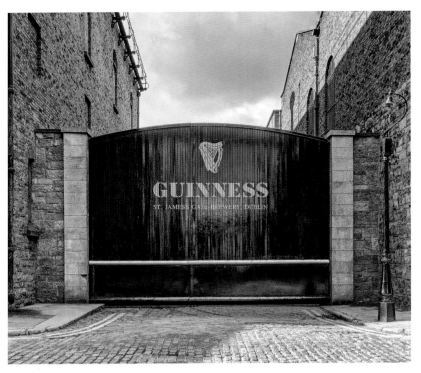

PUBS AND ST. PATRICK'S FESTIVAL
Dublin, Ireland

// Celebrating
All Things Irish

You'll find plenty of Guinness and *craic* (Irish for "sociable good times") when you join the locals in one of the city's 1,000-plus pubs that draw frothy pints of what James Joyce called "the wine of Ireland." When March rolls around, Dublin turns to honoring St. Patrick with a 4- to 5-day celebration, including the St. Patrick's Day parade as a highlight.

Must Do // Spend a few hours at the Guinness Storehouse [*left*], the former fermentation plant // Visit lantern-lit Brazen Head, the oldest pub in Ireland, born as a coaching inn in 1198 and licensed as a pub in 1661 // Enjoy an impromptu jam session at O'Donoghue's.

ARAN ISLANDS
County Galway, Ireland

// Windswept Outposts
of Gaelic Culture

The trio of windblown Aran Islands off Ireland's western shore offers a window onto centuries past. These hardscrabble limestone islands—which are scattered with Iron Age stone forts, Neolithic wedges, early Christian churches, and *clocháns* (monastic beehive stone huts)—became home to native Irish forced by 17th-century British penal laws to migrate west. Playwright John Millington Synge immortalized the Arans as "Ireland at its most exotic, colorful, and traditional."

Must Visit // Dún Aengus, the haunting ruins of a 4,000-year-old megalithic cliff fort on Inishmore, the largest and most-visited island // Inisheer during its traditional summer drum festival // Inishmaan, and Synge's cottage, now a seasonal museum filled with Synge memorabilia, and run by a descendant of his original host

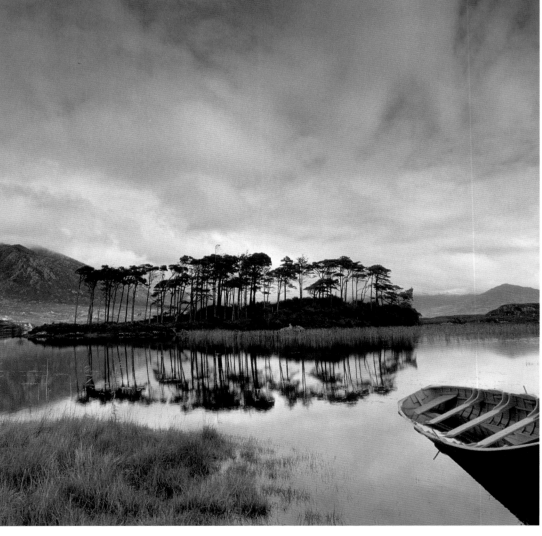

CONNEMARA
County Galway, Ireland

// The Wild West

Oscar Wilde called this rugged and lonely area a "savage beauty." Connemara, which was once part of the biggest private estate in Ireland, makes up the western third of County Galway, a region known for its romantic landscapes and peat bogs.

Must Visit // Clifden, the unofficial capital of the region, for access to the Sky Road that offers glimpses of the sharp peaks of the Twelve Bens // Nearby Ballynahinch Lake [*above*] for salmon fishing // Connemara National Park, with herds of red deer and Connemara ponies

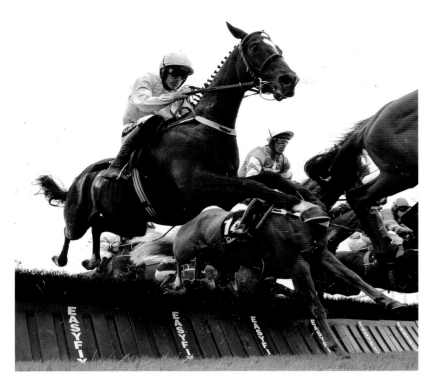

GALWAY
County Galway, Ireland

// Ireland's Most
Festive Town

Galway hosts Ireland's largest interdisciplinary arts extravaganza, with public performances including a festival of medieval, Renaissance, and Baroque music; major literary events; and Ireland's leading film festival. Foodies make the short trip to the neighboring fishing village of Kilcolgan to celebrate the oyster at a massive festival in September.

Must Do // Attend the Galway Races, which attract around 150,000 horse racing fans // Join in the festival of Galway "hookers," traditional sailboats constructed for rough seas // Explore Galway's Medieval Quarter and Lynch's Castle // Cross the Corrib River and visit Claddagh, where the world-famous ring—two hands clasping a crowned heart, symbolizing friendship, loyalty, and love—originated.

DINGLE PENINSULA
County Kerry, Ireland

// Last Stop Before Brooklyn

Dingle Peninsula, the westernmost point in Europe, juts out fiercely and dramatically into the Atlantic. The lilt of Irish Gaelic is still heard here, and Celtic monuments to ancient Christianity litter the rugged and spectacularly scenic coastline.

Must Do // Drive up and over sinuous Conor Pass for its breathtaking views // Visit Dingle (*right*), the prettiest town in all of County Kerry, where *Ryan's Daughter* was filmed.

THE RING OF KERRY
County Kerry, Ireland

// A Dream Drive Along
the Iveragh Peninsula

The Ring of Kerry reveals particularly breathtaking vistas of land, sea, and sky as it unfurls along a 110-mile coastal route around the Iveragh Peninsula. Most drivers begin in Killarney, a village near the ivy-covered Victorian mansion Muckross House, now a museum and the entrance to car-free Killarney National Park and its beautiful waterfalls.

Must Do // Ride a horse-drawn "jaunting car" in Killarney National Park // Walk the Kerry Way, a strenuous, 120-mile trek that encircles the peninsula // If the sea is calm, take a boat from Port Magee to Skellig Michael, the island home of a well-preserved 7th-century monastery.

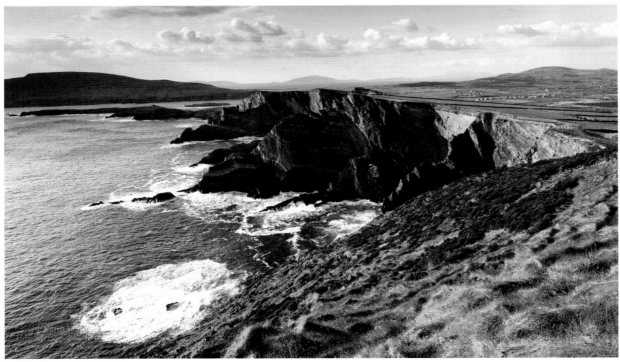

HORSE COUNTRY
Straffan (County Kildare) and Thomastown (County Kilkenny), Ireland

// Riding and Golf in the Heart of Thoroughbred Country

Kildare and Kilkenny counties are home to many of Ireland's 300 stud farms and the site of the famous Curragh Racecourse, where the Irish Derby is held during the last week in June.

Must Do // Visit the Irish National Stud (*left*), where some of the country's most famous horses have been born and raised. Stroll its Japanese Gardens or golf at one of the property's two top-ranked 18-hole courses // Ride the bridle trails at Mount Juliet's Ballyinch Stud Farm or fish for trout and salmon on the River Nore.

ADARE
Adare, County Limerick, Ireland

// Ireland's Most Charming Village

One of Ireland's most photographed villages, Adare is a snug collection of thatch-roofed cottages (*right*), Tudor-style houses, good restaurants, and ivied medieval ruins.

Must Do // Take in historic Adare Manor Hotel's colossal halls, ornate fireplaces, enormous oil portraits, and Waterford-crystal chandeliers // Golf the castle hotel's 18-hole championship course.

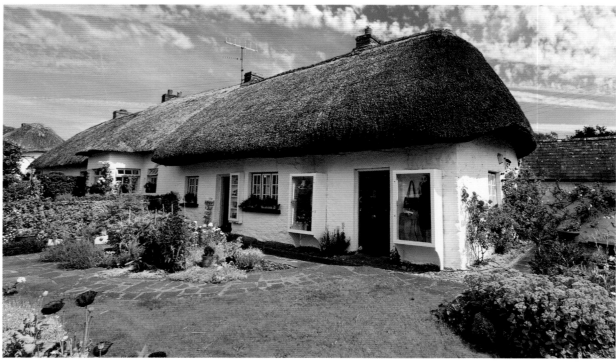

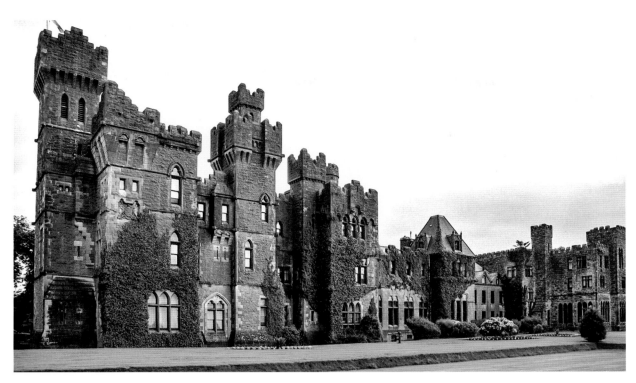

ASHFORD CASTLE
Cong, County Mayo, Ireland

// The Fairest of Them All

Once the home of the Guinness family, Ashford Castle is now one of Europe's most imposing castle hotels. Turrets, drawbridge, and battlements are coupled with gracious service, canopied four-poster beds, and crackling fires. When John Ford filmed scenes of *The Quiet Man* on Ashford's extensive grounds and in the neighboring village of Cong, some of the cast called the stately castle home.

Must Visit // The bronze memorial—at the base of County Mayo's sacred mountain, Croagh Patrick—dedicated to the victims of the famine its residents once experienced // Mayo's Ceide Fields, the world's most extensive Stone Age site

THE BOYNE VALLEY
County Meath, Ireland

// Ancient History's
Sacred Ground

The megalithic monuments called Brú na Bóinne cluster along the banks of the River Boyne just north of Dublin. The main site, Newgrange [*right*], encloses a long, narrow stone passageway that ends in a cruciform, corbel-vaulted room, likely a tomb and royal chamber.

Must Visit // Newgrange, during the winter solstice. Enter the lottery for a chance to climb inside to see the first light of day illuminate the chamber for 20 minutes // Knowth, which displays the greatest concentration of megalithic art in Western Europe // The sacred Hill of Tara and its Stone of Destiny, reputed to be the coronation site of ancient Irish kings // Trim, Ireland's largest Anglo-Norman castle, where Mel Gibson shot parts of *Braveheart*

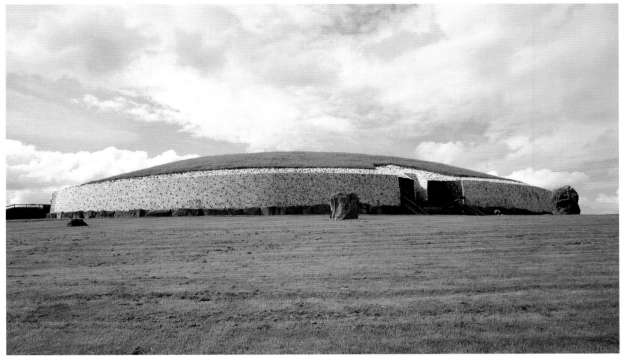

YEATS COUNTRY
County Sligo, Ireland

// Terrain of
the Celtic Twilight

William Butler Yeats spent summers in County Sligo with his mother's family when he was a child. His later poems, plays, and prose were often inspired by Sligo's evocative landscapes and legends.

Must Do // Wander along the banks of Lough Gill [*left*], whose Innisfree Isle inspired one of Yeats's most famous poems, and visit the Dooney Rock and the hazel woods. Or climb Knocknarea Mountain, then continue east to the Glencar waterfall // Pause a moment at the writer's final resting place in Sligo's Drumcliffe graveyard at St. Columba's Church. The church's door handles, Yeats's epitaph, and a statue crouched outside the graveyard all recall parts of Yeats's poems.

WEXFORD OPERA FESTIVAL
Wexford, County Wexford, Ireland

// Showcasing the Offbeat and Little Known

The whole town turns out for Wexford's renowned Opera Festival. Nonelitist and often offbeat, the 3-week festival showcases lesser-known operas and world-class performers.

Must Do // Attend the festival that begins in October and enjoy the myriad art exhibitions, traditional Irish music, and lively atmosphere.

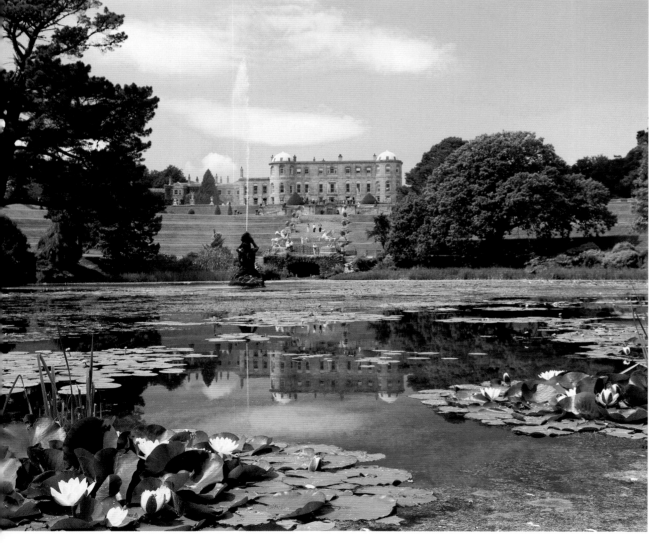

THE GARDENS OF WICKLOW
County Wicklow, Ireland

// Pride of the Emerald Isle

County Wicklow, known as the "Garden of Ireland," is home to more than 30 public gardens, from tiny half-acre cottage plots to the sprawling 47 acres of Powerscourt (*left*), Ireland's most visited garden.

Must Do // Take in Powerscourt's richly textured landscape, including formal flower beds, ornamental lakes, a Japanese garden, and more than 200 varieties of trees and shrubs // Strike off across the 1,000-acre estate for a picnic at its waterfall, the highest in the British Isles at 398 feet // Hike a stretch of the 79-mile Wicklow Way in Wicklow Mountains National Park.

BELFAST'S MOMENT
County Antrim, Northern Ireland

// Leaving the
Troubles Behind

Belfast grew rapidly during the Industrial Revolution, thanks to its linen, tobacco, rope, and shipbuilding industries (the *Titanic* launched from its quays in 1912). In 1922, most of Ireland obtained independence from England, except for 6 of its 32 counties. A schism was created and Belfast suffered during a decades-long political conflict with Britain. But ceasefires, peace treaties, and tenuous power sharing by Nationalists and Unionists have ushered the capital of Northern Ireland into a new era.

Must Do // The museum devoted to the *Titanic* // A black cab tour to see the painted murals (*right*) created by both the Nationalists and Unionists // The Botanic Gardens' Palm House Conservatory and St. George's Market, an indoor bazaar

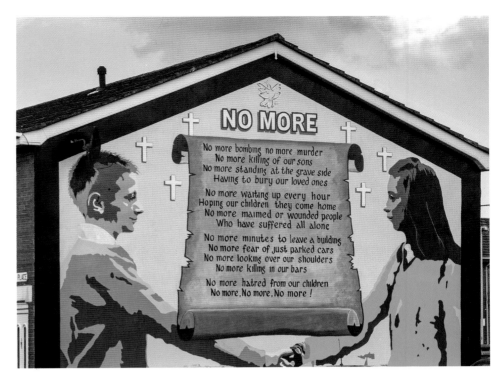

THE CAUSEWAY COAST
County Antrim, Northern Ireland

// Nature's Masterwork

The rugged scenery of Northern Ireland is easily traversed on the scenic Causeway Coastal Route. The small country's biggest attraction is the grand, strange, and astonishing Giant's Causeway (*left*), the country's only UNESCO World Heritage site. This honeycomb mass comprises over 40,000 basalt columns created by volcanic eruptions some 60 million years ago.

Must Do // Hopscotch around the tightly packed formations of the Giant's Causeway. Or wander along the cliff-top belvederes to marvel from above // Stop for a tipple at Bushmills, Ireland's oldest-known whiskey distillery // Brave the Carrick-a-Rede rope bridge, a wobbly path over a watery chasm to rocky Carrick Island // Golf at the top-ranked Royal Portrush, with striking views of the 13th-century Dunluce Castle, the largest Norman castle in the north.

THE KINGDOM OF MOURNE
County Down, Northern Ireland

// Wuthering Heights

The remote Mournes, Northern Ireland's highest mountain range, contain 50-some granite peaks over 2,000 feet high that resemble "earth-covered potatoes," according to C. S. Lewis, and offer the best hiking in the country.

Must Do // Climb the highest peak, Slieve Donard (2,796 feet), starting near Bloody Bridge // Hike the challenging 22-mile Mourne Wall trek (*right*) that crosses 15 peaks // Reserve your time at the Royal County Down Golf Club, founded in 1899 and arguably the top course in Ireland

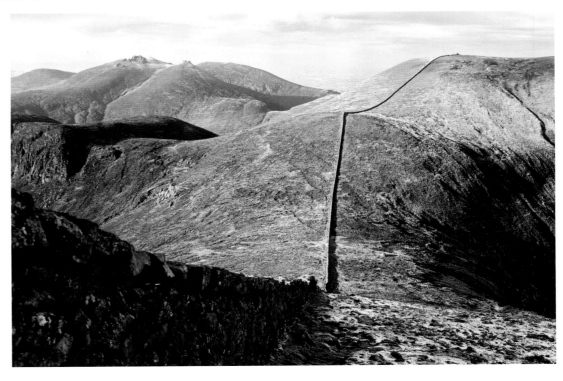

Western Europe

ARLBERG REGION AND KITZBÜHEL
Austria

// The Pinnacle of
Alpine Playgrounds

Choice downhill skiing can be found in
the western reaches of the Austrian Alps.
Picturesque Arlberg [*right*]—encompassing
the charming towns of Lech, Zürs, St. Anton,
St. Christoph, and Stuben—ensures ample
amounts of powder. Kitzbühel, equidistant
from Innsbruck and Salzburg, is beloved for
its glamorous atmosphere.

Must Visit // The sister hamlets of Lech-
Zürs to find groomed and ungroomed runs,
including the magnificent 12-mile Madloch
tour // Kitzbühel, home of its world-famous
Hahnenkamm downhill run with its heart-
stopping cable-car rides and 120 miles of
summertime hiking trails // Kitzbühel's
historic town center of cobbled streets and
pastel-painted medieval houses

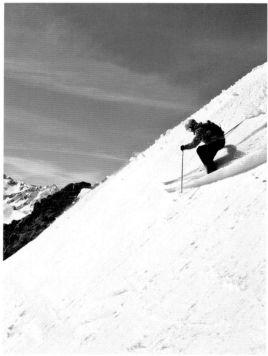

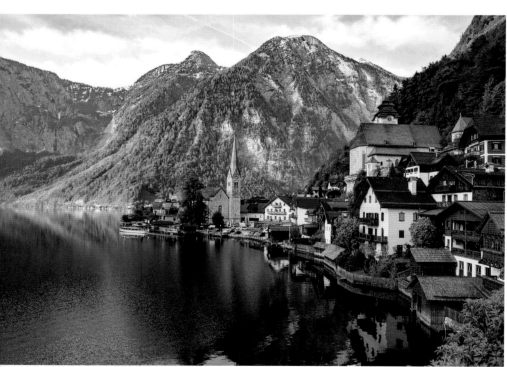

GROSSGLOCKNER ROAD AND HALLSTATT
Austria

// From Picturesque Peaks
to Lakeside Splendor

Grossglockner Road is a white-knuckle,
breathtaking drive through some of Austria's
most scenic regions. An important trading
route between Germany and Italy in the
Middle Ages, the current road between
Bruck in Salzburg and Heiligenblut in
Carinthia was built between 1930 and 1935.

Must Visit // Hallstatt [*above*], the storybook
lakeside village 34 miles southeast of
Salzburg that is home to the world's first
known salt mine // Hohe Tauern National
Park and its towering centerpiece, the
12,460-foot-tall Grossglockner

AUSTRIA'S MUSIC FESTIVALS
Austria

// Pulling the Right Strings

The hills *are* indeed alive with the sound of
music in Austria, thanks to the spectacular
Bregenz Festival on a floating stage at
the edge of Lake Constance; the Salzburg
Festival, Europe's largest annual musical
event, held in Mozart's birthplace; and the
Schubertiade [*above*], a festival honoring
Franz Schubert held in the charming
villages of Schwarzenberg and Hohenems.

Must Do // Take a ferry from Bregenz across
Lake Constance or ride the gondola up
Pfänder Mountain for panoramic views //
Join a hokey but fun *Sound of Music* tour in
Salzburg.

OLD GRAZ
Austria

// Historic Architecture
and Modern Design

Established as the southeastern seat of
the Hapsburg Empire in 1379, Graz features
one of Central Europe's best-preserved
Old Towns, known for its magnificent
architecture from the Middle Ages and
the Renaissance. In striking contrast
to the Old Town's medieval contours
are contemporary landmarks such
as the Kunsthaus art museum (*right*),
which stands out against its historic
surroundings.

Must Visit // The 17th-century
Landeszeughaus, Europe's largest
armory, with more than 30,000 pieces
of every kind of armory and weaponry
// The Murinsel, a floating glass-and-steel
platform that hosts an amphitheater and
playground // The Bundesgestüt in nearby
Piber, where the famous Lipizzaner horses
are bred and raised for the Spanish Riding
School in Vienna

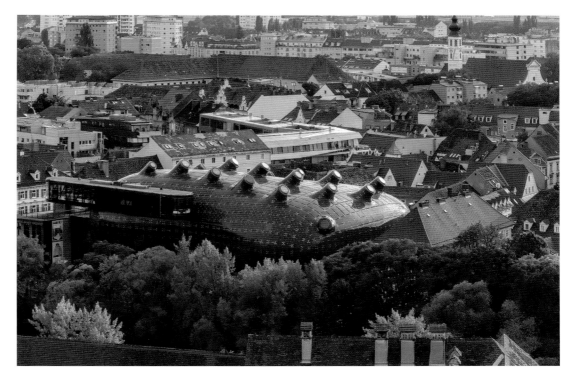

SALZBURG:
BAROQUE
AND MODERN
Austria

// Much More Than Just Mozart

Dominated by the cliff-top medieval
Hohensalzburg Fortress, Salzburg's
wealth of High Baroque architecture is
due in large part to prince-archbishop
Wolf Dietrich, who rebuilt Salzburg into
an Italianate city in the late 16th century.
He also commissioned the French-style
Schloss Mirabell for his mistress and
their 15 children.

Must Visit // The 17th-century cathedral
Salzburger Dom (*left*), renowned for
its 4,000-pipe organ and elaborate
frescoes // The hilltop Museum der
Moderne, with a terrace restaurant
offering spectacular views // The
Residenz, historic home of the ruling
prince-bishops // Mozart's birthplace,
now a museum containing many of his
childhood belongings

THE WACHAU VALLEY
Austria

// Winning Wines
Along the Danube

Head northwest from Vienna to the Wachau
Valley for award-winning rieslings and
grüner veltliners known for their rich fruit
flavors. A mild climate and the beautiful
Danube have made the region ideal for vine
cultivation since Roman times, and today
cyclists pedal through the valley's terraced
vineyards and apricot orchards along one
of Europe's most beloved bike paths.

Must Do // Visit the region's largest
winemaking community, Langenlois,
and its honeycomb of wine caves // Travel
to medieval Dürnstein and the ruins of
17th-century Kuenringer Castle // Browse
manuscripts and precious works of art at
Melk Abbey, a 1,000-year-old Benedictine
monastery // Take a short boat cruise from
Vienna along this picturesque 21-mile
stretch of the Danube or a weeklong cruise
from Budapest.

VIENNA
Austria

A fresh breeze of creativity has swept through this gracious old-world city, adding 21st-century appeal to the legacies of Beethoven, the Strausses, Freud, Klimt, and Mahler. Vienna is being rejuvenated with contemporary art and emerging design districts while new hotels and cutting-edge restaurants offer a contrast to the historic Musikverein, home to the Vienna Philharmonic and its globally broadcast New Year's concert, and the Vienna State Opera, which presents masterworks by Verdi, Mozart, and Strauss.

Christmas in Vienna features traditional decorations; the festive outdoor stands of City Hall's centuries-old Christkindlmarkt; and the bohemian Spittelberg neighborhood's more intimate market, where artisanal stalls front Biedermeier and Baroque façades. Beginning on New Year's Eve, white-tied and elegant-gowned waltzers attend more than 300 formal balls during the Viennese Ball Season that runs until Lent begins.

More than ever, the romantic city on the Danube—famous for its *gemütlichkeit*, cafés and coffeehouses, dazzling confections, and Lipizzaners—is a delightfully elegant place and a timeless destination for art, music, and culture.

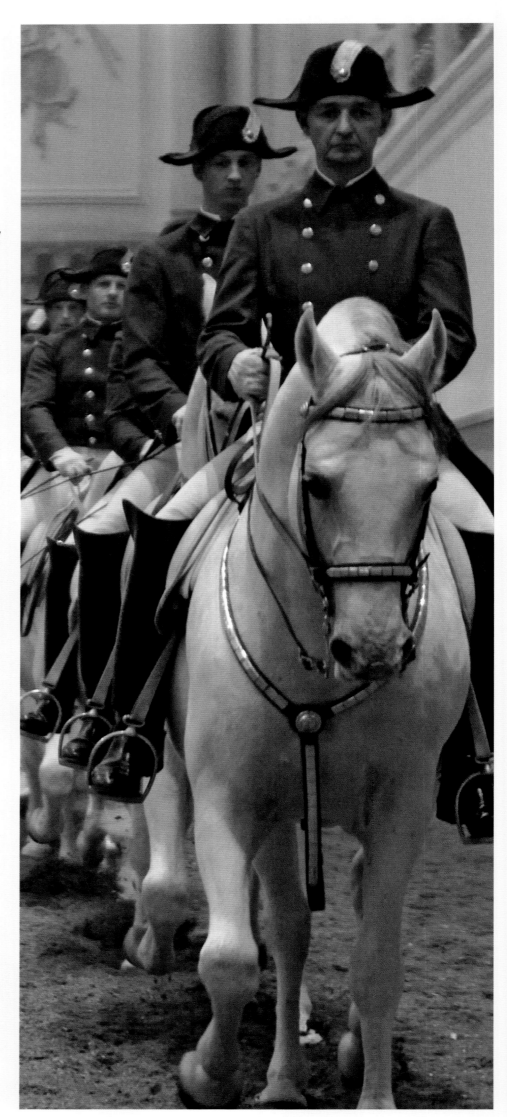

RIGHT // Once the sprawling imperial palace of the Hapsburg emperors, the **Hofburg** offers visitors the opportunity to tour Franz Joseph I's opulent private rooms, attend presentations of classic dressage featuring the Lipizzaners of the Spanish Riding School (*pictured*), and view the imperial crowns of the Holy Roman and Austrian empires in the Treasury.

BELOW // The rich collection of art at the **Kunsthistorisches Museum** contains works from the ancient world and all over Europe. The Italian and Flemish collections are especially fine, as is the world's largest collection of paintings by Pieter Brueghel the Elder.

BELOW // An enormous summer palace inspired by Versailles, **Schloss Schönbrunn** is filled with delicate Rococo touches. Mozart performed here at age 6, and Emperor Franz Joseph was born here. About 40 of its opulent rooms are open to visitors, as is the palace's park.

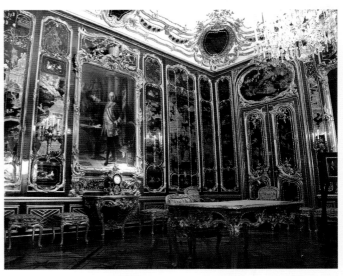

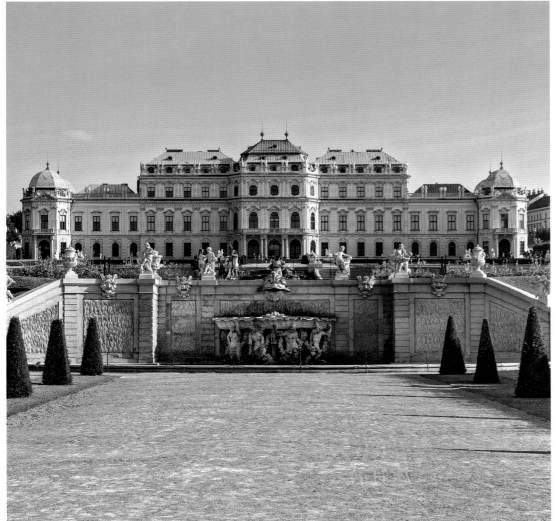

ABOVE // **St. Stephen's Cathedral** retains a medieval atmosphere with its towering Gothic spires that dominate the city skyline. Inside, it's full of monuments, sculptures, and paintings.

LEFT // The **Belvedere Palace** is actually two 18th-century buildings separated by landscaped gardens. The upper palace (*pictured*) exhibits 19th- and 20th-century Viennese art, including the world's largest collection of paintings by Gustav Klimt. The lower palace showcases the Gothic and Baroque.

THE RUBENS TRAIL
Antwerp, Belgium

// Epicenter of
Art and Fashion

Antwerp was a trading powerhouse in the 16th and 17th centuries, a golden age of intellectual, commercial, and artistic life. This port on the River Scheldt now known for its diamond and fashion industries was home to Peter Paul Rubens, whose early showpieces were a pair of triptychs made for the Cathedral of Our Lady, the largest Gothic cathedral in the Low Countries.

Must Visit // Grote Markt, the old town square [*right*] // The Rubenshuis, where Rubens lived and worked, and where several of his canvases are on display // The Rockoxhuis, the home of one of Rubens's wealthy patrons, filled with furniture, paintings, and objets d'art // The Museum Plantin-Moretus, the former home and workshop of an influential printer who worked with Rubens // The Royal Museum of Fine Arts Antwerp, which has one of the world's largest collections of Rubens's work

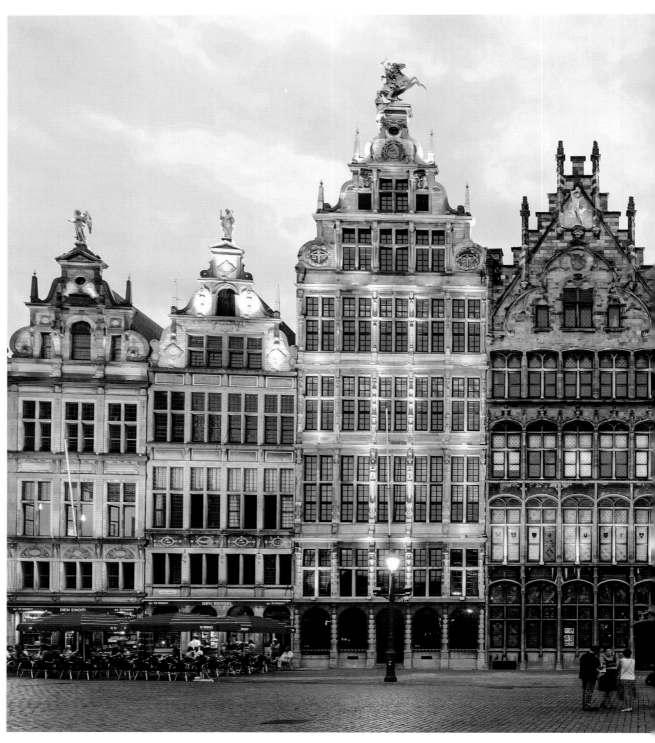

BEER IN BELGIUM
Belgium

// Heavenly Brews

The breadth of Belgium's beer-brewing industry is astonishing. Some 125 breweries produce several hundred varieties [some sources say 800], including "white beers" made of wheat, stratospherically strong Bush beers, dark and winey Rodenbach, and the famous Trappist beers brewed for centuries under the watchful eyes of St. Arnold, Belgium's own patron saint of beer.

Must Visit // The Abbaye d'Orval, a Trappist brewery in the Ardennes region south of Brussels where the famous Orval beer is sold // Boon Brewery [*right*] in Lembeek, to sample traditional *lambic* beer // The Brasserie du Bocq, founded in 1858 and still operated by the Belot family // The Half Moon in Bruges, founded in 1856, which turns out Brugse Zot and Straffe Hendrik // The Cantillon Brewery in Brussels, where you can view unique brewing methods

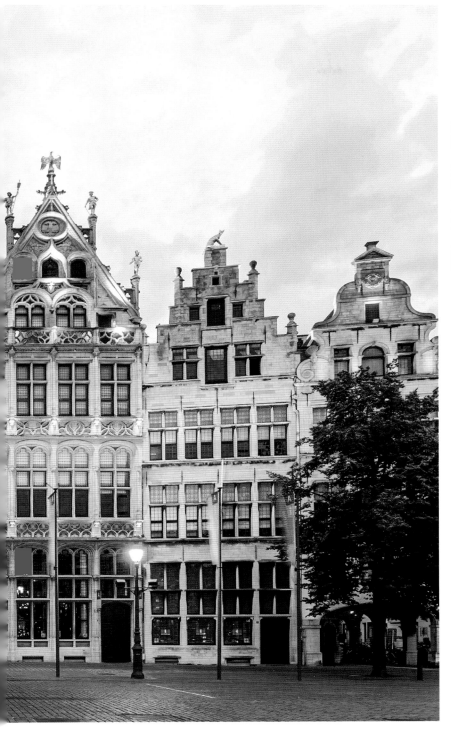

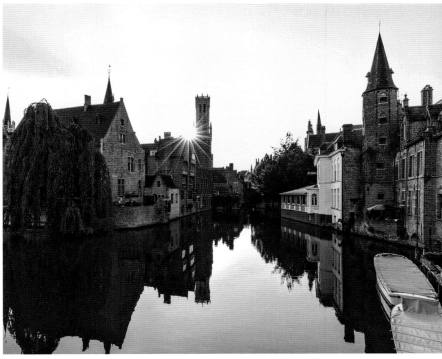

BRUGES
Belgium

// A Medieval Moment Captured in Time

Bruges is brimming with reminders of its golden age of glory in medieval times and later as the capital of the Dukes of Burgundy, when it was a busy trading hub. It's easy to explore on foot, but take a tour in an open boat on the meandering, willow-lined canals (*above*) to learn why Bruges is called the "Venice of the North."

Must Visit // The small but exquisite Groeninge Museum // The towering town belfry // The chapel of Sint-Janshospitaal, the medieval hospital that displays works by Hans Memling // The 14th-century Gothic town hall // The Church of Our Lady and its white marble *Madonna and Child* by Michelangelo // The 13th-century Begijnhof, a conventlike community that flourished for 600 years

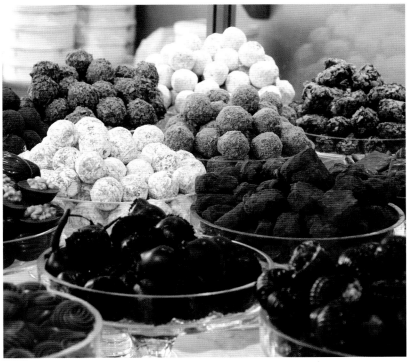

BELGIAN CHOCOLATE
Brussels, Belgium

// A Connoisseur's Nirvana

Brussels claims to be the birthplace of the praline—the triumph of Jean Neuhaus, who sold his confections in the elegant 19th-century shopping arcade near the Grand Place. Once an indulgence of the rich, the filled chocolates wrapped in gilded treasure boxes called *ballotins* make for the perfect gift and are a first-choice souvenir to take home.

Must Visit // The Musée du Cacao et du Chocolat near the Grand Place, to learn what makes Belgian chocolate so wonderful // Mary's chocolate shop (*left*) in Rue Royale, where the artisanal bonbons are displayed like precious baubles // Wittamer, which produces pralines to match their exquisite cakes // Pierre Marcolini, across the square from Wittamer, where you can savor new innovations in chocolate

BELGIAN FRITES
Brussels, Belgium

// The Original
Golden Wonders

Belgians make the best *pommes frites* in the world. The bintje potato they're made from and the double frying are what make Belgium's *frites* so crispy and sweet. These lightly bronzed fries are sold from roadside stalls called *friteries* or *frietkoten* and can be smothered with a healthy dollop of mayonnaise for a delicious snack any time of day.

Must Visit // Maison Antoine, the stand-at-the-counter outdoor eatery in the middle of Place Jourdan that offers more than 25 sauces to go with its celebrated *frites* // Chez Léon (*right*), near the Grand Place, to sample Belgium's unofficial national dish, *moules frites* (mussels and fries)

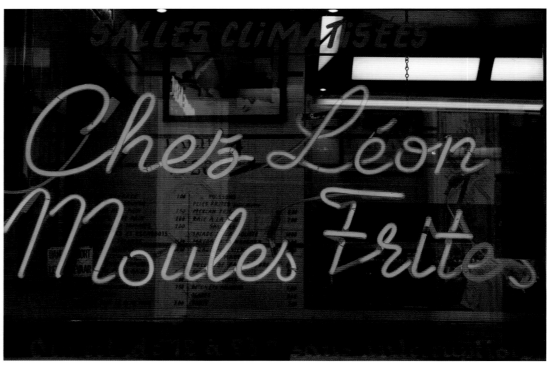

LA GRAND PLACE
Brussels, Belgium

// At the Heart of the
Continent's Capital

Few urban squares have the impact of Brussels's gigantic, one-of-a-kind Grand Place. Jean Cocteau called the heart of Brussels a "splendid stage." The ornate Flemish Renaissance and Baroque façades of the guild houses provide the perfect foil for the Gothic Hôtel de Ville, which dates to 1449 and is the only building to have survived Louis XIV's bombardment of the entire city center in 1695.

Must Visit // The Musée de la Ville de Bruxelles, which tells the story of the city // The bronze statue and fountain a short walk west of the Grand Place that depict the city's mascot, the Manneken-Pis, doing what the name suggests // Visit mid-August of even-numbered years for the Tapis de Fleurs, a "carpet" of living flowers (*left*).

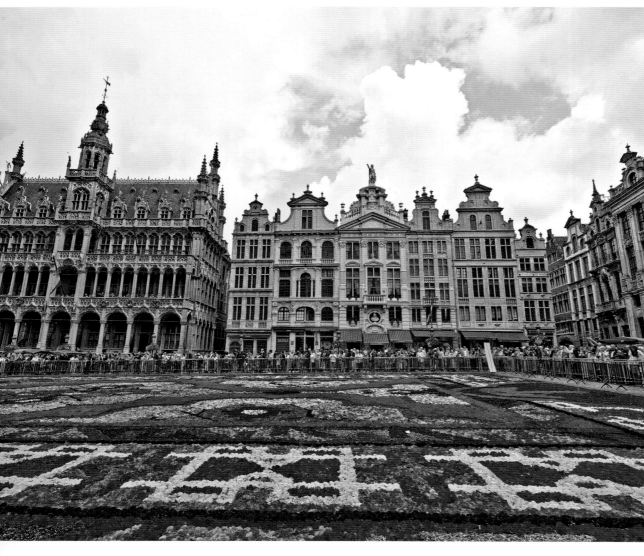

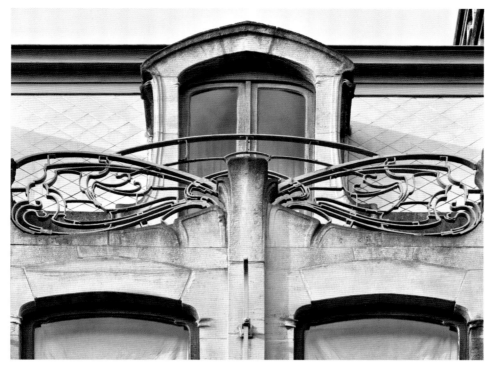

A SHOWCASE OF ART NOUVEAU
Brussels, Belgium

// Birthplace of
an Enduring Style

Brussels is a place of pilgrimage for
Art Nouveau fans, and the first stop is
often architect Victor Horta's home built
in St-Gilles. Completed in 1901 and now
preserved as the Musée Horta, the house
is a showcase of stained glass, wrought
iron, and finely crafted woodwork.

Must Visit // The Hôtel Tassel, with its
groundbreaking floor plan and interior iron
structure // The Maison Cauchie and the
Maison St-Cyr // The Musée des Instruments
de Musique, housed in the iron-and-glass
former Old England department store // The
Centre Belge de la Bande Dessinée, which
is housed in a fabric warehouse designed
by Horta

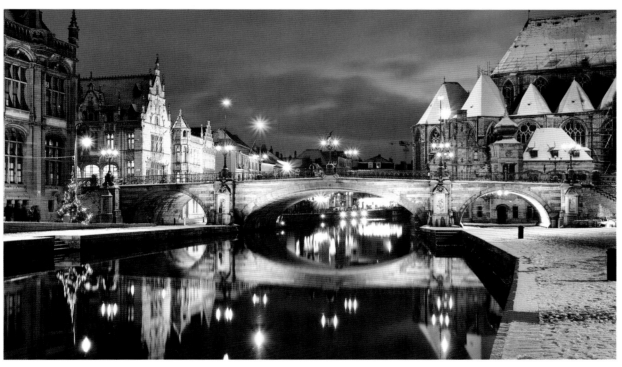

GHENT
Belgium

// A Country's
Best-Kept Secret

Warehouses once dominated the quays of
this port on the River Leie, overseeing trade
that linked Ghent to the rest of the world.
From St. Michael Bridge, the towers and
spires built during those days line up like
masts in a harbor now filled with bustling
cafés and restaurants. The Belfort, the
city belfry with its 54-bell carillon, and
the massive cathedral of St. Bavo housing
Hubrecht and Jan van Eyck's *Adoration of
the Mystic Lamb* are testaments to Ghent's
medieval wealth and standing.

Must Visit // The lavish Vlaamse Opera
// Design Museum Gent, which tracks the
city's history through the evolution of
decorative style // The Municipal Museum
for Contemporary Art // Het Groot Vleeshuis,
a 15th-century butcher's hall that now
showcases local food specialties

LIÈGE
Belgium

// A City of Folklore

Visitors arriving by train at Gare de Liège-
Guillemins are greeted by an exhilarating
wave of glass and steel designed by the
Spanish architect Santiago Calatrava that
was commissioned to place the city of
Liège on the map not only as a stop along
the international high-speed train network
but also as a destination in itself.

Must Visit // The Musée Grand Curtius,
among Europe's important decorative-art
museums // La Batte, the largest market
in Belgium, held every Sunday morning
along the north bank of the River Meuse
// A converted 17th-century convent in the
historic heart of the city where the folkloric
side of Liège is wonderfully documented

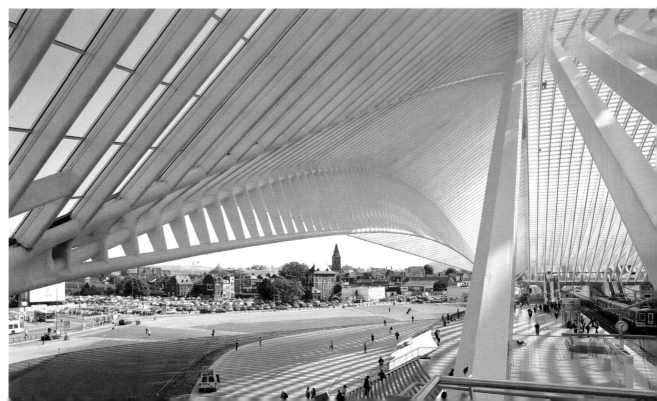

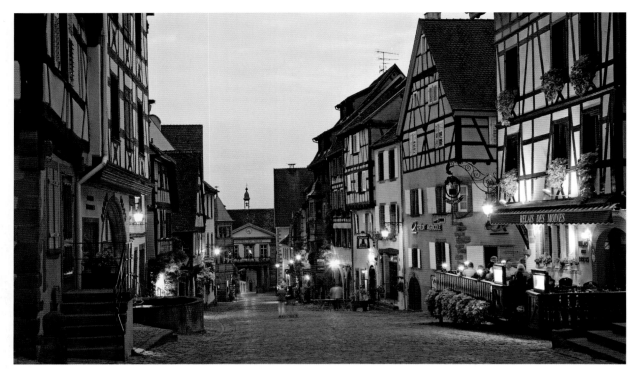

STRASBOURG AND THE ALSACE WINE ROAD
Alsace, France

// Vineyards, Country Cuisine, and Half-Timbered Houses

Strasbourg is the picturesque seat of the European Parliament and Council of Europe. Ownership of Alsace has passed between France and Germany for centuries, and the Germanic feel lingers along the Alsatian Wine Road, a 106-mile route from Strasbourg to Thann, southwest of Colmar, the capital of the Wine Road region, that passes through one of France's premier white and dessert wine regions.

Must Visit // Riquewihr (*left*), the showpiece of the Wine Road, and nearby Kaysersberg // Turckheim, for some of the best-preserved medieval architecture in France // Strasbourg in December for its Christmas market

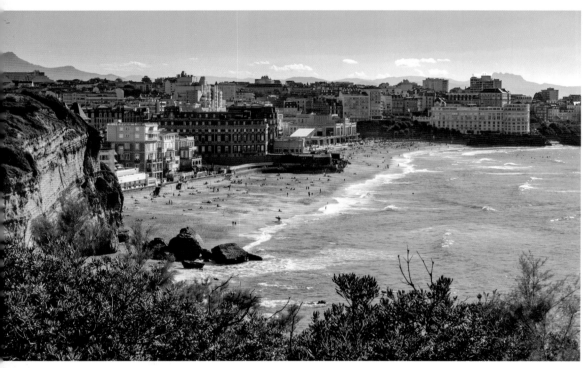

BIARRITZ AND THE PAYS BASQUE
Aquitaine, France

// The Royal and Rustic in the Shadow of the Pyrenees

The resort town of Biarritz (*above*), on France's southwest coast near the Spanish border, has been a favorite international destination for nobility since Napoleon III built a villa there in 1855 for his bride, the Empress Eugénie. Later a playground for artists, writers, and glitterati, Biarritz is the unofficial surfing and windsurfing capital of the Continent. Nearby Pays Basque, an unofficial region that straddles the French-Spanish border, is known for its rustic cuisine and *pelota*, a sport similar to racquetball but played with balls hurled by long, curved baskets.

Must Visit // The elegantly refurbished Hôtel du Palais, Napoleon's former villa, for tea // St-Jean-de-Luz, down the coast from Biarritz, with one of the finest beaches in France // Aïnhoa, Ascain, or Sare, inland villages in the hills, for a taste of the region's landscape and new Basque cooking

BORDEAUX
Aquitaine, France

// Basking in Historic Wine Country

Home to the Médoc, St-Émilion, and Graves vineyards, this fertile region has a temperate climate, thanks to its proximity to the Atlantic. The city of Bordeaux is the largest urban UNESCO World Heritage Site in the world, displaying polished jewels like the Place de la Bourse; the Grand Théâtre, one of Europe's most beautiful opera houses; and the majestic and voluptuously renovated Grand Hôtel Bordeaux across the street.

Must Visit // Médoc, north of Bordeaux on the left bank of the Gironde estuary, home to some of the more fabled château wines in the country // St-Émilion, with its steep cobblestone streets and dramatic views of small-parcel vineyards // The Graves region south of Bordeaux and Sauternes, home to France's most famous sweet white

DORDOGNE VALLEY
Aquitaine, France

// Brimming Markets,
Medieval Hamlets,
and the Lascaux Caves

Described by the novelist Henry Miller as a "country of enchantment," the Dordogne is rich with medieval hamlets, village markets, imposing châteaux, Romanesque churches, and tranquil rivers. The site of great battles during the Hundred Years' War, the Dordogne's most significant history is revealed in painted prehistoric caves, particularly those of Lascaux.

Must Visit // Lascaux II, a dazzlingly accurate replica of the bison, horses, boars, and bulls drawn by Cro-Magnon man found in Lascaux, which is permanently closed // The National Prehistory Museum in Les Eyzies-de-Tayac-Sireuil in the Vézère Valley, which displays more than 18,000 ancient artifacts, and the nearby Font-de-Gaume cave, with Paleolithic artwork that approaches Lascaux's in importance // Rocamadour (*below*), a pilgrimage site that rises up the side of a cliff to the Church of Notre Dame, the sanctuary of the Black Madonna

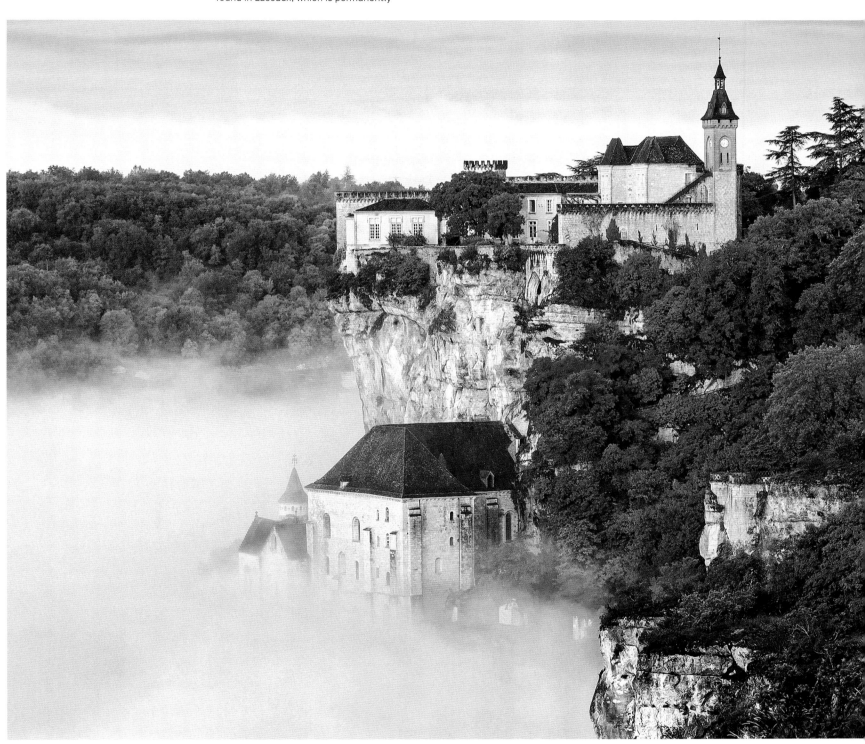

BRITTANY'S EMERALD COAST
Brittany, France

// Seaside Resorts,
Fresh Oysters,
and Medieval Ramparts

Named for the green-blue color of the sea and its dramatic landscape, the rugged coast of north Brittany features steep cliffs, curving sandy beaches, and galloping high tides, while the 5,000-year-old megaliths found inland reveal the region's deep Celtic roots.

Must Do // Wander the cobblestone streets of Dinan, noted for its well-preserved medieval architecture // Drive north along the Rance River to the town of Dinard, popular with Picasso and Hollywood's elite in the 1920s // Explore the walled town of St-Malo and its museum devoted to Jacques Cartier // Travel east from St-Malo to Cancale [right], the "Oyster Capital of Brittany," to sample the local fare and enjoy the views of Mont St-Michel.

BELLE-ÎLE, ÎLE DE RÉ, AND ÎLE DE PORQUEROLLES
Brittany, Poitou-Charentes, and Provence-Alpes-Côte d'Azur, France

// A Trio of Island Beauties

France has several coasts but only a handful of islands. Three in particular are wonderful places to unwind. The sophisticated yet laid-back Belle-Île-en-Mer, off the coast of Brittany near Quiberon, features rugged shorelines, sandy beaches, and grassy moors with ancient Celtic menhirs. Farther south is Île de Ré, near La Rochelle, a favorite spot for well-heeled Parisians in August. Île de Porquerolles, near Toulon, suggests what the French Riviera might have been like a century ago, with its subtropical shoreline, forests, and beaches bounded by heather, scented myrtle, and pine trees

Must Do // Visit the Port of Sauzon [left] and bike the untrafficked dirt roads on Belle-Île // Climb Île de Ré's Whales Lighthouse for a view of the untamed beach on the north coast // Enjoy the beautiful view from the outdoor terrace at Mas du Langoustier on Île de Porquerolles.

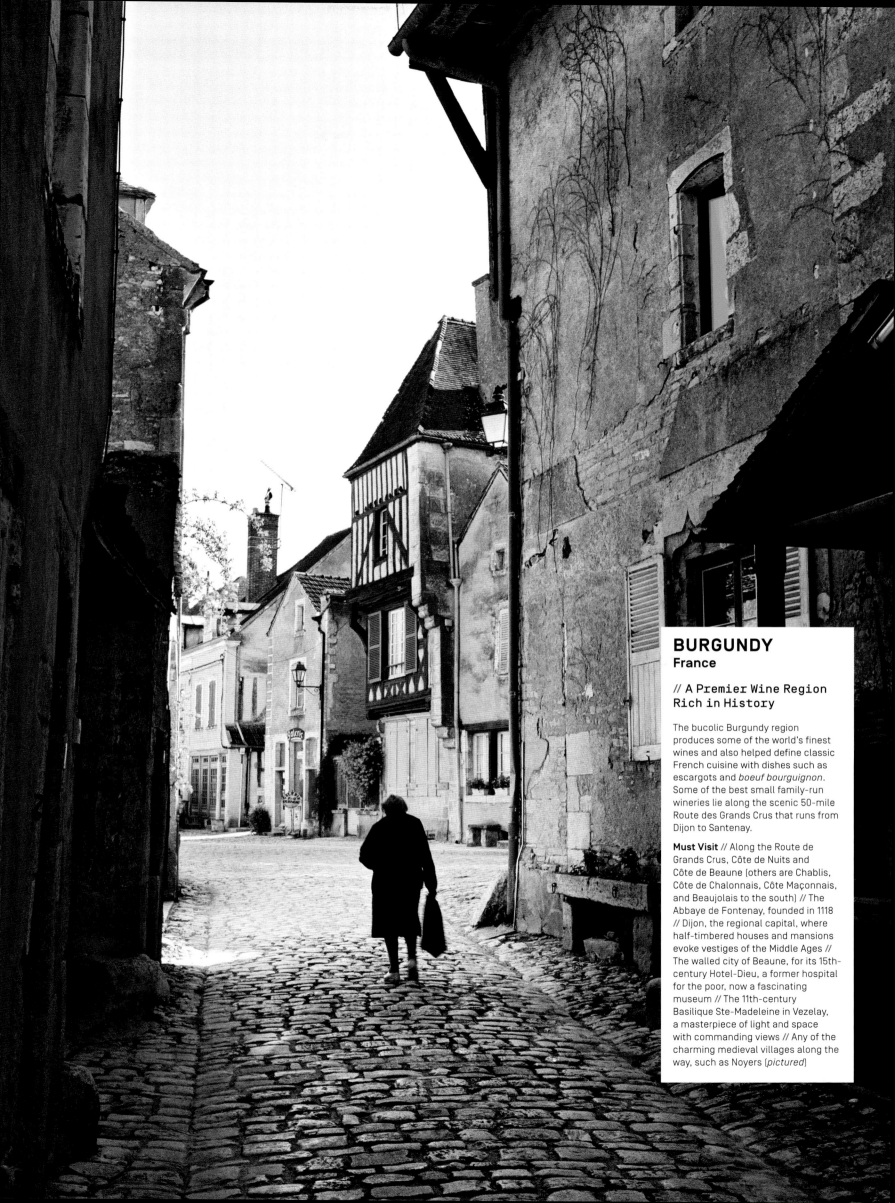

BURGUNDY
France

// A Premier Wine Region Rich in History

The bucolic Burgundy region produces some of the world's finest wines and also helped define classic French cuisine with dishes such as escargots and *boeuf bourguignon*. Some of the best small family-run wineries lie along the scenic 50-mile Route des Grands Crus that runs from Dijon to Santenay.

Must Visit // Along the Route de Grands Crus, Côte de Nuits and Côte de Beaune (others are Chablis, Côte de Chalonnais, Côte Mâconnais, and Beaujolais to the south) // The Abbaye de Fontenay, founded in 1118 // Dijon, the regional capital, where half-timbered houses and mansions evoke vestiges of the Middle Ages // The walled city of Beaune, for its 15th-century Hotel-Dieu, a former hospital for the poor, now a fascinating museum // The 11th-century Basilique Ste-Madeleine in Vezelay, a masterpiece of light and space with commanding views // Any of the charming medieval villages along the way, such as Noyers (*pictured*)

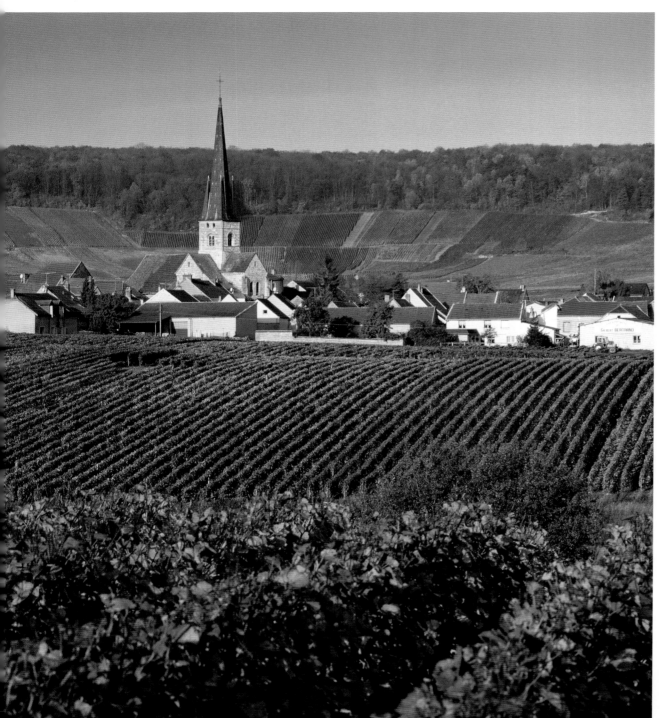

CHAMPAGNE
Champagne-Ardenne, France

// Cathedrals and Bubbly Wine

Champagne with a capital "C" comes only from Champagne, a region of 75,000 vine-laden acres that produces more than 200 million bottles of the coveted bubbly each year. Anchoring the region's rolling countryside and chalky plains is Reims, a graceful masterpiece of Gothic art with a richly sculpted façade and beautiful stained-glass windows by Marc Chagall.

Must Do // Tour the caves in Épernay, where Moët et Chandon [*below*], Taittinger, Mumm, and Veuve Clicquot Ponsardin tend to their bottles // Drive or bike along the scenic Route du Champagne through Bouzy, Verzy, and Rilly-la-Montagne // Visit stunning Gothic cathedrals in Reims and nearby Amiens, Laon, and Soissons.

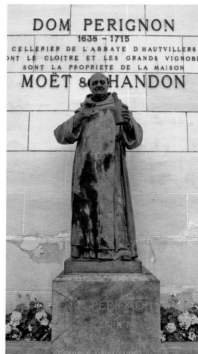

LES CALANCHES
Gulf of Porto, Corsica, France

// The Rugged Beauty of Corsica's Cliffs and Beaches

The French call Corsica "Île de Beauté." The island's rugged coastline is dotted with sun-drenched sand beaches and picturesque coastal towns; its wild and sparsely inhabited interior is linked by roads with stunning vistas and hairpin turns. Nationalist tempers have calmed since a 2003 referendum rejected greater autonomy for the birthplace of Napoleon Bonaparte, and today the island's greatest drama lies in its astonishing natural beauty, such as the cliff and rock formations of Les Calanches on the Gulf of Porto [*right*].

Must Do // Visit Les Calanches and admire how the hues of the granite pinnacles and rock outcroppings shift from orange to pink to vermilion as the light changes // Head into the craggy interior to Corte // Hike the challenging 112-mile GR20 or the more easygoing Tra Mare e Monti route.

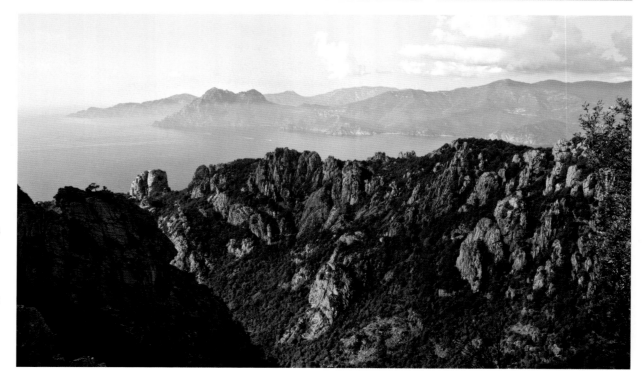

IMPRESSIONIST NORMANDY
Normandie, France

// From Giverny to Rouen and Honfleur

In the 1860s, Claude Monet, Alfred Sisley, Pierre-Auguste Renoir, and Camille Pissarro rode the new train lines from Paris north to the pretty towns and striking coastline of Normandy. Dubbed the Impressionists, after Monet's early *Impression, Sunrise*, they strove to capture the beauty and changing light of this picturesque landscape, and their radical work altered the course of 19th- and 20th-century art.

Must Visit // Claude Monet's house in Giverny, where the artist captured the beauty of his gardens [*right*] in his famous Water Lily series // Rouen's grand cathedral, which inspired more than 30 of Monet's paintings, a few of which hang in the city's Fine Arts Museum // The pretty port town of Honfleur and its Eugène Boudin Museum

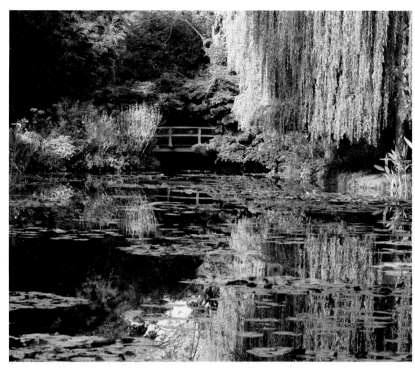

MONT ST-MICHEL
Normandie, France

// A Gothic Wonder Surrounded by Galloping Tides

The fortified island-village of Mont St-Michel ranks among the wonders of the Western world. The ancient abbey and town, on the summit of a dramatic granite outcropping rising from a flat seabed, are a marvel of engineering and sheer audacity. Once a pilgrimage site, an unassailable fortification, and a prison after the French Revolution, it now stands as a tribute to French medieval architecture, connected to the mainland by an elevated bridge.

Must Do // Visit Mont St-Michel off-season—May to June or September to October—to avoid the crush of tourists // Stay overnight after day-trippers are gone.

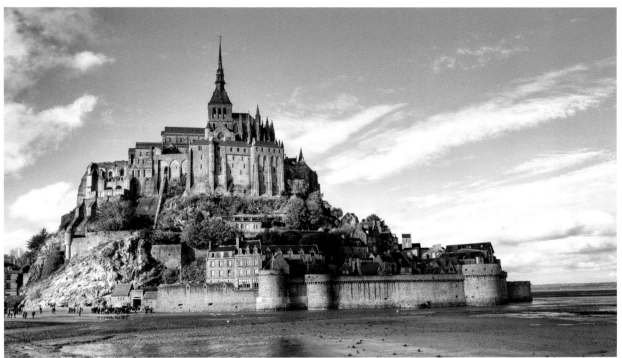

NORMANDY'S D-DAY BEACHES
Normandie, France

// Where the Liberation of Europe Began

On June 6, 1944, the Allied Forces launched the largest seaborne invasion in history from the British coast through thick fog to Nazi-occupied northern France. The battle was bloody and the cost of human life high on the beaches code-named Omaha, Utah, Gold, Juno, and Sword, but the landing launched the Allied march across Europe that helped to end Adolf Hitler's dream of world domination.

Must Visit // Les Braves monument [*right*] on Omaha Beach // Colleville-sur-Mer's American Cemetery and the British Cemetery at Bayeux // The D-Day Museum at the site of Mulberry Harbor, an artificial port built during the landing // The Caen Memorial—A Center for History and Peace, about 30 miles to the south, for an overview of the invasion

PARIS
Île-de-France, France

Paris is possibly the most beautiful and romantic city in the world. The joie de vivre of its soigné citizens conspires to make the City of Light a timelessly exciting place to visit. Sample Parisian nightlife at Au Lapin Agile, a Montmartre landmark frequented by Picasso; enjoy a lavish show at the Moulin Rouge; or rub elbows with the ghosts of Sartre and Hemingway at Les Deux Magots in the Left Bank. Try the salted caramel ice cream at Berthillon on the Île St-Louis or ply the River Seine on a glass-enclosed *bateau-mouche* to absorb the esprit of Parisian life.

Painters, sculptors, and writers have always flocked to Paris. View *The Thinker* at the Musée Rodin, Monet's *Water Lilies* at the Musée de l'Orangerie, and the Marc Chagall ceiling at the Opéra Garnier, or stroll through the Place des Vosges, on the way to No. 6, Victor Hugo's former home, now a museum.

Admire one of the world's largest mosaics on the inside of the dome of the hilltop Basilique du Sacré-Coeur or visit the largest expanse of stained glass at Ste-Chapelle, or pause at Napoleon's Tomb in the church at l'Hôtel Nationale des Invalides.

Take day trips to Chartres's incomparable Gothic cathedral, or to Versailles, the home of the French monarchy from 1682 whose most famous room, the Hall of Mirrors, was where the Treaty of Versailles was signed after World War I.

Discover your own Paris, the birthplace of style and savoir vivre, where everything is magic and anything can happen.

LEFT // Possibly the most recognized structure in the world and the iconic symbol of Paris, the **Eiffel Tower** was built as a temporary centerpiece for the 1889 Universal Exhibition. The much maligned "metal asparagus" was saved from demolition only because—as the tallest structure in Europe at the time—it was useful as a radio tower.

RIGHT // Once the largest palace in the world, the **Louvre** is now its most visited art museum, home to the *Mona Lisa* (*pictured*), the armless *Venus de Milo*, I. M. Pei's controversial glass pyramid, and some 400,000 works of art.

BELOW // With more than 3,500 drawings, engravings, paintings, ceramic works, and sculptures, the **Musée Picasso** is the greatest single collection of the artist's work in the world (*pictured, from left: Homme à la Mandoline, Geometrical Composition: The Guitar, La Cuisine*) and also displays Picasso's personal art collection of such masters as Braque, Cézanne, Matisse, and Modigliani.

ABOVE // Built in the 15th century as a residence for the abbot of the Cluny Abbey, the **Museum of the Middle Ages** displays *The Lady and the Unicorn*, a unique series of six late-15th-century tapestries.

RIGHT // The **Arc de Triomphe** was erected by Napoleon in 1806 to commemorate his army's victories. It's the site of France's Tomb of the Unknown Soldier, and at the top is a viewing platform and multimedia exhibit allowing you to inspect the arch's glorious sculptures and friezes up close.

LEFT // Completed in 1248 to house Louis IX's precious collection of holy relics, **Ste-Chapelle**'s walls form the largest expanse of stained glass in the world—so be sure to visit on a sunny day. It is also just a brief stroll from Notre Dame, a construction site following its catastrophic 2019 fire. The gothic shell still stands.

BELOW // Planned as a votive offering after France's humiliating defeat in the Franco-Prussian War, the gleaming white hilltop **Basilique du Sacré-Coeur** was built between 1876 and 1914 in an ornate Romanesque-Byzantine style. Inside is one of the world's largest mosaics, depicting Christ with outstretched arms, and the view from the dome is breathtaking.

ABOVE // The world's most visited cemetery, **Cimetière du Père-Lachaise** opened its one-way doors in 1804. Among the 800,000 souls who call it "home" are Chopin, Molière, Proust, Gertrude Stein, Colette, Sarah Bernhardt, Yves Montand, Édith Piaf, Isadora Duncan, Oscar Wilde, and Jim Morrison.

LEFT // Housed in the Neoclassical Gare d'Orsay railroad station completed in 1900, the **Musée d'Orsay** exhibits works from 1848 to 1914, a period that saw the rise of Impressionism, Symbolism, Pointillism, Realism, Fauvism, and Art Nouveau. The dazzling collection includes works by Degas (pictured, *Little Dancer of Fourteen Years*), Manet, Monet, Cézanne, Renoir, Matisse, and Whistler.

ALBI
Languedoc-Roussillon, France

// In the Footsteps of Toulouse-Lautrec

Albi was the stronghold of the Cathars, an ascetic religious movement wiped out in a vicious inquisition in the 12th and 13th centuries. But this well-preserved market town is also the birthplace of artist Henri de Toulouse-Lautrec, the famous interpreter of bohemian life in and around Paris's Montmartre at the turn of the 20th century.

Must Visit // Musée Toulouse-Lautrec, a former fortress that now houses the world's most important collection of the artist's drawings of dancers, prostitutes, and cabaret life // Cathédrale Ste-Cécile [*right*], built as a symbol of Catholic power after the crusade against the Cathars and now displaying the largest collection of Italian Renaissance paintings in a French church // Cordes-sur-Ciel, an isolated and picture-perfect hill town a short drive from Albi

CARCASSONNE
Languedoc-Roussillon, France

// Medieval Military Might and Serious Cassoulet

Carcassonne is both a storybook medieval town and an extraordinary example of early military architecture. Built in the 6th century on Roman foundations and fortified in the 12th and 13th centuries, the city was virtually impenetrable for centuries. Restored in the 1800s, Carcassonne is surrounded by nearly 2 miles of turrets, battlements, drawbridges, and more than 50 watchtowers.

Must Do // Enjoy Carcassonne in the evening, when its walls are illuminated, or on July 14 for its famous fireworks // Sample Languedoc's famous cassoulet on the Cassoulet Trail, which connects restaurants and inns between Carcassonne and Toulouse // Explore the region by barge along the picturesque Canal du Midi, a 149-mile man-made waterway that passes through Carcassonne.

NANCY
Lorraine, France

// Where Rococo and Art Nouveau Flourished

An urban center where art and culture have long flourished, Nancy is one of the loveliest cities in Europe. Its centerpiece is the Place Stanislas, named for a king of Poland and father-in-law to Louis XV. The epitome of Rococo delicacy, Place Stanislas features gilded wrought-iron gates and decorative gold railings and integrates the classic French architecture of the nearby Hôtel de Ville and what is today the Grand Hôtel de la Reine, a splendid 18th-century mansion with a certain decadent charm.

Must Visit // The Musée des Beaux-Arts, which exhibits works by Delacroix, Modigliani, and Rubens // The Musée Lorrain, devoted to the art and history of the region // The Musée de l'École de Nancy, which showcases the Belle Époque style of Art Nouveau

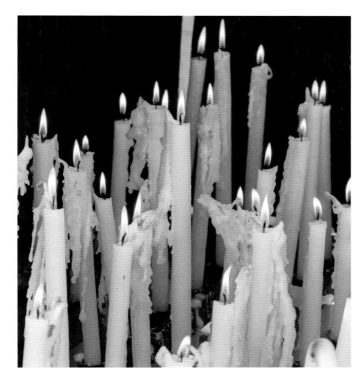

LOURDES
Midi-Pyrénées, France

// Pilgrimage to Mystical Waters

Every year, 6 million pilgrims and visitors flock to this small town perched on the lower slopes of the Pyrenees to stand where a 14-year-old peasant girl named Bernadette had 18 visions of the Virgin Mary in 1858. France's most visited city after Paris and the second most popular Christian pilgrimage site after St. Peter's Basilica in Rome, Lourdes somehow maintains a benevolent sanctity that disarms even the most skeptical.

Must Do // Join the evening candlelight procession to the neo-Byzantine Basilique du Rosaire, a church built beneath Basilique Supérieure // Drink from a spring that apparently welled up in the grotto following one of the Virgin Mary's apparitions and is believed to have miraculous healing powers.

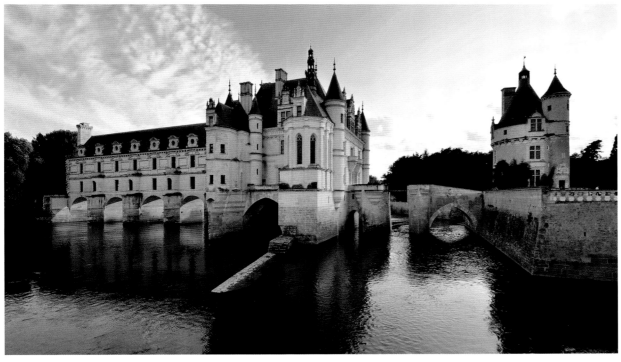

LOIRE VALLEY
Pays de la Loire, France

// The Playground of Kings

Hundreds of châteaux line France's "Royal River," the highest concentration of castles in the world. The valley, created by the winding Loire River, has captured travelers' hearts and imaginations for centuries. The châteaux began as castle fortifications in the Middle Ages as the British and French battled over this strategic valley; they reached their pinnacle of artistic splendor during the French Renaissance, when royalty and nobility from Paris turned the valley into their power base and playground.

Must Visit // Chambord, François I's favorite hunting lodge and, with 440 rooms and 365 fireplaces, the largest // Chenonceau (*left*), a Renaissance masterpiece with ornamental gardens, spanning the River Cher // Cheverny, a fine example of 17th-century elegance // Château d'Ussé, said to have inspired Charles Perrault's *Sleeping Beauty*

AIX-EN-PROVENCE
Provence-Alpes-Côte d'Azur, France

// Charming Town of Thermal Springs, Music, and Art

With gurgling Rococo fountains and stately 17th- and 18th-century buildings, Aix is one of the loveliest towns in Provence. Author Émile Zola grew up here and often ate at the town's most famous brasserie, Les Deux Garçons, as did his friend Paul Cézanne. Founded by Romans who came for its thermal springs, Aix hosts one of the most famous summer classical music and opera festivals in Europe.

Must Visit // Cézanne's atelier (*right*), where his coat still hangs on the wall and his easel holds an unfinished painting // The Musée Granet, where nine of Cézanne's paintings hang next to works by Giacometti, Picasso, Matisse, Mondrian, and Léger // Montagne Ste-Victoire, outside Aix, for beautiful views after a 3-hour climb to the summit

ARLES AND LES ALPILLES
Provence-Alpes-Côte d'Azur, France

// On the Trail of Van Gogh

Arles [*right*] is a town of classic antiquities, leafy squares, and art festivals, and boasts a well-preserved Roman amphitheater, but it is perhaps best known as the place where Van Gogh painted his famous *Sunflowers*—and where he cut off his ear. After his tumultuous year in Arles, Van Gogh committed himself to the sanatorium in nearby St-Rémy, a town in the foothills of the Alpilles—jagged mounds and cliffs called the "little Alps."

Must Visit // The Place du Forum, laid out by Julius Caesar, a perfect spot for a café au lait or an aperitif // The Grand Hôtel Nord Pinus, a favorite among the toreadors who take part in the bullfights at Les Arènes // Les Baux, a medieval city nestled on a craggy bluff of the Alpilles, which offers spectacular views

AVIGNON
Provence-Alpes-Côte d'Azur, France

// Jewel of the Vaucluse

Avignon was the capital of the Christian world in the 14th century when it became home to popes at odds with the courts in Rome. The small town swelled as fortified ramparts, bridges, the huge Papal Palace, and cardinals' residences were built. The palace has been stripped of finery, but a vibrant cultural city flourishes today, thanks in part to Avignon's famous summer international theater and dance festival.

Must Do // View the Papal Palace's collection of medieval Christian art [*above*] and sculpture in the nearby Petit Palais museum // Head west on a day trip to the Pont du Gard, a three-tiered aqueduct built by the Romans // Take a day trip to L'Isle sur la Sorgue, a pretty town east of Avignon with picturesque waterways and a Sunday antiques market, France's largest outside Paris // Explore the lavender fields surrounding Sault, an hour's drive south.

THE CAMARGUE
Provence-Alpes-Côte d'Azur, France

// Wild Horses, Bulls, and Pink Flamingos

The untamed Camargue, a government-protected habitat on France's southern coast, is a 360-square-mile delta of pastures, wetlands, and salt flats that are home to more than 640 species of plants and at least 500 types of birds, including as many as 40,000 pink flamingos. The most dramatic sights are of the chalky-white Camargue horses and small black bulls running free, overseen by *les gardians* [*above*], some of the last cowboys in Europe.

Must Do // Ride one of the Camargue horses or watch a roundup of bulls in Le Sambuc, 20 miles southeast of Arles // Travel to Les Stes-Maries-de-la-Mer in May, when more than 20,000 Roma pay homage to Sara, their patron saint // Attend one of the horse shows or bloodless bullfights held throughout the year in the historic arena in Stes-Maries-de-la-Mer.

CANNES
Provence-Alpes-Côte d'Azur, France

// Queen of the Côte d'Azur

Host of the world's most glamorous film festival, Cannes has more to offer than just star gazing. The charming old quarter of Le Suquet, a lively food market, and beautiful beaches make this one of the nicest stops on the Riviera. For a taste of daily life in Cannes, head to the old port west of La Croisette (right), the famous palace- and palm-studded seafront boulevard.

Must Do // Settle in for a cocktail or tea on the terrace of the Hotel InterContinental Carlton Cannes, the glittering Neoclassical command post of the annual film festival // Stroll along picturesque Rue St-Antoine, which is lined with attractive restaurants // Explore Marché Forville, the vibrant Cannes food and flower market // Drive 10 minutes north of Cannes to Mougins, the hill town where Picasso lived and worked for the last years of his life.

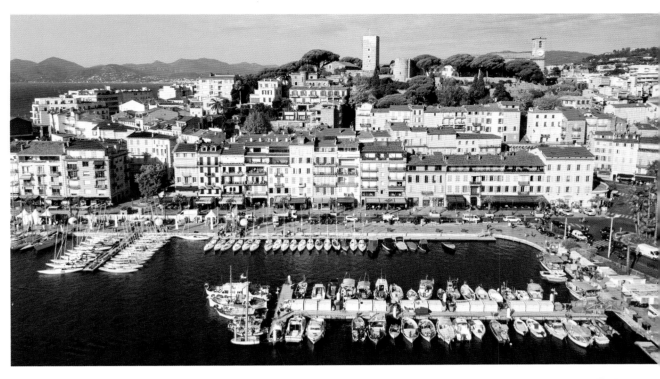

THE FRENCH RIVIERA
Provence-Alpes-Côte d'Azur, France

// Glamour and Beauty Along the Mediterranean

Stretching from Marseilles to Menton at the Italian border, the French Riviera is among the world's most coveted parcels of real estate. Enticing attributes include a temperate climate, unending ocean views, beautiful seaside marinas, rustic hilltop towns, opulent villas, and the glamorous cities of Cannes, Monte Carlo, and Nice (left). Despite coastal overdevelopment and the crush of summer visitors, the Côte d'Azur has a magic that has made it a magnet for tourists of all social strata for centuries.

Must Visit // St-Tropez, where Brigitte Bardot starred in *And God Created Woman* in 1956 // Antibes, on the Bay of Angels facing Nice, where the Picasso Museum houses some of the artist's most joyous works // Cap d'Antibes, one of the coast's most beautiful and exclusive hideaways // The Villa Ephrussi de Rothschild, a grand mansion with legendary gardens in St-Jean-Cap-Ferrat

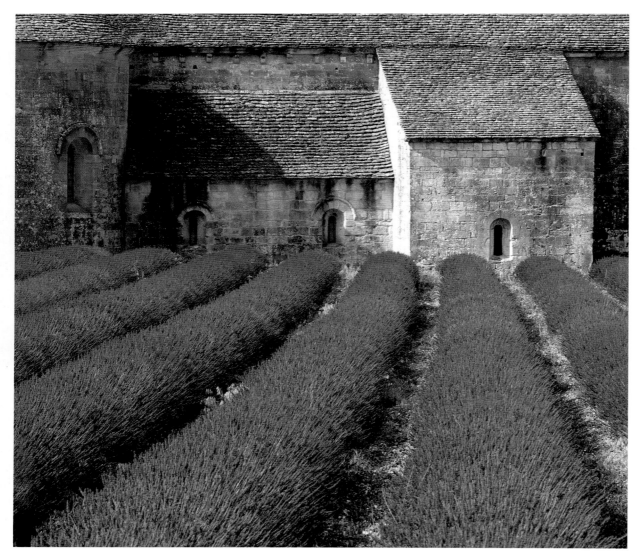

THE LUBERON
Provence-Alpes-Côte d'Azur, France

// Picturesque Hilltop Villages

East of Avignon in Provence, the Luberon region is home to sleepy villages perched atop rugged hills that overlook vineyards and fields of lavender. The narrow streets and dramatic views of Ménerbes have become wildly popular, thanks to Peter Mayle's books about Provence. But despite the tourist crush, the town remains one of the country's prettiest hilltop villages and a perfect base for exploring the region.

Must Visit // Oppède-le-Vieux, a "ghost village" near Ménerbes that was abandoned in the 19th century // The town of Gordes, its gray-and-white stone houses rising around a hill, and its stunning Renaissance castle // The 12th-century Abbaye de Sénanque (*left*), carpeted with rows of lavender, where a handful of monks still live // Bonnieux, one of Provence's most impressive hilltop towns, with views of three neighboring villages // Roussillon, known for its blazing red cliffs and buildings of red stone mined from nearby quarries

OLD MARSEILLES AND CASSIS
Provence-Alpes-Côte d'Azur, France

// Forts, Ports, Bouillabaisse, and Dramatic Cliffs

Colorful, energetic, and slightly rough-and-tumble, Marseilles is undergoing an urban revival. The oldest city in France has new waterfront development, but its spice markets, bathhouses, and hookah cafés still recall the North African origins of one-quarter of its population. One of the prettiest coastal towns in Provence, nearby Cassis (*right*) is most famous for Les Calanques: dramatic white limestone cliffs with finger-shaped fjords.

Must Do // Shop the fish market on the Quai des Belges and sample the traditional bouillabaise stew // Hike the cliffs of Cassis or take one of the twice-daily boat tours to visit several calanques, including the prettiest, the Calanque en Vau.

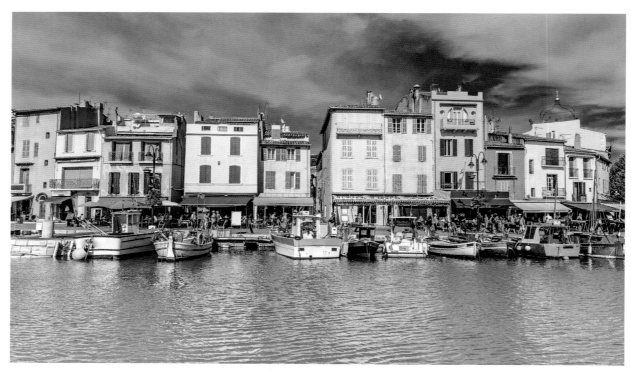

MOUSTIERS AND LES GORGES DU VERDON
Provence-Alpes-Côte d'Azur, France

// A Village Perched at the Grand Canyon of France

A 90-minute drive northwest of Nice leads you to the pottery shops of the medieval village of Moustiers-Ste-Marie and the western entrance of the Gorges du Verdon (*right*). It is considered Europe's Grand Canyon, and one of the most spectacular natural sights in France and a favorite spot for rock-climbing, hiking, rafting, and kayaking.

Must Do // Make the steep climb to the 12th-century cliff-top church Notre-Dame-de-Beauvoir for beautiful vistas of Moustiers and waters in the gorge below // Use Castellane, Bauduen, or Ste-Croix-du-Verdon as a center for boating the gorges // Hike the 9-mile Martell trail, a popular 9- to 12-hour route with sensational views // Drive around the rim of the gorges on the Route des Crêtes.

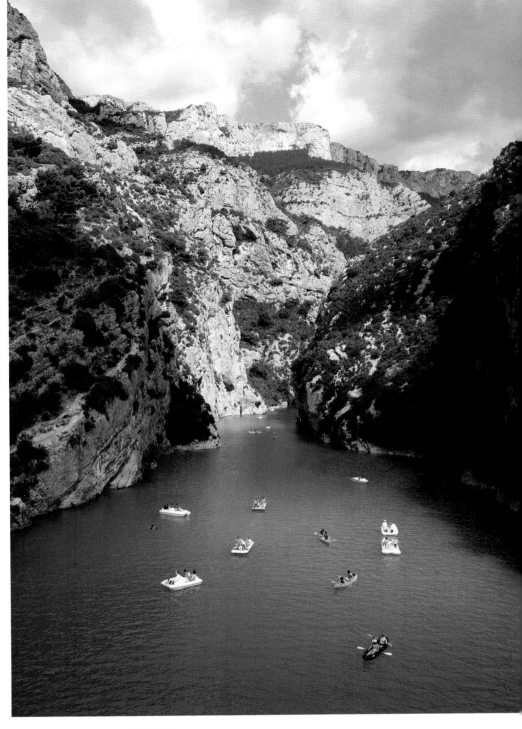

ST-PAUL-DE-VENCE AND VENCE
Provence-Alpes-Côte d'Azur, France

// Artistic Havens in the Hills of Provence

The walled medieval village of St-Paul-de-Vence (*left*) high above Cannes was a magnet for artists such as Picasso, Braque, Matisse, Chagall, Dubuffet, and Léger in the 1920s. Nearby Vence, with one of the best outdoor markets in the region, was also an artists' haven—Chagall produced a beautiful mosaic in the village's 11th-century cathedral.

Must Visit // Colombe d'Or, an eclectic hotel and restaurant, where the walls are lined with works by artists who spent time there // The Fondation Maeght, which displays the richest collection of 20th-century art of any private museum in Europe // In Vence, the Chapelle du Rosaire, to view Matisse's greatest ensemble artwork of the 20th century

VIEUX NICE
Provence-Alpes-Côte d'Azur, France

// A Beautiful Diva on the Sea

On balmy summer nights, the warren of medieval streets of Vieux Nice and its long pedestrian thoroughfare, the Cours Saleya, are abuzz with a mix of young and old, locals and tourists. Although this is the largest city on the Riviera, Vieux Nice has a small-town ambience.

Must Do // Spend time in Vieux Nice's main food and flower market, where its colors and scents evoke the Provençal countryside // Nibble on *socca*, the grilled chickpea snack unique to Nice // Make the 7-mile drive north to the medieval village of Èze for sensational views of the Mediterranean 1,400 feet below.

BEAUJOLAIS AND THE RHÔNE VALLEY
Rhône-Alpes and Provence-Alpes-Côte d'Azur, France

// Excellent Wines and Inspired Cuisine

Scenic and unpretentious, Beaujolais (*left*) is France's least crowded wine region, although the area is lauded for the quality and value of its light-bodied, fruity reds. The Rhône Valley begins at Lyon, where the Rhône and Saône rivers join. This is the nation's second largest wine-growing region and also its oldest: Romans planted vines here 2,000 years ago.

Must Visit // In the Beaujolais region, the medieval hilltop village of Pérouges // The southern Rhône Valley's gently sloping hillsides with a marvelous variety of red and white grapes, shared with lavender fields and olive, almond, and pear orchards

THE FRENCH ALPS
Chamonix, Megève, and Courchevel, Rhône-Alpes, France

// Year-Round Playground and Top-of-the-World Views

Dominated by 15,761-foot Mont Blanc, the highest peak in Western Europe, the French Alps are legendary for their natural beauty and unsurpassed ski resorts. Chamonix, the site of the first Winter Olympic Games, is home to Vallée Blanche, the longest and most rugged off-piste ski run in Europe. Chic Megève is a storybook village and one of Europe's best ski schools, and Courchevel is one of the highest, best-equipped, and most immaculately groomed ski locations in the French Alps.

Must Do // Take the cable car to Aiguille du Midi for unmatched views // Drive the 460-mile Route des Grandes Alpes from Evian to Nice in the summer months // Hike two of Europe's most popular trails: the Haute Route and the Tour de Mont Blanc.

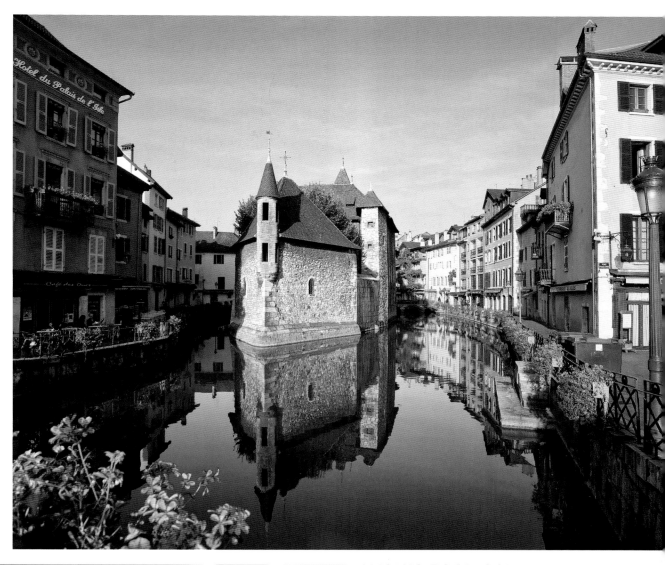

LAC D'ANNECY
Rhône-Alpes, France

// A Jewel in the French Alps

An unspoiled medieval and Renaissance treasure, the Alpine resort of Annecy sits on the north shore of pristine Lake Annecy. Framed by snowcapped mountains and forests, the "Venice of the Alps" is home to handsome churches, flower-bedecked quayside town houses, and arched pedestrian bridges that are reflected in the crystal-clean canals fed by the Thiou River.

Must Do // Wander the streets in Vielle Ville (Old City), lined with half-timbered houses, restaurants, and shops // Tour the 12th-century Palais de l'Isle (*right*), which sits in the middle of a canal // Take a boat tour or a drive along the scenic shores of Lake Annecy // Visit the charming town of Talloires, south of Annecy, for lunch at the lakefront.

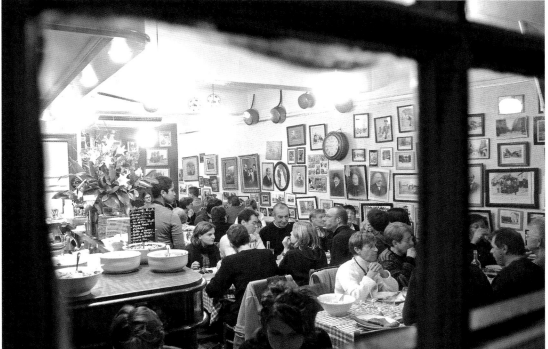

LYON'S FOOD SCENE
Lyon, Rhône-Alpes, France

// Bouchons and Brasseries

Lyon sits between Paris and the Mediterranean near the Burgundy and Beaujolais regions, a location that helps explain why it has more restaurants (*left*) per square mile than any other European city except Paris. A flourishing silk trade left behind Europe's largest collection of Renaissance architecture, but today it is a passion for food that defines France's third-largest city.

Must Do // Shop at the city's greatest food market, the indoor Les Halles de Lyon // Visit the Presqu'île peninsula between the Saône and Rhône rivers, home to museums, fashionable shops, an opera house, and traditional brasseries // Visit one of the city's small *bouchons*—traditional, homey brasseries that once dished up hearty fare for tradesmen and workers.

BADEN-BADEN AND THE BLACK FOREST
Baden-Württemberg, Germany

// A Belle Époque Spa and
Picture-Book Woodland

This town at the northern edge of the Black Forest has been the "summer capital of Europe" since the mid-19th century, when Queen Victoria and Napoleon III basked in its curative springs. Dignified old-world glory still abounds in the elegant gilt-and-stucco casino and the Lichtentaler Allee, a lushly landscaped promenade along the Oos River.

Must Do // Visit the Museum Frieder Burda on the Allee, a Richard Meier–designed showcase for modern and contemporary art // "Take the waters" in the palatial Caracalla baths [*left*] or the unisex (suits-off) Friedrichsbad // Drive the Black Forest Crest Road from Baden-Baden to Freudenstadt // Hike or bike some of the more than 14,000 miles of trails in the Black Forest.

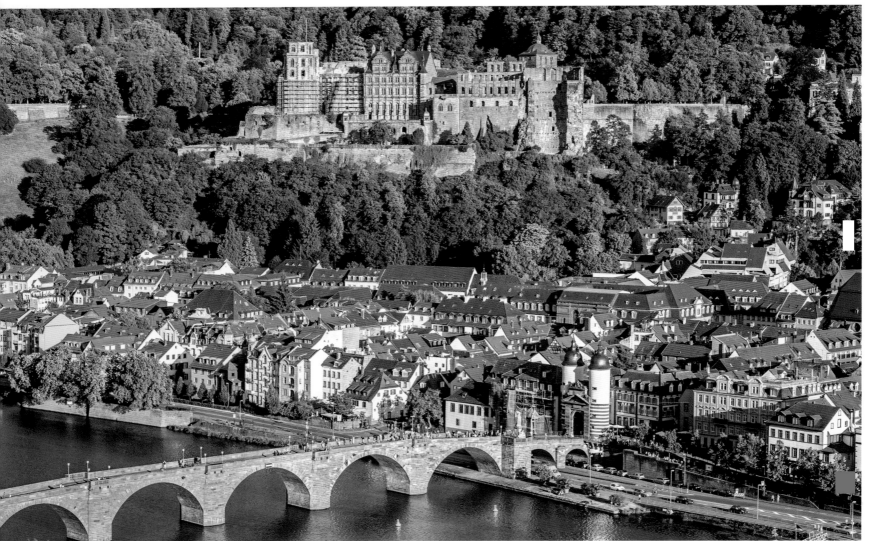

HEIDELBERG CASTLE
Heidelberg, Baden-Württemberg, Germany

// Time Travel in
the Neckar Valley

Possibly Germany's most famous castle, Heidelberg's magnificent, crumbling Schloss stands in a glorious hilltop setting of woodland and terraced gardens [*above*]. Built over 3 centuries beginning in 1400, the red sandstone castle was sacked by Louis XIV's troops in 1689. Ever since, painters and poets have fallen under the romantic ruin's spell.

Must Do // For a vision of the castle to cherish, stroll along Philosopher's Walk, a wooded path on the north bank of the Neckar River, where Goethe and Hegel wandered // Spend Christmas in Heidelberg, when one of Germany's best holiday markets enchants the old quarter.

BAMBERG
Bavaria, Germany

// A Beer Drinkers' Eden Amid Architectural Treasures

One of the most beautiful small towns in Europe, this Franconian jewel was the capital of the Holy Roman Empire under Heinrich II, Bamberg's most famous son. More than 2,000 well-preserved buildings showcase architecture of all periods in a city that is a joy to visit for its history, antiques stores, and surprising number of excellent breweries.

Must Visit // The Kaiserdom cathedral, famous for its interior's elaborate sculptural decoration // The half-timbered, frescoed Altes Rathaus (Old Town Hall), which occupies its own island in the middle of the Regnitz River (*left*) // The Domplatz square, which illustrates the town's architectural evolution from Romanesque to Baroque // Picturesque Kleine Venedig (Little Venice), where red geraniums spill from flower boxes on half-timbered cottages

CHRISTKINDLMARKT
Bavaria (and beyond), Germany

// A Charmed Time of Year

During Advent, towns all over Germany turn into three-dimensional Christmas cards. But the country's Christmas markets are the most numerous in Bavaria. The best markets feature handblown glass ornaments, artisanal hand-carved crèche figures, painted wooden nutcrackers, homemade gingerbread and mulled wine, and candle-powered merry-go-rounds called Weihnachtspyramiden that will melt the heart of any Scrooge.

Must Visit // Nuremberg's picturesque market, where candlelit stalls vie for first prize for the most gorgeous display // The Christkindlmarkt on Marienplatz in Munich, where the Christkindl Tram offers tours of some of the city's highlights

GERMANY'S BEER CULTURE
Bavaria, Germany

// Where Oktoberfest Happens All Year Long

Germany plus beer equals Oktoberfest. But those who arrive outside of festival time won't go thirsty. Bavaria boasts more than one-sixth of the world's breweries. And festivals, such as Fasching (Germany's version of Carnival) and Starkbierzeit, warm up the winter months until April, when Munich's outdoor beer gardens spring to life during Volksfest.

Must Do // Take tours and sample wheat beers at Erdinger in Erding and Paulaner in Munich // Hoist a stein in one of the massive tents in Theresienwiese, Munich's Oktoberfest central, during the city's 2-week festival that opens with a colorful parade of horse-drawn beer wagons followed by a number of big brass bands and hundreds of waitresses in traditional dirndls.

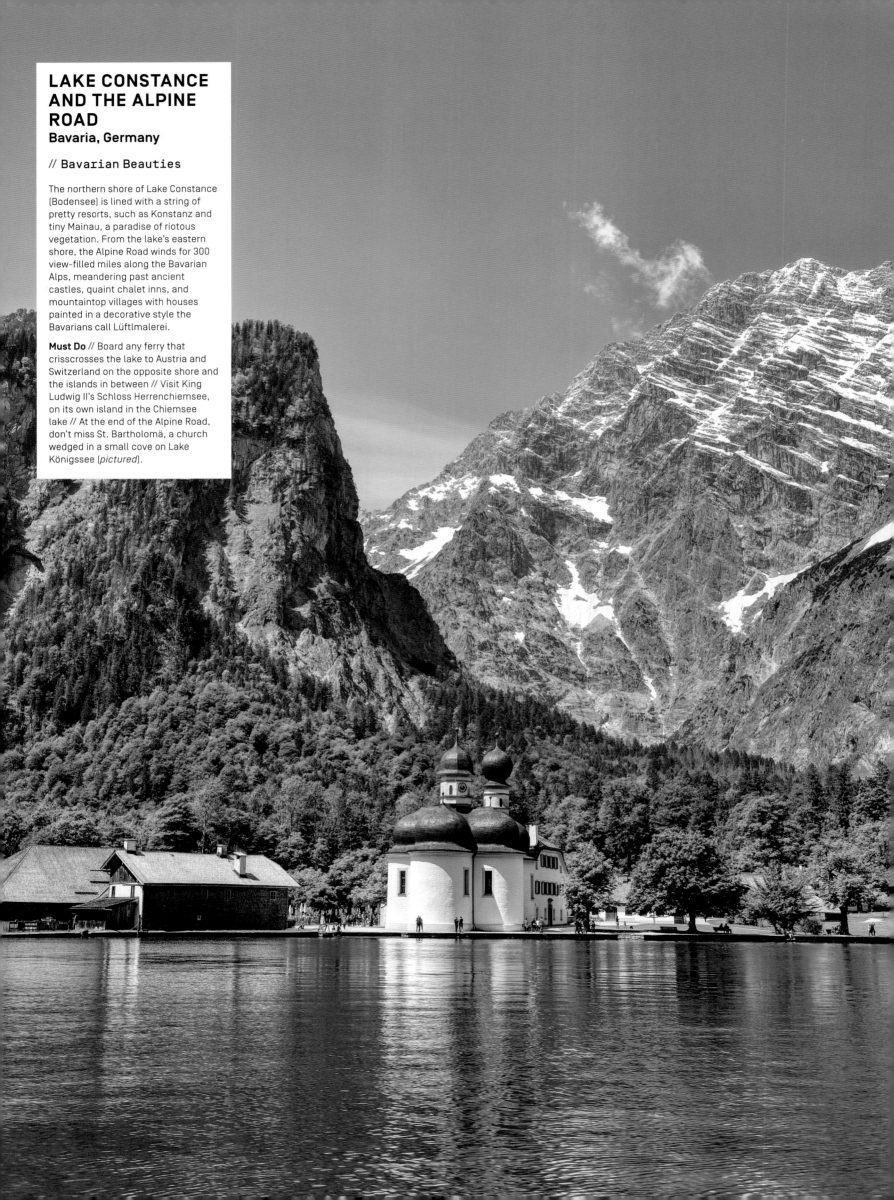

LAKE CONSTANCE AND THE ALPINE ROAD
Bavaria, Germany

// Bavarian Beauties

The northern shore of Lake Constance (Bodensee) is lined with a string of pretty resorts, such as Konstanz and tiny Mainau, a paradise of riotous vegetation. From the lake's eastern shore, the Alpine Road winds for 300 view-filled miles along the Bavarian Alps, meandering past ancient castles, quaint chalet inns, and mountaintop villages with houses painted in a decorative style the Bavarians call Lüftlmalerei.

Must Do // Board any ferry that crisscrosses the lake to Austria and Switzerland on the opposite shore and the islands in between // Visit King Ludwig II's Schloss Herrenchiemsee, on its own island in the Chiemsee lake // At the end of the Alpine Road, don't miss St. Bartholomä, a church wedged in a small cove on Lake Königssee (*pictured*).

MUNICH'S PINAKOTHEKS AND THE DEUTSCHES MUSEUM
Munich, Bavaria, Germany

// Treasures Abound,
Innovations Astound

Many of Munich's world-class museums are clustered around the city's Art District, making it one of the very few cities that can boast so much high-quality art in such a small area.

Must Do // Explore Germany's first submarine and an eerily convincing replica of Spain's Altamira caves at the Deutsches Museum [*below*], a science and technology museum for kids and adults // Marvel at Leonardo da Vinci's *Virgin and Child* at the Alte Pinakothek // Enjoy paintings by Van Gogh, Cézanne, and Klimt at the Neue Pinakothek, sister museum to the Alte Pinakothek // View artworks by Klee, Picasso, and Warhol at the Pinakothek der Moderne.

REGENSBURG
Bavaria, Germany

// Medieval Masterpiece
on the Danube

One of the most beautiful medieval cities in Germany, Regensburg was considered a veritable dead end during the years of Communist control, which left its surviving architecture dating to the 13th and 16th centuries unchanged. Unlike the reconstructed buildings in many German towns damaged by World War II air raids, Regensburg's architecture is original, and authorities exaggerate only a little in listing no fewer than 1,300 buildings as being of historical interest.

Must Do // Visit the Gothic Dom St. Peter [*right*], famous for both its 14th-century stained-glass windows and its renowned boys' choir // Enjoy the best sunset view of the Danube from the 12th-century Old Stone Bridge // Hop a boat on the Danube to Walhalla, the Parthenon-inspired marble temple built by King Ludwig I in 1842.

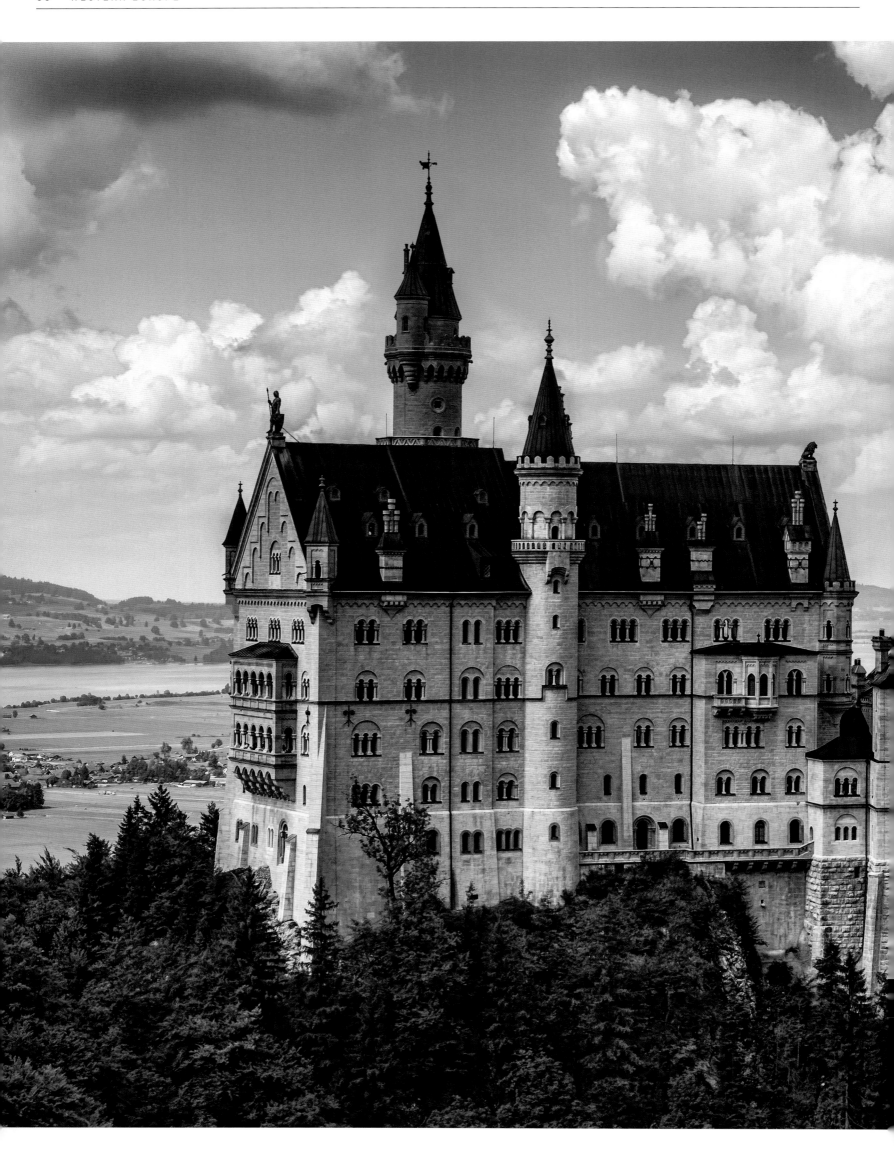

THE ROMANTIC ROAD AND NEUSCHWANSTEIN CASTLE
Bavaria, Germany

// A Historic Road and a Fairy-Tale Castle

Stretching nearly 200 miles from Würzburg southeast to Füssen, the Romantic Road is as enjoyable for the dozens of medieval towns, villages, and castles it links as for the landscape of rivers, lakes, and dense forests in between.

Must Visit // Begin the journey in Würzburg, the hub of Franconia's wine region, and stop at the 18th-century Residenz, one of Europe's most sumptuous palaces // Continue south to Rothenburg ob der Tauber, one of the best-preserved medieval towns in Europe // End by touring Mad King Ludwig's two royal castles that cap the southern end of the road. Neuschwanstein (*left*), set on an isolated rock ledge, is the most theatrical, created by the royal court's set designer rather than an architect.

BERLIN'S MUSEUM SCENE
Berlin, Germany

// Wall Falls, Art Thrives

Of Berlin's array of more than 170 museums, the Gemäldegalerie is in a class all its own for the breadth and depth of its collection of European masterpieces from the 13th to the 18th centuries. Lovers of antiquities could spend days on Museum Island in the middle of the River Spree, a cache of five museums whose lodestone is the Pergamonmuseum, built to house a 40-foot-high colonnaded Greek temple.

Must Visit // The Neues Museum, for its sublime bust of Nefertiti (*left*) // The East Side Gallery, the longest remaining stretch of the Berlin Wall and the world's largest open-air gallery // The Mauer Museum, a mock-up of Checkpoint Charlie, for tales of escapes and tragically failed attempts // The Berlin Wall Memorial's chapel commemorating the men and women shot while trying to escape into West Berlin

BERLIN'S (RE)DEFINING ARCHITECTURE
Berlin, Germany

// A Cityscape Transformed

With the fall of the Berlin Wall in 1989, an unprecedented period of restoration swept through this capital famous for its experimental arts and architecture. World War II and the Cold War took their toll on the city, and reminders of this period persist in several iconic structures, including Hans Scharoun's 1963 masterpiece of acoustic design that is home to the Berlin Philharmonic.

Must Visit // The Kulturforum complex, which includes Mies van der Rohe's Neue Nationalgalerie and the Philharmonic // The Reichstag, the seat of the German parliament, and its Norman Foster-designed glass-walled debating chamber (*right*) // The Jewish Museum, housed in a spectacular zinc-clad structure designed by Daniel Libeskind // The Topography of Terror, a museum on the site of the former SS and Gestapo headquarters, which explores the horrors of the Nazi era

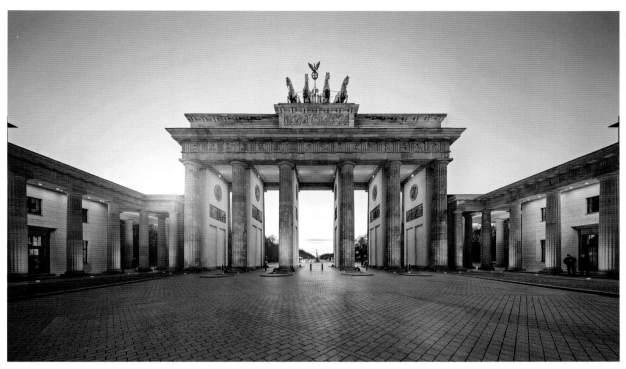

MITTE
Berlin, Germany

// A Neighborhood Reunites in Grand Style

This showpiece of 18th-century Berlin, the Mitte district has reclaimed its place at the heart of the city, evolving into a stately yet hip district after 4 decades as the grim no-man's-land of East Berlin. Bustling with round-the-clock energy, the Mitte district is home to imposing historical monuments and avant-garde galleries that showcase emerging talent.

Must Visit // The Brandenburg Gate [*left*], the 1791 "Gate of Peace," once ironically incorporated into the Berlin Wall in 1961 // The Staatsoper, the most famous of Berlin's three opera houses // The Holocaust Memorial, a field of concrete slabs designed by Peter Eisenmann as a stark reminder of that horrific period // Gendarmenmarkt, Berlin's prettiest plaza, home to the Berlin Symphony Orchestra's Neoclassical Konzerthaus

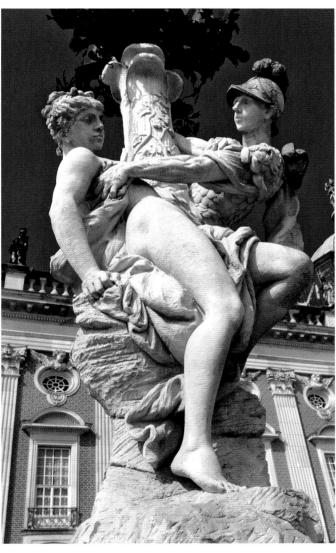

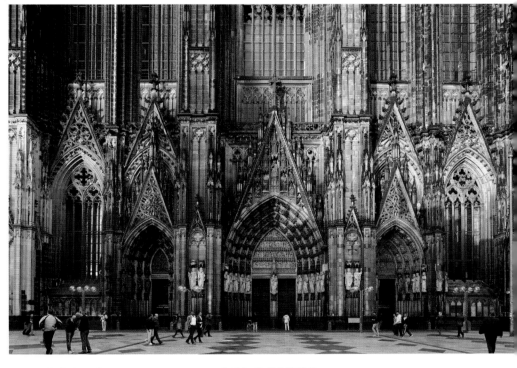

SANSSOUCI
Potsdam, Brandenburg, Germany

// Carefree and Rococo

Meant to rival Versailles, Sanssouci, Frederick the Great's royal summer palace just outside Berlin, is the finest example of Rococo architecture in Europe. Amid superb lakeland scenery, the Prussian ruler was free to indulge in cultural pursuits *sans souci*—without care—with such visiting guests as the French philosopher Voltaire.

Must Visit // The Neue Palais [*left*] and its 638 rooms, the largest building on the grounds // Schloss Cecilienhof, a Tudor-style manor, partially used as a hotel today, also on Sanssouci's grounds, the site of the Potsdam Conference that hammered out the division of postwar Germany

COLOGNE'S CATHEDRAL
Cologne, Rhineland, Germany

// European Art: Then and Now

Constructed on top of Roman ruins after Holy Roman Emperor Frederick Barbarossa donated the relics of the Three Magi to Cologne, the cathedral established the city as an important pilgrimage destination. The cathedral's relics are encased within their original 12th-century gilded reliquary behind the high altar.

Must Do // Admire the cathedral's massive new abstract window, climb the highest church tower in the world, or listen to the world's largest church bell ring the hour // Visit the nearby Romano-Germanic Museum and its perfectly preserved Roman mosaic floor; the Wallraf-Richartz Museum, which contains paintings from the 14th to the 20th centuries; and the Museum Ludwig, for its fine collection of modern art.

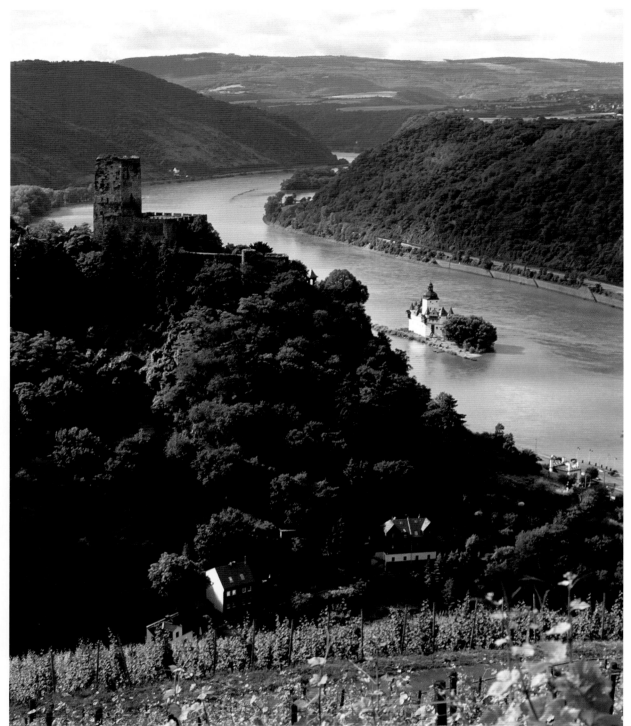

THE RHINE VALLEY
Rhineland, Germany

// Rivers, Rieslings,
and Ruins

Flanked by hillside vineyards, wooded forests, and castle-topped crags, the 50-mile Middle Rhine or Rhine Gorge (*left*), stretching from Mainz to Koblenz, is where the river exhibits its greatest beauty and where the 433-foot Lorelei Rock, named for a mythic siren who sang sailors to their doom, juts over the river's narrowest point.

Must Do // Explore the area on scenic roads and rails that hug the riverbanks, or take one of the river cruises that range from a few hours to several days // Attend the summer Rhine in Flames festival, which lights up the river with fireworks, floodlit castles, and a fleet of illuminated boats // Visit during the autumn grape harvest to sample Germany's noblest grape, riesling, at its most famous vineyards // Explore the Mosel River, which meets the Rhine at the Koblenz.

DRESDEN'S ALTSTADT
Saxony, Germany

// Cultural Capital on
the Elbe, Reborn

Roughly 80 percent of Dresden's medieval inner city was destroyed in one of World War II's most savage air raids. Among the casualties was the Frauenkirche (Church of Our Lady). Reconsecrated in 2005, the star of rebuilt Dresden stands as a symbol of the city's rebirth.

Must Visit // Baroque Zwinger palace, to see ornamental armor and weaponry and the world's most significant Meissen porcelain collection // The palace's Old Masters Picture Gallery, to view works by Raphael and Titian // The *Procession of Princes* mural (*right*) in the Royal Complex's Stall Courtyard // The Green Vault, where the world's largest green diamond highlights a collection of Saxon treasures // The Semper Opera, where Wagner and Strauss premiered most of their large-scale works

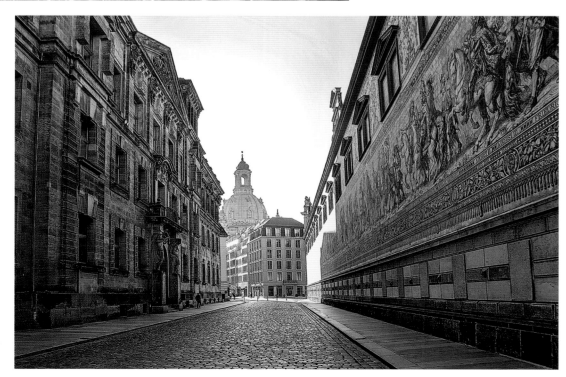

QUEDLINBURG
Saxony-Anhalt, Germany

// A Wealth of Half-Timbered
History

The home of the finest timber-framed
townscape in Germany, Quedlinburg
(*right*) also boasts a treasure trove of
medieval religious art, which is displayed
in Stiftskirche St. Servatius, the town's
hilltop Saxon-Romanesque cathedral.
The church's former abbey has been
transformed into a Renaissance castle
that houses a small museum containing
more priceless artifacts.

Must Visit // Hotel Theophano, a half-
timbered landmark created from five
17th-century buildings // Hotel am Brühl,
a converted 350-year-old timbered
farmhouse and 1920s stucco home
// Brauhaus Lüdde, a restored brewery
serving local fare and Braunbier, a
centuries-old local brew

LÜBECK
Schleswig-Holstein, Germany

// Belle of the Baltic

This Baltic river port was the capital of
the Hanseatic League in the Middle Ages,
and Lübeck's fortified Old Town remains
steeped in the history of the city's rich
powerful past, while the shattered church
bells lie where they fell during a World
War II air raid as a memorial to the city's
more recent history.

Must Do // Take a boat ride along the Trave
River for unrivaled views of the 15th-century
Holsten Gate // Attend July's Schleswig-
Holstein Music Festival, Germany's largest
summer cultural event // Sample the
marzipan and the famous cream-filled
Nusstorte at Café Niederegger.

SYLT
Schleswig-Holstein, Germany

// Glamorous and Fragile,
an Island Beauty

Stylish boutiques, excellent seafood
restaurants, small high-end hotels, and a
tiny casino bestow a cosmopolitan flair on
this windswept barrier island off the northern
tip of Germany. However, biking, horseback
riding, and walking are the preferred means of
transportation, illustrating the islanders' desire
to keep the modern world on the mainland.
Just 1,148 feet wide at its narrowest point and
with a shifting landscape of soft dunes, Sylt is
in danger of one day being eroded off the face
of the map.

Must Visit // The village of Keitum, Sylt's
"green heart" // Any of the oyster and shrimp
stands for a just-caught meal

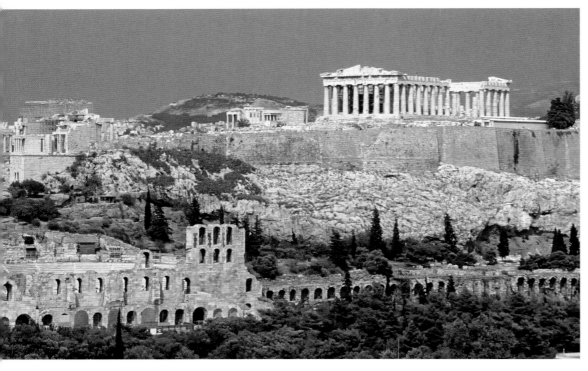

THE ACROPOLIS
Athens, Greece

// The Most Important
Ancient Monument in the
Western World

Constructed during ancient Greece's Golden Age, this 5th-century BC Doric temple dedicated to Athena, the patron goddess of Athens, was originally painted in vivid colors. Today, the Parthenon shimmers golden white, visible through the glass walls of the ultramodern Acropolis Museum in the Archaeological Park, a walkway that skirts the base of the 8-acre Acropolis plateau. The museum also houses four of the original Caryatids that served as the Parthenon's columns and the fragments from the frieze left behind by Lord Elgin, who carted off the rest to London in 1801.

Must Do // Attend the ancient dramas, operas, music, and ballet performed in the 2nd-century AD Odeon of Herod Atticus during the summertime // View the Acropolis from various points, such as the elegant Grande Bretagne hotel's rooftop bar for a sunset drink.

ATHENS'S MUSEUMS
Athens, Greece

// Preserving Greek Heritage

While the dazzling new Acropolis Museum tends to grab the spotlight, Athens is also home to several other world-class collections of ancient artifacts. On the short list of must-see sights in Greece is the National Archaeological Museum (*above*, detail of a helmeted warrior, circa 490 BC) that houses more masterpieces of art and sculpture from ancient Greece than any other museum in the world.

Must Visit // The Benaki Museum, which houses 20,000 items from throughout Greek history // The Museum of Cycladic Art, to see elegantly elongated stone figures sculpted 5,000 years ago

SARONIC GULF ISLANDS
Attica, Greece

// Island Style, Without Cars

The islands of the Saronic Gulf hug the coast of the Peloponnese. Athenians visit Aegina for a day at the beach or a walk to the graceful hilltop Temple of Aphaia. But Poros is a good base to explore mainland Nafplion and its nearby classical sites. Hydra (*right*) and Spetses, in the south of the archipelago, not only remain relatively unspoiled but are especially pleasant due to the banning of cars. Since the 1960s, Hydra has been popular with artists, writers, and the glitterati.

Must Visit // Spetses, the most verdant of the islands, and home to a museum in the former home of Laskarina Bouboulina, the female hero of the 1821 Greek War of Independence

DELPHI
Central Greece

// Famous Oracle of Antiquity at the Navel of the Earth

For more than 1,000 years, pilgrims arrived at Delphi with questions inscribed on stone tablets (many of which have survived) for a priestess who would utter cryptic prophecies from a cave within the Temple of Apollo. Set against Mount Parnassus and considered to be the center of the world by the ancients, Delphi and the ruins of the temple still resonate with mystery.

Must Visit // Tholos, a temple erected to Athena, the goddess of wisdom // The theater (*right*) and stadium built for the Pythian Games, forerunners of the Olympics // The Delphi Museum and its bronze statue of a charioteer // The nearby 10th-century Monastery of St. Luke, home to some of the finest mosaics in Greece

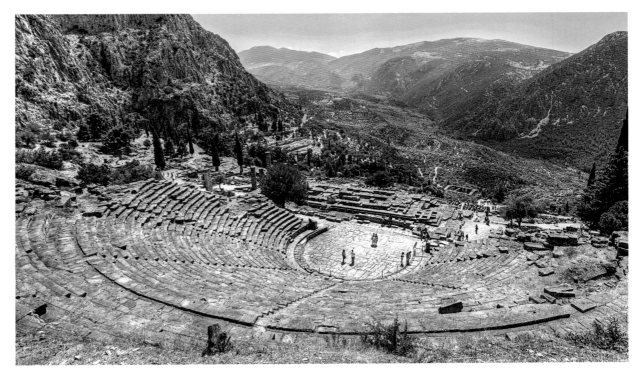

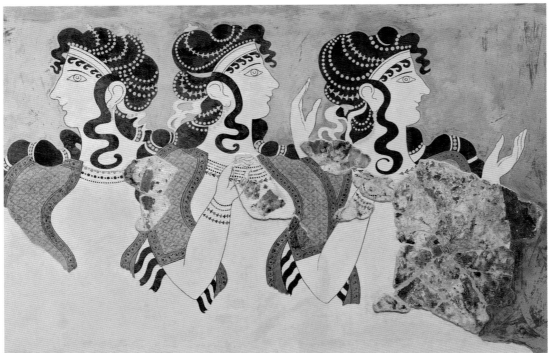

CRETE
Greece

// Traces of an Early Civilization Amid Spectacular Scenery

The largest of the Greek islands and also one of the most fascinating and beautiful, Crete is the birthplace of the Minoans, Europe's first advanced civilization. The reconstructed Palace of Knossos—dating to 1700 BC—was their cultural and administrative center. But Crete also boasts isolated coastlines and snowcapped mountains laced with deep gorges, none more dramatic than the Samariá Gorge.

Must Do // View the vibrant frescoes at Heraklion's Archaeological Museum (*left*, *Ladies in Blue*) // Explore the Samariá Gorge on a well-trodden but strenuous 11-mile trail that ends with a cool dip in the Libyan Sea // Visit Chania, the character-filled former capital of Crete on the north coast, a common jumping-off place for gorge excursions.

MYKONOS AND DELOS
Cyclades, Greece

// Cycladic Chic and Magnificent Ruins

Although Mykonos is one of the smallest Greek islands, it has long been popular for its nightlife, stylish hotels, sophisticated but casual restaurant scene, fine beaches, and the centuries-old windmills that line the ridges above the sea. A short boat trip takes you to the uninhabited island of Delos, mythical birthplace of Apollo and an open-air museum covered with the ruins of temples, theaters, markets, and villas decorated with mosaics.

Must Do // Wander Mykonos's labyrinth-like streets (*right*) filled with white sugar-cube houses with splashes of sky-blue doors and domes and brilliant red and pink bougainvillea // Stroll the Little Venice quarter and the waterfront promenade in Chora, the main town on Mykonos // Relax on Mykonos's Paradise Beach or swim at Agios Sostis.

NAXOS AND PÁROS
Cyclades, Greece

// Green Valleys and Ancient Marbles

Part of the 220-island Cycaldic archipelago and a short boat trip from each other, Naxos and Páros lure visitors looking for a taste of authentic island life and exceptional beaches. Páros's celebrated quarries of translucent white marble gave the world the *Venus de Milo* (left) and other great monuments.

Must Visit // The 13th-century Venetian chapel that dominates an islet just offshore of Naxos // The Portara, a massive marble doorway from an unfinished temple to Apollo that crowns a hilltop on Naxos // The temple to Demeter, goddess of fertility, which stands amid tended fields on Naxos // Parikia's 10th-century Church of a Hundred Doors on Páros, the oldest church in Greece in continuous use

SANTORINI
Cyclades, Greece

// The Most Spectacular Greek Island of Them All

Santorini's slim 12-mile crescent of land is the rim of an ancient volcano. Villages of dazzling white cubic houses and blue-domed churches cling to cliffs above the indigo sea that now floods the sunken caldera.

Must Visit // Oia, one of the most beautiful settlements in the Mediterranean // Santorini's beaches of red and black sand // Fira, the island's main town, for an evening stroll along the shop-lined streets // Akrotiri, a Minoan village preserved in Pompeii-like ash // Ancient Thera, a 9th-century jumble of Egyptian, Greek, Roman, and Byzantine ruins

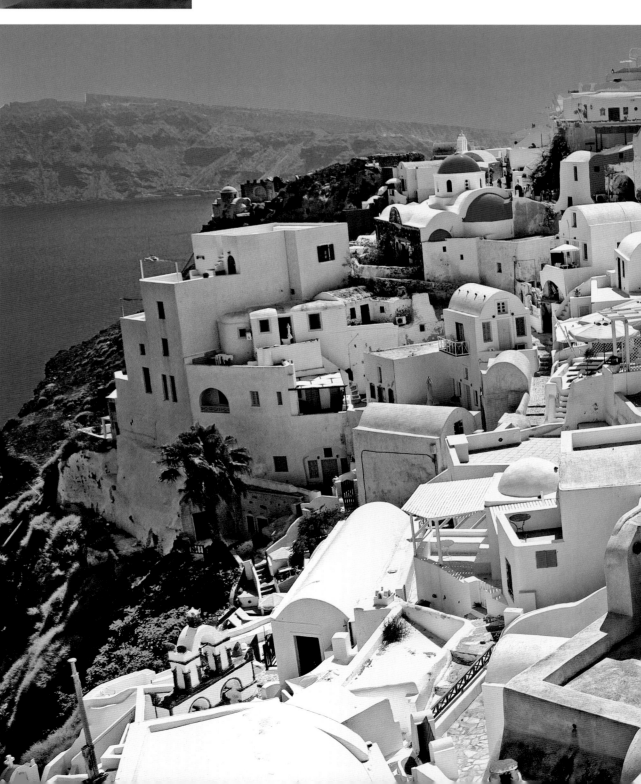

SIFNOS
Cyclades, Greece

// A Quiet, Unspoiled Getaway

Sifnos is a favorite getaway of discerning Athenians, who take over the place in August but like to keep quiet about this hikers' delight. Stone paths rise and drop from Apollonia, the capital, to Artemonas, where the Kochi church sits on the site of an ancient temple to Artemis.

Must Visit // Kastro, a medieval town an easy 1-mile walk from Apollonia that has a small but impressive archaeological museum and the picturesque Church of Seven Martyrs (*right*) // The Panagia Chrysopigi monastery, a popular point of pilgrimage // The 12th-century Profitis Elias O Pilos, perched on 2,200-foot summit and accessible only by a 2-hour climb from Apollonia, well worth it for the Aegean views

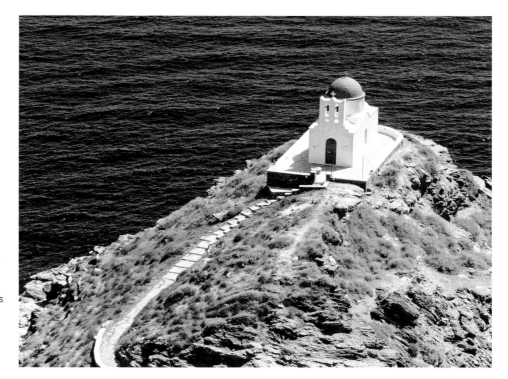

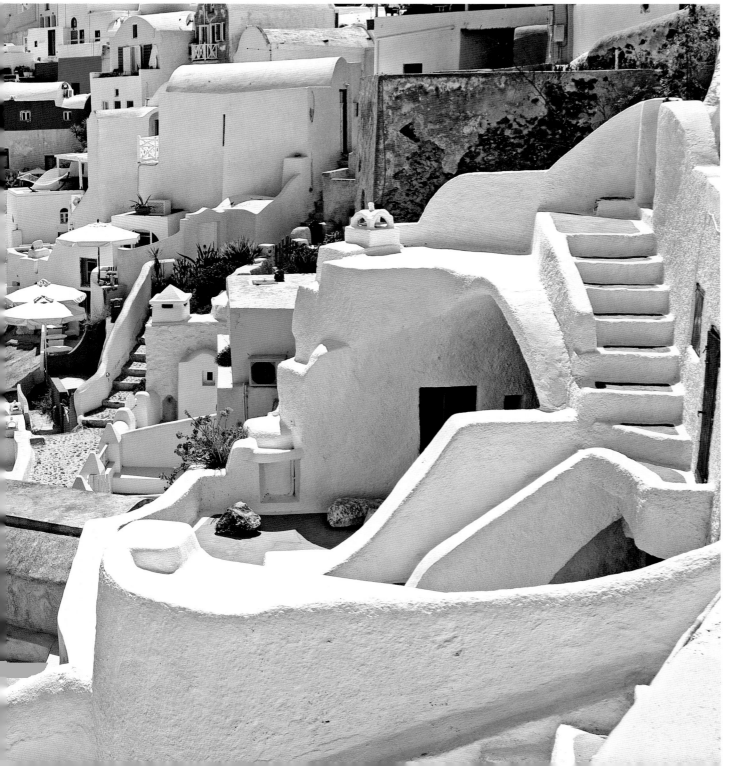

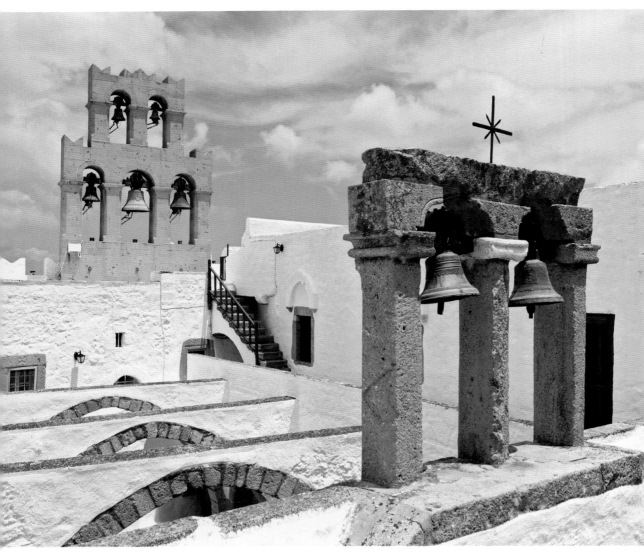

PATMOS
Dodecanese, Greece

// Religious Fervor Coupled with Worldly Sophistication

Patmos features isolated coves and untrammeled beaches as well as one of Greece's most important monastic complexes. Built on a hillside midway between Skala, the main port on the island, and the hilltop town of Chora with its quiet lanes lined with old aristocratic mansions, the Monastery of the Apocalypse is the site of the cave known as the Sacred Grotto, where St. John the Theologian is said to have composed the Book of Revelation (or the Apocalypse) in AD 95.

Must Do // View religious treasures at the 11th-century Monastery of St. John the Theologian (*left*) // Enjoy Psili Ammos, Lambi, and other beautiful beaches // Hike on the donkey paths that crisscross Patmos's hilly interior.

RHODES AND SÍMI
Dodecanese, Greece

// Medieval Might and Neoclassical Splendor

Even though little remains of Rhodes's ancient past after an earthquake toppled the Colossus of Rhodes in 226 BC, the Middle Ages remain very much in evidence in the Old Town. The largest inhabited medieval enclave in Europe, enclosed within preserved walls, 3 miles long, was home to the powerful knights of St. John of Jerusalem following the Crusades. The island of Sími is 45 minutes away via a ferry that docks at a harbor considered to be among the most beautiful in Greece, rimmed with 19th-century Neoclassical mansions.

Must Do // In Rhodes, visit the acropolis that still rises above the seaside town of Lindos (*right*) // Stroll down the Street of the Knights in Rhodes to the Archaeological Museum and the Palace of the Grand Masters // Strike off on a hike that follows Sími's coastline, or make the easy 6-mile trek through Sími's interior to the monastery of the Archangel Michael at Panormiti.

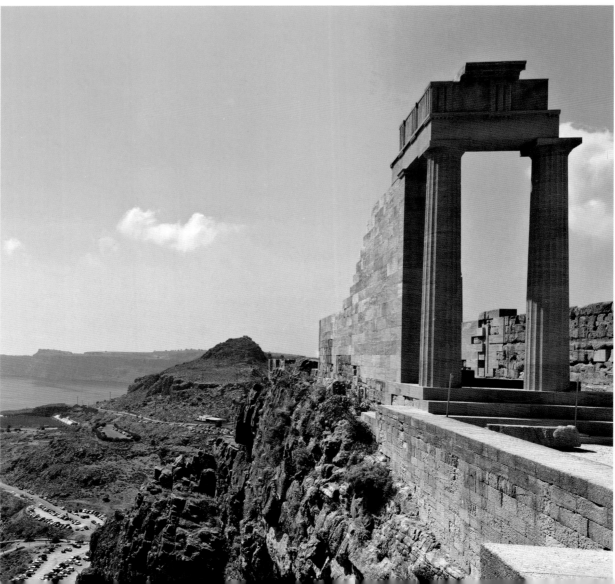

MOUNT ATHOS
Macedonia, Greece

// Spiritual Focus for the
Eastern Orthodox World

The monks of Mount Athos carry on a
1,000-year tradition of study and liturgy
on a rugged peninsula where women and
children have not been allowed since
the 11th century. Only 100 Orthodox and
10 non-Orthodox men, with the appropriate
permit, are allowed to visit each day, but
women (and men) can view the peninsula
and seaside monasteries on one of
many boat tours that cruise along the
mountainous shore.

Must Do // For men who have procured a
permit, take the 2-hour boat ride to Mount
Athos from the nearby town of Ouranoupolis
// Get in rhythm with monastic routines
that begin with prayer at 4:00 a.m., then
see the sacred trove of relics, mosaics,
and icons that the monks have amassed
// Hike across the peninsula on paths that
climb forested mountainsides and plunge
through unspoiled valleys.

THE MANI PENINSULA
Peloponnese, Greece

// Haunting Landscapes and
Austere Towers

For centuries, few outsiders dared to
enter the Mani, a rugged corner of the
Peloponnese peninsula rife with bandits
and bloody feuds. Today, the narrow
peninsula between the Aegean and Ionian
seas is one of Greece's most unspoiled
getaways. Looking at the wind-shaped
rock formations rising from the sea at Cape
Tenaro, visitors can understand why the
ancients believed that this southernmost
tip of the Mani was the entrance to the
Underworld.

Must Do // Visit the tower houses of Vathia
[*right*], built to protect against warring
neighbors // Explore the Pirgos Dirou Caves
by boat along subterranean waterways
canopied by fantastic stalactites // Hike
through mountain ravines past Byzantine
chapels shaded by cypress trees.

MONEMVASSIA
Peloponnese, Greece

// Medieval Splendor on a Seaside Rock

The "Greek Mont St-Michel" is a walled medieval town that clings to the side of a rock jutting out of the southern Peloponnesian coast. Monemvassia controlled the sea lanes between Western Europe and the Levant during the Byzantine, Venetian, and Ottoman empires. Among Monemvassia's 40 beautiful Byzantine churches, the octagonal 12th-century Agia Sofia (*left*) is perhaps the most beloved.

Must Do // Climb to the ruined Venetian fortifications high on a mountaintop to view the sunset over the Mirtoon Sea.

NAFPLION AND NEARBY CLASSICAL SITES
Peloponnese, Greece

// Ancient Wonders Surround the Prettiest Town in the Peloponnese

This beautiful and well-preserved city tucked onto a peninsula on the Bay of Argos and backed by a range of imposing mountains offers such simple pleasures as long walks along a seaside promenade where the miniature 15th-century Bourtzi island fortress looms offshore. But it is the town's proximity to Athens and to some of the most evocative remains of ancient Greece that sets it apart.

Must Visit // The perfectly preserved theater at Epidaurus, the perfect venue for classic plays and musical concerts during the summertime Athens and Epidaurus Festival // North of Nafplion, the treasures at the Mycenae and its Archaeological Museum, of Ancient Corinth and the ruins of the landmark Temple of Apollo

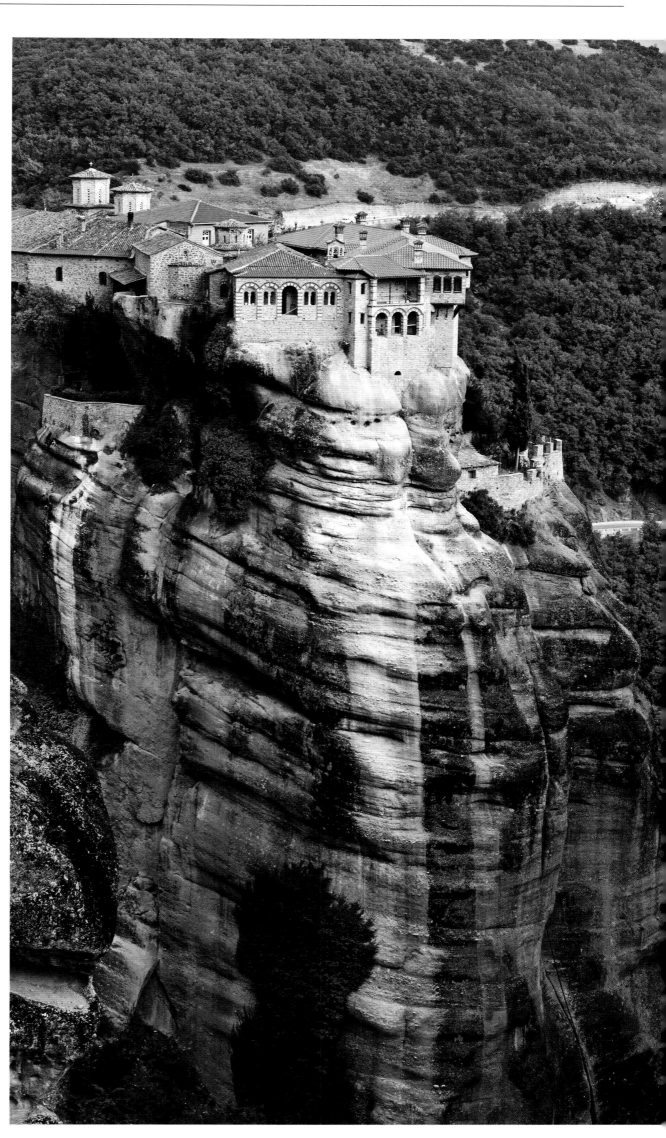

METÉORA
Thessaly, Greece

// Monasteries Suspended Between Heaven and Earth

Hermit monks began living in the caves of Metéora in the 9th century. As Turks took over the mainland, the monks built safe refuges on the seemingly inaccessible pinnacles high above the Piniós Valley. Until the 1920s, the only way for visitors to reach them was by retractable ladders or nets. Since then, steps have been hewn into the rocks, and today six working monasteries are now accessible by paths and roads and open for visits.

Must Visit // The 14th-century Megálou Meteórou, the grandest and highest monastery // Varlaam Monastery [*right*] and Agia Triada, for their spectacular views

CYPRUS'S PAINTED CHURCHES
Troodos Mountains, Cyprus

// Byzantine Wonders on Aphrodite's Island

Divided between Greece and Turkey, Cyprus is home to both crowded beach resorts and off-the-beaten-path places in the interior. Above seaside Lemosos and on the eastern flank of Mount Olympus are ten magnificent medieval churches and monasteries whose interiors are embellished with some of the finest Byzantine frescoes and icons in the Mediterranean.

Must Visit // The ornate 11th-century Kykkos Monastery (*left*) and its golden icon of the Virgin, said to work miracles // Chrysorrogiatissa Monastery, for a taste of Commandaria, a sweet wine favored by medieval crusaders // On the southwestern coast, Paphos and the Rock of Aphrodite, where Aphrodite allegedly rose from sea foam

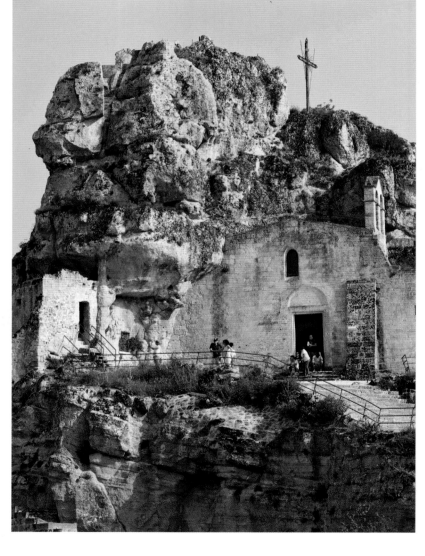

ALBEROBELLO AND THE SALENTO PENINSULA
Apulia, Italy

// Whimsical Trulli and Golden Beaches

Alberobello's whitewashed, conical-roofed houses (*above*) take visitors inside a child's storybook—imagine Snow White and the Seven Dwarfs as interpreted by J. R. R. Tolkien. Cropping up like mushrooms, the *trulli* date mostly to the 18th century and are used today as homes, stores, storage space, inns, restaurants—even a church.

Must Do // Head east from Alberobello to stay at one of the hotels in the old fortified farmhouses called *masseri* that are unique to the region // Visit Lecce in the heart of the Salento Peninsula where Baroque palazzos and churches are ornately carved in golden stone.

THE SASSI OF MATERA
Matera, Basilicata, Italy

// A City Carved Out of Stone

Some of the cave houses (or *sassi*, Italian for "stones") in Matera, etched out of the soft tufa walls of a ravine, have been inhabited for the past 9,000 years. The jumble of houses and churches, such as the Church of Santa Maria de Idris (*right*), is so evocative of biblical times that the town has served as a backdrop for dozens of movies including Pier Paolo Pasolini's *The Gospel According to St. Matthew* and Mel Gibson's *The Passion of the Christ*.

Must Do // Visit the Crypt of Original Sin outside the city center, known as the Sistine Chapel of cave churches // Check into a refurbished cave dwelling–turned–stylish hotel.

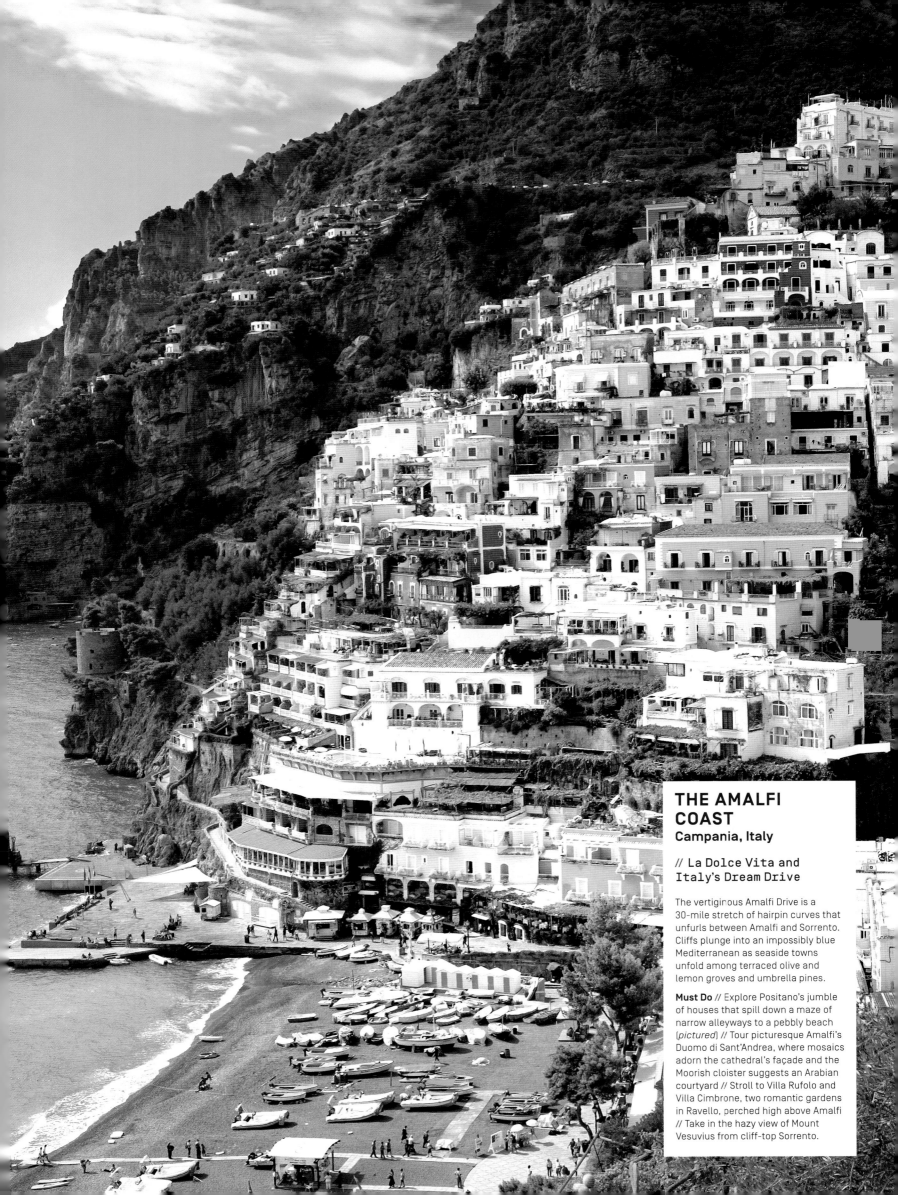

THE AMALFI COAST
Campania, Italy

// La Dolce Vita and Italy's Dream Drive

The vertiginous Amalfi Drive is a 30-mile stretch of hairpin curves that unfurls between Amalfi and Sorrento. Cliffs plunge into an impossibly blue Mediterranean as seaside towns unfold among terraced olive and lemon groves and umbrella pines.

Must Do // Explore Positano's jumble of houses that spill down a maze of narrow alleyways to a pebbly beach (*pictured*) // Tour picturesque Amalfi's Duomo di Sant'Andrea, where mosaics adorn the cathedral's façade and the Moorish cloister suggests an Arabian courtyard // Stroll to Villa Rufolo and Villa Cimbrone, two romantic gardens in Ravello, perched high above Amalfi // Take in the hazy view of Mount Vesuvius from cliff-top Sorrento.

CAPRI AND ISCHIA
Campania, Italy

// Playground of Roman
Emperors and Modern-Day
Sybarites

Capri [*above*] has been a summer
playground since the Roman emperor
Tiberius made the Villa Jovis—now a cliff-
top ruin with breathtaking views—his ruling
seat in AD 26. Today, artists, movie stars,
writers, and royals stroll the Piazzetta,
described by Noël Coward as "the most
beautiful operetta stage in the world." The
volcanic and much larger, more laid-back
island of Ischia floats nearby in the Bay of
Naples, so forested with fragrant pines that
it's known as the Emerald Island.

Must Do // View the Faraglioni, three
needlelike rocks towering just off the
rugged coast of Capri // Take a boat trip
to Capri's Blue Grotto, one of the world's
most written-about tourist experiences
// Enjoy a volcanic mud treatment or a soak
in one of Ischia's many thermal pools.

NAPLES
Campania, Italy

// Twenty-Five Centuries of Culture, Neapolitan-Style

More than 2 millennia of history stoke the vitality and energy of this port city. Spaccanapoli is the colorful heart of Old Naples, once an enclave of monumental palazzos and magnificent churches. The neighborhood now bustles against a backdrop of time-battered tenements and workshops; laundry hangs across narrow alleys, and Vespa-filled streets thrum with local vendors who hawk everything from contraband DVDs to gelato. Pizza was invented here, insist Neopolitans—it certainly was perfected here.

Must Visit // The Cathedral of San Gennaro and its richly filigreed interior // The National Museum of Archaeology, which holds priceless antiquities from nearby Pompeii // The Castel Nuovo, a 13th-century fortification now home to Naples's civic museum // The Palazzo Reale, the 17th-century palace that was home to Naples's monarchs // The Teatro di San Carlo opera house, one of Europe's largest and most splendid // Da Michele, an institution considered by many the "sacred temple of pizza"

NAPLES'S ANTIQUITIES
Campania, Italy

// Treasures of Vanished Civilizations

Mount Vesuvius spewed ash and mud over Pompeii and Herculaneum on August 24, AD 79, thereby preserving them almost intact and giving modern visitors a window on life during the days of the Caesars. Herculaneum is less thronged than Pompeii and gives fascinating insights into the lifestyles of the Roman elite at the House of the Stags and the public baths of the House of Neptune and Amphitrite. Most of the precious sculptures, murals, and mosaics excavated from Pompeii and Herculaneum can be found at Naples's National Museum of Archaeology.

Must Visit // The Greek temple complex at Paestum, including the Temple of Poseidon (*right*), on the nearby Sorrentine Peninsula, one of the oldest and best preserved // Pompeii's House of the Faun, the Casa dei Vettii, and the House of Mysteries, for their mosaics and frescoes // The Stabian Baths in Pompeii and their rather explicit frescoes suggesting that something more than bathing went on // Herculaneum's Villa dei Papiri, home to some 1,800 papyrus scrolls

THE QUADRILATERO
Bologna, Emilia-Romagna, Italy

// Where Food Is a Magnificent Obsession

"Bologna la Grassa" (Bologna the Fat One) is the preeminent culinary center of a food-conscious country. Explore the Quadrilatero, the city's medieval district just east of Piazza Maggiore, where windows display fish, cheeses, wild mushrooms, cured meats, and Bologna's own mortadella sausage (the distant granddaddy of American bologna) and trattotias serve local specialties like tortellini and *ragù alla bolognese*.

Must Visit // Tamburini, Italy's most lavish food emporium // The many trattorias that lend credence to the old Italian saying that the two best places to eat are your mother's house and Bologna // The Due Torri, the famously leaning medieval twin towers

PIAZZA DEL DUOMO
Parma, Emilia-Romagna, Italy

// A City of Great Art and Refinement

Parma—the home of Arturo Toscanini, Giuseppe Verdi, Parmigiano cheese, and prosciutto—offers visitors much more as soon as they set foot in the Piazza del Duomo, one of the loveliest in Italy, where the octagonal Battistero, clad in pink Verona marble and festooned with reliefs, stands next to the 12th-century Duomo and its cupola that houses Antonio Correggio's *Assumption of the Virgin*.

Must Visit // The Galleria Nazionale, a former ducal palace filled with art // The Teatro Reggio, one of the world's finest opera houses // The Musei del Cibo, a collection of food museums located in and around the city

RAVENNA
Emilia-Romagna, Italy

// Dazzling Mosaics in a Former Capital of the Byzantine Empire

Ravenna's mosaics evoke the city's storied past as the last capital of the Western Roman Empire after the fall of Rome in the 5th century AD. Today the town is sleepy, unpretentious, and rarely crowded—a blessing for art lovers. There are six places to see the tapestries of mosaics commissioned by the Byzantine rulers that cover the interiors of churches and mausoleums with designs of epic proportion and detail.

Must Visit // The 6th-century Tomb of Gallia Placidia, who ruled for 20 years as regent to her son // The adjacent Basilica di San Vitale (*below*), one of the crowning achievements of Byzantine art in the world // Among other monuments, the tomb of Dante Alighieri, author of *The Divine Comedy*, who died here in 1321

FRIULI
Friuli–Venezia Giulia, Italy

// Crossroads of the North

Tucked away into Italy's northeast corner, just south of Austria, snug against the border of Slovenia, Friuli is where Italians escape on gastronomic holidays to savor sweet prosciutto hams from the village of San Daniele, robust artisanal cheeses, the celebrated local asparagus, white wines from the Friulano grape, and cuisine influenced by Latin, Germanic, and Slavic cultures.

Must Visit // The medieval city of Udine, with Renaissance buildings by Andrea Palladio, a wealth of luminous paintings by Tiepolo, and on its outskirts the Abbey of Roses (*left*), home to one of Friuli's oldest wine cellars // Cividale del Friuli, the hub of the local wine trade a few minutes' drive east of Udine

ROME
Lazio, Italy

Take in the chaotic traffic and exuberance of life in the Italian capital, and it's easy to believe that all roads lead to Rome. Behold the original mosaics at the Basilica of Santa Maria Maggiore and plant your feet at the Umbilicus Urbus, the designated city center of Rome and ground zero from which all distances in the Empire were measured. Via Condotti and its pedestrian grid of cobbled offshoots at the foot of the Spanish Steps offer ultrasmart shopping and the ideal venue for an early evening *passeggiata*, or stroll. Stop in at Caffè Greco, Rome's oldest watering hole, frequented by Casanova, Goethe, and Lord Byron.

The city can overwhelm its visitors with millennia of history, unrivaled art collections, neighborhoods that feel like small villages, and an enviable marriage of carpe diem and la dolce vita. See the sights, embrace the vitality, and do as the Romans do: Linger awhile with a *caffè* or *aperitivo* in the timeless oval-shaped Piazza Novona while watching the unfolding spectacle that is Rome, *caput mundi*.

LEFT // Vatican City, the world's smallest independent state, is the epicenter of Roman Catholicism and home of one of the world's greatest collections of art and architecture, including La Basilica di San Pietro, the Sistine Chapel (see Michelangelo's magnificent ceiling frescoes), and the Vatican Museums (*pictured*).

RIGHT // The **Basilica of Santa Maria Maggiore**, one of the city's four major basilicas, was built in the 5th century—and later expanded—on a site said to have been chosen by the Virgin Mary. The original mosaics are among the oldest and most beautiful in the city.

BELOW // The **Coliseum**, once able to seat 50,000, is the largest Roman amphitheater in the world. Begun in AD 72 by Vespasian, it is the enduring symbol of the Eternal City and the grandeur that was Rome.

BELOW // Marble sculptures such as Bernini's *Apollo and Daphne* [pictured] and Casanova's *Pauline Bonaparte* join Caravaggio's *David with the Head of Goliath* and other treasures at the **Borghese Gallery**, a 17th-century villa.

ABOVE // Designed by Michelangelo in the 16th century, the **Piazza del Campidoglio** is one of Rome's most elegant spaces. Three palazzos framing the piazza are home to the Capitoline Museums, which display a treasure trove of ancient Roman sculpture and Renaissance paintings.

RIGHT // Built in 27 BC by Marcus Agrippa and reconstructed by Hadrian in the early 2nd century AD, the **Pantheon** is an architectural wonder that is exactly as wide as it is high.

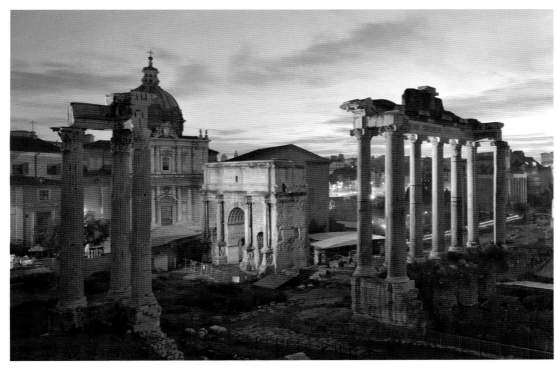

LEFT // The center of Roman political, judicial, and commercial life in the days of the Republic, the **Roman and Imperial Forums** are an evocative jumble of pillars and ruins.

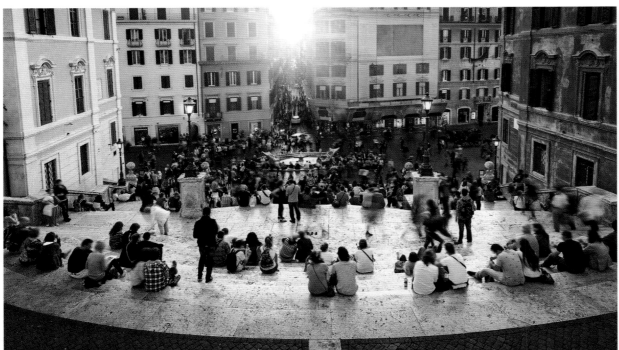

ABOVE // Rome's oldest and best outdoor marketplace is at **Campo de' Fiori**, where the city's chefs snatch up the freshest produce available.

LEFT // Built in 1725, the **Spanish Steps** ascend in three majestic tiers from Piazza di Spagna to the French Trinità dei Monti church. Their name originates from the Spanish Embassy, which occupied a nearby palazzo in the 19th century.

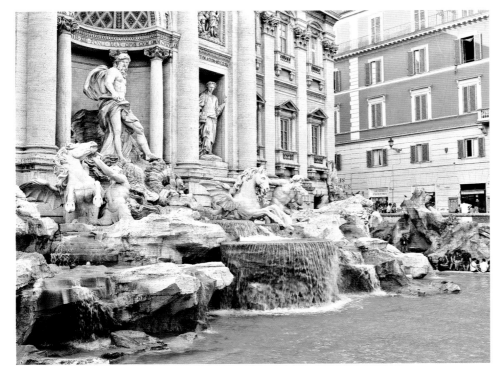

LEFT // At the **Trevi Fountain**, two Tritons guide Oceanus's shell chariot drawn by winged sea horses across a wildly fanciful Baroque assemblage of white marble and cascading water, completed in 1762. The piazza and fountain evoke the legend that a backward toss of a coin over the left shoulder into the basin ensures a return to Rome.

CINQUE TERRE
Liguria, Italy

// A Coastline Hike with
Inspiring Seascapes

The five villages hidden in tiny coves along the craggy southern stretch of the Ligurian Riviera offer a glimpse of Italy as it must have been a century ago. The fishing hamlets of the Cinque Terre were once accessible only by boat or mule paths strung along the precipices. Today they have been discovered by hikers who come to traverse some of the most gorgeously scenic and not-too-difficult trails in Europe.

Must Do // Visit Monterosso, with its notable selection of small hotels and restaurants and a good stretch of beach // Follow the Blue Trail from Monterosso to reach the southernmost village, Riomaggiore, in 5 or 6 hours or travel by train or boat to the other towns // Hike the steep 26-mile Red Path between Levanto and Portovenere.

THE ITALIAN RIVIERA
Liguria, Italy

// Idyllic Harbors
and Famous Retreats

The Italian Riviera unfolds from the French border against a glittering panorama of turquoise sea and rugged mountains. The 220-mile Ligurian coastline is made up of palm-fringed resort towns, with their historical centers and charming trompe l'oeil painted façades. Though the coast is now mostly developed, you can still hire a local fisherman to transport you to quiet, craggy coves with surprisingly unspoiled views along the way.

Must Do // Take the train from Santa Margherita Ligure to Camogli, a relatively unspoiled fishing village with lovely views (*left*) // Hike the well-marked paths (20 minutes by summertime-only boat) from Portofino to the 10th-century Abbey of San Fruttuoso for a waterfront lunch // When tiny Portofino is overcome by high tides or crowds, visit neighboring Santa Margherita Ligure for its beaches and wide promenade.

THE ITALIAN LAKES
Lombardy, Italy

// Shimmering Beauties
at the Foot of the Alps

Italy's three major lakes—Maggiore, Como, and Garda (left)—have long inspired music, poetry, and no end of appreciation from those who have witnessed their Alpine-framed spectacle. They hint of Switzerland just to the north, yet with their profusion of elegant villas, stylish lakeside villages, and lush gardens, they are inherently Italian too.

Must Do // Drive an hour from Milan to Maggiore, where Ernest Hemingway set *A Farewell to Arms*, and visit its two Borromean Islands // Visit Orta San Guilio, west of Maggiore, where the Basilica di San Giulio appears to float on Lake Orta // Explore Bellagio on Lake Como, one of the prettiest towns anywhere // Tour the ruins of the Grotte di Catullo on the shores of Lake Garda, Italy's largest lake.

PALAZZO DUCALE AND PALAZZO TE
Mantua, Lombardy, Italy

// A Celebration of
Renaissance Splendor

Mantua owes its rich past to the Gonzaga family, who were to this city what the Medicis were to Florence. Under their influence, the city flourished for 400 years. Their sumptuously decorated Palazzo Ducale (right) is filled with vibrant canvases by Renaissance masters. Palazzo Te, created by Federico II, displays Giulio Romano's rich frescoes, which are among the world's greatest masterpieces of Mannerist art.

Must Do // Visit when a vial allegedly containing the Most Precious Blood of Christ is paraded through the streets on Good Friday // Attend mid-September's Festivaletteratura, a series of concerts and plays.

THE LAST SUPPER AND OTHER WORKS OF LEONARDO DA VINCI
Milan, Lombardy, Italy

// Genius of a
Renaissance Man

Completed for the convent of Santa Maria delle Grazie in 1498, Leonardo da Vinci's *Il Cenacolo* (*The Last Supper*; right) can be viewed only by reservation because of its fragility due to Leonardo's experimental use of paint mixed with egg yolks and vinegar on dry plaster.

Must Visit // Castello Sforzesco, to view Leonardo's fresco (and the *Rondanini Pietà*, the last work of Michelangelo) // The Biblioteca Ambriosana, which displays Leonardo's *Codex Atlanticus*, a 1,100-page notebook of writings and drawings // The National Museum of Science and Technology, to see replicas of Leonardo's airplanes, helicopters, and submarines

ON AND AROUND PIAZZA DEL DUOMO
Milan, Lombardy, Italy

// The Epicenter of Fashion, Design, and Good Living

A stroll across Milan's Piazza del Duomo appeals to anyone who enjoys the finer things in life. The Duomo (*below*), Milan's most famous landmark and one of the world's largest cathedrals, has an exterior topped with 135 marble spires and adorned with 2,245 marble statues while the interior seats 40,000. Milan's preoccupation with design is showcased a few blocks away on the Via Montenapoleone and its offshoots, part of the single most fashionable retail acre in the world.

Must Visit // The roof of the Duomo (take an elevator up) to stroll amid the white marble pinnacles and to study the flying buttresses up close—and, if it's a clear day, to see the Swiss Alps 50 miles away // The Galleria Vittorio Emanuele II, one of the world's first enclosed, pedestrian-only shopping malls // Teatro alla Scala, the world's most famous opera house, where Verdi and Puccini debuted works and Maria Callas sang // Peck, Milan's legendary food-as-art emporium

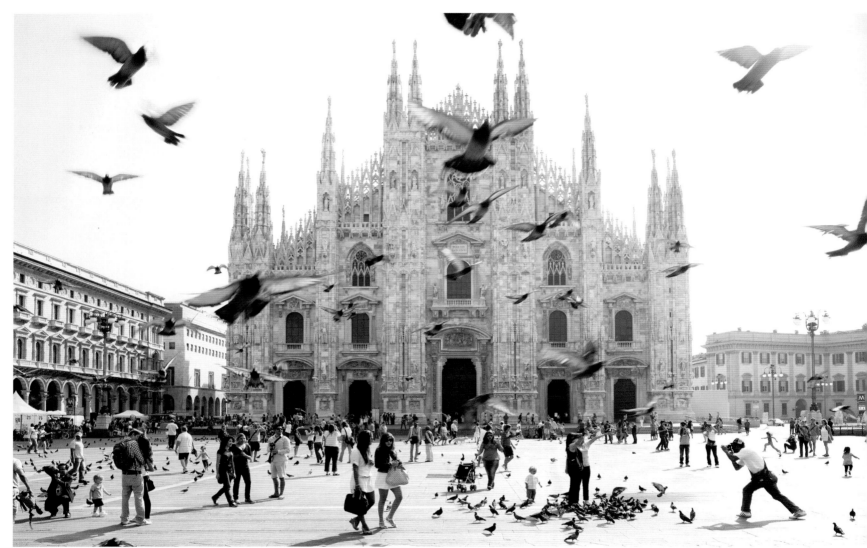

URBINO AND PESARO
Le Marche, Italy

// Grand Palazzo Ducale and Bel Canto Opera

Underrated Urbino could easily share the spotlight with better-known Italian cities for its history, art, architecture, and gastronomy if not for its off-the-beaten-track location atop a steep hill in the Le Marche region. The city's Palazzo Ducale (*right*) is considered the perfect expression of the early Renaissance and now houses the Galleria Nazionale delle Marche, which displays works by native son Raphael and Piero della Francesca.

Must Do // Visit in late July for Urbino's Festival Internazionale di Musica Antica, Italy's most important Renaissance and Baroque music festival // Make your way down the coast to Pesaro, an attractive resort and hometown of Gioacchino Rossini, composer of *The Barber of Seville*. Visit in August for the Rossini Opera Festival.

LE LANGHE
Piedmont, Italy

// Where Truffles and Wine Take Center Stage

The hills and towns of Le Langhe are as mellow as the famous Barolo, Nebbiolo, and Barbaresco wines they produce, and the climate is also hospitable to the white truffle. With these culinary pleasures, the Langhe is reminiscent of Tuscany, but for now this quiet corner of Italy is a well-kept secret.

Must Do // Visit Asti, famous for its sparkling whites, during late September for the Palio, a bareback horse race around the Piazza Alfieri // Explore nearby Alba on a Saturday morning, when a lively food market winds along Via Vittorio Emanuele.

SARDINIA
Italy

// Coastal Glamour and the Interior's Mystique

Sardinia, Italy's second-largest island, is both a glamorous playground with more than 1,000 miles of soft-sand beaches and a rugged holdout of traditional life. While the Costa Smeralda attracts the rich and famous who arrive on their private boats, much of Sardinia has not changed. A unique dialect not far removed from Latin is still spoken in the interior's medieval towns, and natives tend sheep and vineyards that produce rich cheeses and flavorful wines.

Must Visit // Maddalena Archipelago National Park // The walled port of Alghero, the island's prettiest town // The Grotta di Nettuno, where boat tours ply a string of underground lakes // The Nuraghe Palmavera, where 50 conical stone huts (*nuraghe*) from around 1500 BC surround a beehive-shaped tower

AEOLIAN ISLANDS
Sicily, Italy

// Volcanic Drama and Barefoot Chic

Named for Aeolus, god of the winds, the eight Aeolian Islands off Sicily's northeastern flank are washed by Italy's clearest waters and blessed with grottoes, bays, hidden coves, black sand beaches, and still-active volcanoes. Lipari, the attractive capital island, has an animated old town dominated by a 17th-century *castello* that houses a noted archaeological museum.

Must Do // Visit Salina (*left*), the greenest of the islands // Dive or snorkel the dazzling seafloor off Panarea // Make the 5- to 6-hour round-trip climb up the still-active volcano on Stromboli.

THE GEMS OF PALERMO
Palermo, Sicily, Italy

// From Sacred and Serene to Modern-Day Chaos

Palermo's 25 centuries of tumultuous history is reflected in the Palazzo dei Normanni, home to Sicily's 9th-century Arab rulers and transformed into a sumptuous palace by the Normans in the 12th century. The palace's Cappella Palatina is encrusted with Byzantine mosaics that blend Western and Eastern traditions while the Duomo melds similar influences with domes, towers, and tiled arches.

Must Visit // The Church of St. John of the Hermits, topped with five red domes and surrounded by exotic gardens // The 12th-century Cattedrale di Santa Maria la Nuova in Monreale (*right*), 5 miles from Palermo, known for its golden mosaics // Palermo's vibrant markets of Ballarò, Capo, and Vucciria

SICILY'S GREEK TEMPLES
Sicily, Italy

// Splendid Monuments
of the Ancient World

The Greek colonists who began arriving in Sicily in the 8th century BC brought their Hellenic politics and culture with them. A Greek presence remains in many cities, such as Siracusa, on the southeastern tip of the island, where the amazingly well-preserved Teatro Greco stages classic plays each summer. Other important landmarks are preserved in the nearby Parco Archeologico and on the small island of Ortigia.

Must Visit // Agrigento's Valley of Temples (*left*), home of the Tempio della Concordia and the Tempio di Giove, one of the largest Greek temples ever built // The five temples and an acropolis in Selinunte, an hour's drive west of Agrigento // Segesta, northwest of Palermo, the site of a perfectly proportioned temple and a beautifully preserved theater

TAORMINA AND MOUNT ETNA
Sicily, Italy

// A Fashionable Resort
and a Fiery Volcano

This town 650 feet above the Mediterranean has been enticing travelers since the days of ancient Greece. Take a leisurely *passeggiata* past charming boutiques and ceramic shops, then linger for a lemon granita (shaved ice) or fruit-studded cannoli while admiring 11,000-foot-high Mount Etna standing in the distance against the blue Sicilian sky.

Must Do // Attend a summertime performance in Taormina's ancient Greek amphitheater (*right*) // Take a jeep tour to Mount Etna and make the final ascent via cable car to the summit of Europe's most active volcano.

THE DOLOMITE DRIVE AND CORTINA D'AMPEZZO
Trentino-Alto Adige, Italy

// Italy's High Haven

The Dolomite Drive rises and falls for 68 miles through the majestic beauty of the Dolomite Mountains (*left*) in the northern reaches of Alpine Italy. From Bolzano, the road climbs the 7,500-foot-high Passo del Pordoi before descending to Cortina, the home of more than 95 miles of ski runs, summertime hiking trails, and the "via Ferrata" iron path, a network of cables, ladders, and rungs put in place during World War I and loved by adventurers today.

Must Do // Enjoy the sunset that envelops the limestone peaks surrounding Cortina in a rosy glow // Ski or hike to the more than 50 shelters in the mountains above Cortina that have been converted to restaurants.

FLORENCE
Tuscany, Italy

Once ruled by the Medicis, a wealthy family who founded Europe's largest bank in the 15th century, Florence is home to museums and churches filled with countless treasures by the artists who made the city the cradle of the Renaissance. The capital of Tuscany is crowned by the octagonal dome designed by Filippo Brunelleschi more than 600 years ago for the Cattedrale di Santa Maria del Fiore, one of the central achievements of Renaissance architecture, which shares the Piazza del Duomo with the bronze *Doors of Paradise* by Ghiberti and Giotto's slender bell tower. For a sense of the city's history, visit the New Sacristy of the Medici Chapels, Michelangelo's first architectural project, which houses the tombs of Lorenzo the Magnificent and other members of the ruling clan, or stroll across the medieval Ponte Vecchio that spans the Arno to the Palazzo Pitti.

The Florentine lifestyle is a work of art as well, to be savored in historic cafés, welcoming trattorias, stylish boutiques, and the city's medieval streets and piazzas. Enjoy the street life on the Piazza della Signoria, where a replica of Michelangelo's *David* stands. Savor the hilltop views from Piazzale Michelangiolo that have inspired both Renaissance masters and modern-day photographers, or let the daily program of Gregorian chant at the nearby Chiesa di San Miniato al Monte transport you back to the Middle Ages.

Whether offering up priceless treasures from the past or treats from the present-day food halls at the Mercato Centrale, Florence is truly a city for all the ages.

LEFT // **The Galleria dell'Accademia** has been the home of Michelangelo's *David* (*pictured*) since 1873 as well as the artist's unfinished *Prisoners*, their forms struggling to break free from the raw marble that encases them.

RIGHT // The **Uffizi Galleries** house masterworks collected by the Medicis and bequeathed to the people of Florence. Botticelli's *Birth of Venus* is one of the standouts in halls filled with works by Michelangelo, Cimabue, Raphael, Giotto, Leonardo da Vinci, Piero della Francesca, and Filippo Lippi.

BELOW // Behind the massive doorways of the **Basilica of Santa Maria Novella** are some of Florence's greatest treasures: frescoes by Domenico Ghirlandaio, Filippino Lippi, and Nardo di Cione; Masaccio's *Trinità*, the first painting to use perspective; and the pulpit from which Galileo was denounced for saying the earth orbits the sun.

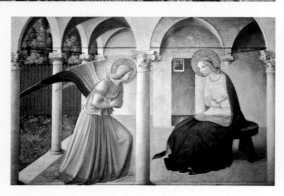

ABOVE // The most celebrated friar of the 13th-century Dominican monastery that is now the **Museo San Marco** was the mystical Fra Angelico, and three of his masterworks, including *The Annunciation* (*pictured*), are found here, as is an important work by Domenico Ghirlandaio, who taught a young Michelangelo the art of fresco painting.

ABOVE // The **Palazzo Vecchio**, in the Piazza della Signoria, was the home of the Medicis until they moved into the Palazzo Pitti across the Arno. You can now find Michelangelo's statue *Victory*, Vasari's *Quartiere degli Elementi*, and Donatello's original *Judith and Holofernes* here.

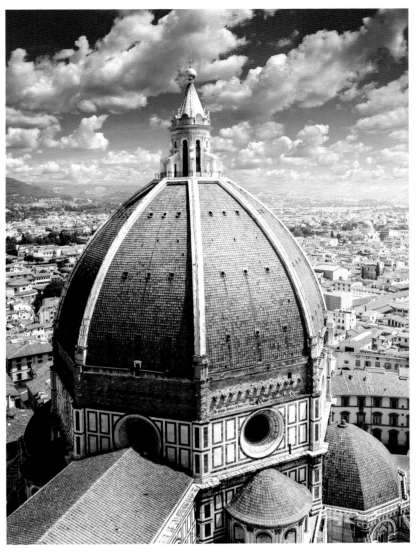

LEFT // **Il Duomo** is arguably the central achievement of Renaissance architecture. The cathedral, consecrated in 1436, is topped by Filippo Brunelleschi's enormous octagonal dome (now the very symbol of Florence) and houses an enormous Last Judgment fresco by Vasari and Federico Zuccari. Other landmarks on the Piazza del Duomo are the freestanding baptistery, with its famous bronze Doors of Paradise by Ghiberti, Giotto's slender bell tower, and the Duomo Museum.

BELOW // Decorated with Giotto's masterful frescoes, the **Basilica of Santa Croce** contains the tombs of Michelangelo, Machiavelli, Galileo, and Ghiberti as well as magnificent art treasures.

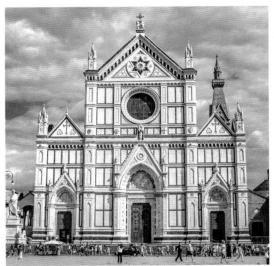

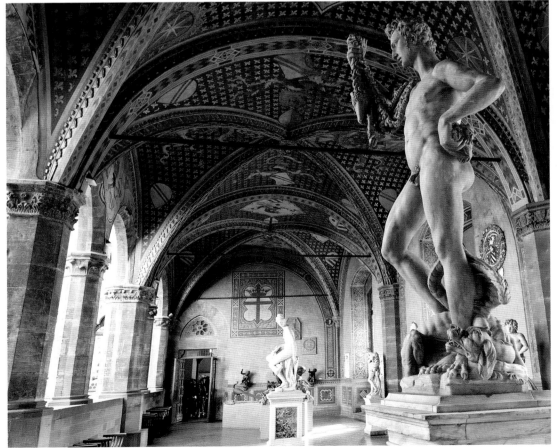

ABOVE // Built in the late 15th century and surrounded by the hill-climbing Boboli Gardens, the **Pitti Palace** was bought by the Medicis in 1550 and substantially enlarged. Today it houses the Palatine Gallery, whose 26 rooms display works by Titian, Raphael, Rubens, Murillo, and Caravaggio.

LEFT // Housed in a Gothic fortress from 1255, the **Bargello National Museum** displays Florence's greatest collection of Renaissance sculpture, including Michelangelo's slightly tipsy-looking *Bacchus* and a bronze of David by Donatello.

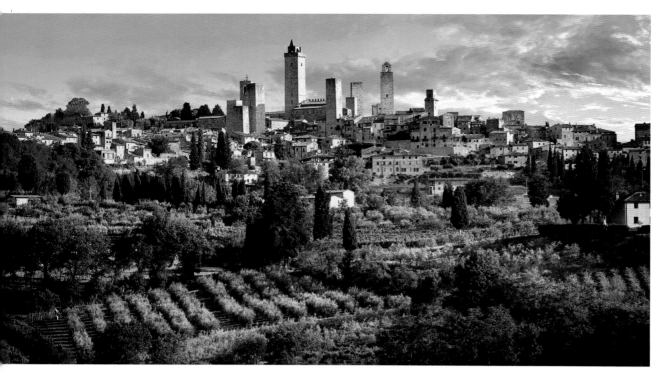

THE HILL TOWNS OF TUSCANY
Tuscany, Italy

// Connecting the Dots in a Postcard-Perfect Landscape

Few travel experiences in Italy are more exhilarating than winding along a country road and coming upon the silhouette of yet another Tuscan hilltown on a cypress-lined crest. The Chianti area just beyond Florence is one of the most beautiful wine regions in Italy. Follow the old Chianti Road from Florence to Siena through rolling hills, medieval castles, and stone farmhouses.

Must Do // Stop at Greve, where some of the finest Tuscan reds are produced, on your way to San Gimignano (*left*) and its 12th-century towers // Visit Montalcino, the "Pearl of the Renaissance," as well as the hill towns of Pienza, Volterra, Montepulciano, and Cotona.

LUCCA AND PISA
Tuscany, Italy

// Puccini's Hometown and a Leaning Tower

Lucca is a perfect town to explore on foot or by bicycle. Follow the 3-mile path atop the city's ramparts for a bird's-eye view of the endless olive groves beyond the town that give the world some of its finest olive oil. The neighboring city of Pisa deserves to be seen for its Leaning Tower (*right*) alone. After completion, it leaned a fraction of an inch more each year until a 1990s restoration arrested the tilt.

Must Do // Visit Lucca's San Michele in Foro and the even older Duomo, both masterpieces of intricate Romanesque stone carving // Attend the Puccini Opera Festival held in Torre del Lago from mid-July to mid-August.

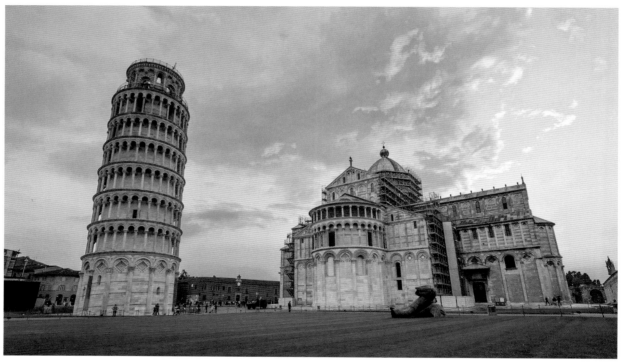

MAREMMA
Tuscany, Italy

// Etruscans and Cowboys in the Far Reaches of Tuscany

Southwestern Tuscany's sun-burnt hills are covered in golden wheat and grazing lands where *butteri*, a dying breed of cowboys, tend the region's white, long-horned maremmano cattle (*left*). Maremma's acclaimed beaches extend along Italy's longest stretch of unspoiled coastline, much of it protected by the Parco Nazionale della Maremma.

Must Visit // The Etruscan tombs in and around the village of Sovana // The elaborate thermal baths at Saturnia

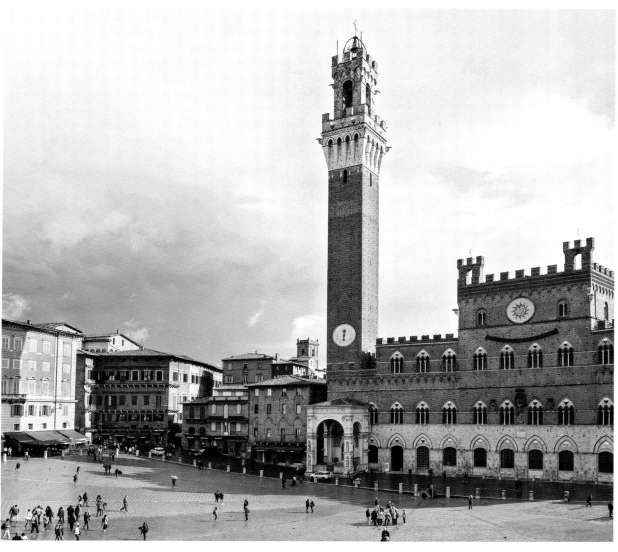

SIENA
Tuscany, Italy

// Horse Races Amid Medieval Monuments

Siena reached its zenith in the 13th century, but the High Renaissance largely bypassed the city after the Black Death struck in 1348, leaving its medieval monuments intact. Piazza del Campo is the heart of the city and the site of the raucous Palio bareback horse race that takes place each year on July 2 and August 16. Following a procession of drummers and banner bearers (*above*) comes the 90-second race, three hair-raising laps around the piazza covered with dirt for the occcasion.

Must Do // Climb the 505 steps of the Palazzo Pubblico bell tower in the Piazza del Campo (*left*) for an unforgettable view of the Tuscan countryside // Visit the Duomo of Santa Maria Assunta, a Gothic cathedral whose interior and exterior is striped with black and white marble.

ASSISI AND GUBBIO
Umbria, Italy

// In the Footsteps of St. Francis

St. Francis's spirit of humanity, humility, and love for nature infuses the pink-hued Umbrian hill town of Assisi (*right*). An enormous basilica was built in honor of the barefoot friar, although its size would most likely have mortified him. St. Francis is also associated with nearby Gubbio, where an ancient amphitheater attests to the town's Roman roots.

Must Visit // The Basilica of San Francesco d'Assisi, where the tomb of Italy's patron saint draws pilgrims while Giotto's remarkable frescoes depict his life // The Basilica of St. Clare, the burial site of one of St. Francis's most ardent followers

IL DUOMO
Orvieto, Umbria, Italy

// High in the Sky,
a Romanesque Jewel

Orvieto commands a position atop a high, flat column of tufa stone more than 1,000 feet above sea level. The Duomo, the centerpiece of this ancient town, can be seen from far across the plains below when the sunlight catches the ornate Gothic façade's glistening mosaics.

Must Do // View the cycle of frescoes that cover almost 10,000 square feet of the walls and ceiling of the Duomo's San Brizio chapel // Sample Orvieto's famous dry white wine at local wine cellars and restaurants.

PERUGIA
Umbria, Italy

// History and the Arts in
the Umbrian Hills

One of Italy's most beloved hill towns, Perugia dates back to the days of the Etruscans and flourished in the Middle Ages. At its center is the 13th-century Fontana Maggiore, the terminus of the city's ancient aqueducts, and the nearby Collegio del Cambio, built for money changers and traders. Next to chocolate, native son Pietro Perugino, one of the most important painters of the High Renaissance, may be the city's best-known export.

Must Do // Visit the Palazzo dei Priori, the home of the Galleria Nazionale dell'Umbria and its comprehensive collection of regional sculpture and paintings // Take a self-guided tour of the Basilica of San Domenico (*left*), overlooking Piazza Giordano Bruno // Take a stroll along Corso Vannucci, where locals shop and argue over soccer scores or the most recent political scandal.

COURMAYEUR AND MONT BLANC
Valle d'Aosta, Italy

// High Life in the Alps

Nestled at the base of Mont Blanc, Europe's highest mountain, Courmayeur is one of the most popular ski resorts in the Italian Alps, with slopes geared to beginners as well as die-hard enthusiasts. Some visitors may never strap on a pair of skis but pass the time enjoying the town's chic bars, boutiques, and numerous restaurants.

Must Do // Take the cable car from nearby La Palud up and over Mont Blanc, one of the most breathtaking rides in the world // Bike around the mountain in 4 days on the demanding Tour du Mont Blanc // Hike hundreds of miles of summertime trails, including those of the nearby Parco Nazionale del Gran Paradiso.

VENICE
Veneto, Italy

The watery world of Venice never fails to enchant. Begin your love affair with the city by tossing the map and wandering among its Byzantine domes and palazzos in neighborhoods where not much has changed since Marco Polo, a Venetian native, set sail for uncharted lands. Jump aboard the number 1 *vaporetto* at Piazza San Marco or the Santa Lucia train station and float through 1,000 years of history down the 2-mile Grand Canal, or take a gondola ride along more than 150 back canals to see hidden corners of this unique "city built on water."

To escape the throngs that can overwhelm the city, attend a performance of native son Antonio Vivaldi's work at the Chiesa della Pietà, or picnic on Torcello and view the island's Byzantine mosaics. Make the 40-mile jaunt to Asolo, the hilltop retreat Robert Browning called "the most beautiful spot I ever was privileged to see," or travel west to Vicenza to take in one of Andrea Palladio's finest works, the Teatro Olimpico. Padua's 13th-century Scrovegni Chapel, where Giotto and his students transformed late-medieval and early Renaissance painting, is also just a day trip away.

Venice also offers many opportunities to rub elbows with festive crowds, starting with the theatrical Carnevale 2 weeks before Ash Wednesday and September's Regata Storica, when decorated gondolas carry passengers in historical costumes down the Grand Canal. The Film Festival and the Art Biennale (in odd-numbered years) bring an air of glamour to the Queen of the Adriatic.

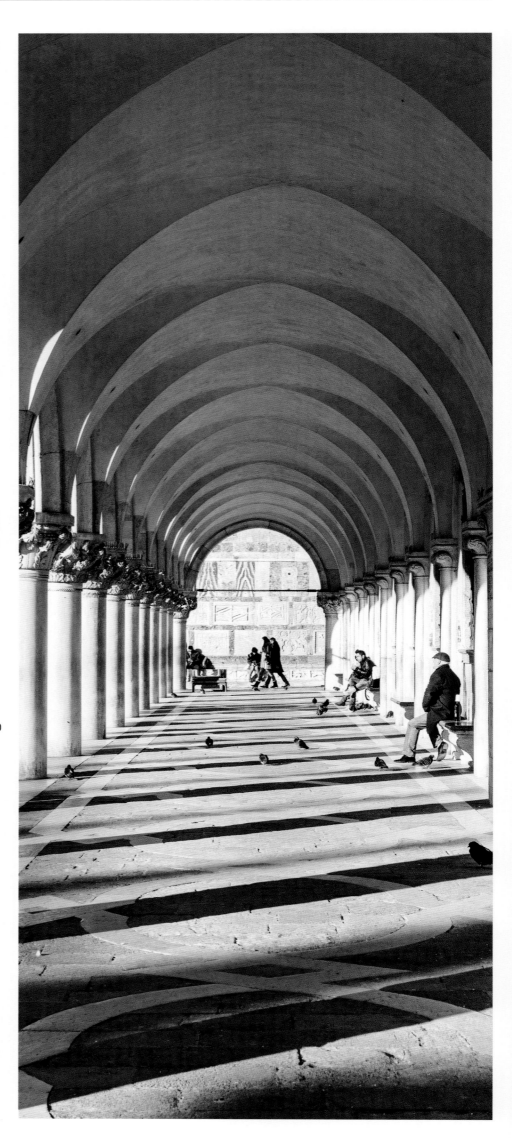

RIGHT // The pink-and-white-marble **Palazzo Ducale**, the former home of the Doges who ruled the Most Serene Republic of Venice, is filled with paintings by Veronese, Tintoretto, and other Venetian masters. The Bridge of Sighs links the palace with the Palazzo delle Prigioni, where prisoners were held after being judged.

ABOVE // The **Peggy Guggenheim Collection** displays works by Pollock, Brancusi, Picasso, Klee, Rothko, Chagall, and Max Ernst in the American collector's former home, as well as works by Alexander Calder and Claes Oldenburg (*pictured*) in its sculpture-filled garden.

LEFT // The most extensive collection of Venetian masters in the world fills the **Gallerie dell'Accademia** with works by Titian (*pictured*, *Presentation of the Virgin at the Temple*), Giorgione, Bellini, Carpaccio, and Tintoretto.

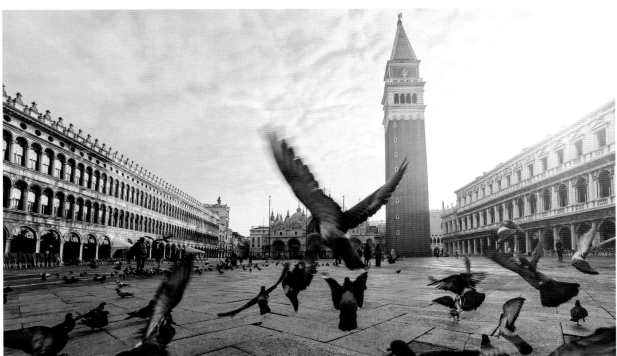

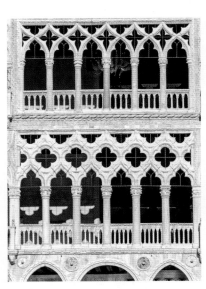

ABOVE // Titian's *Venus at the Mirror* vies with Mantegna's *St. Sebastian* for attention at the **Ca' d'Oro and the Galleria Giorgio Franchetti**, a 15th-century palazzo on the Grand Canal.

ABOVE // Two bronze Moors atop the 15th-century Clock Tower strike the hour in **Piazza San Marco**, where the Campanile (*pictured*)—the tallest structure on the Venice skyline—provides a miraculous view over the city. Byzantine and almost mosquelike, the Basilica di San Marco houses the relics of St. Mark, the city's patron saint.

LEFT // The **Grand Canal**, Venice's Main Street, is a 2-mile-long, S-shaped aquatic thoroughfare lined with hundreds of weatherworn Byzantine and Gothic palazzos and abuzz with canal life. *Vaporettos* (water buses), water taxis, commercial boats, and gondolas barely avoid collision as they vie for space.

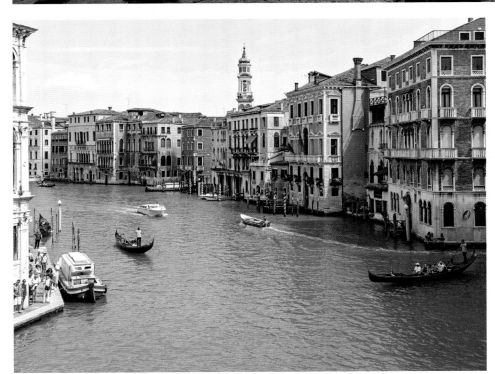

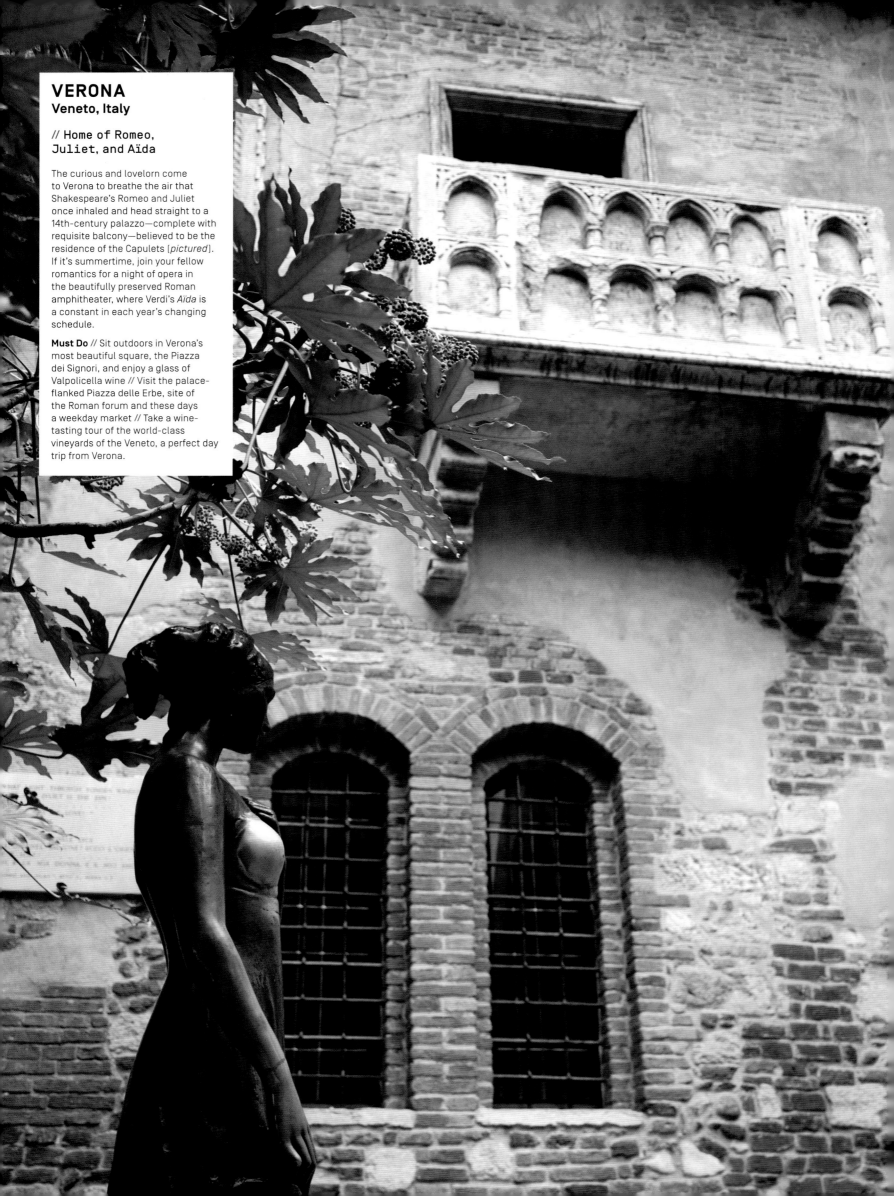

VERONA
Veneto, Italy

// Home of Romeo,
Juliet, and Aïda

The curious and lovelorn come
to Verona to breathe the air that
Shakespeare's Romeo and Juliet
once inhaled and head straight to a
14th-century palazzo—complete with
requisite balcony—believed to be the
residence of the Capulets (*pictured*).
If it's summertime, join your fellow
romantics for a night of opera in
the beautifully preserved Roman
amphitheater, where Verdi's *Aïda* is
a constant in each year's changing
schedule.

Must Do // Sit outdoors in Verona's
most beautiful square, the Piazza
dei Signori, and enjoy a glass of
Valpolicella wine // Visit the palace-
flanked Piazza delle Erbe, site of
the Roman forum and these days
a weekday market // Take a wine-
tasting tour of the world-class
vineyards of the Veneto, a perfect day
trip from Verona.

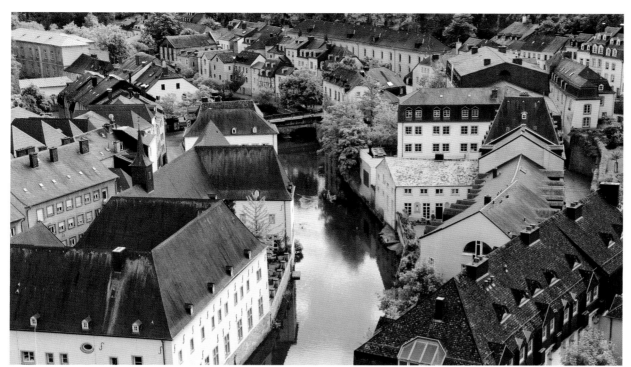

LUXEMBOURG CITY
Luxembourg

// A Hidden Fortress

Built around a 10th-century castle at the crossroads of Belgium, France, and Germany, Luxembourg City has only about 115,000 residents, but it's the undisputed heart of the country. Just 10 percent of the fortifications remain in the Old Town (*left*), but the medieval ambience is still palpable, albeit mixed with a contemporary vibe.

Must Do // Visit the Museum of Modern Art, a striking glass structure designed by I. M. Pei // Attend a concert at the teardrop-shaped Grand-Duchesse Joséphine-Charlotte Concert Hall.

VALLETTA
Malta

// Historic Headquarters of the Knights of St. John

Located at the crossroads of the Mediterranean, the tiny island of Malta was presented as a gift to the Knights of St. John by the Holy Roman Emperor Charles V in 1530, after they had been driven from Rhodes by the Ottoman sultan. The knights designed and constructed Valletta, one of Europe's first planned cities, a city "built by gentlemen for gentlemen" in the assessment of Benjamin Disraeli.

Must Do // Visit the museum at St. John's Co-Cathedral to see Caravaggio's *The Beheading of St. John the Baptist* // Tour the nearby Grand Masters' Palace (*right*), home to colorful frescoes and priceless Gobelin tapestries. Inspect the Armory's 5,000 suits of armor // Walk around the city's massive walls and pause at the Upper Barrakka Gardens for a superb view over the Grand Harbor.

MONACO
Monaco

// World-Famous Enclave of Royalty and the Jet Set

The tiny principality of Monaco has been a playground for Europe's elite for more than a century, drawn by its sandy beaches, Mediterranean panoramas, and Monte Carlo's renowned Grand Casino (*right*). Slot machines in the lobby of the casino are free of charge if you dress nicely and carry a passport, but there's a fee to enter the front gambling rooms and those leading to the Salons Privés, the high rollers' inner sanctum.

Must Visit // The Grimaldi family's fortified palace, to watch the daily changing of the guard // The nearby Oceanographic Museum, home to one of Europe's best aquariums

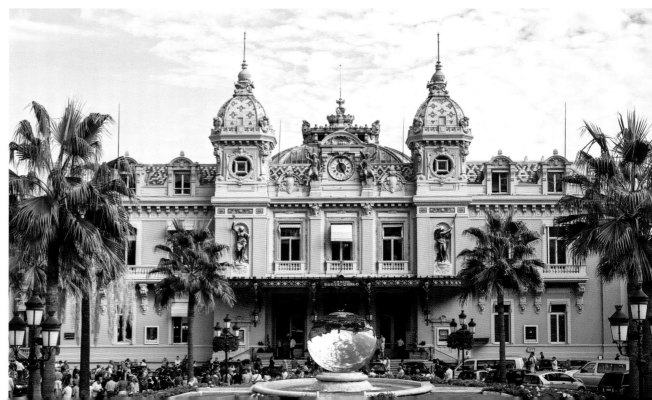

AMSTERDAM
Netherlands

BELOW // The **Rijksmuseum** houses Rembrandt's *The Night Watch* as well as paintings by Jan Vermeer, Frans Hals, Jacob van Ruisdael, Anthonis Mor (*pictured, Portraits of Sir Thomas Gresham and Anne Fernely*), and other Old Masters.

World-class museums, the heritage of a glorious golden age, and a vibrant contemporary culture await visitors to Amsterdam. Though small enough that one can walk or cycle almost anywhere, this City of Canals was meant to be seen by boat. But head to solid ground to experience Amsterdam's *gezelligheid*—an amalgam of "coziness" and "conviviality"—in a "brown café," not to be confused with a coffee shop, where mind-altering substances are legally sold. Experience historical Holland firsthand at Zaanse Schans, an open-air museum with working windmills near Zaandam.

ABOVE // At the heart of Amsterdam's **Red Light District** is the Old Church, known for having one of the best carillons in the world. The joyful sound of the bell music cascades down the cobblestoned streets where women sit in rose-tinted windows. The world's oldest profession is legal, regulated, taxed, and unionized in this historically tolerant city.

ABOVE RIGHT // Amsterdam's famous **Flower Market** sells sealed bags of bulbs that you can take back home; you can also head to the flower-growing region west of the city to visit the vast seasonal Keukenhof Gardens or Leiden University's Hortus Botanicus, where the first tulips in Holland, imported from Turkey, were planted.

LEFT // Almost unbearably poignant, the **Anne Frank House** contains the "Annex," the small group of rooms where the diarist and her family hid from the Nazi occupying forces. Today, the Annex is stripped bare of furniture, though some of the magazine cuttings Anne pasted on her bedroom wall remain. Downstairs, a new wing adjacent to the building holds exhibitions on tolerance and oppression.

ABOVE // The **Van Gogh Museum** displays some 200 of Vincent van Gogh's paintings (*pictured, Self-Portrait with Grey Felt Hat*), 500 drawings, and 700 letters as well as Japanese prints and other 19th-century works that influenced him, making this the largest collection of his work anywhere in the world.

DE HOGE VELUWE NATIONAL PARK
Apeldoorn, Netherlands

// Splendid Marriage of Art and Nature

Anton Kröller and his wife, Helene Kröller-Müller, established what became De Hoge Veluwe, Holland's largest national park, with the Kröller-Müller Museum at its heart. The museum's collection features 278 works by Van Gogh, including one of his sunflower paintings. The museum is also home to paintings by Courbet, Seurat, Picasso, and Mondrian. It is surrounded by one of Europe's largest outdoor sculpture gardens, which displays works by Henry Moore, Richard Serra, Claes Oldenburg, and Marta Pan (*right foreground, Floating Sculpture*).

Must Do // Jump on one of the free white bicycles to explore the property (keeping an eye open for deer and wild boar) // Make the short drive to Het Loo, an exquisitely restored royal palace with formal Baroque gardens.

DELFT
Netherlands

// Blue Porcelain and the House of Orange

Known worldwide for its characteristic blue-and-white china, Delft transports visitors back to the time of Vermeer with its delicate gables, tree-lined canals, and ancient spires. Still made and hand-painted here, delftware's timeless patterns and color scheme have survived the passage of centuries and collectors' trends.

Must Visit // The Vermeer Center, which reveals how the artist dealt with light and color // The 14th-century Gothic New Church (*left*), where the founder of the House of Orange lies in a marble and alabaster mausoleum // The nearby Old Church, the final resting place of Vermeer // The Prinsenhof, a former 15th-century royal residence, now a museum displaying prized objects from the golden age of Delft

HET MAURITSHUIS
The Hague, Netherlands

// A Feast of Fine Art

Vermeer's *Girl with a Pearl Earring* (left) and Rembrandt's *Anatomy Lesson of Dr. Nicolaes Tulp* form the core of this collection of the great 17th-century Dutch masters. Acknowledged as one of the world's finest small museums, it occupies the Palladian-inspired mansion of the 17th-century Dutch governor-general of Brazil.

Must Visit // The Galerij, just across the pond from the Mauritshuis, and its grand Louis XVI stucco ceilings

ZEELAND
Netherlands

// The Essence of the Low Countries

A patchwork of land and water forms the appropriately named province of Zeeland ("Sea-Land"). The complex system of dams, dikes, and levies built following a disastrous flood in 1953 are an impressive sight—the longest barrier stretches 5.6 miles across the water.

Must Do // Visit the pretty medieval towns of Zierikzee, Veere, and Middelburg (above), which date back to when Zeeland's rivers were busy channels of trade // Take a bicycle ride across flat farmland dotted with windmills to the waterside village of Yerseke, famed for its mussels and oysters.

ESTREMOZ AND MARVÃO
Alentejo, Portugal

// Hilltop Castles in
Ancient Border Towns

The Moors, Christians, Portuguese, and Spaniards fought over Alentejo, and there is a medieval fort or castle on almost every hilltop of this region to prove it, many of them now government-owned *pousadas* or inns. Estremoz's 13th-century castle constructed by King Dinis for his child queen—the sainted Isabel—is now the Pousada de Estremoz Rainha Santa Isabel, while tiny Marvão is one of Portugal's most charming and dramatic border towns.

Must Visit // In the Pousada de Estremoz Rainha Santa Isabel, the room where Saint Isabel died, now a small chapel open to the public in Estremoz // The Natural Park of Serra de São Mamede surrounding Marvão // Marvão Castle, for magnificent views of the Serra de Ossa and Serra de São Mamede mountains [*below*]

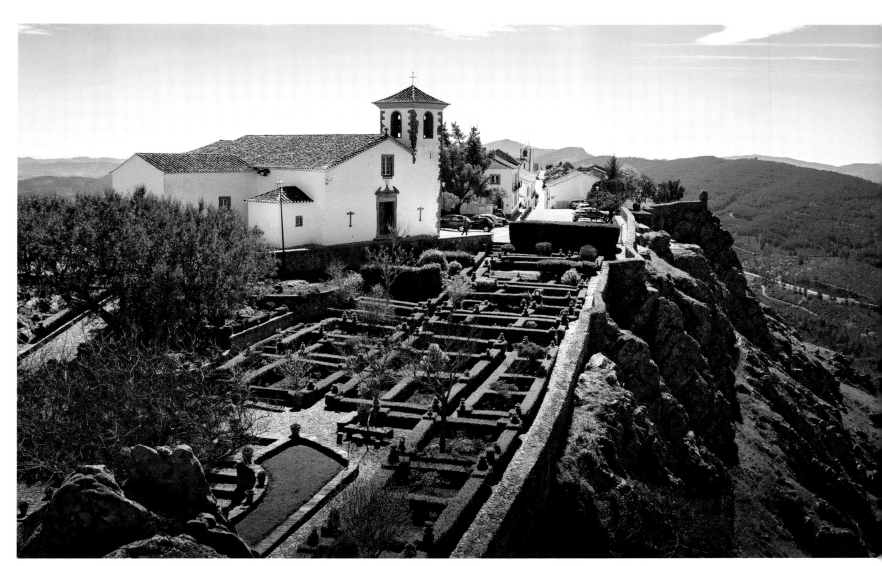

ÉVORA
Alentejo, Portugal

// An Open-Air Museum of
Portuguese Architecture

Évora's mansions and palaces are wonderful examples of Manueline, an exuberant style that combines the rock-solid proportions of the Gothic with the harmonious scale of the Renaissance. Often likened to Florence and Seville, Évora, protected as a national treasure, is far more intimate and wonderfully Portuguese, with Moorish overtones in its pierced balconies, whitewashed homes, and tiled rooms and patios.

Must Visit // The Gothic cathedral, the 16-century Church of dos Lóios, and the Misericórdia Church [*left*], famous for its *azulejos*, hand-painted tiles // The well-preserved ruins of a 2nd-century Roman temple dedicated to Diana // The Almendres Cromlech, megalithic stones standing on the hill above Évora, Portugal's Stonehenge

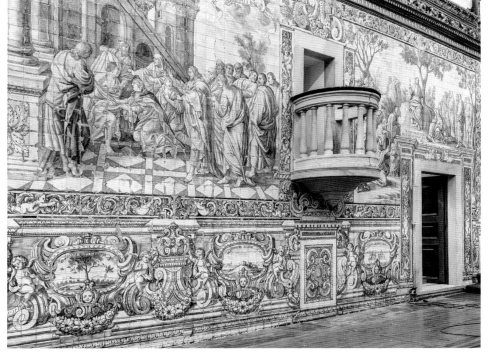

BUSSACO FOREST
Beiras, Portugal

// Sylvan Setting for
a Pleasure Palace

Bussaco Forest isn't a natural forest but
a walled arboretum planted by Carmelite
monks in the 17th century. Exotic trees
were brought in from all corners of the
globe, and King Carlos I built a 19th-
century summer palace in the midst of
the 250-acre wood, which is now the
Palace Hotel do Bussaco (*right*), a good
base for exploring the romantic city of
Coimbra nearby.

Must Do // Explore Portugal's oldest
university in Coimbra // Listen to fado,
Portugal's popular folk music, at
àCapella, a club housed in an old chapel
in the Jewish Quarter in Coimbra.

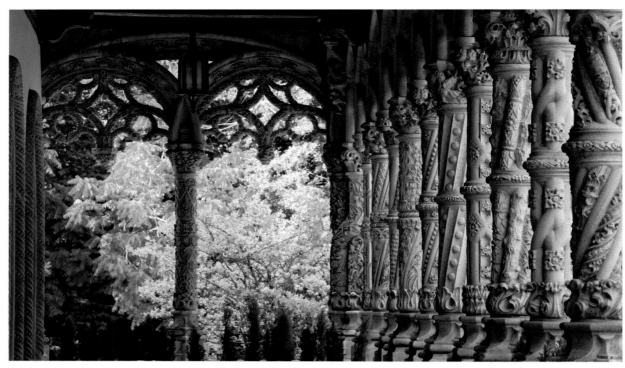

ÓBIDOS
Estremadura, Portugal

// A Town That Belonged to
the Queens of Portugal

Óbidos was deemed so lovely that King
Dinis presented the fief to Queen Isabel
as a wedding present in 1282, and for the
next 600 years, every Portuguese monarch
did the same. Visitors enter this museum
of a town through massive gateway arches
characteristic of a medieval fortress.
The ramparts of Óbidos, almost a mile
of crenellated battlements, have wide
walkways at the top that yield spectacular
views of the town and surrounding
countryside.

Must Do // Stroll the ramparts of Óbidos
// Visit the nearby picturesque fishing
village of Peniche.

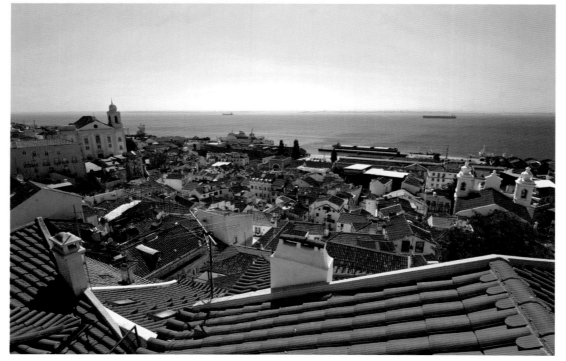

BAIRRO ALFAMA
Lisbon, Portugal

// An Ancient Neighborhood
Where History and Fado Live

The steep streets and twisting alleyways
of the Alfama (*left*) still bear witness to
the Moors, who built a fortress on Lisbon's
eastern hill in this neighborhood (*bairro*)
that later became home to fishermen,
sailors, and other hardworking families.
It was this tight-knit community that
spawned and nurtured fado, Portugal's
most vivid art form, sung in a minor key
with great emotion and accompanied by
the Spanish guitar, mandolin, and 12-string
guittara portuguesa.

Must Do // Follow the ancient paths to the
Castle of St. George for stupendous views
// Hear top female fado performers pour out
their hearts at the legendary Parreirinha de
Alfama // Visit the Museu do Fado, which
traces fado's evolution with displays and
audio recordings.

TWO GREAT MUSEUMS
Lisbon, Portugal

// Awe-Inspiring Gifts

Spread across seven hills overlooking the Tagus River, Lisbon is one of Europe's smallest capital cities. It's also one of the most alluring, with gracious architecture, broad plazas, mesmerizing black-and-white mosaic sidewalks, and magnificent museums founded by two astute collectors.

Must Visit // The Museu Calouste Gulbenkian, which displays work by Rembrandt, Renoir, Monet, Manet, Turner, and Fragonard // The Berardo Collection Museum in the Belém Cultural Center (*left*, *Untitled* by Alexander Calder), to view pieces by Picasso, Dalí, Duchamp, Magritte, and Pollock

SINTRA
Lisbon, Portugal

// Summer Resort of Palaces and Castles

Lord Byron called this favorite summer destination for Portuguese royalty "perhaps the most delightful [village] in Europe," Today, Sintra's cool climate and garden setting provide an idyllic respite from the heat and bustle of Lisbon for city dwellers and visitors alike.

Must Visit // The Pena Palace (*right*), for a revealing look at the vanished lifestyle of the Portuguese nobility who lived here until 1910 // The 8th-century hilltop ruins of the Castelo dos Mouros, for a heavenly view to the sea // The Sintra Palace, known for the glazed tiles on its walls and the ceiling of swans in the banquet room

MADEIRA
Portugal

// Pearl of the Atlantic

This volcanic island off the coast of Africa is Portugal's own floating garden. The early 15th-century discovery of Madeira by Prince Henry the Navigator launched Portugal's golden age. It was "discovered" again in the 19th century by winter-weary British vacationers who were taken by the lush vertical landscapes, the dark sweet wine, and "days of perpetual June."

Must Do // Hike along the old *levadas*—man-made irrigation channels // Make the serpentine drive from Ribeira Brava to São Vicente for views of Pico Ruivo, Madeira's highest mountain // Tour Blandy's Wine Lodge to learn about Madeira's unique *canteiro* aging system and taste the local elixir // Stroll through the gardens and grottoes at Quinta Palmeira, a lush landscape punctuated with tiled fountains // In Monte village, take a ride in its famous two-seater wicker toboggans, guided by two men down a staggeringly steep 1-mile descent.

PORTO AND THE DOURO VALLEY
Porto, Portugal

// Storied History on the Golden River of Wine

The vineyards that cling to the towering cliffs along the upper Douro river are tended by hand because tractors can't negotiate the steep inclines. Yet out of this unlikely landscape comes one of the world's sweetest and richest wines—port, which then comes downriver to Porto to be blended, fortified, stored, and aged.

Must Do // Stop at the Quinta do Seixo Wine Center in the upper Douro to learn how port is made // Take a river tour of Porto to visit the town of Pinhão [*right*] and for views of the Douro bridge designed by Gustave Eiffel in 1877, or a 1-week river cruise to explore the valley's vineyards.

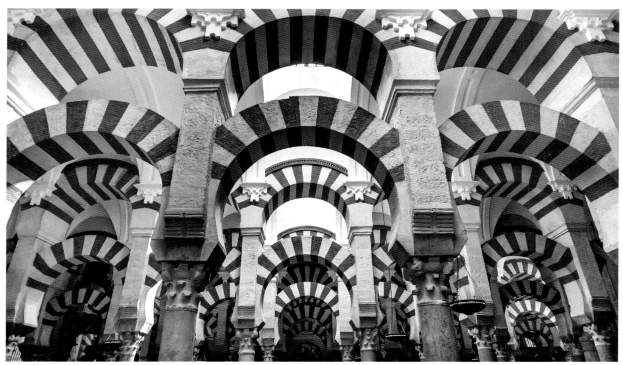

LA MEZQUITA–CATEDRAL
Córdoba, Andalusia, Spain

// The Flower of al-Andalus

Constructed between 784 and 987, La Mezquita, the Great Mosque of Córdoba, transcends the modifications made in the following centuries; beginning in the 13th century, following the Christian conquest, a cathedral was built on this same site. The Mezquita's 856 columns standing today create a forest of onyx, jasper, marble, and granite topped by horseshoe arches of red-and-white marble (*left*). Decorative mosaics, plasterwork, and the Courtyard of the Oranges complete this breathtaking example of European-Muslim architecture.

Must Do // Explore the nearby Barrio de la Judería, the old Jewish and Arabic quarter // Tour the Alcázar, the 14th-century fortress-cum-royal-residence used by Ferdinand and Isabella.

THE ALHAMBRA
Granada, Andalusia, Spain

// What Wonders Lie Within

With the white peaks of the Sierra Nevada rising behind it, the breathtaking complex of the Alhambra, the "Red Fortress," served the Moorish rulers of Granada as palace, harem, and residence for court officials. After the kingdom of al-Andalus fell to Christian Spain, the Moors of Granada struck a deal with the kings of Castile and the city became a refuge for Muslim artists, scholars, and intellectuals, effectively concentrating Spanish Muslim high art and culture in Granada.

Must Visit // The Generalife, a summer palace separated from the Alhambra by a patch of woodlands // The Mirador de San Nicolás in the Albaicín quarter, for the finest views of the city

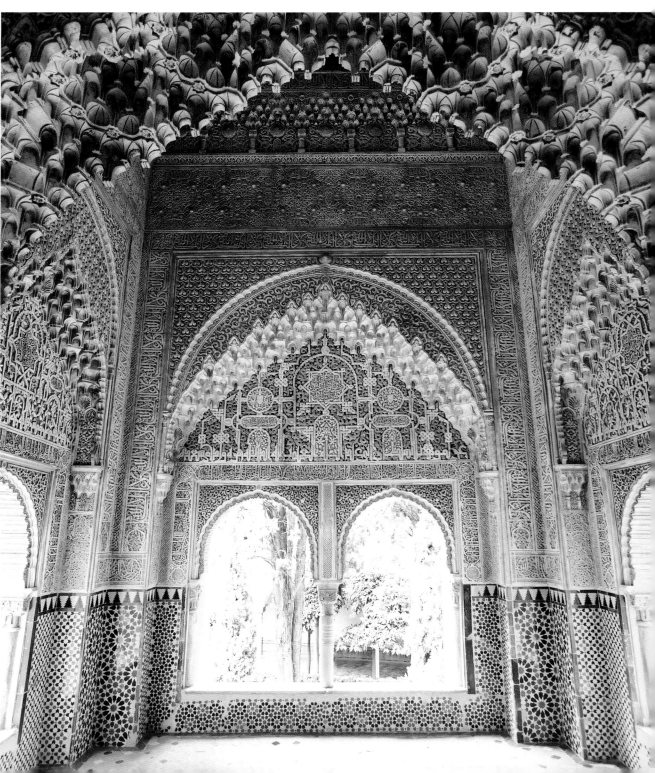

JEREZ DE LA FRONTERA
Andalusia, Spain

// Raise a Glass to
the Dancing Horses

A compact, muscular breed, Andalusian horses were bred here by Carthusian monks in the late Middle Ages and became the darlings of the aristocracy in the 19th century in and around Jerez. Best known as the world headquarters of sherry, an English corruption of the city's name, Jerez is also the birthplace of a distinctive flamenco style.

Must Do // Experience horse mania during the Feria del Caballo in early May // Attend a performance at the Royal Andalusian School of Equestrian Art (*right*) // Tour González Byass, a sherry bodega and maker of Tio Pepe next to the 12th-century Alcazar Castle // Visit Centro Andaluz de Flamenco for tips on where to see live performances.

RUTA DE LOS PUEBLOS BLANCOS
Andalusia, Spain

// A Scenic Drive
Through History

To experience the mountain scenery and splendid whitewashed villages of the Sierra de Grazalema, follow the Ruta de los Pueblos Blancos from Arcos de la Frontera to Ronda. Rising steeply on a sandstone ridge, Arcos is crowned by a ruined Moorish castle. The villages east of here also wear history on their sleeves—from the distinctly Berber look of Grazalema to the fortress at Zahara de la Sierra. The drive ends with the dramatic sight of Ronda (*left*) perched on a limestone escarpment sliced in two by the deep El Tajo gorge.

Must Do // Spend time in Grazalema, a gateway to mountain hikes and Europe's southernmost trout streams // Visit Ronda's bullring, Spain's oldest and a favorite of Hemingway's.

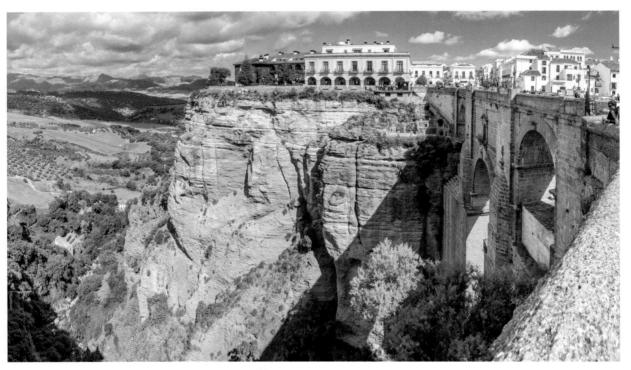

SEVILLE
Andalusia, Spain

// The City of Don Juan
and Carmen

From the encrusted Baroque decoration of its churches to a nightly devotion to flamenco and tapas, Seville is a city that celebrates excess. The Alcázar and Cathedral lie at its heart (the Giralda bell tower of the Cathedral is the old Moorish minaret). During Semana Santa, barefoot men dressed in hooded robes slowly drag chains through the darkened streets to haunting devotional music. Two weeks later, the city does an about-face with the exuberant Feria d'Abril (April Fair, *right*)—a week of flamenco dancing, drinking, and bullfights topped off by fireworks.

Must Do // Attend a weekend performance at the Museo del Baile Flamenco in the central neighborhood of Santa Cruz // Follow Sevillanos as they tapas hop, and stop at El Rinconcillo, the city's quintessential bar.

BALEARIC ISLANDS
Spain

// Mediterranean Idylls

The Balearic Islands are the jewels of the western Mediterranean. Fought over by the Carthaginians and Romans, then by the Moors and Christians, the Balearic Islands were later invaded by artists, hippies, and partyers bound for the club scene on Ibiza (*right*), still the Mediterranean's party island. The capital city of Palma on Mallorca boasts the lavish Gothic Catedral de Santa María de Palma with *modernista* iron canopies designed by Antoni Gaudí above the altar.

Must Do // Visit the Fundació Pilar i Joan Miró on the outskirts of Palma // Drive clockwise around Mallorca on the Costa Rocosa // Visit Valldemossa's Carthusian monastery, where Frédéric Chopin and George Sand spent a creatively productive winter // Sample the Saturday market in Sant Carlos on Ibiza // Hop a boat to Formentera, popular with nudists and divers.

GUGGENHEIM MUSEUM BILBAO
Bilbao, Basque Country, Spain

// A Masterwork of Architectural Sculpture

The Guggenheim Museum Bilbao has become this Basque port city's signature building and jump-started the economic and architectural revival of this once gritty port on the shores of the Nervión River. Cross the river on a glass-floored pedestrian bridge by architect Santiago Calatrava for the best views of the Guggenheim building, designed in 1997 by Frank Gehry.

Must Do // Stroll the walking path leading to Bilbao's Casco Viejo (old city) and Plaza Nueva to sample some of Spain's finest *pintxos* (Basque tapas) and noted restaurants.

RIOJA
La Rioja and Basque Country, Spain

// A Newly Stylish Wine Region Emerges

Rioja's wine tourism was revolutionized when Frank Gehry integrated the 19th-century warehouses of the Marqués de Riscal winery (right) in the tiny Basque village of Eltziego with the visionary 21st-century complex known as the City of Wine. Other world-class architects have also put their stamp on Rioja. Zaha Hadid designed a postmodern tasting pavilion for Bodegas López de Heredia in Haro, and Santiago Calatrava created undulating buildings for Bodegas Ysios in Laguardia.

Must Do // Reserve ahead for a tour of the Marqués de Riscal winery or attend the casual tastings at the shop // Visit Haro on June 29 for the "Wine Battle," when participants dressed in white squirt one another with red wine, or in late August through early October for harvest season.

SAN SEBASTIÁN AND BASQUE COUNTRY
Spain

// Culinary Mecca in a Coastal Belle Époque Setting

Along with France's Biarritz, just over the border, San Sebastián is the great Belle Époque resort of the Basque coast. Crescent-shaped La Concha beach is perhaps the most beautiful urban beach in Europe. The Basques have political autonomy within Spain but have yet to get their own country. Nonetheless, they conquered the tables of Spain in the 1980s with the explosion of New Basque cuisine and remain masters still.

Must Do // Savor inventive cuisine in the tapas bars of the gentrified Gros district // Attend late July's jazz fest or mid-September's film festival at San Sebastián's Kursaal cultural center.

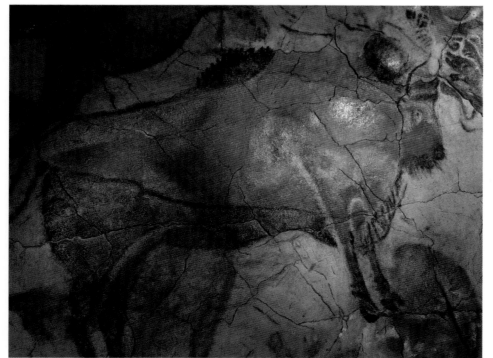

THE CAVES OF ALTAMIRA AND SANTILLANA DEL MAR
Cantabria, Spain

// Fragile and Invaluable Link to the Ice Age

The Caves of Altamira are often described as the Sistine Chapel of prehistoric art (left). Unfortunately, a century's worth of heat and moisture caused serious deterioration, and public admissions were suspended in 2002. The adjacent Museo de Altamira, however, re-creates the setting and paintings. The caves and museum are 2 miles outside of Santillana del Mar, a cluster of perfectly preserved medieval mansions and homes

Must Visit // Santillana del Mar's 12th-century church of St. Juliana, the burial place of the 3rd-century saint // The nearby 400-year-old Convent of the Poor Clares, for its rich collection of religious paintings and statues

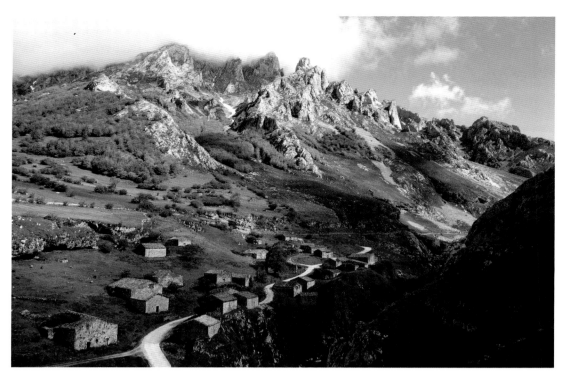

PICOS DE EUROPA
Cantabria and Asturias, Spain

// Spain's Greenest Heights

These mountains walling off the northern coast of Spain from the high plateau of Castile and León are home to the remote forests and deep gorges of the 250-square-mile Parque Natural de Picos de Europa (*left*). Outside Cangas de Onís is Covadonga National Park, where the near-legendary Don Pelayo led his revolt against the advancing Moors in 722 and began the reconquest of Spain.

Must Do // Tour historic sites, hike, canoe, or go spelunking in Covadonga National Park // Ride the gondola in Cantabria to alpine hiking trails // Drive the twisting roads of the Picos and stop off in Las Arenas de Cabrales for locally made Cabrales blue cheese and a loaf of bread.

CUENCA
Castilla-La Mancha, Spain

// A Gravity-Defying Aerie That Is Home to Abstract Art

Cuenca is perched high above the confluence of the Júcar and Huécar rivers, and its *casas colgadas* (hanging houses) cantilevered over the gorges (*right*) make the city feel like a three-dimensional puzzle. It's no wonder abstract artists fell in love with Cuenca in the 1950s, leaving three fine museums as their legacy.

Must Visit // The small Museo de Arte Abstracto Español in one of the city's most famous *casas colgadas*

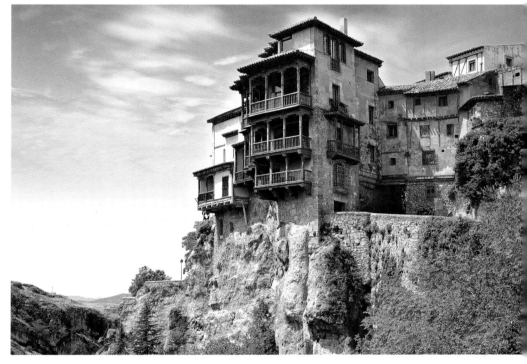

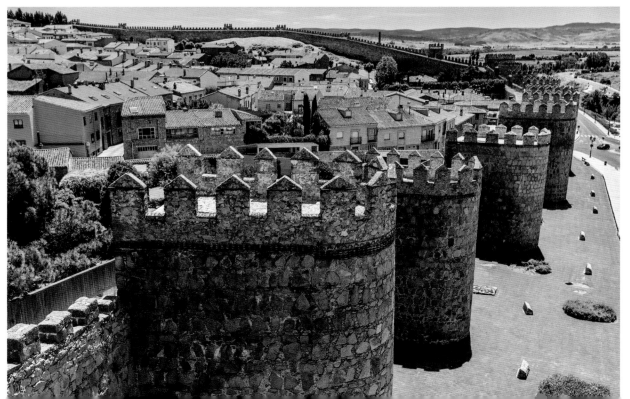

ÁVILA
Castilla y León, Spain

// A Saint's Birthplace Conveys a Vivid Sense of the Past

The 11th-century walls of Ávila wend a mile and a half around this much-photographed hilltop town (*left*), and include 90 semicircular guard towers, 9 narrow arched gates, and more than 2,300 embattlements. A walkway along the top allows you to get a good view of the storks that nest in the town's bell towers. Ávila is the hometown of St. Teresa, a Carmelite nun born here in 1515 who became the patron saint of Spain.

Must Visit // The city's 12th-century cathedral built into the walls to serve partly as a military fortress // The walls of Ávila at night, when they become the world's largest illuminated monument

LEÓN
Castilla y León, Spain

// An Architectural Wonder
and a Shelter for Knights

One hundred and twenty-five stained-glass windows, 3 rose windows, and 57 oculi fill the interior of León's Gothic cathedral (*right*) with bejeweled shafts of light. In the Middle Ages, European cities strove to outdo one another with the highest steeples and biggest rose windows, and artisans from across Europe made León's cathedral, begun in 1205, a building that amazes even modern-day architects.

Must Do // Tour the adjacent Cathedral Museum, home to some of Spain's most important sacred art // Visit the Royal Pantheon in the convent of Colegiata de San Isidro, where 12th-century ceiling frescoes look down on the tombs of kings and queens // Take a weeklong train excursion from León to Santiago de Compostela on El Transcantábrico Classico.

SALAMANCA'S PLAZA MAYOR
Salamanca, Castilla y León, Spain

// Spain's Most Beautiful
Square

Visitors to Salamanca inevitably gravitate to the heart of the town, the lovely 18th-century Baroque Plaza Mayor. This ancient city's other attractions are within walking distance of the plaza, but linger awhile to take in the spirit of Salamanca. What was once Spain's most important university was founded here in 1218 by Alfonso IX, and you can still visit the buildings of the original school.

Must Do // Search for the good-luck frog among the elaborate carvings on the façade of the university's entryway // Visit the "new" 16th-century cathedral that shares a wall with its older Romanesque sibling.

CIUTAT VELLA
Barcelona, Catalonia, Spain

// Ancient Heartbeat of
a Modern City

While *modernista* architecture defines Barcelona's L'Eixample neighborhood, the Ciutat Vella (Old City) is filled with the atmospheric twisting alleys of the Gothic Quarter, which is dominated by the Cathedral of Barcelona, whose plaza becomes especially festive on Sunday afternoons when it swells with people performing the Catalan circle dance known as the *sardana*.

Must Do // Visit the Museu Picasso, second only to Paris's Picasso Museum // Stroll along La Rambla boulevard to the Mercat de la Boqueria (*left*), the city's temple of fresh food // Stop midway on La Rambla to see the Gran Teatre del Liceu, one of the world's grandest opera houses.

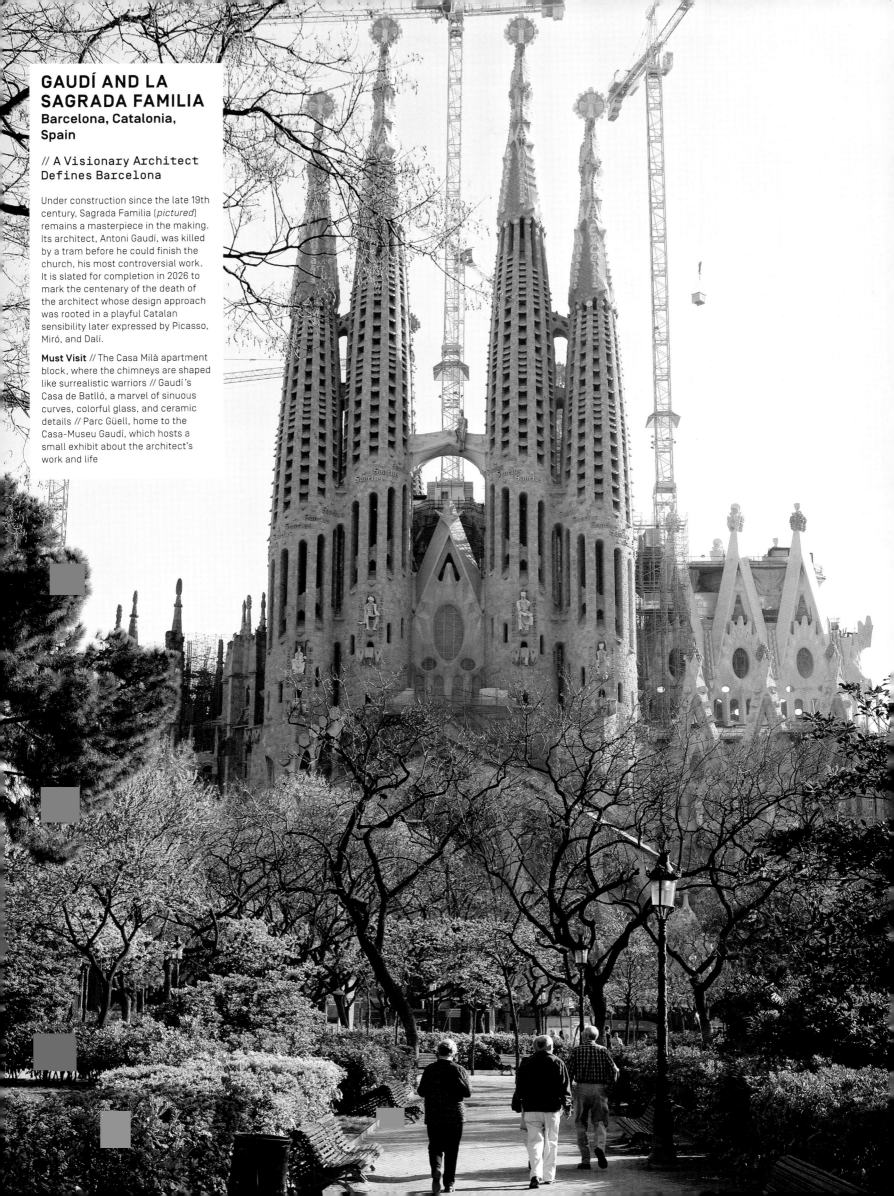

GAUDÍ AND LA SAGRADA FAMILIA
Barcelona, Catalonia, Spain

// A Visionary Architect Defines Barcelona

Under construction since the late 19th century, Sagrada Familia [*pictured*] remains a masterpiece in the making. Its architect, Antoni Gaudí, was killed by a tram before he could finish the church, his most controversial work. It is slated for completion in 2026 to mark the centenary of the death of the architect whose design approach was rooted in a playful Catalan sensibility later expressed by Picasso, Miró, and Dalí.

Must Visit // The Casa Milà apartment block, where the chimneys are shaped like surrealistic warriors // Gaudí's Casa de Batlló, a marvel of sinuous curves, colorful glass, and ceramic details // Parc Güell, home to the Casa-Museu Gaudí, which hosts a small exhibit about the architect's work and life

PARC DE MONTJUÏC
Barcelona, Catalonia, Spain

// Gardens and Culture on
Barcelona's Green Crown

The most exciting way to get to this park
atop the hill of Montjuïc is to soar from the
port on the Transbordador Aeri, an aerial
tram that arrives amid cactus gardens. But
the landscape shifts to rolling greenery
and formal gardens as you walk toward the
Fundació Joan Miró, which displays work
by the 20th-century Catalan Surrealist in
a sleek building whose sculpture-dotted
grounds have unsurpassed views (*right*,
Wings by Alexander Calder).

Must Visit // The nearby Teatre Grec de
Montjuïc, a replica of a Greek theater that
hosts concerts and dance performances
all year long // The Museu Nacional d'Art de
Catalunya in the Palau Nacional, home to
the world's finest collection of Romanesque
and Gothic artwork, and the choreographed
fountain of the Font Màgica at the foot of
the palace's steps

COSTA BRAVA
Catalonia, Spain

// Surreal Art on the Wild
Coast

Reachable only by sea or a precipitous
switchback road, Cadaqués is often called
the world's most painted village. Picasso,
Utrillo, Miró, Max Ernst, Man Ray, and
filmmaker Luis Buñuel all took inspiration
from this whitewashed village wrapped
around a rocky harbor at the eastern tip
of the Empordà peninsula, but Salvador
Dalí, who had a studio (now a museum) in
adjoining Portlligat for many decades, is
the most enduring presence.

Must Visit // The Teatre-Museu Dalí (*left*)
in the artist's nearby hometown of Figueres
// San Feliu de Guixols and the castle-
topped headlands of Tossa del Mar farther
south along the coast

CÁCERES
Extremadura, Spain

// City of Conquerors
and Warriors

Alfonso VIII of Castile presented land in Cáceres to his knights in 1212. Often building around the original Arab towers (30 are still standing), the warriors constructed fortified houses. Plunder from Mexico and Peru allowed many to convert their medieval fortresses into Renaissance palaces—making Cáceres unique in Spain for the variety of its architecture, now often used as a backdrop in historical films.

Must Do // Visit the Monastery Santa María de Guadalupe (*left*), built on the site where, in the 13th century, a shepherd allegedly discovered a statue of the Madonna // Go when hundreds of storks return to nest in the city between February and August // Try a dish flavored with local smoked paprika that's prized all over Spain // Visit the childhood home of Francisco Pizarro in the nearby town of Trujillo.

EL CAMINO DE SANTIAGO AND SANTIAGO DE COMPOSTELA
Galicia, Spain

// The Road to Heaven

The Christian faithful have made the long walk to the city of Santiago de Compostela on the Camino de Santiago (the way of St. James, *above*) ever since the bones of St. James the Apostle were brought here in the 9th century. Most travelers follow a variant of the 500-mile French Route, which begins in Roncesvalles. Those who lack time or stamina for the 4-week-plus journey by foot walk only the final 62 miles.

Must Do // Find the Cathedral of Santiago de Compostela's bejeweled statue of St. James above the main altar and hug him—a longtime tradition // Attend one of the special masses for pilgrims, where the massive silver-plated incensory swings like a pendulum through the sanctuary.

MADRID
Spain

By day, Madrid is an elegantly formal city. Visit the Palacio Real, the official residence of the king and queen of Spain (although the Palacio de la Zarzuela is where they actually live). The palace's Throne Room, Reception Room, Royal Pharmacy, Painting Gallery (with works by Caravaggio, Velázquez, and Goya), and Royal Armory are open to the public. When night falls, however, Madrid is transformed into one of Europe's liveliest capitals. Embrace the Madrileño nightlife by strolling the streets around Plaza de Santa Ana to sample tapas at the area's many watering holes or enjoy the lively scene on Cava Baja (south of Plaza Mayor), where some of the best food is the Basque fare. In between small plates of meatballs, scallops, or smoked trout, enjoy the foot-stomping passion of flamenco performances at Corral de la Morería or Casa Patas.

Bullfighting is a controversial sport, but it is inextricably part of Spanish history, culture, and national identity. Or enjoy a Sunday-morning stroll through Retiro Park, 300 acres full of fountains, statues, and 19th-century exhibition halls, while early birds can shop for bargains at El Rastro Flea Market at Plaza Cascorro and Ribera de Curtidores.

Travelers can also follow El Greco south to his adopted hometown of Toledo, where about 30 of his paintings hang in the sacristy of the 13th-century cathedral, or head northwest to Segovia's Roman Aqueduct and its Alcázar Palace, said to have inspired the castle in Disney's *Snow White*.

RIGHT // Known for its huge collection of paintings by El Greco, Goya, Murillo, Rubens, Titian, Bosch, Raphael, Botticelli, and Fra Angelico, the **Prado** also displays 80 percent of Velázquez's paintings, including his *Las Meninas*.

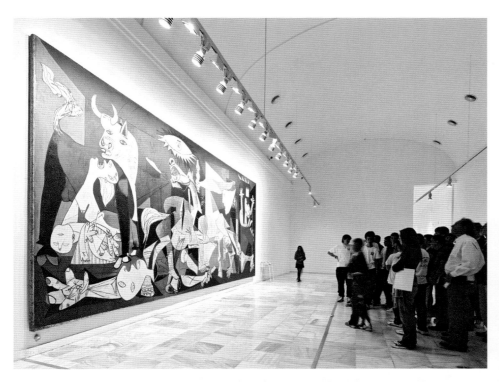

LEFT // Home of Picasso's *Guernica* (*pictured*), the **Centro de Arte Reina Sofía** is just a few blocks from the Prado and houses works by modern and contemporary artists, including Miró, Dalí, Calder, and Man Ray.

BELOW // Housing two of the most extraordinary private art collections amassed in the 20th century, the **Thyssen-Bornemisza Museum** exhibits 13th-century Gothic art to 15th-century baroque artists (*pictured*, Caravaggio's *Saint Catherine of Alexandria*) through 19th-century Impressionists (notably Monet) and 20th-century works by American Abstract Expressionists.

LEFT // The huge cobblestone square of the **Plaza Mayor** has seen its share of bullfights, hangings, riots, wild carnivals, and the nasty doings of the Inquisition. Today it's the heartbeat of Old Madrid that leads to streets crowded with tapas bars and restaurants, and the revitalized **Mercado de San Miguel** (*above*).

VALENCIA
Spain

// Architecture, Paella, and Big Bangs

The birthplace of paella and the home of the 86-acre City of Arts and Sciences, Valencia becomes a madhouse when local people dressed in historical costumes take to the streets and plazas to celebrate a constant parade of Las Fallas, elaborate sculptures made from wood and papier-mâché that are carried around town to the accompaniment of relentless firecrackers. Things kick off in late February, but the final days leading up to the March 19 feast day of St. Joseph will see these massive figures—some of them 40 feet tall—set afire in a pyromaniac's equivalent of Mardi Gras.

Must Visit // L'Hemisfèric (*left*), the planetarium in the City of Arts and Sciences, constructed by Santiago Calatrava, which opens and closes like a blinking eyelid // The complex's fish-shaped performance halls of the Palace of Arts and L'Oceanogràfic Aquarium, organized like an underwater coral reef // The Mercado Central, a temple of food in a vast 1928 *modernista* building

THE ALPS' MOST SCENIC TRAIN TRIPS
Switzerland

// Riding the Rails

Over the past century, Swiss engineering expertise has created an elaborate system of narrow passes, viaducts, and tunnels that make even the most dramatic Alpine scenery accessible to all. Ride the rails through the riveting scenery of the Swiss Alps between Zermatt and St. Moritz on the Glacier Express (*right*), or board the Bernina Express in St. Moritz for the trip to Tirano that goes past the Morteratsch Glacier, with its jaw-dropping views and the highest peak in the Eastern Alps, the Piz Bernina (13,284 feet), before arriving in Italy on a famous corkscrew viaduct. You can sample the chocolate and cheese served on the Chocolate Train, a daylong journey that runs between Montreux and Broc in summer and fall.

Must Do // From the Chocolate Train, visit Gruyère's turreted castle and tuck into fondue at the cheese dairy, and tour Broc's Cailler-Nestlé chocolate factory, which produces 65 tons of chocolate every day.

BASEL: ART CITY
Switzerland

// Crossroads of Creativity

Every June, this sophisticated city on the banks of the Rhine hosts Art Basel, the world's leading international art show for modern and contemporary works [like Nedko Solakov's *I miss Socialism, maybe . . .* , *left*]. Nearly 290 galleries display works by more than 4,000 artists—from the great masters of modern art to the latest emerging stars—and culture vultures canvas the town for smaller exhibitions, film screenings, concerts, and parties during this art-rich week.

Must Visit // The impressive Kunstmuseum of fine art // The Museum Tinguely and its playful mechanized sculptures // The Fondation Beyeler's superb 20th-century art collection in a Renzo Piano–designed building

GSTAAD
Bernese Oberland, Switzerland

// Magnificent Mountain Playground

Dubbed the Aspen of the Bernese Oberland, Gstaad reigns as one of the world's best winter playgrounds. With its 155 miles of downhill runs, 60 miles of cross-country trails, and a host of year-round activities, this is where royalty and the world's celebs ski, bike, and hike, yet an unspoiled and unpretentious air prevails.

Must Do // Take the cable car to the mountaintop Berghaus Eggli restaurant for unforgettable views // Visit nearby Château-d'Oex in January for the annual International Hot-Air Balloon Festival.

HIGH-COUNTRY HIKING
Bernese Oberland, Switzerland

// Walking on Top of the World

With its 1,553 miles of trails, the Bernese Oberland is Switzerland's most popular choice for hiking, thanks to its idyllic scenery that rejuvenates both body and soul. The ravines of Kandersteg are a rambler's paradise. Head for the cable car that lifts walkers to the historic Gemmi Pass or to Lake Oeschinen (*left*), one of Switzerland's most striking natural wonders.

Must Do // Take the railway or cable car to Mürren, the highest year-round inhabited village in the canton // Ride Mürren's cable car to the Schilthorn's 9,742 foot summit, Piz Gloria, for panoramic views from the revolving restaurant made famous by the James Bond thriller *On Her Majesty's Secret Service* // Take a high-country hike from Birg down to quaint Gimmelwald // Ride the rails to Jungfraujoch to visit the Eispalast (Ice Palace), then return via Grindelwald for high-terrain hiking.

DAVOS-KLOSTERS
Graubünden, Switzerland

// A Pair of Peak Performers

The highest city in Europe, Davos is great for cold-weather sports even in warm winters. Long, scenic valley trails make it second only to the neighboring Engadine region for cross-country skiing. Davos shares a sweeping network of lifts and slopes with its (barely) lower twin city, Klosters (*left*), whose more attractive Alpine village is where you want to unpack your bags. Klosters still nurtures its sobriquet of "Hollywood on the Rocks" because of the international movie set it attracts.

Must Do // In Klosters, ski the thrilling 8-mile piste in the Parsenn-Weissfluh ski area, one of the finest in Europe // Visit in March for skiing, July for Alpine flowers, and August through September for hiking.

ST. MORITZ AND THE ENGADINE VALLEY
Graubünden, Switzerland

// Top-Notch Skiing and
an Untrammeled Valley

Despite its celebrated glamour, St. Moritz is a lot more welcoming than its popular image suggests. The world-class resort has superb downhill skiing for all levels and ideal cross-country skiing. The nearby Engadine Valley supplies countless hiking paths and high-mountain trails, and lovely Pontresina (right) has become one of Europe's best mountaineering centers.

Must Do // At St. Moritz, hop the cable car to Piz Corvatsch, almost 11,000 feet above sea level // Taste the pure mineral water bubbling from Scuol's fountain before going to the first Roman-Irish baths in Switzerland // Wander the ancient cobbled streets of Guarda, one of the country's most photogenic hamlets // Explore Switzerland's only national park, Parc Naziunal Svizzer.

LUCERNE RIVIERA
Switzerland

// Lakeside Music Mecca

Lucerne's much-photographed Chapel Bridge and Water Tower (left) make this lakeside medieval town a longtime tourist favorite. Music lovers descend here every summer for the Lucerne Festival to hear big-name conductors, orchestras, soloists, and chamber ensembles perform at a variety of locations, including the ultramodern KKL Culture and Convention Center.

Must Do // Across Lake Lucerne, watch the sun rise over the Alps from the summit of Mount Rigi in Vitznau accessible by cog railway, Europe's oldest // Take the many railways and aerial tramways to the surrounding mountains for spectacular views.

LUGANO
Ticino, Switzerland

// Swiss Living,
Italian Style

With its palm trees and magnolia blossoms, Switzerland's southernmost corner is a blend of Italian charm and Swiss efficiency, and sun-drenched Lugano, its main town, seduces with ancient churches and piazzas connected by a maze of steep cobblestone streets that spill down to its namesake lake.

Must Do // Stroll Lugano's lakefront promenade past magnificent private villas and their meticulously tended gardens // Visit the serene lakeside Ciani Park (right) // Take a pleasant hour-long *passeggiata* to the lakeside town of Gandria on the wooded flank of Monte Brè.

VERBIER
Valais, Switzerland

// Thrill Seeking on and
off the Slopes

Verbier, in the French-speaking region of
Valais, is a magnet for young, adventurous
ski buffs who consider this stylish but
relaxed town nothing short of heaven.
Advanced skiers will have a field day at
this nexus of more than 250 miles of pistes
where they can enjoy wonderful top-to-
bottom off-piste runs in the company of
a guide before enjoying Verbier's vibrant
après-ski scene.

Must Do // Ski the off-piste runs Stairway to
Heaven and the Backside of Mont Fort with
a guide // Visit in mid-July for the Verbier
Festival of classical music.

ZERMATT AND
SAAS-FEE
Valais, Switzerland

// In the Matterhorn's Shadow

The granite profile that launched a million
postcards rises above the music-box
chalets and car-free streets of Zermatt,
the home of three ski areas that draw
intermediate and advanced skiers.
Saas-Fee, 11 miles east of Zermatt,
delivers equally spectacular views of the
Matterhorn [above]. Although its steep
terrain and extensive glaciers have limited
ski runs, Saas-Fee does offer some of
the best snow conditions and the longest
season in Europe.

Must Do // Take the Kleine Matterhorn
cable car at Zermatt and ski across the
border for lunch in Italy // Take a helicopter
from Zermatt to Monte Rosa and ski
through remarkable glacier scenery.

MONTREUX JAZZ FESTIVAL
Vaud, Switzerland

// Music Takes Center Stage

July's Montreux Jazz Festival has blossomed into an international celebration of all types of music and made this town hugging the banks of Lake Geneva even more alluring. Idle at any of the waterside cafés amid the palms, cypresses, and magnolias that flourish here thanks to the mountains that protect the city from winter winds and you'll understand why Lake Geneva is called the Swiss Riviera.

Must Do // Visit the Château de Chillon, Switzerland's most important and most photographed castle // Take the postcard-worthy 2.5-mile walk along the shore from Montreux to Chillon.

ZÜRICH'S ART BEAT
Switzerland

// A Wealth of Culture

Coupled with Basel, Zürich pumps the country's artistic heart. The birthplace of the Dada movement in 1916, modern Zürich boasts not only a top-ranked orchestra and superb theater company but a 19th-century opera house acclaimed for its stellar acoustics. Even the Fraumünster and Grossmünster churches are testaments to Zürich's creative leanings, with stained-glass windows by Marc Chagall and Augusto Giacometti, respectively.

Must Visit // The Kunsthaus (*left*, *45* by Georg Baselitz), which displays the largest collection of works by Alberto Giacometti // The Kunsthalle contemporary art museum in the Zürich West neighborhood, home to trendy art galleries and a bustling nightlife

Eastern Europe

DUBROVNIK AND THE DALMATIAN COAST
Croatia

// Playground on the Adriatic

A rugged shoreline and more than 1,000 islands in the warm, turquoise waters of the Adriatic Sea make the Dalmatian Coast one of Europe's most beautiful seaside playgrounds. Dubrovnik, "the Pearl of the Adriatic," is the most magical of Croatia's many coastal towns. Stroll atop the city walls and look down at terra-cotta roofs and the narrow side streets and alleys that lead to the cathedral, busy squares, a monastery with Renaissance and Romanesque cloisters, and a synagogue established in the 15th century.

Must Do // Visit Dubrovnik's Old Town (*right*), ringed with 15th-century stone walls as much as 80 feet high and 20 feet thick // Stroll the Placa, a main thoroughfare lined with boutiques, cafés, and galleries // Make your way to Split, north of Dubrovnik, the site of Emperor Diocletian's 3rd-century estate and the hub for a ferry system serving the coastal islands (such as Brač, Hvar, and Korčula, which claims to be the birthplace of Marco Polo) // Travel north from Split to Zadar to its seafront promenade and listen to the Sea Organ, tubes installed beneath large marble steps to let the wind and waves make music // Take a boat trip to Kornati National Park, 89 stark-white limestone islands popular with divers and sailors.

ISTRIA
Croatia

// The Tuscany of Croatia

In Croatia's northwest corner, the peninsula of Istria juts into the Adriatic Sea just south of Trieste, Italy. It resembles Tuscany in both looks and spirit, with its vineyards and olive groves and coastal towns like Rovinj (*left*), a tangle of steep, narrow streets and centuries-old stone houses and its imposing 18th-century Church of St. Euphemia. Poreč's 6th-century St. Euphrasius Basilica boasts intricate mosaics that are considered among the finest examples of Byzantine art.

Must Visit // Pula's Roman amphitheater, one of Europe's largest and best preserved ancient arenas, left behind after the Romans colonized Istria in the 2nd century BC // The inland fortified town of Motovun, a medieval time capsule with a hilltop 17th-century Venetian palazzo, and its annual film festival

PLITVICE LAKES NATIONAL PARK
Croatia

// Wonderland of Water

High in the Dinaric Mountains between Zagreb and Split, the Korana River drops through a valley of stair-stepped lakes and dozens of waterfalls. One of Europe's premier natural wonders, the terraced and interconnected Plitvice Lakes vary from deep blue to turquoise as sunlight refracts at different angles off minerals in the water.

Must Do // Hike to the Veliki Slap (Big Waterfall), which drops 230 feet into a steep canyon // Visit in winter when the park is void of bus tours to see waterfalls and cascades transformed into icy stalactites.

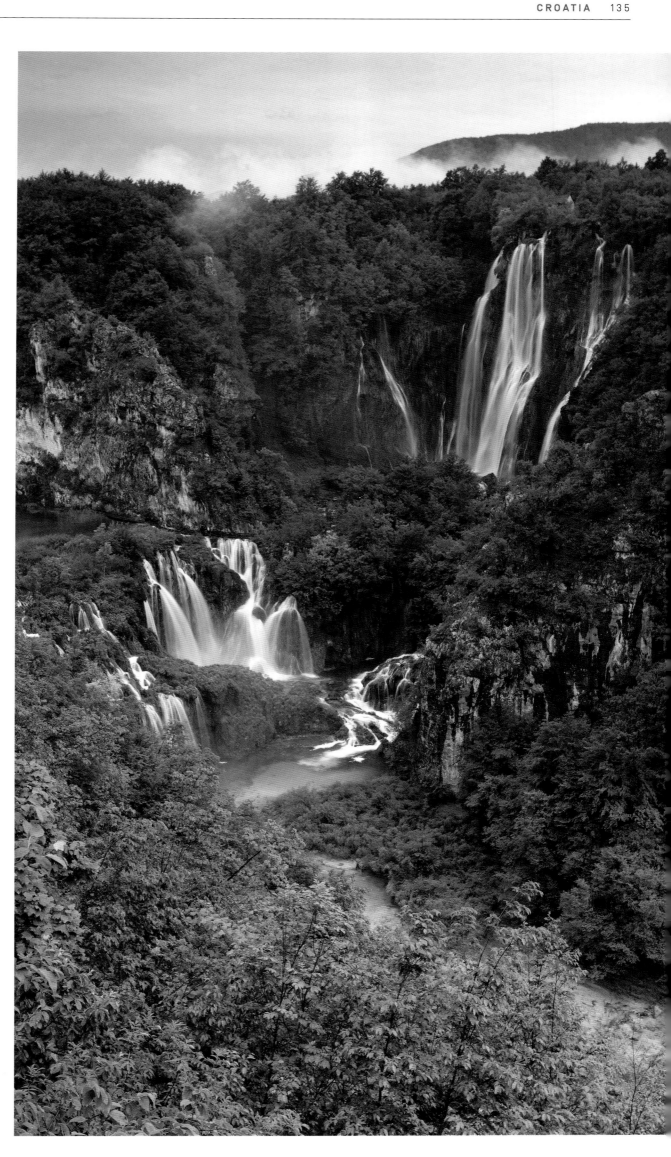

ČESKÝ KRUMLOV
Bohemia, Czech Republic

// A Medieval Town on the Meandering Vltava

The fairy-tale river town of Český Krumlov is an architectural collage of medieval, Renaissance, Baroque, and Rococo buildings, and the home of Schwarzenberg Castle, the Czech Republic's second largest fortress after Prague's. Cross from the Round Tower through the stone arches of the Most na Plášti bridge to the castle gardens where ballet, opera, and theater are performed alfresco in the Revolving Theater.

Must Do // Sample the Eggenberg brewery's dark lager // Hire a flat-bottomed boat for a ride on the city's meandering river or raft or canoe through the forests of south Bohemia.

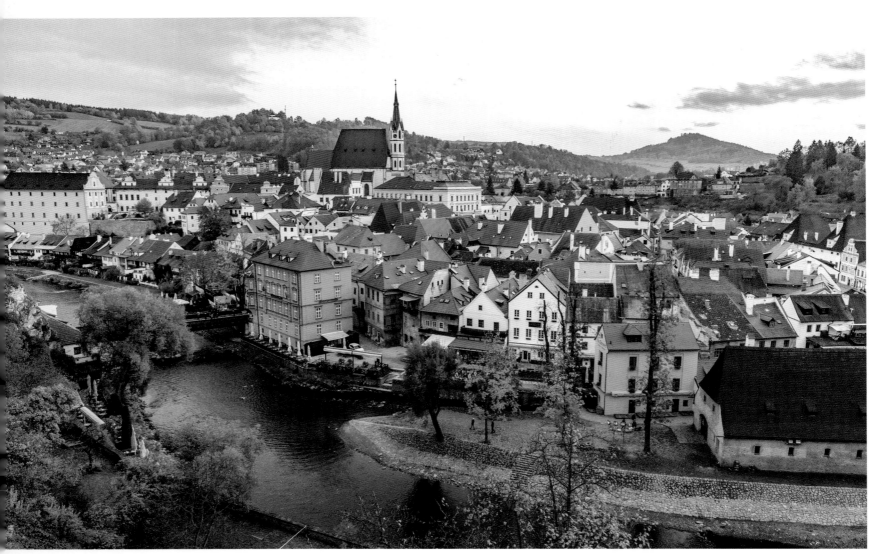

KARLOVY VARY
Bohemia, Czech Republic

// Trio of Bohemian Spas

Karlovy Vary is the largest and most renowned of the Czech Republic's 30-plus spa towns, and for more than 400 years, the world's rich and famous have come to "take the waters" of its 12 natural thermal springs. Forty-five minutes' drive south is the smaller Mariánské Lázně [right], whose 40 mineral springs were favored by Kafka, Chopin, and England's King Edward VII. Continue to Františkovy Lázně, the smallest and most unspoiled town in the country's spa triangle despite its 23 curative springs.

Must Do // Drive 20 minutes from Karlovy Vary to Loket, a medieval village on a scenic bend of the Ohře River // Bathe in restorative tubs of beer in Chodová Planá near Mariánské Lázně.

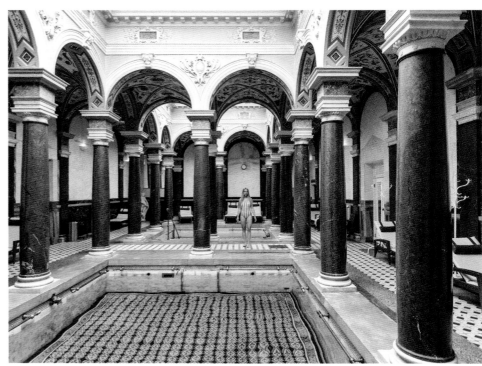

KUTNÁ HORA
Bohemia, Czech Republic

// A Cathedral to Rival Prague's, and a Macabre but Compelling Display

During the reign of Wenceslas II, Kutná Hora minted coins from the silver ore found in the surrounding hillsides. The silver coins were the monetary lingua franca of central Europe, and Prague and Kutná Hora became fierce economic, cultural, and political rivals. Dedicated to the patron saint of miners, the Gothic Cathedral of St. Barbara stands proudly on a ridge above the old town. Kutná Hora's better known treasure is the Bone Church (Sedlec Ossuary, *right*), built to house the remains of countless victims of the Black Plague in surprisingly artistic displays.

Must Visit // The Silver Museum, originally part of the city's fortifications // The chandeliers, pyramids, coats of arms, and crosses made from bones in the Bone Church

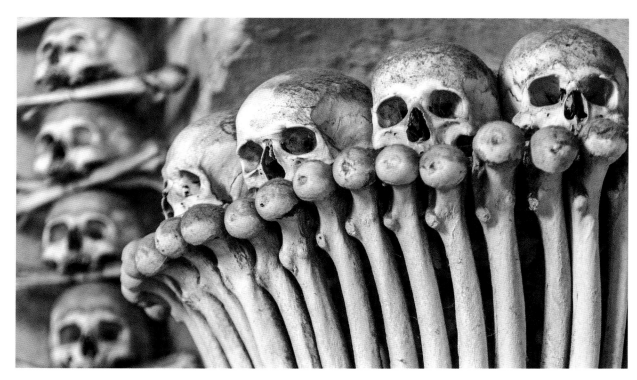

CZECH BEER
Prague and Plzeň, Bohemia, Czech Republic

// A Country's Proud Heritage

"Whenever beer is drunk, life is good" goes the proverb in a country whose per capita beer consumption is the world's highest. A tour of Prague's breweries might begin at the Pivovarsky Dum, where you can try "beer champagne" or coffee- or banana-flavored beer, or at the Pivovarsky Klub, which showcases the best of regional Czech brewers. Take a day trip 50 miles west to Plzeň's Pilsner Urquell Brewery and the nearby brewery museum.

Must Visit // The beer garden in Prague's 12th-century Strahov Monastery // The Prague Beer Museum in Old Town, for as many as 30 beers on tap

OLD TOWN SQUARE
Prague, Bohemia, Czech Republic

// Center Stage in the City of 100 Spires

Once the neighborhood of Franz Kafka, today Old Town Square overflows with tourists watching the hourly procession of apostles and allegorical figures on the Orloj, Prague's 600-year-old astronomical clock (*right*). Walk to the nearby Estates Theatre, where Mozart premiered *Don Giovanni*, or meander west down Karlova Street to the Charles Bridge, a city icon, for views of Prague Castle high atop the opposite bank of the Vltava River.

Must Do // Ascend the 200-foot tower of the former Town Hall to view the twin gables of the Church of Our Lady Before Týn, one of Prague's most recognizable silhouettes // Visit Prague in late November or December for Christmas markets in Old Town and Wenceslas squares // Visit the Jewish Museum and its synagogues and adjacent cemetery.

PRAGUE'S CASTLE DISTRICT
Bohemia, Czech Republic

// Religious and Political Symbol of Might and Glory

Perched high above the Vltava River, and best viewed from the statue-lined Charles Bridge, Prague Castle is a monumental collection of buildings dating from the 10th to the 20th centuries. Its spiritual core is the Gothic masterpiece of St. Vitus Cathedral (*right*) and its lavish chapel dedicated to King Wenceslas, patron saint of Bohemia. Amble through this hilltop town-within-a-town for views of Old Town, then descend to Malá Strana, a labyrinth of quiet lanes and small plazas.

Must Visit // Salm Palace for its stellar collection of 19th-century Neoclassical and Romantic art // The Sternberg Palace, to view 5 centuries of European art // The Lobkowicz Palace, which showcases paintings by Canaletto and handwritten scores by Mozart and Beethoven

BORDERLANDS OF SOUTHERN MORAVIA
Moravia, Czech Republic

// Châteaux, Wine, and a Little Slice of Italy

Described by Czech poet Jan Skácel as "a piece of Italy moved to Moravia by God's hand," the castle-topped town of Mikulov north of the Austrian border is an excellent base to explore the 124-square-mile Lednice-Valtice Cultural Landscape (*left*), home to two castles that were once owned by the aristocratic Liechtenstein family. The area's rolling hills are perfect for gentle bicycling and hiking through what is now the hub of the country's wine scene.

Must Do // Visit Mikulov in September for the Pálava Vine Harvest // Tour the synagogue built in 1550 in Mikulov's well-preserved Jewish quarter.

OLOMOUC
Moravia, Czech Republic

// Moravia's Underrated Gem

About 3 hours east of Prague, Olomouc and its pristine Renaissance, Baroque, and Gothic buildings are one of the Czech Republic's underrated and undervisited gems. The 100-foot-high Holy Trinity Column in the city's Upper Square is an exceptional example of the Baroque style popular in Central Europe. And in Wenceslas Square is the brooding St. Wenceslas Cathedral, originally consecrated as a Romanesque basilica in 1131.

Must Visit // Six of Olomouc's famous fountains in the Upper Square, including the Hercules Fountain, depicting the last mortal son of Zeus warding off the attack of the nine-headed Hydra, and Caesar Fountain (*right*), the largest, portraying Caesar on horseback // The Olomouc Archdiocesan Museum in the nearby Přemysl Palace complex, which hosts a dazzling collection of treasures from the 12th to 18th centuries

OLD TALLINN
Tallinn, Estonia

// A Perfectly Preserved
Medieval City

The heart of Tallinn's Old Town is Raekoja Plats, a 13th-century square that is now filled with outdoor cafés ringed by historic pastel-painted buildings with the 14th-century Gothic Raekoda, one of Europe's oldest town halls, at its center. Don't bypass the adjoining Katariina Passage; browse its artisan workshops where ceramics, glasswork, quilts, and jewelry are made and sold.

Must Do // Arrive by ferry or cruise ship from Helsinki for scenic views of Tallinn's soaring spires, including that of St. Olaf's Church (*above, background*), and glistening church domes // Visit the museum in Kiek in de Kök (*above, foreground*) // Peruse homemade crafts at the outdoor market on Müürivahe Street, a short walk east of Raekoja Plats.

SAAREMAA ISLAND
Estonia

// The Epitome of
Baltic Beauty

Saaremaa is a forested island in the Baltic Sea with old-fashioned seaside villages and desolate beaches. Kuressaare, the biggest community on the island, harbors the Baltic's best-preserved castle, a 14th-century dolomite fortress with a drawbridge. The Sõrve Peninsula, on the southwestern reaches of the island, has jagged cliffs and fine sea views; the ruins of an old Soviet military base and various gravesites attest to the heavy fighting here in World War II.

Must Do // A bit north of Kuressaare, visit Angla Windmill Mount (*right*) // Attend Castle Days in early July or the midsummer night's festival on June 23 // Visit the Viidumäe Nature Reserve, home to unusual orchid and bird species and rare plants as well as 600 species of butterflies and moths.

VARDZIA
Samtskhe-Javakheti, Georgia

// Cave City and
Cradle of Culture

The 800-year-old cave town of Vardzia
(*right*) is one of Georgia's greatest
cultural treasures. Houses, monks' cells,
workshops, and wine cellars, all linked by
tunnels and staircases, were hewn into
the side of a mountain near the Turkish
border. An earthquake in the 15th century
caused the outer face of the mountain to
collapse, creating the honeycomb view of
600 chambers spread over 13 levels that
visitors see today.

Must Do // See the 12th-century frescoes
in the Church of the Assumption // Come
prepared for the 2-hour taxi ride from
Akhaltsikhe, the closest town to remote
Vardzia.

OLD TBILISI
Tbilisi, Georgia

// The Heart and Soul
of Georgia

Tbilisi's Old Town is a delightful maze
of cobbled alleys and old houses with
carved wooden balconies and stained-
glass windows. At the north end is the
Anchiskhati Basilica, erected in the 6th
century. To the south is Sioni Cathedral.
Inside is Georgia's holiest relic, a cross
made of braided grapevines entwined
with the hair of St. Nino, the woman who
brought Christianity here in the 4th century.

Must Do // Soak in the historic ornately
tiled Orbeliani thermal spring baths in
the Abanotubani district (*left*) // Visit the
Janashia Museum in New Town to view a
priceless collection of pre-Christian gold
objects and jewelry // Travel 15 miles west
to Mtskheta's 11th-century Svetitskhoveli
Cathedral, the country's most important
church // From Mtskheta, take a short taxi
ride to the 6th-century Jvari Monastery for
spectacular views.

BUDAPEST'S TRADITIONAL THERMAL BATHS
Budapest, Hungary

// Spa City

Built above more than 120 thermal springs that range from warm-as-toast to boiling, Budapest has about a dozen traditional thermal baths, some of them a legacy of the Turkish occupation that began in 1541. Some baths are splendors of Art Nouveau, while others are spic-and-span modern establishments.

Must Visit // The historic Rudas baths below the sleek Elizabeth Bridge // The Széchenyi Baths (*right*), in Pest's enormous City Park, where patrons play chess on floating boards in the pools // The Gellért Baths, said to be modeled after the baths of Caracalla in ancient Rome

CHAIN BRIDGE
Budapest, Hungary

// Where History and Scenery Vie for Attention

The first permanent bridge spanning the Danube, the Chain Bridge connected Buda and Pest (pronounced *pesht*) in 1849. On the east bank of the Danube, Pest is the city's commercial, entertainment, and shopping district. Across the river, Buda is dominated by Castle Hill, the site of the 13th-century Buda Castle, home to Hungarian kings for almost 7 centuries.

Must Do // Stroll across the Danube from Pest on the Chain Bridge (*above, foreground*) and board the funicular to Castle Hill // Take in the wonderful views from the Fishermen's Bastion on the edge of Buda's Old Town // On the banks of the Danube in Pest, take a tour of the 600-plus-room Parliament building, one of the largest in the world.

THE DANUBE BEND
Hungary

// The Most Beautiful Section of Hungary's Revered River

The Danube begins in the Black Forest in southwest Germany and flows east until it reaches a point about 25 miles north of Budapest where it is called the Danube Bend. This is the most beautiful stretch of the river before it continues on past Budapest and empties into the Black Sea and is favored for the interesting and historically significant riverside towns along the way. Most popular is Szentendre, a charming artist colony since the 1920s. A bit farther west is Visegrád, home to Renaissance palace ruins and a forbidding hilltop castle. Carry on to Esztergom, seat of the Magyar kingdom until the 13th century.

Must Visit // Szentendre's museum dedicated to the work of Hungarian ceramicist Margit Kovács // Esztergom's 19th-century basilica, Hungary's largest, and its Christian Museum [*left*]

LAKE BALATON
Central Transdanubia, Hungary

// Hungary's Inland Sea

The largest freshwater lake in Europe outside Scandinavia, Balaton has something of a split personality. On the north shore are lush hills, vineyards, and historic towns and spas. On the southern shore are grassy beaches and the razzle-dazzle of a "seaside" resort, ideal for families with children. The lake is relatively shallow; you can wade for half a mile before the water reaches your waist.

Must Visit // Tihany, a thumb-shaped peninsula jutting into the Balaton, and the most historic spot on the lake, with the Benedictine Abbey Church [*right, background*] celebrated for its carved altars, pulpits, and screens // Tihany peninsula's nature reserve, to hike past ancient ruins to geyser cones // Hévíz, a spa town on the western end of Balaton, on the shores of a thermal lake of the same name.

PÉCS
Southern Transdanubia, Hungary

// A Town Full of
Mediterranean and
Turkish Delights

Pécs is a small Central European city
that seems to have it all: fine museums,
fabulous Moorish-style buildings left
behind by the Turkish occupiers, and a
mild, almost Mediterranean climate in
which almonds and apricots thrive. What's
more, Hungary's premier region for red
wine, Villány, is close by.

Must Visit // The Inner Town Parish Church,
aka the Mosque Church (*left*), the largest
Ottoman structure left standing in Hungary
// The Vasarely Museum, home to works
by local son Victor Vasarely, sometimes
called the father of Op Art // The Csontváry
Museum, to view paintings by Tivadar
Kosztka Csontváry

OLD RIGA
Latvia

// From the Medieval
to the Art Nouveau

Riga boasts a stunningly preserved
Old Town, home to the Dome Cathedral
(founded in 1211) and the House of
Blackheads (*above*), a painstakingly
reconstructed 14th-century guild hall
with a Dutch Renaissance façade.
Next door is the Latvian Museum of
the Occupation, which provides an
eye-opening account of Latvian life
under Nazi and Soviet rule. But its
gorgeous Art Nouveau (aka Jugendstil)
buildings are the reason Riga was called
"the Paris of the Balkans."

Must Do // Stroll down Alberta Street and
nearby Elizabetes Street to see buildings
bearing the stylized motifs and bold
geometry of Riga's Art Nouveau // Visit the
nearby Riga Art Nouveau Museum, housed
in a 1903 building // Sample a shot of Riga
Black Balsam, a strong traditional liqueur,
if you dare.

THE CURONIAN SPIT
Lithuania

// Fragile Seascape of Beaches, Dunes, and Forests

Sometimes described as "the Sahara of Lithuania" because of its wildly shifting sands, the Curonian Spit has some of the most dramatic landscapes in the Baltic countries. The entire 60-mile spit is protected as a national park and is a major site for bird-watchers.

Must Do // Visit Nida, about 30 miles south of mainland Klaipėda, once a summer home for writer Thomas Mann // Take a boat ride from the Curonian Lagoon, where 2-hour sails to all-day fishing jaunts are on offer // Climb the steps to the top of Parnidis Dune, for views of the rippling sands stretching to the south // Cycle 18 miles to the seaside village of Juodkrantė.

OLD VILNIUS
Vilnius, Lithuania

// A Great Baroque Beauty

The Old Town of Vilnius—one of the largest historic districts in Europe— s a magnificent canvas of Gothic, Renaissance, and Baroque architecture. Don't miss the dramatic Vilnius Cathedral (*below*), which dates back to the 14th century. Above it looms Gediminas Castle, with sunset views over the city. Mcre than 40 centuries-old churches can be found along the narrow streets, including the 15th-century St. Anne's, one of the city's most photogenic churches.

Must Visit // Pilies Gatvė, the main thoroughfare through the old quarter, with shops and cafés, buskers, and folk artists selling their wares // The 1903 Choral Synagogue, just outside Old Town, one of the few prewar prayer houses still functioning // The Museum of Genocide Victims, a quiet tribute housed in the former headquarters of the KGB

BAY OF KOTOR
Montenegro

// Fjordlike Wonder

Described as "the most beautiful encounter between land and the sea" by Lord Byron, the Bay of Kotor thrusts deep into coastal highlands and steep mountains. At the head of the bay is secluded Kotor, one of the best-preserved medieval ports in Europe. The town's 3 miles of defensive stone walls are especially beautiful when illuminated at night.

Must Do // In Kotor, visit St. Tryphon Cathedral, which dates back to 1166, and climb the 1,300 steps up to St. John's Fortress, stopping at the Church of Our Lady of Remedy (*right*, *foreground*) on the way, for unforgettable views of the bay // Explore the ancient town of Perast or whitewater raft in the nearby Tara River Canyon, some of Europe's best.

THE BUDVA RIVIERA
Montenegro

// A Highlight of the Adriatic Coast

Montenegro's most stunning beaches stretch along the 62-mile expanse of mountainous coastline between Budva and the Albanian border. Budva has new beach resorts, but its pedestrian-only Old Town (*left*) is a lively vestige of medieval architecture. Sveti Stefan, a cluster of 15th-century fishermen's cottages sometimes called a Mediterranean Mont St-Michel, is just 5 minutes south of Budva by car.

Must Do // Enjoy an alfresco seafood meal in Rafailovići, east of Budva.

AUSCHWITZ
Poland

// Killing Fields in the Center of Europe

The industrial city of Oświęcim, known as Auschwitz in German, is where workers at the concentration camp of the same name, and at nearby Birkenau, organized the systematic murder of an estimated 1.6 million people. The majority were Jews, transported here from all over Nazi-occupied Europe. Auschwitz is a harrowing place to visit, beginning with the infamous motto above the camp's entrance (*Arbeit Macht Frei*, or "Work Brings Freedom") and continuing on to the "barracks"—built for 52 horses but later housing up to 300 people—and the haunting exhibits of confiscated shoes, suitcases, and other personal effects.

Must Do // Board one of the hourly buses or walk just over 1 mile between Auschwitz and Birkenau, the largest and most lethal of the camps intended to be the "final solution to the Jewish Question."

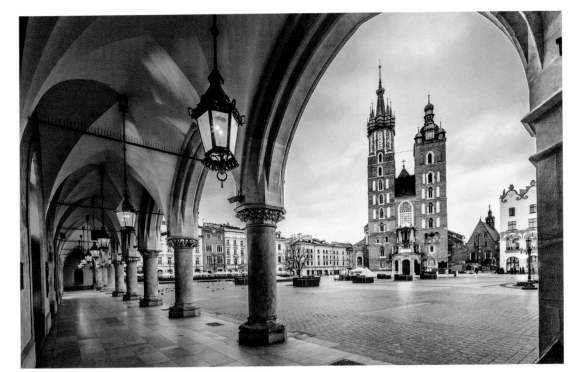

RYNEK GÓWNY
Kraków, Poland

// Europe's Largest Medieval Market Square

All of Kraków sooner or later passes through Rynek Gówny (Main Market Square), Europe's largest and one of its most authentic medieval market squares. Ringed by Gothic, Renaissance, and Baroque buildings, this massive plaza is dominated by the 15th-century Cloth Hall, but it's the mismatched towers of St. Mary's Church (*left*) that catch the eye. The taller of the two was once the city's watchtower.

Must Do // View St. Mary's wooden altarpiece carved by renowned Gothic sculptor Wit Stwosz in 1489 // Venture beyond the square and stroll through Kraków's Old Town, about 4 square miles of preserved streets and centuries-old buildings and monuments.

WAWEL HILL
Kraków, Poland

// Symbol of the Nation's Identity

Kraków's centerpiece is the Royal Castle and Cathedral, a majestic complex of Gothic and Renaissance buildings on a rocky hill above the Vistula River. The Royal Castle is the guardian of a millennium of Polish history and the most visited site in the country. Wawel Cathedral (*right*), consecrated in 1364 and dubbed "the sanctuary of the nation," was led by Karol Wojtyla from 1964 until his election as Pope John Paul II in 1978 (he served as pope until his death in 2005 and was canonized in 2014).

Must Do // Tour the castle's lavish staterooms, crown treasury, and armory // Visit Wawel Cathedral and pause at the tomb of Tadeusz Kościuszko, who fought in the American Revolutionary War // Climb the cathedral's bell tower for views of Old Town's impressive buildings.

SHOWCASES ON CHOPIN
Warsaw and Żelazowa Wola, Poland

// Tributes to Poland's Poet of the Piano

Frédéric Chopin, who turned Polish folk tunes and dances into virtuoso concert pieces, is Poland's greatest cultural export. Chopin aficionados in Warsaw can visit the Ostrogski Palace, the headquarters of the Chopin Society and an intimate venue for chamber music concerts, before making the pilgrimage 33 miles west to Żelazowa Wola (*left*), where the great composer was born in 1810.

Must Do // Schedule your trip to Chopin's birthplace to coincide with one of the Sunday concerts performed from May to September by noted pianists in Żelazowa Wola's museum // Explore Kampinos National Park on the trail originating in Żelazowa Wola.

ZAKOPANE
Poland

// Mountain Resort Town with Its Own Architectural Style

Poland's highest town, Zakopane, in the Tatra Mountains (*above*), is the nation's center for winter sports and a base for hiking and trekking during the warmer months. When he was known as Karol Wojtyla, the late Pope John Paul II liked a good schuss on the ski slopes here, the highest of which grace Mount Kasprowy Wierch and are suitable for skiers of all levels.

Must Do // Tour the Stanisaw Witkiewicz–designed Villa Koliba—the finest example of the local architectural style—which now houses the Museum of Zakopane Style // Hike some of the 186 miles of trails that crisscross Tatra National Park, just south of Zakopane.

MARAMUREȘ
Romania

// The Last Thriving Peasant Culture in Europe

Folded into the Mara and Izei valleys in northern Romania, Maramureș is where traditional villages are improbably preserved and centuries-old customs are still followed. Travelers who spend time in this landscape of haystacks, ancient farmsteads, and fields plowed with teams of oxen will find a warm welcome, often punctuated with a shot of homemade plum brandy.

Must Visit // The famous wooden markers in the Merry Cemetery in Săpânta (*right*), 13 miles northwest of Sighetu Marmației, the unofficial tourism hub of Maramureș // The wooden Orthodox churches built in the 17th century without the use of a single metal nail in Surdești and Călinești

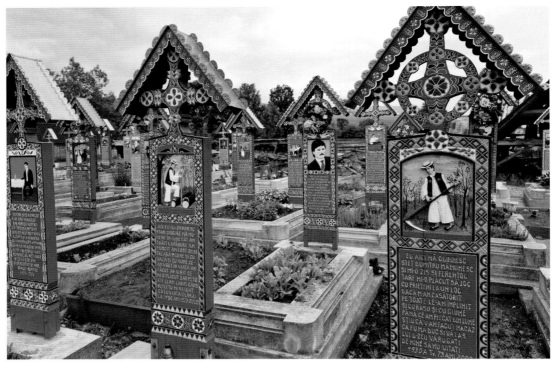

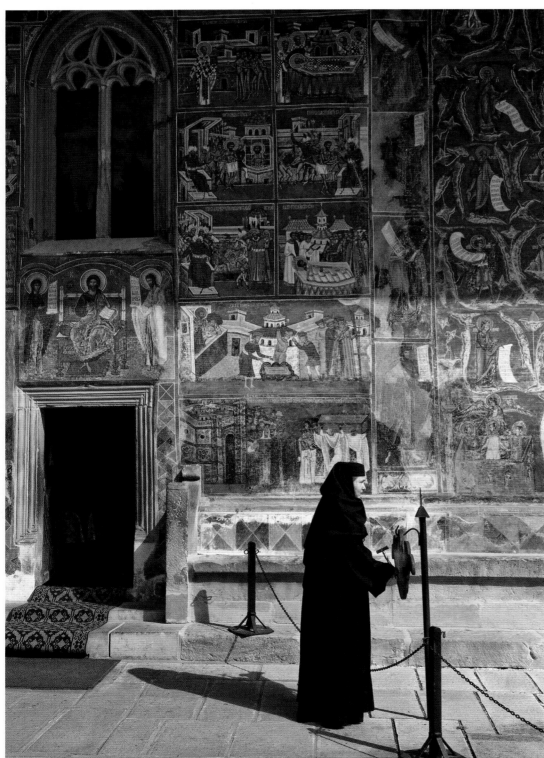

THE PAINTED MONASTERIES OF SOUTHERN BUCOVINA
Moldavia, Romania

// The Sistine Chapels of the East

In the 15th and 16th centuries, painters in northeastern Romania covered a cluster of small monasteries from top to bottom with brightly colored frescoes to record victories in battle and tell stories of redemption and damnation to a largely illiterate populace. They left modern Romania with a unique and enduring cultural gift.

Must Visit // The 15th-century monastery of Voronet (*left*), famous for its unique cerulean blue // The nearby monasteries of Humor, Moldovita, and Sucevita, where nuns keep their faith alive in this ruggedly beautiful area

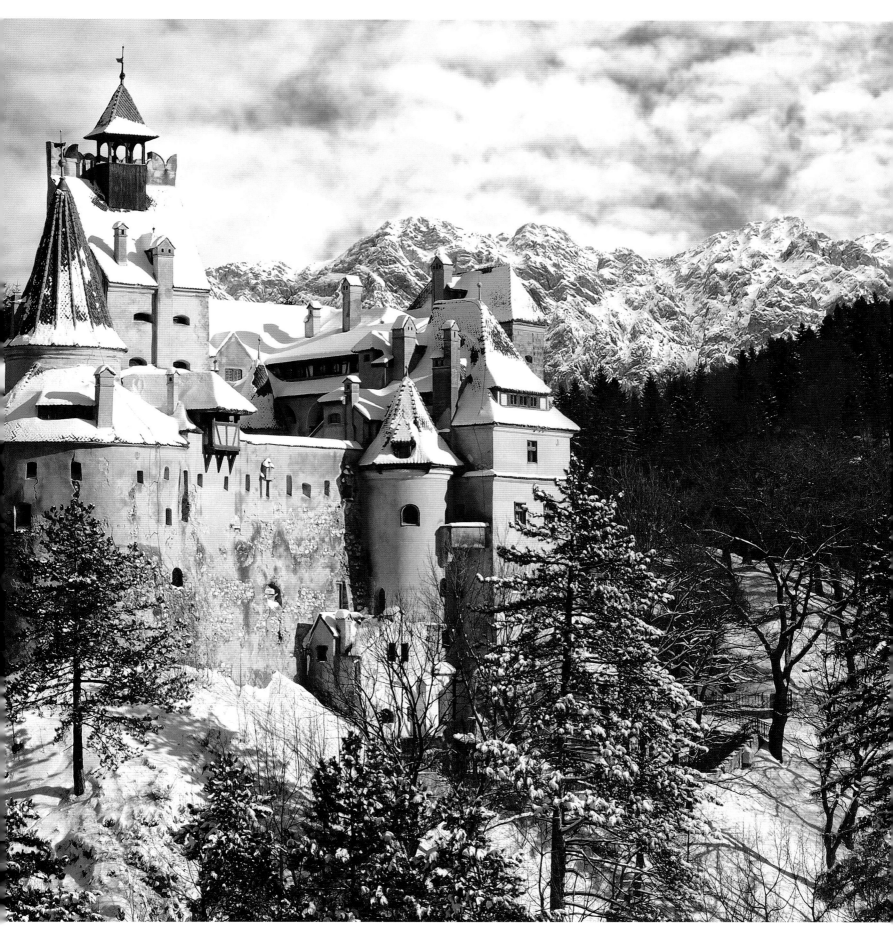

SOUTHERN TRANSYLVANIA
Romania

// Mountains, Saxon Villages, and Folklore of the Undead

Thrill seekers, wine lovers, and photographers are drawn to Transylvania, one of the last great European wildernesses. Cradled by the Carpathian Mountains, it is replete with ancient towns, fortified churches, Gothic castles, and legends about a certain nocturnal humanoid with prominent canines.

Must Do // Explore the Saxon towns of Brașov, Sibiu, and Sighișoara, for their mix of traditional and modern culture // Hike, bike, or ski the nearby Bucegi and Fagăraș

mountains // Book guided trips to the area's castles, especially the 14th-century Bran Castle, inaccurately but fondly known as Dracula's Castle. [Bram Stoker's 1897 novel *Dracula* was inspired by Vlad Dracula, a 15th-century Transylvanian prince known for impaling his enemies on stakes. Vlad spent at most a few nights in Bran Castle (*above*), but that hasn't stopped the steady flow of *Dracula* buffs, especially around Halloween time.]

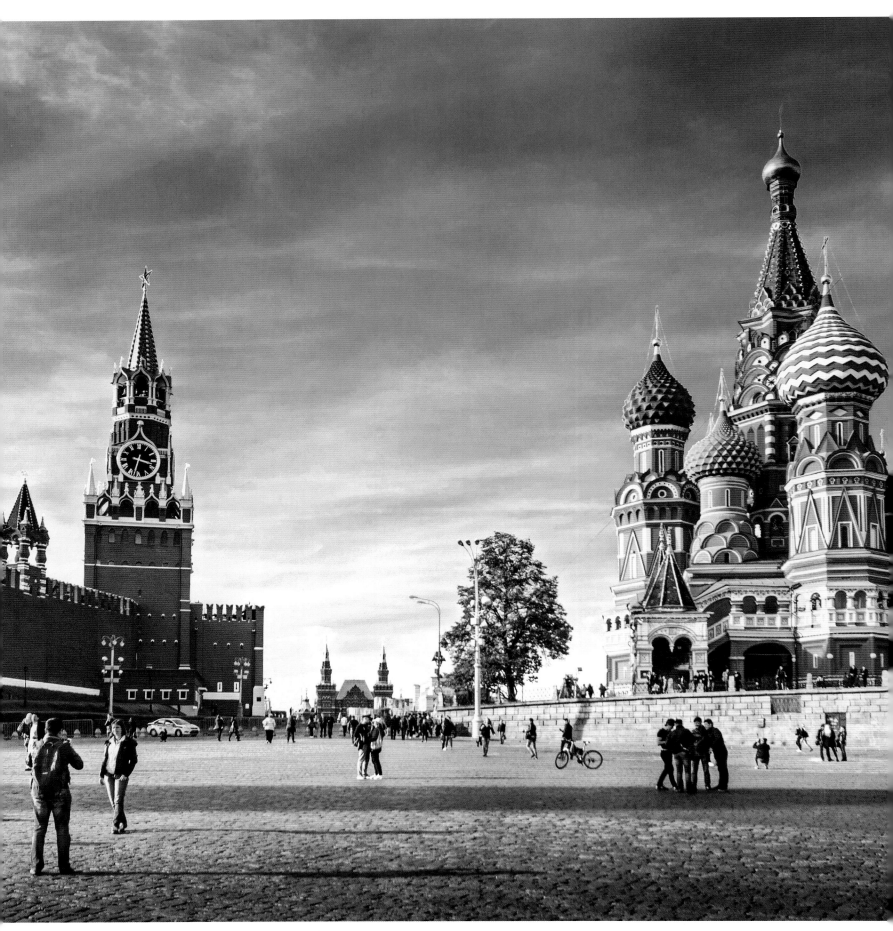

THE KREMLIN AND RED SQUARE
Moscow, Russia

// Inside—and Outside— the Fortress Walls

Originating as wooden stronghold built beside the Moscow River in the 12th century, the Kremlin, meaning "citadel" or "fortress," is the official residence of the president of Russia, though it is perhaps better known for its magnificent architecture and the dazzling treasures it houses inside more than a mile of walls. The vast, magnificent Red Square (*above*) stands just outside the Kremlin's east wall, and at its far end are the onion domes of St. Basil's Cathedral (*above, right*), a city icon commissioned by Ivan the Terrible in the mid-1500s.

Must Visit // At the Kremlin, the Armory Museum, which displays Fabergé eggs, the jewel-studded helmet of the first czar, and the ivory throne of Ivan the Terrible; and the Almazny Fond, home of the scepter and coronation crown of Catherine the Great // Among the Kremlin's star attractions: the 15th-century Assumption Cathedral, the Archangel Cathedral, and the Cathedral of the Annunciation // In the Red Square, the Lenin Mausoleum, where the Soviet leader's embalmed body has lain in state since his death in 1924.

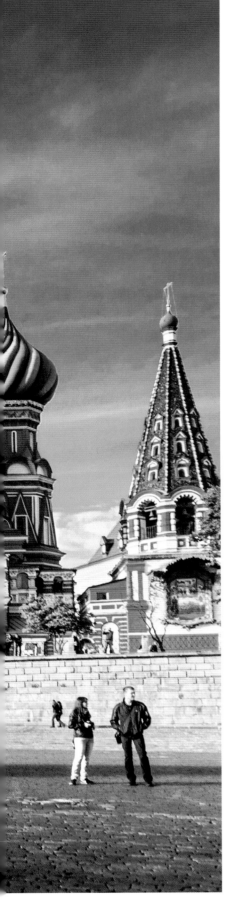

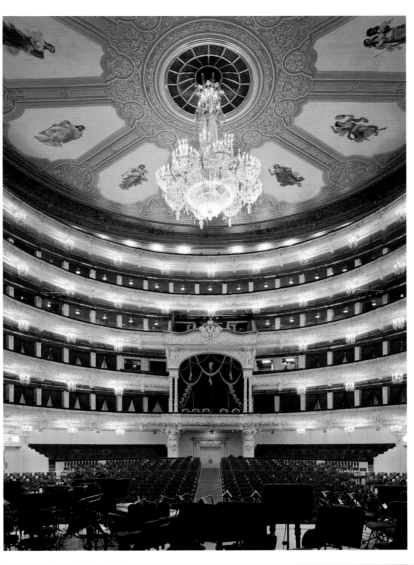

THE BOLSHOI THEATER
Moscow, Russia

// Russia's Most Famous Temple of Culture

Located in the heart of Moscow, near Red Square, the Bolshoi Theater was founded in 1824 and debuted Tchaikovsky's *Swan Lake* in 1877 (it was not well received, being considered too complex, but remains a popular standard on the program today). For much of the 20th century, it continued to serve as a launch pad for some of Russia's best-known operas and ballets, including works by Prokofiev and Shostakovich, while star dancers like Galina Ulanova, Rudolf Nureyev, and Nadezhda Pavlova helped bring world renown to the Bolshoi Ballet.

Must Do // See *The Nutcracker* at Christmastime // Visit the nearby Hotel Metropol, an enclave of early-20th-century Russian opulence where scenes in *Doctor Zhivago* were filmed and Lenin once delivered impassioned speeches.

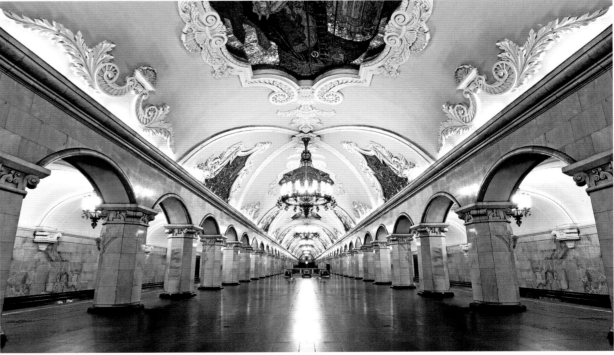

THE TRETYAKOV AND THE MOSCOW METRO
Moscow, Russia

// A World of Art Above- and Belowground

The Tretyakov Gallery (*left, exterior*) houses one of the country's finest collections of Russian art. A nearby branch of the Tretyakov showcases Russian avant-garde artists of the 20th and 21st centuries—including Kandinsky and Chagall—and also displays works of Socialist Realism created in the 1930s. More art from the Soviet period can surprisingly be found in the Moscow metro, a repository of elegant marbles, bas-reliefs, and mosaics. Much of the artwork found in the stations pays tribute to historical events—portrayed through a pro-Soviet lens.

Must Visit // The museum complex's 17th-century Church of St. Nicholas in Tolmachi, home of a five-tiered iconostasis // Komsomolskaya metro station (*above*), Mayakovskaya station, and Novosloboskaya station

WATERWAYS OF THE CZARS
Moscow, Russia

// Cruising the Volga and Beyond

Neither Moscow nor St. Petersburg is actually on the Volga River, but interconnected canals, locks, and lakes make a journey by boat possible from either city. On your way, you'll pass medieval towns with Orthodox monasteries and cathedrals standing silently on the banks, towns that make up what's known as Moscow's "Golden Ring" for their wealth of artistic and architectural treasures.

Must Do // From Moscow, river journeys head south to Kazan, the center of Tatar culture, then continue to Volgograd, formerly Stalingrad, the site of World War II's bloodiest battle (memorialized today by the 280-foot-high statue *Motherland Calls*), and end at Astrakhan, the world capital of caviar, where the river meets the Caspian Sea // Explore the island of Kizhi in Lake Onega, the site of an open-air museum of centuries-old wooden buildings, including the 17th-century St. Lazarus church and the 22-dome Church of Transfiguration (*right*) // Visit the 17th-century Church of St. Dmitry on the Blood in the city of Uglich, erected in memory of Ivan the Terrible's son.

NOVGOROD
Novgorod Oblast, Russia

// The Birthplace of Russia

Led by Rurik of Jutland, Vikings made this strategic town overlooking the Volkov River their capital in the 9th century, and by 880, the budding empire of Kievan Rus—the early progenitor to modern-day Russia—was born. Novgorod continued to flourish, becoming 12th-century Russia's biggest center for trade, education, and the arts.

Must Visit // The beautifully preserved kremlin (*left*), originally constructed in the 9th century and later rebuilt of brick // The Cathedral of St. Sophia, built in 1052 to withstand attack

THE WHITE NIGHTS FESTIVAL
St. Petersburg, Russia

// Twilight Magic in the City of the Arts

When it comes to the arts, St. Petersburg is Russia's brightest star. Boasting renowned ballet and opera companies and a world-class symphony, the city is especially vibrant during the performance-packed White Nights Festival, an 8-week spectacle that lasts from May to July, named after the long days of the midnight sun.

Must Do // Get a coveted ticket to one of the Stars of the White Nights concerts held at the dazzling Mariinsky Theater [*left*] // Attend a concert at the nearby state-of-the-art Mariinsky Concert Hall // Visit during the Scarlet Sails celebration in late June, for rowing competitions, outdoor concerts, and fireworks over the Neva River // Take a late-night river and canal cruise to see the raising of the bridges in this "Venice of the North."

THE WINTER PALACE AND THE HERMITAGE
St. Petersburg, Russia

// Splendors of Another Age

Designed for Empress Elizabeth I in 1754, the sumptuous Winter Palace [*above*] served as the official residence of the czars until the 1917 Revolution. But the palace is best known as the home of the Hermitage Museum, Russia's Louvre, with more than 40 works by Rembrandt, 40 by Rubens, 8 Titians, and masterpieces by Michelangelo, Leonardo da Vinci, and a host of Impressionists and Postimpressionists.

Must Visit // The Malachite Hall, filled with decorative details made of the gemstone // The Treasury Gallery, laden with gold and jewelry dating back to the 7th century BC // The 18th-century Yusupov Palace and its Rococo theater, a 20-minute stroll away from the Winter Palace // The nearby St. Isaac's cathedral, decorated with frescoes, mosaics, and 14 kinds of precious stones

CATHERINE PALACE AND PAVLOVSK PALACE
Pushkin and Pavlovsk, Leningrad Oblast, Russia

// Imperial Grandeur in Two of Russia's Greatest Homes

Two of Russia's most magnificent imperial estates are a short journey from St. Petersburg: the flamboyant Rococo Catherine Palace [*right*] and the neo-Palladian Pavlovsk. Although the original buildings were largely destroyed by Hitler's troops during World War II, an army of artisans created extraordinary reproductions that are filled with original furnishings and artwork that were hidden by loyal palace staff.

Must Visit // The Catherine Palace's Agate Rooms, covered in semiprecious stones, and the awe-inspiring Amber Room // Pavlovsk's ponds, lime tree–lined allées, rolling lawns, pavilions, and woodlands

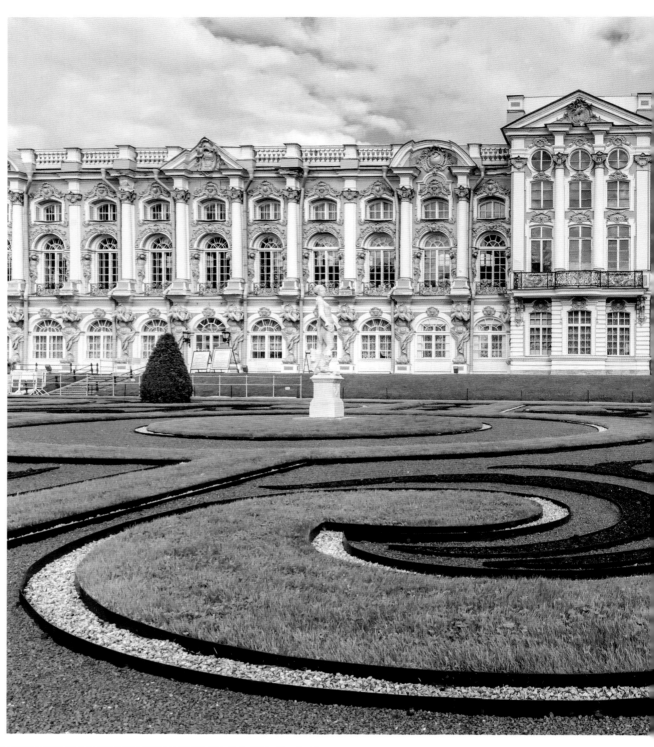

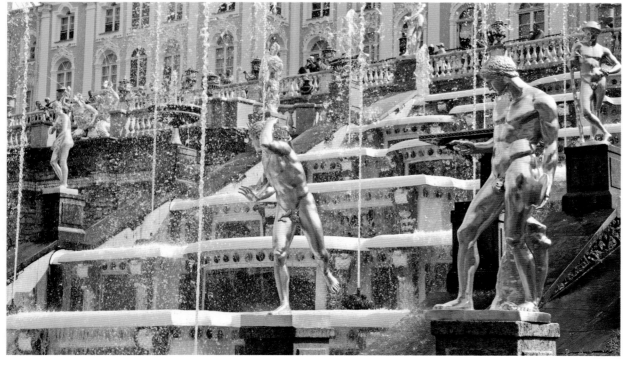

PETERHOF
Leningrad Oblast, Russia

// A Czar's Palace to Rival Versailles

One of Russia's most splendid gilded palaces is Peterhof, just outside St. Petersburg. Taking his inspiration from Versailles, Peter the Great wanted to introduce European grandeur to Russia when he moved the imperial seat of power from Moscow to St. Petersburg in 1712 and designed this summer palace on the Gulf of Finland to be his "window to Europe." It was completed during the reign of Peter's daughter, Empress Elizabeth.

Must Visit // The Grand Cascade [*left*], a series of more than 170 fountains and canals partly designed by Peter himself // The photogenic Chesma Hall, adorned with oversize paintings depicting the victory of the Russian navy over the Turkish fleet in 1770 // Peter the Great's simple but beautiful study—one of the few rooms to survive the destruction of World War II

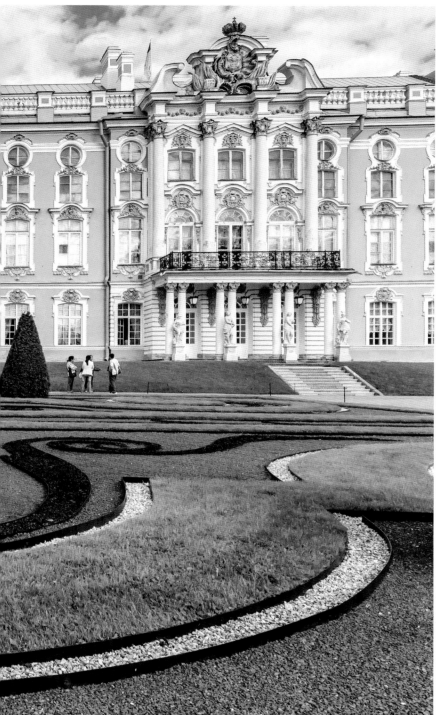

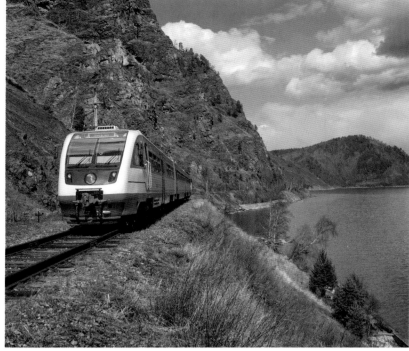

THE TRANS-SIBERIAN EXPRESS AND LAKE BAIKAL
Russia

// An Epic Train Ride Across Mother Russia

The Trans-Siberian Railway stretches more than 6,000 miles and crosses seven time zones between Moscow and Vladivostok on the Pacific coast. Accessible from any of the three routes that connect Moscow to the far east, Lake Baikal—the world's oldest and deepest freshwater lake and home to an extraordinary variety of flora and fauna—is one of the most interesting off-rail excursions. The most luxurious rail option is the *Golden Eagle*, a private train offering 11- to 15-day tours between Moscow and either Vladivostok or Ulaan Baatar, Mongolia, including stops and excursions en route.

Must Do // Board a lake cruiser to explore pristine islands, bays, and rivers, or take a hiking tour // Stop at Kazan, the Tatar capital on the Volga River, and Yekaterinburg, a city of theaters and museums // Visit Tomsk, one of Siberia's highlights, with lovely wooden mansions and a vibrant arts scene.

BRATISLAVA'S OLD TOWN
Bratislava, Slovakia

// Central Europe's Unsung Capital City

Since the peaceful dissolution of Czechoslovakia in 1993, the relaxed and easygoing capital of Slovakia, a 4-hour train journey from Prague or a 75-minute boat ride on the Danube from Vienna, is becoming an essential detour. Standing on a rocky outcrop above the labyrinthine Old Town, Bratislava Castle (*right, background*) boasts views along the river toward Austria and Hungary.

Must Visit // The Blue Church, the city's architectural gem // The 1911 Church of St. Elizabeth, a pristine Art Nouveau confection // Bratislava Castle's Museum of Jewish Culture, a small but excellent museum

LAKE BLED AND THE JULIAN ALPS
Gorenjska Region, Slovenia

// A Lake and Fairy-Tale Castle

The old lakeside spa town of Bled is the country's attention-getter. To enjoy the emerald-green glacial lake surrounded by the snow-dusted Julian Alps, jump aboard a gondola-like *pletna* for a visit to the tiny island at its center, then ring the 16th-century "wishing bell" in the church belfry (*left*). Or climb to the 11th-century cliffside Bled Castle for sweeping views and a visit to its museum.

Must Do // Drive the scenic 25 miles northwest to Kranjska Gora, Slovenia's top ski resort and the gateway to Triglav National Park // Climb to the top of Mount Triglav, the country's highest peak // Follow the Soča River to Kobarid, a pretty market town with a small but fine World War I museum.

LJUBLJANA'S OLD TOWN AND CASTLE
Ljubljana, Slovenia

// Medieval Core Overlooked by a Hilltop Fortress

Medieval and Baroque stand companionably side by side in the old quarter of Ljubljana, Slovenia's small capital, while the early 20th century is represented by the unique designs of local architect Jože Plečnik. Ljubljana Castle's varying architecture mirrors the city's history as it stands guard over the Old Town from atop a wooded hill.

Must Do // Start a walking tour of Old Town in the colorful Central Market area at the foot of the 18th-century cathedral and head south // Stroll across the landmark Dragon Bridge, Plečnik's triple bridge (*right*), or the new Butchers' Bridge // Tour the museums in Ljubljana Castle for an overview of the city's and nation's history.

THE CAVES OF THE KARST PLATEAU
Notranjska and Primorska Regions, Slovenia

// Land of Underground Caverns and Snow-White Horses

Visitors to Slovenia's Karst region can explore some of the world's largest and most astonishing caves, whether at Postojna's stalactites and stalagmites (*right*), or at the smaller Škocjan caves that are right out of Jules Verne's *Journey to the Center of the Earth*.

Must Do // Take a 90-minute guided tour of Postojna via a miniature electric open-topped train // Head northwest of Postojna to Predjama Castle, built in the mouth of a cavern // Cross the dizzying footbridge above the Reka River in the Škocjan caves // Visit the town of Lipica, where Lipizzaners are bred for Vienna's Spanish Riding School.

KIEV CAVES MONASTERY
Kiev, Ukraine

// A Timeless Byzantine Wonder

A center of Ukrainian Orthodoxy, Kiev is home to scores of cathedrals and monasteries. The city's first great church was St. Sophia's Cathedral, but don't miss the equally splendid Kiev Caves Monastery (*left*), founded in 1051. An elaborate network of caves served as study and meditation rooms for the reclusive monks, whose bodies were placed on display enclosed in glass coffins and naturally mummified after they died.

Must Visit // The sprawling aboveground Lavra complex, the Dormition Cathedral, and its soaring bell tower topped by a radiant gold cupola // The Lavra's Historical Treasures Museum, to view ancient Scythian gold jewelry // The unusual Museum of Microminiatures

THE HISTORIC CENTER OF LVIV
Lviv, Ukraine

// Ukrainian Beauty Finally Flourishing

The Western Ukrainian city of Lviv was once known as the Florence of the East, but years of Soviet neglect left it crumbling and faded. It took more than a decade after independence to resuscitate its spirit, but today Lviv is a delightfully uncrowded, culture-packed Western-leaning destination.

Must Do // Stroll Old Town's Market Square and climb the town hall's 210-foot tower for panoramic views // Explore the alleys off Market Square that are home to small museums and a memorial to Lviv's lost Jewish population // Tour the Armenian Cathedral, the Florentine Dormition Church, the Baroque Bernadine Church, and the Rococo-domed Dominican Church // Attend a performance in the beautiful Opera House (*right*), completed in 1900.

Scandinavia

BORNHOLM
Hovedstaden, Denmark

// The Sunniest Spot in the Baltic

Herring smokehouses and the runic stones found in Almindingen forest are the legacy of the early Viking inhabitants of Bornholm, while the island's whitewashed 12th-century *rundkirkem*, or round churches, reflect its medieval past. A popular summer retreat for Danes and Germans, Bornholm also illustrates the Danish concept of *hyggelig* (cozy and warm).

Must Do // Visit one of the more impressive *rundkirkem* in Østerlars (*left*) // Tour the remains of northern Bornholm's 13th-century cliff-top castle, Hammershus Slot, the largest such ruins in Northern Europe // Bicycle south to explore Dueodde, the island's longest beach // Explore Gudhjem (God's Home), Bornholm's best-preserved fishing village.

DANISH DESIGN
Copenhagen, Hovedstaden, Denmark

// Timeless Appeal of Impeccable Style

Furniture by Arne Jacobsen, Georg Jensen's silver work, the simple lines of Lego blocks, and architect Jørn Utzon's Sydney Opera House are elegant illustrations of Danish design's enduring success. To peruse the country's best work under one roof, visit the Dansk Design Center's changing exhibits that feature everything from the legendary artichoke lamps by Poul Henningsen to stylized housewares.

Must Visit // Copenhagen's Opera House (*right*), an eye-catching structure by Henning Larsen // The cubist København Koncerthuset, which is swaddled in blue fabric "skin" that projects dancing images of performers

DENMARK'S CULINARY REVOLUTION
Copenhagen, Hovedstaden, Denmark

// New Nordic Cuisine: Paying Homage to the Soil and the Sea

Denmark is consistently voted one of the happiest nations in the world. Perhaps it's because of the food—fresh, land and sea sourced, delectable. There's no escaping the neo-Nordic culinary movement that is redefining Danish cuisine, and Noma is at the helm. It consistently tops the world's short list of best restaurants and is headed up by the visionary chef René Redzepi. Noma pays homage to the "soil and sea," with a rarefied menu (*left*) that hopscotches across the region.

Must Visit // Ida Davidsen, to sample the national open-faced buttered treat called *smørrebrød* // Kong Hans Kaelder, for classic Danish cuisine with modern flourishes

TIVOLI GARDENS
Copenhagen, Hovedstaden, Denmark

// A Theme Park That Inspired Disney

Copenhagen's fabled Tivoli Gardens is one of the world's oldest theme parks—said to have inspired Walt Disney—and Denmark's most popular attraction. Beer gardens, open-air stage performances, and the parade of the red-uniformed Tivoli Boys Guard keep young and old entertained and coming back.

Must Do // Visit Tivoli at night when it is the most magical and romantic // Ride the 1914 roller coaster or the merry-go-round of tiny Viking ships.

KRONBORG SLOT
Helsingør, Hovedstaden, Denmark

// To Be or Not to Be at Hamlet's Elsinore

Elsinore Castle's real name is Kronborg Slot (*slot* means "castle" in Danish), and it was built centuries after the time of the Danish prince Shakespeare based his tormented character Hamlet on. But this moat-encircled castle rising grandly above the town of Helsingør, with its gloomy dungeon and cannon-studded battlements, is a perfect backdrop for a dark tragedy.

Must Do // Explore the castle's chapel, the dream wedding location for many Danish couples // Attend one of the occasional summertime performances of *Hamlet* staged in the torch-lit courtyard // Make the easy day trip from Copenhagen to Frederiksborg Slot, the largest and most sumptuous Renaissance castle in Scandinavia.

LOUISIANA MUSEUM OF MODERN ART
Humlebaek, Hovedstaden, Denmark

// A Memorable Marriage of Art and Nature

Take one of Zealand's scenic drives north of Copenhagen to this museum that combines art, nature, and architecture in perfect harmony. Exhibiting classics of the post–World War II era as well as the sometimes controversial vanguard of contemporary art, the Louisiana Museum's light-flooded halls embody the very essence of Danish modernism.

Must Do // View artworks by Alberto Giacometti, Pablo Picasso, Francis Bacon, and Henry Moore // Stroll through the open-air sculpture garden to see works by Alexander Calder (*left*, *Almost Snow Plow*) and Jean Arp // Attend one of the museum's outdoor chamber music concerts.

ÅRHUS
Midtjylland, Denmark

// Where the Ancient and Avant-Garde Merge

Founded in the 10th century as a Viking settlement, Århus is one of the oldest cities in Scandinavia as well as Denmark's second largest, with an art and architecture scene that rivals Copenhagen's. The Danish royals summer in this municipality that has all the requisites of a university town: progressive art museums, indie bands, and outdoor bars and cafés flowing with Danish beer and high spirits.

Must Do // Visit the 12th-century Århus Domkirke to view its unique painted-glass window behind the altar // Head to Århus's Den Gamle By (Old Town), an open-air museum of 75 traditional half-timbered houses brought here from around the country (*right*) // Tour the Cubist ARoS art museum's collection of works by Danish artists.

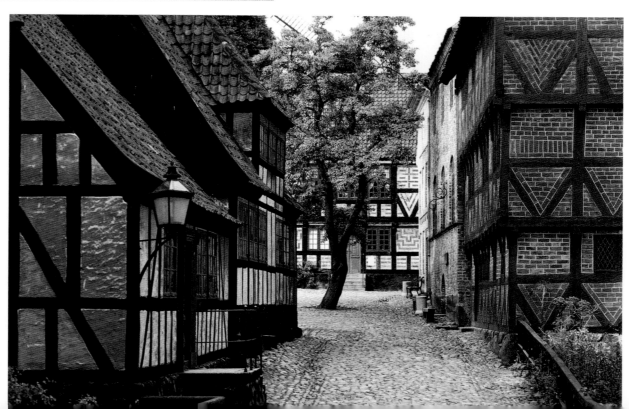

SKAGEN
Nordjylland, Denmark

// Remote and Romantic, the "Land's End" of Denmark

The small fishing communities on the Jutland peninsula's northernmost tip have been joined by a thriving artists' colony. Isak Dinesen wrote much of *Out of Africa* while a guest at Brøndums Hotel, and tourists followed, lured by Skagen's simple life, unspoiled dunes, and luminous skies.

Must Do // Visit Skagens Museum, which showcases works from the Danish Impressionist movement // At Grenen, the country's northernmost point, stand in the frothy coupling of two seas, the Skagerrak and the Kattegat.

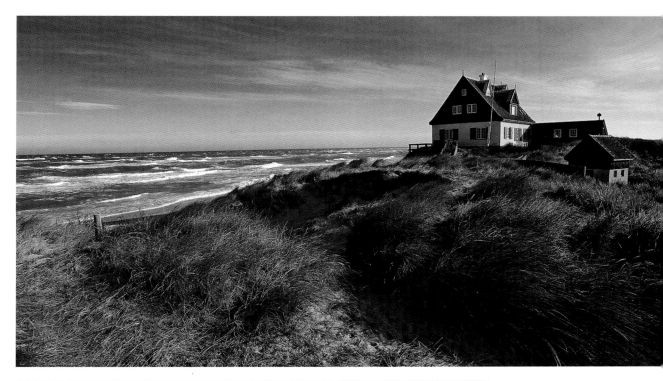

ROSKILDE
Sjælland, Denmark

// A Stroll Through Danish History in a Former Royal Capital

Roskilde was the ecclesiastical seat and royal capital of Denmark until 1455. Thirty-eight Danish kings are buried in royal marble and alabaster tombs (*right*) in the city's hallmark building, a twin-spired 13th-century Gothic cathedral, Denmark's answer to Westminster Abbey.

Must Do // Tour the Vikingeskibsmuseet Roskilde, the nation's best Viking ship museum, which displays five perfectly preserved Viking longships discovered and reconstructed in 1957 // Cruise Roskilde's fjord, one of the longest and largest in Denmark // In late June or early July, join the international crowd that descends on Roskilde for one of Europe's largest open-air rock festivals.

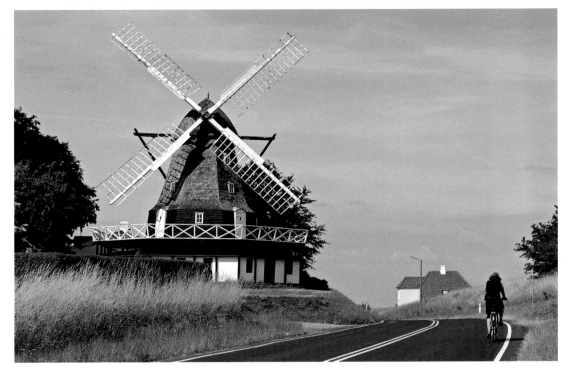

ÆRØ
Syddanmark, Denmark

// History on a Windswept Isle

To really get away, folks from Copenhagen head south to Ærø, with quiet marinas, quintessentially Danish villages, and a patchwork of farms. Ærø has always been popular with sailors; the 14th-century market town of Ærøskøbing was once home to more than 100 windjammers. Today, visitors can enjoy exploring one of Denmark's greenest islands, where wind turbines produce more than 50 percent of the energy for its 7,000 residents.

Must Do // Visit Denmark's oldest post office, built in 1749 // Bike past old windmills, a 12th-century Gothic church, and thatched houses.

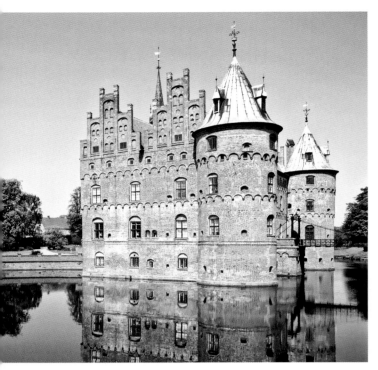

FUNEN
Syddanmark, Denmark

// Fairy Tales in the
Garden of Denmark

Known as the Garden of Denmark for
its farmlands and meadows, the island
of Funen is also the birthplace of Hans
Christian Andersen. Visitors can view
original manuscripts and his letters to
Charles Dickens at the museum adjoining
his childhood home in Odense, then explore
the town's charming medieval core.

Must Do // Visit the moated Renaissance
Egeskov Castle (*above*), 17 miles south
of Odense, home of one of Denmark's
most important private gardens // Explore
Funen's bucolic countryside by bicycle.

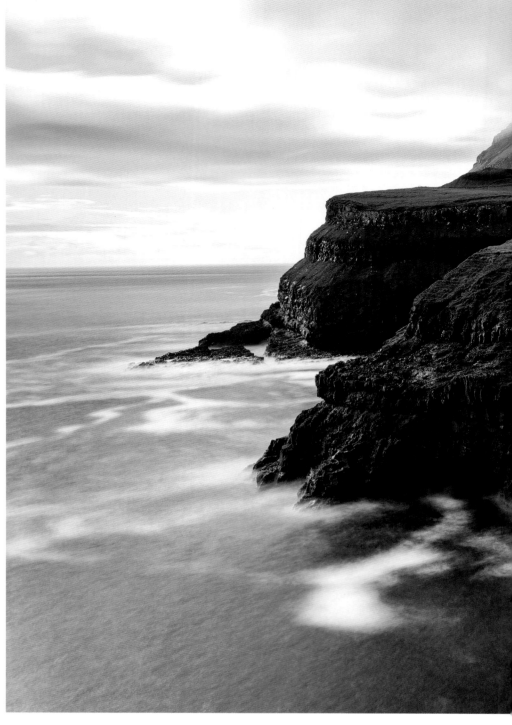

RIBE
Syddanmark, Denmark

// Denmark's Oldest and Best-
Preserved Medieval Town

Ribe's medieval cathedral, the Ribe
Domkirke (*left, foreground*), was one of
the first Christian houses of worship in
the country. It is well worth climbing the
cathedral's 248 steps for panoramic views
of the Danish countryside. Then stroll
through Gamle Stan, the ancient core of
Denmark's oldest town, founded in the
9th century as a Viking trading center.

Must Do // Visit in late March through
August to see white storks nesting atop
Ribe's chimneys // Take a day trip to
Legoland, one of Denmark's most kid-
friendly spots.

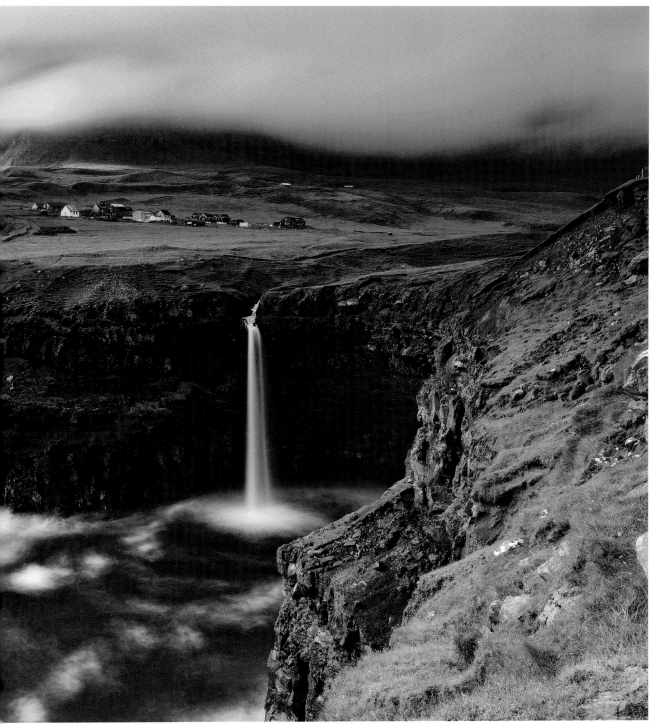

FAROE ISLANDS
Autonomous Region of Denmark

// Moody and Humbling Nature in the North Atlantic

Amid the foamy waves of the North Atlantic, midway between Scotland and Iceland, lie the breathtakingly scenic Faroe Islands that form an achingly beautiful 22-island archipelago. The islands have a unique history, culture, and language, and are home to ancient Viking settlements, medieval churches, colorful fishing boats, and turf-roofed houses. Torshavn, on the principal island of Streymoy, features an atmospheric old quarter and a 15th-century monk's house built by Irish friars.

Must Do // Throughout the islands, take in the spectacular backdrop of craggy mountains, bright green valleys with tumbling waterfalls, and treeless expanses // View an astonishing array of seabirds that flourish in the Faroes—puffins, fulmars, guillemots—from the Vestmanna Bird Cliffs to the remote island of Mykines // Visit in the colder months to witness the magnificent northern lights.

DISKO BAY
Greenland, Autonomous Territory of Denmark

// Glorious Corner of the Largest Island in the World

For many adventure travelers, sparsely populated Greenland is the ultimate frontier. About 85 percent of the island is covered in ice, and adrenaline-spiking activities abound, from sea kayaking ("kayak" is from the Greenlandic word *qajaq*) and rockclimbing to musk ox safaris and biplane flights over mountain-size icebergs. For prime exploring, head west to Ilulissat ("icebergs" in the local Inuit) and Disko Bay to take a tour boat past massive blue-streaked icebergs floating in the fjord.

Must Do // Take a boat from Nuuk, Greenland's tiny capital, to look for minke and humpback whales (*left*) // Visit Northeast Greenland National Park for a chance to see the elusive and endangered polar bears.

THE ÅLAND ARCHIPELAGO
Finland

// Islands of Enchanting Beauty

The Åland Archipelago, jutting into the Gulf of Bothnia, consists of more than 6,500 small islands. Most residents—citizens of Finland—speak Swedish and take pride in their autonomy. Åland has its own parliament, flag, license plates, and stamps. The islands offer a vision of tranquility, with lush oak and elm forests amid the emerald hues of the Baltic.

Must Do // Hire a car or rent a bicycle in Mariehamn, the principal town on Fasta Åland // Visit the 12th-century Sankt Michaels Kyrka in Finström and the 14th-century Kastelholms Slott, a citadel beautifully sited east of Finström in Sund // Long-distance ice-skating, ice fishing, and iceboating in winter // Head west to Eckerö, a picturesque island with a harbor lined with red boathouses.

THE DESIGN DISTRICT
Helsinki, Finland

// Grand Finnish

From Marimekko to the architectural superstars Eliel and Eero Saarinen, Finland has a formidable reputation for turning everyday objects and places into timeless works of art, such as the Helsinki Central Train Station and its "Lantern Carriers" (*above*), and Helsinki's Design District promises cutting-edge galleries, stores, hotels, and restaurants eager to share their design smarts.

Must Visit // Design Forum Finland, to see the works of both celebrated and up-and-coming Finns // The Design Museum, for a crash course on modern Finnish design

THE WORLD OF ALVAR AALTO
Helsinki and Jyväskylä, Finland

// The Father of Modern Scandinavian Design

Among the greatest 20th-century architects, Alvar Aalto also made good design affordable, and his flowing vases, wooden stools (*right*), and curved-wood chairs are sought-after collectibles today. Jyväskylä, 3 hours north of Helsinki, is where Aalto studied and designed the Palladian-inspired Workers Club Building, the Muurame Church, and eight buildings of the University of Jyväskylä.

Must Do // Visit Aalto-designed Finlandia Hall, one of Helsinki's most famous buildings // Head to Artek's flagship store, which still carries Aalto's signature pieces // Tour the four museums that convey the architect's philosophy through exhibits, video footage, and building designs.

FINNISH LAPLAND
Lapland, Finland

// Santa's Busy Workshop,
an Exhilarating Icebreaker
Cruise, and a Real-Life
Snow Castle

Rovaniemi is the gateway to Finnish
Lapland (and to Finland's Arctic Circle),
home to herds of roaming reindeer and the
indigenous Sami people. It's also Santa's
home turf, where he's in attendance every
day and where the post office displays some
of the 700,000 letters he receives every
year. An old-fashioned gift shop stocks
Yuletide presents that can be shipped back
home with a Santa Claus Village postmark.

Must Do // Go for a sleigh ride at Rovaniemi's
nearby reindeer farm // Visit Rovaniemi's
Arktikum Science Center to learn about life
above the Arctic Circle // In Kemi, catch a
4-hour ride on a former Arctic icebreaker,
the MV *Sampo*, and don a watertight
survival suit to float amid the newly broken
ice (*left*).

LAKELAND
Northern and Southern
Savonia, Finland

// Wondrous World of Water
and a Classic Smoke Sauna

Finland is a land of lakes (it has close to
188,000 of them). Lakeland is the heart
of Finland's watery kingdom, home to
the biggest lake system in Europe and
to Saimaa, the largest lake in Finland.
The town of Savonlinna lies on three of
Lakeland's more than 13,000 islands and
is home to the 15th-century Olavinlinna
Castle (*right*), which stands majestically
in a strait connecting two lakes.

Must Do // Take in the idyllic landscape,
from bike rides along country lanes to
canoe trips out on the lake. Or board the
11-hour summertime cruise on the MS *Puijo*
to Kuopio to sit in the traditional log-hewn,
wood-fired Jätkänkämppä smoke sauna
on Lake Kallavesi // Attend the Savonlinna
Opera Festival, held in July inside
Olavinlinna Castle's walls.

TURKU AND
THE KING'S ROAD
Finland

// Cultural Riches and
a Historic Road

Finland's oldest city and its original capital is
historic and free-spirited and has produced
some of Finland's leading artists, many of
whom studied at the venerable Turku Arts
Academy. The centuries-old King's Road
starts here, a 293-mile route that travels east
to Vyborg, Russia, and continues on through
St. Petersburg to Moscow.

Must Do // Gaze at the musical instruments
and memorabilia on display at the Sibelius
Museum, then listen to the works of Finland's
most famous composer // In old Turku,
explore the Tuomiokirkko, called "the mother
church" of Finland's Lutheran faith, and its
dazzling frescoes // Visit Luostarinmäki, an
open-air museum, for a sense of what life
was like in Turku 2 centuries ago // Along
King's Road, stop in Porvoo (*left*), Finland's
best-preserved medieval town.

LAKE MÝVATN AND ICELAND'S GRAND CANYON
Iceland

// Waterfalls, Lava Fields, and Canyons

Photogenic Mývatn, a shallow lake ringed by lava fields, sulfur springs, and otherworldly rock formations, is also home to prolific birdlife. A short drive northeast of the lake is the glacial river canyon Jökulsárgljúfur in the northern section of Vatnajökull National Park. At the southern end of the canyon is the thundering 144-foot Dettifoss (*below*), Europe's most powerful waterfall.

Must Do // Make Reynihlíd your base for exploring the "black castles" of Dimmuborgir—lava formations that resemble the ruins of an ancient citadel // Hike up Hverfjall, a volcano with a massive crater, for panoramic views // Visit Ásbyrgi Gorge, whose cliff walls descend 300 feet to birch-filled woodlands.

THE RING ROAD
Iceland

// Fabled Island of Fire and Ice

Your likely arrival point in Iceland is Reykjavik, the capital of this misnamed volcanic and otherworldly nation. Iceland is, in fact, about 90 percent ice-free, and it boasts lunarlike deserts, windswept tundra, waterfalls, green grasslands, and glacier-carved canyons that can be explored on the two-lane Ring Road, an 830-mile loop around the island that takes about 8 to 10 days to complete.

Must Visit // Geysir, the largest of the island's many hot springs // The glacial lagoon at Jökulsárlón, in the southeast, where icebergs challenge tour boats // The island's fabled Blue Lagoon (*left*), just 35 minutes outside Reykjavik, one of a dozen public thermal pools said to be Icelanc's health and beauty secret

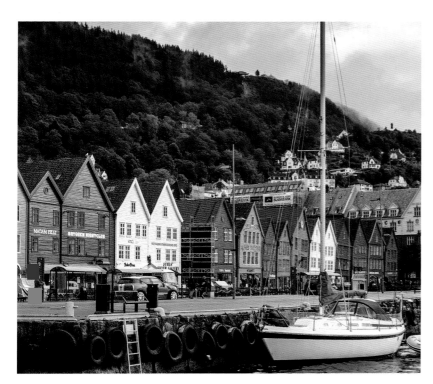

BERGEN
Norway

// Historic "Wooden City" in a Spectacular Setting

Bergen's wharfside district of Bryggen (*left*) is the home of the city's much-photographed gabled wooden buildings. These timbered warehouses and hostelries—responsible for the town's nickname, the Wooden City—now house artisan workshops, restaurants, and the Hanseatic Museum.

Must Do // Pack a picnic and head just south of town to Troldhaugen, the 19th-century summer villa of Edvard Grieg, where summertime concerts are held // Take the funicular to Fløyen for breathtaking views of the fjords // Head to Oslo via the Norway in a Nutshell tour, a full day trip that features the best of this beautiful corner of the country.

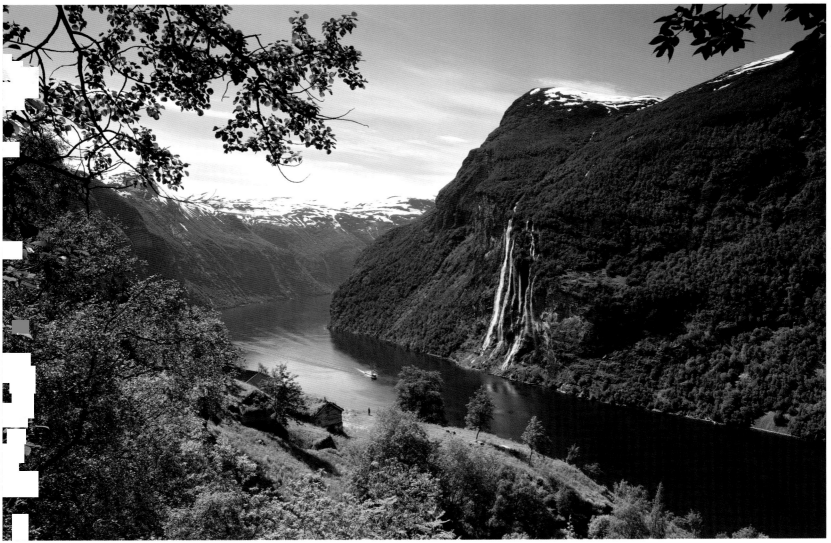

GEIRANGERFJORD
Norway

// Norway at Its Most Majestic

The vertical cliff–walled, 10-mile-long Geirangerfjord is the ne plus ultra of the country's many fjords and is best seen from the remarkable Eagles' Road that snakes from Åndalsnes to Geiranger. Stop at the last bend, known as Eagle's Turn, to take in unforgettable views. Or drive the serpentine Troll's Path that runs from Åndalsnes to Valldal.

Must Do // Excursions to Jostedalsbreen, Europe's largest glacier, and Seven Sisters (*above*) and Bridal Veil, spectacular waterfalls // Visit the waterfront town of Øye, a great base for enjoying the Geirangerfjord area and neighboring Norangsfjord // Spend time in the coastal fishing town Ålesund and its museum for an in-depth look at the town's history and Nordic Art Nouveau architecture.

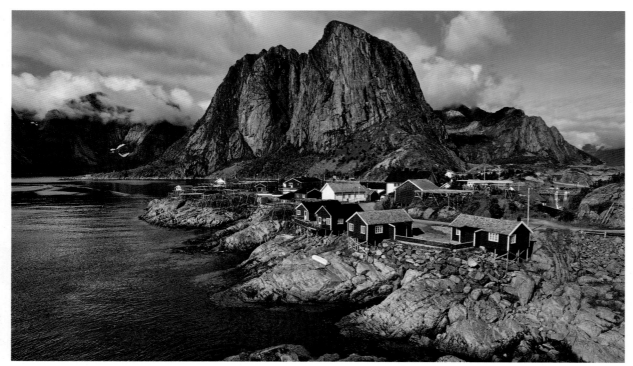

LOFOTEN ISLANDS
Norway

// The Soul of Northern Norway

Although the Lofoten archipelago lies 122 miles north of the Arctic Circle, the climate is surprisingly mild, giving visitors an opportunity to experience firsthand the natural splendor of one of Norway's standout attractions. The islands are dotted by small fishing communities and ringed by towering peaks that date back several billion years. The traditional *rorbus* (fishing cottages) were built on docks extending over the water; today they are popular as rentals for artists who come for the long days of Nordic light.

Must Do // Bodø, where the Saltstraumen Eddy, a furious natural whirlpool, is worth a visit before embarking on a boat to the islands // Explore Svolvær, the islands' small capital and a thriving summer art colony.

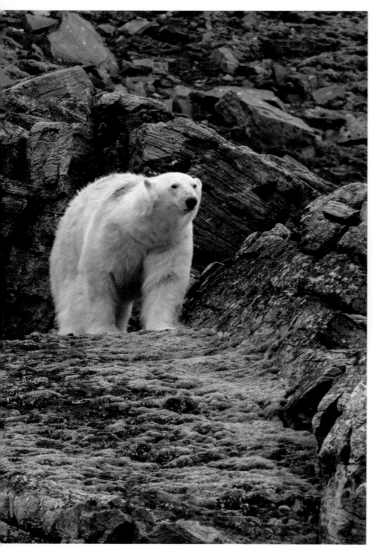

THE NORTH POLE AND SVALBARD
Norway

// Polar Bears and Ice at the Top of the World

Just a century ago, no one had ever stood at latitude 90 degrees north. Today, the North Pole has become a tourist destination, albeit a rarefied one. South of the North Pole, the archipelago of Svalbard is the gateway to Arctic adventure and considered the best place in the Arctic—if not on earth—to observe polar bears in their natural habitat (*left*).

Must Do // Board a nuclear-powered icebreaker sailing from Spitsbergen and Murmansk that navigates the Arctic Basin and the North Pole, and enjoy lectures and presentations, while staying on the lookout for sightings of polar bears, walruses, and Arctic birds // For a different adventure, take a cruise expedition from Svalbard, Europe's most northerly landmass.

NORWAY'S COAST AND THE NORTH CAPE
Norway

// Cruising to—and Beyond— the Arctic Circle

Norway's legendary Hurtigruten cruise steamers have been sailing from Bergen to deep within the Arctic Circle for more than a century. Hugging a filigreed coastline of fjords, glaciers, and mountains, the boats depart Bergen and head north for the 3,200-mile, 7-day trip, making dozens of stops, including to Hammerfest and the North Cape, a sheer granite cliff with an observatory at the top (*above*).

Must Do // Visit historic Trondheim, Norway's third-largest city // Stop in Tromsø, home to the world's northernmost university, brewery, and cathedral, earning it the title of "Paris of the North." It is also among the finest spots to view the famous northern lights // Visit Tromsø's Northern Lights Planetarium.

MUNCH MUSEUM AND NATIONAL GALLERY
Oslo, Norway

// Remarkable Nordic Art and Architecture

Oslo is one of Scandinavia's most artistically diverse cities, and no one is as synonymous with Nordic art as Edvard Munch. Oslo is home to the Munch Museum, which houses *The Scream* and *Night* as well as other works and personal memorabilia, and the National Gallery, where an 1893 version of *The Scream* is exhibited (*right*) and which offers a broad overview of European art from Picasso to Van Gogh.

Must Visit // Oslo's waterfront Opera House, a futuristic building made of white marble designed to resemble a floating iceberg

VIKING SHIP MUSEUM
Oslo, Norway

// Maritime Masterpieces

The Age of the Vikings, when Norsemen terrorized the coasts of Europe, lasted from approximately 800 to 1050. (Perhaps the most famous among them was Leif Ericsson, the bold explorer and son of Erik the Red from western Norway; he is said to have "discovered" America in 1001.) Few of the vivid Norse sagas and legends were written down, but plenty of heritage is preserved at the Vikingskiphuset, the Viking ship museum, which houses three remarkably intact 9th-century Viking burial ships, such as the Gokstad (*above*), which contained the bodies of Viking chieftains and one queen entombed with weapons, horses, jewelry, tools, and artifacts, the largest Viking find ever recorded.

Must Visit // The nearby Kon-Tiki Museum, to see Thor Heyerdahl's balsa-log raft that sailed from Peru to Polynesia

NORWAY'S FJORDS
Norway

// Exploring Norway's Dramatic Coastline

Norway's wild, breathtaking beauty is rooted in its fjords. Sognefjord is the longest and deepest, home to fertile parkland, glassy lakes, thundering waterfalls, and blindingly white glaciers, all bathed in clear northern light. It is also one of the most popular for time-strapped visitors, owing to its accessibility from Bergen. South of Bergen is Hardangerfjord, generally considered Norway's most beautiful fjord, particularly in late spring when the apple and cherry trees are in bloom. At the foot of its steep banks is the petite town of Utne and the excellent open-air Hardanger Folk Museum. From the harbor town of Balestrand, take a breezy sail up the gorgeous little Fjærlandfjord to see the Jostedalsbreen (Jostedal Glacier). Lysefjord, in the Stavanger region, is best known for Preikestolen (the Pulpit rock, *right*), where hikers make a 2-hour trek to the top of the plateau and are rewarded with these spectacular views.

Must Do // Visit the harbor town of Balestrand, the best base for exploring Sognefjord and for hiking and biking into the beautiful countryside // Stroll past Balestrand's romantic 18th-century villas and the wooden St. Olaf's church built in 1897 // Visit the pretty town of Fjærland near the southern end of the glacier or the scenic town of Flåm on Aurlandsfjord, one of the many arms of Sognefjord.

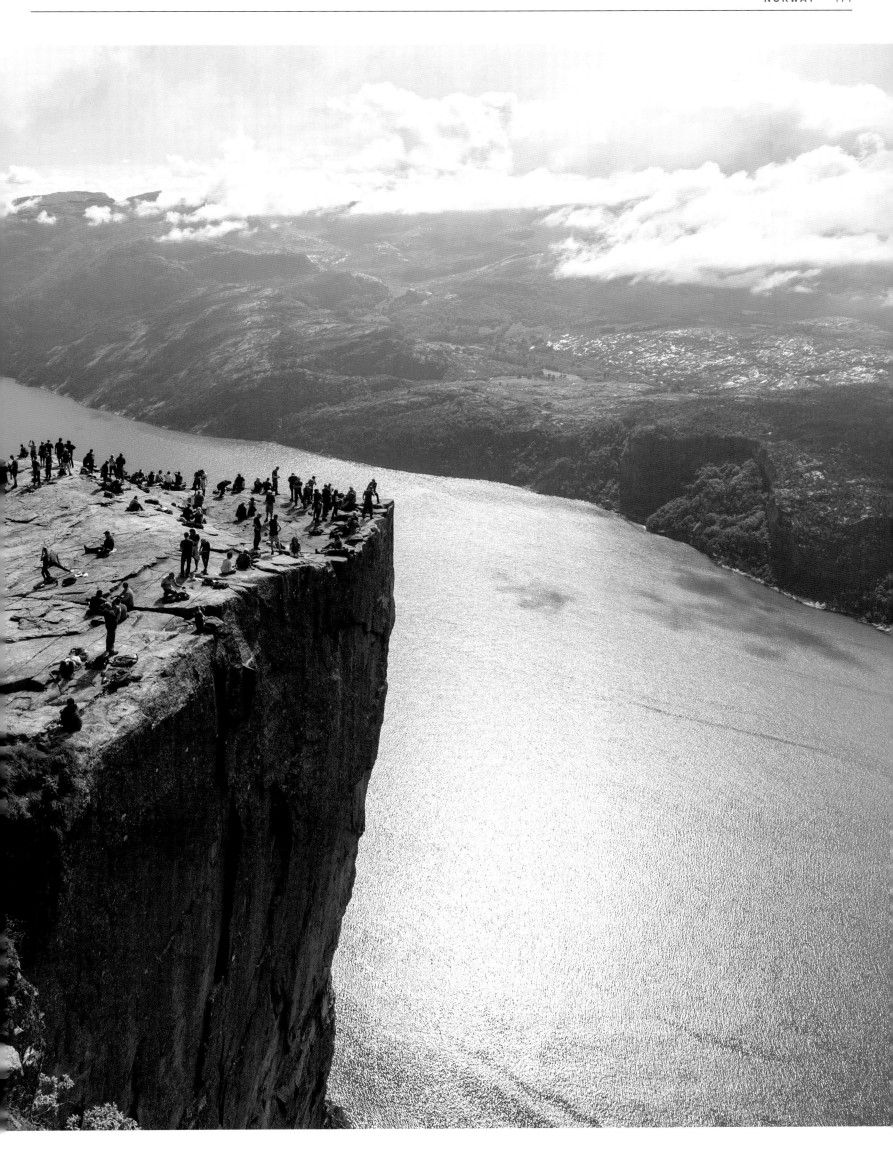

GÖTA CANAL
Götaland, Sweden

// Sweden's Engineering Masterpiece

The Göta Canal is the backbone of an extensive waterway connecting Sweden's two largest cities, Göteborg and Stockholm. Traveling by boat is the best way to appreciate this 118-mile-long canal with 58 locks hand-dug between 1810 and 1832 by close to 60,000 soldiers. A variety of companies offer trips that range from 1 to 6 days.

Must Do // Board one of the century-old ships that traverse Lake Vänern, Sweden's largest // Walk or bike along the leafy canal-side towpaths.

GOTLAND
Sweden

// Viking and Medieval History on a Sea-Swept Island

Once a strategic hub of Hanseatic trade, the Baltic's largest island is the ancient home of the Goths and still exudes an alluring medieval atmosphere. Raukar, dramatic limestone pillars eroded by wind and waves, dot the island's eastern shore of long empty beaches, tiny fishing villages, and steep cliffs.

Must Do // Explore Visby's defensive walls (right); with 44 lookout towers, they are some of the best preserved in Europe // Bike to the northern end of Tofta Strand on the west coast, one of the island's most inviting beaches // Attend Visby's Medieval Week in August.

THE ICE HOTEL
Jukkasjärvi, Norrland, Sweden

// Ephemeral Igloo in the Arctic Circle

This hotel in Lapland, crafted entirely from snow and ice, features ice chandeliers lit by fiber optics, a vodka bar with drinking glasses made from ice, and ice-block beds topped with Arctic-survival sleeping bags (*left*) although there are "warm room" accommodations nearby. Built every November since 1990, the hotel disappears each spring when it melts into the River Torne, though a new permanent ice hotel was built alongside it in 2016.

Must Do // Choose among snowmobile or reindeer safaris, dogsledding, ice fishing, and cross-country skiing // Have lunch with the Sami, the reindeer-herding people who have lived here since ancient times // Visit Jokkmokk, the cultural heart of the Sami, in early February for the Great Winter market // Tour Museum Ájtte in Jokkmokk, to learn about the native people.

STOCKHOLM ARCHIPELAGO
Sweden

// A Capital City's Greatest Natural Asset

The Stockholm Archipelago is a latticework of some 24,000 islands and smooth, glacier-polished outcroppings that dot a 150-mile stretch off of Sweden's eastern coast and is one of the best places to celebrate Sweden's brief but glorious summer. Kayak, bike, or walk the unpaved island roads through magnificent scenery. Or explore the islands by ferry, vintage steamer, or three-masted schooner.

Must Do // Take a 30-minute ferryboat ride from Stockholm to Fjäderholmarna for a seafood lunch // Visit Vaxholm, gateway to the islands, popular with artists and writers // Explore Sandhamn, the site of the prestigious annual Royal Regatta.

GAMLA STAN
Stockholm, Sweden

// The Historic Heart
of Stockholm

Filled with centuries-old squares, medieval buildings, and cobblestone lanes, Gamla Stan (Old Town) charts Stockholm's history through an impressive variety of architecture, culminating with the 16th-century Kungliga Slottet, or Royal Palace, one of the largest in Europe.

Must Visit // Gamla Stan's main square, Stortorget // The Royal Palace's museum and its exhibit of the castle's original walls // The Nobel Museum in the old Stock Exchange building, for an overview of the Nobel Prizes presented each year in Stockholm

VASA MUSEUM
Stockholm, Sweden

// Sweden's Most
Powerful Battleship

Completed after 2 years of work, the 226-foot pride of the Swedish war fleet sank on August 10, 1628, before she left the harbor on her maiden voyage. Salvaged 333 years after her demise and painstakingly restored, the *Vasa* [*right*] can now be viewed at the only maritime museum of its kind in the world.

Must Visit // The nearby Skansen, an outdoor museum that re-creates a 19th-century town with more than 150 dwellings brought here from all over the country

DROTTNINGHOLM PALACE AND COURT THEATER
Lake Mälaren, Svealand, Sweden

// The Versailles of the North

The official home of Sweden's King Carl XVI and Queen Silvia, the Rococo Drottningholm [*right*] is set on its own island in Lake Mälaren and is home to the world's most perfectly preserved 18th-century theater, where performances are given using original sets, stage machinery, and period instruments.

Must Do // Stroll through the palace's gardens to the Chinese Pavilion, built in 1753 // Attend one of the 18th-century operas and ballets performed during the summer season in the historic theater.

GRIPSHOLM CASTLE
Mariefred, Svealand, Sweden

// A Royal Castle in
a Lakeside Village

The endearing lakeside village of Mariefred
(Marie's Place) on the shores of Lake
Malären, with its impressive redbrick
Gripsholm Castle, is the perfect jaunt
from Stockholm—arrive on a century-old,
coal-fired steamboat, the SS *Mariefred*,
then return by vintage narrow-gauge steam
train.

Must Do // View the large collection of
portraits displayed at the castle (*left*)
// Tour Gripsholm Theater, which dates
to 1781 and the reign of Gustav III, the
"actor-king."

MIDSUMMER EVE
IN DALARNA
Tällberg, Svealand, Sweden

// Celebration in the
Spiritual Home of the Swedes

On the Friday closest to the June 24
feast day of St. John, all Scandinavia
celebrates the Nordic festival of *Midsommar*
(Midsummer), but perhaps nowhere is it
heralded with as much enthusiasm as
in Sweden. This ancient Germanic ritual,
originally a fertility rite held at the exact time
the sun and earth were considered at the
peak of their reproductive powers, is found
throughout the rural province of Dalarna,
often referred to as Sweden's "folklore
district." These days, Swedes take to the
countryside, often dressing in colorful local
costumes (*right*).

Must Do // Visit the Dalarnas Museum in
Falun // Tour the cottage of Sweden's most
famous painter, Carl Larsson, outside of
Talun // Explore either Leksand or Tällberg,
the gateways to Lake Siljan.

Africa

Elephants in Serengeti
National Park, Tanzania
(see page 202)

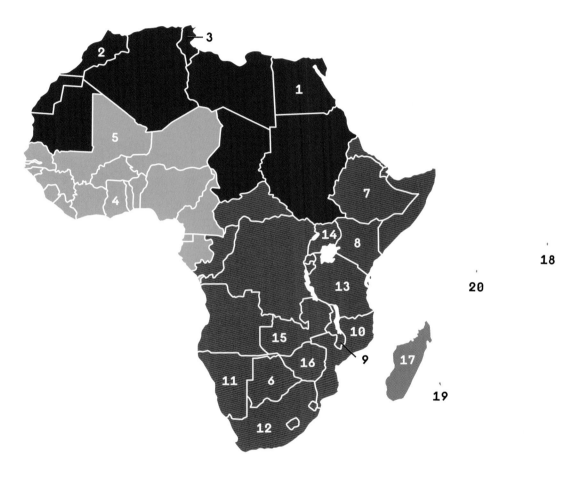

North Africa

1 Egypt
2 Morocco
3 Tunisia

West Africa

4 Ghana
5 Mali

East Africa and Southern Africa

6 Botswana
7 Ethiopia
8 Kenya
9 Malawi
10 Mozambique
11 Namibia
12 South Africa
13 Tanzania
14 Uganda
15 Zambia
16 Zimbabwe

Islands of the Indian Ocean

17 Madagascar
18 The Maldive Islands
19 Mauritius
20 Seychelles

North Africa

ALEXANDRIA
Egypt

// A City By—and Beneath—the Sea

Founded by Alexander the Great on the Mediterranean coast, captured by Julius Caesar, and home to Cleopatra and Antony, Alexandria was a leading city of the classical world, known for its Pharos lighthouse and library. Much of the ancient city lies beneath the water just offshore, and Cleopatra's palace and a treasure trove of thousands of ancient objects have been discovered by archaeologist-divers.

Must Visit // The Bibliotheca Alexandrina [*right*], home to museums, galleries, a planetarium, and a manuscript restoration center // The Roman catacombs not far from Pompey's Pillar, built in AD 297 // The hulking Quaitbey Fort, erected in 1480 on the site of the ancient Pharos lighthouse

ISLAMIC CAIRO
Cairo, Egypt

// A Maze of Bazaars and Medieval Monuments

There are a daunting number of sights to see here, but start at Cairo's wonderful and chaotic centerpiece: the Khan el-Khalili, one of the world's most atmospheric bazaars. After haggling over carpets, gold, and fabrics, be sure to visit the many examples of the architectural grandeur of what is still the intellectual and cultural center of the Arab world, starting with the 12th-century Citadel of Saladin [*left*] for a matchless panorama of Cairo's minaret-punctuated skyline.

Must Visit // The 9th-century Mosque of Ibn Tūlūn, one of the grandest and oldest places of worship in Egypt // The Gayer-Anderson Museum's vast collection of pharaonic artifacts and Islamic art // The Museum of Islamic Art, home to art from the 7th to 19th centuries // The 13th-century richly ornamented Qalawun complex, built by three important Mamluk sultans, containing a madrassa, a hospital, and elaborate mausoleums

MUSEUM OF EGYPTIAN ANTIQUITIES
Cairo, Egypt

// Storehouse of a
Great Civilization

A visit to the Museum of Egyptian Antiquities is a must, with its collection of treasures so vast it would take months to see it all. Highlights are the mummified remains of 27 pharaohs and their queens, and the limestone statues of Rahotep and his wife, Nofret (*right*), along with the 1,700 objects from the tomb of King Tut. The 120-acre Grand Egyptian Museum in Giza, a state-of-the-art complex set to house 50,000 artifacts, including the mask of Tutankhamun, is scheduled to partially open in 2020. The Ministry of Culture originally broke ground in 2002.

Must Do // Stroll to nearby Tahrir Square, where thousands of Egyptians gathered peacefully during the 2011 revolution.

THE PYRAMIDS OF EGYPT
Giza, Saqqara, and Dahshur, Egypt

// Eternal Wonders of
the Ancient World

The only wonder of the ancient world to have survived nearly intact, the Pyramids at Giza (*left*) embody antiquity and mystery. The Great Pyramid of Cheops, the largest in the world, and the iconic Sphinx are most magical at dawn and dusk after the last tourists have returned to nearby Cairo. But just 20 miles south by car lies the less visited Step Pyramid in the complex of Saqqara, the cemetery of Memphis. Farther south, ticket lines won't be long to visit Dahshur's Bent Pyramid.

Must Do // Attend the melodramatic but surprisingly entertaining nightly sound-and-light show at Giza // Descend the thrilling—though tight—staircase into the Red Pyramid in Dahshur, which predates those of Giza.

MOUNT SINAI AND THE RED SEA
Sinai, Egypt

// Heavenly Pursuits

Moses spent 40 days and nights on the rocky slopes of Mount Sinai before he was given the Ten Commandments. For today's pilgrims, the challenging climb up the 3,750 steps of the "Path of Moses" to the summit of Mount Sinai (*right*) takes a few hot morning hours—or part of a dark night if you're seeking a magnificent sunrise (a stretch can be done by camel). Pair your visit with scuba dives off the southern tip of the Sinai Peninsula. The waters of the Red Sea are famed for their diverse marine life.

Must Do // At the mountain's base, visit Saint Catherine's monastery to view some of the world's finest illuminated manuscripts and oldest Christian icons // Book a day boat trip from Sharm al-Sheikh or Dahab to the Straits of Tiran and Ras Mohammed, Egypt's first national marine park.

ABU SIMBEL AND ASWAN

Lake Nasser, Upper Egypt, Egypt

// Irreplaceable Monuments Where Egypt Ends

In the 13th century BC, Ramses II ordered the colossal Sun Temple of Abu Simbel (*below*) to be carved into the side of a cliff—with four 65-foot-high statues of himself, seated, to grace the exterior. The immense monument took 36 years to complete. More than 3,000 years later, UNESCO saved it from being submerged forever. From 1964 to 1968, this $40 million rescue plan worked to move Abu Simbel to higher ground before the Aswan High Dam created the 300-mile long Lake Nasser. Aswan, on the banks of the Nile, 175 miles north of Abu Simbel, should be your base. It is Egypt's southernmost town, with a lively souk that brims with spices, perfumes, and produce.

Must Do // Explore Aswan's Nubia Museum's artifacts rescued before the creation of Lake Nasser // In Aswan, spend a few hours on the Nile on a traditional wooden sailboat known as a *felucca*. Or board the MS *Eugénie* for tours on Lake Nasser to gaze at the temple-dotted shores and beyond to the empty desert, with its wind-hewn natural pyramids and bluffs.

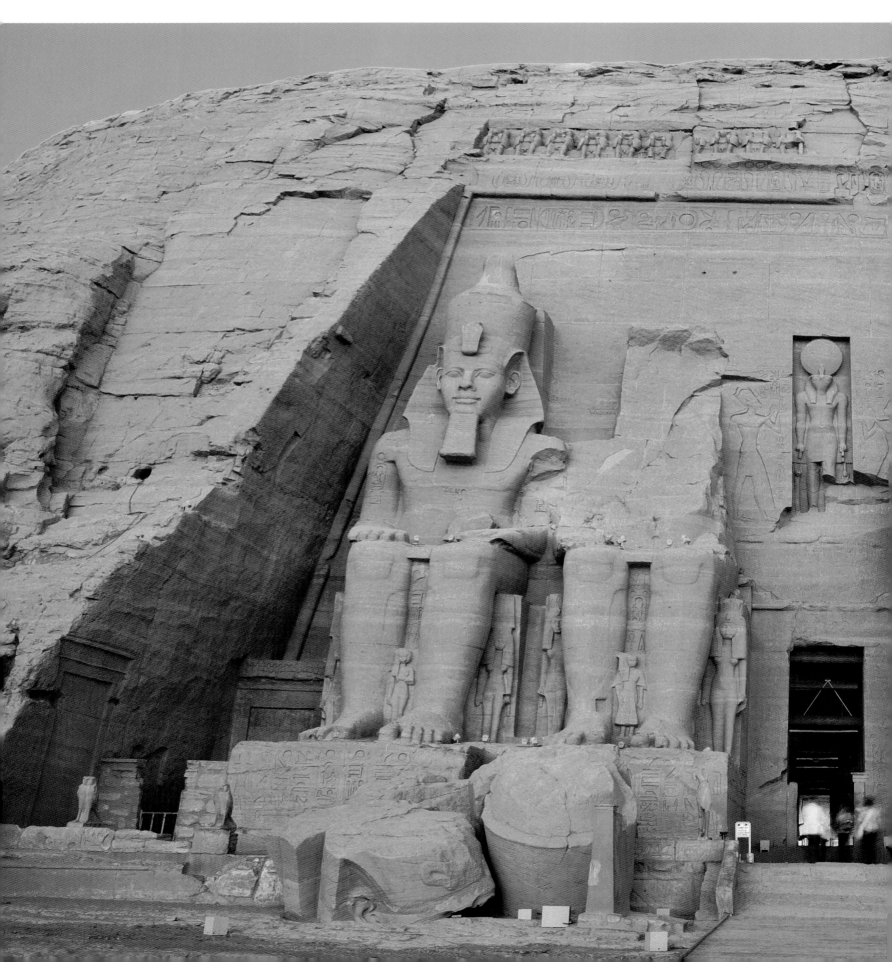

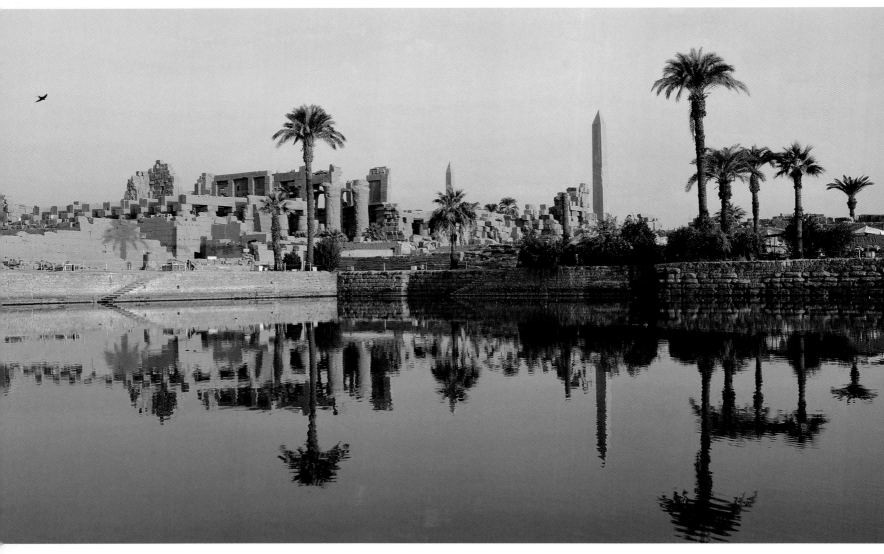

LUXOR AND A NILE CRUISE
Upper Egypt, Egypt

// The Watery Lifeline to the New Kingdom

To sail along the Nile's shores is to understand why ancient Egyptians worshipped it. Most riverboats ply the waters between Aswan and Luxor past ancient ruins that include the Temple of Horus at Edfu, Egypt's best preserved site, and the Temple of Sobek and Horus at Kom Ombo, with its mummified crocodiles.

Must Visit // The Temple of Karnak at Luxor (*above*), the site of ancient Thebes, the capital of Egypt's New Kingdom—the most astounding religious shrine of antiquity // Luxor's Hypostyle Hall, the site of 134 hieroglyphic-clad columns // The nearby Valley of the Kings, ancient Egypt's most famous necropolis, and King Tut's Tomb, reopened in 2019 // The Valley of Queens, home of the intricately painted tomb of Ramses II's consort Nefertari

SIWA OASIS
Western Desert, Egypt

// Better Than a Mirage

Covering two-thirds of Egypt and the antithesis of the green Nile Valley, the Western Desert (an extension of the Sahara) is punctuated by a handful of exotic spring-fed oases. Picturesque Siwa, 30 miles from the Libyan border on a centuries-old caravan route, is the most remote, and produces dates and olives long known as some of the finest in the world. Despite a growing trickle of adventure tourists and the recent arrival of television, Siwa's culture and customs continue much as they did when Alexander the Great visited in 331 BC to consult the legendary Oracle of Amun.

Must Do // Take a day trip on horseback to more springs on the outskirts of town // Explore the Great Sand Sea by jeep or surf the dunes on a modified snowboard // Stay at the magical Adrére Amellal, a completely unplugged luxury lodge.

ESSAOUIRA
Morocco

// A Windsurfer's Paradise

The walled port of Essaouira is perched above some of Morocco's finest beaches, with dunes that unfurl for miles to the south. This city's relaxed atmosphere—along with its exotic medina—first attracted backpackers and hippies in the 1960s. Today's visitors come for some of Africa's best wind- and kite surfing and to kick back and linger awhile and shop for local crafts.

Must Do // Attend the Gnaoua World Music Festival in late June // Explore the city's fortifications [*left*], designed in the 18th century by an imprisoned French architect.

FÈS EL BALI
Fès, Morocco

// Symbolic and Spiritual Heart of Morocco

The intellectual, cultural, and religious center of Morocco for 1,200 years, Fès [or Fez] is also known for Fès el Bali, its sprawling walled medina crammed with every conceivable sort of workshop, market [*left*], rug merchant, tannery, mosque, and restaurant. It will seem overwhelming, so consider hiring an official Fassi guide.

Must Do // Visit the Madrasa Bou Inania, a masterpiece of extravagance built in the 1350s // Tour the Fondouk el-Nejjarin, a museum of woodworking // Attend the weeklong Fez Festival of World Sacred Music in June // Travel 40 miles west of the city to explore Volubilis, the best-preserved Roman ruins in North Africa.

DINING IN MARRAKECH
Marrakech, Morocco

// Romancing the Palate

The food of Morocco owes much of its distinct character to the trade caravans that brought in rare spices. The Berbers also shared their food traditions while French, Portuguese, Arab, and Spanish influences made their way here too. Attending one of the city's cooking schools is a great way to absorb even more of this hybrid food culture.

Must Visit // The evening food market at the Djemaa el-Fna square [*above*]

PLACE DJEMAA EL-FNA AND THE MEDINA
Marrakech, Morocco

// Everyday Carnival at the City's Center

Djemaa el-Fna (*above*), the teeming central plaza at the heart of Marrakech's medina, is an impromptu medieval circus enacted around the clock by snake charmers, performing monkeys, souvenir sellers, and more than 100 food vendors. When Djemaa el-Fna echoes with the call to evening prayer and lights flood the minaret of the Koutoubia Mosque, the impact is magical.

Must Do // Shop for silk babouche slippers, spices, leather goods, silver jewelry, carpets, and objets d'art in the souk north of the plaza (*left*) // Attend the city's Popular Arts Festival in mid-July.

THE GREAT SAHARA
Morocco

// Desert Beauty and Mystique

The Sahara desert is relatively easy to reach in Morocco, and you'll find mountains of sand, vibrant green oases, miles of barren scrub and stone, turbaned nomads astride camels, ancient mud-walled casbahs, and, at night, an ocean of stars. The trip from Marrakech crosses the Atlas Mountains to Ouarzazate, where two routes lead toward the central Sahara. South of Ouarzazate, the road follows the Drâa Valley to Zagora, where a sign at the edge of town reads "Timbuktu: 52 Days by Camel." Leave that trail to the nomads and continue south to M'hamid. Or travel east from Ouarzazate on the Road of the Thousand Kasbahs toward the oasis of Skoura.

Must Do // Explore the Erg Chigaga dunes by jeep or camel from M'hamid // Travel from Skoura to Merzouga and the dunes of Erg Chebbi // Camp among the dunes at night.

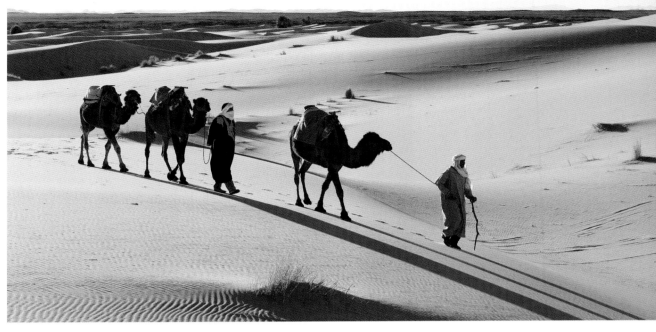

TANGIER'S MEDINA
Tangier, Morocco

// An Ancient Port and Artist's Playground

Largely unconstrained by the mores of Christian Europe or Muslim Africa, Tangier became known for its decadent ways and attracted Henri Matisse, Oscar Wilde, André Gide, Paul Bowles, Allen Ginsberg, and William Burroughs. Tangier has changed since then, though much of the city's medina maintains its slightly seedy and intriguing authenticity.

Must Do // Follow Rue es Siaghin from the Grand Socco, the largest market square, to the Petit Socco, the "small market" ringed with busy cafés // Climb Rue des Chrétiens toward the casbah, the highest point in the medina, a former Roman fortification that is now the Dar El Makhzen museum // Stroll along the Avenue Mohammed Tazi for cliff-top views // Travel an hour south of Tangier to Chefchaouen, a mountain town founded by Moors and Jews in the 15th century and famous for its blue-washed mud walls (left).

TAROUDANNT
Morocco

// Morocco's Little-Changed, Little-Known Walled City

A 4-hour drive from Marrakech along the scenic Tizi n' Test road, picturesque Taroudannt is an authentic Berber market town enclosed within castellated mud walls (*right*) and centers on two vibrant souks. Often called "little Marrakech" because of its ramparts and bustling medina, visitors can experience the daily life of local Berbers.

Must Do // Take a horse-drawn calèche for a 3-mile sightseeing circuit of the medina walls // Browse the Souk Assarag, also called the Arab Souk, which features leather goods, rugs, and silver jewelry of varying quality // Shop for produce and spices at the Marché Berbère // Join wildlife, craft, or trekking tours, or take cooking or language classes.

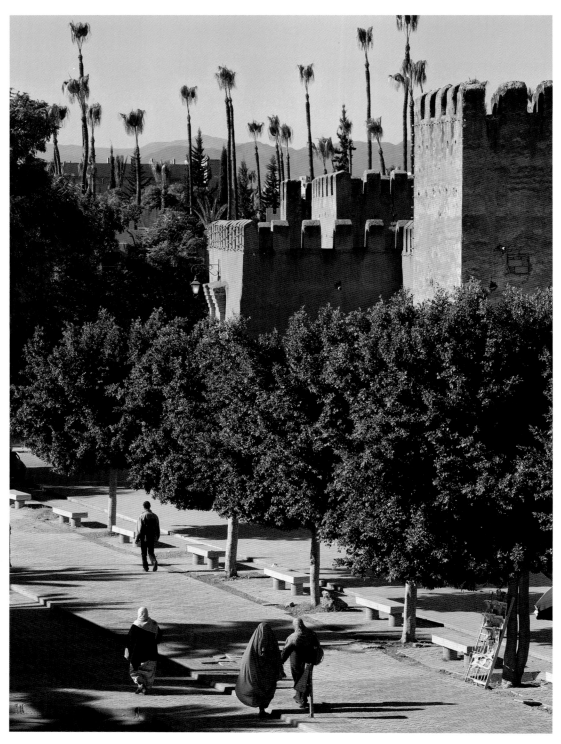

TREKKING AND BEDOUIN TOWNS IN THE ATLAS MOUNTAINS
Morocco

// Cultures and Vistas Untouched by Time

The Moroccans believe that the High Atlas Mountains are as close as you can get to heaven without leaving earth, and they lure an increasing number of hikers who wish to experience the culture and hospitality of Berber villagers.

Must Do // Take a guided 2-day adventure up Mount Toubkal (*left*), the highest peak in North Africa, for stunning views // Visit Imilchil in September for the 3-day Betrothal Festival, though accommodations nearby are sparse.

SIDI BOU SAID AND CARTHAGE
Tunisia

// Cliff-Top Charm and an Ancient Empire

This well-preserved vision in Wedgwood blue and white, Sidi Bou Said (*left*) began as a series of watchtowers built nearly 1,000 years ago and soon became a community of Sufi Muslims. An utterly charming collection of stone houses and cobbled lanes jumbled together on a hill overlooking the Gulf of Tunis, it has long enchanted tourists and artists. Any trip from nearby Tunis should include a stop in ancient Carthage to walk in Hannibal's footsteps.

Must Visit // The National Museum of Carthage and the nearby late-19th-century cathedral dedicated to France's St. Louis

BARDO MUSEUM
Tunis, Tunisia

// Africa's Priceless Mosaics

Tunisia's national museum houses the continent's largest assemblage of ancient mosaics, arguably the finest in the world. Tunisia was the heart of Roman Africa, and the Bardo's offerings date primarily from the 2nd through the 4th centuries AD.

Must Do // View the world's earliest true mosaics, dating to the 5th or 4th centuries BC, discovered in nearby Carthage.

EL DJEM AND FESTIVALS OF THE SAHARA
Tunis, Tunisia

// The Singing Sands

For 3 weeks or more in July and August, the International Festival of Symphonic Music sponsors performances by world-renowned artists in El Djem (*left*), one of the world's best-preserved Roman amphitheaters. The Sahara Festival, held in a Douz gateway to the desert, attracts thousands of visitors, who spend 4 days celebrating desert traditions with music, dance, and camel and horse races.

Must Do // Travel an hour outside El Djem to the seaside resort of Sousse to search the medina for finds // Attend cultural lectures, folkloric theater shows, and poetry readings during the popular Sahara Festival in Douz // Stroll through the atmospheric medina in Tozeur.

West Africa

AKWASIDAE FESTIVAL
Kumasi, Ghana

// Celebrations of
Life and Death

The Ashanti pay homage to their ancestors and present their king with greetings, songs, dances, and gifts during this 3-day festival [*left*] held every 6 weeks in their ancient tribal capital of Kumasi. The first 2 days of the celebration are private, but visitors are welcome to join in on the third day. Ashanti funerals, bon-voyage parties filled with drumming, drinking, and dancing, can be almost as spectacular.

Must Do // Visit Kumasi's modest Manhyia Palace Museum to view royal regalia and gold ornaments.

ELMINA CASTLE
Elmina, Ghana

// The Door of No Return

The first European slave-trading post in all of sub-Saharan Africa, Elmina Castle is perched on the water's edge about 3 hours west of Accra. By the 18th century, an estimated 30,000 slaves a year passed through a small metal-gated exit in the fortress before being loaded on ships for the brutal Middle Passage. The building was restored in 1957, and a plaque now implores, "May humanity never again perpetrate such injustice against humanity. We the living vow to uphold this." Despite its grim past, the town of Elmina now has its lighter distractions.

Must Do // Visit Elmina's harbor-front market // Climb St. Jago hill for views of the "old town" // Stop at one of the shops on the road from Accra that craft brightly colored "fantasy coffins," which come in odd shapes and themes like an airplane or a bottle of Coca-Cola.

THE GREAT MOSQUE OF DJENNÉ AND DOGON COUNTRY
Djenné, Mali

// Magnificent Mud

The market city of Djenné, 60 miles southwest of Mopti, was once an important center of Islamic learning in the 15th century, and today is one of the world's largest and most beautiful mud-brick towns. Head south to Dogon country to see beautifully molded mosques, churches, mud granaries and homes, and intricately carved wooden masks.

Must Do // Visit Djenné's Great Mosque, the largest and most elaborate mud structure in the world, and browse the Monday market in front of the mosque (*left*) // Attend the most important Dogon festival of the year, the Fête des Masques, held every spring.

TIMBUKTU
Mali

// Doorway to the End of the World

Settled by Tuaregs sometime in the 11th or 12th century, Timbuktu was known for its material and intellectual wealth and its dissemination of Islam throughout Africa. In the 15th century as many as 25,000 scholars may have studied here. In 2009, Timbuktu opened a library dedicated to preserving this ancient town's treasure trove of books and manuscripts even though this once glorious city, now one of the world's poorest, is little visited today due to safety concerns.

Must Visit // Djingareyber, Sankoré (*above*), and Sidi Yahia, the city's great mosques, evoke the country's former glory.

East Africa and Southern Africa

CHOBE NATIONAL PARK
Botswana

// The Four Corners of Southern Africa

In a corner of Africa where four countries come together—Botswana, Zambia, Namibia, and Zimbabwe—this 4,200-square-mile park is best known for its incredible birds and huge elephant population (*above*). Sunset boat rides along the Chobe River float past yawning hippos, giant storks, and flocks of waterfowl, and the floodplains are full of grazing buffalo and big game.

Must Do // Take a boat tour of the park from Kasane on the *Zambezi Queen*, for a few hours or a few days.

KALAHARI DESERT
Botswana (and beyond)

// Land of the Bushmen

Promising vast skies, absolute silence, and a surprising diversity of species, the semiarid Kalahari is not your classic desert. In a remote corner of Botswana, the Makgadikgadi salt pans are home to the San Bushmen—some still following a hunter-gatherer lifestyle. Anthropologists believe they represent one of the most ancient races on earth.

Must Do // Take an ATV trek across the pans or sleep under the star-studded sky // Hunt with the San Bushmen or accompany one on a nature walk to learn about wildlife here, including the ever-present meerkats (*right*), and this unique ecosystem // Visit during the winter rains to see flamingos, wildebeests, zebras, lions, cheetahs, and hyenas.

SELINDA RESERVE
Botswana

// Big-Game Hunting—
by Lions Only

You'll see more elephants than tourists on this 320,000-acre private wildlife sanctuary in northern Botswana dedicated to conservation and ecotourism. Selinda's lions (*right*) are legendary, but visitors can also glimpse cheetahs on the open plains and leopards in the dense woodlands or track hippos and giraffes.

Must Do // Observe packs of wild dogs resting or hunting, or wait in a secret hide for the chance to see rare slaty egrets and wattled cranes or a herd of buffalo.

OKAVANGO DELTA
Botswana

// An Incomparable Wildlife
Oasis

The inland delta where the Okavango River meets the Kalahari Desert has created a unique "water in the desert" ecosystem that is a magnet for wildlife. The birdlife is second to none, and there are legions of elephants, zebras, buffalo, giraffes, and hippos. As a local brochure puts it, "If you see 10 percent of what sees you, it's an exceptional day."

Must Do // Explore the delta in a *mokoro* dugout canoe (*above*) or on foot or by jeep to experience otherworldly colors and sounds // Visit the Moremi Wildlife Reserve, which is surrounded by several excellent private safari concessions.

GONDER
Amhara Region, Ethiopia

// Palaces, Castles, and Churches in an Ancient Capital

Strategically positioned in the foothills of the Simien Mountains at the meeting point of three caravan routes, Gonder became the first capital of the Ethiopian empire in the 17th century. The Royal Enclosure is still the heart of Gonder and contains the country's most important imperial buildings.

Must Do // Tour Gonder's five castles and ancient stone walls // Visit Debre Birhan Selassie (*right*), a church famous for its walls covered with biblical scenes and its 17th-century ceiling fresco of 80 cherubic faces.

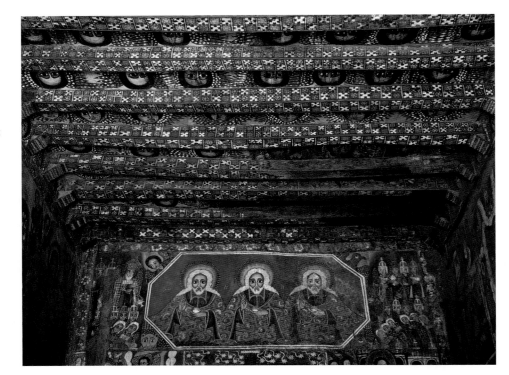

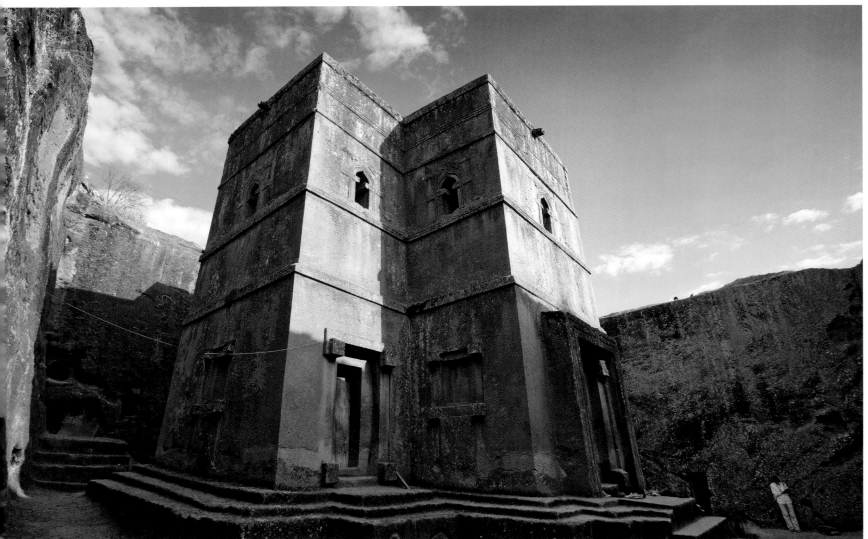

LALIBELA
Amhara Region, Ethiopia

// The Mystery of the Subterranean, Rock-Hewn Churches

The eleven 12th-century subterranean rock-hewn churches of Lalibela—still in use today—are Ethiopia's most popular attraction. They are all unique in size, shape, and execution, but all of them are carved out of solid bedrock. They are also remarkable for their colorful paintings, frescoes, carvings, cross-shaped windows, and handwoven rugs. But the reason they were built and the precise construction method remain a mystery.

Must Visit // The oft-photographed St. George's church (*above*), with a flat roof carved with concentric Greek crosses // The undeveloped town of Lalibela's lively market and unique round homes

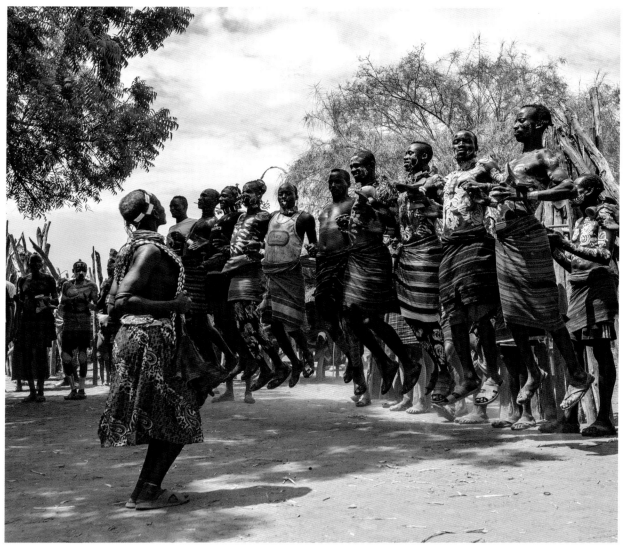

OMO RIVER VALLEY
Ethiopia

// Disappearing Tribes

The few thousand people who live in these hills have preserved their culture to a remarkable degree even as their numbers dwindle. Those who come to glimpse their distinct way of life before it disappears stay in tented camps or basic lodges, hiring guides to take them on trips to the communities nearby to experience ancient traditions now lost to the rest of humanity.

Must Visit // The remote Mursi (*above*) and Suri tribes, whose women wear huge lip plates and whose men engage in ritualistic stick duels to determine who can marry // The nearby Hamar tribe, where men jump across the backs of cattle to prove their worth // The Nyangatom, who harpoon crocodiles from dugout canoes where the Omo River ends at Lake Turkana // The Karo tribe (*left*), who paint their faces and bodies with charcoal, chalk, and other minerals.

SIMIEN MOUNTAINS NATIONAL PARK
Ethiopia

// A Trek over the Roof of Africa

Known as the "Roof of Africa," the Simien Mountains offer some of the continent's most dramatic scenery: great volcanic plugs eroded into fantastic crags, pinnacles, and flattopped peaks. Established to protect this area and its wildlife, Simien Mountains National Park has just one dirt road and sees relatively few international visitors, so exploring by foot offers a rare experience.

Must Do // Join an organized trek that employs a guide, an armed scout, and mules to carry supplies // Watch for the walia ibex and troops of gelada found only here, the last surviving grazing monkeys in the world // Make the 9-hour climb of Ras Dashen, Africa's fourth-highest peak.

THE LEWA WILDLIFE CONSERVANCY
Isiolo, Central Highlands, Kenya

// In the Shadow of Mount Kenya

In the foothills of Mount Kenya, on the edge of the Laikipia Plateau, a few fortunate guests can revel in spellbinding views of ridge after mountain ridge and see wild game—everything from elephants, giraffes, zebras, and antelopes—on vast private properties. The Lewa Wildlife Conservancy offers game drives led by top-notch trackers and guides as well as horseback expeditions that allow for close wildlife encounters.

Must Do // Be on the lookout for both white and black rhinos // Go on a nighttime game drive to spot shy nocturnal creatures.

CLIMBING MOUNT KENYA
Kenya

// Seat of the Gods

Elephants, buffalo, and rare striped antelopes roam the lower slopes of Mount Kenya, the country's highest peak. Here, moss-covered cedars and giant lobelias vie for space amid ferns, wildflowers, and orchids. The massif's highest peaks are reserved for experienced climbers.

Must Visit // Point Lenana, open to serious trekkers who can complete a guided ascent in 4 or 5 nights

ISLAND OF LAMU
Kenya

// Locked in Time on the Swahili Coast

The relatively unspoiled island of Lamu 1 mile off the mainland in the Indian Ocean is home to Kenya's oldest living city and provides a fascinating glimpse of the country's ancient Swahili and Islamic cultures. Men wear full-length white robes, veiled women are clothed in black, and travel is by the traditional sailing vessels called dhows.

Must Do // Rent a dhow (be sure to negotiate) for a day trip arcund the Lamu archipelago // Visit in May or June for the Maulidi Festival, which celebrates the birth of Mohammed.

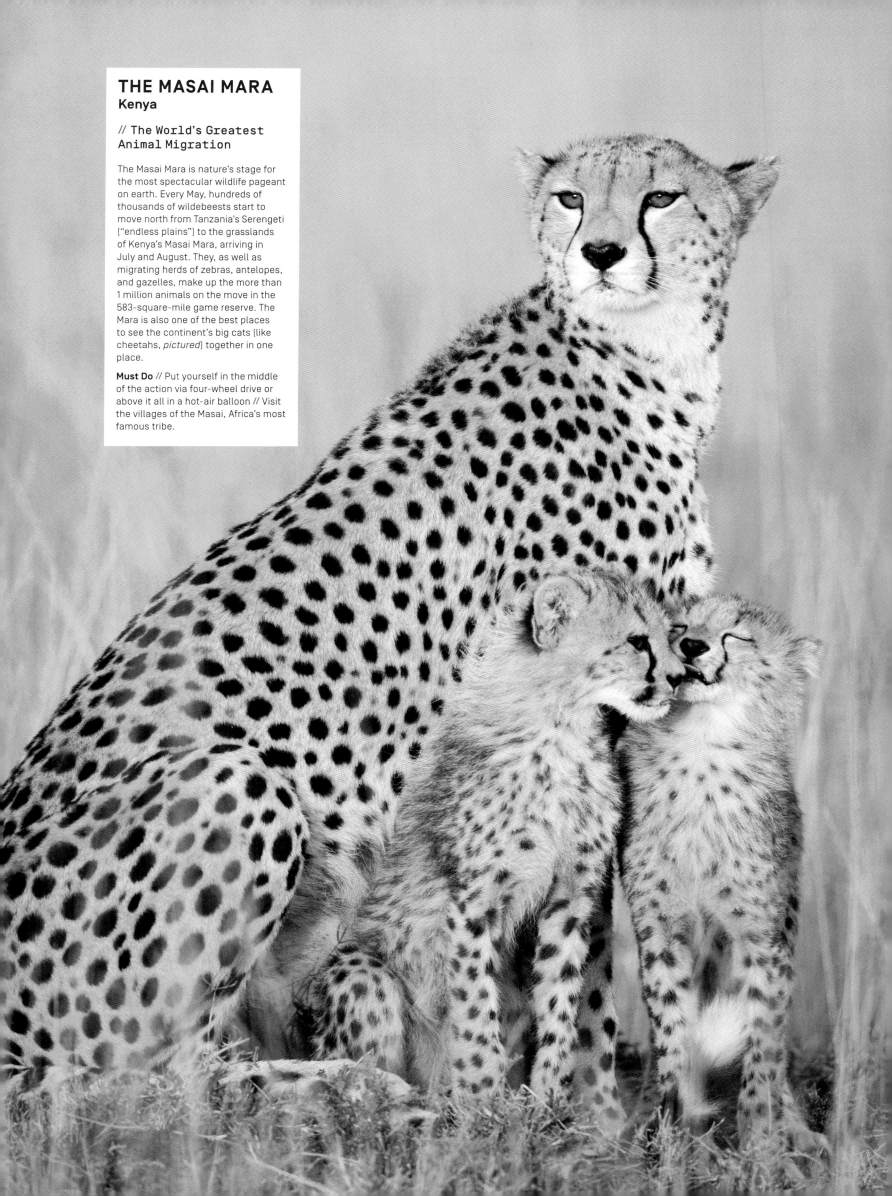

THE MASAI MARA
Kenya

// The World's Greatest Animal Migration

The Masai Mara is nature's stage for the most spectacular wildlife pageant on earth. Every May, hundreds of thousands of wildebeests start to move north from Tanzania's Serengeti ("endless plains") to the grasslands of Kenya's Masai Mara, arriving in July and August. They, as well as migrating herds of zebras, antelopes, and gazelles, make up the more than 1 million animals on the move in the 583-square-mile game reserve. The Mara is also one of the best places to see the continent's big cats (like cheetahs, *pictured*) together in one place.

Must Do // Put yourself in the middle of the action via four-wheel drive or above it all in a hot-air balloon // Visit the villages of the Masai, Africa's most famous tribe.

LAKE MALAWI
Malawi

// God's Aquarium

Lake Malawi is 365 miles long and 52 miles wide, making it the third-largest lake in Africa, and the second deepest (at 2,300 feet). The clear, warm water teems with more species of tropical fish than any other lake on earth, including more than 800 species of neon-colored cichlids.

Must Visit // Blissfully remote Likoma Island, on the eastern shore, home to some of the friendliest people you'll meet, who are ready to teach you to snorkel and sail // Likoma Island's 1903 Anglican church, which rivals Winchester Cathedral in size

ARCHIPELAGOS OF MOZAMBIQUE
Mozambique

// Azure Waters and White Beaches

Unspoiled, uncrowded specks of land with china-white beaches of sand so fine it squeaks and turquoise waters dotted with some of the world's most pristine unbleached reefs—this is the magic of Mozambique. After 2 decades of war and instability, Mozambique is still struggling to restore its image as a safe place to visit, but the Quirimbas (*left*) and Bazaruto archipelagos offer spectacular snorkeling and diving among schools of brightly colored fish, dolphins, rays, and dugongs. Both island chains are also home to samango monkeys, nesting turtles, and more than 100 species of tropical birds.

Must Visit // Benguerra Island, a national park on the second-largest island in the Bazaruto Archipelago

ETOSHA NATIONAL PARK
Namibia

// Southern Africa's Big Wild

Despite its harsh climate, Namibia has some of the world's most compelling scenery and is home to diverse wildlife that has adapted to the country's desertlike conditions. Etosha National Park, in the north, a semiarid savanna grassland ten times the size of Luxembourg, offers visitors the chance to see elephants, zebras, giraffes, blue wildebeests, oryx (*right*), and springboks, although the endangered black rhino, leopards, and cheetah also inhabit the park. And for a few days every year after the rains, when the Etosha Pan—the vast, shimmering salt pan in the heart of the park—fills with water, flamingos and pelicans descend by the tens of thousands.

Must Do // Join a night game drive for unbeatable stargazing and a look at nocturnal wildlife.

SKELETON COAST
Namibia

// Haunting Beauty and Unconfined Space

Namibia's Skeleton Coast is a desert paradise of wide-open, undeveloped spaces far from civilization. Its name refers to the shipwrecks and whale bones littering the shoreline. Light aircraft is the only way to visit much of this desolate land, which at times resembles a vast sea of shifting dunes, twisted veins of schist, and shelves of granite.

Must Do // Visit the Cape Cross Seal Reserve (*right*) to see thousands of Cape fur seals // Explore geologic formations, wildlife, and ancient Bushman paintings by jeep, boat, or on foot // Book your trip between June and October for the mildest weather in the desert.

SOSSUSVLEI DUNES
Namibia

// Waves of Sand and a Sea of Stars

The Namib Desert is known for its apricot-red Sossusvlei Dunes shaped and driven by sea winds. At 1,000 feet, some of the highest in the world, these dunes are most magnificent at sunrise and sunset.

Must Do // Take a quad bike tour of the desert for chances to see the long-nosed elephant shrew, the spotted leopard tortoise, the sturdy buffalo weaver, the fuzzy antlion, and the horned rhino beetle // Enjoy excellent stargazing at night when almost all the constellations are visible to the naked eye.

CAPE TOWN
South Africa

The cosmopolitan city of Cape Town, where Africa and Europe culturally collide at the tip of the continent, is one of the most beautifully sited coastal cities in the world. Overlooking it is the iconic Table Mountain and its rolling "tablecloth" cover of clouds; reach its summit by cable car to take in the breathtaking panorama of blue sea and sky and the modern expanse of South Africa's oldest and favorite city. Then drive to the rugged and windswept Cape Point for great hiking paths, deserted beaches, and a bottom-of-the-world feeling.

Everyone winds up at the busy Victoria and Alfred Waterfront, still a working harbor and the heart of the city, with its endless mix of shops, bars, eateries, and aquarium. The Bo-Kap neighborhood promises an authentic Cape Malay meal of curries and samosas. And don't forget to visit the penguins at Boulder Beach.

While Cape Town enthralls visitors with its eclectic mix of Dutch, English, Malay, and African cultures, the nearby wilderness and world-class vineyards are an added treat.

BELOW // On the slopes of Signal Hill above the city center is the historic suburb of **Bo-Kaap**. Once called the Malay Quarter, this neighborhood is filled with brightly painted houses, mosques, restaurants, and a cannon that sailors set their watches by.

ABOVE RIGHT // A cable car takes just 5 minutes to reach the flat summit that gave **Table Mountain** its name. You can also make the journey via a 2- to 3-hour hike, nicest between September and March when the flowers are in bloom.

RIGHT // Cape Town is best viewed from the 30-minute ferry on the way to **Robben Island**, where former president Nelson Mandela was incarcerated for 18 years. The small island is now a museum where some of the guides were once political prisoners and contemporaries of Mandela. Boats leave from the busy Victoria and Alfred Waterfront. As you leave, turn around for the best view of the harbor and Table Mountain.

RIGHT // More than 3,000 penguins rule the relatively warm waters of **Boulders Beach** and neighboring Foxy Beach. Wooden walkways allow visitors to watch the birds surfing, sunning themselves, and nesting.

THE DRAKENSBERG MOUNTAINS
KwaZulu-Natal and Mpumalanga, South Africa

// A Journey to Middle Earth

Believed to have inspired the setting for the *Lord of the Rings* cycle, written by South African–born J. R. R. Tolkien, the Drakensberg Mountains offer opportunities for hiking, horseback riding, bird-watching, golfing, fishing, and exploring countless sites where ancient rock art dates back 3,000 years.

Must Visit // The Blyde River Canyon (*below*), a 15-mile-long gorge, the third largest in the world by some measures // Fugitives' Drift, a national heritage site, to learn about the region's conflict-filled history on a guided tour // God's Window, the Blyde River Canyon's lookout point

GREATER KRUGER PARK AREA
Mpumalanga, South Africa

// Beauty and the Beasts

Some of South Africa's best game-viewing can be found west of Kruger National Park. Sharing an unfenced border with the enormous park, these collectively owned and managed private reserves and concessions are home to a remarkable variety of wildlife. The animals are not tame, but they are accustomed to the sight of vehicles and let them approach fairly close.

Must Do // A jeep tour with educated and entertaining rangers and trackers through various habitats and ecosystems to see elephants, leopards (*right*), cheetahs, African wild dogs, and rhinos as well as prides of lions, and scores of zebras, hippos, and giraffes

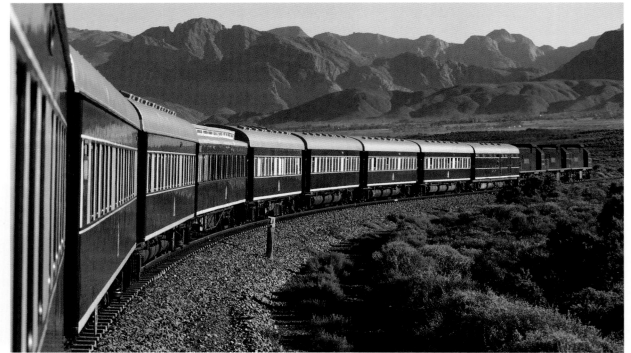

ROVOS RAIL AND THE BLUE TRAIN
South Africa

// The Golden Age of Train Travel, Past and Present

These two exemplary rail options in South Africa take travelers through a world not many see. The Rovos Rail (*left*) is a throwback to the golden days of steam travel, and the Blue Train is all contemporary luxury and efficiency. Both run from Cape Town northeast to Johannesburg and Pretoria, a journey of nearly 1,000 miles across the plains of the Great Karoo and the canyons of the Highveld.

Must Do // Take Rovos Rail's 25-hour Cape Town to Knysna round-trip through the Hottentots Holland Mountains // Book one of Rovos Rail's three annual 14-day odysseys from Cape Town to Dar es Salaam, Tanzania, with stops at Victoria Falls, Kruger Park, and Zambia's Chishimba Falls.

THE CAPE WINELANDS
Western Cape, South Africa

// An Oenophile's Odyssey

A wine safari combines two of South Africa's greatest treasures: the bounty of the Cape wine region with its excellent regional cuisine. Cabernet sauvignon, pinotage, sauvignon blanc, and chenin blanc are among the varietals produced by this area's wine estates, which are all within easy reach of Cape Town.

Must Visit // Banhoek Valley (*left*), near the town of Stellenbosch, for its picturesque settings and renowned wines // Franschhoek, the gourmet capital of South Africa, which boasts more than 40 wineries and award-winning restaurants // Groot Constantia wine estate, originally owned by the first governor of the 17th-century Dutch colony in Constantia // Buitenverwachting, a wine estate whose name is Old Dutch for "beyond expectations"

THE GARDEN ROUTE
Western Cape, South Africa

// Africa's Southernmost Coast

This 130-mile stretch begins east of Cape Town and runs along Africa's southernmost tip past lakes, mountains, forests, and the Indian Ocean. Beautiful year-round, the area is positively glorious between July and October, when many varieties of wildflowers burst into bloom and give meaning to the drive's name.

Must Visit // The town of Wilderness, and its stunning beach (*above*) // Knysna's cliff-fringed harbor and the Heads, rock sentinels at the mouth of the lagoon // Hermanus, not officially on the Garden Route, for great whale watching // Nearby Dyer Island, for shark diving from safety cages // Tsitsikamma National Park, home of the Otter Trail, a 5-day trek through jaw-dropping scenery

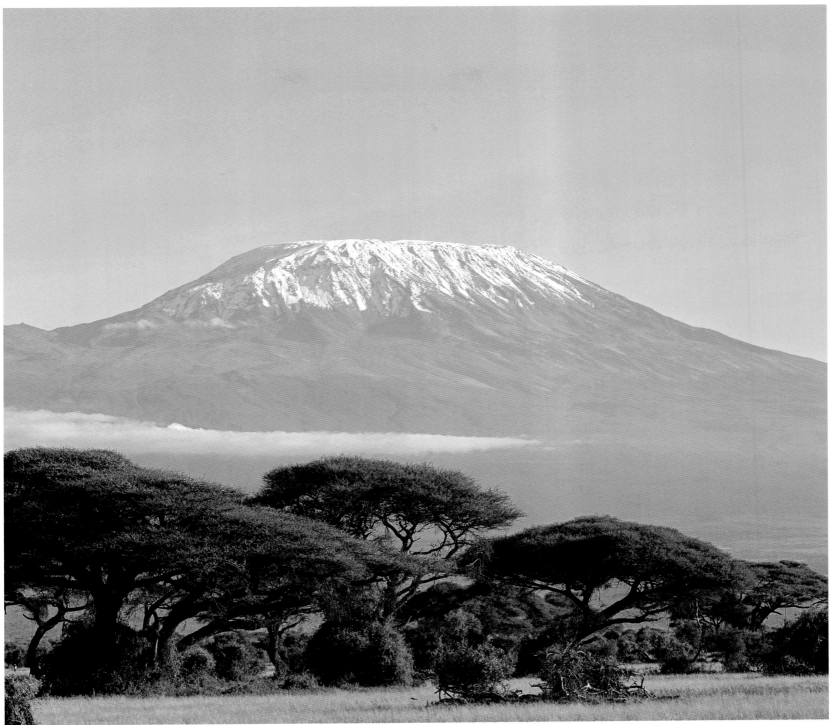

MOUNT KILIMANJARO
Kilimanjaro National Park, Tanzania

// The Continent's
Highest Peak

Few mountains rival Kilimanjaro; at 19,340 feet, it dwarfs all of Africa's other peaks. The 9-day, 25-mile round-trip trek to the dormant volcano's oddly flat top by way of the less-used Shira Plateau avoids the hordes of trekkers on the more popular 5-day Marangu Trail and allows more time to get acclimated to the altitude, an often underestimated obstacle.

Must Do // Go slowly and make the ascent with an organized group // At the summit, enjoy epic views over the plains of Tanzania and Kenya more than 3 miles below at sunrise.

MAHALE MOUNTAINS NATIONAL PARK
Tanzania

// Life Among the
Chimpanzees

Road-free Mahale Mountains National Park is home to the world's largest known population of wild chimpanzees (*right*). Knowledgeable guides lead visitors along forests paths to watch the Mimikire clan—habituated to human visitors—groom, wrestle, bicker, forage, eat, and nurture their young.

Must Do // Take other guided walks for the chance to spot colobus monkeys and leopards // Visit August to October when the chimpanzees are often closer to the bottom of the mountains.

NGORONGORO CRATER
Tanzania

// Africa's Garden of Eden

This unique volcanic crater is the world's largest unflooded, intact caldera and possibly the best place on earth to see the rare black rhino. Wildebeests, zebras, and gazelles also roam this 12-mile-wide, vegetation-dense natural amphitheater. Elephants, buffalo, hippos, and dark-maned lions add to this staggering concentration of wildlife.

Must Visit // Lake Magadi, in the middle of the crater, for excellent bird-watching

THE SERENGETI
Tanzania

// Magnificent Migration in the Cradle of Mankind

An important region for the study of human origins ever since Louis and Mary Leakey began excavating in Olduvai Gorge in the 1950s, the Serengeti is known for its large lion population and, perhaps more importantly, where wildebeests (*right*), zebras, and gazelles star in the grandest of all wildlife shows—the annual migration of millions of animals chasing the rains north to Kenya's Masai Mara.

Must Do // Book a mobile lodge to follow the migrating animals.

ZANZIBAR
Tanzania

// Island Outpost of Old
Araby in the Indian Ocean

The very name Zanzibar conjures up images of romantic spice islands—the name alone is almost reason enough to make the trip. Stone Town (*right*), the historic center of Zanzibar's capital city, is a maze of narrow streets and crumbling houses built by Arab traders who trafficked in gold, ivory, cloves, and slaves. Today, the two main islands of Zanzibar—Zanzibar Island and Pemba—have become popular beach getaways.

Must Do // Tour Stone Town's Anglican church, erected to celebrate the end of the slave trade in 1873 // Peruse the Swahili market's colorful fruits and spices // Snorkel off the satellite island of Chumbe // Beachcomb or dive on the tiny island of Mnemba.

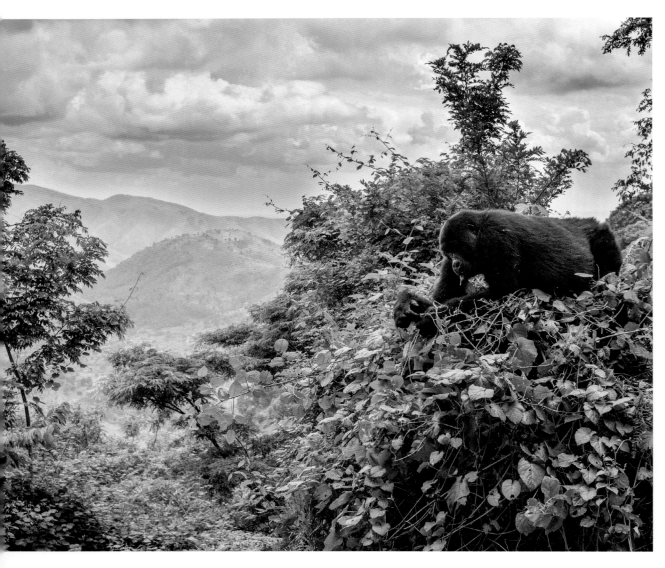

TRACKING THE MOUNTAIN GORILLA
Bwindi Impenetrable National Park, Uganda

// The Last Great Apes

Bwindi Impenetrable Forest is one of the last remaining habitats of the magnificent mountain gorilla. Poaching and political unrest have diminished their numbers, and Uganda and Rwanda are now courting tourism to help protect them.

Must Do // Take a guided trek for a chance to see mountain gorillas, 300 species of birdlife, baboons, chimpanzees, and colobus monkeys // Visit neighboring Rwanda's Karisoke Research Center, founded by Dian Fossey.

MURCHISON FALLS
Uganda

// Through the Eye of a Needle

Located in Uganda's largest national park, Murchison Falls is where the mighty Nile explodes through a rock cleft 23 feet wide before plunging 131 feet with unimaginable force. If the landscape looks familiar, it may be because it was used as a location for the 1951 Hollywood classic *The African Queen*.

Must Do // Tour the base of the falls by boat to see hippos, alligators, and rare shoebills.

SOUTH LUANGWA NATIONAL PARK
Zambia

// Hippos, Bee-Eaters,
Leopards, and Much More

South Luangwa National Park's dry season is when carmine bee-eaters [*below*] dig thousands of nest burrows in the riverbanks while buffalo, pukus, impalas, waterbucks, and hippos look on. And South Luangwa is big-cat country, so you are almost guaranteed to see a leopard during its twilight hunt and lion kills during the hot summer months.

Must Do // See massive herds of big game around the shrinking Luangwa River during the dry months from July to October // Explore the area by boat during the "emerald season" that follows the January to March rains.

VICTORIA FALLS
Zambia and Zimbabwe

// The Smoke That Thunders

Spanning the breadth of the Zambezi River, and creating a natural border between Zambia and Zimbabwe, the monumental Victoria Falls, whose mists can be seen 40 miles away, are also called Mosioa-tunya, "the smoke that thunders." As they crash from a height twice that of Niagara, they create endless rainbows, especially during the wet season from March to May.

Must Do // Tour the falls by helicopter, single-engine plane, or microlight aircraft // Raft the white-knuckle rapids at the foot of the falls // Travel by boat to Livingstone Island (where Dr. Livingstone first set up camp) for unforgettable views // Bungee jump off the bridge that connects Zimbabwe and Zambia.

MATOBO NATIONAL PARK
Matobo Hills, Zimbabwe

// A Landscape Wild and Weird

Huge granite masses sculpted by time and the elements form whalebacks, fanciful castles, and precariously balanced boulders (left) throughout the Matobo Hills. This bizarre landscape bewitched British statesman Cecil J. Rhodes, and no one leaves the park without spending an awe-inspiring moment at his hillside grave.

Must Do // View one of Africa's largest concentrations of cave paintings // Look for the rhinos, leopards, cheetahs, and the world's largest number of raptors that live in the park, among them black eagles, hawks, and owls.

Islands of the Indian Ocean

MADAGASCAR
Madagascar

// Expedition into the Eighth Continent

Everyone comes for the island's monkey-like lemurs—from the archetypal ring-tailed and white-headed lemur (*left*) to the indri, the largest of them all—which exist nowhere else on earth in the wild. But there are plenty of other weird and wonderful creatures here as well. Madagascar, the fourth-largest island in the world (almost the size of Texas), promises adventurers to this isolated destination in the Indian Ocean a newfound fascination for its epic mountainous scenery. Pristine, ever-changing landscapes of incredible diversity range from terraced rice paddies and red soil (hence the country's nickname, "Red Island") to gigantic baobab trees and desert to ancient rain forests, making long drives on ubiquitously dismal roads more tolerable. As a result of the island's isolation over time, about 80 percent of the flora and fauna that you see here is endemic.

Must Do // Enjoy the tongue-twisting capital city of Antananarivo, congested and busy but interesting for first-timers // Visit local markets for a glimpse of the day-to-day life of the friendly Malagasy people // Enjoy the coffee, vanilla, and cloves that are proudly grown on the island // Recharge on the island of Nosy Be, where gin-clear waters and upscale resorts make it feel like another country.

THE MALDIVE ISLANDS
Maldives

// Delicate Masterpieces of the Indian Ocean

Made up of 26 atolls scattered across the Indian Ocean, the Maldive islands are a fragile wonderland of white sand, palms, lagoons, reefs, and Hockney-blue seas. And don't underestimate the suggestion that you see the world's lowest-lying nation before sea levels rise.

Must Do // Dive and snorkel miles of coral gardens in shallow, crystal-clear waters among small creatures like unicornfish, schooling bannerfish (*right*), harlequin sweetlips, and glassfish, as well as reef sharks and manta rays // Enjoy deep-sea fishing, kayaking, or luxuriating in an overwater bungalow for which the islands are known.

MAURITIUS
Mascarene Islands

// Heaven's Prototype

Thanks to an enlightened policy of ecotourism and preservation, this tiny volcanic speck in the middle of the Indian Ocean remains an unspoiled and exotic mosaic of Indian, African, British, Continental, and Chinese influences. It's a long way from anywhere, but people flock here to unwind at the island's exquisite resort hotels and enjoy its natural beauty.

Must Do // Stroll along Le Morne Beach, or hike Le Morne Brabant Mountain (*above, background*) for spectacular views // Attend the horse races at the Champ de Mars in Port Louis // Take a road trip through picturesque Mahébourg, then visit the ruins and monuments at Vieux Grand Port that hark back to the arrival of the Dutch in 1598 // Enjoy the public beaches and deep-sea fishing on the western part of the island.

BIRD ISLAND
Seychelles

// Fearless and Protected Wildlife

Bird Island is the home of tropical birds so isolated that they nest, court, and preen within arm's length of visitors. This most northerly of the Seychelles islands hosts more than 100 endemic and migratory bird species (*above*, crab plovers), and some birders consider it one of the best wildlife experiences in the world.

Must Do // Watch 2 million sooty terns drop seawater on the grass, then build nests, from May to October // View the endangered green and hawksbill turtles as they nest or lay their eggs // Snorkel or swim in gin-clear waters.

MAHÉ AND LA DIGUE
Seychelles

// Crystalline Water, Talcum Sand, and Swaying Palms

An archipelago of 115 coral and granite islands in the middle of the Indian Ocean, the Seychelles are an idyllic destination for travelers looking to relax on blindingly white beaches, and most head to the resorts on Mahé, the country's biggest island and home to 90 percent of its population and some of its loveliest shoreline. However, the neighboring island of La Digue is home of the boulder-strewn beach of Anse Source d'Argent (*below*), one of the world's most photographed.

Must Do // Stroll through the colorful market in the capital city of Victoria // Visit Victoria's National Botanical Gardens, for a look at the coco de mer, the country's famous national tree // From Victoria, take the short boat ride to Sainte Anne Marine National Park, the Indian Ocean's first // In La Digue, jump on an oxcart and have a guide take you into the forest in search of 12 endemic bird species, including the Seychelles paradise flycatcher.

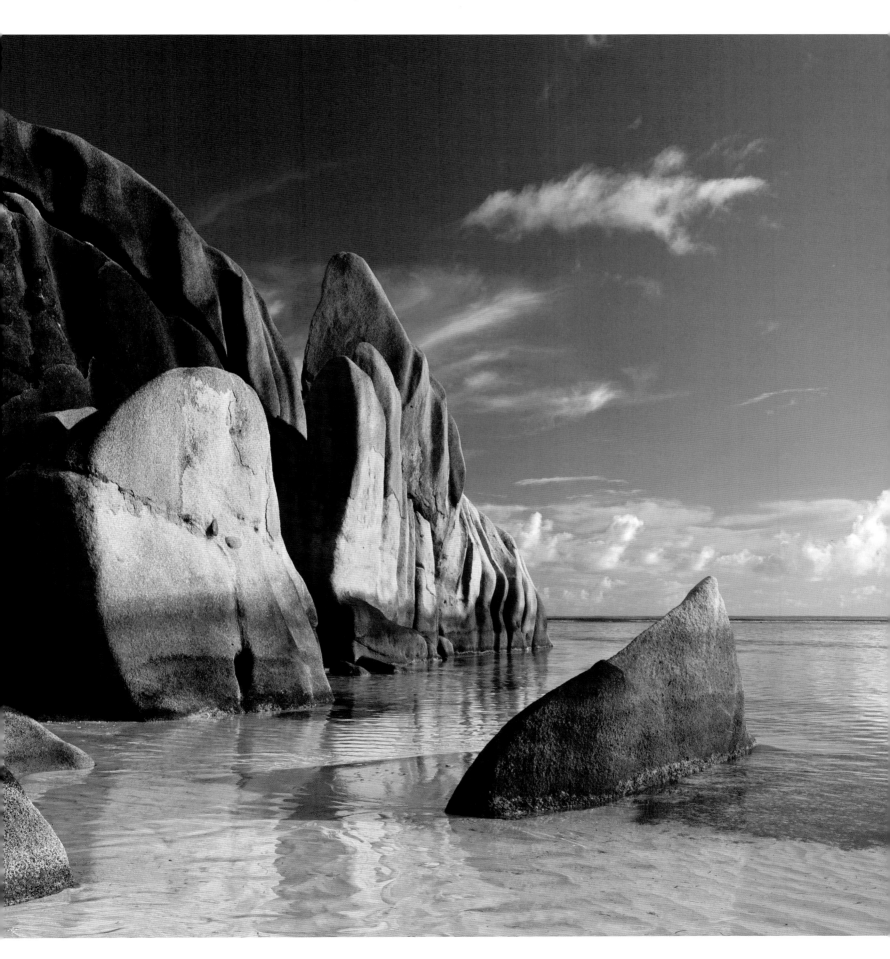

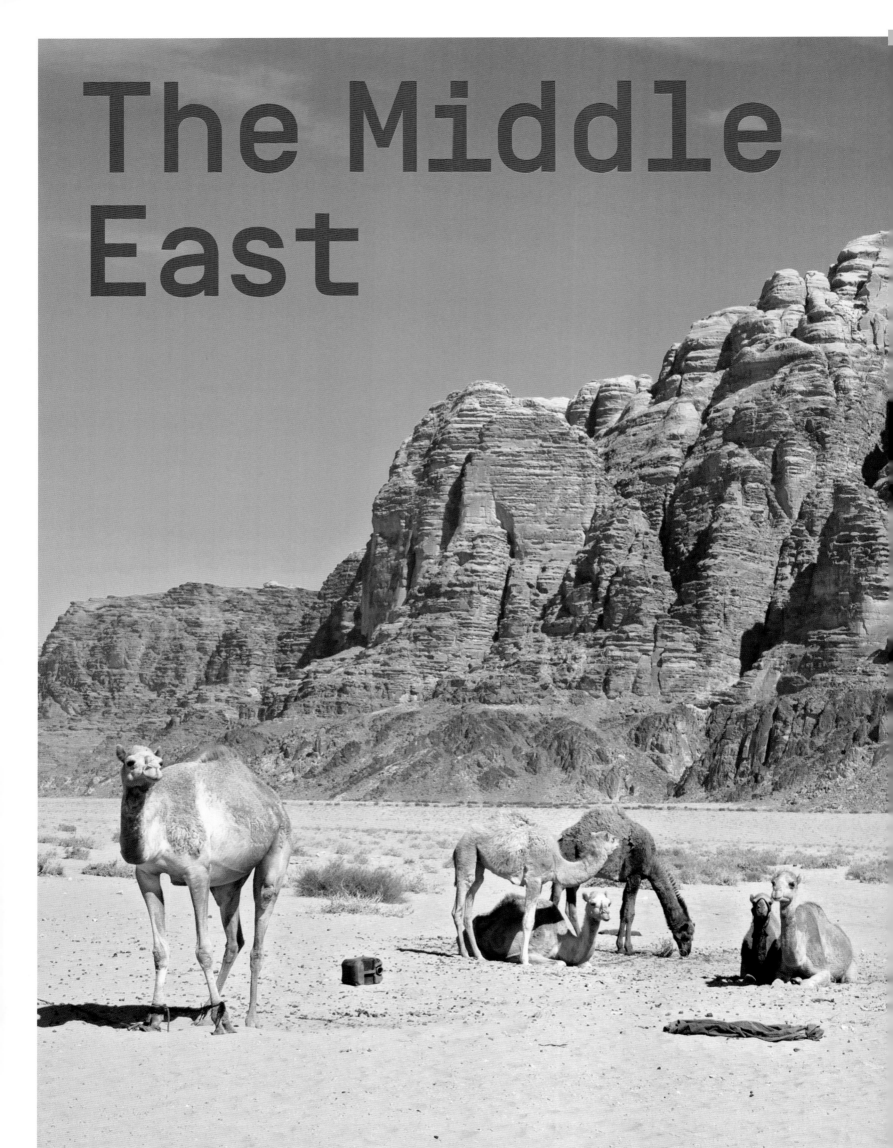

The Middle East

Wadi Rum (see page 216), the largest valley in Jordan, is a land of massive canyons, nature-sculpted rock formations, and granite ridges. Sandstone mountains reach 2,625 feet above the desert floor, where seminomadic Bedouins live in scattered villages.

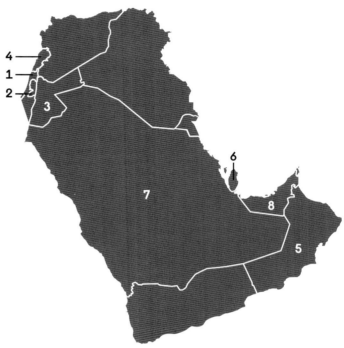

The Middle East

1 Israel
2 Palestine
3 Jordan
4 Lebanon
5 Oman
6 Qatar
7 Saudi Arabia
8 United Arab Emirates

ACRE
Israel

// Crusader Stronghold on the Sea

Acre (also known as Akko) has been visited by everyone from Marco Polo to St. Francis during its more than 4,000 years of existence. The Crusaders left their imprint, establishing this ancient port as the maritime center and largest city of their Christian empire. They built a citadel and monumental fortifications, seawalls (*left*), and the Knights' Halls, a subterranean network of vaulted corridors that held 50,000 soldiers during their 12th-century heyday.

Must Visit // Acre's teeming souk, Turkish baths, and portside restaurants // The Knights' Halls, the subterranean network of vaulted corridors built by the Crusaders // In nearby Haifa, the gardens at the Shrine of the Báb, the city's centerpiece and an important site for the Bahá'i faith

CAESAREA
Israel

// Roman Fortress by the Mediterranean

Built some 2,000 years ago by Herod the Great, who dedicated it to Caesar Augustus, Caesarea is the site of some of the Levant's most important Roman ruins. A double aqueduct, Herod's palace, and one of the largest and best-preserved hippodromes in the classical world have survived the ages.

Must Do // Tour the mostly re-created Roman theater (*right*), perhaps Caesarea's greatest highlight and still used for events today // Explore the remnants of the 12th-century citadels built by the Crusaders // View sunken statues and Roman shipwrecks at the city's underwater archaeological park.

THE GALILEE AND THE GOLAN HEIGHTS
Israel

// Nature-Filled, with Wineries and Sacred Sites

The Galilee is home to some of Israel's most important pilgrimage sites, including Nazareth and the Sea of Galilee, a freshwater lake. Surrounded by lush volcanic hills, the Golan Heights, a region captured from Syria during the Six-Day War, is a popular destination today, with nature reserves, Druze villages, boutique vineyards, and Israel's only ski resort.

Must Do // Visit Nazareth's Basilica of the Annunciation, the largest church in the Middle East // Hike the 40-mile Jesus Trail, which follows where he would have walked during his ministry // Trek up to Safed, Israel's highest town and home of Kabbala // Hike up to the Nimrod Fortress (*left*) for beautiful views of the Golan Heights // See the ruins at the settlement of Gamla, known as the "Masada of the North."

HISTORIC JERUSALEM
Jerusalem, Israel

// Spiritual Enclave of Ancient Sites and Sacred Places

Ancient Jerusalem transcends time, place, and faith with more than 200 historic sites sacred to Judaism, Christianity, and Islam.

Must Visit // Take in the views from the Tower of David before strolling to the Western Wall (*right*), Judaism's holiest site // The Dome of the Rock (*right, background*), the oldest existing Islamic shrine // The mile-long Via Dolorosa, the path Jesus took as he carried his cross to his crucifixion // The Church of the Holy Sepulchre, built on the site where Jesus is believed to have been crucified, buried, and resurrected

WEST JERUSALEM
Jerusalem, Israel

// Millennia-Old Capital Gets a Contemporary Makeover

The ancient City of David has developed a modern edge in its western quarters. While the area still abounds with ancient treasures, it's now also filled with world-class contemporary architecture, culture, and cuisine.

Must Visit // The Santiago Calatrava-designed Chords Bridge, an anchor for Jerusalem's mass transit system // The Holocaust History Museum at the Yad Vashem Holocaust Memorial (*left*), designed by architect Moshe Safdie in Ein Kerem // The Israel Museum, home of the Dead Sea Scrolls

WEST BANK
Palestine

// The Site of Jesus's Birth

Israeli-occupied since 1967, the West Bank remains one of the most hotly disputed and spiritually rich places on earth. Visitors not put off by the checkpoints, roadblocks, and security wall can take the road from Jerusalem to Bethlehem for a glimpse of life in this land sacred to Muslims, Jews, and Christians.

Must Visit // Bethlehem's Church of the Nativity (*right*), built on the site thought to be where Jesus was born // The tomb of Rachel in Bethlehem, the third holiest site in Judaism // The ancient town of Jericho, where Joshua led the Israelites from bondage in Egypt // The 12th-century Greek Orthodox Monastery of Deir Quruntal atop the Mount of Temptation // Nabi Musa, outside of Jericho, an Islamic shrine to Moses

MASADA
Israel

// A Legendary Fortress Near the Dead Sea

"Masada will not fall again," a phrase known by every Israeli youth—a declaration of invincibility commemorating the 967 Jewish men, women, and children who died atop this stark plateau defending themselves from Roman forces in AD 73. At that time, Palestine was a Roman colony, and Masada was built and ruled—with an iron fist—by Herod the Great. Abandoned after Herod's death, Jewish patriots who found refuge in Masada repelled 15,000 Roman troops for 3 years until they opted for mass suicide over defeat.

Must Do // Take a 5-minute cable-car ride or climb one of two hiking paths to reach this well-preserved complex // Make a predawn climb to witness sunrise over the Dead Sea and the Judean Desert // Visit the Dead Sea—at 1,300 feet below sea level, the lowest land point in the world—and a landlocked salt lake that creates a natural border with Jordan // Soak in the springs at En Gedi Nature Reserve on the shore of the Dead Sea // Escape the heat in the Qumran Caves, where the Dead Sea Scrolls were found in 1947.

OLD JAFFA
Tel Aviv–Jaffa, Israel

// Tel Aviv's Ancient Quarter
Shines with a Charm All
Its Own

Jaffa is home to the Bronze Age harbor
that Jonah reputedly sailed from before his
encounter with the whale. One of Israel's
few Arab-Jewish urban enclaves, the once
run-down Old Jaffa Port area has been
restored and offers incredible views of
downtown Tel Aviv.

Must Visit // The Ilana Goor Museum,
located in a stunning 18th-century mansion
// The flea market just past the Ottoman-
era Clock Tower, for antiques and textiles
// The gardens of Peres Peace House, in the
Ajami neighborhood

THE WHITE CITY
OF TEL AVIV
Tel Aviv, Israel

// European Bauhaus on
Mediterranean Shores

Tel Aviv's roughly 4,000 Bauhaus-style
edifices (*left*) make up the world's largest
trove of buildings from this design
movement, which became an efficient way
to house immigrants pouring in just before
the nation's 1948 independence.

Must Do // Stroll down Rothschild Boulevard
and Ahad Ha'Am Street to see pristine
architectural beauties // Join a walking tour
sponsored by the Bauhaus Center Tel Aviv
// Visit the Bauhaus Foundation Museum,
to view works by Marcel Breuer and Ludwig
Mies van der Rohe.

THE DEAD SEA
Israel and Jordan

// Nature's Largest Spa

Lying 1,305 feet below sea level, the
Dead Sea—actually a landlocked lake
in the middle of the desert—has one of
the highest concentrations of sea salt
in the world. Bathers float effortlessly
on the surface of the mineral-packed
waters whose nutrients are believed to
heal skin problems and arthritis.

Must Do // Visit soon, as evaporation
and industrial exploitation are shrinking
the Dead Sea // Luxuriate in the spas
located on both the Israel and Jordan
shores // Drive a half hour east to the
dramatic hiking trails at the Mujib
Nature Reserve.

AQABA AND WADI RUM
Jordan

// Red Sea Diving and Desert Canyons

The waters off Aqaba boast some of the Red Sea's most pristine dive sites. But this ancient port city is also known as the gateway to nearby Wadi Rum (left), a majestic desert moonscape where parts of David Lean's *Lawrence of Arabia* were filmed.

Must Do // Snorkel or dive along Aqaba's 15 miles of shoreline to see fields of technicolor coral // Camp in Wadi Rum with a local outfitter to enjoy the light and color at dawn and dusk and the stars at night.

JERASH
Jordan

// Monument to the Power and Brilliance of the Roman Empire

Considered one of the largest and best-preserved provincial Roman cities outside Italy, Jerash dates to the 4th century BC. Visitors can still see a triumphal arch built for Emperor Hadrian (left), a massive column-ringed oval forum, and a large hippodrome where chariot races are frequently reenacted.

Must Do // Tour some of the city's 15 ancient churches // Visit the Temple of Artemis, accessed via a column-lined avenue // Attend the annual 3-week-long festival featuring performances in the Roman-era theater.

KING'S HIGHWAY
Jordan

// Connecting the Dots in an Ancient Land

This 5,000-year-old route first mentioned in the Old Testament begins just outside of Amman and ends at Aqaba on the Red Sea. Today's well-paved road twists and winds through deep ravines, fertile farmland, and red-rock desert.

Must Do // See the oldest-known map of the world in Ma'daba's basilica of St. George // Climb Mount Nebo, 8 miles west of Ma'daba, for views of the Dead Sea, Bethlehem, and Jerusalem // Visit Kerak, the largest Crusader castle in the Levant outside of Syria // Tour the Dana Biosphere Reserve, home to a rich, diverse, and unique ecosystem.

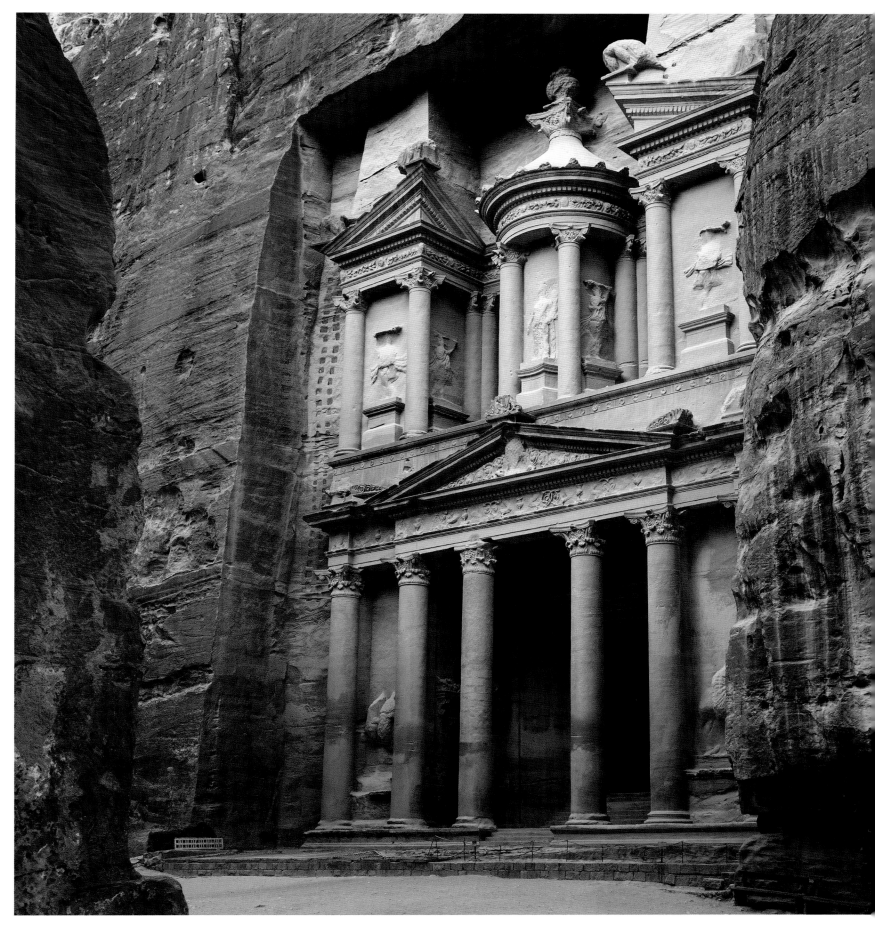

PETRA
Jordan

// Pink Palaces Half
as Old as Time

Petra is called the "Pink City" because of the red-hued sandstone of the canyon walls where the Nabataeans carved out palaces, tombs, homes, and warehouses. The narrow, mile-long Siq gorge is the only way in and out of this ancient site that dates back to 1200 BC and was declared one of the New Seven Wonders of the World in 2007.

Must Do // View the Khaznah (*above*), which is known as the Treasury, Petra's best-preserved monument // Climb the 800 steps or ride a donkey to El Deir monastery for views of the entire Petra basin // Book a hotel nearby and arrive at dusk, when visitors are welcomed with candlelight, Bedouin music, and mint tea.

BAALBEK
Lebanon

// One of Rome's Greatest Achievements

Baalbek is the site of the largest Roman temple complex ever built, supported by the tallest columns ever attempted. Set high on a plateau in the Bekáa Valley, the city reached its zenith under Julius Caesar and is now home to some of the Middle East's most impressive ancient ruins.

Must Visit // The nearby Temple of Jupiter (*right*), the largest Roman temple ever built // The Temple of Bacchus, the best-preserved Roman temple in the world

BEIRUT'S CORNICHE
Beirut, Lebanon

// Born-Again Glamour in the Land of the Cedars

Beirut is enjoying a period of relative calm after Lebanon's 20-year civil war destroyed its thriving tourism scene, and visitors once again stroll on the Corniche, a palm-lined seafront promenade with the striking Pigeon Rocks in front and towering Mount Lebanon visible to the east.

Must Do // Enjoy cool breezes and picture-perfect sunsets in an open-air restaurant // Sample arak, a potent local anise-flavored liqueur // Enjoy Lebanon's famed cuisine, a refined melding of Arab, Armenian, and Turkish influences.

NIZWA AND MUSCAT
Oman

// Old-World Arabia and a Capital City

Nizwa's 17th-century fort [*left*] is Oman's most visited national monument. Most visitors arrive from the capital of Muscat, itself home to an impressive array of royal and Islamic wonders.

Must Do // Shop Nizwa's souk for silver jewelry, frankincense, and intricate silver daggers // Visit Muscat's dazzling Sultan Qaboos Grand Mosque // Tour the nearby Sultan's Palace, guarded by a pair of 16th-century Portuguese forts.

MUSEUM OF ISLAMIC ART
Doha, Qatar

// An Architectural Treasure Box

Over the past decade, the sheikhdom of Qatar has become a dynamic cultural destination in the Persian Gulf, thanks in part to the arrival of Doha's 2008 Museum of Islamic Art, designed by I. M. Pei, that displays more than 700 priceless works from the 7th through the 19th centuries.

Must Visit // The Falcon Souq, for all things related to falconry, a favorite Qatari pastime // The newly opened National Museum of Qatar, designed by French architect Jean Nouvel

OLD JEDDAH
Jeddah, Saudi Arabia

// The Gateway to Mecca—Where History and Modernity Meet

Much of Jeddah's original core has been left mostly in tact as the coastal city has developed and expanded around it. The best of what remains is located in Al-Balad [*left*], the heart of Old Jeddah, where many homes (a number of which are now museums) made from coral feature ornate details carved from local hardwoods.

Must Visit // Naseef House, Jeddah's oldest and most impressive museum // The Al-Tayibat City Museum for International Civilization, known as "Jeddah's Louvre" // The Shallaby Museum's trove of silver antiques, coins, and traditional Bedouin clothing

MADA'IN SALEH
Saudi Arabia

// A Magnificent Secret City

The second most important Nabataean city, after Petra in Jordan, Mada'in Saleh—also built on an important biblical-era caravan route—is emerging as one of Saudi Arabia's historical crown jewels as the country slowly opens up to tourism.

Must Do // Tour Mada'in Saleh's columned tombs, many of which are better preserved than those in Petra // Explore the unusual rock formations and mineral strata in this vast compound in the desert.

MECCA
Saudi Arabia

// Islam's Holiest of Holies

The birthplace of the Prophet Mohammed, and the religion he founded, Mecca is the destination of more than 2 million people a year during the Hajj, a pilgrimage of the Islamic faithful. But the Holy Mosque Al-Masjid al-Haram and the shrine of Kaaba (*right*) are strictly forbidden to non-Muslims.

Must Do // Travel 250 miles to Medina, home to the remains of the world's first mosque, the Masjid al-Quba, and the al-Nabawi Mosque, the second most important site in Islam, which stands over the site of Mohammed's home and tomb.

THE EMPTY QUARTER
Abu Dhabi, United Arab Emirates

// Oasis in a Sea of Sand

Despite its unpromising name, there's much to see in the Empty Quarter, a massive 250,000-square-mile desert expanse. Tourists anxious to leave behind the urban attractions of Abu Dhabi have begun to explore this corner of the Liwa Desert, near the Saudi border.

Must Do // Book an off-road adventure across the massive red dunes surrounding the oasis of Al Ain // Take an early-morning ride to watch the sunrise and/or a silent desert walk in the late afternoon // Arrange camel treks or lessons in archery and falconry with the local Bedouins.

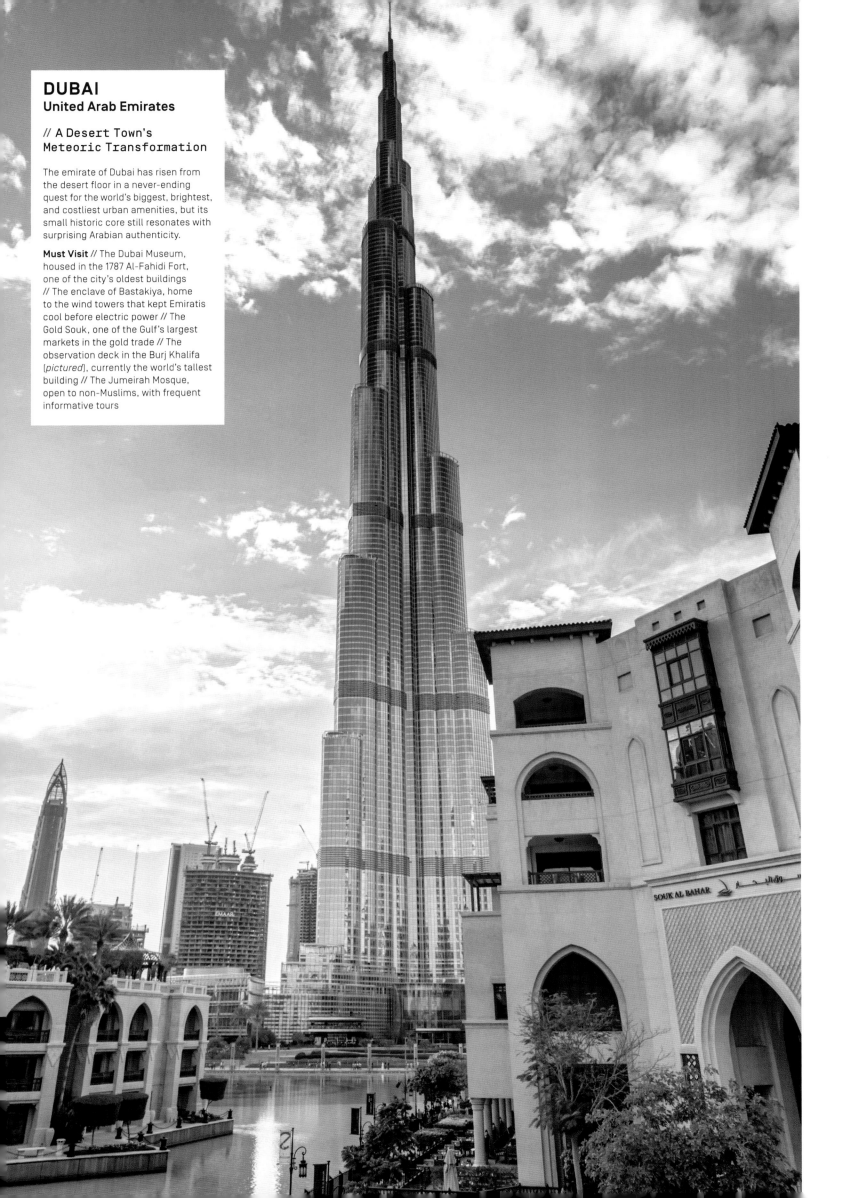

DUBAI
United Arab Emirates

// A Desert Town's Meteoric Transformation

The emirate of Dubai has risen from the desert floor in a never-ending quest for the world's biggest, brightest, and costliest urban amenities, but its small historic core still resonates with surprising Arabian authenticity.

Must Visit // The Dubai Museum, housed in the 1787 Al-Fahidi Fort, one of the city's oldest buildings // The enclave of Bastakiya, home to the wind towers that kept Emiratis cool before electric power // The Gold Souk, one of the Gulf's largest markets in the gold trade // The observation deck in the Burj Khalifa [*pictured*], currently the world's tallest building // The Jumeirah Mosque, open to non-Muslims, with frequent informative tours

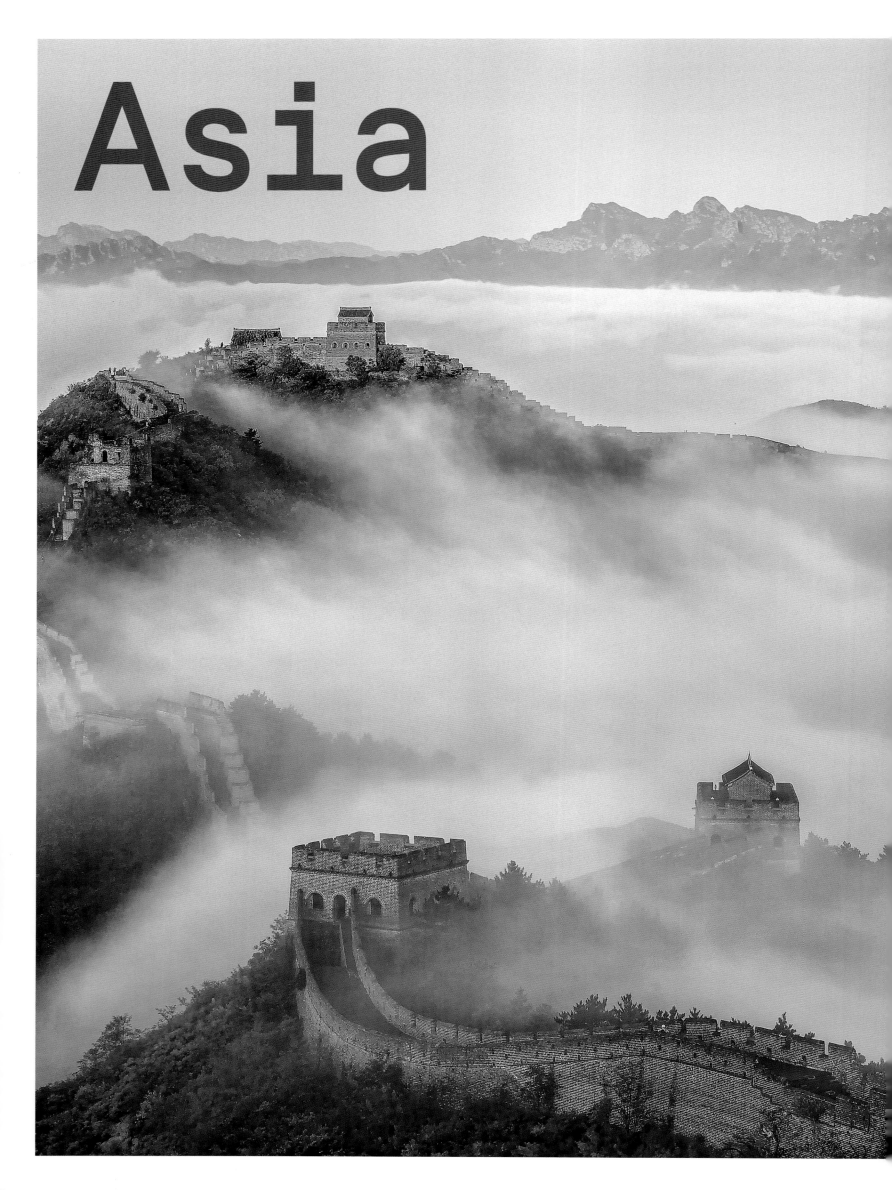

Asia

Bricks, stones, wood, rammed earth, and tile make up the Great Wall of China (see page 228), long a symbol of the country's strength.

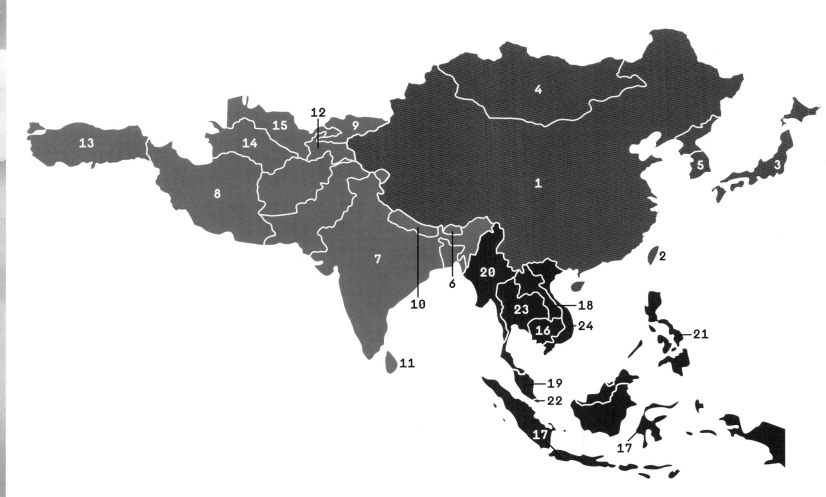

East Asia

1 China
2 Taiwan
3 Japan
4 Mongolia
5 South Korea

West, South, and Central Asia

6 Bhutan
7 India
8 Iran
9 Kyrgyzstan
10 Nepal
11 Sri Lanka
12 Tajikistan
13 Turkey
14 Turkmenistan
15 Uzbekistan

Southeast Asia

16 Cambodia
17 Indonesia
18 Laos
19 Malaysia
20 Myanmar
21 Philippines
22 Singapore
23 Thailand
24 Vietnam

East Asia

HUANGSHAN
Anhui, China

// A Walk in the Clouds

The Huangshan mountain range (Yellow Mountains)—and its misty landscapes—in eastern China's Anhui Province has inspired centuries of admirers and pilgrims. The range comprises over 70 peaks characterized by gnarled pine trees, teetering rock formations, bubbling hot springs, and a shifting sea of clouds.

Must Do // Take a cable car or a sedan to the summit. Hiking is popular for those with good knees. The most challenging 4- to 6-hour trek on western steps promises amazing views // Visit Hongcun, on the southwest slopes of the mountain, one of China's most beautiful historic villages, laid out by a feng shui master in the auspicious shape of a buffalo.

BEIJING
China

Home to approximately 22 million people, Beijing remains in the throes of a vast transformation. Its world-famous historic sights are staggering, but the cultural and political capital of China is also a futuristic and fast-paced modern city that visitors should leisurely explore despite the hectic hustle and bustle.

Get lost in the historic Houhai, or Back Lakes, neighborhood, famous for its timeless alleyways and Prince Gong's Mansion, built in 1777 for a favorite minister at the court of Emperor Qianlong. Travel 7 miles from congested downtown and spend half a day visiting the Summer Palace's Long Corridor, with painted scenes of Chinese history on every beam, pillar, and wall; the Seventeen Arch Bridge, the longest in any Imperial Chinese garden; and the Hall of Benevolence and Longevity, where the Empress Dowager Cixi held court.

Take the time to savor the city's excellent cuisine that features Peking duck and royal dishes from the Qing dynasty, join a tour to sample market and street food, or make a tea-tasting exploration through the Maliandao District.

While the Great Wall's restored viewing points near Beijing are thronged with tourists and souvenir hawkers, a visit to the symbol of China's strength will still impress. A less touristy alternative is the section at Mutianyu or, better yet, at Simatai, where a half-hour hike will put you among soaring hawks and pine trees.

LEFT // **Beijing**'s iconic financial district skyline.

BELOW // The halls and courtyards of the **Lama Temple** in northeast Beijing are filled with decorative stonework, sweeping red-and-gold eaves, and Budchist art, including a 59-foot-tall Buddha sculpted from the trunk of a single sandalwood tree.

BELOW // One of the finest examples of Ming dynasty architecture, the **Temple of Heaven** contains the wooden Hall of Prayer for Good Harvests, a copy of the original rebuilt without a single nail. Locals gather here every morning for tai chi and to socialize.

ABOVE // Located in the northeastern Dashanzi Art District, the **798 Art Zone** boasts exhibit spaces, galleries, studios, design companies, and screening rooms that have given the area a new moniker: the SoHo of Beijing.

ABOVE // It took more than 2,000 years, and more than a million workers to construct the **Great Wall of China** (*pictured*), which at one point spanned 6,200 miles. Only one-third of the original wall remains today, and on average its restored viewing points, near Beijing, are barely able to accommodate the hordes of tourists and souvenir hawkers. Still, a viewing of the Wall is enormously inspiring.

LEFT // Some of the best-preserved ancient buildings in China are in the **Forbidden City**, once the court for 24 emperors. An audio or private guide helps to bring this vast complex alive with tales of eunuchs, concubines, and court intrigues.

ABOVE // The **Summer Palace** is the site of China's largest ancient garden. Spread over 726 acres on the shores of Kumming Lake in a suburb of Beijing, much of the gardens, temples, and pavilions have been reconstructed over time due to invasions and fires.

ABOVE // While many of the city's labyrinthine *hutongs* have disappeared in the rush for development, the remaining ancient residential alleyways are now being carefully preserved to give visitors a taste of imperial Beijing.

GROTTO CAVES OF CHINA
China

// The Peace of the
Thousand Buddhas

Along the Silk Route incredible repositories of Buddhist culture can be found in a series of man-made caves. China's most important are the Longmen Grottoes [below], Mogao Caves [right], and Yungang Grottoes, designated a UNESCO World Heritage Site in 2001. The Mogao Caves, located in Dunhuang, a remote town on the southern Silk Route, boasts 492 man-made caves hidden in the desert that are now recognized as the most significant Buddhist site in China. Guided tours last about 2 hours, with several routes and an alternating selection of caves on offer.

Must Do // Trace Greek, Persian, and Hindu influences in Mogao's caves' sculpted and intricately painted artwork // Don't miss Mogao's seated Buddha of Cave 96 and the sleeping Buddha of Cave 148 // Be sure to explore the Binyang Caves at Longmen, and Yungang's Cave No. 6, its largest.

THE LI RIVER
Guilin, Guangxi, China

// The Magical China of Poets
and Painters

A cruise down the Li River is like floating
through a classical Chinese scroll painting.
From Guilin, the jade-green Li winds
through eroded karst formations with
whimsical names like Bat Hill, Five Tigers
Catch a Goat, and Painting Brush Peak.

Must Do // Watch fishermen and their
trained cormorants that dive and trap fish
in their beaks (*above*) // Take a bicycle day
trip from Yangshuo, the southern terminus
of the cruises // Attend a performance
of *Impression: Liu Sanjie (Third Sister)*,
performed on hundreds of bamboo rafts.

HONG KONG
China

BELOW // **Victoria Harbour** is the soul and centerpiece of this dynamic port city. A 10-minute ferry ride through its aquatic rush hour is a way to experience daily life and view Hong Kong's granite forest of skyscrapers.

This East-meets-West city is fast-paced yet offers tranquil green spaces, like Governor's Walk on Victoria Peak, and other hidden surprises. Each night, the Symphony of Lights laser show illuminates the city's skyline. Have tea in the Nan Lian Garden before haggling over goods in the Ladies' Market in Mong Kok or the Temple Street Night Market in Yau Ma Tei. Peruse antiques or be fitted for a suit by an expert tailor on Hollywood Road. Take the ferry or the new sea bridge to the casinos of Macau and visit the A-Ma Temple and the Guia fortress. Festivals fill the Chinese calendar, and here, Chinese New Year's Eve matches the revelry of Rio's Carnaval.

RIGHT // After climbing the winding entrance path and the 431 steps up to the main temple of **Ten Thousand Buddhas**, reward yourself with a delicious *doufu hua* (tofu custard) sold in the monastery's courtyard.

FAR RIGHT // The **Chi Lin Nunnery**, an impeccable 1998 re-creation of ancient Tang dynasty architecture, is surrounded by meditative gardens filled with lotus ponds and carefully tended bonsai plants and frangipani flowers.

ABOVE // Start your Hong Kong exploration at the **Hong Kong Museum of History** and your stay will be twice as rich. This museum provides an in-depth feel of the city from its beginnings up to its 1997 reunification with China.

RIGHT // On a clear day, you can see the distant coast of mainland China from **Victoria Peak**, which is accessed via one of the world's steepest funicular railways. Visit at dusk when an orgy of neon grips the "Manhattan of Asia."

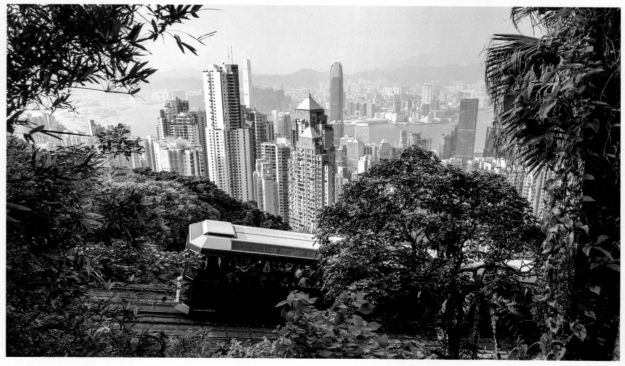

THE THREE GORGES
Hubei and Chongqing, China

// The Yangtze River:
A Gallery of Natural Art

This stretch of the world's third longest river ranks among the world's most beautiful places. Renowned in Chinese poetry and painting, the Three Gorges—Qutang [*right*], Wu, and Xiling—were partially submerged by the world's largest dam in 2009, but they continue to offer unparalleled scenery.

Must Do // Choose a river cruise from the many options offering various durations and itineraries // Make a shore excursion to the immense hydroelectric dam, one of the world's largest power stations, an unexpected highlight for many visitors // Detour to the Three Little Gorges along the even more dramatic Daning River.

THE GARDENS OF SUZHOU
Suzhou, Jiangsu, China

// Landscape Art That Still
Casts a Spell

Praised by Marco Polo, Suzhou was one of the oldest and wealthiest cities in the empire during the Ming dynasty. Today, it's a thriving modern city known for its more than 100 gardens and silk factories.

Must Visit // The Garden of the Humble Administrator [*left*], built in the early 16th century on 10 acres of lakes and pools // The Master of the Nets, considered to be Suzhou's most perfect garden // The Suzhou Museum, designed by I. M. Pei, showcasing more than 30,000 works spanning three dynasties // Liuyuan, the Lingering Garden, considered one of China's four most important gardens

GIANT PANDA TRACKING
Foping, Shaanxi, China

// What's Black and White and Loved All Over?

High in central China's Shaanxi Province, the forests of the rugged Qinling Mountains are home to the Foping National Nature Reserve, the only place in the world where the public is able to track giant pandas in the wild.

Must Do // Join a guided group in search of the animals as they forage for food // Keep an eye out for the rare clouded leopard and other mammals in the reserve.

XI'AN AND THE TERRA-COTTA WARRIORS
Shaanxi, China

// Silent Guardians of Ancient History

The magnificent walled city of Xi'an was home to 11 dynasties, including the Qin dynasty, first to rule over all eastern China (under the powerful Emperor Qin Shi Huang, who died in 210 BC). The life-size honor guard terra-cotta warriors (*left*) that stood near the Emperor's tomb were discovered in 1974 by a well-digging peasant. Today they are considered one of China's supreme cultural treasures and the most sensational archaeological discovery of the 20th century.

Must Visit // The Museum of the Terra-Cotta Warriors (*above*), where three pits have been excavated, the first containing more than 6,000 soldiers and horses, in 38 columns, 16 feet deep; the second containing 1,000 more soldiers and 500 horses, while the highlight of the third is the elaborate war chariot. Every soldier differs in facial features, hair, and expressions // The Shaanxi History Museum // The 8th-century Great Mosque in the Old City, China's oldest

THE BUND
Shanghai, China

// A Spectacular City's Marriage of Past and Future

A waterfront boulevard stretching along the west bank of the Huangpu River, the Bund is the perfect place to experience the juxtaposition of old Shanghai on one bank and the futuristic skyscrapers of Pudong on the other.

Must Do // Stroll the Bund at sunrise, when locals practice ballroom dancing, aerobics, and tai chi // Visit any of the tony hotels, restaurants, and stores housed in the historic buildings along the Bund.

SHANGHAI MUSEUM
Shanghai, China

// Unique Pageant of Chinese Antiquities

This high-tech museum showcases art and antiquities that trace 5,000 years of China's history. Displays are arranged by theme, with galleries devoted to bronzes, ceramics, calligraphy, jade, coins, and furniture.

Must Do // Visit the Bronze Gallery and Stone Sculpture Gallery, considered to have the most impressive collections // Browse for quality mementos and reproduction antiques in the gift shop, the nicest in any of China's museums.

POTALA PALACE
Lhasa, Tibet, China

// Fortress Home of the Dalai Lamas

The epicenter of Tibetan spirituality, Lhasa, which in Tibetan means "Place of the Gods," is home to the Potala Palace, a 13-story fortress that was once the winter palace and seat of the Dalai Lama (the current Dalai Lama fled in 1959 to India, where he still resides). It rises above the holy city on the hill where it has stood since the 17th century. Today, it is a museum and the most recognizable of the city's landmarks.

Must Do // Visit the Jokhang Temple, the spiritual heart of Lhasa city, where a million butter candles illuminate an important statue of Buddha, and the hub of the main market district, known as the Barkhor // Drive to Lhasa from Kathmandu, Nepal, on the "Friendship Highway," a 2-day trip with spectacular vistas.

MOUNT KAILASH
Tibet, China

// Climbing Your Way
to Enlightenment

Revered by Hindus, Jains, Buddhists, and followers of the ancient Bon religion, Mount Kailash has drawn centuries of pilgrims who walk a 32-mile circumambulation around this mountain associated with eternal bliss and spiritual power.

Must Do // Join the pilgrimage to experience the austere beauty of the landscape, visit far-flung monasteries, and encounter the occasional yak herder // Make Darchen, on the mountain's southern flank, the base for expeditions.

SUNDAY MARKET
Kashgar, Xinjiang, China

// The Crossroads of
the Silk Road

At the foot of the Pamir Mountains, the remote city of Kashgar hosts a mind-boggling market that is any photographer's dream. One of Asia's largest, the market has been split between two sites to relieve crowding.

Must Do // Visit the livestock market on the outskirts of town on Sunday to see Muslim Uighurs haggle over sheep, cattle, and horses // From Kashgar to Islamabad, travel on the Karakoram Highway, which winds along the ancient Silk Road, the highest paved international road in the world.

YUNNAN
China

// Remote, Rural, and Rich with Diversity

With its dramatic Eastern Himalayan scenery, ancient trading towns, and many ethnic minorities, Yunnan Province is one of China's most unique destinations and is said to have been the inspiration for James Hilton's *Lost Horizon*.

Must Do // Visit Northern Yunnan's ancient capital of Dali to observe the lives of the Bai people [*left*] // Stroll through Shaxi's Old Town to see beautiful Bai architecture // Journey 90 miles northwest to Lijiang, where Naxi women run the markets while the men raise the children // Take a challenging trek in Tiger Leaping Gorge for extraordinary scenery // Make a day trip from Kunming to Stone Forest, a dramatic landscape of rocks sculpted by wind and rain.

WEST LAKE
Hangzhou, Zhejiang, China

// China's Most Famous Beauty Spot

Described by Marco Polo as the finest and most beautiful city in the world, Hangzhou offers a glimpse of old China despite the current crush of tourists. During off-season or a quiet moment at sunrise, the city's West Lake remains one of the loveliest sights in China.

Must Do // Take the easy 70-minute train from Shanghai // Row a hired boat to the Three Pools Mirroring the Moon, the stone pagodas on the Island of Little Oceans // Attend a performance of *Impression West Lake*, a surreal floating show dramatizing Hangzhou folklore // Visit West Lake's less frequented south or east shore, to meander through old tea plantations.

THE NATIONAL PALACE MUSEUM
Taipei, Taiwan

// More Than 8,000 Years of Art History

The world's largest and most valuable collection of Chinese art is housed at the National Palace Museum in Taipei. Many of the paintings, calligraphy, bronzes, ceramics, rare books, sumptuous jade carvings, curios, and coins came from Beijing's Forbidden Palace and were once part of the private collections of Chinese emperors.

Must Do // View the jadeite carving of a cabbage with a grasshopper hidden among the leaves, nominated by the public as the museum's most outstanding treasure // See the Qingming Scroll, a masterpiece of Chinese painting depicting a Song dynasty festival // Note the blending of West and East in a 1728 study of horses by Jesuit missionary Giuseppe Castiglione.

NISEKO
Hokkaido, Japan

// Ski Hokkaido's
Prince of Powder

Three major bodies of water surround
Japan's main northern island of Hokkaido—
the Sea of Japan, the Sea of Okhotsk, and
the Pacific Ocean—and when winter winds
blow in from Siberia, they dump as much
as 50 feet of dry powder on Japan's main
northern island of Hokkaido, creating some
of the world's greatest ski runs in the resort
area of Niseko, just a two-hour drive from
Sapporo.

Must Do // Buy one lift pass to ski four
separate areas: Grand Hirafu, Niseko
Village, Annupuri (*right*), and Hanazono
// Soak your slope-weary limbs in one of
the many *onsen* (hot springs) in the area
// Hike, bike, and river raft in the summer.

SAPPORO
SNOW FESTIVAL
Sapporo, Hokkaido, Japan

// A Winter Extravaganza

The weeklong Sapporo Snow Festival
showcases mammoth snow and ice
sculptures depicting universal icons
ranging from Michelangelo's *Pietà* to
Hello Kitty as well as ice palaces (*left*)
created from more than 30,000 tons of
snow trucked in before the festival's early
February opening.

Must Do // Watch the Snow Sculpture
Contest, the festival's highlight // Stop
at the 19th-century brick brewery that
produces the famous Sapporo beer
// Visit Daisetsuzan and the Shikotsu-Toya,
two of Hokkaido's wild national parks.

SHIRETOKO
PENINSULA
Hokkaido, Japan

// Japan's Last Frontier

Hokkaido's untamed far northeast is home
to Shiretoko Peninsula (*shiretoko* means
"the end of the earth"), a mountainous
and forested landscape protected within
a national park (*right*) whose standout
features include the Five Lakes and
Lake Rausu.

Must Do // Watch for Steller's sea eagles,
Yezo deer, and the biggest concentration
of brown bears in the world // Take a
sightseeing cruise from Rausu on the
peninsula's east coast for a chance to spot
minke whales and orcas.

TAKAYAMA AND SHIRAKAWA
Gifu, Honshu, Japan

// A Traditional Touch in the Alps of Japan

After centuries of isolation, Takayama retains a traditional feel, particularly in Sanmachi Suji, its beautifully preserved downtown area, where visitors can admire the work of the skilled carpenters who helped to build imperial palaces and temples as far away as Tokyo, Kyoto, and Nara.

Must Do // View four elaborately decorated and beautifully preserved *yatai* at the Takayama Festival Float Exhibition Hall // Take a 5-minute taxi ride to the Hida Folk Village, an outdoor museum made up of more than 20 traditional farmhouses and workshops // See traditional homes in Shirakawa-go, 50 miles northwest of Takayama, whose A-shaped structures with thatched roofs prevent snow from piling up and are called *gasshozukuri* (*left*).

HIROSHIMA AND MIYAJIMA
Honshu, Japan

// Peace and Tranquillity

Devastated on August 6, 1945, Hiroshima is now visited by millions of people who come to pay their respects every year. After viewing reminders of that fateful day, take the half-hour ferry ride to the island of Miyajima. During high tide, view the majestic orange gate (*right*) in the bay when it appears to float on the water. It stands at the entrance to the Itsukushima Shrine, the island's main attraction.

Must Do // Visit the A-Bomb Dome, left in its distressed state as a symbol of humankind's self-destructiveness // Tour the Peace Memorial Park's sobering museum with displays that relive one of the worst days in history // View the touching Children's Peace Monument, featuring a statue of a girl holding a giant origami crane.

KANAZAWA
Ishikawa, Honshu, Japan

// Gorgeous Gardens, Geisha, and the Arts in a Castle Town

One of the few major Japanese cities that escaped World War II air raids, Kanazawa has a historic center rich with the culture and architecture of Old Japan. Its main attraction is Kenroku-en (*left*), Japan's largest garden, considered to be one of its three most beautiful.

Must Visit // The Kanazawa Palace, a replica of the earlier castle that was destroyed by fire // The 21st Century Museum of Contemporary Art, to see James Turrell's *Blue Planet Sky* and Leandro Erlich's *Swimming Pool* // The Higashi-Chaya district, where geisha are trained and give public performances // The Yasue Gold Leaf Museum's fine examples of Buddhist altars, ceramics, and screens // The Museum for Traditional Products and Crafts, to see handmade silks, potteries, and lacquerware

KYOTO
Honshu, Japan

To stroll through Kyoto is to travel through 12 centuries of Japan's history. Once the home of the imperial court, the city is said to hold 20 percent of all Japan's national treasures, including more than 1,700 Buddhist temples and 300 Shinto shrines set amid (and often hidden from) its modern cityscape.

Be sure to visit the Gion quarter, where you might glimpse a geisha dressed in an exquisite kimono. Or sign up for an organized engagement that includes dinner, music, and an enlightening chance to speak with these traditional entertainers. And don't miss a performance at Gion's Minami-za Kabuki Theater.

Visitors can enjoy a wonderful introduction to Kyoto's food culture at the Nishiki Market or unrivaled cherry blossom viewing in late March or early April. But the festivities don't stop once the blossoms are gone. The Jidai, Aoi, and Gion festivals feature theatrical processions of costumed participants and huge wooden floats.

Kyoto is also an excellent base for day trips to Nara's colossal bronze Buddha housed in the world's largest wooden structure; the Miho Museum's collection of classical Chinese, Egyptian, and Assyrian artifacts; and the grand 16th-century Himeji Castle, Japan's oldest UNESCO World Heritage Site.

LEFT // Probably the most photographed structure in Kyoto, the Zen temple **Kinkaku-ji** (Temple of the Golden Pavilion) was rebuilt in 1955 after a fire, and the gold-leaf coating was extended to the top two floors.

RIGHT // One of the most celebrated temples of Japan, **Kiyomizu-dera** was constructed between 1631 and 1633 without a single nail. Below it is the Otowa waterfall, said to have wish-granting powers.

BELOW // Behind a simple and austere exterior, **Sanjusangendo** contains row upon row of life-size statues beautifully carved from Japanese cypress and covered in gold leaf, many of which date back to the 12th century.

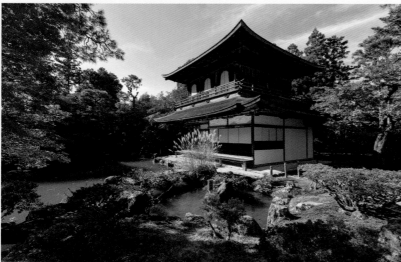

ABOVE // The two-story pagoda **Ginkaku-ji** (Temple of the Silver Pavilion) overlooks a pond and gardens, and the 2-mile-long Philosopher's Walk outside its gate follows a narrow canal that is particularly beautiful when the cherry trees are in bloom.

ABOVE // A lovely half-hour walk from Kinkaku-ji leads to **Ryoan-ji**, whose small garden of raked white gravel and 15 rocks arranged in five groupings has become the very symbol of Zen wisom and is best visited very early in the morning for a moment of quiet contemplation.

LEFT // *Geisha* [*gei*, "art," plus *sha*, "person"], women who are trained in traditional music and dance, and *maiko*, young apprentices, can sometimes be seen in the evenings as they head to their various engagements at exclusive teahouses and restaurants in the Gion entertainment district.

BELOW, LEFT // One of Kyoto's greatest sights is the 2.5-mile tunnel of gates leading up to the **Fushimi Inari shrine**—a 2- to 3-hour walk up to Mount Inari rewards you with magnificent views of the city.

BELOW // **Saiho-ji** is known for its more than 120 varieties of moss. Visitors must write to the temple in advance to gain admission to chant sutras with the monks and practice calligraphy before enjoying the soothing Zen gardens.

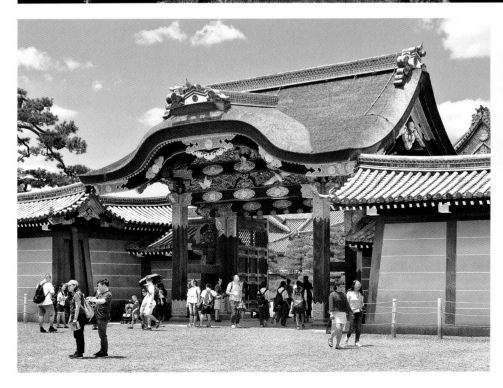

ABOVE // Located in the suburb of Arashiyama, the 14th-century **Tenryu-ji** offers fine Zen gardens, but don't miss the dragon painting (*pictured*) on the ceiling of the lecture hall where monks meditate.

LEFT // The two palaces that make up **Nijo Castle** have secret rooms and corridors where hidden samurai guards could keep watch, and Ninomaru Palace has ingenious "nightingale" floors that "sing" when walked upon.

WALKING THE NAKASENDO
Narai, Tsumago, and Magome, Nagano, Honshu, Japan

// In the Footsteps of Samurai

In the 17th century the 330-mile Nakasendo was the principal inland route between the imperial capital of Kyoto and Edo, the Shogun's seat of power now known as Tokyo. The towns of Narai, Tsumago, and Magome are particularly worth visiting for their efforts to preserve the look and feel of feudal Japan.

Must Do // Hike the 5 miles from Tsumago to Magome on a popular stretch of the Kiso-ji section of the Nakasendo [right] // Join a guided trek of the area that starts in Kyoto and finishes in Tokyo and stay in traditional family-run *ryokans* (inns), a highlight of the trip.

CHERRY BLOSSOM VIEWING
Yoshino and Beyond, Honshu, Japan

// A Venerated National Pastime

Witnessing the exquisite yet fleeting beauty of cherry blossoms is a quintessential Japanese experience not to be missed. A half hour's train ride from Nara, visitors can witness tens of thousands of wild cherry trees in bloom across the slopes of Mount Yoshino.

Must Visit // Tokyo's cherry blossom hot spots, including Ueno Park, Shinjuku Gyoen, the northwest corner of the Imperial Palace grounds, and Denboin Garden [left] near Senso-ji temple // Kyoto's many key blossom-viewing locations, including Philosopher's Path and Maruyama-koen, a park that is home to a spectacular weeping cherry tree illuminated at night

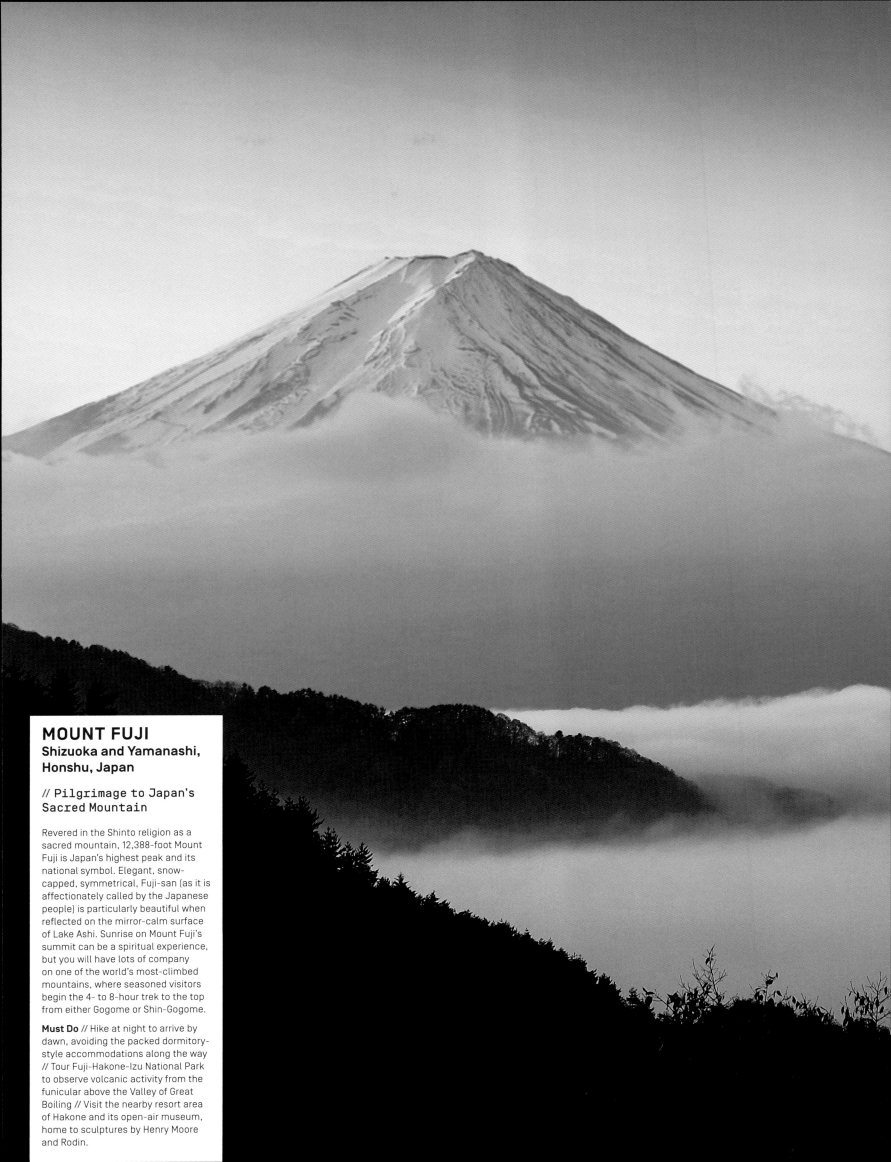

MOUNT FUJI
Shizuoka and Yamanashi, Honshu, Japan

// Pilgrimage to Japan's Sacred Mountain

Revered in the Shinto religion as a sacred mountain, 12,388-foot Mount Fuji is Japan's highest peak and its national symbol. Elegant, snow-capped, symmetrical, Fuji-san (as it is affectionately called by the Japanese people) is particularly beautiful when reflected on the mirror-calm surface of Lake Ashi. Sunrise on Mount Fuji's summit can be a spiritual experience, but you will have lots of company on one of the world's most-climbed mountains, where seasoned visitors begin the 4- to 8-hour trek to the top from either Gogome or Shin-Gogome.

Must Do // Hike at night to arrive by dawn, avoiding the packed dormitory-style accommodations along the way // Tour Fuji-Hakone-Izu National Park to observe volcanic activity from the funicular above the Valley of Great Boiling // Visit the nearby resort area of Hakone and its open-air museum, home to sculptures by Henry Moore and Rodin.

TOKYO
Honshu, Japan

Japan's frenetic capital is both reassuringly familiar and unsettlingly strange. Offering up neon-bright canyons of consumerism, contemporary pop culture, outstanding dining, and Zen-calm gardens and shrines, Tokyo is home to everything from the remnants of a 17th-century castle to high-tech towers wrapped in giant LED displays.

For a fascinating alternative view of Tokyo, take a boat up the Sumida River from Hinode Pier that sails past the Tsukiji Fish Market and Tsukuda Island, a center of old Edo culture, then get off either at Asakusa, where you can walk to Senso-ji, Tokyo's most visited Buddhist temple, or at the beautiful Hama Rikyu Teien garden. For another unique look at Tokyo, arrange a tour of the training stables for sumo wrestlers that are situated near the National Sumo Stadium in Ryogoku.

The Japanese love to shop, and Tokyo is the jackpot. Ginza and neighboring Nihombashi have long been the domain of high-end boutiques and venerable department stores. Stiff competition comes from the avenue Omotesando in Aoyama, home to some of Tokyo's classiest fashion labels.

Tokyo is one of the world's largest yet safest cities. However you choose to explore it, it promises the ultimate urban adventure.

RIGHT // Walk the colorful Nakamise Dori, a historic lane lined with souvenir shops that lead to **Senso-ji**, Tokyo's oldest temple and one of the country's most visited.

LEFT // Younger shoppers will appreciate the quirky emporiums of "Cat" Street and **Takeshita-dori** in Harajuku, and the buzz of Shibuya.

BELOW // The **Tokyo National Museum**'s main gallery is devoted to Japanese art, while the Toyokan houses Asian art and archaeological artifacts from outside Japan, including a mummy from Egypt.

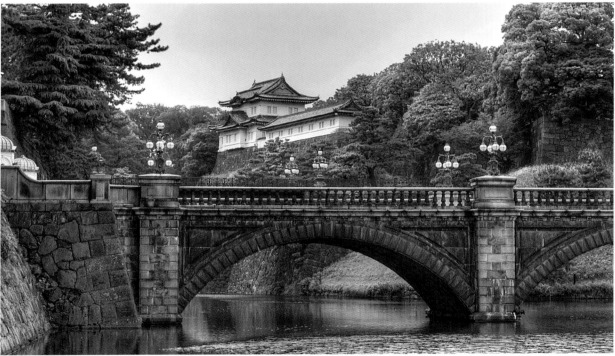

ABOVE // The cavernous **Tsukiji Fish Market** supplies 90 percent of the fish consumed in Tokyo (more than 2,000 tons per day), and no one guarantees fresher fish nor a wider variety than the market's no-frills sushi bars.

ABOVE // While the **Imperial Palace** is off-limits, part of the royal compound is open to official tours (advance booking essential). But no reservation is needed to access the palace's 50-acre impeccably manicured East Garden.

LEFT // The rules of **Sumo wrestling** are simple: The extremely large wrestler who goes over the boundaries or touches the ground with his body (aside from the soles of his feet) is the loser. Tournaments (called *basho*) are held six times a year—three of them in Tokyo (January, May, and September).

SHIKOKU ISLAND
Japan

// The Smallest Island with the Biggest Heart

Exquisite scenery, historical castles, and villages with 300-year-old craft shops, along with excellent river rafting and easy cycling, are just a few of the delights found on Shikoku, the smallest and least visited of Japan's four main islands.

Must Do // Join thousands of pilgrims paying their respects at the island's 88 temples on one of only two UNESCO World Heritage routes in the world // Tour Ritsurin-koenin, a traditional garden in Takamatsu, the island's capital // Visit Tokushima in August when thousands of dancers spill onto the streets to celebrate the spirits of the dead // Take a restorative soak at the public baths, the Dogo Onsen Honkan, housed in a wooden structure dating to 1894.

THE GOBI DESERT
Mongolia

// Remote, Vast, and Hauntingly Beautiful

Covering nearly one-third of Mongolia, the Gobi is one of the most remote and least trodden deserts in the world. On organized four-wheel-drive or camel trips, visitors can spot wild horses and double-humped Bactrian camels [*left*]. You'll likely encounter nomadic families living in traditional felt-covered homes known as *gers*.

Must Do // Visit the Singing Sands dunes that make a peculiar sound when the winds blow // Tour the Flaming Cliffs, where the world's first discovery of dinosaur eggs was made // Trek along the Jargalant mountain range or within Gobi Gurvansaikhan National Park.

THE GOLDEN EAGLE FESTIVAL
Mongolia

// An Ancient Tradition in the Altai Mountains

Every October the nomadic people of Mongolia's Altai Mountains dress in traditional cloting and test their magnificent hunting eagles' speed, agility, and accuracy at the Golden Eagle Festival [*left*] held in Mongolia's Bayan-Ölgii Province.

Must Do // Visit an eagle hunter's family to see how the birds are trained // Join an organized hike through untracked terrain for the chance to meet nomadic Kazakh families, camp along alpine lakes, and see Neolithic petroglyphs.

THE STEPPES AND FORESTS OF MONGOLIA
Mongolia

// In the Wake of Genghis Khan

Ever since Genghis Khan encouraged his people to live by the sword, not the plow, Mongolians have been nomadic herders, holding to their horse-based culture and leaving vast tracts of ruggedly beautiful countryside virtually untouched over the centuries.

Must Do // Visit in July and attend Naadam, a 3-day test of participants' archery, wrestling, and horseback-riding skills held each July throughout the country // Watch more than 600 horses gallop headlong over a 10-mile course just outside the capital of Ulaanbaatar during the games.

SEOUL'S DESIGN BOOM
Seoul, South Korea

// An Ancient Capital
Embraces Modernity

Seoul is a city in continuous transformation with ambitious design projects regularly under construction. You can wander through Dogndaemun Design Plaza (DDP, *left*), a cultural hub created by architect Zaha Hadid, and explore the flourishing art scene in the Samcheong-dong neighborhood.

Must Do // Tour all that's new in the Cheongdam-dong district near Dosan Park // Visit the Leeum Samsung Museum of Art, which features art by Korean and international artists // View the Moonlit Rainbow Fountain on the Banpo Bridge, the world's longest bridge fountain // Glimpse Seoul's high-tech future at the Digital Media City complex.

THE PALACES OF THE JOSEON DYNASTY
Seoul, South Korea

// Splendors from the Past

Despite being a sprawling metropolis of high-rises and neon-lit streets, Seoul is also home to some of the country's most historic and beautiful buildings, including the elaborate Five Grand Palaces, a testament to Korea's feudal past right in the heart of bustling downtown.

Must Visit // The Gycongbokgung Palace and the Jongmyo Royal Shrine on the edge of the palace grounds (*left*), the country's oldest preserved royal Confucian shrine // The Changdeokgung Palace and the Secret Garden to stroll wooded pathways and elegant stone bridges

West, South, and Central Asia

THE FESTIVALS OF BHUTAN
Bhutan

// A Whirling Spectacle of Tradition

The sacred festivals of Bhutan, known as *tsechus*, are the perfect way to take in the rich Buddhist heritage of this small Himalayan kingdom. Filled with the sounds of flutes, cymbals, and trumpets and the sight of whirling costumed dancers in magnificent, brightly colored traditional dress (*right*), the festivals take place around the country throughout the year. The largest are usually held in the courtyards of the great *dzongs*—the fortified monasteries that are centers of religion, education, and government in Bhutan.

Must Do // Visit mid-March for Bhutan's most famous annual festival in Paro, in honor of Guru Rinpoche, who introduced Tantric Buddhism to the Himalayan region in the 8th century // Attend Thimphu's festival that celebrates the birth of Guru Rinpoche at the beginning of October // Join the procession during October's Bumthang Fire Dance Festival // View a reenactment of a 17th-century Bhutanese victory at the Punakha festival in late February.

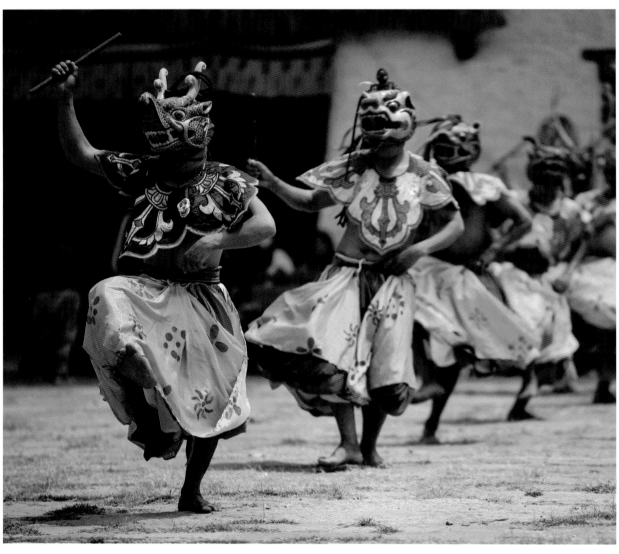

THE TIGER'S NEST AND THE CHOMO LHARI TREK
Paro Valley, Bhutan

// Untrammeled Terrain in a Himalayan Kingdom

Bhutan is one of the most remote and protected places in the world, tantalizing for its pristine natural beauty and rich cultural heritage. The greatest of all Bhutanese monuments is the famed monastic retreat of Taktsang, the "Tiger's Nest" (*left*), which clings to a sheer cliff face 2,700 feet above Paro Valley, accessible only by a bridge and steep, winding track. Since its near-destruction by fire in 1998, the structure has been painstakingly restored.

Must Do // Follow the Chomo Lhari Trek to the base of Mount Chomo Lhari, Bhutan's highest and most sacred mountain // Bird-watching in Bhutan, among the best in the world, with more than 700 species

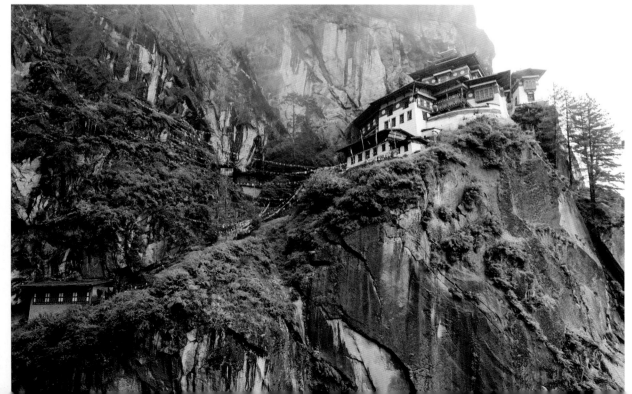

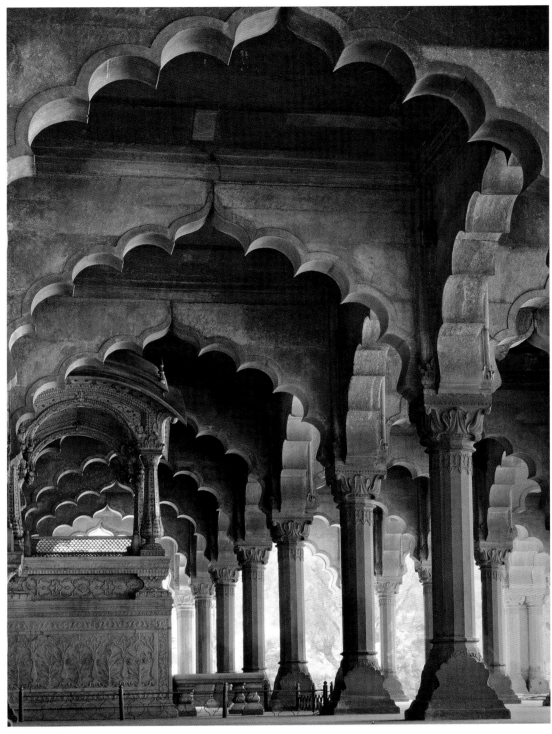

RED FORT AND CHANDNI CHOWK
Old Delhi, Delhi, India

// Sensory Overload in the City's Beating Heart

Make your way to Shahjahanabad (Old Delhi) and its most visted site, Lal Quila, the Red Fort (*left*), named for the color of its 1.5 miles of turreted sandstone walls and the former seat of Mughal power. Hop a rickshaw at Lahore Gate and negotiate fiercely, then let your driver navigate the ancient lanes and timeless bazaars off of Chandni Chowk (Moonlight Alley).

Must Visit // The tomb of the 16th-century Mughal emperor Humayun, and Jama Masjid, the country's largest mosque // Khari Bioli, one of Asia's largest spice markets // The nearby Kinari Bazaar, where local Hindu families shop for wedding festivities that will go on for days

THE BEACHES OF GOA
Goa, India

// The Good Life with More Than a Touch of Portugal

Transformed from the hippie nirvana of yesteryear, Goa is now the place where Indian urbanites and Europeans come to recharge and enjoy the languid pace of this former Portuguese colony on the Arabian Sea.

Must Visit // North Goa's lively towns, weekly markets, and the Calangute and Arambol (*right*) beaches // The basilica of Bom Jesus, which houses the remains of St. Francis Xavier, cofounder of the Jesuit order // Om Beach, 150 miles south in Karnataka, every bit as beautiful as the shores of Goa

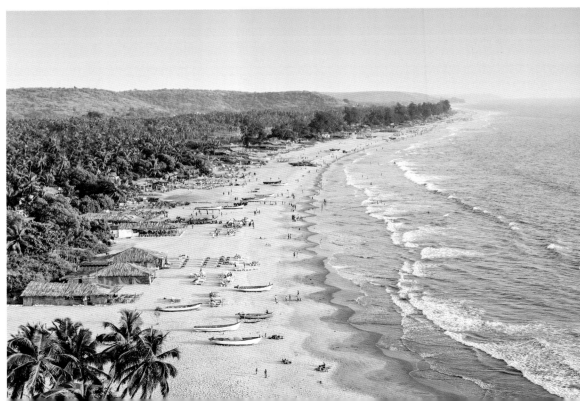

SHIMLA
Himachal Pradesh, India

// In a Former Summer Capital, a Relic of the Raj

During the summer, the British headed to the Himalayas and the town of Shimla, where melting snows kept the temperature tolerable, and Victorian architecture, gardens, and entertainment—including the Mall, Gaiety Theatre, and lawn tennis at the posh Viceregal Lodge (*above*)—helped to create a simulacrum of the sceptered isle they'd left behind. Shimla remains one of India's most venerated stuck-in-time hill stations and an excellent base for exploring Himachal Pradesh, one of India's loveliest states.

Must Do // Golf the century-old Naldhera Course at Wildflower Hall // Arrive in Shimla on the "toy train," a narrow-gauge railroad that departs from Kalka to view endless high-altitude beauty.

LADAKH
Jammu and Kashmir, India

// Altitude, Snow Leopards, and a Taste of Tibet

Also known as Little Tibet and Moon Land (for its unearthly landscape), the awe-inspiring, high-altitude plateau of Ladakh sits between the world's two highest mountain ranges, the Karakoram and the Great Himalayas. While politically Indian, Ladakh is geographically and ethnically Tibetan and today contains one of Asia's most intact Buddhist societies. Closed to tourism until 1974, this remote region in northern India has attracted a slowly growing trickle of tourism.

Must Do // The flight to Leh, the region's principal city, for spectacular views // Drive to the Nubra Valley through Khardung La Pass, one of the world's highest drivable roads // Visit Hemis National Park, one of the few places where elusive snow leopards can be tracked on foot // Tour Hemis Gompa, one of the state's most interesting and best-known Buddhist monasteries. Its festival of masked dances, music, and handicrafts (*above*) in June and July draws villagers from all parts.

THE BACKWATERS
OF KERALA
Kerala, India

**// Unique Waterworld
of Canals and Lagoons**

Located on the tropical Malabar coast,
the southernmost state of Kerala is well
known for its Backwaters, a labyrinth of
rivers, lakes, canals, and lagoons that link
sleepy islands and villages inhabited by a
hospitable people known for their religious
tolerance and famous for their coconut-
based curries and flavorful cuisine and
their Ayurvedic traditions.

Must Do // Get a massage that uses oils
made from exotic spices at a traditional
Ayurvedic spa // Visit St. Francis Church in
the old quarter of Kochi, the first European
church to be built in India // Explore
Kochi's Pardesi Synagogue, the oldest in
the Commonwealth // Float through silent
backwaters on a canoe-style boat or a
converted barge houseboat.

BANDHAVGARH
AND KANHA
NATIONAL PARKS
Madhya Pradesh, India

**// On the Trail of India's
2,500-Year-Old Emblem**

Bandhavgarh National Park, one of India's
most scenic, has one of the subcontinent's
highest densities of tigers as well as
leopards, Indian bison, nilgai antelope, rich
bird life, and 111 species of butterflies. If
time allows, drive 6 hours south to Kanha
National Park, one of the nine founding
reserves of Project Tiger.

Must Do // Set off by foot or jeep in search
of the Big One // Visit Bandhavgarh's
2,000-year-old fort and the 10th-century
statue of Lord Vishnu.

THE TEMPLES OF KHAJURAHO
Madhya Pradesh, India

// Erotic Tableaux in
the Middle of Nowhere

Between the 10th and 13th centuries,
85 temples were created in this sleepy
town (22 temples remain). The temples,
both Hindu and Jain, are decorated with
friezes that intersperse scenes of daily life
with military processions. But the most
renowned are highly erotic (*left*): Celestial
maidens pout and pose while other figures
engage in every imaginable position of the
Kama Sutra.

Must Do // Tour the Archaeological
Museum, located among the best-known,
oldest, and largest temples // Attend the
weeklong Khajuraho Dance Festival of
classical dance held the end of February
and early March.

THE CAVE TEMPLES OF AJANTA AND ELLORA
Maharashtra, India

// Architectural
Achievements of
Mysterious Power

Ajanta is the site of dozens of ancient
Buddhist temples and monasteries carved
from solid rock faces that date from 200 BC
to AD 650. While these caves dazzle with
their paintings, the 34 rock-cut temples
of Ellora (*right*), used until the 1800s, are
sculptural masterpieces. Begun in AD
600, work continued until the 11th century,
producing a mix of Buddhist, Hindu, and
Jain temples and grottoes.

Must Visit // Ellora's Kailash Temple,
the largest known rock-cut temple
in the world, which covers twice the
area of the Parthenon in Athens

THE GOLDEN TEMPLE
Amritsar, Punjab, India

// A Place of Extraordinary Peace Where Everyone Is Welcome

One of India's most beautiful buildings, the Harmandir Sahib, also called the Golden Temple, the Sikh religion's holiest shrine, welcomes everyone, regardless of religion, race, or caste, and seems to float on an island in the middle of a serene lake. Construction began in 1574, and more than 220 pounds of gold and an inverted lotus-shaped dome have been added since then.

Must Do // Join worshippers for the nightly Palki Sahib ceremony, when the Sikh holy book is returned to its resting spot // Stop by the Langar, a giant communal dining hall where more than 30,000 people are fed for free every day.

KEOLADEO NATIONAL PARK
Bharatpur, Rajasthan, India

// Strictly for the Birds

Between the historic cities of Agra and Jaipur lies Keoladeo Ghana National Park, aka the Bharatpur Bird Sanctuary. The 18-square-mile, car-free park's marshland attracts staggering numbers of migratory birds, especially in the winter. Even the highly endangered Siberian crane occasionally makes an appearance.

Must Do // Hire a rickshaw pulled by staff trained to spot the park's more than 400 resident (*left*, painted storks) and migratory species // Keep an eye out for pythons, porcupines, mongooses, jackals, civets, wild boars, and the endangered jungle cat.

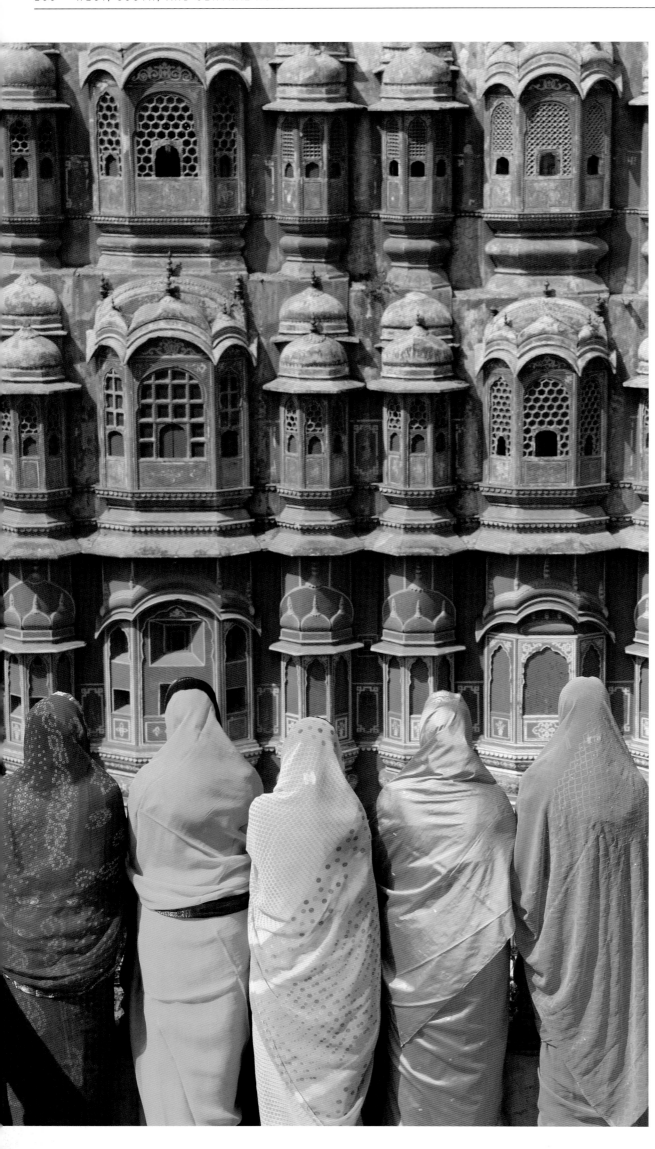

PALACE OF WINDS
Jaipur, Rajasthan, India

**// Where Royal Concubines
Watched the World Go By**

Pink is the Rajput color of hospitality,
and Jaipur, capital of the desert state of
Rajasthan, is known as the "Pink City."
It is home to Hawa Mahal, the five-story
"palace of winds" built in 1799 with
honeycomb windows. The upper two stories
are really an elegant façade, just one room
deep but pierced by 953 windows from
which the ladies of the royal household
in *purdah* (concealment from men) could
enjoy the breeze while viewing everyday life
in the Old City below.

Must Visit // The nearby City Palace
complex, an exotic blend of Rajasthani and
Mughal architecture that houses the former
maharaja and his family on a high floor

JAISALMER
Rajasthan, India

// A Giant Sand Castle
in the Heart of the
Great Indian Desert

This once important caravan stop on the route to the Khyber Pass is famed for its 12th-century sandstone fortress, which makes Jaisalmer the only functioning fortress city in India, as one-quarter of its population still lives within the Sonar Killa, or Golden Fort.

Must Do // Stroll past handsome mansions (called *havelis*) with elaborate façades and balconies carved from the local golden stone // Sign up for a jeep or camel jaunt into the shifting sands of the Thar Desert // Visit during the full moon in January or February for the exotic 3-day Desert Festival of Jaisalmer.

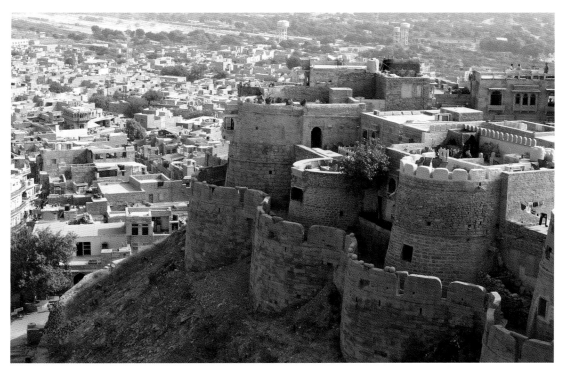

THE PUSHKAR CAMEL FAIR
Pushkar, Rajasthan, India

// A Tribal Gathering
Unlike Any Other

Thousands of people converge on this lakeside town every November shortly before the full moon to parade, race, trade, and sell their prized dromedaries. But the humans can outshine the steeds with their jewelry, saris, and turbans, which helps explain the festival's popularity with tourists, filmmakers, and photographers.

Must Do // Enjoy camel polo, bazaars, and dancing under the stars // Visit some of the Hindu temples lining the banks of Lake Pushkar.

THE CITY PALACE
Udaipur, Rajasthan, India

// Opulence and Romance in
the City of Lakes

The largest palace complex in Rajasthan, this massive group of elaborately decorated buildings in Udaipur serves mostly as a museum. The exceptions are the private wing, where the present maharana still resides, and the royal guesthouse, which has been reincarnated at the Shiv Niwas Hotel.

Must Do // Wander the City Palace's courtyards and pavilions and its museum.

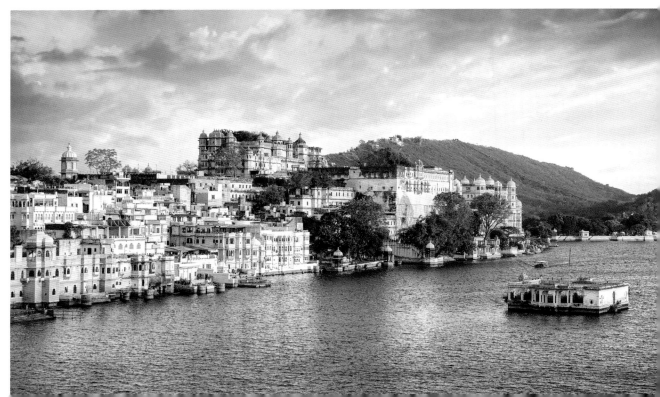

ROYAL WHEELS OF INDIA
India

// Once the Private Trains of Maharajas

Many visitors only ride the rails from New Delhi to Agra for a brief day trip to the Taj Mahal. But there are a handful of long-distance luxury trains that treat passengers like royalty. Luncheons are arranged at lavish former palaces, camel treks and tiger photo safaris fill out the days, and nights are spent back on board.

Must Do // Book trips on New Delhi's Palace on Wheels (*right*) or the Royal Rajasthan on Wheels for full days of sightseeing in Jaipur, Udaipur, Jodhpur, and the Taj Mahal // Ride the Deccan Odyssey south from Mumbai to Goa, Pune, and the ancient sites at Ajanta and Ellora // Travel through ancient Karnataka and stop at Nagarhole National Park on Bangalore's Golden Chariot.

HIKING IN SIKKIM
Gangtok, Sikkim, India

// Isolated Splendor No Longer Out of Bounds

One of the smallest and least visited of India's 29 states, Sikkim is bordered by Nepal, Tibet, and Bhutan in the heart of spectacular mountain scenery. It was an independent Buddhist kingdom before joining India in 1975 and is still regarded as one of the last Himalayan Shangri-las. Ancient Buddhist *gompas* (monasteries; *above*) are perched on almost every outcrop of this landscape. Straddling the border of Nepal and Sikkim is the sacred Mount Kanchenjunga. At 28,169 feet, it is the third-highest mountain in the world and is worshipped as a guardian deity.

Must Do // Take an organized trek to Sikkimese villages, the most meaningful and exhilarating way to experience Sikkim's dramatic beauty and serene culture // Glimpse more than 550 species of birds, 500 kinds of orchids, and 35 varieties of rhododendrons while enjoying luxuriant pine forests.

RISHIKESH
Uttarakhand, India

// Nirvana in the Himalayas

Known as the gateway to the Himalayas and the birthplace of yoga, the Hindu pilgrimage town of Rishikesh is where the Beatles sought enlightenment in the 1960s and found inspiration for their *White Album*. Here, every evening at sunset, the Hindu ritual of *aarti* (*left*) is performed on the banks of the Ganges, during which lamps are lit and hymns are sung to the deities.

Must Do // Sign up for any of the classes in yoga, stress reduction, and meditation // River-rafting trips down the Ganges

THE TAJ MAHAL
Agra, Uttar Pradesh, India

// The World's Greatest Monument to Love

Nothing can adequately prepare visitors for their first glimpse of the Taj Mahal. It may be the Niagara Falls of architecture, but it's also the embodiment of grace and romance, of balance and symmetry, an architectural icon built by Shah Jahan as a tomb for his favorite wife, Mumtaz Mahal. It took 22 years and 20,000 laborers to build the white-marble mausoleum, completed in 1653.

Must Visit // Agra Fort, where Shah Jahan was imprisoned by his son // The landmark fort of Fatehpur Sikri, to learn about the legacy of the Mughal dynasty // The Tomb of Itmad-ud-Daulah, a precursor to—and likely the inspiration for—the Taj Mahal

THE GHATS OF VARANASI
Varanasi, Uttar Pradesh, India

// An Eternal City on the Banks of the Sacred Ganges

One of the world's oldest continuously inhabited cities, Varanasi has been the center of Hinduism throughout recorded time. Some 70 stone ghats (steps leading down to the river) line a 4-mile stretch of the Ganges, which Hindus believe washes away their sins and holds salvation in every drop.

Must Do // Hire a cyclo driver to take you through streets lined with shops selling colorful silk saris // Arrange for a boatman to take you on the river at dawn, when the light and the scene are the most magical and the blowing of a conch shell welcomes the sun's first rays.

THE DARJEELING HIGHLANDS
West Bengal, India

// Teatime and the Glory of the Raj

Guarded by the Himalayan peaks, the 7,000-foot summer retreat of Darjeeling was founded by the British as a sanatorium and later a plantation, producing what would become known worldwide as "the champagne of teas." Darjeeling later became a scenic escape from the steamy heat of Calcutta and the low-lying Bengali plains for socialites, diplomats, and other government workers.

Must Do // Visit one of the working tea estates (*left*) in Darjeeling for tours and tastings // Watch the sun rise over Mount Kanchenjunga, a Darjeeling tradition // Hike or drive to the top of Tiger Hill, 5 miles outside town, for a look at Mount Everest // Arrive in Darjeeling on one of the steam "toy trains" from New Jalpaiguri or Siliguri, the most scenic way to reach the hill station.

PALACES OF KOLKATA
Kolkata, West Bengal, India

// Museums in India's Cultural Nerve Center

The Indian Museum is right at home in Kolkata (formerly Calcutta), a city that boasts nine universities as well as being the center of the Bengali film industry. Among the more than 1 million items in what the locals call Jadu Ghar—House of Magic—is an urn believed to contain the Buddha's ashes, an emerald goblet that once belonged to Shah Jahan, and a 4,000-year-old mummy.

Must Visit // The Victoria Memorial (*left*) built to memorialize Queen Victoria, today a museum // The crumbling 19th-century Marble Palace, to see paintings by Reynolds, Rubens, and Titian

IMAM SQUARE
Isfahan, Iran

// A Former Capital's
Rich Legacy

Isfahan was once the capital of the Persian Empire during the Safavid dynasty, and the city today remains one of Iran's most cultured and striking, with sculpted gardens, historic bridges, and the finest concentration of Islamic monuments in the country. The most exquisite examples of architecture can be found in the city's showstopping Imam Square, one of the largest public spaces in the world.

Must Visit // The Masjid-i-Imam mosque, Isfahan's crown jewel // The Alī Qapū palace, to experience the elegance of the Safavid Royal Court // The Sheikh Lotf-Allah Mosque [below], a showcase of Islamic architecture // The Bazar-e-Bozorg, one of the largest and oldest markets in Asia

PERSEPOLIS
Iran

// Ceremonial Center
of an Ancient Empire

The massive palace complex of Persepolis was the glory of the Persian Empire until Alexander the Great destroyed it in 330 BC. Now there are more than a dozen columns and re-created buildings on display as well as carved reliefs [left], the main staircase built by Darius, and an entryway flanked by giant carved bulls.

Must Do // Make Shiraz, an hour's drive from Persepolis, your base for exploring the area.

YURT STAY AT LAKE SONG KÖL
Kyrgyzstan

// Awaken Your Inner Nomad

This is cowboy country, Kyrgyz-style, where the golden grass that grows along the shores of Lake Song Köl is ideal for grazing animals. For the visitor, this pastureland is an idyllic and welcoming escape from civilization, where a peek inside the yurt [*left*] of a nomad family is a highlight of any visit.

Must Do // Arrange a visit with a local family through local tour operators // Horseback riding can usually be arranged as part of your stay // Plan ahead to catch a horse games festival, a great time to see the Kyrgyz in traditional dress and listen to their lyrical music.

OSH
Kyrgyzstan

// A City Older Than Rome

One of the most important centers for silk production in the 8th century, Osh is one of the oldest cities in Central Asia, and the legacy of the Silk Road lives on in the great Jayma Bazaar [*right*], which offers everything from local fruit to traditional *kalpaks*, the tall black-and-white hats favored by Kyrgyz men.

Must Do // Make the 20-minute climb to the top of Solomon's Throne for spectacular views of the city // Make an overnight trip to the base of Lenin Peak, a great area for hikers and mountain climbers.

CHITWAN NATIONAL PARK
Nepal

// Asia's Richest Wildlife Sanctuary, Home of the Royal Bengal Tiger

Once the private hunting grounds of the king of Nepal, today Chitwan National Park is one of the finest protected forest and grassland regions in Asia as well as Nepal's best birding destination. Seasonal guides take visitors in search of the great one-horned rhinoceros (*left*) and the 50 endangered Bengal tigers that live in Chitwan and the adjacent Parsa Wildlife Reserve.

Must Do // Sign up for boat and jeep safaris and jungle walks led by naturalists and expert guides // Visit the villages of the Tharu, Bote, and Mushyar tribes, who have lived here for millennia.

KATHMANDU VALLEY
Nepal

// Ancient Palaces Frozen in Time

Kathmandu Valley is Nepal's political, cultural, and commercial hub; before commercial development began 30 or so years ago, it held as many temples and shrines as it did houses. While some damage remains from the 2015 earthquakes, repairs have been impressive and ongoing.

Must Do // Visit Durbar Square in the heart of Kathmandu, a concentration of historic temples, shrines, and old palaces // Head to the small city of Bhaktapur for impressive medieval architecture // Explore Bhaktapur's Palace of Fifty-Five Windows, home of the Golden Gate, held to be the most important piece of art in the valley.

MOUNT EVEREST AND BASE CAMP
Nepal

// Sagarmatha, "Mother Goddess of the Universe"

After a number of failed attempts, New Zealander Edmund Hillary and Sherpa guide Tenzing Norgay were the first documented climbers to reach the top of the world's tallest mountain, in 1953, and thousands of adventurers have tried (often unsuccessfully) to repeat their feat ever since. But trekkers don't need to scale the summit to experience the might of Sagarmatha, as Everest is known to the Sherpas. Most who come here encounter the legendary mountain by way of a journey to the beautiful Khumbu Valley, with its timeless Sherpa villages (*above*),

spectacular Buddhist monasteries, and unique wildlife.

Must Do // Explore the 17,600-foot-high Everest Base Camp, where climbers prepare for their summit attempts, amid the jumble of boulders, tents, and prayer flags // Hike the trails surrounding the base camp for breathtaking close-ups of the 29,035-foot peak and of Lhotse, Makalu, and Cho Oyu, all over 26,000 feet high // Enjoy the friendly hospitality of the Sherpa people, an experience as memorable as Everest itself.

MUSTANG
Nepal

// The Last Forbidden Buddhist Kingdom

One of the last remnants of ancient Tibet, Mustang and its medieval culture were off-limits to tourists until 1992, and travel to Mustang is still restricted today. Visitors must arrange treks through a licensed company to experience the largely autonomous region's rugged and austere landscape flanked by towering peaks.

Must Do // View Buddhist monuments (called chortens or stupas; *right*) in Mustang's capital city, Lo Manthang // Attend the colorful 3-day Buddhist festival of Tiji, held in Lo Manthang in May.

POKHARA AND THE ANNAPURNA SANCTUARY
Nepal

// Rooms—and Treks— with a View

Situated on Lake Phewa Tal, Pokhara is known as the trekker's capital of the world. Most visitors here are gearing up for (or recovering from) treks on the Annapurna Circuit, which rival—and are less crowded than—those around Everest Base Camp. Set out for the glorious Annapurna Sanctuary (*left*), a glacial basin that serves up a 360-degree panorama in the heart of the Himalayas and the best views of Annapurna I, the world's tenth-highest mountain and one of the most treacherous.

Must Do // Explore Old Pokhara on foot or bicycle, to see decorative brickwork and unique woodcarvings // Take the rope-operated ferry to historic Fish Tail Lodge for views of the Annapurna massif and Machhapuchhare.

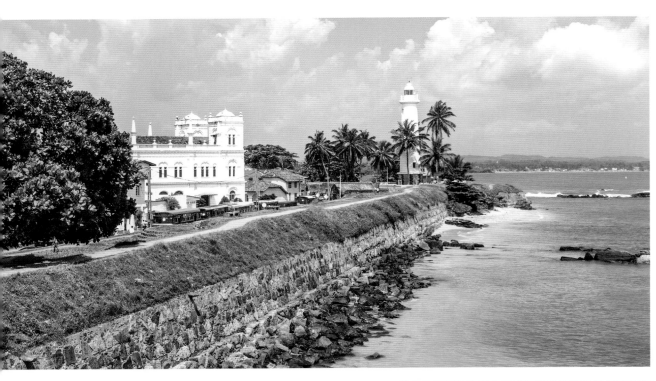

GALLE FORT
Galle, Sri Lanka

// The Deep South

The former Ceylonese headquarters of the Dutch East India Company, the city of Galle Fort is still protected by 17th-century stone-and-coral ramparts. Walk around this coastal city to soak up the history embedded in its churches, mosques, temples, warehouses, and hundreds of tile-roofed houses.

Must Do // Swim and snorkel at Unawatuna beach or the quieter beaches of Dalawella and Thalpe farther to the east // Take a whale-watching boat from Mirissa beach between November and April.

THE CULTURAL TRIANGLE
Kandy, Anuradhapura, and Polonnaruwa, Sri Lanka

// A Treasure Trove at the Island's Heart

Three ancient capitals form Sri Lanka's Cultural Triangle: Kandy, Sri Lanka's cultural and religious stronghold; Anuradhapura, ruled by 117 kings and queens whose magnificent palaces stood alongside dozens of monasteries; and Polonnaruwa (*above* and *right*), the capital of Sri Lanka after the fall of Anuradhapura, was a fabulous garden city that today has many well-preserved ruins.

Must Do // Visit Anuradhapura's Jetavanaramaya Dagoba, the second-largest man-made structure from the ancient world // Make the steep climb at Dambulla, in the center of the triangle, to Buddhist cave temples with stunning views // Climb the steps of Sigiriya (Lion Rock) to see dozens of frescoes depicting beautiful women.

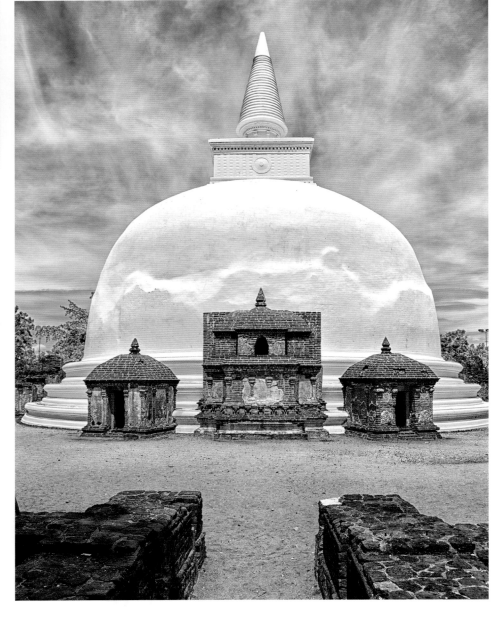

KANDY AND THE ESALA PERAHERA
Sri Lanka

// A Sacred City and
Its Glorious Festival

Nestled in the lush hill country, Kandy
forms the southern tip of the nation's
Cultural Triangle. Temples and colonial-
era houses blanket its hills, and everyone
enjoys a stroll around its large artificial
lake, created in 1807 by the last of the
Sinhalese kings who made Kandy their
capital.

Must Do // Visit in July or August for the
Esala Perahera festival (*left*), one of Asia's
greatest spectacles // Make the trip to the
Pinnawela Elephant Orphanage, home to
dozens of rescued elephants // Tour the
Royal Botanical Gardens near Gunnepana
that display more than 400 species of
exotic plants.

THE HILL COUNTRY
Nuwara Eliya, Sri Lanka

// Tea Plantations and
Adam's Peak

Vestiges of the British era linger in the
cool plantation-blanketed hills surrounding
Nuwara Eliya (*right*), Sri Lanka's highest town.
Arrange a day trip to Adam's Peak, a cone-
shaped mountain with a footprint-shaped
depression at the summit thought to be
Adam's. Try to arrive at dawn, when the
peak casts a spectacular shadow across
the morning mist.

Must Do // Visit a tea factory and enjoy a
tea tasting // Take an early-morning hike
through Horton Plains National Park to
the World's End escarpment for dramatic
views // From Kandy, take the scenic train
ride to hill country.

PAMIR HIGHWAY
Tajikistan

// A Ride on the Roof
of the World

This incredibly scenic road begins at
Khorog, in southern Tajikistan, and loops
its way north through the Pamir Mountains
before dropping down into the lush Fergana
Valley to end up at Osh, in Kyrgyzstan. The
450-mile journey should be done in a four-
wheel-drive vehicle with a local driver or by
organized trip.

Must Do // Bring your camera; the photo
ops leave visitors breathless (as does the
thin mountain air) // Make Murghak, the
halfway point, a base for overnight hikes
and camel treks // Stop at Kara-Kul, a lake
formed by the impact of a meteor some
10 million years ago.

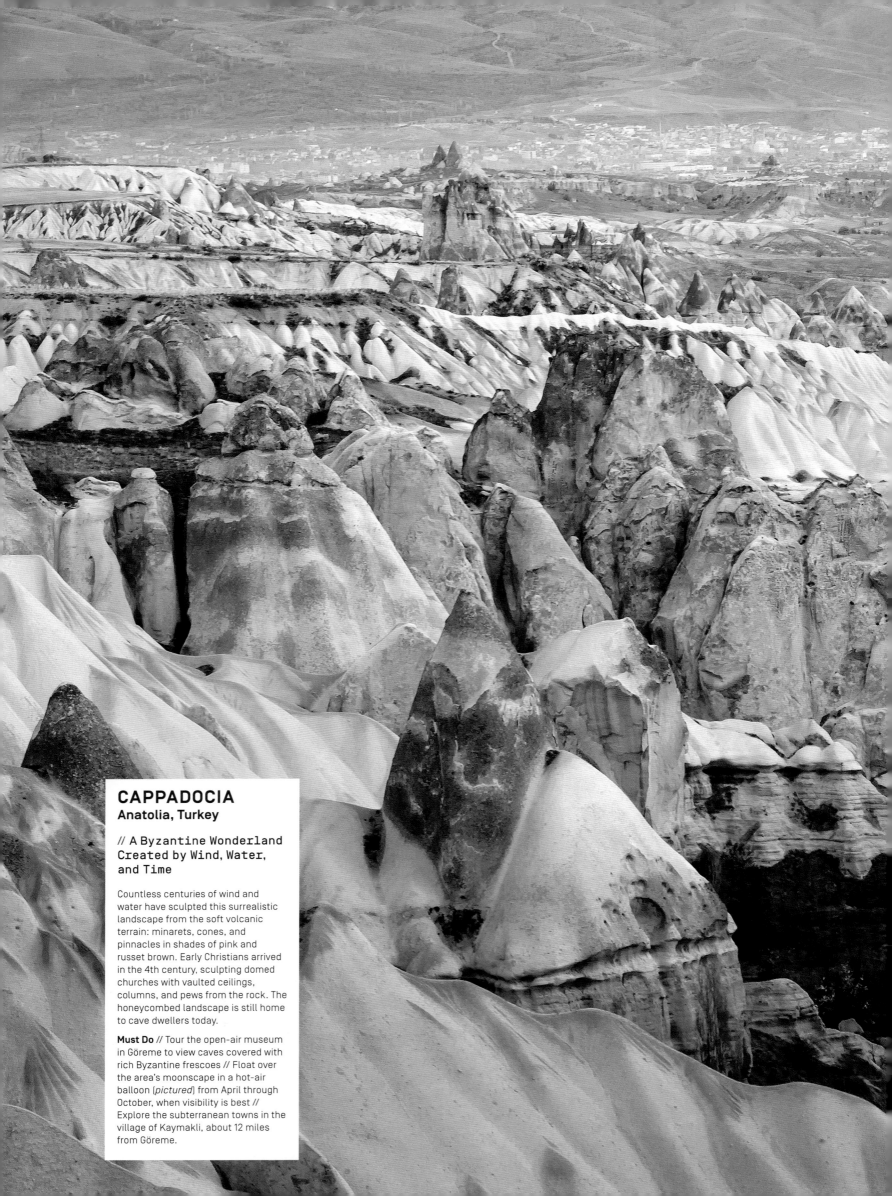

CAPPADOCIA
Anatolia, Turkey

// A Byzantine Wonderland
Created by Wind, Water,
and Time

Countless centuries of wind and
water have sculpted this surrealistic
landscape from the soft volcanic
terrain: minarets, cones, and
pinnacles in shades of pink and
russet brown. Early Christians arrived
in the 4th century, sculpting domed
churches with vaulted ceilings,
columns, and pews from the rock. The
honeycombed landscape is still home
to cave dwellers today.

Must Do // Tour the open-air museum
in Göreme to view caves covered with
rich Byzantine frescoes // Float over
the area's moonscape in a hot-air
balloon [*pictured*] from April through
October, when visibility is best //
Explore the subterranean towns in the
village of Kaymakli, about 12 miles
from Göreme.

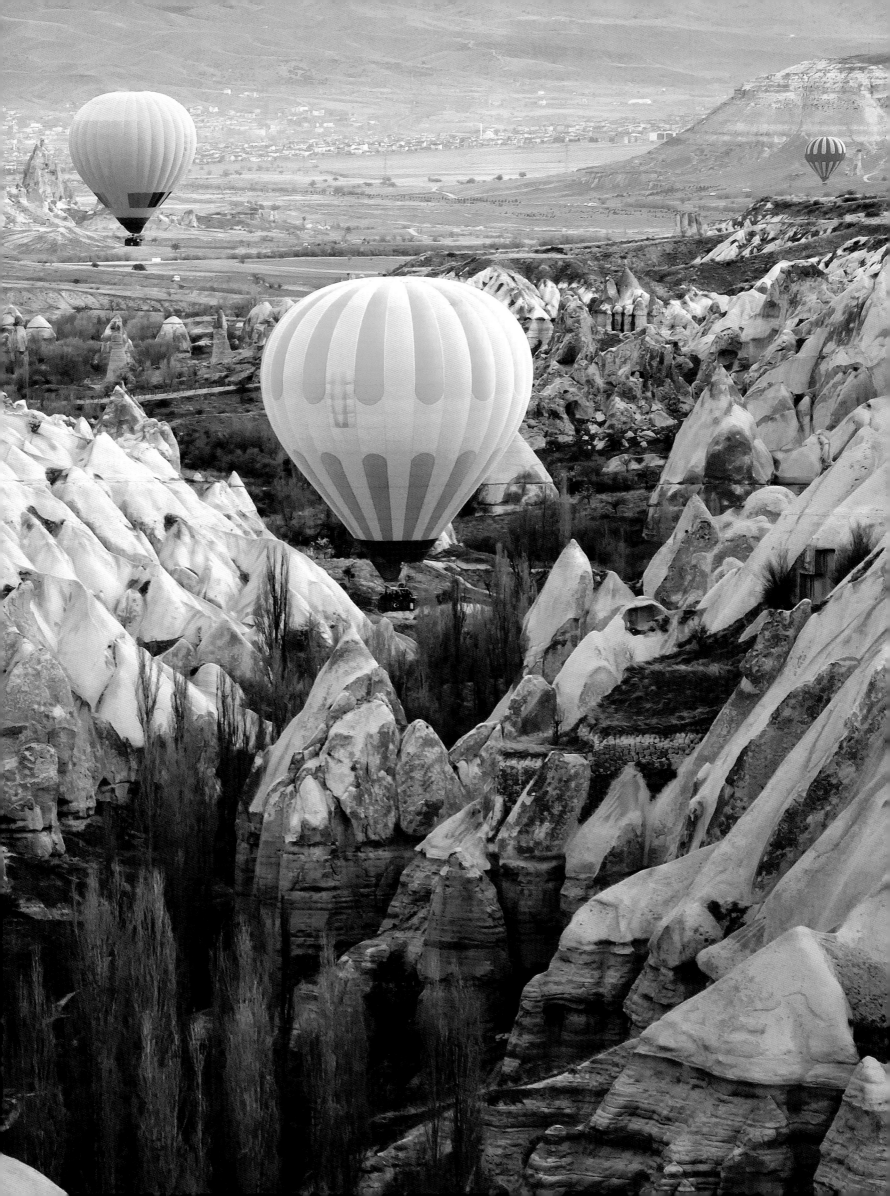

PAMUKKALE
Anatolia, Turkey

// Dazzling Both Ancient
Romans and Modern-Day
Visitors

A popular resort since Roman times, Pamukkale resembles a series of travertine terraces (*below*), the result of hot mineral springs, whose calcium-rich deposits have been accumulating for millennia. Very few pools are open to the public now, but visitors can enjoy relaxing mineral baths at the nearby ancient spa town of Hierapolis.

Must Do // Tour the ruins of the ancient amphitheater in Hierapolis // Swim over submerged ancient marble columns in Hierapolis's Sacred Pool // Visit nearby Aphrodisias, the city of Aphrodite, to pay homage to the goddess of love, beauty, and sexuality.

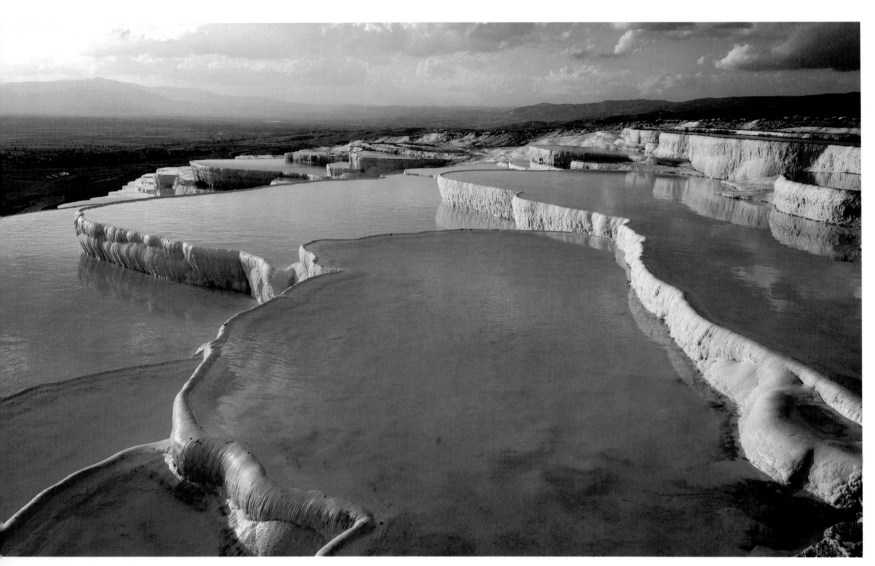

THE BLUE VOYAGE
Bodrum and Antalya, Turkey

// Sailing the
Turquoise Coast

Whether chartered by a group or individually rented by the cabin, a wooden *gulet*, a traditional two-masted diesel-propelled boat, is the perfect way to explore the coast from Bodrum to Antalya (*left*). The waters are a luminous blue that gave rise to the phrase *mavi yolculuk*, or "blue voyage." The boats take in Greco-Roman and Lycian ruins, sun-drenched beaches, and an uninhabited island reportedly given to Cleopatra by Mark Antony.

Must Do // Most cruises cast off from Göcek, Fethiye, or Bodrum, a whitewashed seaside resort whose harbor is dominated by St. Peter's Castle, one of the finest examples of Crusader architecture in Turkey // Tour the Museum of Underwater Archaeology in St. Peter's Castle, to view historic wrecks and treasures // Take a 1-day sail from Bodrum to Gökova Körfezi for lunch in a secluded cove.

THE DATÇA PENINSULA
Turkey

// Unspoiled Turkey on the Aegean

West of Marmaris, the mountainous Datça Peninsula is Turkey at its wildest and most unspoiled. Boaters appreciate the pine-clad coasts and hundreds of secluded coves. Others come to explore sleepy fishing villages and isolated mountain hamlets or take the peninsula's single roadway to the ruins of Cnidus.

Must Do // Visit the delightful harbor town of Datça (*right*), a favorite post-ruins stop // Explore the ruins of two amphitheaters in Cnidus and enjoy spectacular views.

EPHESUS
Turkey

// Turkey's Most Spectacular Roman Ruins

Ephesus is Turkey's showpiece of archaeology. Its extensive and impressive ruins testify to its role as capital of the Roman province of Asia. Today, a marble-paved street grooved by chariot wheels leads past partially reconstructed buildings, including the Great Theater and the Celsus Library (*below*) built in AD 135.

Must Visit // The Great Theater with a capacity of 25,000 spectators // The ruins of the Greek Temple of Artemis, one of the Seven Wonders of the Ancient World // The Ephesus Museum, home to one of the best collections of Roman and Greek artifacts in Turkey // The House of the Virgin Mary, just outside Ephesus, believed to be the final home of the Virgin

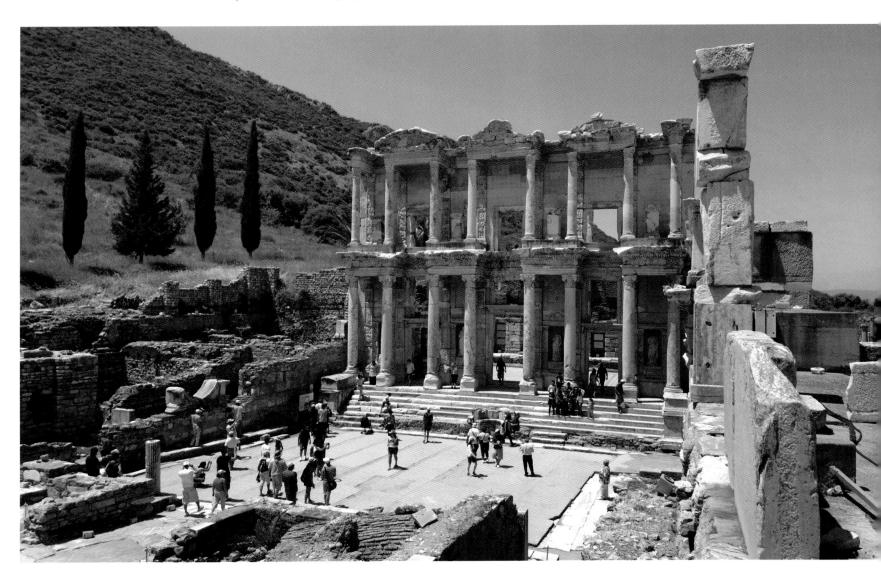

ISTANBUL
Turkey

Istanbul—the only city in the world that straddles two continents, Europe and Asia—has captured visitors' imaginations for centuries with its dazzling legacy of the Byzantine and Ottoman empires. Today's Istanbul offers the traveler a rich array of contemporary and historical museums, world-class restaurants, and glamorous hotels—a sensory overload where East meets West at every turn.

The city has made great strides in establishing world-class privately funded art museums—complete with trendy eateries. The Istanbul Modern is housed in a stylishly renovated warehouse overlooking the Bosporus. The Sakip Sabanci Museum in the Emirgan district has a new wing that houses its top-notch collection of Ottoman calligraphy and paintings, and the Pera Museum in the 19th-century Bristol Hotel displays more than 300 Orientalist paintings.

But visitors should not neglect Istanbul's outstanding natural feature: the 20-mile Bosporus that separates Europe from Asia. Special public ferries depart from the Eminönü pier, and excursion boats go as far as Rumeli Hisari, a 15th-century fortress. For a trip back in time, take a 90-minute ferry ride from the pier at Kabatas to the Princes' Islands in the Sea of Marmara. Cars are banned, the wooden Ottoman and Victorian homes are genteel, and the air is fresh on Heybeliada and Büyükada, the most rewarding of the four inhabited islands in the group.

Set against a backdrop of hills, water, and the delicate spires of minarets, the enchanting and complicated Istanbul radiates a unique energy that will be memorable for all who visit.

LEFT // Distinguished by its six slender minarets, the 17th-century Mosque of Sultan Ahmet I is more commonly called the **Blue Mosque** for the 20,000 shimmering handmade blue İznik tiles across the upper reaches of the interior.

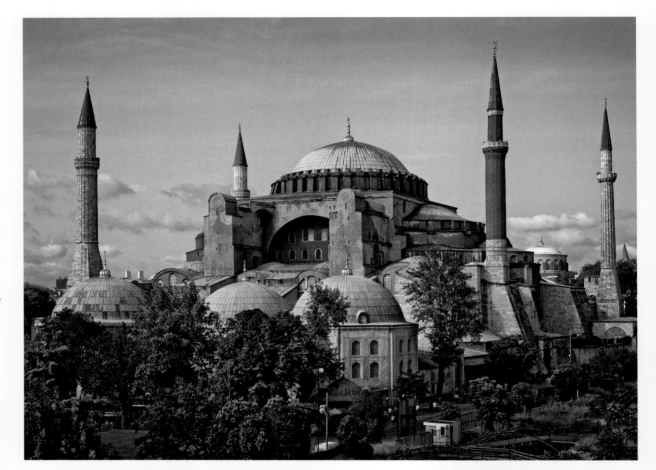

RIGHT // Capped by a massive dome and four elegant minarets, the **Hagia Sophia**—built as a church in the 6th century, then converted to a mosque, and now a museum—is one of the largest enclosed spaces in the world. This spiritual oasis remains the finest structure to have survived from late antiquity.

BELOW // To visit the heart of modern Istanbul, head to the always busy **Istiklal Caddesi**, a pedestrian-only thoroughfare in the Beyoğlu neighborhood. Enjoy a ride on a vintage tram, the stylish shops, and the ornate Çiçek Pasaji (Flower Passage).

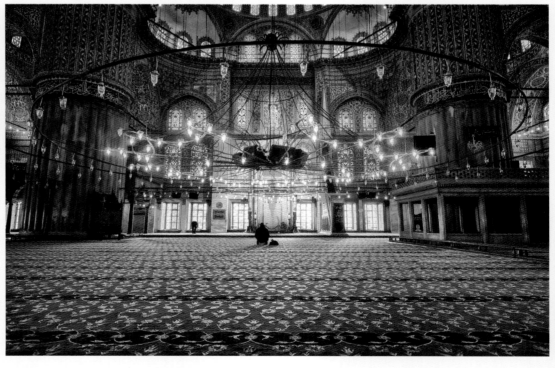

ABOVE // Known for its graceful minarets and stained-glass windows, the **Mosque of Suleiman the Magnificent** is the largest and arguably most beautiful of all of the mosques in Istanbul.

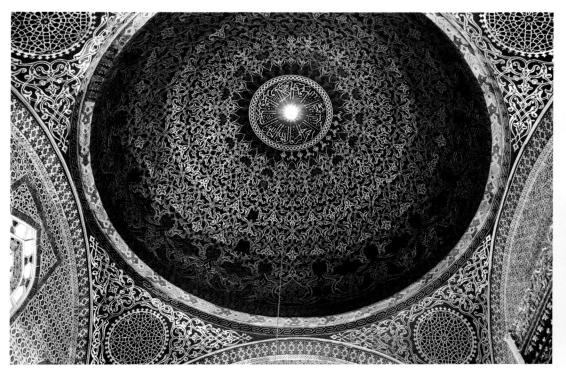

LEFT // Over a period of nearly four centuries, 25 sultans ruled the vast Ottoman Empire from the sprawling 175-acre **Topkapi Palace**. The Treasury's highlights are the emerald-encrusted Topkapi dagger and the 86-karat Spoonmaker's Diamond, but for many visitors, the most exotic stop is the 400-room Harem.

BELOW // Also called the Egyptian Market because many of its goods were once imported from there, the 17th-century **Spice Market** is the place to buy *lokum* (Turkish delight), figs, spices, coffee, tea, apricots stuffed with almonds, pistachios, and honey.

ABOVE, TOP // Commonly known as the Chora Church, the **Kariye Museum** awes visitors with its dazzling 14th-century mosaics and frescoes as well as its extensive collection of Byzantine paintings.

ABOVE, BOTTOM // Everything imaginable can be purchased at Istanbul's **Grand Bazaar**, a warren sprawling across 65 streets that houses some 4,000 shops, tiny cafés, and restaurants. Follow the locals to the less touristy outer corners.

ABOVE // Indulge in a traditional Turkish bath at **Cağaloğlu Hamam** near the Hagia Sophia. The Cağaloğlu was a gift to the city in 1741 from Sultan Mehmet I.

THE WHIRLING DERVISHES OF KONYA
Konya, Turkey

// Prayer in Motion in Turkey's Holiest City

Turkey's most important center of Sufism, a mystical sect of Islam, Konya is home to the Whirling Dervishes of the Mevlevi order, founded by the followers of the 13th-century Persian poet and philosopher Rumi. They believe that a state of universal love can be induced by whirling around and around.

Must Do // Attend mid-December's *semâ*, a ritual dance that is one of the world's most mesmerizing spectacles // Tour the Mevlana Monastery, now a museum containing the elaborate tomb of the sect's founder.

PATARA AND DEMRE
Turkey

// Looking for St. Nick on the Lycian Coast

Children would be astonished to learn that Santa Claus hails not from the North Pole but from Turkey's Mediterranean coast. St. Nicholas was born at Patara, now known for its pristine beach on the Lycian Coast, and eventually made his way to nearby Demre, the ancient city of Myra, where he was regional bishop until his death in AD 343.

Must Visit // Ruins in Myra (*left*) // The well-preserved amphitheater in Patara National Park // The 8th-century Church of St. Nicholas in Demre, where it is believed the saint is buried

GALLIPOLI
Thrace, Turkey

// Pilgrimage to a Solemn
World War I Battleground

It's not difficult to imagine that ghosts still haunt Gallipoli more than a century after the greatest Allied disaster of World War I, in particular the Australians and New Zealanders killed at Anzac Cove. Visitors come to Gallipoli to pay homage to the 130,000 men killed and 400,000 wounded during the 9-month battle in 1915 to gain control of the Dardanelles, the strategically important sea lane that connects the Black Sea with the Mediterranean.

Must Do // Visit the more than 50 cemeteries and memorials [left] scattered along the rugged 22-mile peninsula, which today is a peaceful national park covered in brush and pine forests // On April 25, attend the annual memorial service—along with thousands of Australians and New Zealanders—at Anzac Cove, the disastrous landing site of their troops.

TOLKUCHKA BAZAAR
Ashgabat, Turkmenistan

// Color and Chaos in
the Desert

Turkmenistan is a fascinating and enigmatic country. Isolated and reticent toward foreigners (visitors are required to have a guide at all times), it is also the home of the massive Tolkuchka Bazaar near the capital city of Ashgabat. Customarily a Sunday market, the bazaar is now open on Thursdays and Saturdays as well.

Must Do // Shop for pretty much anything here—the traditional handwoven and naturally dyed carpets that Marco Polo praised in letters home; livestock, including horses and camels; or produce // Make Ashgabat the jumping-off point for trips to the ancient ruins of Merv or neighboring Uzbekistan.

BUKHARA
Uzbekistan

// Holy City Suspended in Time

Bukhara's Old Town remains as lived-in as it was 500 years ago. Its maze of mud-brick alleys takes visitors to hidden mosques, splendid 19th-century homes, and even old synagogues. Outside the protected center are more architectural gems, including the 1,000-year-old Ismail Samani Mausoleum and the opulent summer palace of the last Bukharan emir.

Must Visit // The Kalon Minaret, built in 1127, one of the few buildings not destroyed by Genghis Khan // The spectacular Mir-i-Arab Madrassa [right], opposite the Kalon Minaret

KHIVA
Uzbekistan

// Time Travel in a Silk Road Capital

The finest showcase of medieval Islamic architecture in Central Asia and the best-preserved city on the old Silk Road, Khiva rises miragelike from the desert, an ancient walled fortress built from the earth on which it stands.

Must Visit // Ichan-Kala fort [*left*], one of Khiva's most impressive features // Kuhna Ark, the Old Citadel, a palace with harems, stables, a throne room, and a jail lined with manacles // The 10th-century Djuma Mosque, supported by more than 200 wooden columns // Pahlavan Mahmoud Mausoleum, royal burial tombs that are a masterpiece of graceful architecture

SAMARKAND
Uzbekistan

// Crossroads of Culture in the "Rome of the East"

Genghis Khan reduced Samarkand to rubble in 1220, but Tamerlane the Great later restored the city and built the colossal mausoleum Gūr-e Amīr. The city is also home to the Sha-i-Zinda, a huge necropolis overlooking the tomb of Qussam Ibn Abbas, a cousin of Mohammed who is said to have brought Islam to the region in the 7th century.

Must Visit // The Registan [*above*], an ensemble of three madrassas flanking a vast square, Samarkand's pièce de résistance // The Bibi Khanum mosque near Sha-i-Zinda, dedicated to the memory of Tamerlane's favorite wife

Southeast Asia

KEP
Cambodia

// A Colonial Coastal Retreat

From the 1900s to the 1960s, colonials journeyed to this seaside town on the Gulf of Thailand, and the graceful arc of the island's main beach still seems like an early-20th-century French daydream. With its broad pedestrian corniche punctuated by graceful wrought-iron lamps, Kep is blissfully free of modern distractions, and is slowly being sought out by Phnom Penh's expat set.

Must Do // Check out the afternoon crab market // Trek to the monkey-populated jungle of Kep National Park // Sail to nearby Koh Tonsay, for immaculate beaches and snorkeling.

THE SILVER PAGODA
Phnom Penh, Cambodia

// Khmer Treasures in a City Rediscovering Itself

Once considered the loveliest of the French-built cities of Indochina, Phnom Penh still retains much of its charm despite the violence of Cambodia's late-20th-century history. The Silver Pagoda (*left*) in the sprawling Royal Palace complex remains a showcase for the brilliance of Khmer art and civilization.

Must Visit // The Silver Pagoda's life-size gold Buddha adorned with more than 9,500 diamonds // The National Museum, an open-sided pavilion a pleasant stroll away, for an interesting counterpoint to Angkor Wat

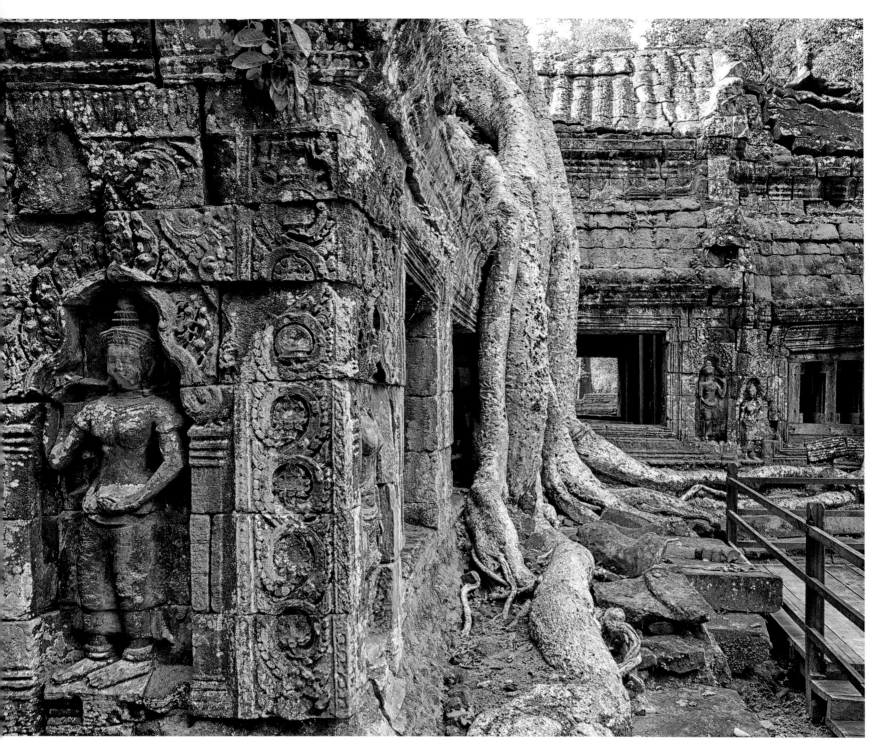

ANGKOR WAT
Siem Reap, Cambodia

// A Temple City Reborn

One of the world's premier architectural sites, Angkor's temples and monuments encompass about 40 square miles in northwestern Cambodia. The capital of the Khmer Empire from AD 800 to approximately 1200, the site was abandoned in 1431 following the conquest of the Khmer kingdom by the Thai kingdom. The area's uncontested highlight is Angkor Wat (*right*), a vast temple complex built at the beginning of the 12th century. It took 25,000 workers more than 37 years to complete, but after the fall of the empire it was unknown to the outside world until 1860, when French botanist Henri Mouhot stumbled upon it deep in the jungle. Cambodians revere the site, whose iconic profile is featured on the national flag, and it's especially important to Buddhists.

Must Visit // The Bayon, in nearby Angkor Thom, the last great temple built at Angkor // The much-photographed Ta Prohm temple complex (*above*), a labyrinth of porticoes and halls that is slowly being entombed by the massive roots of ancient trees, a mile east of the Bayon

BEACHES OF BALI
Bali, Indonesia

// Oceanfront Escapes on the Island of the Gods

Beautiful Bali is justly celebrated for its many palm-fringed beaches. In the south, the graceful arc of Jimbaran Bay is an antidote to the nightclub-enhanced shopping mall that Kuta Beach is now known for and on the island's northwest coast, Lovina Beach is a quieter alternative to the energetic south coast.

Must Do // Get up early to go dolphin watching // Explore Singaraja, near Lovina Beach, for a glimpse into the days of Dutch colonial rule // Make the 2-hour drive west to Pulau Menjangan (Deer Island), renowned for scuba diving and snorkeling // Travel the beautiful coast road from Amed around Bali's eastern tip back to the south coast.

UBUD
Bali, Indonesia

// Bali's Capital of Art and Culture

The Balinese believe that the gods live in the mountains, and this is as good a reason as any to leave the busy beach areas of Kuta and Sanur and head north into the hills to Ubud, the capital of Bali's artistic heritage that still possesses much of the allure that first drew European painters and sculptors in the 1920s.

Must Do // Rent a bicycle or jeep to get away from Ubud's congested main strip and take in its fabled rice fields (*right*) for a closer look at village life // Journey by bicycle for a closer look at village life // Join a river-rafting trip down Ubud's Ayung River, past towering cliffs and cascading waterfalls // Sign up for cooking classes to explore the rich local cuisine // Visit the many villages, each known for a different craft.

BOROBUDUR AND PRAMBANAN
Java, Indonesia

// Discovering Java's
Hindu-Buddhist Past

The hike to the top of the 9th-century Buddhist monument of Borobudur rewards travelers with 360-degree views of a quartet of active volcanos. A massive UNESCO-directed restoration was completed in 1983, refurbishing more than 3 miles of hand-carved reliefs that wrap around the pyramidal structure's ten terraces. The higher levels are studded with 72 bell-shaped stupas and more than 400 Buddhas (*right*). Nearby and southeast of Borobudur is the Hindu site of Prambanan, a 9th-century complex of more than 200 temples and shrines, 8 of which have been restored.

Must Do // Rise early to catch sunrise at Borobudur—it's magical // Attend Prambanan's Ramayana ballet under a full moon in the dry season.

YOGYAKARTA
Java, Indonesia

// Keeper of
Javanese Heritage

Known to Indonesians as Yogya, this cultural hub is still ruled by sultans, whose sprawling palaces are windows into 18th-century Islamic court life and often host performances of mesmerizing gamelan music, which has been describec as the "sound of moonlight."

Must Do // Attend classical dance productions along with the royal family and their batik-uniformed court (*above*) // Shop for intricate silverware, leather shadow puppets, and colorful batiks // Sample local cuisine such as a *lumpia ayam* (chicken spring roll) and *kelepons* (sweet rice-flour rolls in shredded coconut).

KOMODO NATIONAL PARK
Komodo, Indonesia

// Into the Dragons' Den

Komodo Island is the nearest thing to a 21st-century Jurassic Park. It was established as a national park in 1980 to protect the Komodo dragon [*right*], which grows to between 6 and 10 feet long, weighing around 150 pounds. The park is home to 5,000 Komodo dragons, as well as Timor deer, wild horses, wild boar, long-tailed macaques, palm civets, and giant fruit bats. It is also regarded as one of the world's richest marine environments, which makes for spectacular diving and snorkeling.

Must Do // Visit the park as part of a guided tour—Komodo dragons are very dangerous, as are the island's hooded cobras and Russell's pit vipers // Head to Pantai Merah, or Pink Beach, on the nearby island of Rinca for excellent diving and snorkeling.

LOMBOK AND THE GILI ISLANDS
Lombok, Indonesia

// An Evolving Alternative to Bali

Lombok may not have Bali's Hindu temples, colorful festivals, or lush vegetation, but its drier climate, unspoiled beauty, and relative lack of commercial tourism make it a compelling alternative. And just off the northwest coast, the three smaller Gili islands [*left*] offer excellent diving and snorkeling with a growing number of overnight options.

Must Do // Make the 3-day trek to the top of Mount Rinjani, considered one of the best climbs in the area // Take a guided 4-hour hike along terraced rice paddies through farming villages to 150-foot waterfalls // Arrange a private sailing or motor boat outing for a day trip around the island.

BALIEM VALLEY
Papua, Indonesia

// Bridging Cultures and the Centuries

Indonesian West Papua is the home of the Asmat people, famous for their wooden carvings and rituals, and the Dani tribesmen [*right*], the "gentle warriors" of Baliem Valley, who wear ornamental headdresses, war paint, and pig tusks through their noses, though much of this is staged these days for tourists or special festivals.

Must Do // Arrange a visit through a specialist company, as travel in Papua is not for the inexperienced // Take tours or treks from Wamena, the Baliem Valley's commercial center.

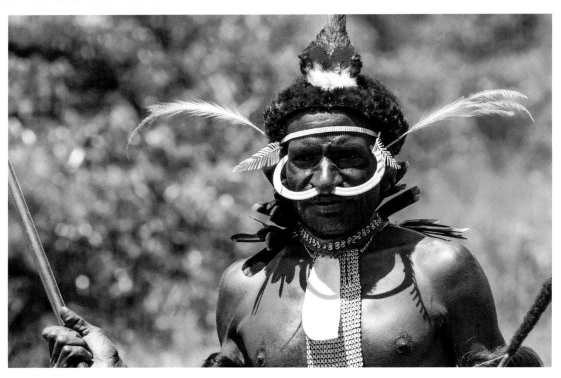

RAJA AMPAT ARCHIPELAGO
Papua, Indonesia

// A Coral Cornucopia

A naturalist's dream and a diver's paradise, Raja Ampat is home to one of the richest coral reef ecosystems on the planet. Located off the Bird's Head Peninsula of Indonesia's Papua Province, this archipelago of more than 1,500 islands and islets clusters around the 3 main islands of Waigeo, Salawati, and Misool.

Must Visit // Cendarawasih Bay, the largest marine national park in the country.

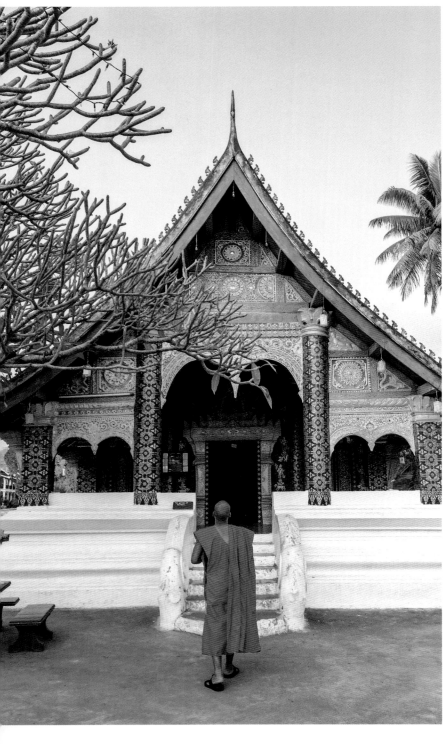

LUANG PRABANG
Laos

// Ancient Capital and Spiritual Heart

This former royal capital sits on a peninsula between the Mekong and Khan rivers and is the center of Laotian Buddhism today. The most exceptional of the city's 32 temples is the 16th-century Wat Xieng Thong, the Golden City Temple, which contains impressive images of the Buddha.

Must Do // Stroll Luang Prabang's main streets lined with well-preserved French-Colonial architecture // Explore waterfalls, mountains, and caves, all within an easy day trip.

SAILING THE MEKONG
Laos (and beyond)

// Indochina's Timeless Lifeline

The Mekong River was once the major artery of the Angkor Empire and remains a symbol and lifeline of Indochina, whose principal sites and cities flourished beside it. Both commuter and river cruise boats ply the Mekong, and travelers have many options for sailing distance and level of comfort. Even small local boats will take on intrepid travelers who want to cruise along the river for a few miles or a few days.

Must Do // Sail on the *Luang Say*, a restored river barge, from Luang Prabang to Houie Say on an overnight cruise // Spend 3 days aboard the *Vat Phou* and tour the southern segment of the river // Visit the waterfalls of Phapheng, the largest in Southeast Asia // Tour the pre-Angkorian Wat Phou, home of some of the best Khmer art in Southeast Asia.

VIENTIANE
Laos

// Sleepy Capital Rich
with Pleasures

Much of Vientiane, the capital city of
Laos, was razed in 1828 by the Siamese
in response to a failed attack. The oldest
structure that remains today is Wat Sisaket,
completed in 1824. One of its newer additions
is the "Friendship Bridge" (*left*) connecting
Laos to Thailand, which brings tourists who
come to slow down, chill out, and recharge.

Must Do // Visit the Nam Phou Palace, the
gold-gilded stupa Pha That Luang, and the
central market // Enjoy barbecued chicken
and spicy green-papaya salad with a cold
Beer Lao at sunset at any of the thatched
bars or casual eateries along the Mekong.

SIPADAN
Sabah, Borneo, Malaysia

// Epic Diving in
the Celebes Sea

Part of the Semporna Archipelago off
the coast of Borneo, tiny Sipadan sits
atop a submerged volcano in a protected
conservation zone. With a cap of 120 visitors
a day, no overnight accommodations, and
12 dive locations, this speck in the Celebes
Sea appears on every diver's dream list.

Must Do // Keep an eye out for green
turtles (*right*) and hawksbill turtles, various
species of shark, barracuda, and manta
rays // Book overnight accommodations on
the islands of Mabul and Kapalai for great
shore and boat diving on Sipidan, minutes
away by speedboat // Make the short sail to
the Kapalai sandbar, for diving, snorkeling,
kayaking, and exploring the islands of
Mataking and Sibuan.

BORNEO
Sarawak and Sabah, Borneo, Malaysia

// Island of Incredibly Big Adventures

Start your exploration of the world's third largest island in Kuching, the historic capital of the Malaysian state of Sarawak and a picturesque spot from which to organize expeditions to the Danum Valley, the Kelabit Highlands, and Gunung Mulu National Park. Over in the neighboring state of Sabah, visit the Sepilok Orangutan Rehabilitation Centre, which raises orphaned and injured orangutans before releasing them into the forest.

Must Do // Share gifts and *tuak* (hooch made from fermented rice) with the inhabitants of a longhouse // Seasoned hikers might consider the 2-day climb up Mount Kinabalu, stamina-sapping but manageable if you are accompanied by a guide // Visit the Tunku Abdul Rahman Marine Park on Gaya Island, a short boat trip from Kota Kinabalu.

PULAU LANGKAWI
Langkawi, Kedah, Malaysia

// Jewel of Kedah

Located where the Andaman Sea meets the Straits of Malacca, the Langkawi archipelago of 99 islands is remarkable for remaining a genuine tropical paradise of pure white sand, primary rain forest, magical sunsets, and sun-filled days. Mountainous Pulau Langkawi is one of only two inhabited islands.

Must Visit // The cable car up to the Langkawi Sky Bridge (*right*), a curved pedestrian bridge with incredible views // Pantai Cenang, Pulau Langkawi's most commercial beach strip

FEASTING ON KL'S STREETS
Kuala Lumpur, Malaysia

// A Melting Pot of Cuisines

Boasting an authentic array of edible delights, Malaysia's cosmopolitan capital offers a feast of dining options from streetside stalls (*left*) and brightly lit night markets to white-tablecloth restaurants with world-class chefs. The range spans the globe, focusing principally on a fusion of Chinese, Indian, and Malay cuisines.

Must Do // Join the locals at the outdoor restaurants lining the Jalan Alor in the Golden Triangle district // Explore the nearby Changat Bukit Bintang, a sophisticated strip of restaurants and bars // Have breakfast from the stalls on Madras Lane.

MELAKA
Malaysia

// Malaysia's Historic Cradle

Located in a pivotal spot on the once important and highly lucrative spice route between China and Europe, the glory days of Melaka (also known as Malacca) may now only be a page in Malaysia's textbooks, but the town's abundance of monuments and historic buildings attract ever-growing numbers of visitors.

Must Do // Tour St. Paul's Church, which dates back to 1521 when St. Francis Xavier was a regular visitor // Hire a trishaw (*right*) at Stadthuys, the former governor's residence, to see more of the town // Head to Chinatown's Jalan Hang Jebat for the Jonker's Walk Night Market, held every Friday and Saturday.

PENANG
Malaysia

// Pearl of the Orient

The island of Penang is one of the most colorful, multiethnic communities in Asia, and a ride on a trishaw is the classic way to tour the main city of Georgetown's colonial-era shops, temples (*left*), and clan houses that make up Chinatown and Little India.

Must Visit // The ornate Khoo Kongsi clan house and the impressively restored Anglo-India Suffolk House // The shops along Stewart Lane and nearby Armenian Street // The peak of Penang Hill, for panoramic views via a funicular

MERGUI ARCHIPELAGO
Andaman Sea, Myanmar

// Home to a Nomadic Seafaring People

The Moken people (*right*) who live on this mostly uninhabited and relatively unexplored archipelago move in flotillas to trade whatever bounty can be foraged from the sea. Their boats, called *kabangs*, are made from a single tree and when lashed together, they form a small floating village.

Must Do // Access the main islands from Kawthaung on the mainland // Arrange a land or water excursion at one of the few hotels on Fork (Macleod) Island // Visit Lon Khuet island, where birds' nests are farmed in huge caverns // Explore Lampi Kyun island's mountainous interior, home to a wide variety of wildlife.

BAGAN AND A CRUISE ON THE AYERWADY RIVER
Bagan and Mandalay, Myanmar

// Drifting Down Myanmar's Watery Highway

Board any of the eminently comfortable river boats for a cruise on the Ayerwady to observe the languid and timeless rhythms of rural life and the area's 2,500 years of history. The most arresting of the riverside settlements is the ancient city of Bagan (*left*), where some 2,200 Buddhist pagodas create a forest of spires and pinnacles.

Must Do // Visit the Ananda Temple, in Bagan, and its four 30-foot golden statues of the Buddha // Tour the Shwezigon in Bagan, said to house the collarbone and a tooth of the Buddha // Enjoy sunrise from a hot-air balloon or sunset from a hotel-top terrace // Head to Mandalay, north of Bagan, an important historical and religious destination.

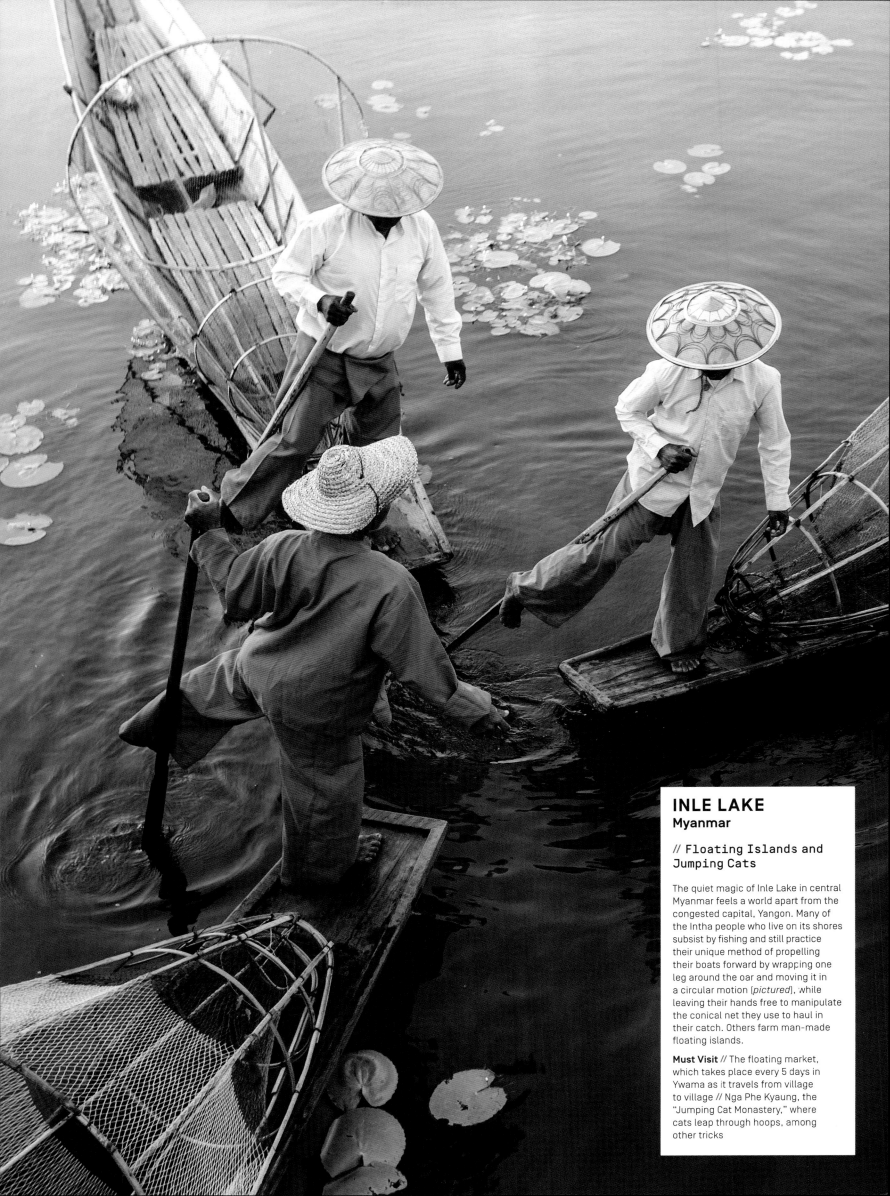

INLE LAKE
Myanmar

// Floating Islands and Jumping Cats

The quiet magic of Inle Lake in central Myanmar feels a world apart from the congested capital, Yangon. Many of the Intha people who live on its shores subsist by fishing and still practice their unique method of propelling their boats forward by wrapping one leg around the oar and moving it in a circular motion (*pictured*), while leaving their hands free to manipulate the conical net they use to haul in their catch. Others farm man-made floating islands.

Must Visit // The floating market, which takes place every 5 days in Ywama as it travels from village to village // Nga Phe Kyaung, the "Jumping Cat Monastery," where cats leap through hoops, among other tricks

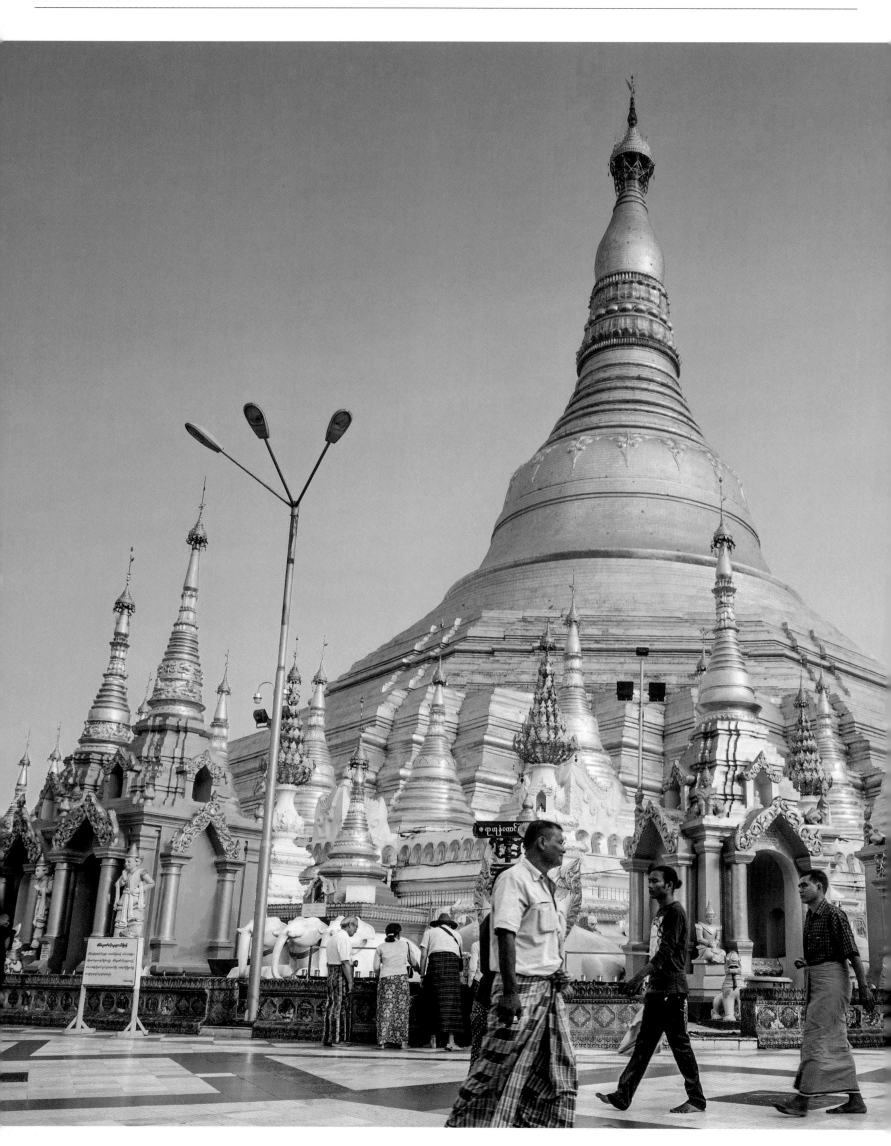

SHWEDAGON PAGODA
Yangon, Myanmar

// The Soul of Burma

Rising majestically above Yangon's tangled skyline, the 320-foot Shwedagon Pagoda with its radiant 32-story stupa and some 60 tons of gold leaf can leave visitors grasping for superlatives. To Buddhists, this is the most revered site in the country. Tradition dictates that devotees and visitors walk clockwise around a profusion of mosaic-covered columns, spires, ornate prayer pavilions, images of Buddha, and 78 smaller filigreed pagodas.

Must Do // Visit the pagoda at the end of the day, when the sun's last rays create a dramatic orange glow.

THE IFUGAO RICE TERRACES
Cordillera, Luzon, Philippines

// Millennia-Old Earth Art

Hand-hewn more than 2,000 years ago by the Ifugao people, who populate the Cordillera's eastern flank around the town of Banaue, these massive rice terraces are flooded through a sophisticated irrigation system.

Must Do // Take a guided walking tour of the picturesque rice terraces in the village of Batad, about 10 miles from Banaue // Make the tricky climb that begins near Batad and ends at the base of the Tappia Waterfall.

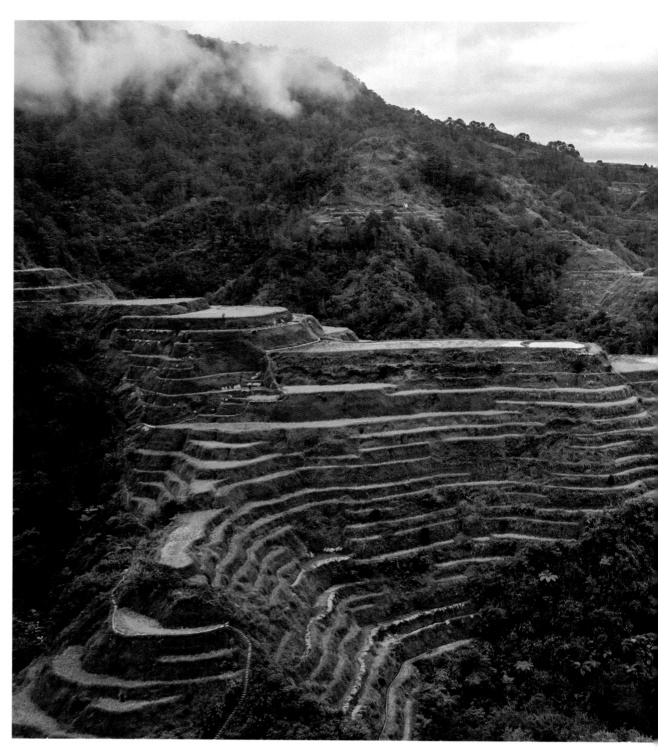

PALAWAN
Philippines

// A Last Frontier of Extraordinary Natural Beauty

A 270-mile-long sliver of island, Palawan is promoted as the Philippines' Last Frontier. Off the northwest tip lies its showpiece: the Bacuit Archipelago—40 islands featuring see-through waters and deserted white sand beaches surrounding jagged limestone outcroppings that soar hundreds of feet into the air.

Must Do // Island-hop in a *bangka* (a traditional outrigger canoe) // Visit the town of El Nido for front-row access to the archipelago or a ferry to the nearby island of Coron // Tour Puerto Princesa's Subterranean River National Park // Arrange for a live-aboard dive trip to the Tubbataha Reefs.

BORACAY
Visayas, Philippines

// Heaven in a Former
Backpacker Haven

This 4-mile-long island is home
to White Beach, the crown jewel of
Philippine tourism and the country's
most famous image. An oasis for
backpackers in the 1970s, Boracay is
now one of Southeast Asia's trendiest
destinations.

Must Do // Kite surf, windsurf, and swim
// Scuba dive in one of the 20 nearby sites
// Venture beyond Boracay to the island of
Panay's vibrant Iloilo City and the Bulabog
Puti-An National Park, for hiking and
trekking.

THE NEW FACE OF SINGAPORE
Singapore

// A City-State's
Extreme Makeover

Having evolved from a sparsely populated island crawling with tigers to a scruffy port city in the 19th century, Singapore has transformed itself again into an economic heavyweight and equatorial tourism destination, following its independence from Malaysia in 1965.

Must Visit // The Sands Sky Park, a cantilevered platform on top of the three towers of the Marina Bay Sands hotel, for 360-degree views from the longest elevated swimming pool in the world // Gardens by the Bay (*above*) for its grove of man-made super trees and a sound and light show at night // The family-friendly Resorts World Sentosa on an island off southern Singapore, home to sandy beaches, an aquarium, Universal Studios, and a maritime museum

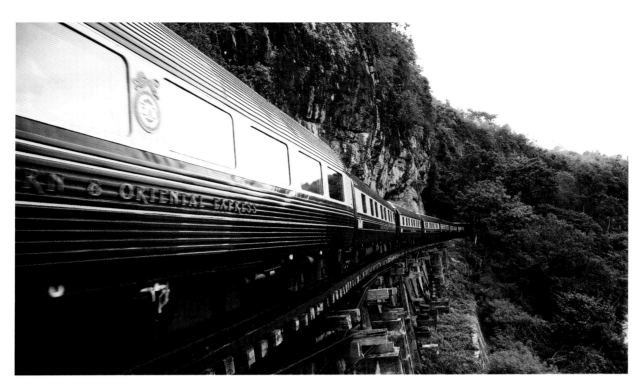

THE EASTERN & ORIENTAL EXPRESS
Singapore

// Colonial Time Travel

The same people who operate the legendary Orient Express in Europe are also behind the E&O Express, a luxurious hotel on wheels, which runs from Singapore to Bangkok, a 1,200-mile, 2-night journey up the Malay Peninsula, with excursions along the way.

Must Do // Hop off the E&O Express to ride a trishaw through old Penang or visit the bridge over the River Kwai // Other options include Bangkok to Chiang Mai and Bangkok to Vientiane on the E&O's 7-day Epic Thailand run for temple touring and elephant rides.

SINGAPORE'S STREET FOOD
Singapore

// Where Dining Is King

Singapore's astonishing variety of Asia's many cuisines is unmatched—Malay, Indonesian, Indian, and Chinese dishes, and the unique local Peranakan, a blend of Chinese and Malaysian traditions. Street food is sold ubiquitously at countless government-regulated "hawker centers," or open-air food courts, where the smells of fermented fish paste, ginger, and curry waft in the air.

Must Do // Sample Sri Lankan chili crab, Hainanese chicken rice, *nasi goreng* (fried rice), or *roti martabak* (flatbread stuffed with meat and rice) // Try durian fruit for dessert if you're feeling adventurous // Explore the well-known hawker centers of Newton and the Maxwell Road cluster (considered one of the best in the city by loyal locals, but don't miss the smaller and always busy ones either).

AYUTHAYA
Thailand

// The Ancient Capital of Siam

Once called the "Pearl of the East," Ayuthaya was the artistic, spiritual, and military center of Southeast Asia and the capital of Thailand. Thirty-three kings created hundreds of temples and thousands of images of Buddha, which were destroyed by the marauding Burmese in 1767. Rather than rebuilding, the heartbroken king relocated his court to Bangkok, 50 miles downriver, where it remains today.

Must Do // Visit Ayuthaya's evocative ruins, including Wat Mahathat (*right*) // Check out the former stockade where wild elephants were once kept, now used to rehabilitate them.

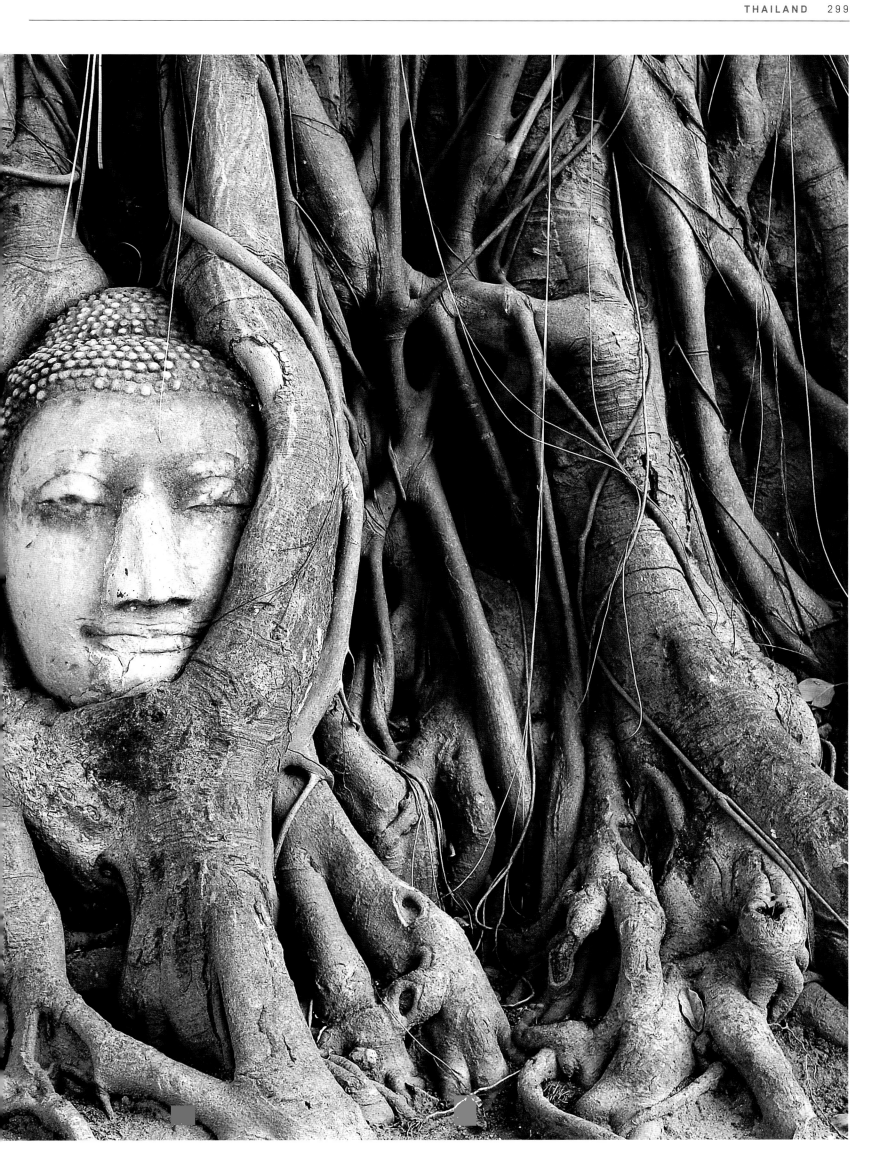

BANGKOK'S MARKETS
Bangkok, Thailand

// Food, Flowers, and a Shopping Frenzy

Chatuchak is one of the world's largest outdoor markets, and the ultimate Bangkok shopping experience. Pak Khlong Talat, another essential market experience, is transformed every night from a vegetable market to the city's biggest flower market.

Must Do // Shop for heady spices, delicate orchids, and creatures like Siamese fighting fish at Chatuchak // Stop at Chatuchak's food stalls for pad thai or brave the zingier chile flavors of *som tam*. For something sweet, line up for *khao tom ka thi*, coconut-infused sticky rice wrapped in a banana leaf // Take a water taxi along the Chao Phraya River to the Tha Saphan Phuts boat stop, and fcllow the crowds to Pak Khlong Talat, where bartering continues until well after midnight.

THE GRAND PALACE AND WAT PHO
Bangkok, Thailand

// Royal Digs and Ancient Massage

Once the walled residence of the Thai monarch, the Grand Palace was created more than 2 centuries ago by the Chakri dynasty of the Kingdom of Siam. The palace complex's labyrinth of more than 100 buildings includes the most famous of Bangkok's 400-odd temples: Wat Phra Kaeo, popularly known as the Temple of the Emerald Buddha.

Must Do // Visit Wat Phra Kaeo to see Thailand's most venerated religious object, a delicate 26-inch seated Buddha carved from semiprecious jade // Explore Wat Pho, a 10-minute stroll south of the Grand Palace, to view the gold-leaf-covered reclining statue of the Buddha [*right*] // Sign up for a traditional Thai massage at Wat Pho and expect a thorough workout for all your body's pressure points as you are rigorously stretched into a state of bliss, fully clothed.

CHIANG MAI
Thailand

// Markets and Temples in the "Rose of the North"

Dubbed the "Rose of the North," Chiang Mai is Thailand's second largest city and the unofficial capital of the country's north. Some of Southeast Asia's best temple visits and crafts and market shopping can be enjoyed here. And the street food can't be beat.

Must Do // Tour the Old City's ancient walls, moats, and beautiful Buddhist temples, the oldest dating to the late 13th century // Savor *laab gai* (spicy chicken salad) washed down with coconut juice straight from the fruit at the Saturday and Sunday Walking Street markets // Shop for woven textiles and myriad other crafts at the night markets, where cheap quality knock-offs are increasingly hard to ignore.

GOLDEN TRIANGLE
Thailand

// Where Borders Meet and Elephants Thrive

The rugged north where Thailand, Laos, and Myanmar meet and the Ruak and Mekong rivers converge was once notorious for illicit opium manufacturing. Today, visits to temples, shrines, and hill tribes are a favorite experience.

Must Do // Arrange a visit by foot, jeep, or boat to any of the region's hill tribes // Stay overnight or visit the Anantara Chiang Rai Resort (*below*) for its much-respected elephant camp, and spend time observing and even helping to bathe them, or walk alongside them as you explore the surrounding jungle.

HUA HIN
Thailand

// Thailand's Royal Resort

Hua Hin, a former fishing village, became the Thai royal family's favorite weekend escape from steamy Bangkok in 1922 when King Rama VII built his summer compound in what would become the country's first glamorous getaway.

Must Do // Take the 4-hour train ride from Bangkok to Hua Hin's 1920s station [*left*] and its Royal Waiting Room, a red-painted teak confection combining Thai style with British whimsy // Enjoy the area's beaches, a favorite of Thai and international visitors alike.

THAILAND'S IDYLLIC ISLANDS
Thailand

// Floating Gems

Thailand is blessed with a bevvy of beach-fringed islands—each distinct from the next. Phuket [*right*] and Samui were some of the original Thai sensations to arrive on the scene in the 1970s, followed by Koh Phi Phi Leh (and the larger Koh Phi Phi Don; *koh* means "island") when it was used as the setting for *The Beach*, starring Leonardo DiCaprio. Those islands originally known for inexpensive digs and full-moon parties have grown up and now boast beaches lined with exclusive resorts and first-class spas, although others have retained something of their early kick-back vibe. Those with airports (Phuket, Samui) facilitate travel time, while many can be reached via ferry from Krabi or Samui. However you arrive, you most likely won't want to leave.

Must Visit: // Phuket is the country's biggest and busiest with the ultimate list of options // Koh Tao attracts those who come to dive—newbies can get certified—and won't break the bank // Koh Pha Ngan is still the place for partygoers, but a low-key vibe can still be found on the other side of the island // Koh Yao Yai and its little sister, Koh Yao Noi, promise a more quiet and idyllic setting with stunning views.

PHANGNGA BAY
Krabi, Thailand

// A Wonderland of Spectacular Limestone Peaks

Phangnga Bay is a spectacular profusion of sheer limestone mountain peaks rising up to 1,000 feet from the Andaman Sea's pistachio-green waters is one of the world's most beautiful natural phenomena. It was the island setting for *The Man with the Golden Gun*, parts of which were filmed on Koh Phing Kan, now known as "James Bond Island."

Must Do // Explore stalactite- and stalagmite-embellished caves, fishing villages built on stilts, and narrow caverns via long-tail boats (*left*) or sea kayaks from the city of Krabi, nearby Phuket // Take the 1-hour boat trip from either Phuket or Krabi to Koh Yao Yai and Koh Yao Noi, islands that are part of a national park.

MAE HONG SON
Thailand

// "City of Mist"

Located in the cool hills 600 miles northwest of Bangkok near the border of Myanmar, Mae Hong Son was founded as an elephant training camp in the 1830s. It remained cut off from the world until a paved road was built from Chiang Mai. A distinct Burmese influence lingers, especially in the town's brightly colored and zinc-trimmed temples and stupas. The swirling mists that give the town its name lift by late afternoon.

Must Do // Travel down the gentle Pai River on a bamboo raft, visit an elephant rehab camp, or hike to tribal villages // Motorbike to the top of Doi Kong Mu hill and the 19th-century Wat Phra That temple for a spectacular view of the Pai Valley and the surrounding mountains.

DA LAT
Vietnam

// Highland Honeymoon in the City of Eternal Spring

Da Lat was a favorite hill station for royalty and the colonial French who wanted to escape the heat of Vietnam's coastal plains. Almost 5,000 feet above sea level, Da Lat is known as the "City of Love" for the Vietnamese honeymooners who come for the clear lakes (*left*), waterfalls, evergreen forests, and flowering gardens.

Must Do // If you have the time to get there by car, travel the 4-hour journey from Ho Chi Minh City to see some of Vietnam's finest scenery.

HA LONG BAY
Vietnam

// The Mythical Bay of Dragons

Vietnamese legend maintains that dragons spouted streams of jade droplets into the waters of Ha Long Bay, forming thousands of islands to protect the bay and its people from invading marauders. Ha Long Bay on the edge of the Gulf of Tonkin is studded with more than 2,000 soaring limestone monoliths that resemble dogs, elephants, toads, and monkeys—creatures that have inspired the islands' names. Cruise boats of every size and shape ply the bay's waters, serving freshly grilled seafood often caught minutes before mealtime.

Must Do // Visit Cat Ba, the largest island in the bay popular for its park, whose grottoes and caves include the multichambered Trung Trang Cave // Join a kayaking trip through the maze of jagged isles // Sign up for an overnight cruise to see craggy peaks being slowly revealed in the indigo dawn of a misty morning.

THE FOOD SCENE IN HANOI
Hanoi, Vietnam

// A Culinary Outpost, Now a Hot Spot

Visitors to Hanoi are spoiled by great street food, outstanding local eateries, and well-priced restaurants serving Pan-Asian and international cuisine. The city's iconic dishes are *bun cha*—a bowl of fresh rice noodles, shredded herbs and vegetables, and grilled pork, served with a sweet-salty-spicy sauce, crispy crab spring rolls, and as much or little chile and garlic as you'd like—and *cha ca* (*above*)—turmeric fish with dill and noodles, which originated at Cha Ca La Vong and is now found citywide.

Must Do // Pull up a child-size plastic stool in any of the holes-in-the-wall popular with the locals; get adventurous and point and say you'd like whatever the table next to you is having.

HANOI'S OLD QUARTER
Vietnam

// A Street for Every Ware

Tucked between the green oasis of Hoan Kiem Lake and the Red River, the Old Quarter of Hanoi (*left*) has been a shopping venue since the 15th century. Rice Street, Silk Street, and Gold Street are named for the goods once sold there (Bootleg DVD Street and Fake iPhone Street have yet to be designated).

Must Do // Bargain for noodles, flowers, antiques, and handicrafts // Visit the 19th-century St. Joseph Cathedral // Explore the quarter on foot, but if the tropical heat rolls, flag down a cyclo, Hanoi's version of a rickshaw // Bock a ticket for the Thang Long Water Puppet Theater for a long-standing puppet show that delights all ages.

SAIGON'S BUSTLING MARKETS
Ho Chi Minh City, Vietnam

// Traders and Terrific Food

Vietnam is a Communist country, but its capitalistic drive is on full display in more than 40 local markets spread around Ho Chi Minh City (still called Saigon by many). The city's largest and oldest, Ben Thanh Market (*right*) is where the traditional is stacked up alongside the modern, and animated haggling is a given.

Must Do // In or near Ben Thanh, tuck into a bowl of *pho* (pronounced *fuh*)—beef noodle soup with fresh herbs—or a *banh mi*, a baguette stuffed with pork pâté, cool cucumber, and spicy condiments // Follow your nose to the herb shops between Luong Nhu Phuc and Trieng Quang Phuc streets before diving into Binh Tay Market in Cholon, the city's Chinatown.

HOI AN
Vietnam

// A Quaint Port with European Influences

Hoi An clings to its charm and heritage despite growing numbers of tourists. Its 800-plus historic structures were miraculously unscathed by the Vietnam War, and many have been converted to shops or restaurants that have helped to create a vibrant, eclectic food scene.

Must Do // Try popular local dishes in the restaurants lining the Thu Bcn River (*above*) // Take a day to see the abandoned Hindu temple complex at My Son, 30 miles southwest of Hoi An // Have customized clothing made in 1 or 2 days; tailor shops are everywhere, though quality can vary.

THE IMPERIAL CITY OF HUE
Hue, Vietnam

// Ghosts of the
Nguyen Dynasty

Halfway between Hanoi and Ho Chi Minh
City, the Hue Citadel was Vietnam's
political, religious, and cultural center from
1802 to 1945. The Imperial City suffered
during the French occupation and the
Vietnam War, but ongoing restoration is
gradually transforming the crumbling ruins
into evocative treasures.

Must Do // Visit the Forbidden Purple City
and the Citadel's Museum of Royal Fine
Arts, for a glimpse of the grand lives of
the royal family // Take a boat down the
Perfume River to see the extravagant
mausoleums of the Nguyen dynasty rulers
// Stop by the city's shop houses to try *banh
khoai*—a rice-flour pancake stuffed with
pork, bean sprouts, and peanut sauce—and
the locally brewed Huda beer.

THE MEKONG DELTA
Vietnam

// Vietnam Through
the Back Door

Referred to as "Vietnam's rice bowl," the
fertile Mekong Delta supplies the country
with most of its rice, fruit, and seafood. Day
visitors from Saigon will see a countryside
little changed by the centuries and
experience the warmth of the local people
in riverside villages accessible only by boat.

Must Do // Explore Can Tho's Phung
Hiep floating market (*left*), where seven
branches of the Mekong converge // Visit
the popular beaches of Ha Tien, just a few
miles from the Cambodian border // Charter
your own wooden sampan at Cai Be, about
60 miles southwest of Ho Chi Minh City.

NHA TRANG
Vietnam

// Beachside R&R

Vietnam's beach capital has one of the most beautiful stretches of sand on the South China Sea. Spend a leisurely evening sampling lemongrass prawns, chile crabs, and abalone at any of Nha Trang's outdoor restaurants or find a spot at Cho Dam, the central food market.

Must Do // Charter a boat or take a guided tour of the scenic islands to the north and south of the beach // Dive or snorkel in the crystal-clear waters off the coast.

PHU QUOC
Vietnam

// Untrammeled and Lovely, Vietnam's Largest Island

Around 30 miles long—roughly the size of Singapore—Phu Quoc features pristine beaches, a lush interior, a handful of resorts, inexpensive local eateries, and a national park that protects 70 percent of the island. The recent opening of an international airport means development is slowly making inroads.

Must Do // Sample dishes prepared with *nuoc mam*, a pungent fish sauce that is Phu Quoc's most famous export // Try to visit before the oncoming tourist boom leaves its mark on this idyllic and unspoiled island.

SAPA
Vietnam

// Tribal Markets in the Vietnamese Alps

The northern town of Sapa is perched at 5,000 feet in the Hoang Lien Mountains, home to 30-odd hill tribes collectively known as Montagnards. The Black Hmong and Red Dao people fill the marketplace on Saturdays to trade their homegrown produce, sell handicrafts, and socialize at the evening's "love market."

Must Do // Head 4 hours north on a Sunday to the market in Bac Ha, home to the colorfully dressed Flower Hmong people (*right*) // Make Sapa the base for day trips or overnight treks to Mount Fansipan (the country's highest peak) // Enjoy long treks along the terraced rice fields for which this mountainous area is known.

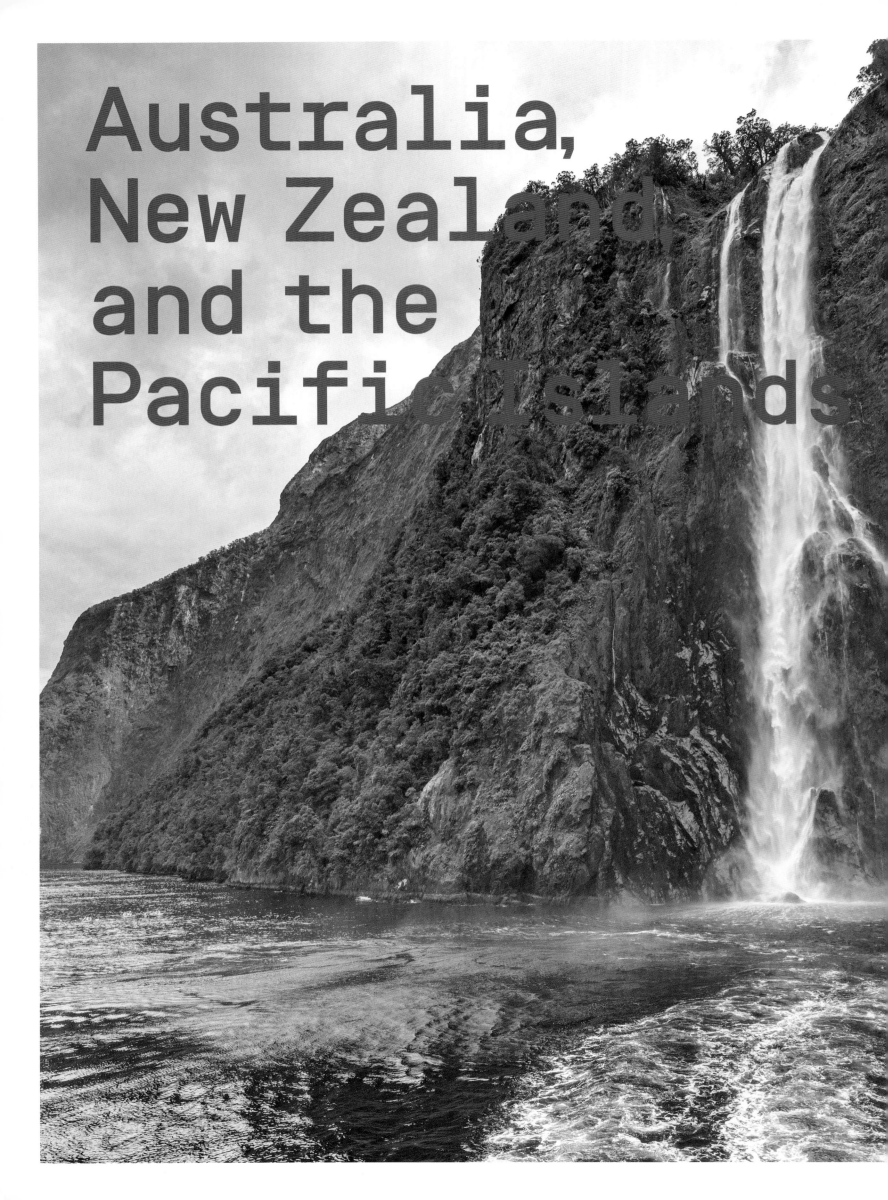

Australia, New Zealand, and the Pacific Islands

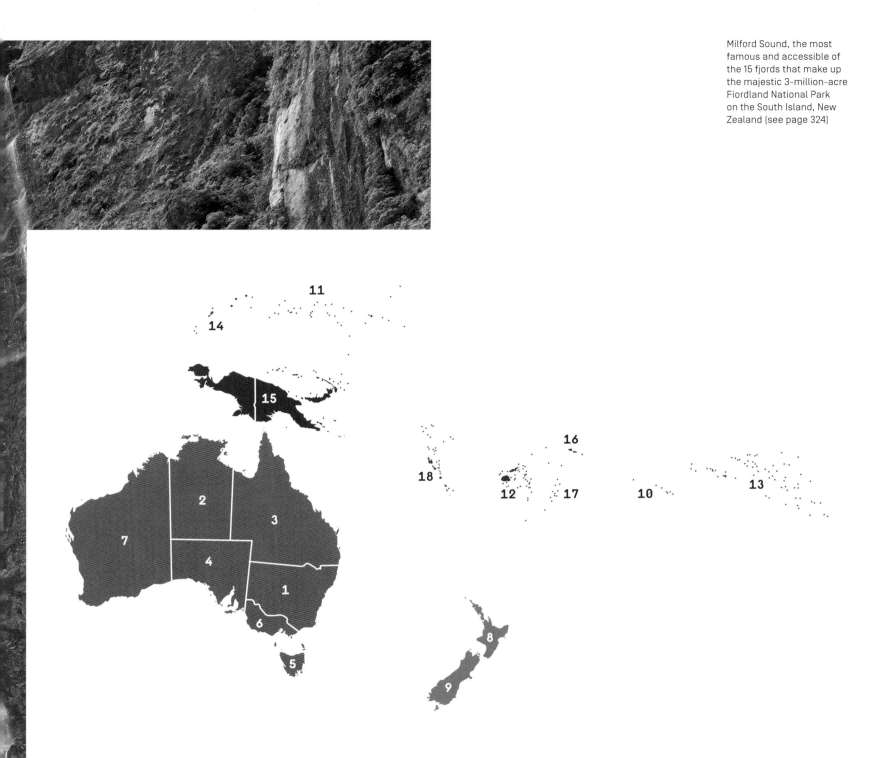

Milford Sound, the most famous and accessible of the 15 fjords that make up the majestic 3-million-acre Fiordland National Park on the South Island, New Zealand (see page 324)

Australia

1 New South Wales
2 Northern Territory
3 Queensland
4 South Australia
5 Tasmania
6 Victoria
7 Western Australia

New Zealand

8 North Island
9 South Island

The Pacific Islands

10 Cook Islands
11 Federated States of Micronesia
12 Fiji
13 French Polynesia
14 Palau
15 Papua New Guinea
16 Samoa
17 Tonga
18 Vanuatu

Australia

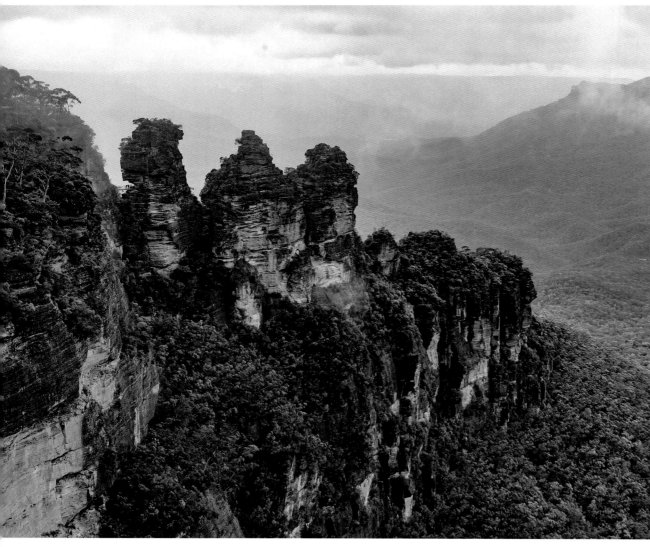

THE BLUE MOUNTAINS
New South Wales, Australia

// Spectacular Scenery in Sydney's Backyard

The highlands 90 minutes away from Sydney in Blue Mountains National Park are not true mountains but a vast sandstone tableland whose dramatic scenery is best enjoyed from lookouts such as Govett's Leap or Echo Point, a good vantage point for viewing the park's famous sandstone pillars, the Three Sisters (*left*).

Must Do // Hop aboard the Scenic Skyway, a glass-floored gondola that travels 1,000 feet above the park // Ride the Katoomba Scenic Railway, an open-sided cog-rail incline that descends at 52 degrees but feels nearly twice as steep.

LORD HOWE ISLAND
New South Wales, Australia

// A Forgotten Paradise in the Tasman Sea

The tiny crescent of Lord Howe Island boasts 90 species of coral, 500 species of fish, and more than 130 recorded bird species, including the endemic woodhen. But crowds on the island will never be an issue; visitors are limited to 400 at a time.

Must Do // Dive or snorkel in this kaleidoscopic underwater world // Picnic on the white sand of Ned's Beach, where tropical fish will eat out of your hand // Hike or bike around this island, which is 7 miles long and 1.2 miles across at its widest.

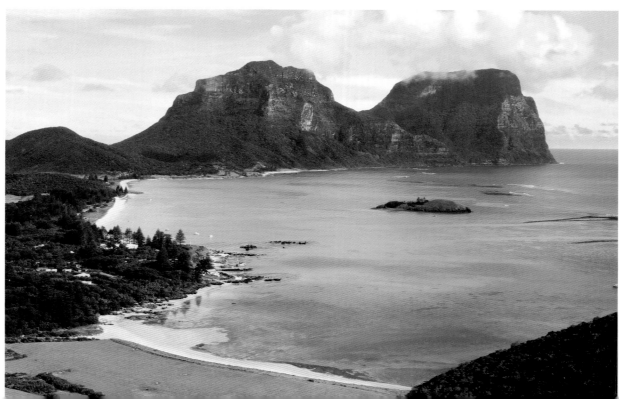

SYDNEY OPERA HOUSE AND THE HARBOUR
New South Wales, Australia

// Great Icons of the Magnificent Waterfront City

The Opera House's sail-like shape is as emblematic of Sydney as the Eiffel Tower is of Paris. After taking the popular 2-hour backstage tour, visitors can explore nearby Circular Quay, the launching point for hundreds of boats and ferries that zigzag across Sydney Harbour.

Must Do // Visit the Royal Botanic Gardens, a 70-acre oasis offering some of the finest strolls in town // Explore the Rocks, home to the Lord Nelson, Sydney's oldest continuously operating pub // Sign up for the Bridge Climb, a 1,300-step trek to the top of the Harbour Bridge, for 360-degree views and bragging rights for life // Catch a ferry to Manly to stroll or bike the 6-mile-long Manly Scenic Walk for spectacular harbor views.

KAKADU NATIONAL PARK AND ARNHEM LAND
Northern Territory, Australia

// Aboriginal Rock Art and Bush Culture

Awarded a rare double honor by UNESCO for both its natural wonders and 5,000 rock paintings (*left*), Kakadu National Park is adjacent to Arnhem Land, one of the few places in Australia where Aboriginal culture still dominates.

Must Do // Visit Ubirr, 27 miles north of park headquarters, where images record life from the Stone Age to the early 20th century // Sign up with Lords Safaris, the only accredited outfitter to offer access to Arnhem Land, Koolpin Gorge, and the Mary River floodplains // Take an airboat ride on the floodplains to look for blue-winged kookaburras or set off in a four-wheel-drive vehicle to view wallabies, wallaroos, dingoes, and crocodiles in the drier months.

ULURU AND KATA TJUTA (AYERS ROCK AND THE OLGAS)
Northern Territory, Australia

// Spiritual Shrines in the Outback

The great orange-red monolith of Uluru (Ayers Rock, *left*) rises 1,142 feet above the desert plain and has a circumference of nearly 6 miles. Visitors can no longer climb the rock because of both its religious significance to the Aborigines as well as possible risk of injury, so opt to walk the trail at its base. About 30 miles west of Uluru lies Kata Tjuta (the Olgas), a similarly spectacular group of 36 gigantic rock domes spread over an area of 15 square miles.

Must Do // Hike Kata Tjuta's Valley of the Winds, a 4.6-mile loop best experienced in the cool of early morning.

THE TIWI ISLANDS
Northern Territory, Australia

// Keep Ancient Ways Alive

All but unknown to the outside world, Bathurst and Melville islands are home to the Tiwi Islanders, who originally came from mainland Australia and were isolated some 7,000 years ago when sea levels rose. Sparsely populated, traditional ways prevail: Dugong and turtle eggs are still hunted and gathered and are essential to the islanders' diet. Tourists can visit Bathurst Island only as part of a Tiwi-owned-and-operated tour (Melville is closed to the public).

Must Do // Be sure to see the *pukumani* (*above*)—elaborately carved and painted poles erected at gravesites // Tour the Catholic church, which reveals the unique blend of Tiwi culture and Christianity // Visit artists' workshops and the Ngaruwanajirri Art Community // Don't miss a "boiling of the billy" tea with Tiwi ladies who chat as they weave (batik patterns are used in the local textile crafts) and paint.

CAPE TRIBULATION
Queensland, Australia

// Where Earth's Oldest Living Rain Forest Meets the Great Barrier Reef

Given its name after Captain James Cook's ship hit a coral reef, this area is protected within the Cape Tribulation and Daintree national parks, and is believed to have been the evolutionary cradle for much of Australia's unique wildlife. The rain forest here (*above*) contains trees that are 3,000 years old, including 85 of the 120 rarest species on earth.

Must Do // Sign up for an adventure trip to snorkel on the Mossman River // Cross the Daintree River by vehicle ferry, then continue to Cape Tribulation beach, where you can zip line through the rain forest canopy // Take a wildlife-watching cruise on the Daintree River to spy crocodiles and all manner of bird species.

FRASER ISLAND
Queensland, Australia

// A Romp on the World's Largest Sand Island

Called K'Gari (Paradise) by the Butchulla Aboriginal people, this is the only place on earth where rain forests are rooted in sand dunes. The 53-mile Fraser Island Great Walk links the island's highlights, but unless you have 6 to 8 days, plan to walk just a portion of it.

Must Do // Swim in freshwater lakes, walk through the Valley of the Giants rain forest, bird-watch with local rangers, join a four-wheel-drive tour, or take long walks on 75 miles of broad coastal beach—the world's most unusual "highway" // Cruise the southernmost tip of the Barrier Reef // Explore the northern tip of the island, where huge sand mountains tower above a vibrant blue sea // Climb to a lookout for a chance to spot manatees, sharks, manta rays, and whales offshore // From August to October, watch humpback whale migration past Fraser to the Antarctic.

THE GREAT BARRIER REEF AND THE CORAL SEA
Queensland, Australia

// Wondrous Undersea Panorama

The Great Barrier Reef, the only living organism on the planet that's visible from outer space, stretches for more than 1,400 miles and is an association of approximately 2,900 separate fringing reefs, with about 600 tropical islands and 300 coral cays sprinkled among them. The largest marine preserve in the world is home to a stupefying profusion of sea creatures, including 1,500 varieties of fish. But the waters of the Coral Sea beyond the reef are in some ways more wonderful yet.

Must Do // Board one of the high-tech catamarans that depart from Port Douglas for the 90-minute trip to an anchored glass-bottomed platform where you can swim, snorkel, or scuba dive // Ride in a semisubmersible vessel and listen to your guide's running commentary on the underwater spectacle outside your window // Explore the wreck of the SS *Yongala*, a mind-boggling sight for experienced divers.

HERON ISLAND
Queensland, Australia

// Jewel of the Reef

This 30-acre island is a coral cay—literally part of the reef itself—half of which is protected as a national park. All you have to do is wade out from the beach and look down. Although no day-trippers are allowed on the island, its sole lodging, the eco-sensitive Heron Island Resort, sponsors reef walks at low tide and offers diving and snorkeling off a private beach.

Must Do // Strap on a tank and mask or take a semisubmersible ride to glimpse fish, turtles, mantas, reef sharks, and stingrays // Join divers hoping to witness the brief but awesome annual coral spawning that takes place between November and early December // Watch green and loggerhead sea turtles lay their eggs from November to March or view the hatchlings scamper into the sea from January to late April.

SAILING THE WHITSUNDAYS
Queensland, Australia

// A Dazzling Archipelago in the Heart of the Great Barrier Reef

Cradled by the Great Barrier Reef in the Coral Sea, these 74 islands (only 8 are inhabited) are a sailor's dream and offer deserted palm-fringed beaches, scenic bushwalks, and superb snorkeling and diving.

Must Do // Visit Whitsunday Island's Whitehaven Beach, possibly Australia's finest, and Hill Inlet at its northern end (*right*) // Sail on luxury crafts or bareboats for DIY adventurers, or sign up for a half or full day of diving and snorkeling // Fly into Hamilton Island, the most developed of the Whitsundays // Golf the 18-hole championship Hamilton Island Golf Club.

ADELAIDE
South Australia, Australia

// High Culture in South Australia

Much of this "city within a park" is made up of green spaces, including the Botanic Gardens, Veale Gardens, Himeji Garden, and Elder Park. But one of Adelaide's best-known landmarks is the Central Market, where growers and producers sell gourmet cheeses, smoked meats, artisanal breads, fruits, and vegetables. The city is also home to the world's largest collection of Aboriginal artifacts at the Australian Aboriginal Cultures Gallery in the South Australian Museum (*left*).

Must Do // Drive 15 minutes to Penfolds Magill Estate to sample world-renowned wines // Visit in March for the biennial Adelaide Festival of the performing arts; the annual Fringe Festival; and WOMADelaide, an annual world music festival.

AUSTRALIAN WINES
Australia

// World-Class Vineyards

An easy 2-hour drive from Sydney, Hunter Valley draws lovers of fine wine from across the globe for some of the world's best shiraz sémillon, award-winning chardonnay, cabernet sauvignon, and a vibrant gourmet food culture. The wine industry has given a cosmopolitan veneer to Margaret River [*right*], a remote and beautiful southwestern corner of the country. And picturesque Barossa Valley just outside Adelaide is another epicenter for all things gastronomic.

Must Do // Near Hunter Valley, the Tallavera Grove winery // Visit Margaret River mid-September to mid-November to see the area's many wildflowers at their peak and explore its delightful town // Stop at a Barossa butcher for smoked mettwurst, lachsschinken, and bratwurst, reflecting the area's early German settlers.

FLINDERS RANGES
South Australia, Australia

// Authentic Outback,
Untamed and Raw

Fascinating in their rugged beauty and
for their renowned geological formations,
the Flinders Ranges are estimated to be
800 million years old and harbor some of
the planet's oldest animal fossils. These
desert mountains start about 125 miles
north of Adelaide and stretch for more
than 265 miles, but the most stunning
landscapes are preserved in Ikara-Flinders
Ranges National Park.

Must Do // Explore Wilpena Pound (*left*),
a 31-square-mile natural amphitheater.

KANGAROO ISLAND
South Australia, Australia

// Australia's Galápagos
in the Southern Ocean

Sheep outnumber people 300 to 1 on
Kangaroo Island, which also boasts
kangaroos, Tammar wallabies (now
extinct on the mainland), fairy penguins,
and one of the world's rarest species of
seals, the Australian sea lion, which can
often be seen lounging by the hundreds
at Seal Bay.

Must Do // Explore the Remarkable Rocks,
wind-and-sand-sculpted boulders that
resemble abstract art // Visit Admirals Arch,
a natural limestone bridge that attracts
thousands of fur seals.

CRADLE MOUNTAIN NATIONAL PARK
Tasmania, Australia

// Walks on the Wild Side

Lying 150 miles off the southern coast
of Australia, isolated and mountainous
Tasmania has flora and fauna that exist
nowhere else in the world. The jewel in
this natural crown is Cradle Mountain–
Lake St. Clair National Park, which you can
explore on the 4- to 6-day, 53-mile Overland
Track that begins in Launceston, 120 miles
north of Hobart, the island's capital.

Must Do // Hike the trail around Dove Lake
(*right*), one of the park's most popular
// Book a guided trek covering 6 to 11 miles
a day and ending with a cruise on Tasmania's
most beautiful lake // Take the 4-day guided
Maria Island Walk on an island a short boat
ride from Orford, on Tasmania's east coast.

FREYCINET NATIONAL PARK
Tasmania, Australia

// Inspiring Nature Way Down Under

Freycinet National Park is a dramatic combination of the pink granite Hazard Mountains, white sand beaches, and lapis-blue ocean. A self-guided 2-hour nature walk through fields of wildflowers up and over a spine of mountains leads to Wineglass Bay (*left*), one of Australia's most beautiful panoramas.

Must Do // Hike the 17-mile, 2- to 3-day Freycinet Peninsula circuit for stunning scenery and a rich array of wildlife // Visit the breeding grounds of fairy penguins and black swans // Sign up for a guided walk for the chance to see brilliant parrots, yellow wattlebirds, and laughing kookaburras.

THE GREAT OCEAN ROAD
Victoria, Australia

// An Inspirational Ride to the Twelve Apostles

One of the world's most scenic drives, this 150-mile-long highway hugs the cliffs southwest of Melbourne as it passes the surfing town Bell's Beach, the rock formation of Loch Ard Gorge, the Bay of Islands, and the famous Twelve Apostles (*right*)—seven limestone sea pillars that can be seen from Shipwreck Coast.

Must Do // Hike the 65-mile Great Ocean Walk trail that connects Apollo Bay and the Twelve Apostles // Explore the forested beauty of the Great Otway National Park // Enjoy all manner of water sports at the beach in Apollo Bay.

CABLE BEACH
Broome, Western Australia, Australia

// Pearling Paradise on the Edge of the Continent

Located on the far western edge of the Kimberley region, Broome was a center of the pearling industry in the early 1900s. But the reason to visit today is Cable Beach, which Australians claim is among the continent's most beautiful.

Must Do // Take a sunset camel ride on the beach (*left*) to watch the sun disappear into the Indian Ocean in a swath of color // Visit between March and October to watch for the natural phenomenon called Staircase to the Moon, when the moon's reflection on exposed mudflats at extremely low tide looks like stairs reaching up to the heavens.

SNORKELING WITH WHALE SHARKS
Ningaloo Reef, Western Australia, Australia

// Where Gentle Giants Gather

Ningaloo Reef is one of the few spots in the world where whale sharks (*right*) appear regularly, arriving from April to July to feed on huge shoals of plankton. But the world's largest fish is now listed as a threatened species, and local tour operators restrict the number of people who are allowed to join the sharks in the water at one time.

Must Do // Board a specially designed 50-foot vessel for an intimate and up-close look at these gentle giants // Explore the dunes of Cape Range National Park, where the beach meets the reef, a major breeding ground for three kinds of turtles.

THE KIMBERLEY AND THE BUNGLE BUNGLE RANGE
Purnululu National Park, Western Australia, Australia

// Ancient Mountain Range Hidden in the Outback

At the heart of the Kimberley region in northwestern Australia are thousands of orange-and-black-banded, beehive-shaped sandstone formations known as the Bungle Bungle Range (*left*). While rich in Aboriginal art, this rarely visited but magnificent part of Purnululu National Park is best appreciated from a helicopter or plane.

Must Do // Join a camping safari or hire a local Aboriginal guide to trek through majestic gorges // Take a four-wheel-drive jaunt with one of El Questro Wilderness Park's rangers to see thermal springs, waterfalls, and ancient Aboriginal rock art.

New Zealand

THE BAY OF ISLANDS
North Island, New Zealand

// In the Wake of Captain Cook

The nation of New Zealand was born along a knotty section of coast in the far north of the North Island, where over 150 tiny islands hopscotch across the deep blue waters. The Bay of Islands is renowned as a recreational playground, particularly for its big-game fishing. The majority of fishing and kayaking trips, as well as those that take you to see dolphins—and even swim with them—begin in the beachside town of Paihia.

Must Do // Tour the town of Waitangi, where British officers and Maori chiefs entered into a treaty that granted Queen Victoria sovereignty over New Zealand in 1840 // Make the charming historic town of Russell a departure point for bay excursions // Experience the region the way Captain James Cook did by sailing on the schooner *R. Tucker Thompson* // Watch for minke and Bryde's whales from August to January.

LAKE TAUPO AND TONGARIRO NATIONAL PARK
North Island, New Zealand

// A Paradise for Rainbow Trout and Those They Lure

Located near the center of the North Island, Lake Taupo is in the crater of an ancient volcano framed by the three active volcanoes in nearby Tongariro National Park. Local bumper stickers call New Zealand's largest lake "the Rainbow Trout Capital of the Universe," and they're not exaggerating.

Must Do // Spend an afternoon at Huka Falls on the Waikato River // Visit the nearby Volcanic Activity Center, for insights into the area's geothermal activity // Take the hour's drive north to the bubbling spectacle of Rotorua // Tackle the 11-mile Tongariro Alpine Crossing, which traverses a stunning volcanic landscape across old lava flows to a cold mountain stream and brilliant emerald and blue lakes (*right*).

NAPIER AND HAWKE'S BAY
North Island, New Zealand

// An Art Deco Time Capsule in a Wine Lover's Enclave

Napier stands alongside Miami Beach as one of the world's great Art Deco communities and serves as a delightful base to explore the area's well-known food and wine offerings. Hawke's Bay is the country's second-largest wine-growing region, dating back to the arrival of French missionaries who planted vines here in 1851 and started the Mission Estate Winery, which offers historical tours and some of the bay's finest bottles.

Must Do // Attend February's annual Art Deco Weekend in Napier, replete with vintage cars and flappers // Golf the championship course at Cape Kidnappers, 30 minutes south of Napier, rated as one of the world's finest // View the largest mainland colony of gannets in the world that nests at Cape Kidnappers from September through May.

BUBBLING ROTORUA
North Island, New Zealand

// The World Cracked Open

At the center of an intense thermal field, Rotorua is where mud pools spit, geysers shoot high into the air, and sulfurous steam and gas hiss through crevices in the earth's surface. And although it has become a commercialized enterprise, visitors are still drawn to the geothermal spectacle that George Bernard Shaw called "the most hellish scene" he had ever witnessed.

Must Do // Watch the unpredictable Pohutu Geyser spray up to 100 feet in the air // Head 17 miles south to Wai-O-Tapu to see the Champagne Pool (*left*), an effervescent pond rimmed with brilliant orange minerals, and Lady Knox Geyser, which erupts every morning at roughly 10:15 a.m. // Visit Rotorua's Mitai Maori Village, a living-history museum, to learn about the Maori (one-third of New Zealand's Maori live in the North Island) and the area's indigenous culture.

AORAKI/ MOUNT COOK NATIONAL PARK
South Island, New Zealand

// The Alpine Training Grounds of Sir Edmund Hillary

While the South Island of New Zealand is known for its palm trees and hibiscus plants, one-third of the mountainous Aoraki/Mount Cook National Park found here [*above*] is covered in permanent snow and ice. Visitors should splurge on flightseeing tours of some of the park's 72 named glaciers (keep an eye out for the 17-mile-long Tasman Glacier) and 22 mountain peaks, including the park's namesake, New Zealand's highest mountain at 12,316 feet.

Must Do // Tour two glaciers by boat or kayak to view towering ice cliffs and huge icebergs floating in turquoise waters // Choose from guided heli-skiing, an exhilarating 8-mile-long glacier run, and downhill skiing // Take guided or self-guided walks that take anywhere from 30 minutes to 3 days along the Copland Track // Visit the Sir Edmund Hillary Alpine Centre, to view mementos of one of New Zealand's most admired citizens who trained here.

ARTHUR'S PASS
Canterbury, South Island, New Zealand

// A High-Country Visit in the Southern Alps

Where the Southern Alps run the length of South Island, dividing the east coast from the west, the Kiwis created Arthur's Pass, the highest and most breathtaking of three coast-to-coast shortcuts. Visitors can ski, hike, or mountain bike while reveling in the alpine scenery of the vast Arthur's Pass National Park.

Must Do // Drink in gorgeous vistas on the TranzAlpine Express's scenic 4-hour rail journey from Christchurch to Greymouth.

FIORDLAND NATIONAL PARK
South Island, New Zealand

// The Spectacular Milford and Doubtful Sounds

Of the 15 fjords in Fiordland National Park on the South Island's southwestern coast, Milford is the most famous and accessible, while Doubtful Sound is the deepest and, some say, most beautiful. But the centerpiece of the park is Mitre Peak (*right*), a pinnacle whose reflection is one of New Zealand's most photographed sites.

Must Do // Book flightseeing tours or 2- to 4-hour boat trips or overnight cruises in the park // Hike Milford Track, a trek that takes 4 days and covers 33 miles, for awesome scenery // Don't skip the optional hike to Sutherland Falls, a treat only Milford trekkers can enjoy up close // Drive from Te Anau along the scenic Milford Road that passes through Homer Tunnel, an engineering marvel that brought cars to the sound in 1954.

THE GRAND TRAVERSE
South Island, New Zealand

// Routeburn and Greenstone Tracks

The 24-mile Routeburn Track (*left*), the first leg of the Grand Traverse, crosses the Southern Alps over the breathtaking 3,900-foot Harris Saddle and descends through the landscape of Mount Aspiring National Park, one of the locations used by Peter Jackson for his *Lord of the Rings* trilogy. The trail then picks up the 25-mile Greenstone Valley Walk, which follows an ancient Maori path through Fiordland National Park.

Must Do // Be in top shape for this 6-day trek—it's not just the scenery that will take your breath away // Book guided tours or solitary hikes well in advance and register with the Department of Conservation, as the number of hikers is strictly controlled.

MARLBOROUGH SOUNDS
South Island, New Zealand

// On the Trail of the Grape

The grandeur of the unspoiled Marlborough Sounds and the award-winning vineyards (*right*) encircling the town of Blenheim are two irresistible reasons to visit the Marlborough region, which was first settled by Maori more than 1,000 years ago and where Captain Cook landed in the 1770s.

Must Do // Hike the Abel Tasman Coastal Track or the 42-mile coastal Queen Charlotte Track, which can be done in 1- to 4-day segments // Book customized tours that include guided walks, stays at charming lodges, dolphin- and whale-watching cruises, and visits to local vineyards.

THE HOME OF BUNGEE JUMPING AND JET BOATING
Queenstown, South Island, New Zealand

// Thrill Seeking in the Adventure Capital of the World

Originally a coming-of-age ritual on the Pacific islands of Vanuatu, bungee jumping has been wholeheartedly embraced by thrill seekers who come from all over the globe to jump off Queenstown's Kawarau Suspension Bridge or the Ledge Urban Bungy. Adrenaline junkies who can't get enough can ride a jet boat (right) over the Shotover River, negotiating huge boulders and rushing rapids.

Must Do // Attach a thick rubber cord to your ankles and dive headfirst, a 143-foot drop.

The Pacific Islands

AITUTAKI
Cook Islands

// A Turquoise Carpet on an Indigo Sea

Most first-time visitors to Aitutaki are day-trippers from Rarotonga, the Cook Islands' capital. They come to enjoy the empty shores of the island's 30-mile necklace of 15 palm-studded *motus* (small islands), perfect destinations for picnicking and strolling, not to mention swimming and snorkeling.

Must Do // Take a day trip to one of the islets for a lunch featuring barbecued freshly caught fish // Photograph the flawless white beaches on One Foot Island, the only inhabited motu // Bike to banana and coconut plantations, or take a jeep tour to ancient *marae* (sacred communal spaces) or World War II ruins.

RAROTONGA
Cook Islands

// An Idyllic Island Dedicated to Dance

Rarotonga is a little jewel of an island with most of the action centered around Muri Lagoon, which is ideal for swimming, snorkeling, windsurfing, and sailing. But what really sets the Cook Islands' capital apart is its lively nightlife; there is at least one "island night" feast and authentic dance show (*left*) most days of the week.

Must Do // Find excellent snorkeling off Titikaveka, on the south coast // Hike the 3- to 4-hour Cross-Island Track that starts in Avarua and heads to Te Rua Manga, a landmark needlelike rock // Plan your trip around the Te Mire Kapa (Dancer of the Year Competition) in April or May.

CHUUK LAGOON
Chuuk, Federated States of Micronesia

// A Ghost Fleet in the Graveyard of the Pacific

The island group of Chuuk, known as Truk during World War II, was the stronghold of the Imperial Japanese fleet. But a surprise attack by the US Navy turned Chuuk Lagoon into the graveyard of the Pacific. Today, the lagoon contains the coral-encrusted hulls of 60 Japanese ships (right) that have been transformed into a garden of magnificent artificial reefs.

Must Do // Dive around and in the *Fujikawa Maru,* an aircraft ferry with intact fighter planes standing upright in water 90 feet deep, and the nearby *Shinkoku,* whose operating room makes for an eerie visit.

YAP
Federated States of Micronesia

// Grass Skirts, Stone Money, and Manta Rays

Yap is home to one of the Pacific's last island cultures still resistant to modern ways. Other than the frequently topless islanders wearing grass skirts, the most oft-photographed sights are rai, the wheel-shaped stones once used as money that measure up to 10 feet in diameter. But most of the few visitors who do come are divers who head straight underwater in one of the world's top dive destinations.

Must Do // Swim with 1,000-pound manta rays in their natural habitat.

BEQA LAGOON
Beqa Island, Fiji

// Kaleidoscopic Marine Life

Just off the south coast of Viti Levu, Fiji's main island, the Beqa Lagoon is enclosed by one of the world's longest barrier reefs—90 miles of dazzling coral that makes for a premier diving and snorkeling site. Big-game fishing also beckons, while the surf break known as Frigate Passage offers world-class waves for experienced surfers.

Must Do // Dive with sharks at the Shark Reef Marine Reserve // Watch locals fire-walk across 1,200°F stones, a skill that is now mostly on display at Viti Levu's big resort hotels.

MATANGI ISLAND
Fiji

// Deserted Beaches on
Horseshoe Bay

Horseshoe-shaped Matangi Island is all
that remains of an ancient volcano, half of
which fell away into the sea, leaving behind
two of the finest beaches in Fiji, whose only
visitors are guests of the 240-acre island's
single accommodation, Matangi Private
Island Resort.

Must Do // Dive at the Purple Wall, which
has a 200-foot drop and is covered with
purple soft corals, sea whips, and large
gorgonian fans // Hike across the crater's
rim for sweeping views.

TAVEUNI ISLAND
Fiji

// Colorful Coral Around
a Garden Island

The dense tropical flora growing from fertile
volcanic soil is the reason Taveuni is called
the Garden Island. Hikers can cool off under
Bouma Falls (above), explore the Vidawa
Rainforest Hike, and discover pristine
beaches along the Lavena Coastal Walk, all
part of Bouma Falls National Heritage Park.

Must Do // Dive the premier sites in the
Somosomo Straits, including the 20-mile-
long Rainbow Reef and its stunning Great
White Wall—Taveuni's Mount Everest of reefs.

THE YASAWA ISLANDS
Fiji

// A String of Blue Beads

The daily catamaran service from Fiji's main island of Viti Levu has turned the Yasawas into one of the island nation's most popular destinations. They are loved for accommodations on idyllic beaches that run from high-end resorts to rustic thatched-roofed *bures* (bungalows) and are staffed by people who are some of the friendliest in the South Pacific.

Must Do // Visit the beach at Nalova Bay on Nacula Island, Fiji's most spectacular // Explore this 56-mile stretch of islands with sailings that vary in itinerary and length operated by Blue Lagoon Cruises.

THE MARQUESAS ISLANDS
French Polynesia

// A Cruise to Wild Beauty

The untouched beauty of the little-visited Marquesas Islands has drawn artists and writers for years. Paul Gauguin came for a brief visit and never left. Herman Melville jumped ship off Hiva Oa and later based his novel *Typee* on his time in the Marquesas, while Taiohae Bay on Nuku Hiva inspired Jack London to write, "One caught one's breath and felt the pang that it almost hurt, so exquisite was the beauty of it."

Must Do // The best way to see the Marquesas is on the *Aranui 5*, which links the Marquesas with the outside world // View the dramatic Bay of Virgins on Fatu Hiva, the most beautiful of the Marquesas // Tour the small museums in Atuona on Hiva Oa dedicated to Paul Gauguin and Jacques Brel, who are buried there.

BORA-BORA
Society Islands, French Polynesia

// The World's Most
Beautiful Island

Bora-Bora and its dramatic tombstone-shaped Mount Otemanu [*below*] have mesmerized visitors ever since Captain James Cook saw the island and its famous landmark more than 200 years ago. James Michener called this "the South Pacific at its unforgettable best."

Must Do // Snorkel inshore to see trumpet fish, angelfish, and parrot fish, as well as the rarer Pinocchio and Napoleon fish // Submerge yourself amid dozens of 5-foot blackfin lagoon sharks, which are hand-fed by local divers // Take a four-wheel-drive vehicle up into the mountains, for cliffside views over the lagoon.

HUAHINE
Society Islands, French Polynesia

// Steeped in
Polynesian Tradition

Huahine is one of the few Polynesian islands Captain James Cook might recognize if he were to return today. Tourism has been slow to arrive to this beautiful place, which is still largely agricultural and is often compared to what Bora-Bora and Moorea were before the luxury hotels arrived.

Must Do // Watch the sun set over neighboring Raiatea, Tahaa, and Bora-Bora at Fare, the island's seaport // Take a tour led by a local anthropologist to the ancient *marae* (sacred places) along the shore of Lake Fauna Nui.

MAUPITI
Society Islands, French Polynesia

// The Last Great Secret of French Polynesia

Devoid of luxury resorts, the island gem of Maupiti remains blessedly quiet and laid-back. The only pass into the island's shallow lagoon is so narrow and treacherous that large ships dare not enter, so the only way to visit is by air or a private taxi boat.

Must Do // Bike the 5.5 miles around the island and stop at Plage Tereia, one of the finest beaches in all of French Polynesia // Climb to the summit of the 1,220-foot Mount Hotu Parata with a local guide for a spectacular vista.

MOOREA
Society Islands, French Polynesia

// The Prodigal Beauty of Nature

There is no South Pacific view as spellbinding as the one from Moorea's Le Belvédère, a lookout high on the wall of the extinct volcanic crater that forms this extraordinarily beautiful island, which has served as the backdrop for numerous Hollywood films.

Must Do // Bike, drive, or walk the 36 miles around the island for incredible views of Cook's and Opunohu bays and Mount Rotui (*left*) // Come face-to-face with spinner dolphins at the Moorea Dolphin Center // Visit the Tiki Theatre Village for an island-style dinner and one of the most authentic Tahitian dance shows in French Polynesia.

HEIVA I TAHITI
Papeete, Tahiti, Society Islands, French Polynesia

// The Mother of All Island Festivals

Tahiti has been the most famous South Pacific island since English captain Samuel Wallis became the first European to lay eyes on it in 1767. But with few white sand beaches to keep them here, most visitors quickly move on to the outer islands after arriving at Faa'a's airport, the country's only international gateway.

Must Do // Visit during Heiva i Tahiti (*right*), the 7-week celebration of all things Polynesian that takes place in June and July // Don't miss the dance, fire-walking, and stone-lifting contests // Board the *Paul Gauguin* to visit the other islands.

RANGIROA
Tuamotu Islands, French Polynesia

// Wading with Baby Sharks

Unlike many of the region's volcanic islands, Rangiroa is pancake flat and, with an astonishing array of attractions on and under the water, has been called "God's aquarium." Swimmers love its placid, breeze-brushed waters, while sun worshippers head for its gorgeous pink-hued beaches.

Must Do // Dive in the rip currents of Avatoru and Tiputa passes, to view sharks, dolphins, and manta rays // Take a day trip to the Blue Lagoon to wade amid baby black-tip reef sharks [right].

PALAU
Palau

// Some of the Richest Marine Life on the Planet

Stretching 400 miles along the far western Pacific, Palau consists of 343 islands that many say offer the best diving in the world. The warm, nutrient-rich water supports more than 1,300 species of fish and four times the number of coral species found in the Caribbean.

Must Do // Dive the Ngemelis Drop-off, widely considered the world's best // Explore the Blue Corner's abundant fish life and more than 50 World War II shipwrecks // Tour the 200 Rock Islands, lush limestone outcrops home to cockatoos, parrots, kingfishers, and reef herons // Swim with the nonstinging invertebrates in Jellyfish Lake.

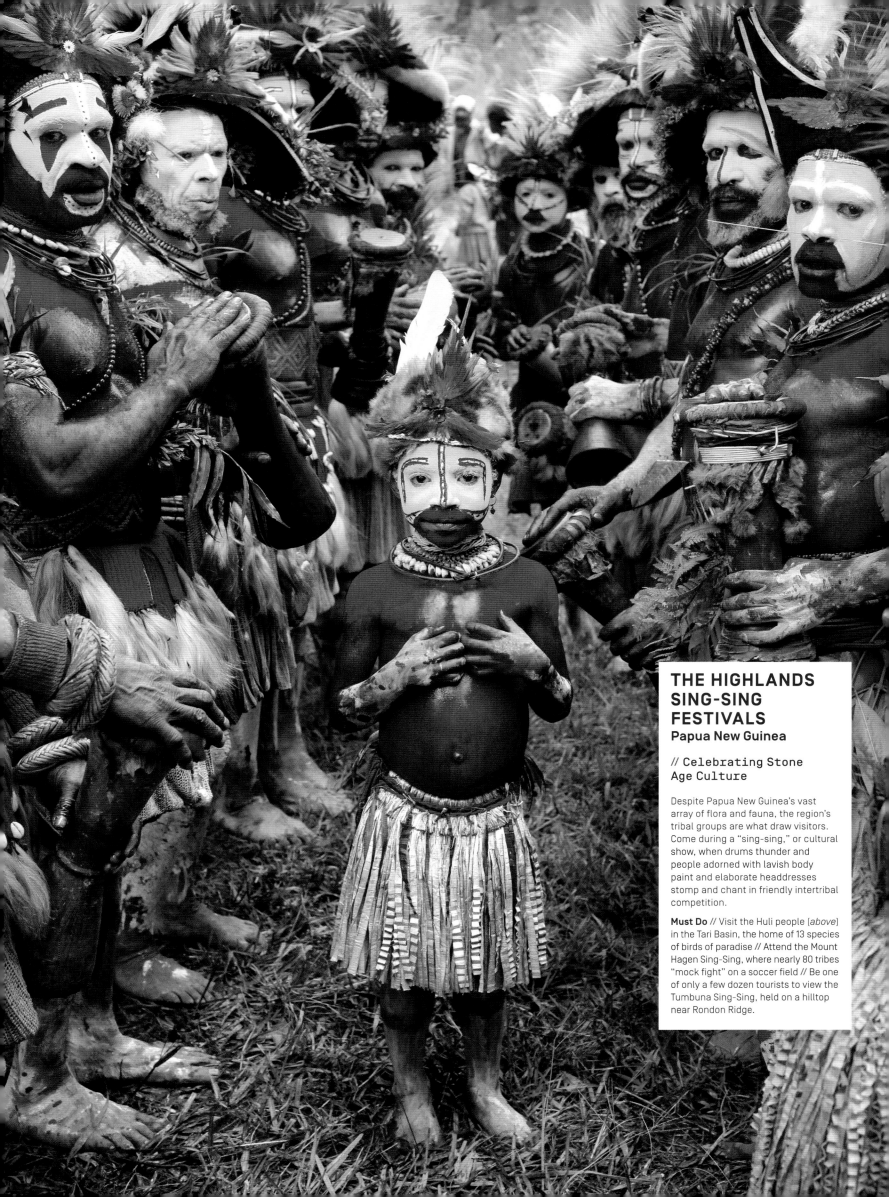

THE HIGHLANDS SING-SING FESTIVALS
Papua New Guinea

// Celebrating Stone Age Culture

Despite Papua New Guinea's vast array of flora and fauna, the region's tribal groups are what draw visitors. Come during a "sing-sing," or cultural show, when drums thunder and people adorned with lavish body paint and elaborate headdresses stomp and chant in friendly intertribal competition.

Must Do // Visit the Huli people (*above*) in the Tari Basin, the home of 13 species of birds of paradise // Attend the Mount Hagen Sing-Sing, where nearly 80 tribes "mock fight" on a soccer field // Be one of only a few dozen tourists to view the Tumbuna Sing-Sing, held on a hilltop near Rondon Ridge.

SEPIK RIVER
Papua New Guinea

// A Mysterious River, Tribal Art, and Birds Galore

The Sepik River was once the domain of anthropologists, naturalists, and adventure seekers. Today, an expedition up this river is for anyone wanting to explore one of the world's last unspoiled reservoirs of nature, culture, and indigenous art. The Sepik peoples express themselves through their wood carving (*left*). Their *tambaran* spirit houses, embellished with intricate posts and gables, are living museums of their past.

Must Do // Join an organized tour, the only feasible way to visit this remote region of few roads and limited air service // Take a canopied motor launch to villages where ancient and modern cultures collide // View cormorants, cockatoos, hornbills, kingfishers, and parrots on the quiet waterway.

SAVAI'I
Samoa

// Lava Fields and a Cultural Storehouse

While Western civilization has affected Upolu, Samoa's main island, the old way of life is still very much alive on Savai'i. This "soul of Samoa" is home to a people who practice ancient customs and religion in *fales* (oval houses) that appear much as they did centuries ago, except the thatched roofs have been replaced by tin ones.

Must Do // Hike to the Afu Aau waterfalls and Pulemelei Mound, the largest archaeological ruin in Polynesia // View the lava blowholes that can shoot up to 100 feet high // Visit Matavanu, a shield volcano created almost entirely of fluid lava flows that resembles a warrior's shield.

ROBERT LOUIS STEVENSON MUSEUM
Apia, Upolu, Samoa

// Telling Tales in Samoa

Robert Louis Stevenson arrived in Samoa in 1889 in search of a climate that would help ease the symptoms of his tuberculosis. The Scottish author and his wife built a Western-style mansion on the slopes of Mount Vaea above Apia, Samoa's picturesque capital. Now home to the Robert Louis Stevenson Museum, the house has been restored to look as it did in 1894.

Must Do // Take the Road of Loving Hearts to Stevenson's grave high on Mount Vaea // Attend a *fiafia* evening of Samoan entertainment.

VAVAʻU
Tonga

// Whale Watching,
Kayaking, and Sailing
in the South Pacific

Humpback whales (*left*) can be seen off many tropical islands, but Tonga's Vavaʻu island group allows visitors to swim and snorkel with the mighty beasts almost as if you were one of them. The whales appear between July and November during their 5,000-mile journey from Antarctica to mate and bear their young.

Must Do // Sign up for a day trip to swim with—and listen to—humpbacks // Explore marine coves and secret beaches on a guided kayak tour // Visit outer-island villages with a guide to experience local culture and attend a traditional umu feast.

VANUATU
Vanuatu

// Wreck Diving, Volcanoes,
and Ancient Bungee Jumping

The 82 islands in the archipelago of Vanuatu present a fascinating mélange of cultures. Well-dressed Europeans dine in French restaurants in Port Vila, the capital city on the island of Efate, while tribes on other islands live as they have for ages.

Must Do // Check out the land-diving ceremony (*right*) on Pentecost Island, a precursor to bungee jumping held on Saturdays from April until June // Dive the World War II–era SS *President Coolidge*, which sank almost completely intact near Espiritu Santo, an hour's flight from Efate // Explore Mount Yasur, one of the world's most easily visited active volcanoes, on the island of Tanna.

The United States
of America
and Canada

The 151-foot-tall Statue of Liberty, designed by Frédéric-Auguste Bartholdi and engineer Alexandre-Gustave Eiffel, was a gift from France in 1885. It sits on Liberty Island in New York Harbor, a symbol of freedom and democracy (see page 397).

← 9

The United States of America

1 Alaska	
2 Arizona	
3 California	
4 Colorado	
5 Connecticut	
6 Delaware	
7 Florida	
8 Georgia	
9 Hawaii	
10 Idaho	
11 Illinois	
12 Indiana	
13 Iowa	
14 Kentucky	
15 Louisiana	
16 Maine	

17 Maryland	
18 Massachusetts	
19 Michigan	
20 Minnesota	
21 Mississippi	
22 Missouri	
23 Montana	
24 Nevada	
25 New Hampshire	
26 New Jersey	
27 New Mexico	
28 New York	
29 North Carolina	
30 Ohio	
31 Oklahoma	
32 Oregon	

33 Pennsylvania	
34 Rhode Island	
35 South Carolina	
36 South Dakota	
37 Tennessee	
38 Texas	
39 Utah	
40 Vermont	
41 Virginia	
42 Washington, D.C.	
43 Washington	
44 West Virginia	
45 Wisconsin	
46 Wyoming	

Canada

47 Alberta
48 British Columbia
49 Manitoba
50 New Brunswick
51 Nova Scotia
52 Newfoundland
53 Labrador
54 Nunavut
55 Ontario
56 Prince Edward Island
57 Quebec
58 Yukon

The United States of America

THE IDITAROD
Anchorage, Alaska, U.S.A.

// "The Last Great Race
on Earth"

Every March competitors mush sled
dogs across 1,150 miles of snow and
ice, in temperatures as low as 60°F
below zero, from Anchorage to Nome
in one of the great endurance tests in
sport. Now a National Historic Trail, the
Iditarod began as a mail and supply route
for miners. In 1925, part of the Iditarod
Trail became a lifesaving highway when
intrepid mushers and their hard-driving
dogs brought serum to diphtheria-ravaged
Nome. In commemoration of those heroic
feats, the route was turned into a race
course in 1973.

Must Do // Bid for a spot on a musher's
sled for the first 11 miles (the auction
begins in November) // View the northern
lights in Nome or participate in the Bering
Sea Ice Golf Classic.

DENALI
NATIONAL PARK
Alaska, U.S.A.

// The American Safari

The tallest peak in North America,
Mount McKinley was named after the
25th U.S. president but is now called
Denali, Athabascan for "the high one."
Visitors to this 6-million-acre park and its
centerpiece mountain can spot grizzlies,
moose, and golden eagles, and enjoy
vistas of the Alaska Mountain Range.

Must Do // Board a bus to tour the park,
as motorized traffic past the 15-mile
point is limited // Arrange flightseeing
excursions or join naturalist-guided hikes
// Take the Denali Star train, which travels
from Anchorage to Fairbanks and passes
through the park, to drink in Alaska's
sweeping beauty.

INSIDE PASSAGE AND GLACIER BAY
Alaska, U.S.A.

// Land of Water and Ice

Visitors can take in some of Alaska's most beautiful coastal scenery while sailing the Inside Passage, which stretches from British Columbia's Queen Charlotte Islands to Canada's Yukon Territory. A ferry from Juneau takes travelers to Gustavus, the gateway to Glacier Bay National Park (*right*), a wonderland at the northernmost point of the Inside Passage.

Must Do // Choose between the 30-plus cruise lines that sail every summer or the long-distance ferries that depart year-round from Bellingham, Washington // Visit Sitka's icon-filled Russian Orthodox St. Michael's Cathedral and the Russian Bishop's House, now a museum // Ride Skagway's narrow-gauge railroad to the summit of White Pass.

THE KENAI PENINSULA AND PRINCE WILLIAM SOUND
Alaska, U.S.A.

// A Majestic Microcosm of Alaska

Lying across a narrow channel from Anchorage, the Kenai Peninsula offers incredible fishing, hiking, kayaking, and wildlife watching, and to its east is the stunning Prince William Sound (*left*), ringed by the Chugach Mountains.

Must Do // Drive the Seward Highway from Anchorage to Girdwood to view extraordinary natural beauty // Stop in Cooper Landing, where fishermen pull in some of the world's biggest salmon // Tour Homer, a small cultural and fishing hub, then kayak or boat across gorgeous Kachemak Bay to Halibut Cove // Board a sightseeing boat in Seward to Kenai Fjords National Park.

CANYON DE CHELLY
Arizona, U.S.A.

// Sacred Outdoor Museum of the Navajo Nation

Multistory dwellings carved into sandstone walls around AD 700 and the area's natural beauty are the principal attractions of Canyon de Chelly (*de-SHAY*), one of the holiest places on the vast Navajo Indian Reservation.

Must Do // Take a Navajo-led jeep tour through the canyon (which is accessible by guided vehicle tour only) // Travel the 15-mile North Rim Drive to Navajo Fortress, where warriors hid from U.S. troops in 1863 // Opt for the 16-mile South Rim Drive for even more remarkable views // Take the steep trail a mile down to White House Ruins // Stop at the spectacular Spider Rock Overlook.

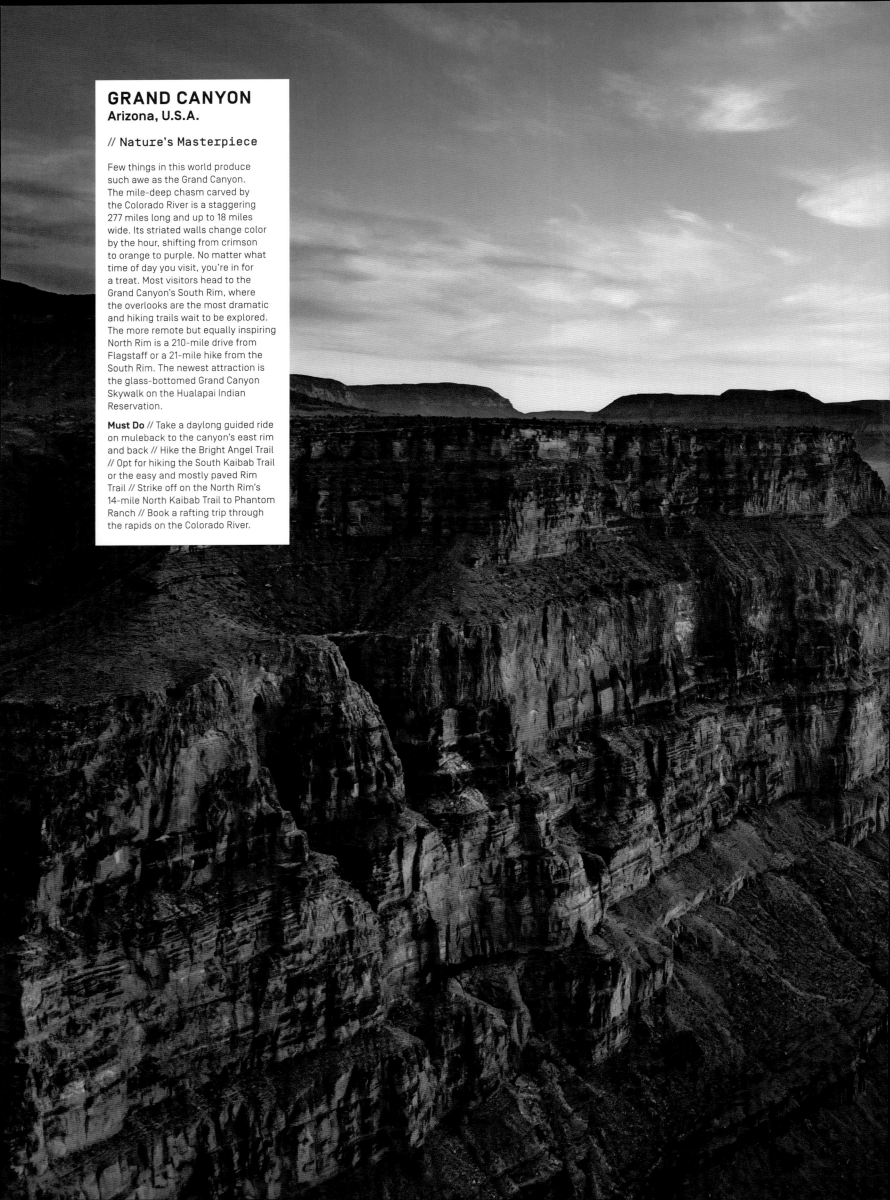

GRAND CANYON
Arizona, U.S.A.

// Nature's Masterpiece

Few things in this world produce such awe as the Grand Canyon. The mile-deep chasm carved by the Colorado River is a staggering 277 miles long and up to 18 miles wide. Its striated walls change color by the hour, shifting from crimson to orange to purple. No matter what time of day you visit, you're in for a treat. Most visitors head to the Grand Canyon's South Rim, where the overlooks are the most dramatic and hiking trails wait to be explored. The more remote but equally inspiring North Rim is a 210-mile drive from Flagstaff or a 21-mile hike from the South Rim. The newest attraction is the glass-bottomed Grand Canyon Skywalk on the Hualapai Indian Reservation.

Must Do // Take a daylong guided ride on muleback to the canyon's east rim and back // Hike the Bright Angel Trail // Opt for hiking the South Kaibab Trail or the easy and mostly paved Rim Trail // Strike off on the North Rim's 14-mile North Kaibab Trail to Phantom Ranch // Book a rafting trip through the rapids on the Colorado River.

LAKE POWELL
Arizona and Utah, U.S.A.

// Man-Made Sea of
the Southwest

Fill the Grand Canyon with water and you get Lake Powell: at 185 miles long and creating some 2,000 miles of more or less road-free shoreline, it is the "houseboat capital of America." Free tours from the Carl Hayden Visitor Center take people inside the 710-foot-high Glen Canyon Dam to see the gigantic turbines that generate power for states across the West.

Must Do // Explore Lake Powell's shoreline in a kayak or houseboat rented in Page, Arizona // View Rainbow Bridge on the southern end of the lake, a site of deep spiritual significance to the Navajo // Visit Antelope Canyon, a popular day trip from Page.

MONUMENT VALLEY NAVAJO TRIBAL PARK
Arizona and Utah, U.S.A.

// The West Written in Stone

Monument Valley is a vast barren plain punctuated by towering red rock formations. A spectacularly scenic—and rough—17-mile dirt road runs from the visitor center past mesas and starkly eroded buttes. But if visitors want to wander off the road, they must be accompanied by a Navajo guide.

Must Do // Visit Window Rock's Navajo Nation Museum // Drive one of the most eye-catching stretches of the Painted Desert from Window Rock to Tuba City // Attend Tuba City's Western Navajo Fair in October for music, dancing, and a parade // Stop at the Hopi Cultural Center, a museum, motel, and restaurant serving traditional fare in the heart of Second Mesa.

SEDONA AND RED ROCK COUNTRY
Arizona, U.S.A.

// "Layer Cake" Terrain and Sandstone Skyscrapers

As if sculpted in crimson stone, the city of Sedona and its red rock towers stand tall against pine-green hillsides and a cerulean sky. The Yavapai Apache consider this area sacred, and seven supposed energy vortexes known for their healing properties draw spiritualists and would-be shamans. Hiking and mountain biking opportunities abound, or visitors can gaze at the scenery from a hot-air balloon or one of the distinctive pink jeeps available for tours.

Must Do // Swim in Slide Rock Canyon State Park or splash about in Oak Creek Canyon // Explore the shops in the Tlaquepaque Arts & Crafts Village // Visit the Chapel of the Holy Cross, a spiritual must-see built into the rock 200 feet above the valley.

CALIFORNIA MISSION TRAIL
California, U.S.A.

// Along El Camino Real

In 1769, Mission San Diego de Alcalá was the first of 21 Franciscan missions established along the coastal El Camiro Real (The Royal Road) that extended from present-day San Diego to Sonoma. A cornerstone of California history, culture, and architecture, these buildings are considered among the most beautiful and important in the state.

Must Visit // The hilltop "Queen of the Missions" in Santa Barbara, for its distinctive twin bell towers and views of the Channel Islands // Mission San Juan Capistrano, famous for its gardens and its migrating swallows // Mission San Buenaventura in Ventura, which looks much as it did when it was constructed // Carmel's San Carlos Borroméo (*below*, exterior and interior), one of the most authentically restored mission churches in California

CALIFORNIA WINE COUNTRY
California, U.S.A.

// Napa and Sonoma:
America's Premier Vineyards

If America has an answer to Tuscany, the Napa and Sonoma valleys are it. Napa is the better known and more densely populated, with 300-plus wineries along Highway 29 and the scenic Silverado Trail. Sonoma is lusher, greener, and cooler than Napa, and is known for California's best chardonnays and pinot noirs.

Must Do // Visit Napa's Robert Mondavi Winery in Oakville; Francis Ford Coppola's Inglenook Estate; Yountville's Domaine Chandon; and Sterling Vineyards near Calistoga // Board the Napa Valley Wine Train, a 3-hour journey from Napa to St. Helena in restored 1915-era Pullman cars // Sonoma's Russian River Valley (*left*), anchored by the lovely town of Healdsburg // Explore the town of Sonoma's shady plaza and its 1824 adobe mission // Head a few miles northeast of the town of Sonoma to Buena Vista, one of California's first estate wineries.

DEATH VALLEY NATIONAL PARK
California, U.S.A.

// As Low as You Can Go

Located in the northern reaches of the Mojave Desert, Death Valley National Park is the lowest, driest, and hottest spot in America, but there's a striking beauty here, from the stark Deadman Pass and Dry Bone Canyon to the soaring drama of Telescope Peak.

Must Do // View the hills colored orange, pink, purple, and green by mineral deposits at Artists Palette // Hike to Zabriskie Point, for views of Sahara-like sand dunes, including the Badwater salt flats (*right*) // Enjoy the 360-degree panoramas from mile-high Dantes View // Head south to Joshua Tree National Park, one of the most popular rock-climbing areas in the country.

LOS ANGELES
California, U.S.A.

If one city characterizes the American dream, it's Los Angeles, a magnet for the countless dreamers who come here to remake themselves in the land of year-round sunshine and commercialized make-believe.

Visitors might wonder if anyone walks in this city riddled by freeways and near-constant traffic jams, but Santa Monica boasts the pedestrian-only Third Street Promenade, and five excellent museums are within walking distance on Wilshire Boulevard's Museum Row, including the LA County Museum of Art (LACMA), the Craft and Folk Art Museum, and the Petersen Automotive Museum, and a stroll down Rodeo Drive in nearby Beverly Hills is a quintessential L.A. experience. Downtown L.A. is where you'll find the multivenue Music Center, including the Walt Disney Concert Hall, as well as the imposing Cathedral of our Lady of the Angels and the new Broad museum. Flanking Downtown are Chinatown, Little Tokyo, and the Mexican enclave along Olvera Street.

Yet it's worth getting in the car to drive to Anaheim's Disneyland and Disney California Adventure, and to visit the Huntington Library, home to a Gutenberg Bible from the 15th century and the earliest-known manuscript of Chaucer's *Canterbury Tales*. Be sure to head outside to the Japanese Garden, the Rose Garden, and the Garden of Flowing Fragrance.

But movies and TV are what make this town tick. For a glimpse of Tinseltown's storied past, visit the Hollywood Museum, take a tour of the Dolby Theatre, and walk Hollywood Boulevard's famous Walk of Fame. Revel in Old Hollywood history at Grauman's Chinese Theatre. And don't forget that famous Hollywood sign. The best view is from the corner of Sunset Boulevard and Bronson Avenue: Get your iPhones out!

RIGHT // The iconic Hollywood sign is 350 feet long.

BELOW // The commanding hilltop citadel of the **Getty Center** holds the J. Paul Getty Museum's collection of pre-20th-century European art. The nearby Getty Villa, close to Malibu, displays Greek, Etruscan, and Roman antiquities on the edge of the Pacific Ocean.

BELOW // View rotating exhibits drawn from contemporary American art (pictured, *Cracked Egg* and *Balloon Dog* by Jeff Koons) as well as historic art and artifacts at the **Los Angeles County Museum of Art** (LACMA).

ABOVE // Studio tours of **Paramount Pictures** in Hollywood, Universal Studios in the San Fernando Valley, and Warner Bros. take visitors behind the scenes of some of the world's most famous television shows and movies including *Friends* and *Psycho*.

LEFT // Frank Gehry's **Walt Disney Concert Hall** has become downtown L.A.'s landmark while providing state-of-the-art acoustics for the Los Angeles Philharmonic Orchestra, which also gives concerts in the Hollywood Bowl in the summer.

ABOVE // Upscale, laid-back Santa Monica fronts the Pacific 15 miles from central L.A. Visitors should head to the beach and the 1909 **Santa Monica Pier**, with its classic carnival rides, seashell souvenir shops, and genuine 1920s carousel.

LEFT // Although some of the original canals still exist, **Venice** is more famous for its boardwalk, or Ocean Front Walk, where street musicians, muscle men, Rollerbladers, and surfers are perpetually on parade.

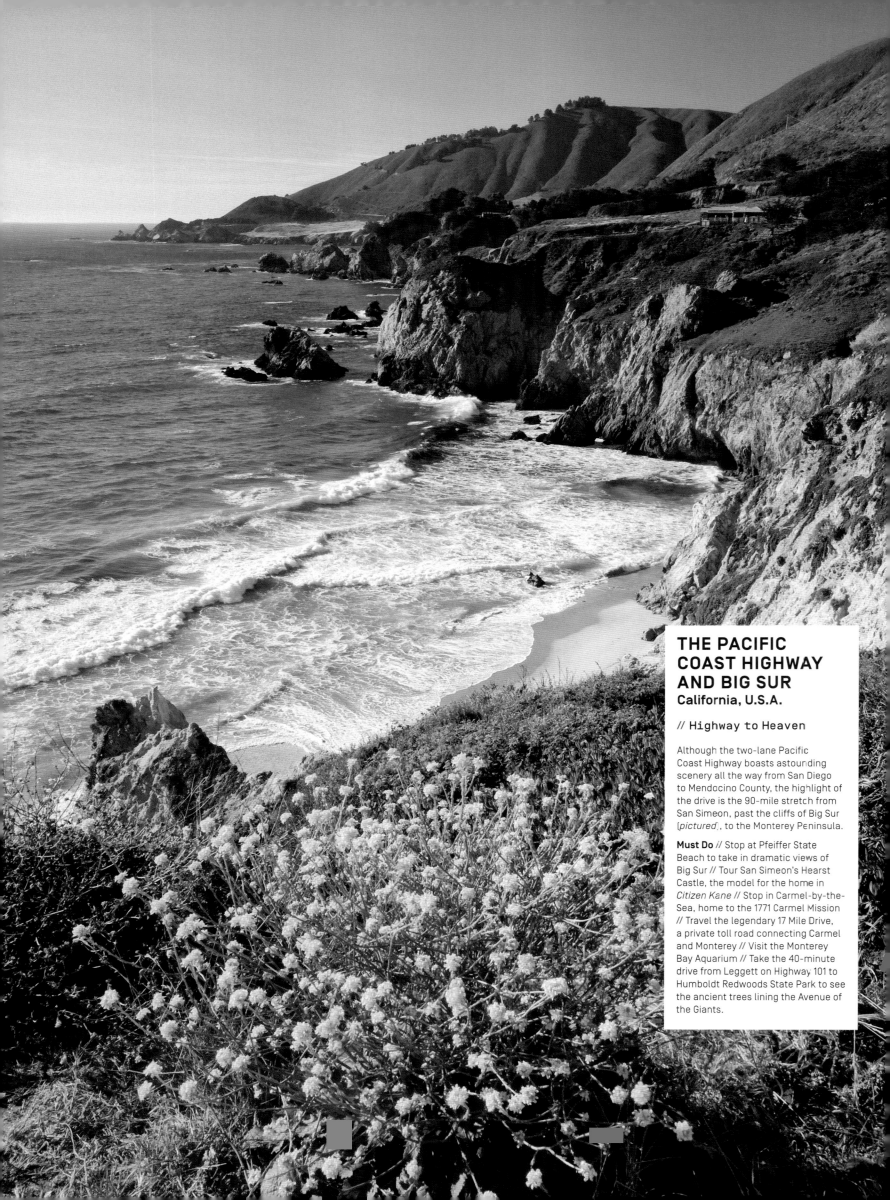

THE PACIFIC COAST HIGHWAY AND BIG SUR
California, U.S.A.

// Highway to Heaven

Although the two-lane Pacific Coast Highway boasts astounding scenery all the way from San Diego to Mendocino County, the highlight of the drive is the 90-mile stretch from San Simeon, past the cliffs of Big Sur (*pictured*), to the Monterey Peninsula.

Must Do // Stop at Pfeiffer State Beach to take in dramatic views of Big Sur // Tour San Simeon's Hearst Castle, the model for the home in *Citizen Kane* // Stop in Carmel-by-the-Sea, home to the 1771 Carmel Mission // Travel the legendary 17 Mile Drive, a private toll road connecting Carmel and Monterey // Visit the Monterey Bay Aquarium // Take the 40-minute drive from Leggett on Highway 101 to Humboldt Redwoods State Park to see the ancient trees lining the Avenue of the Giants.

THE SAN DIEGO ZOO
San Diego, California, U.S.A.

// Animal Attraction
by the Sea

The world-famous San Diego Zoo, the centerpiece of Balboa Park, with more than 4,000 animals representing 800 species, has set the standard for wildlife conservation around the world. Two of the most popular exhibits are the Elephant Odyssey and the Giant Panda Research Center.

Must Do // Explore Balboa Park, a verdant 1,200-acre recreational area, and its 14 museums in Spanish-Moorish buildings constructed for the 1915 Panama-California Exposition // Travel 35 miles north to visit the San Diego Safari Park to see African lions, white rhinos, warthogs, and cheetahs roaming in a safari-like setting.

BELOW // A landmark in the South of Market neighborhood, the **San Francisco Museum of Modern Art** displays 20th- and 21st-century works by such artists as Matisse, O'Keeffe, and Picasso as well as photographs by Alfred Stieglitz and Ansel Adams.

BELOW // The imposing 1898 **San Francisco Ferry Building** is a showcase for many of Northern California's legendary food purveyors and the home of an outdoor farmers' market that continues indoors.

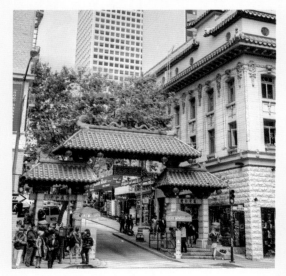

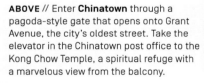

ABOVE // Enter **Chinatown** through a pagoda-style gate that opens onto Grant Avenue, the city's oldest street. Take the elevator in the Chinatown post office to the Kong Chow Temple, a spiritual refuge with a marvelous view from the balcony.

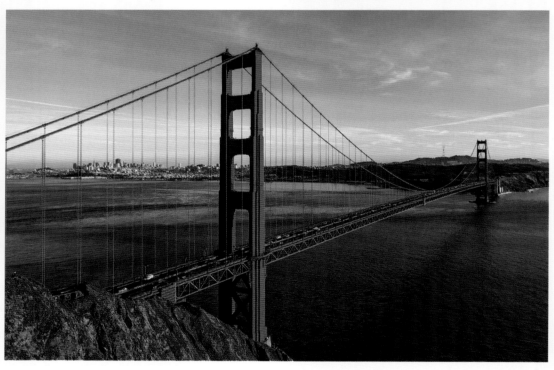

ABOVE // Traverse the east-side walkway of the **Golden Gate Bridge** (*pictured*) for an enthralling panorama of bay and city. The Presidio has been a fortification since at least 1776, but in 1994 the Army transferred this parklike property to the National Park Services. The Golden Gate Bridge rises from its tip.

RIGHT // Though a small fishing fleet still departs from **Fisherman's Wharf**, this tourist mecca is largely dedicated to souvenir shops and take-away food. Head to the bay front to enjoy straight-from-the-boat fish-and-chips and freshly cracked Dungeness crab, then head to Ghirardelli Square for dessert.

SAN FRANCISCO
California, U.S.A.

San Francisco is a place of myth and magic on par with Paris and Venice. With a stunning waterfront setting, it offers wonderful food, a raft of great hotels, and fascinating and unique neighborhoods like North Beach, perfect for strolling along Columbus Avenue to the landmark City Lights Books. Then make your way through the Telegraph Hill neighborhood to Pioneer Park's Coit Tower for some of the best views in town. Don't miss wandering around Golden Gate Park, the home of redwood forests, a Japanese tea garden, and outstanding museums, including the de Young, as well as the California Academy of Sciences that combines the Steinhart Aquarium, the Morrison Planetarium, the Kimball Natural History Museum, and world-class research and education programs. Other museums not to miss are the Asian Art Museum and the landmark SF MOMA.

When its undulating hills tire you out, jump aboard one of San Francisco's cable cars that climbs past the mansions of Nob Hill or that goes to Fisherman's Wharf, the tourist mecca. Nighttime offerings include the Fillmore Theater, the Boom Boom Room, and a daunting choice of the city's world-class restaurants.

Cross the San Francisco Bay to explore Berkeley's food scene or take the scenic 25-minute ferry ride to Sausalito's bayfront restaurants. Point Reyes National Seashore beckons hikers and birders to Marin County while the nearby villages are loaded with good restaurants. And no trip to San Francisco is complete without a tour of Alcatraz Island, America's best-known—and escape-proof—prison, reachable via ferry, which once housed such notorious criminals as Al Capone.

LEFT // One of the three iconic San Francisco cable car routes, and one of the few National Historic Landmarks that moves.

YOSEMITE NATIONAL PARK
California, U.S.A.

// A High Sierra Gem

Millions of visitors converge on Yosemite Valley and its sheer granite cliffs and domes, but avoiding the park's summertime crowds is easy: Strike out on foot, horseback, or mule to explore the wilder 95 percent of the park along any of its 800 miles of trails.

Must Do // Hike the moderately strenuous Mist Trail for a close-up view of Vernal and Nevada falls // Make sure to see Half Dome, Yosemite's 8,842-foot trademark peak; El Capitan, the largest single granite rock on earth; and the magnificent Yosemite Falls [*right*], the highest on the continent // Raft the rapids on the Merced River or the Tuolumne River just outside the park // Pull over at Glacier Point for spectacular views.

ASPEN
Colorado, U.S.A.

// High-Society Glamour and Glorious Skiing

Strip away its celebrity veneer and Aspen shines as one of the country's best places to ski. Four mountains offer nearly 5,000 skiable acres linked by a free shuttle service and transferable lift tickets. Snowmass is perfect for families; Aspen Mountain is a challenging peak; Aspen Highlands is a favorite with many locals; and Buttermilk is the best for beginners.

Must Do // Ride the Silver Queen Gondola, the longest single-stage gondola in the country // Visit in the summer and fall for the Aspen Music Festival, the Aspen Dance Festival, Jazz Aspen Snowmass, or the Food and Wine Classic.

DURANGO
Colorado, U.S.A.

// A Young-at-Heart
Mountain Town

This popular mountain biking town close to Mesa Verde National Park has an upbeat air thanks to students attending Fort Lewis College. It is a good starting point for driving the San Juan Skyway that loops through the San Juan Mountains to Ouray and Silverton before linking up with the Million Dollar Highway, the visual highlight of the journey.

Must Do // Kayak the Class II and III rapids on the Animas River, which flows right through the center of town // Ride the Durango & Silverton Narrow Gauge Railroad (*left*) that ascends 3,000 feet while crossing narrow bridges that span roaring whitewater canyons // Ski any of the 85 trails on Purgatory Mountain.

MESA VERDE
Colorado, U.S.A.

// Awe-Inspiring Cliff
Dwellings in Desert Canyons

Located in the area known as the Four Corners, where Colorado, New Mexico, Arizona, and Utah meet, Mesa Verde is the only national park in the United States devoted exclusively to archaeology. Members of the Ancestral Puebloan culture (also known as the Anasazi) that flourished here between AD 600 and 1300 created masonry dwellings tucked into alcoves along the steep canyon walls. A handful of the multistory cliff dwellings have been stabilized and opened to the public.

Must Do // Get a ticket for a ranger-led tour of Cliff Palace (*above*), the largest cliff dwelling in North America, and Balcony House, which requires climbing ladders and crawling through a 12-foot-long tunnel // View Spruce Tree House's 130 rooms and 8 kivas on Chapin Mesa // Drive the 6-mile Mesa Top Loop Road for easy access to dozens of overlooks.

ROCKY MOUNTAIN NATIONAL PARK
Colorado, U.S.A.

// A Natural High

Rocky Mountain National Park is Colorado's natural showpiece, a place of sparkling streams, glacial lakes, and rugged peaks. Most visitors begin at Estes Park, 3 miles from the park's eastern edge, and take Trail Ridge Road through 48 miles of astonishing scenery while crossing the Continental Divide.

Must Do // Hike from Bear Lake (*left*) to Emerald Lake and the nearby trails to Glacier Gorge and the not-to-be-missed Mills Lake // Keep an eye out for elk, moose, and bighorn sheep, and the wildflowers that bloom from May through August // Sign up for a dude ranch experience in the area to ride horseback by day and tuck into Western cookout fare at night.

STEAMBOAT SPRINGS
Colorado, U.S.A.

// Birthplace of Skiing in Colorado with an Old West Flair

Equal parts ranching community and Ski Town, U.S.A., Steamboat Springs began as a summer resort. But with the opening of Howelsen Hill in 1914, it became the first ski destination in the state, and today is the hometown of more Olympic athletes than any other place in North America.

Must Do // Sign up for Olympic silver medalist Billy Kidd's ski clinic // Ski Steamboat Ski Resort, 3 miles from town, where the term "champagne powder" was coined // Soak in one of the outdoor mineral pools at Old Town Hot Springs or Strawberry Park Hot Springs // Take a short ride to one of the nearby ranch resorts (*right*) for a cozy out-of-the-way retreat.

TELLURIDE
Colorado, U.S.A.

// Epic Scenery and Skiing Second to None

Located in one of the most scenic settings in the Rockies, Telluride is also one of the best-preserved mining towns in Colorado. An outstanding ski resort and a jam-packed cultural season are evidence that things have changed since Butch Cassidy robbed his first bank here in 1889.

Must Do // Ski the See Forever trail, which lives up to its name on a crystal-clear day // Take the breathtaking gondola ride from town to the European-style Mountain Village // Attend Telluride's many festivals, including Mountainfilm (late May), the Bluegrass Festival (mid-June), the Jazz Celebration (late July), and the Telluride Film Festival and Blues & Brews (September).

VAIL
Colorado, U.S.A.

// Powder Bowls and
Perfect Snow

The largest single ski resort in North America has more than 10 square miles of skiable terrain, including the seemingly endless majesty of the world-famous Back Bowls. Thirty-four lifts crisscross the slopes, including the biggest, fastest set of high-speed detachable quads on one mountain.

Must Do // Ski the Blue Sky Basin's 645 acres of runs carved out of pristine wilderness // Spend time at nearby Beaver Creek, which offers 146 trails across three mountains.

ESSEX
Connecticut, U.S.A.

// The Perfect American
Small Town

A Revolutionary War–era spirit lingers in Essex, a mint-condition town on the Connecticut River, where Colonial and Federal houses hark back to a shipbuilding heyday, and white picket fences frame landmark buildings while sailboats bob in nearby marinas.

Must Do // Visit the Connecticut River Museum to see a full-scale replica of America's first submarine // Ride the vintage Essex Steam Train north to Deep River, where a summertime Fife & Drum Muster of more than 70 units marches down Main Street.

THE MARK TWAIN HOUSE
Hartford, Connecticut, U.S.A.

// Home of a Literary Legend

Mark Twain lived in this beautifully restored 25-room mansion, including a library (*right*) and featuring decorative work by Louis Comfort Tiffany, from 1874 to 1891 when he penned some of his most acclaimed works.

Must Visit // The contemporary museum next to the house to learn more about this master storyteller // The nearby Harriet Beecher Stowe Center, which celebrates the legacy of the author of *Uncle Tom's Cabin* // Hartford's Wadsworth Atheneum, the nation's first public art museum and just minutes from the state capitol, to see a collection of Hudson River School paintings

LITCHFIELD HILLS
Connecticut, U.S.A.

// Rural Sophistication Under the Elms

A landscape of 18th- and 19th-century saltbox farmhouses, red barns, and tidy villages draws visitors to Litchfield Hills in the northwestern corner of Connecticut.

Must Visit // The White Memorial Foundation, Connecticut's largest natural preserve, home to 35 miles of leafy trails // The charming towns of Washington and Litchfield, dotted with restaurants, galleries, and bookstores // Woodbury, 10 miles southeast of Washington, the Antiques Capital of Connecticut

MYSTIC SEAPORT
Mystic, Connecticut, U.S.A.

// America's Maritime Museum

Much of Mystic Seaport's riverfront site encompasses a re-created coastal village that brings 19th-century American seafaring to life. Among the many fully rigged sailing ships open for visits is the *Charles W. Morgan*, the world's last surviving wooden whaling ship, and the *Joseph Conrad* sailing ship (*right*).

Must Visit // The Mystic Aquarium & Institute for Exploration, for exhibits of sea life and an outdoor beluga whale exhibit // Stonington Borough, 5 miles away, one of New England's most endearing coastal communities

BRANDYWINE VALLEY
Delaware and Pennsylvania, U.S.A.

// Family Legacies of the du Ponts and Wyeths

The grand houses the du Pont family built in the Brandywine Valley gave rise to the area's nickname, "Chateau Valley." Another family legacy is found at the Brandywine River Museum, which houses art by three generations of Wyeths.

Must Visit // The Hagley Museum, to learn the du Pont family's story // Nemours, a Louis XVI–style mansion filled with museum-quality works of art // Winterthur (*above*—exterior and interior), considered the world's premier museum of American antiques and decorative arts // Longwood Estate and its 1,050-acre gardens // N. C. Wyeth's house and studio, where the painting he was working on at the time of his death is on display // The Brandywine Battlefield, where the largest battle of the Revolutionary War took place

AMELIA ISLAND
Florida, U.S.A.

// A Seaside Escape That's Not Always on the Map

Fernandina Beach, Amelia Island's only town, features some of the nation's finest examples of Queen Anne, Victorian, and Italianate mansions. On cobbled Centre Street, you'll find galleries, restaurants, and the Palace Saloon, which bills itself as Florida's oldest bar.

Must Do // Attend the Spring Shrimp Festival, which features boatloads of seafood and fireworks // Explore the island's two state parks, which showcase a blend of maritime forest and saltwater marsh // Horseback ride on the long uninterrupted beaches and into the ocean.

KENNEDY SPACE CENTER
Cape Canaveral, Florida, U.S.A.

// "We choose to go to the moon."
—JFK, September 12, 1962

The Kennedy Space Center has been the headquarters of American rocketry and space exploration since the launch of the unmanned Bumper 8 research rocket in July 1950.

Must Do // Tour the Kennedy Space Center Visitor Complex, which houses a collection of NASA rockets and two IMAX theaters showing films about space exploration // Visit the U.S. Astronaut Hall of Fame to take a virtual ride on Mars in the G-Force Trainer.

SWIMMING WITH THE MANATEES
Crystal River, Florida, U.S.A.

// Rubenesque Mermaids
on the Gulf Coast

Some 6,000 West Indian manatees, once thought to be mermaids by old-time sailors, live in the warm waters off Florida's coasts, and 1,000 in the springs of its Citrus County, the "Manatee Capital of the World." Citrus County is the only place in the United States where you can legally swim with these surprisingly graceful 8- to 12-foot mammals on a guided tour.

Must Do // Sign up with an outfitter in Crystal River to travel to nearby Kings Bay, where many of the area's 400 creatures tend to loll // Wait for the manatees to approach—which they almost always do.

DAYTONA SPEEDWAY
Daytona Beach, Florida, U.S.A.

// The Home of Speed

Daytona Beach hosts eight different annual race weekends, including the Daytona 500, the most prestigious stock car race in America, and the Daytona 200, the most important motorcycle race in the United States.

Must Do // Visit in late December for Daytona KartWeek, a 4-day event featuring go-kart races for both children and adults // Sign up for the Richard Petty Driving Experience to slip behind the wheel or be a passenger on the Daytona International track // Visit the Motorsports Hall of Fame of America at the speedway.

EVERGLADES NATIONAL PARK
Florida, U.S.A.

// River of Grass

Today, 120 miles long and 50 miles wide, Everglades National Park is home to thousands of animals and plants that live in the park's tangled mangrove thickets and labyrinthine channels. After decades of urban sprawl diverted and polluted the steady flow of water the Everglades needs to survive, various groups continue their work to restore the region's ecological balance.

Must Do // Explore the peripheral marshland via air boat, wooden walkways, and bicycle trails // Venture out in a kayak or canoe with a knowledgeable guide // Enjoy outstanding bird-watching, especially when the winter's migratory guests join about 350 resident species // Keep an eye out for the swamp's alligators, hawksbill turtles, manatees, and rare Florida panthers.

THE FLORIDA KEYS
Florida, U.S.A.

// The American Caribbean

The 800 islands of the Florida Keys (30 of them inhabited) are connected by the 128-mile-long extension of Route 1 called the Overseas Highway. It ends in Key West, the southernmost point of the continental United States, known for its fusion of Caribbean, Latin, and American culture; relaxed Margaritaville lifestyle; and the hand-rolled-cigar shops and legendary bars lining Duval Street.

Must Do // Sign up for a chartered trip to fish for sailfish, tuna, mahimahi, tarpon, and bonefish // Ride a glass-bottom boat at John Pennekamp Coral Reef State Park in Key Largo // Interact with Atlantic bottlenose dolphins at Marathon's Dolphin Research Center in Grassy Key // Tour Key West's Butterfly Conservatory // Visit Hemingway's house and studio, and the Little White House, President Truman's vacation home in Key West // Take Key West's Conch Tour Train to view one of North America's largest concentrations of 19th-century wooden houses, and wind up at Mallory Square pier for the daily sunset-watching ritual.

SOUTH BEACH
Miami Beach, Florida, U.S.A.

// Art Deco on the
American Riviera

Fashion, celebrity, design, hip beach
culture, and wealth come together
against an architectural backdrop built
between the late 1920s and early '40s
that is as beautiful as today's bronzed
and buffed denizens.

Must Do // Take a tour of South Beach's
Art Deco district from the Miami Design
Preservation League // Visit in early
December when Art Basel Miami Beach
comes to town for 4 event-packed days
featuring work from the world's top
galleries.

WALT DISNEY WORLD
Orlando, Florida, U.S.A.

// America's Most
Popular Resort

The brainchild of Walt Disney is an
ever-expanding universe of escapism.
Celebrating magic, technology, nature,
and Mickey Mouse, four distinct parks
demand that visitors leave the real world
at the gate.

Must Visit // The original Magic Kingdom,
with Cinderella Castle at its center (*left*)
// Epcot Center, for a mix of science-
oriented films, rides, and interactive
experiences // Disney's Hollywood Studios,
to ride the Twilight Zone Tower of Terror
// Animal Kingdom, for a safari not unlike
a trip to Botswana // The nearby Universal
Studios Florida

SANIBEL AND
CAPTIVA ISLANDS
Florida, U.S.A.

// A Beachcomber's Bonanza

A good northwest wind can fill the beaches
of Sanibel (*above*) and Captiva islands with
hundreds of varieties of shells. Collectors
wake before dawn and patrol the sands
with flashlights, scrunched over in the
"Sanibel Stoop" or the "Captiva Crouch."

Must Do // Head to secluded Bowman's
Beach for a little less competition // Visit
Sanibel's Bailey-Matthews Shell Museum,
where some 150,000 specimens are displayed
// Explore Sanibel's J. N. "Ding" Darling
National Wildlife Refuge on foot, bicycle,
and kayak or motor along Wildlife Drive.

THE APPALACHIAN
TRAIL
Georgia to Maine, U.S.A.

// A 2,178-Mile Walk
in the Woods

The Appalachian Trail, the world's longest
continuously marked footpath, wends its
way through 14 eastern states from Georgia
to Maine. Most hikers tackle only a portion of
the trail, while 500 to 600 "through-hikers"
complete the entire journey each year from
Georgia's Springer Mountain to Maine's
Mount Katahdin—a trek of about 5 million
steps.

Must Visit // The Appalachian Trail
Conservancy headquarters in Harpers
Ferry, Virginia // New York's Harriman-
Bear Mountain State Park, which contains
the first portion of the trail, completed
in 1923 // The portion of the trail in New
Hampshire's majestic White Mountains

THE GOLDEN ISLES
Georgia, U.S.A.

// History, Aristocrats,
and Splendid Isolation

The Astors, Rockefellers, Vanderbilts, Goodyears, and Pulitzers began vacationing in the winter months on Georgia's barrier islands, five of which are now known as the Golden Isles for their special light and privileged lifestyle.

Must Do // Take the ferry to Cumberland, home to sea turtles, wild horses, and more than 300 species of birds // Visit Jekyll Island (*left*), most of which is off-limits to developers, and bike its paved paths past grand "cottages" from its gilded past // Golf Sea Island's two 18-hole championship courses // Visit Simons Island and its 1872 lighthouse // Hike the moss-draped forests of Little St. Simon's Island with a guide.

SAVANNAH'S HISTORIC DISTRICT
Savannah, Georgia, U.S.A.

// Georgia's Jewel

America's best walking city, Savannah is a living museum with the country's largest National Historical Landmark District: more than 2,300 Colonial and Victorian buildings within 2.5 square miles that can be taken in by horse-drawn carriage, trolley, or bicycle or on foot.

Must Do // Tour the Davenport House Museum, one of the nation's finest Federal-style urban houses // Sign up for a tour of the highlights from the 1994 bestseller *Midnight in the Garden of Good and Evil* // Visit the Owens-Thomas House, an 1819 mansion in Oglethorpe Square, and the nearby Telfair Academy, both part of the Telfair Museum of Art, the South's oldest public art museum.

HAWAI'I ISLAND (BIG ISLAND)
Hawaii, U.S.A.

// From Rain Forests to
Black Lava Fields

The youngest and largest of the 1,500-mile-long Hawaiian archipelago, Hawai'i Island, best known as the Big Island, has the world's most active volcano, Kilauea (above), which has been spewing lava almost continuously since 1983. The Big Island is also the birthplace of the great warrior King Kamehameha I, who in 1812 conquered the other islands and created the Kingdom of Hawai'i.

Must Do // Watch the streaming molten lava of Kilauea glow like an incandescent

ribbon // Visit the 330,000-acre Hawai'i Volcanoes National Park to see the island's five volcanoes—the largest, Mauna Kea, extends from sea level to 13,796 feet. Follow the Crater Rim Drive to Kilauea Volcano, the park's crown jewel // Drive from sea level to the summit of Mauna Kea in a few hours for the best place on earth to view the cosmos // Take in the majestic views of Waipi'o Valley—a Garden of Eden dense with fruit trees, waterfalls, and a gorgeous beach of black sand—from Waipi'o Valley Overlook. Many *ali'i* (royalty) rest in ancient burial

caves in the cliffs of this "Valley of the Kings" // Head down into the Waipi'o Valley on guided four-wheel-drive tours or on foot, then ride horseback or take a mule-drawn wagon tour of the valley floor. See the 1,200-foot Hiilawe Falls, Hawaii's tallest // Take the iconic 45-mile trip along the Hamakua Coast to Hilo // Kealakekua Bay to see its dramatic cliffs, underwater park, and marine reserve for excellent snorkeling and diving // The Big Island's best beaches: Hapuna, Kauna'oa, and Anaeho'omalu Bay

KAUAI
Hawaii, U.S.A.

// Lush Valleys and Dramatic Peaks

The greenest and oldest of the main Hawaiian islands, Kauai is essentially a single massive volcano rising 3 miles from the ocean floor. Two-thirds impenetrable, it has provided a scene-stealing vision of tropical paradise for many Hollywood movies and TV shows. More rain falls here than in the rest of Hawaii, and it's so extravagantly covered with flowers and dense vegetation that it effortlessly earns its nickname, "the Garden Isle."

Must Do // A helicopter or boat ride to see the exquisite Na Pali Coast (*below*) // Hiking in Waimea Canyon, dubbed "the Grand Canyon of the Pacific," and Koke'e State Park, a vast network of trails that snake through some 6,200 acres of rain forest // Helicopter sightseeing past sites such as Manawaiopuna Falls (also known as "Jurassic Park Falls"); Hanapepe Valley; the azure waters of Hanalei Bay; and weather permitting, fly into the crater of the 5,148-foot Mount Waialeale, where waterfalls plunge down walls nearly a mile high // Visit the National Tropical Botanical Garden and the National Garden's Limahuli Garden, as well as the island's best beaches, which include Poipu Beach, Hanalei Bay, Kalihi Wai Beach, and Makua Beach.

LANA'I
Hawaii, U.S.A.

// Pineapple Island

Tiny and secluded Lana'i was once the state's largest pineapple plantation. Since then it has become a luxury retreat for the rich and an adventure outpost for day-trippers from Maui, a short ferry ride away.

Must Do // Explore Hulopoe Bay, a marine preserve where spinner dolphins cavort in clear, blue waters // Tee off at either of the two prestigious golf courses, Manele and Koele, both managed by the island's Four Seasons Resort // Visit Lana'i City, a quintessential 1920s plantation company town with a charming village square // Take one of Hawaii's toughest hikes, the 14-mile round-trip Munro Trail to the top of the island's highest peak // Rent a four-wheel-drive vehicle and explore the plateau of encrusted lava called Garden of the Gods.

MAUI
Hawaii, U.S.A.

// Bike Down a Volcano to Red, White, and Black Sand Beaches

Who's to argue with the local saying "Maui no ka oi"—"Maui is the best"? Known for its miles of stunning beaches and lush rain forest, the "Valley Isle" is named for the Polynesian demigod who, after having plucked all the Hawaiian islands up out of the sea, decided to make this one his home.

Must Do // Make a predawn ascent through 38 miles of upcountry landscape for views of and from Haleakala Volcano, the world's largest dormant volcanic crater. Come back down Crater Road by bicycle, an hours-long ride that requires next to no pedaling // Drive the famous Hana Highway, beginning at the former sugar-plantation town of Paia. The 50-mile drive takes 2 to 3 hours, the road climbing and dropping along some 617 curves, crossing 54 one-lane bridges, and wending past dozens of waterfalls and vistas before reaching the sleepy, eye-blink town of Hana // In Hana Village, luxuriate on Hamoa Beach, climb the hill to Fagan's Cross, then hike the ancient 6-mile trail of Wai'anapanapa State Park // Visit Maui's best beaches, including Kapalua Bay, Oneloa Beach, Hookipa Beach, and Hamoa Beach // In winter, see the humpback whales from a whale-watching boat, a ferry to neighboring Moloka'i or Lana'i, or by scanning the horizon from McGregor Point Lookout, Keawakapu Beach, or Big Beach. Calm conditions are ideal for sightings of breaching whales // Stroll through the 19th-century whaling village of Lahaina and take the town's Historical Walk // Experience Maui's most authentic luau at the nightly Old Lahaina Luau.

MOLOKA'I
Hawaii, U.S.A.

// Timeless Hawaii

Moloka'i is Mother Nature's wild and uninhibited work of art and one of Hawaii's least developed places. Fewer than 7,500 people live on this small island, the majority of them native Hawaiians who carry on traditional ways of fishing and hunting.

Must Do // Book a helicopter ride to see the Papalaua Falls (*right*) // Hit the beachfront bar in Kaunakakai on Fridays for a couple of hours of Moloka'i-style singing // Sign up for a muleback tour of Kalaupapa National Historic Park, the site of a former colony for people suffering from Hansen's disease started by a Belgian priest, Father Damien.

O'AHU
Hawaii, U.S.A.

With daily rainbows that arch over its beaches, thundering waterfalls that cascade into crystal blue lagoons, and perfect waves that roll steadily to shore, O'ahu is the third-largest island in the chain but by far the most populated and most visited.

Visit the Bishop Museum, home to the world's greatest collection of Hawaiian and Pacific artifacts; watch hula demonstrations or competitors vie for the title of world's best fire knife dancer every May at the Polynesian Cultural Center. Or attend the Aloha Festivals, the state's largest cultural celebrations. Visit Iolani Palace, the only official state residence of royalty in the United States, built by King David Kalakaua between 1878 and 1882.

For more recent history, explore Pearl Harbor's Pacific Aviation Museum, with World War II bombers, flight simulators, and an authentic Japanese Zero. Another legacy of World War II, when fresh food was scarce, is the island's love affair with Spam. Every April Kalakaua Avenue shuts down for a surprisingly fun street festival featuring canned-ham dishes in myraid interpretations.

O'ahu is home to more than 125 beaches, and is also a nightlife and shopping mecca, a commercial and culinary hub, and a cultural hot spot.

RIGHT // The 6-mile stretch of O'ahu's **North Shore** from Haleiwa to Sunset Beach is surfing's spiritual home and greatest testing ground. Monster swells from winter storms rush toward Waimea Bay, Sunset Beach, and the Banzai Pipeline off Ehukai Beach Park. Yet calmer water beckons swimmers, kayakers, snorkelers, divers, and fishermen from April to October.

BELOW // When Honolulu became the capital of the Kingdom of Hawaii in 1845, Hawaiian royalty built their homes on **Waikiki Beach**, now home to a profusion of high-rise hotels and condos with a view. The outdoor shopping area on Kalakaua Avenue is lined with designer boutiques while the popular Waikiki Beachwalk features live-music bars and surfboard sign-ups for the next day's lesson.

BELOW // Visitors can experience a variety of cultures at the **Polynesian Cultural Center** in Laie. The museum illustrates the lifestyles, songs, dances, costumes, and architecture of a number of Pacific islands in re-created villages scattered throughout a 42-acre park.

ABOVE LEFT // After paying their respects at the **USS *Arizona* Memorial** in Pearl Harbor, visitors can go below deck on the World War II submarine USS *Bowfin*, then tour the USS *Missouri*, where the war finally came to an end with the signing of the Japanese surrender on September 2, 1945.

ABOVE RIGHT // Visitors can reach the summit of **Diamond Head** for 360-degree views of O'ahu via a steep 1.5-mile path crowded with other hikers. Less crowded is the unpaved trail to Diamond Head Beach, a small strip of sand at the volcano's base with breathtaking views of the ocean.

ABOVE // O'ahu's most popular spot to don a mask and fins and ogle clouds of parrot fish is **Hanauma Bay Nature Preserve**. But before you put a toe in the water, visit the Marine Education Center, which features a variety of informative marine exhibits.

LAKE COEUR D'ALENE
Idaho, U.S.A.

// A Pine-Forest-Enshrouded
Gem

The town of Coeur d'Alene stands at the
head of the bewitchingly azure lake of
the same name that delights visitors
with Chinook salmon and trout fishing,
steamboat rides, water-skiing, and sunset
dinner cruises.

Must Do // Hike up Tubbs Hill for great views
of the lake and its 135-mile shoreline [*right*]
// Drive the Lake Coeur d'Alene Scenic
Byway along the eastern shore // Follow the
scenic I-90 freeway east to Wallace, a well-
preserved late-19th-century mining town
// Ski nearby Schweitzer Mountain Resort,
a best-kept secret.

MIDDLE FORK OF
THE SALMON RIVER
Idaho, U.S.A.

// America's Greatest
White Water

This is ranked as one of the top stretches
of whitewater river in the world, churning
through 100 Class III and IV rapids carrying
rafters to sandy beaches for overnight
camping and natural hot springs for soaking
paddle-weary bones.

Must Do // Fish for rainbow, cutthroat, and
Dolly Varden trout // Look for vivid rock
art on canyon walls // Drive the 162-mile
Salmon River Scenic Byway, a picturesque
route along the river's upper reaches.

SUN VALLEY
Idaho, U.S.A.

// A Rockies Classic

Sun Valley in the Sawtooth Mountains
is America's original ski destination
and still one of the finest ski resorts on
the continent. Bald Mountain boasts a
3,400-foot vertical drop; of its 65 runs,
42 percent are an intermediate's dream.

Must Do // Use the 25 miles of groomed
trails at the Nordic and Snowshoe Center
// Enjoy Galena Lodge's 31 miles of
cross-country skiing trails and 15 miles
of snowshoe trails // Head a few miles
down the road to the old mining town of
Ketchum, where Ernest Hemingway set
up camp.

CHICAGO
Illinois, U.S.A.

Chicago is the quintessential American city. With its global sophistication, the "City of Big Shoulders" lives up to its reputation as a dining hotbed, a world-class center for art, and a showcase for jazz and blues.

Stroll along the 14-block stretch of bustling North Michigan Avenue known as the Magnificent Mile and admire the John Hancock Center. During winter's Magnificent Mile Lights Festival, more than a million lights twinkle along the length of the avenue. For a bird's-eye view of the city, visit the Skydeck of the Willis Tower.

In June, the Chicago Blues Festival draws throngs, but you can catch great performances anytime at Buddy Guy's, Kingston Mines, and Rosa's Lounge.

BELOW // **Millennium Park** has quickly become a focal point for the city. The centerpiece is the Jay Pritzker Pavilion, but the "Bean" (*pictured*)—officially titled *Cloud Gate*—by Anish Kapoor is the favorite photo op.

ABOVE // Famed for its collection of French Impressionist and Postimpressionist paintings, the **Art Institute of Chicago** also holds American masterpieces such as *American Gothic* by Grant Wood (*pictured*).

ABOVE RIGHT // The second-oldest ballpark in the majors, **Wrigley Field** is the quintessential place to take in a game. The fans' contagious optimism is a key part of the experience.

RIGHT // To view the city's showcase 20th-century architecture, sign up for guided walking or bus tours and boat cruises down the **Chicago River** from April through November sponsored by the Chicago Architecture Foundation.

THE LINCOLN TRAIL
Springfield, Illinois, U.S.A.

// Honest Abe:
A Man for the Ages

The unofficially designated Lincoln Trail marks Abraham Lincoln's route from his Kentucky birthplace to Springfield, Illinois, where the Abraham Lincoln Presidential Library and Museum displays a copy of the Emancipation Proclamation, a draft of the Gettysburg Address, and his stovepipe hat.

Must Visit // The Old State Capitol (*left*), where Lincoln lay in state after being assassinated // Abraham and Mary Todd Lincoln's family home // The Lincoln Tomb in Springfield's Oak Ridge Cemetery // The New Salem State Historic Site 20 miles northwest of Springfield, an authentic re-creation of the village where a young Lincoln received an education in law and politics

SHIPSHEWANA
Indiana, U.S.A.

// A Lifestyle Going,
Going . . .

Horse-drawn buggies start arriving before daybreak at the weekly auction in Shipshewana, the heart of America's third-largest Amish community, which can be explored on the 100-mile Heritage Trail.

Must Do // Visit Nappanee's Amish Acres south of Shipshewana for a tour of a restored 19th-century Amish farm // Sample shoofly pie at a thresher's dinner in the round barn at Amish Acres.

IOWA STATE FAIR
Des Moines, Iowa, U.S.A.

// America's Most Famous
Ag-stravaganza

For 11 days in August, more than a million people enjoy stomach-churning rides, sugar-dusted funnel cakes, deep-fried everything, and big-name entertainers at one of the world's largest livestock exhibitions.

Must Do // Watch hog- and husband-calling and cow-chip-throwing contests // View the Butter Cow, sculpted from 550 pounds of the stuff // Observe all kinds of competitions from cattle to homemade pies.

BLUEGRASS COUNTRY
Kentucky, U.S.A.

// Horse Heaven

Drive through the undisputed center of Thoroughbred horse breeding on the scenic Old Frankfort Pike and Paris Pike that wend past farms housing former Kentucky Derby winners in central Kentucky's bluegrass country.

Must Do // Tour the International Museum of the Horse and the American Saddlebred Museum at the Kentucky Horse Park north of Lexington // Watch early-morning workout sessions at the Keeneland Race Course in Lexington // Visit quaint Harrodsburg, the state's oldest town // Tour the nearby town of Berea, an idyllic Appalachian arts and crafts center.

THE BOURBON TRAIL
Kentucky, U.S.A.

// America's Great
Homegrown Spirit

Bardstown is the de facto capital of Bourbon Country, with a cluster of eight distilleries—from Jim Beam to Maker's Mark—open for guided tours and its annual Kentucky Bourbon Festival in September.

Must Do // Tour the Oscar Getz Museum of Whiskey, which traces the history of this uniquely flavored drink // Explore Federal Hill, an 1812 plantation in My Old Kentucky Home State Park // Board the My Old Kentucky Dinner Train for gourmet fare served while crossing beautiful countryside.

KENTUCKY DERBY
Louisville, Kentucky, U.S.A.

// Run for the Roses

The Kentucky Derby is one of the most prestigious races in the world, and the 2-week Kentucky Derby Festival that precedes the race allows visitors to join in the festivities while enjoying the Bluegrass State's dogwoods in magnificent bloom.

Must Do // View Thunder Over Louisville, the large fireworks display that kicks things off // Watch the celebrity equines train during Dawn at the Downs, from the Saturday before the Derby through Thursday of Derby Week // Join the crowds packing Churchill Downs the day before the Derby to celebrate Oak Days // Explore the Kentucky Derby Museum to relive the excitement.

THE FRENCH QUARTER
New Orleans, Louisiana, U.S.A.

// A Gumbo of Pleasures in America's Least American City

Melding French, Spanish, Italian, and Afro-Caribbean cultures, New Orleans is a city that is at once elegant and debauched. The French Quarter is the Crescent City's most touristy area, yet also its heart, where visitors can hear jazz on boisterous Bourbon Street and sample café au lait and beignets at Café du Monde or move on to dinner at any of the traditional or cutting-edge restaurants that make this one of the country's most exciting food destinations.

Must Do // Visit St. Louis Cathedral, the country's oldest continuously operating cathedral, facing Jackson Square // Explore the shops on Royal and Chartres streets.

THE GARDEN DISTRICT
New Orleans, Louisiana, U.S.A.

// The Essence of New Orleans High Society

Many of the Garden District's 19th-century Greek Revival, Second Empire, and Italianate mansions still stand, and tour companies lead narrated rambles, describing the homes of many illustrious residents past and present.

Must Do // Take guided tours of the Lafayette Cemetery No. 1 // Enjoy a jazz brunch at Commander's Palace.

MARDI GRAS
New Orleans, Louisiana, U.S.A.

// Laissez les Bons Temps Rouler

Mardi Gras would be heaven without the multitudes of half-lit partygoers, but it also wouldn't be Mardi Gras, America's biggest, liveliest, and most showstopping party.

Must Do // Attend the parades of elaborate two- and three-story floats that take place in the days leading up to Mardi Gras, which means "Fat Tuesday," the day before Ash Wednesday // Arrive early to stake out a spot along the parade routes of St. Charles Avenue and Canal Street.

NEW ORLEANS'S MUSIC SCENE
New Orleans, Louisiana, U.S.A.

// The Lifeblood of the Big Easy

Born in late-19th-century New Orleans, jazz evolved thanks to local musicians such as pianist Jelly Roll Morton and was later given a voice by Louis "Satchmo" Armstrong. Then another group of New Orleans virtuosos, including Wynton Marsalis and his family, made their own version of the New Orleans sound popular.

Must Do // Attend the annual 10-day Jazz and Heritage Festival (aka Jazz Fest) in late April and early May // Visit Preservation Hall (*left*), which showcases traditional New Orleans jazz // Head uptown to Tipitina's, where jazz, Cajun, funk, and R&B keep the dance floor hopping // Stop at Snug Harbor in Faubourg Marigny to hear the likes of Ellis Marsalis and Charmaine Neville // Bowl to zydeco, swing, blues, and jazz at Mid-City Lanes Rock 'n' Bowl.

THE NEW ORLEANS RESTAURANT SCENE
New Orleans, Louisiana, U.S.A.

// From Dives to Palaces of Haute Creole

Crescent City is a place where food is religion and the funkiest neighborhood joint is as beloved as the grandest restaurant. Galatoire's Restaurant in the French Quarter has been a New Orleans tradition together with Antoine's, where the walls are lined with old photographs and memorabilia. And no visit to the Big Easy is complete without a po'boy at Mother's in the Central Business District.

Must Visit // Bayona, for pan-global fare in a Creole cottage setting // The faux-dive Acme Oyster House to savor fried-oyster-filled po'boys (*right*) // Napoleon House, famed for its hot muffuletta sandwiches and local Abita beer // Cochon, which showcases a sophisticated take on down-home Cajun cooking // August, a refurbished French-Creole warehouse, for gnocchi tossed with blue crab and truffles

ACADIA NATIONAL PARK
Maine, U.S.A.

// Rusticating Amid Nature's Glory

Mount Desert Island is as captivating today as when wealthy industrial titans built a summer colony here in the early 20th century. Acadia National Park now covers 60 percent of the island where visitors will find extraordinary oceanside drives, surf-battered bluffs, off-island whale-watching, and lobster shacks with a view.

Must Do // Take advantage of some of the nation's loveliest walking and bicycling paths // Drive up Cadillac Mountain, the highest peak on the Atlantic coast, to catch America's first rays of sun, a park tradition.

THE KENNEBUNKS
Maine, U.S.A.

// George Bush Slept Here

Kennebunk, Kennebunkport [left], and Kennebunk Beach first prospered as shipbuilding towns. That boom went bust, but the profusion of Colonial- and Federal-style houses amid a picture-perfect landscape helped transform the area into one of Maine's most popular destinations. President George H. W. Bush and his family vacationed here for generations.

Must Visit // The Clam Shack, one of America's great seafood dives // The nearby Mabel's Lobster Claw, for a lobster roll and peanut butter ice cream

PENOBSCOT BAY
Maine, U.S.A.

// Of Wind, Waves, and Lobster

Renowned for its craggy, pine-covered coastline, Penobscot Bay has standout sunsets and lighthouses right out of an Andrew Wyeth painting.

Must Do // Linger a moment in Camden's Harbor Park to take in the stunning waterfront // Tour Castine's more than 100 historic sites, including Fort George, built by the British in 1779 // Kayak Merchant's Row between Deer Isle's Stonington and Isle au Haut // Sign up for a sailing adventure on a historic schooner in Rockland, Rockport, or Camden // Time your visit in early August for days of all-American fun at the Maine Lobster Festival (also in Rockland) // Visit the Farnsworth Museum in Rockland to see works by Winslow Homer and Andrew Wyeth.

BALTIMORE CRABS
Baltimore, Maryland, U.S.A.

// Crab Town's Gold Standard

More than 2 million pounds of blue crabs are hauled in from nearby Chesapeake Bay every year, and a sizable chunk of that catch is consumed at tried-and-true Baltimore institutions.

Must Visit // Canton Dockside, a popular destination for meaty blues (blue crabs) // Lexington Market (*left*), Baltimore's beloved grazing ground housing well over 140 merchants, and Faidley's, the market's anchor and uncontested favorite, for jumbo-lump crab cakes

CHESAPEAKE BAY
Maryland, U.S.A.

// American Charm and the Ubiquitous Blue Crab

The triangle formed by Easton (*right*), Oxford, and St. Michaels is the Chesapeake Bay's most popular destination. Browse the antiques stores in Easton before traveling to Oxford, one of the best-preserved colonial settlements in the country.

Must Do // Take the ferry from Oxford to St. Michaels to tour the Chesapeake Bay Maritime Museum, where you'll find experts restoring historic vessels // Head to Tilghman Island, a working watermen's village first charted by Captain John Smith in the early 1600s // Take a class nearby in the state capital at the Annapolis Sailing School.

BOSTON
Massachusetts, U.S.A.

America's early history can be explored on the Freedom Trail and the Black Heritage Trail, which includes stops on the Underground Railroad and the Museum of African American History.

View the 450,000 treasures in the Museum of Fine Arts, or the Harvard Art Museums' extensive collection, now under one roof. Being the biggest college town in the world, Boston's Harvard Square is a must-see.

In summer, the North End fills with street fairs, and Boston's Fourth of July Harborfest lasts a full week. In wintertime, attend performances at Symphony Hall or—a more intimate venue— the Isabella Stewart Gardner Museum.

BELOW // America's first public botanical garden, the **Public Garden** features a small lagoon that's filled in the summer with Swan Boats. In winter, ice-skaters pirouette on the glassy surface of a nearby pond.

ABOVE // Venture inside the **Isabella Stewart Gardner Museum** to discover a re-creation of a 15th-century Venetian palazzo that houses an idiosyncratic collection of European, Asian, and American fine and decorative art.

ABOVE RIGHT // **Fenway Park** is the oldest major league ballpark in America. If you can't make a game, at least take a tour of its quirky architecture and history that oozes from every brick and board.

ABOVE // Beginning at Boston Common, the 2.5-mile self-guided **Freedom Trail** connects 16 of Boston's most important colonial and Revolutionary War landmarks, including the 1680 Paul Revere House, the Old North Church, and Faneuil Hall.

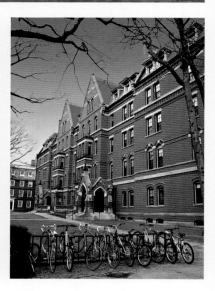

ABOVE // No visit to Boston is complete without a trip across the Charles River to Cambridge, home to MIT, Harvard, and bustling **Harvard Square**, where students, professors, and visitors fill boutiques, restaurants, and bistros.

BRIMFIELD AND STURBRIDGE
Massachusetts, U.S.A.

// Oldies but Goodies

Occupying a 1-mile stretch along Route 20 three times a year, the Brimfield Outdoor Antiques Show is the country's largest and best-known antiques and collectibles market. And it's just 6 miles to another remarkable collection of antiques—Old Sturbridge Village, the largest living history museum in the Northeast.

Must Do // Wear your most comfortable shoes, and note that it frequently rains during Brimfield's May show // Explore Old Sturbridge Village's 40 period buildings, where costumed "residents" demonstrate trades and crafts.

CAPE ANN
Massachusetts, U.S.A.

// The Bay State's "Other Cape"

Early European settlers declared the waters around Gloucester on Cape Ann the best fishing grounds in the New World, and descendants of early Portuguese and Italian fishermen still gather for St. Peter's Fiesta, a summer street fair that includes a blessing of the fleet. Rockport retains its charm as an artist's town with a nice cultural calendar.

Must Do // Visit the historic Eastern Point Lighthouse (*above*) on Gloucester's Eastern Point // Sign up for a whale-watching tour in Gloucester, the "Whale-Watching Capital of the World" // Visit nearby Essex and its small Essex Shipbuilding Museum // Stop at Salem's museum chronicling the town's infamous witch trials and visit the Peabody Essex Museum, the city's cultural centerpiece // Tour the rambling House of the Seven Gables, the setting for Nathaniel Hawthorne's novel of the same name.

CAPE COD
Massachusetts, U.S.A.

// New England's
Summer Playground

Lighthouses, salt marshes, and kettle ponds dot the woodlands of the Cape Cod National Seashore, 40 miles of rolling dunes and gorgeous beaches from Chatham to Provincetown.

Must Do // Visit the old sea captains' town of Chatham, one of the Cape's most desirable destinations // Take the two-lane Old King's Highway (Route 6A) north to Provincetown, an artists' colony with a vibrant gay community // Attend a performance at the Provincetown Theater or sign up for a whale-watching adventure.

BERKSHIRE SUMMER FESTIVALS
Lenox, Massachusetts, U.S.A.

// A Gorgeous Setting for
a Smorgasbord of Culture

When warm weather sets in, musicians from all over the world head to the Berkshires and the Tanglewood Music Festival (*left*), summer home of the Boston Symphony Orchestra, which culminates in early September with the Tanglewood Jazz Fest.

Must Do // Attend one of the more than 200 free performances at the Jacob's Pillow Dance Festival in nearby Becket // Enjoy the Berkshire Theatre Festival in nearby Stockbridge // Tour Stockbridge's Norman Rockwell Museum, which houses the largest collection of works by the beloved American artist.

MARTHA'S VINEYARD AND NANTUCKET
Massachusetts, U.S.A.

// Island Charm off
the Coast of Cape Cod

Martha's Vineyard is the larger and more serene of Cape Cod's two celebrated islands, while Nantucket, the Little Gray Lady of the Sea, retains a more traditional New England appearance.

Must Do // Visit Oak Bluffs on Martha's Vineyard (*left*), distinguished by its colorful Victorian homes, and ride its 1876 carousel // Explore the cliffs of Aquinnah (aka Gay Head) and its landmark lighthouse on Martha's Vineyard // Visit Vineyard Haven (*below*), one of New England's busiest ports in the 19th century // Tour Nantucket's Whaling Museum, for a history of the island's role in the industry.

THANKSGIVING AT PLIMOTH PLANTATION
Plymouth, Massachusetts, U.S.A.

// A Taste of History at
America's Symbolic Doorstep

The living museum of Plimoth Plantation (*right*) re-creates New England's first successful European settlement, from 1627, as well as a Native village, and every fall it hosts a harvest meal from that period as well as serving a classic American Thanksgiving dinner.

Must Visit // Plymouth Rock and the *Mayflower II*, a replica of the ship that carried the Pilgrims // New Bedford's whaling museum, the world's largest, a 45-minute drive southwest of Plymouth, to view a half-scale model of an 1826 whaling bark and a skeleton of a juvenile blue whale

THE MOHAWK TRAIL
Williamstown and Deerfield, Massachusetts, U.S.A.

// Road Trip Filled with History and Culture

Originally a Native American footpath, the Mohawk Trail became the main route connecting the British colonists in Boston to the Dutch in Albany, and today Route 2 twists and turns for 63 miles through gorgeous countryside and appealing towns.

Must Do // Attend the Williamstown Theatre Festival, which has hosted prominent names from Broadway and Hollywood since 1955 // Tour Williamstown's Sterling and Francine Clark Art Institute to view works by Renoir, Monet, Degas, and Pissarro // Explore Deerfield's 13 historic homes that make up an engaging museum devoted to the town's architectural history and American decorative arts // Visit the Massachusetts Museum of Contemporary Art in North Adams (*above left*, *Phoenix* by Xu Bing), the largest contemporary arts center in the country.

MACKINAC ISLAND
Michigan, U.S.A.

// A Victorian Relic in the Great Lakes

Horse-drawn carriages clip-clop down vehicle-free streets and pedestrians stop for ice cream and fudge on Mackinac (*MAK-i-naw*) Island, where the Lower and Upper peninsulas of Michigan are linked by one of the world's longest suspension bridges.

Must Do // Hike to Fort Mackinac or wander the other 80 percent of the island that is protected as a state park // Visit the bluff-top Grand Hotel, a white Greek Revival palace built in 1887 that movie fans will recognize as the setting for the 1980 cult classic *Somewhere in Time*.

BOUNDARY WATERS CANOE AREA WILDERNESS
Ely, Minnesota, U.S.A.

// Paddling—and Sledding— Through Paradise

The BWCA draws outdoor enthusiasts who paddle and portage for days or weeks, camping on forested shores and pulling in walleye or pike for dinner in this wilderness of more than 1,000 lakes. Ely has become the Sled Dog Capital of the United States when snow blankets the area.

Must Do // Keep an eye out for moose, loons, bears, and the occasional wolf // Tour Ely's International Wolf Center to get close to an "ambassador pack" of six wolves born in captivity // Get equipped with gear at the outfitters in Ely or sign up for an overnight dogsled trip during the winter.

NATCHEZ AND THE NATCHEZ TRACE
Mississippi, U.S.A.

// Antebellum Life
in the Old South

Natchez is a living museum of antebellum architecture on the banks of the Mississippi as well as the southern terminus of the Natchez Trace Parkway, an old American Indian and trapper trail and later a colonial trading route that is now one of the country's best places to drive and bicycle.

Must Do // Join the Natchez Spring Pilgrimage, when more than 20 private mansions and gardens are open to the public and the azaleas, camellias, and magnolias are in full bloom // Drive the 444 miles of the Trace from Nashville to Natchez for a glimpse of the Old South // Stop in Tupelo, where Elvis Presley's childhood home is now a museum devoted to the King of Rock 'n' Roll.

KANSAS CITY BBQ AND JAZZ
Kansas City, Missouri, U.S.A.

// A Culinary and
Musical Mecca

In Kansas City, barbecue is king. Queue up at any one of the 100-plus joints in town for short ribs and "brownies" (crispy, coveted scraps of beef brisket) smothered in sauce. Kansas City's dual passions unite at the 18th & Vine Jazz and Blues Festival, an annual barbecue and music event.

Must Do // Attend fall's 2-week American Royal Livestock, Horse Show, and Rodeo that features the American Royal World Series of Barbecue // Tour the American Jazz Museum, home to the Blue Room (*left*), a museum exhibit by day, jazz club by night // Explore the Negro Leagues Baseball Museum // Drop in at the Mutual Musicians Foundation, where Charlie Parker and Dizzy Gillespie reputedly met.

BIG SKY
Montana, U.S.A.

// Mountain Bliss Without
the Crowds

Montana's premier ski resort of Big Sky reaches across three mountains, has magnificent views of the Rockies, and averages only two skiers per acre. Its 11,166-foot Lone Peak is even more deserted. Much of the annual 400-plus inches of snowfall is the bone-dry talc reverently called "cold smoke."

Must Do // Enjoy extreme white-knuckle skiing from the summit of Lone Peak // Ski the more than a quarter of Big Sky's 150-plus trails that are perfect for intermediate skiers.

GLACIER NATIONAL PARK
Montana, U.S.A.

// Ice-Sculpted Majesty: The American Alps

The Blackfeet Indians believed that the epic mountain scenery of what is today Glacier National Park was sacred ground. Hikers can crisscross one of the most intact ecosystems in the temperate zone on more than 700 miles of maintained trails.

Must Do // Be on the lookout for moose, bighorn sheep, mountain lions, lynx, and maybe even a black bear or a grizzly // Drive the spectacular 50-mile, 3-hour Going-to-the-Sun Road, which bisects this mill on-acre wilderness // Don't wait too long to visit; experts believe that the glaciers may all but disappear by 2030.

BIG HOLE COUNTRY
Wise River, Montana, U.S.A.

// Big Sky, Big Country, Big Fish

"Big hole" was frontier-speak for a wide, deep valley. Montana's Big Hole Country, in the state's southwest corner, is one of its most beautiful areas—a 6,000-foot-elevation prairie basin flanked by snowcapped peaks and drained by crystal-clear streams and rivers. Cattle ranches and pastures filled with loose, unbaled piles of hay gave rise to the Big Hole's epithet, the "Valley of 10,000 Haystacks."

Must Do // Soak in the easygoing vibe and cowboy character of the tiny town of Wisdom // Fly-fish on the Big Hole River (*left*), a blue-ribbon trout stream.

THE LAS VEGAS STRIP
Las Vegas, Nevada, U.S.A.

// Where Megawatt Crass Marries Nouveau Class

The 4.5-mile stretch of Las Vegas Boulevard known as the Strip is the world capital of glitter, festooned with neon-lit hotels, 24-hour casinos, and the occasional quick-hitch wedding chapel.

Must Do // View the giant lion outside the MGM Grand and the half-scale copy of the Eiffel Tower at Paris Las Vegas // Watch the Bellagio's dancing fountains [*left*] // Catch one of the many Cirque du Soleil shows // Book in advance for any of the city's top-of-the-line restaurants.

THE GREAT NORTH WOODS
Dixville Notch, New Hampshire, U.S.A.

// In the Heart of the Mountain Wilderness

Blankets of trees, picturesque lakes, and meandering streams envelop the northernmost part of New Hampshire—an area owned largely by lumber and paper companies, where moose are more common than people. The scenic 98-mile Moose Path Trail offers excellent opportunities for wildlife sightings, running from Gorham to Pittsburg and taking motorists through the town of Dixville Notch [*right*] into serene wilderness, where idyllic spots for camping, fishing, rafting, and hiking abound.

Must Do // Chances are good that you'll see moose when you join one of the organized moose tours by van in the town of Gorham.

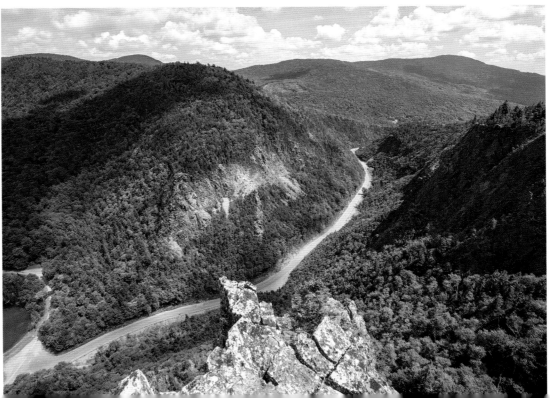

THE LAKES REGION
Lake Winnipesaukee and environs, New Hampshire, U.S.A.

// Summer Playgrounds and Golden Ponds

Of the 273 lakes and ponds that comprise New Hampshire's Lake Region, Lake Winnipesaukee is the largest, and it has one of its prettiest drives: the 97-mile Lakes Region Tour. Or explore the lake aboard the MS *Mount Washington*.

Must Do // Visit the elegant village of Wolfeboro, which claims to be America's oldest summer resort // Explore Squam Lake, the location of the 1981 film *On Golden Pond* // Spend time at the family-friendly Weirs Beach, for water slides, miniature golf, and one of the largest video arcades in the country // Check out (or avoid) Lucania in June, when it hosts the oldest motorcycle rally in the country.

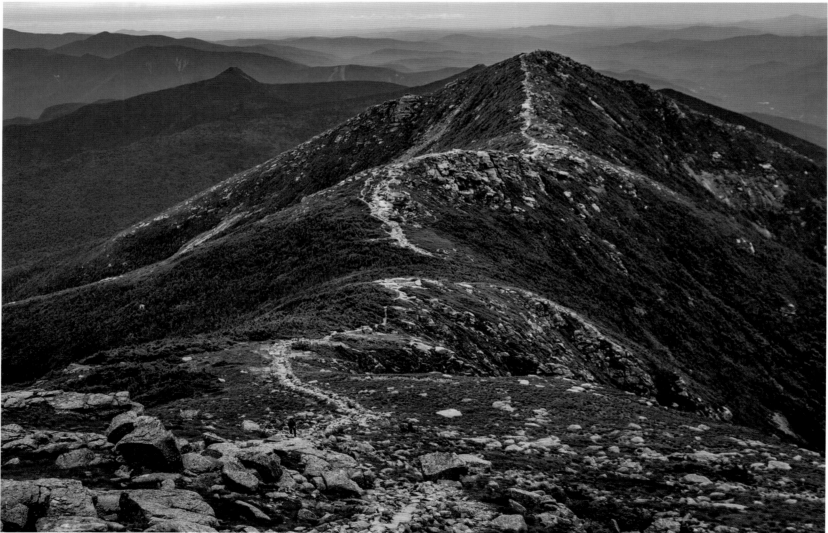

THE WHITE MOUNTAINS
North Conway and environs, New Hampshire, U.S.A.

// The High Point of the Northeast

The White Mountains inspire superlatives—tallest, coldest, windiest—and from the summit of Mount Washington, visitors can take in the majesty of the Presidential Range and, if you're not so lucky, encounter some of the most severe weather in the country.

Must Do // Get to the top of Mount Washington by car on an 8-mile private road // Ride the Mount Washington Cog Railway that pushes rather than pulls its cars up the mountain // Chug around the Mount Washington Valley and through Crawford Notch on the Conway Scenic Railroad // Drive the 26.5-mile section of the scenic Kancamagus Highway that connects Lincoln and Conway.

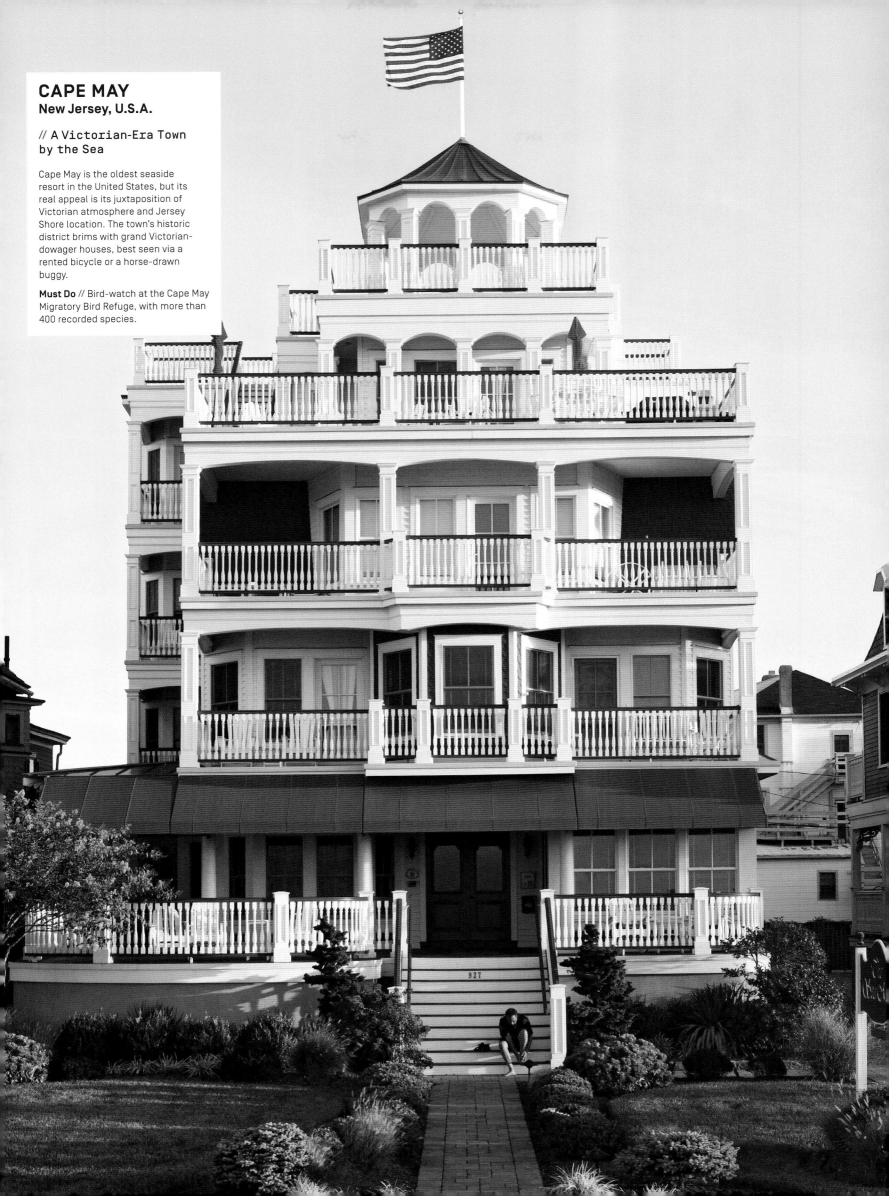

CAPE MAY
New Jersey, U.S.A.

// A Victorian-Era Town by the Sea

Cape May is the oldest seaside resort in the United States, but its real appeal is its juxtaposition of Victorian atmosphere and Jersey Shore location. The town's historic district brims with grand Victorian-dowager houses, best seen via a rented bicycle or a horse-drawn buggy.

Must Do // Bird-watch at the Cape May Migratory Bird Refuge, with more than 400 recorded species.

ALBUQUERQUE INTERNATIONAL BALLOON FIESTA
Albuquerque, New Mexico, U.S.A.

// Up, Up, and Away Through Technicolor Skies

More than 600 hot-air balloons slowly lift off into the sky at the 9-day Albuquerque International Balloon Fiesta, the world's largest hot-air balloon rally, which draws more than 800,000 people.

Must Do // Attend the Special Shape Rodeos, to see balloons shaped like mushrooms, witches, and cows // Show up for Balloon Glow, to see balloons lit up in the evening like giant ornaments // Don't miss the AfterGlow fireworks display // Tour the Anderson-Abruzzo Albuquerque International Balloon Museum // Take a balloon ride // Ride the Sandia Peak Tram, billed as the world's longest aerial tramway.

CARLSBAD CAVERNS
Carlsbad, New Mexico, U.S.A.

// Underground Wonder in the Chihuahuan Desert

Visitors to Carlsbad Caverns National Park and its more than 100 caves can take a steep walkway or ride an elevator down 750 feet to the Big Room, one of the most enormous underground chambers on the planet, then hike a mile-long trail past fantastic shapes sculpted by natural forces.

Must Do // Sign up for a ranger-guided tour of the Queen's Chamber, a site of astounding beauty // View the mass exodus of over 500,000 Mexican free-tailed bats from the cave for a frenzied night of insect hunting from spring through fall // Come early for the prelaunch ranger talks to learn how the bats are vital to the area's ecosystem.

CUMBRES & TOLTEC SCENIC RAILROAD
Chama, New Mexico, U.S.A.

// Train Buffs: All Aboard!

The Cumbres & Toltec Scenic Railroad, which winds its steam-powered way across the scenic New Mexico–Colorado border north of the small town of Chama, offers one of the country's prettiest and most authentic Old West narrow-gauge experiences and—at 128 miles round-trip—the longest.

Must Do // Paddle on the Rio Chama, a National Wild and Scenic River southwest of town.

ROSWELL
New Mexico, U.S.A.

// Out of This World

No one knows what actually crashed to earth near Roswell in 1947. Nevertheless, in the decades since the "incident," this city in southeastern New Mexico has become synonymous with unidentified flying objects.

Must Do // Attend the Roswell UFO Festival on July Fourth weekend for lectures, workshops, lighthearted costume contests, fireworks, and a parade down Main Street // Take the Roswell UFO Tour, to see Hangar 84, where debris from the mysterious crash was stored // Visit the Roswell Museum and Art Center, home to a small but world-class collection of New Mexico modernism, including works by Georgia O'Keeffe // Stop at the Robert H. Goddard Planetarium, which features Viewspace, a link to the Hubble Telescope.

ROUTE 66
New Mexico and beyond, U.S.A.

// Get Your Kicks on America's Mother Road

Commissioned in 1926, Route 66 spawned a profusion of neon and drive-in Americana from Chicago to Los Angeles. Steinbeck and Kerouac wrote about it, Nat King Cole sang about it, and a TV series and an animated film were inspired by it.

Must Do // Drive one of the stretches that still remain, particularly in the Southwest // In New Mexico, visit Tucumcari's Mesalands Dinosaur Museum, home of the world's largest collection of fossils, and don't miss Tom Coffin's huge tail-fin sculpture in Tucumcari's west end // Still in New Mexico, ogle the classic cars at the Route 66 Auto Museum in Santa Rosa and keep heading west to Gallup, where Route 66 still serves as a neon-lined Main Street with trading posts and galleries selling Native American crafts // In Holbrook, Arizona, be sure to stop at the historic Wigwam Motel (*right*).

GEORGIA O'KEEFFE TRAIL
Santa Fe and Abiquiu, New Mexico, U.S.A.

// An Artist's Love Affair with New Mexico's Beauty

A Midwesterner who initially found inspiration in New York City, Georgia O'Keeffe has long been considered New Mexico's most celebrated artist. To get a sense of her world, travel to Abiquiu, 37 miles north of Santa Fe, where she painted colorful, almost surreal depictions of her adopted land.

Must Do // Tour the Georgia O'Keeffe Home and Studio in Abiquiu // Visit Ghost Ranch [*right*], O'Keeffe's beloved residence, now a retreat that offers seminars on spirituality, science, and art // Explore Santa Fe's Georgia O'Keeffe Museum, which houses the world's largest permanent collection of her work // View more paintings at the New Mexico Museum of Art.

MARKETS AND FESTIVALS OF SANTA FE
Santa Fe, New Mexico, U.S.A.

// A Fiesta for All Seasons

The leafy historic plaza in the heart of Old Town Santa Fe is the site of the annual Santa Fe Indian Market, which draws more than 1,000 Native artists, selling everything from beadwork to baskets, and the Traditional Spanish Market, which features the work of 200 local artisans, food, and music.

Must Do // Attend a summer performance of the open-sided Santa Fe Opera [*right*], set on a hilltop with nearly 360-degree views of the mountains and desert // Tour the New Mexico History Museum in the Palace of the Governors // Explore July's Santa Fe International Folk Art Market // Visit in September for the Fiesta de Santa Fe, which features music, crafts, and the burning of Zozobra, a 50-foot effigy.

SANTA FE'S SOUTHWEST CUISINE
Santa Fe, New Mexico, U.S.A.

// Where It's All About the Chiles

There's nothing quite as emblematic of the Southwest as its food. One bite of a blue-corn chicken enchilada covered with red and green chiles, and you're hooked on America's oldest indigenous cuisine, an intriguing blend of beans, tomatoes, rice, corn, and chiles.

Must Do // Visit in September for the Santa Fe Wine & Chile Fiesta // Master some of the secrets and flavors of the region at the Santa Fe School of Cooking // Stop by the vibrant Santa Fe Farmers' Market, to snack on Southwestern specialties and pick up souvenirs.

THE ADIRONDACKS
New York, U.S.A.

// Extravagant Isolation,
Forever Wild

"Great Camps" were built here by 19th-century millionaires with names like Whitney, Vanderbilt, and Rockefeller. But the primeval forests, abundant wildlife, and more than 3,000 lakes and ponds in the 6-million-acre Adirondack State Park will legally remain "forever wild."

Must Do // Hike the 125-mile Jackrabbit Trail // Downhill and cross-country ski near Lake Placid, Olympic host and the Winter Sports Capital of the World // Tour the region on the High Peaks Scenic Byway, a 48-mile stretch of Route 73 that climbs the park's tallest mountains // Stop by the Adirondack Museum in Blue Lake to see works by Thomas Cole and Winslow Homer.

THE CATSKILLS
New York, U.S.A.

// A Manhattanite's Nirvana

Since their wild beauty first captured the imagination of the painter Thomas Cole, the Catskills have lured visitors from New York City, who have found these gentle mountains an idyllic escape.

Must Do // Attend a performance at the Bethel Woods Center for the Arts // Tour the Museum at Bethel Woods, for a music-infused exhibit exploring the 1969 Woodstock concert // Visit in late September or early October for the Woodstock Film Festival // Fish the Beaverkill River, the birthplace of American dry-fly fishing // The Mohonk Mountain House—not officially within the boundaries of the Catskills—has been an upstate favorite since it opened in 1869.

COOPERSTOWN
New York, U.S.A.

// Baseball, Bel Canto, and Bucolic Charm

According to legend, Abner Doubleday created the game of baseball in this village on Otsego Lake. But there's much more to this town than baseball. Cooperstown hosts the summer Glimmerglass Festival, which blends classic operatic repertory with rarities in an acoustically perfect 900-seat house.

Must Do // Explore the National Baseball Hall of Fame and Museum, which displays Joe DiMaggio's locker and a 1909 Honus Wagner card // Visit the Fenimore Art Museum, to see artifacts from local son James Fenimore Cooper's life, North American Indian art, and works by Hudson River School artists.

FINGER LAKES
New York, U.S.A.

// World-Class Wines and Small-Town Americana

These 11 long, narrow lakes are in a bucolic region where waterfront towns invite strolling and antiques hunting, and where vineyards produce some of the country's best rieslings and chardonnays.

Must Do // Drive the Keuka trail to visit the Vinifera Wine Cellars, outside Hammondsport, and nearby Pleasant Valley // Take the Cayuga Lake Scenic Byway to Aurora, a charming lakefront town of 650.

HUDSON VALLEY
New York, U.S.A.

// Where "America the Beautiful" Began

The Hudson has exerted such a profound effect on American culture that Bill Moyers dubbed it "America's First River." 18th- and 19th-century riverfront towns like Cold Spring and Hudson offer excellent antiquing and restaurants with a view.

Must Visit // The Storm King Art Center (*above*, *Adam* by Alexander Liberman), an outdoor sculpture park north of West Point // In the town of Hudson, Olana, an 1874 hilltop Moorish mansion and home of Frederick Church, who helped found the Hudson River School of painting // The world's longest pedestrian bridge in Walkway Over the Hudson State Historic Park near Poughkeepsie // The prestigious Culinary Institute of America in Hyde Park (make a reservation) // U.S. Military Academy at West Point, the nation's oldest military academy // The FDR Presidential Library and Museum in Franklin D. Roosevelt's home in Hyde Park // The nearby Vanderbilt Mansion, the showiest of the valley's historic homes // Dia:Beacon, a gallery in a 1929 printing plant that displays major (and often oversize) works from the 1960s to the present

THE HAMPTONS
Long Island, New York, U.S.A.

// Summer Scene Where the Elite Meet and Greet

The seaside towns on eastern Long Island known as the Hamptons are inundated with city folk in the summer, but along with golf courses and polo fields, there are still roadside farm stands and seafood stores stocked by local fishermen.

Must Visit // Southampton, the grande dame of old money and sweeping estates // Fashionable East Hampton, once the haunt of Willem de Kooning, Jackson Pollock, Truman Capote, and Joseph Heller // Sagaponack, where the potato fields are fragrant with flowers in August // The shop-lined Main Street of Sag Harbor // Montauk and its famous lighthouse and surfing

NEW YORK CITY
New York, U.S.A.

New York is the city other cities wish they were. Skyscrapers loom above canyonlike streets where some 8.4 million New Yorkers go about their daily business—walking fast, talking fast, taking no lip, yet sharing a pride and sense of community.

Visitors can get a glimpse of the city's unique neighborhoods on walking tours that explore Greenwich Village, Harlem, and Chinatown.

Roughly 30 percent of Americans have an ancestor who passed through Ellis Island, where visitors can now view interactive exhibits, research their heritage, and stand where their forebears once did. Hop on the Staten Island Ferry for a free ride and a good view of the Statue of Liberty and the Manhattan skyline.

Rockefeller Center and Radio City Music Hall's Rockettes are two must-dos in wintertime. Summertime in New York includes performances in Central Park by the New York Philharmonic, the Metropolitan Opera, and Shakespeare in the Park. And any time of year is perfect for visits to New York City's many museums, including the American Museum of Natural History, the Metropolitan Museum of Art, the Museum of Modern Art, the Solomon R. Guggenheim Museum, and the 9/11 Memorial and Museum.

Venture beyond Manhattan to explore a few exceptional highlights—the Bronx Zoo, nearby New York Botanical Garden, and Bronx's own baseball mecca, Yankee Stadium. Or escape across the Brooklyn Bridge to the Brooklyn Botanic Garden or the Brooklyn Museum, surrounded by evolving neighborhoods that range from hipster to mainstream.

LEFT // Designed by Frederick Law Olmsted and Calvert Vaux, **Central Park** is an urban miracle where New Yorkers and visitors sunbathe, ice-skate, jog, ride the 58-horse carousel, and stroll the Conservatory Garden.

RIGHT // Visitors to the **American Museum of Natural History** can see a 94-foot model of a blue whale (*pictured*) and a fossil composite of a *T. rex*. And don't miss the Museum of Modern Art, home to the world's finest collection of works from the late 19th century to the present, including Van Gogh's *Starry Night*, Picasso's *Les Demoiselles d'Avignon*, and photographs by Man Ray, Walker Evans, and Ansel Adams.

BELOW // Once a swamp of peep shows, hustlers, and lowlifes, **Times Square** is now a thriving family-entertainment and business district. No one should miss a Broadway show at any of the theaters lining the side streets of the Great White Way.

ABOVE // **Hudson Yards** is home to the *Vessel* (*pictured*), which stands in front of the Shed, a cultural center. The High Line, a 1.5-mile elevated public park built atop a historic railway, stretches from the Meatpacking District in Lower Manhattan through Chelsea to Hudson Yards.

ABOVE // Designed by Frank Lloyd Wright, the **Solomon R. Guggenheim Museum** is shaped like a spiraling seashell. Take the elevator to the top and walk down through the circling gallery to view works that span the late 19th century to the present.

LEFT // The Chrysler Building may be the most beautiful of New York's skyscrapers, but the **Empire State Building** is its most iconic. Visitors can see up to 80 miles in all directions from the 86th floor's open-air observatory. In the background is One World Trade Center, also known as Freedom Tower, the country's highest building.

BELOW // With more than 2 million works, the **Metropolitan Museum of Art** is one of the largest repositories of art and culture on the planet, with highlights that include the Costume Institute, the Egyptian collections, and works by Cézanne, Vermeer, and Monet.

ABOVE // Climb the 364 steps to the crown of the **Statue of Liberty on Ellis Island**, equivalent to 20 stories. Or visit the brand-new museum behind it to learn the history and see the original torch.

LEFT // With 12 resident companies that include the New York City Ballet, the American Ballet Theatre, the New York Philharmonic, and the Metropolitan Opera, **Lincoln Center** is the centerpiece of New York's performing arts scene.

SARATOGA SPRINGS
New York, U.S.A.

// A 19th-Century Queen of Spas

Once known as the "Queen of Spas," Saratoga Springs has been a longtime summer playground for the moneyed, thanks to its natural springs and a horse-racing season considered one of the nation's best.

Must Visit // The National Museum of Racing and Hall of Fame at the Saratoga Race Course, to view Triple Crown trophies, diamond-encrusted whips, and interactive exhibits // The open-air Saratoga Performing Arts Center, for summertime performances by the New York City Ballet and the Philadelphia Orchestra // The Saratoga National Historical Park, to learn how American forces defeated a British army in 1777

BILTMORE
Asheville, North Carolina, U.S.A.

// America's Grandest Estate

Completed in 1895 for the Vanderbilt family, Biltmore is the largest private home ever built in America. Guided tours explore about 100 of the mansion's 250 rooms, decorated with some 1,600 works of art, including pieces by Renoir, Whistler, and Sargent.

Must Do // Stroll more than 400 acres of gardens that showcase dogwoods, roses, and some 50,000 tulips and 1,000 azalea bushes // Tour the Biltmore Estate Winery, which produces several well-respected wines.

THE OUTER BANKS
North Carolina, U.S.A.

// World's Longest Stretch of Barrier Islands

Some of the most beautiful beaches on America's Atlantic coast are in North Carolina's Outer Banks, a string of barrier islands that stretches 130 miles from the Virginia border south to Cape Lookout and Beaufort.

Must Do // Visit Kitty Hawk and Kill Devil Hills, where the Wright brothers pioneered airplane flight // Tour Nags Head and nearby Jockey's Ridge State Park, home to towering sand dunes and the gateway to Roanoke Island // Attend a performance of *The Lost Colony* at Manteo's outdoor Waterside Theatre // South of Nags Head, explore the Bodie Island Lighthouse [*right*] // Check out Cape Hatteras National Seashore and its candy-striped lighthouse // Explore Cape Lookout National Seashore, where wild horses have roamed for centuries // Stop at Beaufort's North Carolina Maritime Museum.

ROCK AND ROLL HALL OF FAME AND MUSEUM
Cleveland, Ohio, U.S.A.

// Cleveland Rocks!!

Cleveland's I. M. Pei–designed Rock and Roll Hall of Fame and Museum guarantees visitors a fun afternoon with interactive exhibits with lots of sound and videos. The permanent collection includes instruments and stage costumes from the likes of Jimi Hendrix and Iggy Pop as well as Jim Morrison's Cub Scout uniform.

Must Do // Don't miss Janis Joplin's psychedelic Porsche, ZZ Top's 1933 Ford coupe, and John Lennon's and Keith Moon's report cards.

OKLAHOMA CITY'S COWBOY CULTURE
Oklahoma City, Oklahoma, U.S.A.

// Where the Wild West Lives On

With more horses per capita than any other state, it is no surprise that Oklahoma City has more horse shows than any other city in America. Stockyards City Main Street, a retail district in the center of town, is at its best during competitions such as November's American Quarter Horse Association World Championship Show.

Must Do // Watch cattle being auctioned at the Oklahoma National Stockyards every Monday and Tuesday // Tour the National Cowboy & Western Heritage Museum, to learn the history of the working cowboy // Visit in June to attend powwows or the annual 3-day Red Earth Native American Cultural Festival, where more than 100 Native American tribes from across the country participate.

GILCREASE MUSEUM
Tulsa, Oklahoma, U.S.A.

// A Treasure Trove of Art and Artifacts Devoted to the American West

The Gilcrease Museum [right] has the world's largest collection of fine art, artifacts, and archives devoted to the American West, including artwork by Charles M. Russell, Frederic Remington, George Catlin, and John Singleton Copley.

Must Do // Visit the Philbrook Museum of Art, known for its fine Italian Renaissance and Baroque paintings // Shop for turquoise, Pendleton blankets, and Oklahoma beadwork at the Warehouse Market Building.

OREGON SHAKESPEARE FESTIVAL
Ashland, Oregon, U.S.A.

// Much Ado About Ashland

The Oregon Shakespeare Festival is the largest and longest-running celebration of the Bard in America. In addition to the 11 plays presented from mid-February through October, there are outdoor concerts, backstage tours, lectures, and discussions led by actors and scholars.

Must Do // Stroll along Ashland Creek in Lithia Park // Make day trips to southern Oregon to visit nearby vineyards // Ski at Mount Ashland in the winter months.

THE COLUMBIA RIVER GORGE
Oregon and Washington, U.S.A.

// A Majestic Cleft in the Cascade Volcanoes

Flanked by Oregon's Mount Hood and Washington's Mount Adams, the Columbia River Gorge through the Cascade Mountains is one of the most dramatic destinations in the Pacific Northwest.

Must Do // Explore the area on the remnants of the Historic Columbia River Highway // Visit the town of Hood River, the hub of the gorge and the windsurfing capital of the world // Ride the Mount Hood Railroad between Hood River and Parkdale // View Multnomah Falls (left), the second-highest year-round waterfall in the United States // Board the *Columbia Gorge* sternwheeler in Cascade Locks to see the river as early pioneers did.

CRATER LAKE NATIONAL PARK
Oregon, U.S.A.

// Nature's Theater in the Round

A massive eruption caused Mount Mazama to collapse inward about 7,700 years ago, and water filled the resulting caldera to create the jewel-like beauty that draws modern visitors to Crater Lake.

Must Do // Hike down the steep mile-long trail on the north side, then board the tour boat to Wizard Island // Drive, hike, or bike the 33-mile Rim Drive, for dazzling views // Cross-country ski or snowshoe on a ranger-guided tour around the lake in winter // Travel the 500-mile Volcanic Legacy Scenic Byway, which starts at the park and ends just south of Lassen Volcanic National Park in California.

THE OREGON COAST
Oregon, U.S.A.

// Rugged Masterpiece
of the Natural World

Set aside as public land in the 1910s, Oregon's 362-mile coastline is one of nature's masterworks, and it's best experienced by driving north to south on the Beaver State portion of Highway 101 from the historic town of Astoria.

Must Do // Stop at Cannon Beach, northern Oregon's most beautiful seaside village, home to the iconic Haystack Rock // Visit Newport's Oregon Coast Aquarium, for a fascinating glimpse into the region's marine environment // Tour the most rugged stretch of the coast south of Yachats (*YA-hots*), home of scenic Cape Perpetua // Explore the Heceta Head Lighthouse and the nearby Sea Lion Caves // Fish or raft on the fast-flowing Rogue upstream from Gold River.

WILLAMETTE VALLEY
Oregon, U.S.A.

// The Way Napa Used to Be

Thousands of acres of rolling vineyards unfold at the end of the historic Oregon Trail in the northern Willamette Valley (*above*), one of the state's two wine-producing regions that have helped make Oregon the envy of vintners from California to France.

Must Do // Drive Route 99W, the main road through Yamhill County, or travel on back roads through the heart of northern Oregon's wine country // Visit Newberg's Rex Hill, where the wines and gardens both warrant a stop // Tour Dundee's Argyle Winery, which produced one of the first Oregon wines served at the White House // Head south from Beaverton to Ponzi Vineyards for top-shelf pinot noirs.

GETTYSBURG NATIONAL MILITARY PARK
Gettysburg, Pennsylvania, U.S.A.

// A Shrine to the Civil War's Fallen

Gettysburg was the bloodiest battle ever fought on American soil. In July 1863, in 3 days of fighting, more than 51,000 men were killed, wounded, captured, or went missing. The battlefield's 6,000-acre grounds are now protected as a national park that features more than 1,300 statues, monuments, and cannons.

Must Do // Visit Gettysburg National Cemetery, where Lincoln gave his famous address // Stop by the visitor center to see the 1884 Battle of Gettysburg cyclorama and view the 22-minute film *A New Birth of Freedom* // Tour the Gettysburg Museum of the American Civil War's extensive collection.

PENNSYLVANIA DUTCH COUNTRY
Lancaster, Berks, and adjacent counties, Pennsylvania, U.S.A.

// Where the Plain People Live

The largely agricultural counties of southeastern Pennsylvania are home to some 50,000 Amish and Mennonites, most of whom wear traditional dark clothing, travel by horse-drawn buggy, and live quite isolated from modern society.

Must Do // Respect the communities' privacy // Visit the Lancaster Cultural History Museum, the Lancaster Quilt & Textile Museum, and the town's busy Central Market // Head north from Lancaster to Lititz and its colonial buildings housing antiques shops and gift stores // Travel to neighboring Ephrata, where a dozen 18th-century restored buildings are open to visit.

INDEPENDENCE NATIONAL HISTORICAL PARK
Philadelphia, Pennsylvania, U.S.A.

// The Birthplace of American Democracy

Created by an act of Congress in 1948, Independence National Historical Park encompasses almost 55 acres, with 20 buildings open to the public, including Independence Hall, Congress Hall, and the Liberty Bell Center (*right*).

Must Do // Visit Carpenters Hall, the site of the first meeting of the Continental Congress in 1774 // Tour Franklin Court, Benjamin Franklin's last home // Stop at the nearby Betsy Ross House, which has been restored to its 1777 appearance // Visit the City of Brotherly Love in March to see the Philadelphia International Flower Show, the country's largest and longest running.

PHILADELPHIA MUSEUM OF ART AND THE BARNES FOUNDATION
Philadelphia, Pennsylvania, U.S.A.

// Temples of Culture in the City of Brotherly Love

The Philadelphia Museum of Art (*left*) is among the country's largest art museums and one of its best, while the recently relocated Barnes Foundation has an important collection of French Impressionist and Postimpressionist paintings.

Must Do // View Van Gogh's *Sunflowers* and Cézanne's *Large Bathers* along with works by Picasso, Dalí, Miró, Léger, de Kooning, Pollock, and Marcel Duchamp at the Philadelphia Museum of Art // See 181 works by Renoir and countless others by Cézanne, Matisse, and Picasso as well as Van Gogh, Degas, Monet, Manet, Goya, and El Greco at the Barnes Foundation.

PHILLY FOOD
Philadelphia, Pennsylvania, U.S.A.

// Life, Liberty, and the Pursuit of Cheesesteaks

Leaving Philly without sampling a cheesesteak would be like going to Napa and not sipping the wine. At the other end of the culinary spectrum are a host of innovative restaurants considered some of the country's best

Must Do // Sample the steak sandwich smothered in gobs of molten Cheez Whiz with onions at Pat's in the 9th Street Italian Market // Check out Geno's, Pat's friendly competitor across the intersection, or Jim's Steaks, also known for their hoagies // Head over to the Reading Terminal Market and visit Bassett's, which has been selling ice cream since the market opened in 1892, and countless other vendors new and old.

BLOCK ISLAND
Rhode Island, U.S.A.

// Eleven Square Miles of
Yankee Paradise

Block Island is a barefoot-and-bicycle kind of place, and a third of this New England gem is a wildlife refuge with more than 30 miles of hiking trails and cliffside biking paths.

Must Do // Explore the Great Salt Pond, which harbors hundreds of pleasure boats // Visit during the autumn migrations to see more than 150 species of birds pass through // View the collection of wooden buildings from the island's Victorian heyday.

NEWPORT MANSIONS AND THE CLIFF WALK
Newport, Rhode Island, U.S.A.

// Seaside Cottages
of the Gilded Age

About a dozen of the summer homes, or "cottages," built by wealthy families in the 19th century are open to the public, including the showstopping Breakers, a 70-room Renaissance-style palazzo completed in 1895 for Cornelius Vanderbilt II.

Must Do // Tour Marble House, built in a style inspired by the Petit Trianon at Versailles // Visit Rosecliff and Doris Duke's Rough Point mansion // Take the 3.5-mile waterfront Cliff Walk for wonderful mansion views // Visit in June for the New York Yacht Club's annual regatta.

BEAUFORT AND THE LOWCOUNTRY
South Carolina, U.S.A.

// Where the Old Times Aren't Forgotten

Gateway to the string of Sea Islands, the antebellum town of Beaufort (*BYEW-fert*) (*left*) has been popular with Hollywood. *The Big Chill*, *Forrest Gump*, and *The Prince of Tides* were all shot here.

Must Do // Golf the famous course on Kiawah Island, where tennis and beach sports are also stellar // Visit St. Helena Island's Penn Center, a modest museum that is the cultural hub of the area's small Gullah community.

THE HEART OF CHARLESTON
Charleston, South Carolina, U.S.A.

// Nothing Could Be Finer

Charleston's wonderfully walkable historic district contains one of the nation's largest collections of antebellum architecture, and a fair share of distinctive Victorian buildings as well.

Must Do // Visit the Charleston Museum, the country's oldest, for a crash course on the city's heritage // Sign up well in advance for the spring Festival of Houses and Gardens and the Fall Tours of Homes and Gardens // Attend Spoleto Festival U.S.A., a 17-day extravaganza featuring more than 120 performances from opera to dance.

LOWCOUNTRY CUISINE
Charleston, South Carolina, U.S.A.

// A Marriage of the Old South and the New

Lowcountry cuisine blends French, Spanish, African, and Caribbean influences, and the traditional ingredients of shrimp, oysters, crab, rice, grits, okra, and fried greens have enjoyed a creative spin in recent years.

Must Visit // Charleston's Peninsula Grill, circa 1886, and Magnolias, for time-honored recipes and innovative dishes // Fig and Husk (*left*), for farm-to-table menus that pay homage to the bounty of the Lowcountry with an updated twist

BADLANDS NATIONAL PARK
South Dakota, U.S.A.

// Nature's High Drama

Sculpted by 75 million years of sedimentation and erosion, the Badlands are an eerily sparse yet spectacular landscape. Some rock formations rise more than 1,000 feet, while others are banded by stratified mineral deposits—nature's brushstrokes.

Must Do // Explore the Badlands by foot using either a quarter-mile loop or the 10-mile Castle Trail // Drive the Badlands Loop at dawn, at dusk, and/or after a rainfall, when the interplay of light and shadow is most poetic // Visit the memorial for the 1890 Wounded Knee Massacre approximately 45 miles south of the park.

THE BLACK HILLS
South Dakota, U.S.A.

// Sacred Land of Heroes:
Mount Rushmore and
Crazy Horse

Named for the inky shade of their
ponderosa pines, the Black Hills of
South Dakota have long been considered
sacred by the Lakota Sioux. Present-day
artists have now made the area hallowed
in a different way.

Must Visit // Mount Rushmore [*right*],
conceived in 1924 by Danish-American
sculptor Gutzon Borglum to be a shrine of
democracy // The Crazy Horse Memorial,
still being sculpted by Korczak Ziolkowski's
family // Custer State Park, home of one of
the largest publicly owned buffalo herds

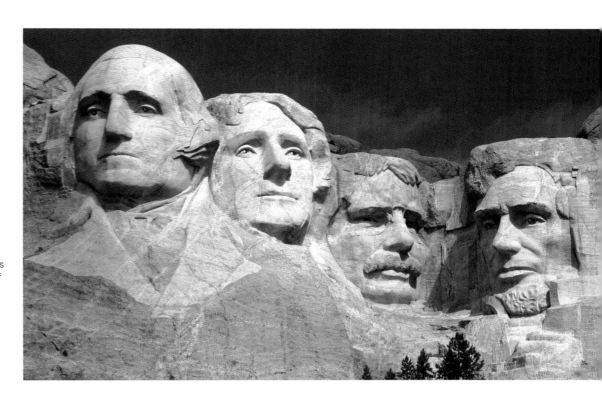

STURGIS MOTORCYCLE RALLY
Sturgis, South Dakota, U.S.A.

// Party!

For folks who like choppers, hogs, and all forms of motorbikes, there's no place like Sturgis, a small town that hosts a week of bike shows, concerts, races, demos, group rides, camaraderie, and plain old partying every August.

Must Visit // The Sturgis Motorcycle Museum and Hall of Fame // The Black Hills National Forest, for scenic motorcycle rides // The nearby Wall Drug Store, a state legend that sells everything from hand-tooled cowboy boots to horse liniment.

THE GREAT SMOKY MOUNTAINS
Tennessee and North Carolina, U.S.A.

// Cloaked in Blue Haze

With 16 peaks rising higher than 5,000 feet often shrouded by water vapor emitted by dense forests and a plethora of native plant, fish, and animal species, the Great Smoky Mountains—the most visited national park in the country—has been designated an International Biosphere Reserve.

Must Do // Hike some of the 150 trails that range from easy walks to a rugged 70-mile stretch of the Appalachian Trail // Drive the 34 scenic miles of the Newfound Gap Road that link Gatlinburg, Tennessee, and Cherokee, North Carolina.

GRACELAND
Memphis, Tennessee, U.S.A.

// The King's Castle on the Hill

Elvis Presley's Graceland Mansion is something of a hoot, but it is also intriguing and at times moving, and much of this has to do with the fans who travel thousands of miles to see the King's home and final resting place.

Must Do // Tour the Jungle Room, with its waterfall wall, shag-carpeted ceiling, and fake-fur upholstery // Pause at Elvis's grave in the Meditation Garden // View the trophy hall's gold and platinum records, stage costumes, and mementos // See Elvis's famous 1955 pink Cadillac Fleetwood.

MEMPHIS BARBECUE
Memphis, Tennessee, U.S.A.

// It's All About the Pork

BBQ in Memphis means pulled pork shoulder and ribs served either "wet" (with sauce) or "dry" (with a rub of spices and herbs). For all-around barbecue nirvana, show up at the World Championship Barbecue Cooking Contest, part of the annual Memphis in May bash.

Must Visit // The Rendezvous, located in a busy cellar near the grand Peabody Hotel, for the dry charcoal-broiled ribs with red beans and rice // Corky's BBQ, with a long list of well-loved dishes // Payne's Bar-B-Que, housed in an old gas station near Graceland, serving legendary chopped pork sandwiches // The Cozy Corner, for tasty BBQ baloney sandwiches // Central BBQ, for meaty ribs (both dry and wet) and thick-cut homemade potato chips // Jim Neely's Interstate Bar-B-Que, which slathers pork ribs with a thick, sweet-and-tangy basting sauce // Coletta's Italian Restaurant, for barbecued pizza

THE MEMPHIS MUSIC SCENE
Memphis, Tennessee, U.S.A.

// Where Blues Legends Began Their Careers

The best bets in Memphis for live music are B.B. King's Blues Club, named for the guitarist who got his start here, and the Rum Boogie Café, which has a killer house band—or the 3-day Beale Street Music Festival in early May.

Must Do // Listen to locals jam at the Hi-Tone Café, near the Memphis College of Art // Visit Wild Bill's for dancing-room-only crowds // Attend a service at the Full Gospel Tabernacle // Tour the Stax Museum of American Soul Music, to see vintage guitars, flashy threads, and Isaac Hayes's gold-trimmed Cadillac // Stop at the Memphis Rock 'n' Soul Museum, to learn about the city's musical roots // Explore Elvis's early career at Sun Studio, where the King recorded his first hit.

THE GRAND OLE OPRY
Nashville, Tennessee, U.S.A.

// The Home of Country Music

Nashville has been known as "Music City, U.S.A." for the better part of a century, since the Grand Ole Opry began its weekend broadcast here in 1925. The world's longest-running live radio show is now broadcast from a modern 4,372-seat venue (right) that dominates the area 20 minutes from Nashville known as Music Valley.

Must Do // Visit the Opry Museum, which tells the story of the show that made country music famous // Tour downtown's Country Music Hall of Fame and Museum, to see Elvis's 1960 "solid gold" Cadillac and Mother Maybelle Carter's 1928 Gibson guitar // Visit the original Grand Ole Opry in downtown's Ryman Auditorium, where concerts are still held // Book a bus tour to the nearby Historic RCA Studio B, on Music Row, where Elvis, Chet Atkins, and others cut hit records.

AUSTIN'S LIVE MUSIC SCENE
Austin, Texas, U.S.A.

// The Lone Star State's Heartbeat

Laid-back and fun-loving, Austin bills itself as the Live Music Capital of the World and claims more than 250 venues showcasing everything from rockabilly to Tejano.

Must Do // Attend mid-March's South by Southwest Music and Media Conference (aka SXSW), one of the biggest music showcases anywhere // Visit in early October for 6 days of rock at the Austin City Limits festival // Explore Sixth Street and the Red River District immediately north of it, the city's music nerve center // Stop by Antone's, Austin's "Home of the Blues" // Head to Stubb's BBQ (*left*), beloved for great music and food, particularly its Sunday Gospel Brunch // Dance your boots off at the Broken Spoke, Texas's premier two-step dance hall.

THE DALLAS ARTS DISTRICT
Dallas, Texas, U.S.A.

// Cultural Jewels in Big D

The Dallas Arts District is the centerpiece of the city's cultural life, a 68-acre, 19-block enclave built to hold some of the best collections of art anywhere.

Must Visit // The Dallas Museum of Art, which contains more than 24,000 pieces from around the globe // The Crow Collection of Asian Art, to see a sandstone façade from an 18th-century home in India // The Nasher Sculpture Center (*right*), for works by Rodin, Picasso, Matisse, and Degas as well as other modern and contemporary artists (*pictured, Eviva Amore* by Mark di Suvero) // The AT&T Performing Arts Center, home of the Winspear Opera House and the Wyly Theater // The Meyerson Symphony Center, which has been delighting music lovers since 1989

HOUSTON'S ART MUSEUMS
Houston, Texas, U.S.A.

// An Eclectic Collection of Texas Treasures

The Museum of Fine Arts, Houston (*right*) is one of the most visited of the 18 venues that make up the city's Museum District, with works by Rembrandt, Van Gogh, Monet, and Picasso, and excellent collections of Latin American art and photography.

Must Visit // The Lillie and Hugh Roy Cullen Sculpture Garden, to see works by Matisse and Calder // The Menil Collection, which displays works by Man Ray, Duchamp, Max Ernst, and Magritte // The Menil's annex across the street, dedicated to the work of Cy Twombly // The quirky Orange Show Center for Visionary Art, an ode to outsider art made from recycled materials

RIVER WALK
San Antonio, Texas, U.S.A.

// A Lively Oasis in
a Multicultural Town

San Antonio's Paseo del Rio, or River Walk, is a flagstone esplanade along both banks of the San Antonio River that is filled with lively sidewalk cafés and shops one level below the city's streets.

Must Do // Visit during the Christmas season, when more than 120,000 twinkling lights illuminate the River Walk // Arrive in late April, for the 11-day Fiesta San Antonio // See the Alamo, the symbol of Texas's independence // Catch the IMAX film *Alamo: The Price of Freedom* at RiverCenter Mall // Visit Market Square's El Mercado for a delicious meal.

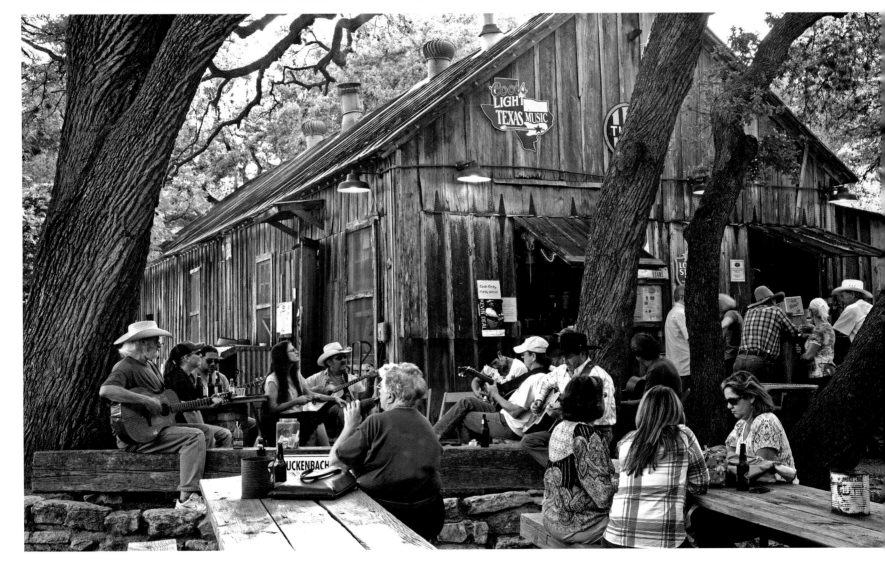

TEXAS HILL COUNTRY
Texas, U.S.A.

// Back Roads and Bluebonnets

Deep in the heart of Texas is an area of grassy pastures and limestone bluffs, crystal-clear streams, rivers, and lakes, a place that local boy President Lyndon B. Johnson called a "special corner of God's real estate." The Hill Country has Lady Bird Johnson to thank for the veritable blanket of wildflowers (especially bluebonnets) that cover the region every spring. Visitors can take in some of the 600 indigenous wildflower species at the Austin-based Lady Bird Johnson Wildflower Center before heading out to enjoy them in situ.

Must Do // Attend the local Oktoberfest and Christmastime festivals in and around Fredericksburg, the area's busiest town // Take the Fredericksburg Wine Road (U.S. Highway 290) to Hill Country wineries, including the popular Becker Vineyards // Enjoy Bandera's Cowboys on Main, a street party held Saturday afternoons between March and December // Bird-watch at the adjacent Hill Country State Natural Area // Scoot your boots at Gruene's oldest continuously operating dance hall in Texas // Go tubing on the Guadalupe River.

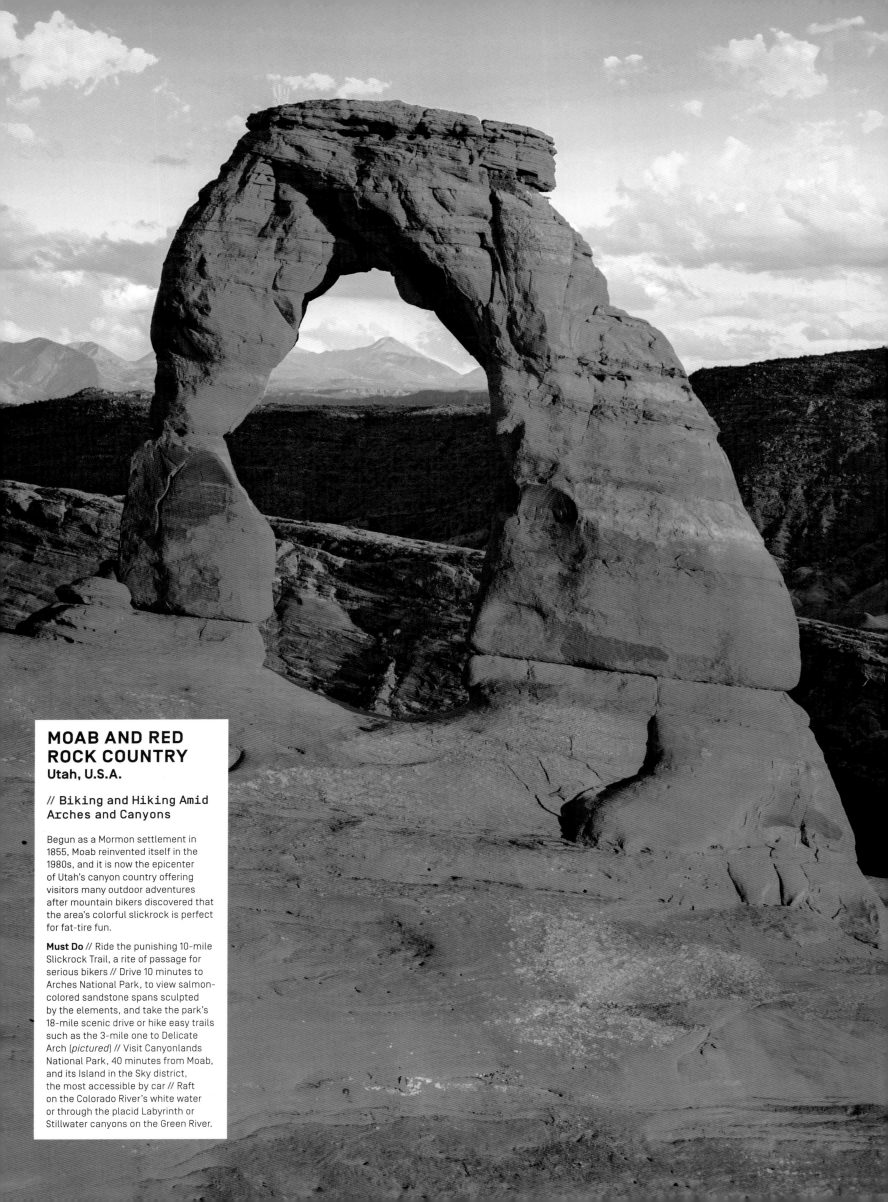

MOAB AND RED ROCK COUNTRY
Utah, U.S.A.

// Biking and Hiking Amid Arches and Canyons

Begun as a Mormon settlement in 1855, Moab reinvented itself in the 1980s, and it is now the epicenter of Utah's canyon country offering visitors many outdoor adventures after mountain bikers discovered that the area's colorful slickrock is perfect for fat-tire fun.

Must Do // Ride the punishing 10-mile Slickrock Trail, a rite of passage for serious bikers // Drive 10 minutes to Arches National Park, to view salmon-colored sandstone spans sculpted by the elements, and take the park's 18-mile scenic drive or hike easy trails such as the 3-mile one to Delicate Arch [*pictured*] // Visit Canyonlands National Park, 40 minutes from Moab, and its Island in the Sky district, the most accessible by car // Raft on the Colorado River's white water or through the placid Labyrinth or Stillwater canyons on the Green River.

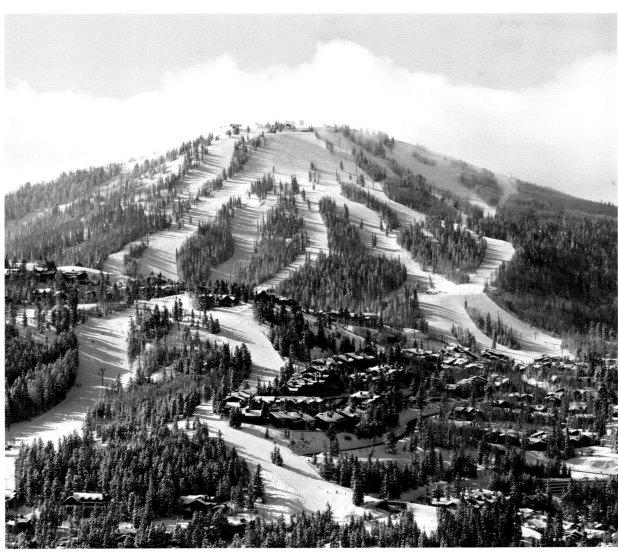

SKIING THE WASATCH RANGE
Park City and environs, Utah, U.S.A.

// The Greatest Snow on Earth

With 15 ski resorts within an hour's drive of Salt Lake City and an annual snowfall of 500 inches in some areas, it's no mystery why Utah was chosen to host the 2002 Winter Olympics. The charming century-old mining town of Park City is one of the best little ski towns in the country.

Must Do // Ski with Olympic athletes and hopefuls at Park City Mountain Resort // Take on the Olympic bobsled track and any of six Nordic jumps at Utah Olympic Park // Try some of the 101 runs at Deer Valley [*left*], Utah's plushest resort // Opt for Little Cottonwood Canyon and its less commercial Alta and Snowbird resorts // Drive to Sundance Resort, whose ski options echo creator Robert Redford's "smaller is better" vision // Attend Park City's Sundance Film Festival in late January.

TEMPLE SQUARE
Salt Lake City, Utah, U.S.A.

// Mormon Mecca and America's Choir

As revered by Latter-day Saints as the Vatican is by Catholics, Temple Square is the heart of Salt Lake City and of the universal community of the Church of Jesus Christ of Latter-day Saints. Young guides offer free tours in 40 languages.

Must Do // View the exterior of the Salt Lake Temple [*right*], topped by a 12-foot statue of the angel Moroni, but the interior is open only to Latter-day Saints Church members // Hear the Mormon Tabernacle Choir on Sunday mornings or attend a rehearsal on Thursday evenings; both events are open to the public // Visit Salt Lake City for the choir's annual Christmas concert, which is televised around the world.

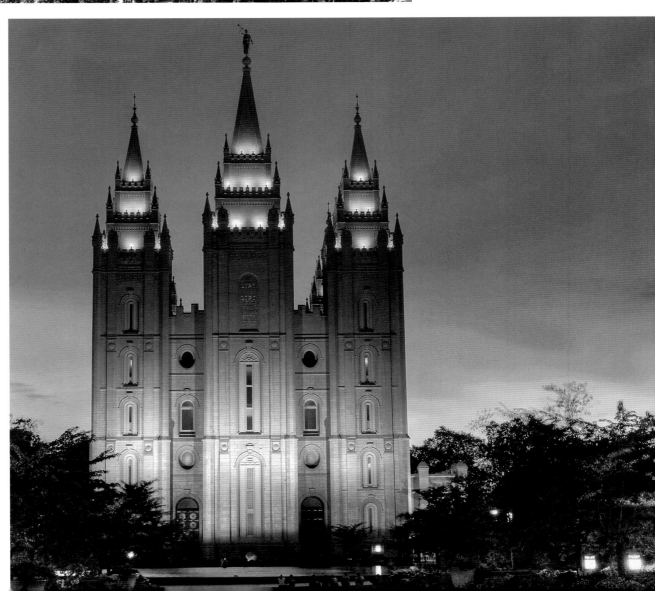

ZION AND BRYCE NATIONAL PARKS
Utah, U.S.A.

// The Quintessential Road Trip

Zion National Park is the oldest and perhaps most beautiful of Utah's five stellar national parks, and 86 miles east is Bryce Canyon National Park, whose thousands of multihued hoodoos (*right*) were believed to be ancient evildoers frozen in time.

Must Do // Drive the 10-mile Zion–Mount Carmel Highway (Highway 9) across the park // Also in Zion, hike to Angel's Landing, or take the Narrows hike through the Virgin River or the forested Emerald Pools Trail to three basins and a waterfall // Take the 18-mile scenic drive along Bryce Canyon's rim or hike down among the formations on 60 miles of trails // Head east on Highway 12, which offers 124 of the prettiest driving miles in the country // Don't miss Grand Staircase—Escalante National Monument.

GRAFTON
Vermont, U.S.A.

// A Cheesemaking Village Stuck in Time

The pitch-perfect Vermont village of Grafton is an authentic showcase of historical buildings. It is also home of the Grafton Village Cheese Company, where visitors can sample one of the world's finest cheddars while watching it be made.

Must Do // Drive to nearby Bellows Falls to catch the seasonal Green Mountain Flyer, a vintage sightseeing train that makes a 90-minute round-trip run to Chester.

KILLINGTON AND WOODSTOCK
Vermont, U.S.A.

// The King of East Coast Skiing

Pretty in every season, and known as the Aspen of the East Coast, Killington uses the largest snow-making system in the world. Nearby Woodstock claims to be the oldest ski resort in the country and the site of the first ski tow, with an inviting town full of charm and small eateries.

Must Do // Ski Outer Limits, a challenging mogul trail, or the double black–diamond runs Anarchy and Downdraft // Visit the Mountain Top Inn & Resort, which offers cross-country skiing on 350 acres surrounded by the Green Mountain National Forest.

MANCHESTER
Vermont, U.S.A.

// An Archetypal New England Town

Ringed by Vermont's Green Mountains, Manchester's white mansions and marble sidewalks retain a peaceful historic feel, while the raft of factory outlets on the edge of town lends a modern allure.

Must Do // Sign up for archery or falconry lessons at the Equinox Resort & Spa, Manchester's star attraction // Visit the flagship Orvis store and fly-fishing school, for field trips to the Battenkill River, famed for its rainbow and brook trout // Visit Hildene, the 1905 home of Robert Todd Lincoln, son of Abraham and Mary.

NORTHEAST KINGDOM
Vermont, U.S.A.

// Fall's Riotous Foliage, Unsurpassed

In 1949, a former U.S. senator from Vermont, struck by the timeless beauty of his state's three northeasternmost counties (Orleans, Essex, and Caledonia), dubbed them the Northeast Kingdom—and when fall arrives, it's among the most stunning places in America.

Must Visit // Small towns such as Peacham, which may be Vermont's finest photo op during foliage season // In winter, Craftsbury, home to the Nordic Ski Center // Big Hosmer Pond, for rowing and paddling as well as biking, walking, and running

SHELBURNE FARMS
Shelburne, Vermont, U.S.A.

// Like Guests at a Vanderbilt Estate

Perched on a bluff overlooking Lake Champlain, the Inn at Shelburne Farms (above) was built in 1886 by Lila Vanderbilt and her husband, William Seward Webb. The crown jewel of a nonprofit conservation center and working farm, it is surrounded by 1,400 acres designed by Frederick Law Olmsted, the landscape architect who designed New York City's Central Park.

Must Do // Visit the hands-on children's farmyard and the dairy known for its excellent cheddar cheese // Tour the Shelburne Museum, nearly 40 structures that hold an excellent collection of Americana.

STOWE
Vermont, U.S.A.

// **Where the Hills Are Alive**

Considered the queen of Northeast ski areas and one of the oldest in the country, Stowe is also home to the country's first cross-country ski center—the Trapp Family Lodge, opened in 1950 by the Austrian family of *Sound of Music* fame.

Must Do // Ride the Over Easy gondola linking the famously steep Front Four trails on Mount Mansfield and Spruce Peak ski areas // Enjoy Stowe's 2,300-foot Alpine slide and extensive hiking trails once the powder's gone // Arrive in Stowe via the highly scenic 2-lane Route 100, stoping in the villages of Weston and Warren along the way.

THE THOMAS JEFFERSON TRAIL
Monticello and environs, Virginia, U.S.A.

// **In Pursuit of Life, Liberty, and Luxury**

Set on a hilltop overlooking Charlottesville, Monticello [*right*] is the dream house of Renaissance man Thomas Jefferson—principal author of the Declaration of Independence and America's third president (1801–1819). He designed the house—you've seen it on the back of the nickel. Jefferson retired to Monticello and founded the University of Virginia, just 2 miles away.

Must Visit // The University of Virginia Art Museum and its nearby Rotunda, designed by Thomas Jefferson and modeled after the Pantheon in Rome // Hot Springs, 100 miles west of Charlottesville, to soak in mineral-rich 98°F waters as Jefferson did // The Monticello Wine Trail in the immediate area

SHENANDOAH VALLEY
Virginia, U.S.A.

// A Scenic Highway Runs Through It

Shenandoah is the name of the mountainous region in western Virginia, the fertile, 200-mile-long valley west of it, and the lazy river that flows between them to the Potomac. It is one of the state's most enchanting regions. In 1939, the 105-mile Skyline Drive was completed; it winds through the Blue Ridge Mountains alongside the Appalachian Trail and hooks up with the Blue Ridge Parkway, a 469-mile moving postcard running south from Waynesboro, Virginia, to Great Smoky Mountains National Park in North Carolina.

Must Do // Savor the area's beauty from any of the roadway's 75 scenic overlooks // Hike some of the Shenandoah National Park's 500 miles of trails // Visit Staunton for its pre–Civil War architecture and to tour Woodrow Wilson's presidential library // Explore Luray Caverns, to hear music played by the Great Stalacpipe Organ.

COLONIAL WILLIAMSBURG
Williamsburg, Virginia, U.S.A.

// Life in 18th-Century America

The country's largest, most popular living-history museum, Colonial Williamsburg re-creates the period in America from 1750 to 1775 with actors channeling statesmen and merchants in authentically replicated surroundings.

Must Do // Attend the trial of a pig thief or follow the town's Fife & Drum Corps parading down cobbled Main Street // Tour the Governor's Palace (*left*) or the Courthouse of 1770 with its pillories and stocks out front // Stop for a tipple and traditional alehouse fare at any of the historic taverns // Head 3 miles south to Williamsburg Winery, an important player in Virginia's flourishing viticultural scene // Drive the 24-mile Colonial Parkway to Jamestown and Yorktown, which, along with Colonial Williamsburg, make up Virginia's "Historic Triangle."

WASHINGTON, D.C.
District of Columbia, U.S.A.

While Washington is all about politics all the time, it's also an impressively beautiful city of museums, parks, and broad boulevards, laid out by Pierre L'Enfant, and home to monuments that serve as the nation's collective memory.

Washington's centerpiece is the National Mall, where visitors will find the U.S. Capitol and the Washington Monument, as well as the Vietnam Veterans Memorial wall inscribed with the names of the almost 60,000 soldiers who died in action, the Korean War Veterans Memorial, and the National World War II Memorial, among many others. In early spring, thousands of Japanese cherry trees burst into bloom around the Tidal Basin.

There is no shortage of museums, such as the many that compose the Smithsonian Institution, as well as the National Gallery of Art and the U.S. Holocaust Memorial Museum. Also here is the Library of Congress, the country's official library, and the National Archives. Among the city's unsung gems is the formal gardens of Georgetown's Dumbarton Oaks, where diplomats met in 1944 to plan the United Nations.

A visit to Washington is a good time to pay your respects at Arlington Cemetery, the final resting place for American military personnel from the Revolutionary War to the war in Iraq, and to visit Mount Vernon, George Washington's home.

LEFT // The **National Mall** is a 2-mile greensward running west from the U.S. Capitol that holds some of the nation's most important monuments, including the Washington Monument, the Lincoln Memorial (*pictured*), and the Thomas Jefferson Memorial on the south side of the Tidal Basin.

BELOW // The brick sidewalks of **Georgetown** are lined with Georgian and Federal homes and tidy Victorian-era row houses; come in late April or early May for house and garden tours that allow an inside look.

BELOW // Giant pandas can be seen on the Asia Trail at the Smithsonian's **National Zoo**. Visitors can also meet the zoo's seven Asian pachyderms on the Elephant Trails. All in all, some 2,400 animals roam these leafy grounds.

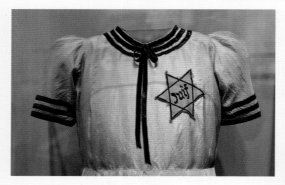

ABOVE // The **U.S. Holocaust Memorial Museum** asks us to never forget by exhibiting a haunting collection of photos, reconstructions, and personal effects of the doomed prisoners.

RIGHT // Visitors lucky enough to join a tour of the **White House** (make advance arrangements through your congressperson) can see the State Dining Room, the Blue Room, and the East Room.

RIGHT // Tour the Main Reading Room of the **Library of Congress** in the Jefferson Building. In the rotunda of the National Archives, view original handwritten copies of the Declaration of Independence, the Constitution, and the Bill of Rights.

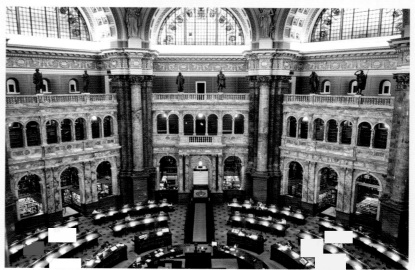

LEFT // The Neoclassical West Building of the **National Gallery of Art** displays works that range from early Italian altar panels to works by Dutch masters and French Impressionists. I. M. Pei's modernist East Building houses gems by Calder (*pictured*, *Untitled*), Matisse, Picasso, Pollock, and Rothko.

ABOVE // Guided tours of the **U.S. Capitol** can include the House and Senate chambers, where visitor galleries are open to anyone who obtains a gallery pass in advance from their senator or congressperson.

ABOVE // Most of the 19 national museums that make up the Smithsonian Institution line the National Mall. The two most popular are the **Air and Space Museum** and the Museum of Natural History.

THE SAN JUAN ISLANDS
Washington, U.S.A.

// Washington's Ferry Land

Despite their proximity to Seattle, the San Juan Islands have significantly better weather than the city and have retained their bucolic allure. Lopez is a great island to explore on two wheels, while many consider the mountainous Orcas Island the most beautiful.

Must Visit // Lime Kiln Lighthouse (*left*), popular with whale watchers // Mount Constitution in Moran State Park on Orcas, for views on a clear day that stretch from Mount Rainier to Vancouver // The nearby Turtleback Mountain Preserve, for excellent hiking // Friday Harbor on San Juan Island, for kayak trips and unmatched whale watching // San Juan Island's Whale Museum, to learn about the San Juan marine ecosystem and the pods of whales that call these islands home

PIKE PLACE MARKET
Seattle, Washington, U.S.A.

// The Gastronomic Heart of Seattle

The always busy, always freewheeling Pike Place Market has a circuslike atmosphere created by street entertainers and fishmongers who toss whole salmon across the counters for the amusement of passersby.

Must Do // Treat yourself to fresh spot prawns, halibut, geoduck clams, and oysters // Head to some of Seattle's best-loved restaurants and watering holes in the market or nearby // Make a pilgrimage to 1912 Pike Place, site of the world's first Starbucks.

WEST VIRGINIA'S WHITE-WATER RAFTING
West Virginia, U.S.A

// Running the Rivers of the Mountain State

West Virginia's rivers are regularly ranked among the top ten white-water runs in the world, passing through a landscape so rugged that it's often referred to as the West of the East.

Must Do // Raft on the Gauley River (*left*) in September and early October when excess lake water turns the river into a roaring beast // Get your feet wet in the New River, which offers a range of rafting experiences along its 53 scenic miles // View the 876-foot-high New River Gorge Bridge, the longest single-arch span in the northern hemisphere.

THE APOSTLE ISLANDS
Bayfield, Wisconsin, U.S.A.

// Sanctuary on North America's Largest Lake

On Lake Superior—the largest freshwater body in the world—all but one of the 21 Apostle Islands are undeveloped and uninhabited. While there are more than 50 miles of trails crisscrossing the islands, they are best explored by boat.

Must Do // Choose a variety of boat trips from the Apostle Islands Cruise Service or captained sailboat charters // Tour some of the eight historic lighthouses in the summer // Kayak between the islands and explore the sea caves (*left*) that pock the sandstone shoreline // Visit Bayfield, a great base to arrange island excursions.

CHEYENNE FRONTIER DAYS
Cheyenne, Wyoming, U.S.A.

// The Daddy of All Rodeos

This celebration of all things Western in the Cowboy State's capital city is a 10-day carnival of rodeos (*below*), wild-horse races, marching bands, intertribal Indian dancing, and a parade that was once led by Buffalo Bill in 1898.

Must Do // Enjoy the free pancake breakfasts, where more than 100,000 flapjacks, 475 gallons of syrup, and 520 gallons of coffee are consumed // Attend the art show and sale of works by Western artists, carvers, and Navajo weavers.

GRAND TETON NATIONAL PARK
Wyoming, U.S.A.

// The West's Most Scenic Mountains

The much-photographed peaks of Grand Teton National Park dominate the skyline with a grandeur that's starkly primeval, and a string of sapphire-blue lakes sit at the foot of the range.

Must Do // Hike up to Cascade Canyon (*left*), one of the park's most popular, starting near Jenny Lake // Visit Jenny Lake Lodge, at the foot of the range, the only lodge within the park // Fly-fish or raft on the Snake River // Cruise to Elk Island on Jackson Lake // Drive the 45-mile loop from Moose by way of Moran Junction, for spectacular scenery // Get an up-close look at elk from a horse-drawn sleigh from mid-December through March at the National Elk Refuge near the park's southern border.

JACKSON HOLE
Wyoming, U.S.A.

// American Grandeur and Awesome Skiing

The center of the scenic Jackson Hole area (a "hole" is a high, enclosed mountain valley), Jackson has evolved from a fur-trading cow town into a bustling community that borders on being cosmopolitan.

Must Do // See the iconic Elk Antler Arch (*right*) in the town square // Drop by Bubba's Bar-B-Que, the Million Dollar Cowboy Bar, and the Silver Dollar Bar and Grill in the historic Wort Hotel // Head to nearby Grand Teton National Park and make a day trip to Yellowstone // Ski down Rendezvous Mountain at Jackson Hole Mountain Resort // Test the slopes at Targhee Ski Resort, one of skidom's holy grails.

YELLOWSTONE NATIONAL PARK
Wyoming, U.S.A.

// The Earth's Extravagant Showcase

Established in 1872, Yellowstone National Park is America's oldest national park, known worldwide for the geysers and geothermal pools that hark back to its volcanic past. Yellowstone's 3,500 square miles encompass rugged plateaus and heavily forested peaks, crystalline lakes, 290 thundering waterfalls, and steaming hot springs—its most famous is the Grand Prismatic Hot Spring (*above*). Over 3 million people visit every year, so if you go between June and September, expect crowds when visiting Old Faithful and other popular spots.

Must Do // Explore the rainbow-hued Grand Canyon of the Yellowstone River, which begins at the Lower Falls // Keep an eye out for bears and herds of bison in the Hayden Valley // Try to spot moose and elk near the hot springs terraces at Mammoth. Wolves, reintroduced to the park in 1995, hunt in the Lamar Valley.

Canada

CALGARY STAMPEDE
Calgary, Alberta, Canada

// The Wild West,
Canadian-Style

The Calgary Stampede is the world's largest and most prestigious rodeo, with more than 400 of the world's elite rodeo contestants competing over 10 days in mid-July in six major events.

Must Do // Enjoy music and dance performances, parades, a Western art showcase, powwow dance competitions, and free pancake breakfasts // View competitions in bull riding, roping, steer wrestling, barrel racing, and the Chuckwagon Race.

BANFF, JASPER, AND YOHO NATIONAL PARKS
Alberta and British Columbia, Canada

// Canada's Rocky Mountain High

Spanning the crown of the majestic Canadian Rockies are Banff, Jasper, and Yoho National Parks, collectively known as the Rocky Mountain Parks. The 142-mile Icefields Parkway links Banff and Jasper, passing through glacier-topped peaks, waterfalls, and turquoise lakes. The literal high point is 11,450-foot Mount Athabasca, surrounded by the Columbia Icefield, which covers more than 200 square miles at the crest of the Continental Divide.

Must Do // View Banff's stunning Moraine Lake (left) and Lake Louise at the base of Victoria Glacier // Raft the Athabasca and Sunwapta rivers, hike Maligne Canyon, ride horseback around Patricia Lake, or canoe Maligne Lake in Jasper // Take the short hike to the viewpoint overlooking Takakkaw Falls in Yoho, one of Canada's highest.

THE CANADIAN ROCKIES BY TRAIN
Alberta and British Columbia, Canada

// Rail Adventure Through Mountain Majesty

VIA Rail Canada offers a year-round 2,775-mile trip between Toronto and Vancouver and one of the best and most relaxing ways to explore this inspiring country. It passes through Jasper National Park, over the Continental Divide, and past the Canadian Rockies' highest peak, 12,972-foot Mount Robson.

Must Do // Take VIA Rail's Snow Train package to Jasper in the winter // Depart from either Seattle or Vancouver and continue to Calgary on the Rocky Mountaineer's all-daylight train service [above] // Ride the Rocky Mountaineer between Vancouver and Whistler along the Sea-to-Sky route and continue to Jasper.

THE GULF ISLANDS
British Columbia, Canada

// A Rustic Getaway

Sprinkled between the mainland city of Vancouver and Vancouver Island, the Gulf Islands are a haven for celebrities, eco-farmers, artists, and travelers seeking gorgeous nature, classy country inns, and top-flight culinary outposts.

Must Do // Reach five of the islands on BC Ferries from Tsawwassen or Swartz Bay on Vancouver Island, one of the most beautiful ferry rides anywhere // Kayak around Mayne Island [left] // Visit Ganges on Salt Spring Island, a thriving artist colony and home to a busy Saturday market // Travel to the two Pender Islands via a ferry or water taxi from Victoria.

HELI-SKIING AND HELI-HIKING
British Columbia, Canada

// High-Altitude Nirvana in Remote Backcountry

The Cariboo, Bugaboo, Monashee, Selkirk, Galina, and Purcell ranges are beyond the reach of roads and ski lifts, but getting to the mountaintops is possible—and exhilarating—with heli-skiing and summer adventures that are just as exciting as the destination itself.

Must Do // Access 8 to 15 different runs per day via helicopter // Hike and mountaineer in the summer // Stay up to a week in staffed lodges.

THE OKANAGAN VALLEY
British Columbia, Canada

// The Napa Valley of Canada

The arid yet fertile Okanagan Valley (with 125 miles of interconnected lakes—think Napa Valley with Lake Tahoe in the middle) is Canada's second-largest wine-producing area. Its 100 wineries produce wines that rival nearby Washington State's in power, richness, and finesse.

Must Visit // Kelowna, the region's wine capital and an excellent base for tasting expeditions // Cedar Creek Estate, for magnificent views and pinot noir // Mission Hill Family Estate Winery, to sample the Bordeaux-inspired Oculus // Quail's Gate Estate, with views of Okanagan Lake // Blue Mountain Vineyards (right) in Okanagan Falls, about 90 minutes south of Kelowna

MUSEUM OF ANTHROPOLOGY
Vancouver, British Columbia, Canada

// First Nations Art and Modern Architecture

The Museum of Anthropology at the University of British Columbia houses phantasmagorical carvings by British Columbia's indigenous artists: towering Haida totem poles (*left*); squat tree-trunk sculptures of ravens, sea wolves, and bears; and intricately painted masks of cedar and feathers. The light-filled space by Canadian architect Arthur Erickson is as dramatic as the art it holds.

Must Do // Don't miss *The Raven and the First Men* by the late Haida artist Bill Reid, a potent expression of spiritual wonder.

SUN YAT-SEN CLASSICAL CHINESE GARDEN
Vancouver, British Columbia, Canada

// Eastern Roots in Canada's West

An exquisite re-creation of a typical 15th-century Ming garden, the Sun Yat-Sen Classical Chinese Garden is an island of calm in Vancouver's frenetic and historic Chinatown.

Must Do // Take the complimentary tour, for perspectives on Chinese culture, architecture, horticulture, and the art of feng shui // Spend time at the garden's Jade Water Pavilion (*above*).

GRANVILLE ISLAND PUBLIC MARKET
Vancouver, British Columbia, Canada

// Showcasing the Culinary Capital of Western Canada

Vancouver enjoys one of North America's most exciting and cosmopolitan dining scenes, and visitors should explore the Granville Island Public Market [right] to see—and taste—Vancouver's rich bounty at its source from over 100 vendors.

Must Do // Getting to and from Granville Island on the Aquabus is half the fun // Enjoy the talented mix of buskers, from musicians to jugglers // Stroll the section of Vancouver's 18-mile seawall that passes through Granville Island.

PACIFIC RIM NATIONAL PARK
Vancouver Island, British Columbia, Canada

// Wilderness on the North Pacific Coast

Vancouver Island's remote western flank is preserved as the three-unit Pacific Rim National Park Reserve, a maritime wilderness that's hallowed ground for ecotourists, long-distance hikers, and sea kayakers.

Must Do // Hike the 47-mile West Coast Trail, one of the most spectacular and challenging hikes on the continent // Sea kayak among the Broken Group Islands // Explore Long Beach, some 500 yards wide at low tide and popular in summer // Visit the quirky end-of-the-road town of Tofino.

STUBBS ISLAND WHALE WATCHING
Vancouver Island, British Columbia, Canada

// Home of the Mighty Orcas

Johnstone Strait near Telegraph Cove is where the world's largest concentration of orcas come to socialize, mate, and eat. Passengers can listen to the whales' vocalizations on two vessels with onboard marine biologists operated by local whale-watching outfitters.

Must Do // Take a tour boat to watch the orcas dive, breech, and spy-hop—the whale equivalent of treading water.

THE INNER HARBOUR
Victoria, Vancouver Island, British Columbia, Canada

// Victoria's Magnificent Waterfront

The Inner Harbour is Victoria's centerpiece, an inlet flanked by historic buildings and bustling with skittering water taxis, bobbing seaplanes, and the mammoth car ferry from Port Angeles, Washington.

Must Do // Enjoy raisin scones, Devonshire cream, and strawberry preserves in the Tea Lobby of the Fairmont Empress // Visit the Royal British Columbia Museum, an exceptional regional museum // Don't miss the museum's First Peoples Gallery, dedicated to the region's indigenous nations.

WHISTLER BLACKCOMB SKI RESORT
British Columbia, Canada

// North America's Ski and Snowboard Showcase

Only 75 miles north of Vancouver on the scenic Sea-to-Sky Highway (Highway 99), Whistler Blackcomb Ski Resort has the greatest vertical drop on the continent, 8,100 acres of skiable terrain, more than 200 marked trails, 17 massive Alpine bowls, and an average of 33 feet of snowfall per year. Together with nearby Vancouver, Whistler Blackcomb cohosted the 2010 Winter Olympic Games.

Must Do // Ride the Peak 2 Peak gondola between Whistler and Blackcomb mountains // Enjoy dogsledding, snowshoeing, snowmobiling, and cross-country skiing // Stroll the pedestrian zone in Tyrolean-style Whistler Village.

POLAR BEAR SAFARI
Churchill, Manitoba, Canada

// Kings of the Tundra
in the Far North

Every October and November, up to
900 polar bears gather outside the tiny
town of Churchill, waiting for the ice
floes to form on Hudson Bay so they
can fatten up on seals before returning
to land again in the spring, some to bear
their young.

Must Do // Join an authorized tour
group to visit Wapusk National Park,
the bears' denning area // Sign up with
an outfitter to observe the bears on the
tundra from a specially designed polar
rover // Visit Churchill in the summer to
see beluga whales, caribou, seals, or more
than 200 species of Arctic waterfowl and
shorebirds // In the late fall, see the aurora
borealis (northern lights) in the night skies
// Fly in or travel by rail from Winnipeg, as
you can't reach Churchill by road.

BAY OF FUNDY
New Brunswick and Nova Scotia, Canada

// A Marine Wonder
of the World

The world's highest tides, which rise as
much as 48 feet in 6 hours, have sculpted
the boulders of the Bay of Fundy's cave-
pocked coastline into fantasy shapes, such
as the Hopewell Rocks (*right*).

Must Do // Visit Fundy National Park, the
best place to observe the bay // Be at Alma
Beach when the water produces the mid-
tide roar called "the voice of the moon"
// Explore dramatic coastal cliffs, sea
caves, and hidden beaches by sea kayak
// Take the scenic 5-hour Fundy Coastal
Drive from Aulac to St. Stephen // Tour the
Kingsbrae Garden in St. Andrews.

GROS MORNE NATIONAL PARK
Newfoundland and Labrador, Canada

// Fjords, Beaches, Mountains,
Bogs, and Meadows

Gros Morne National Park is sometimes
called the "Galápagos of Geology" because
its rocks provide fascinating evidence for
plate tectonics—a theory that is to geology
what evolution is to biology. A place of
immense splendor and forlorn beauty, it is
eastern Canada's most renowned hiking
and adventure destination. The term "Gros
Morne," roughly translated as "big lone
hill," refers to the park's highest point.

Must Do // Head north to Western Brook
Pond (*left*) to hike or float into the heart of
the billion-year-old Long Range Mountains
// Visit Gros Morne's Discovery Centre
// Tour Bonne Bay, where kayaks and
boats ply a double-armed fjord // Hike
the Tablelands, a rugged massif and
indisputable highlight.

CAPE BRETON ISLAND
Nova Scotia, Canada

// Beautiful Drives and Auld Culture in New Scotland

One of the world's great drives, the 184-mile-long Cabot Trail follows the picturesque coastline of Cape Breton Highlands National Park past centuries-old French Acadian and Scottish fishing villages.

Must Do // Attend summer music gatherings at the Gaelic College of Arts and Crafts overlooking St. Ann's Bay // Tour St. Ann's Bay Great Hall of Clans, which depicts the exodus of the Scottish people to the New World // Visit in October for the 9-day Celtic Colours festival, the largest celebration of all things Gaelic in North America.

OLD TOWN LUNENBURG
Nova Scotia, Canada

// A Colonial Town Perfectly Preserved

In the 1750s, lured by the prospect of free land, nearly 1,500 Protestant pioneers from Germany, Switzerland, and France set sail under protection of the British Crown to establish a colony on the coast of Nova Scotia. The Lunenburg colony survived and prospered as a shipbuilding and fishing center. Little change has come to its Old Town and waterfront since the 1700s.

Must Do // Wander historic Lunenburg's steep streets lined with well-preserved, colorful Victorian and Georgian houses (*left*) // Explore the Fisheries Museum of the Atlantic's aquarium and exhibits about Lunenburg's seafaring past // Tour the replica of the 1921 racing schooner *Bluenose* // Take a tour of the harbor on the *Eastern Star*, a 48-foot wooden ketch.

NUNAVUT
Canada

// Rugged Beauty at the Top of the World

Nunavut is Canada's eastern Arctic and its largest territory—approximately the size of Western Europe. Created in 1999 as a territory for the Inuit people, it has a population of 30,000, who are outnumbered 30 to 1 by caribou. Given its precipitous seasonal changes, lack of roads, and minimal infrastructure for tourism, visiting isn't easy, but a handful of backcountry lodges offer comfortable accommodations and guided adventures.

Must Do // Attend one of the Bathurst Inlet Lodge's weeklong programs offered in July, the best time for birding and viewing Arctic wildflowers // Take a guided tour of the rocky islands where musk oxen graze and barren-ground caribou gather // Take a day trip to the 1,000-year-old stone camps built by the Thule people, ancestors of the Inuit.

NIAGARA FALLS AND NIAGARA WINE COUNTRY
Ontario, Canada, and New York, U.S.A.

// Thunderous Grandeur and Sophisticated Vintages

Almost a mile wide in total, Niagara Falls straddles the U.S.-Canada border and is divided by islands into three sections. After taking in the falls, travel north to the 19th-century town of Niagara-on-the-Lake to explore the Niagara wine region.

Must Do // Visit New York's Three Sisters Islands, to stand within a few feet of the brink of the falls // Take the Cave of the Winds tour, to get within 20 feet of the base of Bridal Veil Falls // Board the *Maid of the Mist* or use Canada's Hornblower Niagara

Cruises to sail into the base of Horseshoe Falls // See the back end of Horseshoe Falls at Journey Behind the Falls on the Canadian side // Attend a performance at Niagara-on-the-Lake's acclaimed Shaw Festival // Stop at Peller Estates, Château des Charmes, Vineland Estates Winery, and Inniskillin Winery on the Niagara Peninsula // Sample the region's dessert-like ice wine made from grapes left to freeze on the vine.

WINTERLUDE AND THE RIDEAU CANAL
Ottawa, Ontario, Canada

// Celebrating the Canadian Winter

The Rideau Canal is the centerpiece of Winterlude, Ottawa's February paean to fun in the snow, when 5 miles of North America's oldest continuously operated canal are groomed for skating. During the rest of the winter, the canal doubles as an ice thoroughfare—and the world's largest naturally frozen ice rink.

Must Do // Visit Snowflake Kingdom in Gatineau's Jacques-Cartier Park, the site of the National Snow Sculpture Competition // View the Crystal Garden International Ice-Carving Competition in Ottawa's Confederation Park.

THE STRATFORD FESTIVAL
Stratford, Ontario, Canada

// The Bard—and More— on Canada's Avon River

Now the largest classical repertory theater in North America, the Stratford Festival of Canada presents more than a dozen productions on four stages from mid-April through early November. In addition to world-class productions of Shakespeare (*left*), it mounts a broad range of classic plays, musicals, and cutting-edge dramas.

Must Do // Attend a full program of fringe events, including concerts, discussions, and readings // Explore downtown Stratford's antiques stores, bookshops, art galleries, and restaurants.

ART GALLERY OF ONTARIO AND THE ROYAL ONTARIO MUSEUM
Toronto, Ontario, Canada

// Temples of Canadian Art and Culture

The Art Gallery of Ontario is one of the largest and most important collections of visual art in Canada, while the Royal Ontario Museum (*above*) is Canada's largest museum of natural history and world culture.

Must Do // View works by Brueghel, Van Gogh, Andy Warhol, and Claes Oldenburg as well as Inuit art and pieces by Henry Moore at the Art Gallery of Ontario // See the Royal Ontario Museum's exhibits of Chinese art, European decorative arts, and dinosaur skeletons.

TORONTO INTERNATIONAL FILM FESTIVAL
Toronto, Ontario, Canada

// Hollywood Glamour on Lake Ontario

Showing more than 300 films from over 80 countries, the Toronto International Film Festival is the top film festival in North America. The films are screened in 30 different venues in downtown Toronto and attract more than 400,000 filmgoers.

Must Do // Visit in early to mid-September for this 10-day festival.

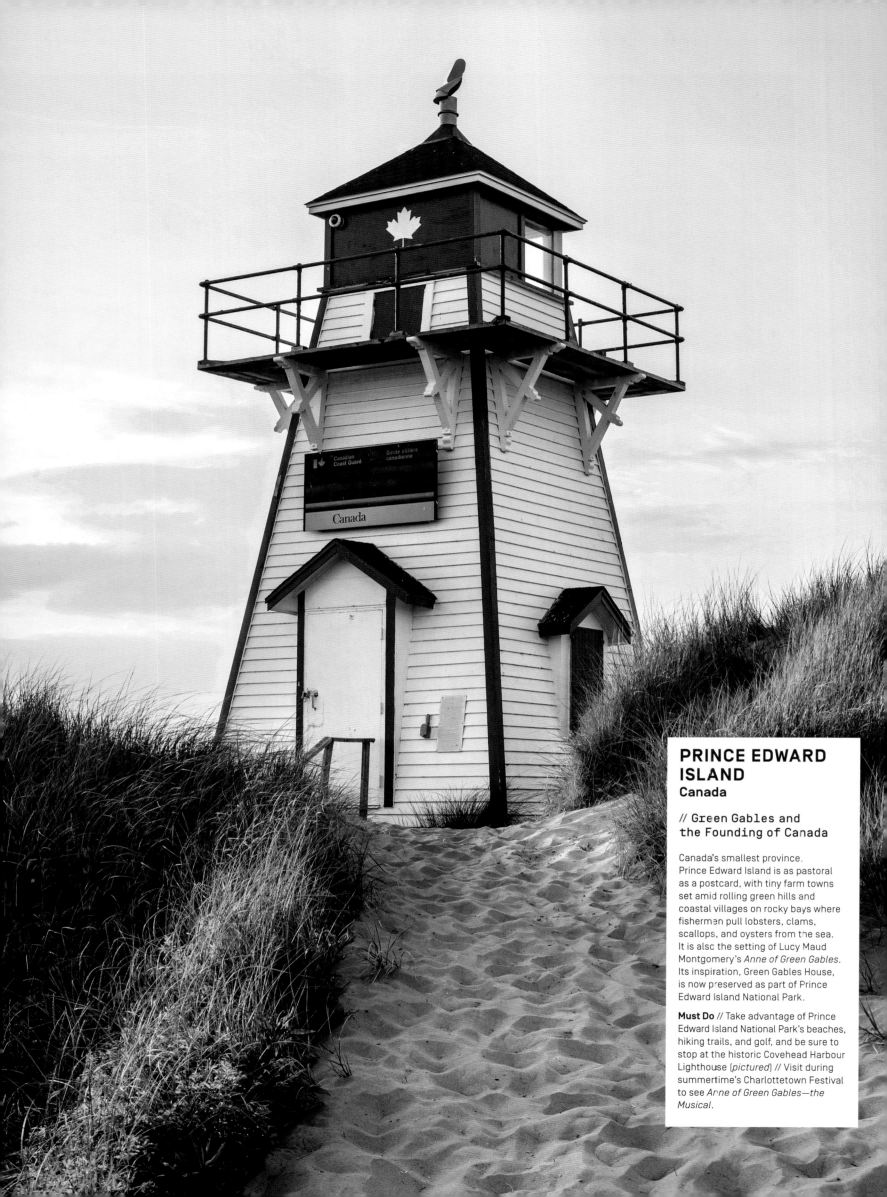

PRINCE EDWARD ISLAND
Canada

// Green Gables and the Founding of Canada

Canada's smallest province. Prince Edward Island is as pastoral as a postcard, with tiny farm towns set amid rolling green hills and coastal villages on rocky bays where fishermen pull lobsters, clams, scallops, and oysters from the sea. It is also the setting of Lucy Maud Montgomery's *Anne of Green Gables*. Its inspiration, Green Gables House, is now preserved as part of Prince Edward Island National Park.

Must Do // Take advantage of Prince Edward Island National Park's beaches, hiking trails, and golf, and be sure to stop at the historic Covehead Harbour Lighthouse (*pictured*) // Visit during summertime's Charlottetown Festival to see *Anne of Green Gables—the Musical*.

CHARLEVOIX
Quebec, Canada

// Wilderness Grandeur in
the Newport of the North

An hour northeast of Quebec City, Charlevoix
is an area of astonishing natural beauty,
long famed for its upscale resorts and
bucolic recreational pursuits along the
shores of the St. Lawrence River.

Must Do // Hike, bike, kayak, and wildlife
watch, especially for beluga whales
// Golf the Fairmont Le Manoir Richelieu's
27 scenic holes on a bluff above the river
// Snowmobile, ski, and ice-skate in the
winter.

LAKE MASSAWIPPI AND THE EASTERN TOWNSHIPS
Quebec, Canada

// Idyllic Retreats and
Gourmet Adventures in
the Quebec Heartland

Quebec's Eastern Townships feature wide
valleys, glacial lakes, low mountains,
farmland, and vineyards. Lake Massawippi
is an idyllic place with prim villages, such
as North Hatley (*left*), scattered around
its shore, their narrow streets lined with
galleries, antiques shops, and excellent
restaurants.

Must Do // Bike the Route des Vins—
a popular circuit of more than 20 wineries
// Sample the award-winning cheese made
by the monks at the Abbey of St. Benoit-du-
Lac on Lake Memphremagog.

MONTREAL'S SUMMER FESTIVALS
Montreal, Quebec, Canada

// A Festival City Par
Excellence

Montreal's most important event is the
early-summer Montreal International
Jazz Festival, but the party keeps going
with the Montreal International Fireworks
Competition (*right*) from mid-June through
late August and July's Just for Laughs
Festival, the world's largest comedy event.

Must Do // Visit in late August and early
September for the World Film Festival
// Attend early June's Les FrancoFolies de
Montréal, which celebrates French music
from around the world // Hear music of
the African diaspora at mid-July's Festival
Nuits d'Afrique.

VIEUX-MONTRÉAL
Montreal, Quebec, Canada

// Paris Without Jet Lag

Vieux-Montréal is Montreal's old city center, and despite the influence of English-speaking Canada and the United States, it remains a bastion of French culture in the second-largest French-speaking city in the world.

Must Visit // Place Jacques-Cartier (right), with its street performers, cafés, and horse-drawn calèches // Place d'Armes, the home of the 1829 Basilica of Notre Dame and the Sulpician Seminary, Montreal's oldest building // Rue St-Paul, the city's oldest street lined with gaslights, art galleries, and boutiques // The Old Port along the St. Lawrence, a promenade full of parks, exhibition spaces, skating rinks, and playgrounds

MONT TREMBLANT RESORT AND THE LAURENTIAN MOUNTAINS
Quebec, Canada

// Eastern Canada's Top Mountain Resort

Mont Tremblant (left) stands atop the highest peak in Quebec's Laurentian Mountains and attracts skiers from around the world with more than 47 miles of trails broken up into 94 runs, including the daunting double-black diamond Dynamite.

Must Do // Explore Mont Tremblant Village, a pedestrian-only area designed to resemble Quebec City's historic district // Visit in the summer for water sports on Lake Tremblant, hiking and mountain biking in the Laurentians, and golf at two world-class 18-hole golf courses.

CARNAVAL DE QUÉBEC
Quebec City, Quebec, Canada

// A Toast to Winter's Chill

The world's largest winter carnival and the Mardi Gras of the north, Carnaval de Québec promises 17 festive days of dancing, music, parades, winter sports, and high spirits.

Must Do // Sample Caribou, a traditional beverage made with brandy, vodka, sherry, and port // Visit the Ice Palace (right), a castle built entirely of ice near the Quebec Parliament building // View the International Snow Sculpture Competition at Place Loto-Québec // Watch the Grande Virée dogsledding competition circle the city.

VIEUX-QUÉBEC
Quebec City, Quebec, Canada

// Old France in the New World

Once the capital of New France, Quebec City is one of the oldest European settlements in North America and the continent's only walled city north of Mexico. Vieux-Québec (Old Québec) is divided into the Haute-Ville and Basse-Ville (Upper and Lower Towns), designations that are now simply geographic but were once economic and strategic. Towering above all of Vieux-Québec with green-copper turrets, and in many ways the symbol of the city, is the Fairmont Le Château Frontenac.

Must Do // Ride Quebec City's Toboggan Run, past the Fairmont Le Château Frontenac [*below*] // Stroll through Haute-Ville, the fortified city occupying the crest of Cap Diamant // Take the Escalier Casse-Cou (the aptly named Breakneck Stairs) or the funicular to Basse-Ville, the old port district at the base of Cap Diamant // Visit the Place Royale, a cobblestone plaza flanked by stone houses, cafés, and the 1688 Église Notre-Dame-des-Victoires.

DAWSON CITY AND THE YUKON RIVER
Yukon, Canada

// Catching Gold Fever in the Klondike

In 1896, a small party of prospectors discovered lots of gold on a remote tributary of the Yukon River [*left*]. Word spread like wildfire, and by 1898, Dawson City, just 165 miles south of the Arctic Circle, counted more than 30,000 inhabitants. Nearly all gold rushers reached Dawson City via the mighty Yukon River, one of the most powerful rivers in North America. Today, Dawson City, with its late-Victorian hotels, saloons, false-fronted stores, mansions, and miner's shacks, is an open-air museum.

Must Do // Visit a replica of novelist Jack London's log cabin // Drop by Diamond Tooth Gertie's Gambling Hall, replete with honky-tonk piano and dancing girls // Arrange a Yukon River expedition with outfitters in Whitehorse.

Latin America

With 45 miles of glorious beaches fringing Guanabara Bay, the city of Rio de Janeiro is famed for its magnificent setting, a combination of tropical beauty and big-city excitement. Across the bay, the dramatic Pão de Açúcar (Sugarloaf Mountain) rises 1,299 feet above sea level (see page 476).

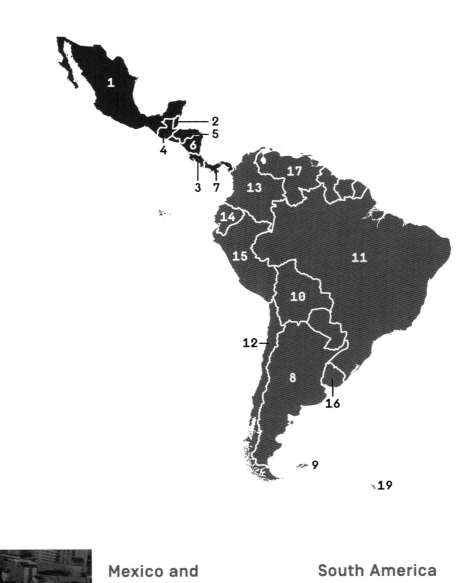

Mexico and Central America

1 Mexico
2 Belize
3 Costa Rica
4 Guatemala
5 Honduras
6 Nicaragua
7 Panama

South America and Antarctica

8 Argentina
9 Falkland Islands
10 Bolivia
11 Brazil
12 Chile
13 Colombia
14 Ecuador
15 Peru
16 Uruguay
17 Venezuela
18 Antarctica
19 South Georgia Island

Mexico and Central America

LOS CABOS
Baja California Sur, Mexico

// Where the Sea of Cortez and
the Pacific Meet

At the tip of the Baja Peninsula, Los Cabos
connects Cabo San Lucas and San José
del Cabo. Cabo San Lucas has earned a
reputation as a cerveza-drenched spring
break destination, but it's equally famous
for its world-class fishing and high-end
resorts.

Must Do // Explore San José del Cabo's pink
church, shady town square, and old adobe
homes // Visit Todos Santos, 30 minutes
north of Cabo San Lucas, a coastal artists'
colony with galleries, boutiques, and
beachfront cafés.

SEA OF CORTEZ AND
SAN IGNACIO LAGOON
Baja California Sur, Mexico

// The Aquarium of the World

Separating the 775-mile-long Baja Peninsula
and the Mexican mainland, the Sea of
Cortez is an amazing ecosystem famed for
its annual migration of gray whales, which
swim 5,000 miles from their chilly Arctic
feeding grounds to the safety of Baja's
warm, shallow waters in order to breed and
calve from December to March. Hundreds
of dolphins (*right*) accompany the whales.

Must Do // Snorkel amid sea lions, dolphins,
manta rays, and fish off Espíritu Santo, Isla
Partida, and Isla Santa Catalina // Take a
panga, a small motorboat, to San Ignacio
Lagoon, to see hundreds of whales.

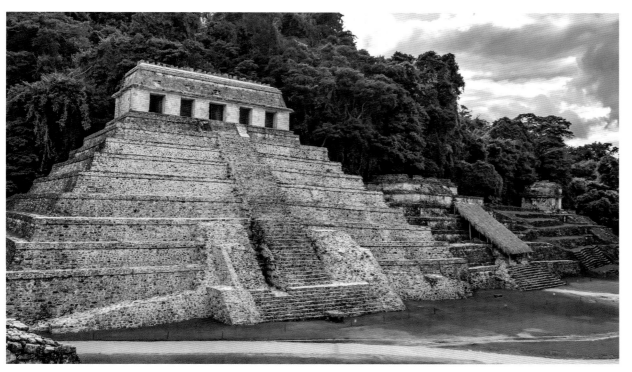

PALENQUE AND SAN CRISTÓBAL DE LAS CASAS
Chiapas, Mexico

// Maya Cities, Ancient and Modern

Palenque remains one of the most majestic and best preserved sites of the ancient Maya, whose descendants live in the pretty city of San Cristóbal de las Casas in the highlands of Chiapas.

Must Do // Tour Palenque's 7th-century Templo de las Inscripciones (*left*), the massive pyramid housing the carved tomb of King Paca // Explore San Cristóbal de las Casas's Saturday market to hear near-extinct tribal languages and see vendors wearing distinctive headdresses and ornately embroidered blouses // See rituals carried out by shamans at any of several churches, including Santo Domingo, the site of one of the city's best crafts markets.

COPPER CANYON
Chihuahua, Mexico

// A Breathtaking Train Ride Through Rugged Splendor

One of the most scenic train rides in the world, the Ferrocarril Chihuahua Pacifico—"El Chepe"—crosses the vast wilderness of Copper Canyon in the Sierra Madre mountains on a 13-hour journey from Los Mochis, on the Pacific coast, to the city of Chihuahua.

Must Do // Watch for the spectacular scenery between El Fuerte and Creel // Take the train east from Los Mochis for the best views in daylight // Take the hair-raising 5-hour, 6,000-foot descent by van from Creel to the old silver-mining town of Batopilas on the canyon floor.

SAN MIGUEL DE ALLENDE AND GUANAJUATO
Guanajuato, Mexico

// Colonial Gems in the Central Highlands

After experiencing San Miguel de Allende's colonial charm that has drawn artists and writers in the 1930s, visitors should travel 60 miles west to Guanajuato, another historic city full of centuries-old architecture.

Must Do // Watch the light change at dusk against the salmon-colored Parroquia, the parish church in San Miguel (*right*) // Visit in October for Guanajuato's Cervantes Arts Festival // Tour Guanajuato's Museo Casa de Diego Rivera, where the artist was born, to see some of his early works.

MEXICO CITY
Mexico

Built on top of the Aztec capital of Tenochtitlán, the largest metropolis in the world in 1519, Mexico City is once again one of the most populous on the planet. The past is alive everywhere here, beginning at its heart, the Zócalo, also known as Plaza Mayor, where epic murals by Diego Rivera grace the 17th-century Palacio Nacional, the country's seat of government. Across town at the Universidad Nacional Autónoma de México, the oldest university in North America, artist and architect Juan O'Gorman designed the 12-story Central Library as his canvas to illustrate 400 years of the country's past.

Other architectural gems—the Palacio de Bellas Artes and the 1907 Palacio Postal—deserve a visit, then stroll in the Alameda, a leafy park across the street. On weekends, the Plaza Garibaldi becomes an open-air mariachi stage. Follow the faithful to the spot where, in 1531, Juan Diego, a poor Mexican, reputedly saw the Virgin Mother, who left her image on his cloak. The Basilica de Guadalupe now stands on this site, attracting more pilgrims than any Catholic site except the Vatican.

Leave the city's congestion behind for Cuernavaca, the "City of Eternal Spring," whose cultural pursuits include the Museo Regional Cuauhnáhuac, to see colonial and pre-Hispanic artifacts and remnants of the ancient pyramid, and the Museo Robert Brady, which exhibits native art and paintings by prominent Mexican artists. From Cuernavaca, continue on to the small, sleepy town of Tepoztlán, where visitors trek to the pyramid dedicated to the feathered serpent god Quetzalcóatl for spectacular views from Tepozteco mountain.

RIGHT // Mexico City's massive Zócalo, also known as Plaza Mayor, is the site of the impressive **Catedral Metropolitana and the Museo del Templo Mayor**, a showcase of the capital's preconquest past.

LEFT // Paseo de la Reforma is one of the most elegant boulevards in the Americas. A stroll west from the center of town leads visitors to Mexico's largest museum, the **Museo Nacional de Antropología**, the repository of the country's pre-Hispanic past.

BELOW // Situated on the edge of the city's colonial core, the opulent **Palacio de Bellas Artes** is home to both the Ballet Folklorico and the country's most important art museum, which displays murals by Diego Rivera (*pictured*).

ABOVE LEFT // Only a few canals remain in **Xochimilco**, where Aztecs once grew produce on reed islands that floated on a now-buried lake. Visitors are likely to see at least one waterborne wedding party floating through this watery maze.

ABOVE RIGHT // The genteel suburb of Coyoacán is home to **Casa Azul**, where Frida Kahlo was born in 1907, now a museum dedicated to her art and life, including her marriage to master muralist Diego Rivera.

LEFT // Visitors can climb the Pyramid of the Sun or the Pyramid of the Moon (*left*) in **Teotihuacán**, 30 miles north of Mexico City, then escape the heat for a few hours in the site's excellent museum.

MORELIA AND PÁTZCUARO
Michoacán, Mexico

// Home to Native Arts and Monarch Butterflies

Michoacán is the land of the Tarascans, people known for their melodic Purépecha language and brilliantly colored handicrafts and folk art. In Morelia, its capital, are rose-colored stone Colonial buildings and a glorious twin-towered cathedral dating to 1640. Michoacán's second city is the picturesque colonial town Pátzcuaro.

Must Do // Visit Michoacán in mid-November through March to see millions of monarch butterflies (*left*) that winter in Mexico's central highlands near Morelia, such as in the El Rosario Butterfly Sanctuary // Visit Morelia's Casa de Artesanías de Michoacán // Bargain at Friday's market day in Pátzcuaro // Take a boat ride to Isla Janitzio in the middle of Pátzcuaro's lake // Visit on November 1 and 2, for Día de los Muertos (Day of the Dead) (*above*).

OAXACA
Oaxaca, Mexico

// A Cultural and Gastronomic Field Day

Oaxaca's blend of old-world Zapotec and Mixtec traditions can be seen in its excellent cuisine and local specialties—mole and fried crickets, as well as tamales (*right*) and empanadas. The surrounding villages specialize in crafts: black pottery in San Bartolo, woolen textiles in Teotitlán del Valle, and brightly painted wood carvings in Arrazola.

Must Do // Visit Oaxaca's Templo de Santo Domingo de Guzmán and its gold-ornamented Rosario Chapel // Tour the Museo Regional de Oaxaca, which traces the area's history from the Olmec period in 1200 BC // Travel just outside of Oaxaca to Monte Albán, one of Mexico's most important archaeological sites.

TULUM AND
THE RIVIERA MAYA
Quintana Roo, Mexico

// The Maya's Only
Seaside City

Once the province of wandering backpackers, Tulum now hosts an influx of environmentally minded travelers who are drawn by fine-white-sand beaches, yoga and wellness resorts, and the ruins of a Maya temple dating from AD 1000.

Must Do // Explore Tulum's walled Maya complex of ruins [*below*] // Take a plunge in one of the cenotes, underground freshwater sinkholes, and rivers at Gran Cenote and Hidden Worlds // Tour the Sian Ka'an Biosphere Reserve, 1.3 million acres of tropical forests, mangroves, coral reefs, and wildlife just south of Tulum.

CHICHÉN ITZÁ
AND MÉRIDA
Yucatán, Mexico

// Into the Yucatán's
Maya Heartland

A complex of grand pyramids, temples, and ornate palaces dating back to roughly AD 432, Chichén Itzá was the principle Maya ceremonial center of the Yucatán and today is an easy day trip from Mérida, the bustling capital of the Yucatán, which is full of history, culture, and music.

Must Visit // The temple of El Castillo de Kukulcán in Chichén Itzá [*right*] // Mérida's San Ildefonso, North America's oldest cathedral // Uxmal [*oosh-MAHL*], 50 miles south of Mérida, a well-preserved Maya ceremonial center

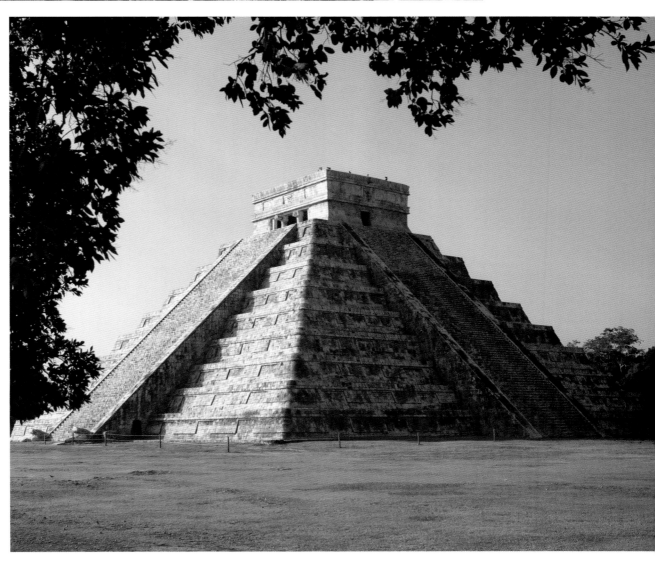

BELIZE'S BARRIER REEF
Ambergris Caye, Belize

// Superb Diving Among
a Necklace of Cays

With more than 450 offshore islets and
500 species of fish, the 185-mile Belize
Barrier Reef is considered one of the
world's ultimate dive sites, and is the
largest in the northern hemisphere.

Must Do // Make San Pedro on Ambergris
Caye the starting point for more than
40 snorkeling and dive sites // Dive or
snorkel at the Hol Chan Marine Reserve,
just off the southern tip of Ambergris, to
see a variety of marine life // Get up close
to gentle nurse sharks (*left*) and stingrays
at Shark Ray Alley // Head to Lighthouse
Reef to dive at the Blue Hole and Half Moon
Caye National Park // Explore Turneffe
Island Atoll's Elbow, a wall dive known for
hawksbill turtles, hammerhead sharks,
and the largest sea fans imaginable.

CARACOL AND THE CAYO DISTRICT
Belize

// A Sojourn into the
Lost World of the Maya

Of the 600 ruins buried in the Cayo District's
jungle—reachable by horseback or jeep—
none compare to Caracol, one of the
great Maya city-states from the 1st to the
11th centuries, known for its "sky palace
pyramid." The nearby site of Xunantunich
was a ceremonial center and home to 25
temples and palaces.

Must Do // Set off with a guide to explore
underground cave systems and natural
pools and waterfalls // Visit El Castillo
(*right*), Xunantunich's largest temple
// Zip-line, hike, kayak, explore butterfly
gardens, or spot the birdlife for which the
country is famous // Ride horseback into
the Mountain Pine Ridge Forest Reserve.

PLACENCIA
Belize

// Whale Sharks, Jaguars,
and Other Natural Wonders

The 11-mile-long peninsula of Placencia
has the country's best beaches with
excellent diving and snorkeling. Placencia
Village provides easy access to dive
outfitters and tours of wildlife habitats.

Must Do // Head 27 miles out to sea to
Glover's Reef Marine Reserve to snorkel
among splendid coral gardens // Take the
45-minute boat ride to the Gladden Spit
Marine Reserve to view whale sharks in late
spring // Spot manatees in the mangroves
of Placencia Lagoon or ride a boat up
Monkey River, a bird-watchers' paradise
// Make an inland excursion to Cockscomb
Basin Wildlife Sanctuary, home to many
jaguars.

ARENAL VOLCANO
**La Fortuna, San Carlos,
Alajuela, Costa Rica**

// Costa Rica's Fiery Streak

The 5,347-foot Arenal is the youngest of Costa Rica's nine active volcanoes. It erupted suddenly and violently in 1968, but since 2010, volcanic explosions have been rare.

Must Do // Soak in natural hot springs or get slathered in detoxifying volcanic mud // Enjoy the country's adventure capital and activities such as zip-lining, hiking, and white-water rafting in beautiful surroundings.

TORTUGUERO NATIONAL PARK
Limón, Costa Rica

// Where Turtles Come to Nest

Reachable only by small plane or boat, Tortuguero National Park is where giant leatherbacks nest from October to March and green and hawksbill turtles can be seen from July through October.

Must Do // Explore the park's canals and inland waterways, home to manatees, river otters, spider monkeys, three-toed sloths, and 320 species of birds.

CORCOVADO NATIONAL PARK
Osa Peninsula, Puntarenas, Costa Rica

// Into the Coastal Wild

The largest and most pristine of Costa Rica's 58 wildlife refuges, Corcovado National Park is home to more than 140 species of mammals, including Baird's tapirs and jaguars, as well as the largest population of scarlet macaws (*right*) in Central America.

Must Do // Listen for the cacophony of Corcovado's birds and monkeys.

MANUEL ANTONIO NATIONAL PARK
Puntarenas, Costa Rica

// White Sand Beaches and Rain Forest-Clad Mountains

Though just 1,680 acres, Manuel Antonio National Park is one of the country's most visited parks, with easily accessible beaches that offer snorkeling and diving in rich coral reefs, surfing, and fishing close to rain forest-clad mountains.

Must Do // Try to spot red-backed squirrel monkeys // Watch out for the white-faced capuchin monkeys (*left*) that love to pester beachgoers.

MONTEVERDE
Puntarenas, Costa Rica

// Quakers and Quetzals in the Cloud Forests

This highland forest is home to 450 varieties of orchids, 500 types of butterflies, and 400 bird species, including the rare, gorgeously plumed quetzal that keen-eyed guides can often spot in the private forests and wildlife reserves that make up Monteverde.

Must Do // Take a zip-line canopy tour (*left*); the high-adrenaline attraction originated here in the 1970s // Visit Monteverde Cloud Forest Reserve, established by Quakers who emigrated from Alabama in 1951 as conscientious objectors to the Korean War.

ANTIGUA
Guatemala

// Colonial Monuments, Poetic
Ruins

Founded in 1543, Antigua is one of the western hemisphere's best-preserved Spanish colonial cities. Some of the town's Renaissance and Baroque buildings have been reconstructed following a 1773 earthquake, others remain evocative ruins, but they all have long lured expats for the city's cultural scene.

Must Do // Visit during the highly dramatic Semana Santa (Holy Week) leading up to Easter Sunday to see processions pass over intricate carpets of flowers and colored sawdust, known as *alfombras* (*below*) // Stroll around Plaza Mayor and visit the Convento de las Capuchinas, now a museum // Visit the restored Baroque Iglesia de Nuestra Señora de la Merced as well as the Convento Santo Domingo, a former convent and now a hotel // Make the 2- to 3-hour climb to the rim of Pacaya, an active volcano east of Antigua.

LAKE ATITLÁN
**Panajachel, Altiplano,
Guatemala**

// Ancient Beauty,
Ancient Ways

Guatemala's western highlands are the country's most stunning region, and Lake Atitlán is the Altiplano's most perfect snapshot, while lakeside villages and mountain towns provide day trips back in time.

Must Do // Make Panajachel the jumping-off point for expeditions // Take a boat tour or water taxi to Santiago Atitlán, where Tzutujil Maya residents still cling to their old customs.

TIKAL
El Petén, Guatemala

// Ghost Metropolis
of the Maya

More than 3,000 temples, ceremonial
platforms, ball courts, and plazas make up
Tikal (*left*) Guatemala's most famous and
impressive Maya ruin.

Must Do // Watch the sun set from the tops
of Temple V or Temple IV // Get a special
pass to visit the Great Plaza after hours
on nights with a full moon // Bird-watch
in Tikal National Park, home of more than
400 species.

MARKET AT
CHICHICASTENANGO
Quiché, Guatemala

// A Still-Thriving
Pre-Columbian Trading Town

A popular day trip from Antigua every
Thursday and Sunday, Chichi's market
features indigenous arts and crafts,
handwoven textiles, wooden masks,
comedores (open-air food stalls), and a
busy covered market hall (*right*).

Must Do // Stay overnight to watch
Maya families set out their wares then
sleep under the stars // Visit the inner
nucleus around the fountain to find the
most traditional goods // Visit on Sunday
to see processions or ceremonies at the
16th-century Church of Santo Tomás.

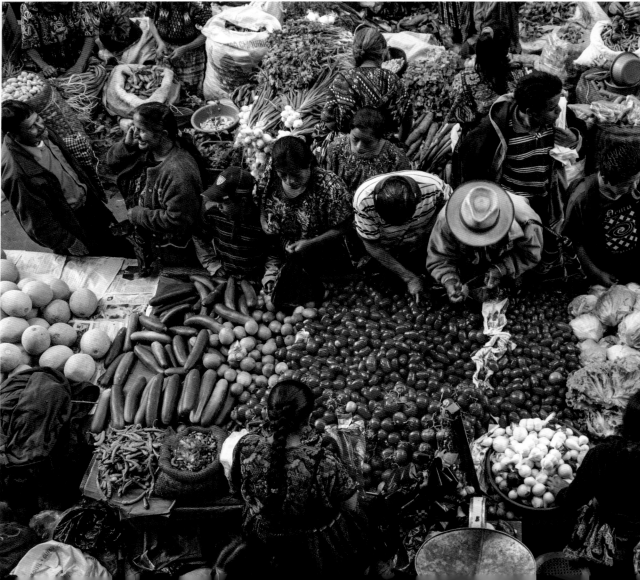

THE BAY ISLANDS
Honduras

// A Diver's Paradise
in the Western Caribbean

The three principal Bay Islands—Roatán, Utila, and Guanaja—are surrounded by reefs that support some of the Caribbean's greatest diversity of corals, sponges, and invertebrates. It's an uncrowded heaven for snorkelers and divers, and one of the best and least expensive places to earn dive certification.

Must Do // View training demonstrations or swim with dolphins at Roatán's Institute for Marine Sciences // View whale sharks on snorkeling outings organized by the Whale Shark & Oceanic Research Center on Utila // Dive in the pristine coral reefs around the Cayos Cochinos (Hog Islands).

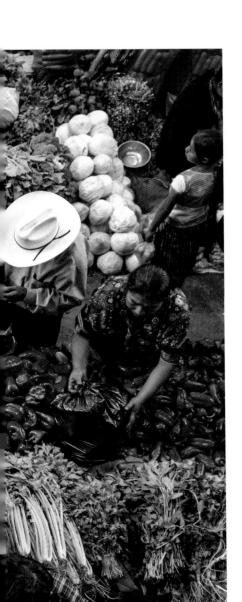

PICO BONITO NATIONAL PARK
Honduras

// Wildlife and
White-Water Rafting

Although the steep Pico Bonito peak outside the city of La Ceiba is mostly off-limits, much of the park surrounding the mountain is not, offering hiking trails that wend through forests where 22 rivers create spectacular waterfalls.

Must Do // Raft the Río Cangrejal (above, background), which offers some of the best Class II to V rapids in Central America // Take the popular hiking path to the waterfall of La Ruidosa (The Noisy One) // Head 20 miles west of La Ceiba to the Cuero y Salado Wildlife Refuge, an estuary brimming with wildlife, including the endangered West Indian manatee.

THE CORN ISLANDS
Nicaragua

// The Caribbean of Yesteryear

With cheap lobster dinners, affordable digs, and undeveloped Picnic Beach, Big Corn island retains the essence of the unspoiled Caribbean of the 1950s. On Little Corn Island (*left*), a 30-minute boat ride to the northeast, dirt paths crisscross the 1-square-mile island, and you can walk just about everywhere.

Must Do // Zip around Big Corn on golf carts, bikes, or mopeds // Sign up for a deep-sea fishing trip.

GRANADA
Nicaragua

// Colonial Grandeur on a Great Lake

A lack of tourism has helped keep Nicaragua's natural environment and its heritage intact. Nowhere is this more evident than in Granada, an elegant and captivating colonial city on the western shores of Lake Cocibolca, the largest lake in Central America.

Must Do // Stroll through the Parque Central, the heart of the city dominated by the Cathedral of Granada (*right*) // Tour the San Francisco Church's museum, to see ancient statues carved on the ceremonial island of Zapatera // Take the boat to the island of Ometepe, to climb its volcanoes and hike among trees ruled by monkeys // Make a day trip to Masaya, a center for handmade crafts // Visit Masaya Volcano National Park, the most accessible live volcano in Nicaragua // Explore the surfing scene in nearby San Juan.

BOCAS DEL TORO
Panama

// An Unspoiled Archipelago of Eco-Surprises

Visitors can trek through wildlife-filled rain forests on these 68 islands, glimpse endangered turtles, and surf the waves off Isla Bastimentos and Isla Carenero, where Columbus made landfall in 1502.

Must Do // Explore the National Marine Park on Isla Bastimentos // Dive or snorkel the coral forests of the two Cayos Zapatillas (Slipper Islands) // Sunbathe on Red Frog Beach.

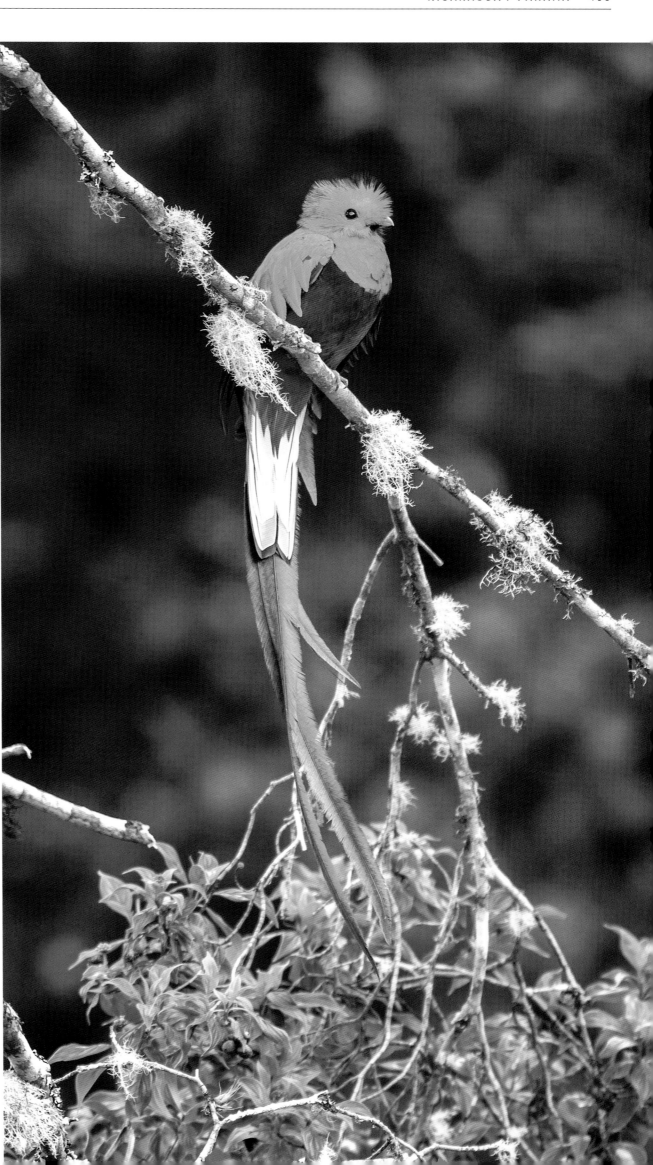

CHIRIQUI HIGHLANDS
Panama

// In Search of the Resplendent Quetzal

Panama is home to more bird species than all of North America. King of them all is the resplendent quetzal (*right*), whose 2-foot-long, iridescent-green tail feathers were used in the headdresses of Aztec rulers and were considered more valuable than gold. Today sighting a quetzal is a treasured experience, and Panama's Chiriqui Highlands are where you're most likely to find them and much more.

Must Do // Hike the 5-mile Quetzal Trail in the Parque Nacional Volcán Baru for panoramic lookouts and a chance to spot the bird for which it is named // Raft the Chiriqui and Chiriqui Viejo rivers, for their Class III to V rides and lush scenery // Strike out into the wilderness from Boquete at the foot of the eastern slope of Baru Volcano // Tour Finca Lérida, a coffee plantation north of Boquete.

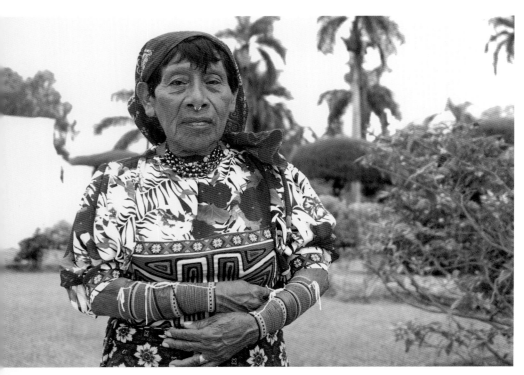

SAN BLAS ISLANDS
Comarca Kuna Yala, Panama

// An Independent Community
Follows Its Ancient Ways

One of the most intact indigenous societies
in the Americas, the Kuna Indians still live
according to their ancient ways on these
islands along the northeastern Caribbean
coast of Panama.

Must Do // Stay with local families in simple
dwellings or in rustic inns owned and run by
the Kuna // Arrange an overnight kayaking
trip to snorkel and visit far-flung Kuna
villages.

PANAMA CANAL
Panama City to Colón, Panama

// The World's Most
Famous Shortcut

Built across the narrowest point between
the Pacific and Atlantic Oceans and
stretching 50 miles from Panama City to
Colón, the Panama Canal is one of the
greatest engineering achievements of the
20th century and took 20 years to build.
A massive expansion project completed
in 2016 doubled its capacity.

Must Do // Visit the museum at Miraflores
Visitors Center, for interactive displays
// Book a partial or full transit boat tour
lasting 4 to 8 hours to fully explore the
canal // Stroll through Plaza Bolívar in
Panama City's 17th-century Old Quarter
// Tour Natural Metropolitan Park, the
world's only tropical rain forest within city
limits // Visit Soberania Park or Pipeline
Road, the canal's former service road, for
unmatched birding.

South America and Antarctica

LAS PAMPAS AND ESTANCIAS
Buenos Aires Province, Argentina

// A Gaucho Lifestyle Minutes from Busy Buenos Aires

Vast, flat grasslands where wheat and soy are grown and grass-fed cattle raised, the pampas are the birthplace of the gaucho, Argentina's cowboy, who worked on sprawling fortresslike estancias, some of which now welcome tourists.

Must Do // Head for the estancias surrounding San Antonio de Areco, known for its silversmiths and the Museo Gauchesco Ricardo Güiraldes, dedicated to the author of *Don Segundo Sombra*, which helped make gauchos a part of the collective culture // Try *mate*, the bitter Argentine herbal tea // Enjoy an *asado* (barbecue) and a glass of Malbec.

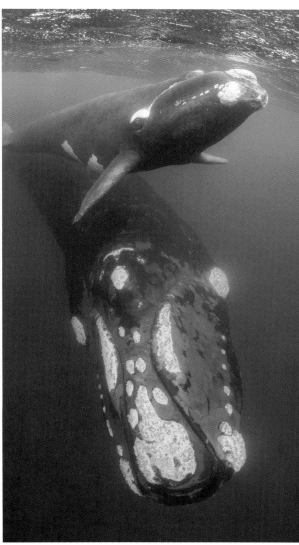

CÓRDOBA'S JESUIT BLOCK
Córdoba, Argentina

// A City's Intellectual Center, Then and Now

Córdoba's heart is the Manzana Jesuítica, or Jesuit Block (*above*), anchored by the University of Córdoba, Argentina's first university, opened in 1613.

Must Visit // The Cabildo, or Old City Hall, an arts center hosting Friday-evening tango performances // The Cathedral of Córdoba, known for its angels with Native American faces // The Museo Histórico Provincial Marqués de Sobre Monte, an excellent example of Colonial architecture // The Feria Artesanal del Paseo de los Artes bustles on weekends with antiques vendors.

PENÍNSULA VALDÉS
Chubut, Argentina

// The Atlantic Coast of Patagonia

The Valdés Peninsula is one of the world's most spectacular marine mammal and bird habitats, with Puerto Madryn the best base for exploring this unique environment.

Must Do // From June to December, head to Golfo Nuevo, south of the peninsula, to see southern right whales (*above*) // Visit Punto Tumbo Nature Reserve to view Magellanic penguins // Arrive in Punte Norte in February and March to view feeding orcas from platforms erected on the beach at Attack Channel.

BUENOS AIRES
Argentina

Once called the Paris of South America, Argentina's capital is a vibrant, elegant, cosmopolitan hub rising where the pampas meet the Río de la Plata. Tango is popular year-round, and there are various venues to choose from—including the city's newest addition, the 100-seat cabaret room Rojo Tango, at the Faena Hotel. For a few midwinter weeks in August, Tango y Festival y Mundial overtakes the city. Argentina is also famous for its beef, and for its *parillas*, eateries where meats are grilled over glowing coals.

BELOW // Featuring marble, bronze, wood carvings, and stained glass imported from Europe, the **Teatro Colón** has hosted Enrico Caruso, Maria Callas, and Plácido Domingo.

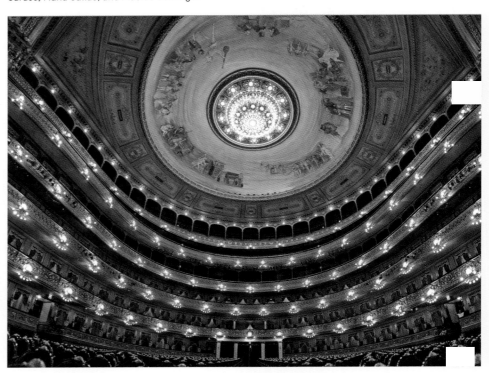

ABOVE // Founded by tango singer Edmundo Rivero, **El Viejo Almacén** offers an intimate show featuring crooners belting out songs by Carlos Gardel while dancers perform in costumes recalling tango's bordello roots. Feria de Mataderos is a Sunday street fair in the outlying Mataderos neighborhood, where folkloric dancers perform and gauchos try to spear hanging rings at full gallop.

ABOVE RIGHT // Housing the largest collection of Argentine art in the world, the **Museo Nacional de Bellas Artes** also showcases works by Rodin, Renoir, and Toulouse Lautrec, along with a broad range of Picasso drawings. The Museo de Arte Latinoamericano de Buenas Aires—or MALBA—is home to works by Frida Kahlo, Diego Rivera, and contemporary Argentine artists.

ABOVE // **Recoleta Cemetery** is the final resting place of María Eva Duarte de Perón, better known as Evita. After stopping at her simple black granite tomb, head to the small Museo Evita in the nearby neighborhood of Palermo.

ABOVE // The Sunday-only **San Telmo Antiques Market** spills out from Plaza Dorrego in one of Buenos Aires's oldest neighborhoods, but the real highlights are the tango dancers performing in the plaza. Also in San Telmo, shows at Casa Blanca mix folkloric dances with tango.

IGUAZÚ FALLS
Argentina and Brazil

// Nature's Mightiest Show
of Sound and Fury

The world's widest waterfall, Iguazú is actually 275 separate falls (and as many as 350 during the rainy season) created by more than 60,000 cubic feet of water per second plunging over 200-foot cliffs. Together, they make a broad horseshoe that forms northern Argentina's natural border with Brazil.

Must Do // In Argentina, take a rafting excursion through Garganta del Diablo (Devil's Throat) canyon, or climb the cliffs on San Martín Island to look down onto the water from their precarious edge // Visit the Brazilian side by bus or ferry // Join a tour departing from the Argentine town of Puerto Iguazú to see some 400 feathered species, including parrots, toucans, manakins, and some of the more than 500 species of butterflies.

MENDOZA
Argentina

// Where Malbec Is King

Rich soil, intense sunlight, and a high-altitude location at the foot of the snowcapped Andes make Mendoza Province Argentina's premier wine capital. The signature grape is the Malbec, now as emblematic of Argentina as the tango.

Must Do // Visit in early March for Vendimia, the harvest festival that features a week of parades and beauty pageants // Raft the Mendoza River, attempt to climb Mount Aconcagua—at 23,000 feet, the highest peak outside the Himalayas—or ski at Andean resorts.

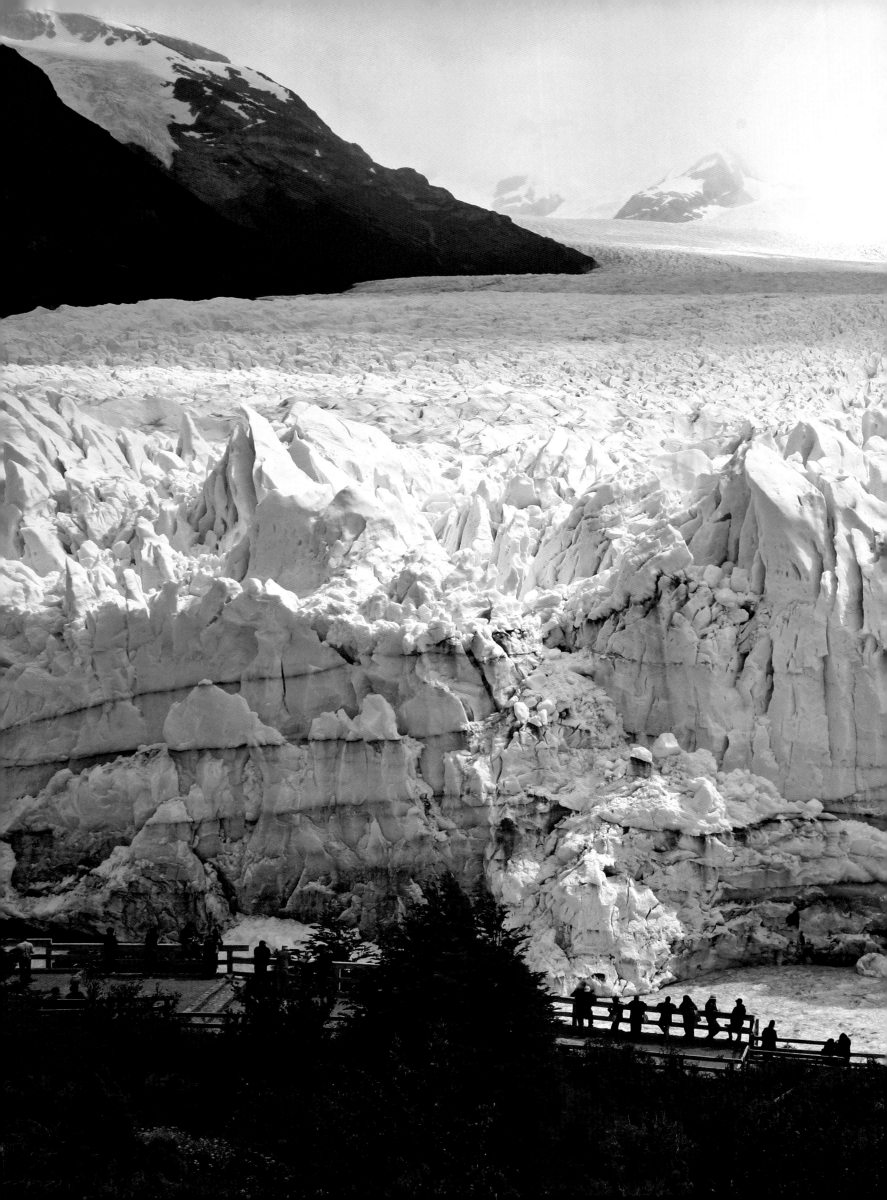

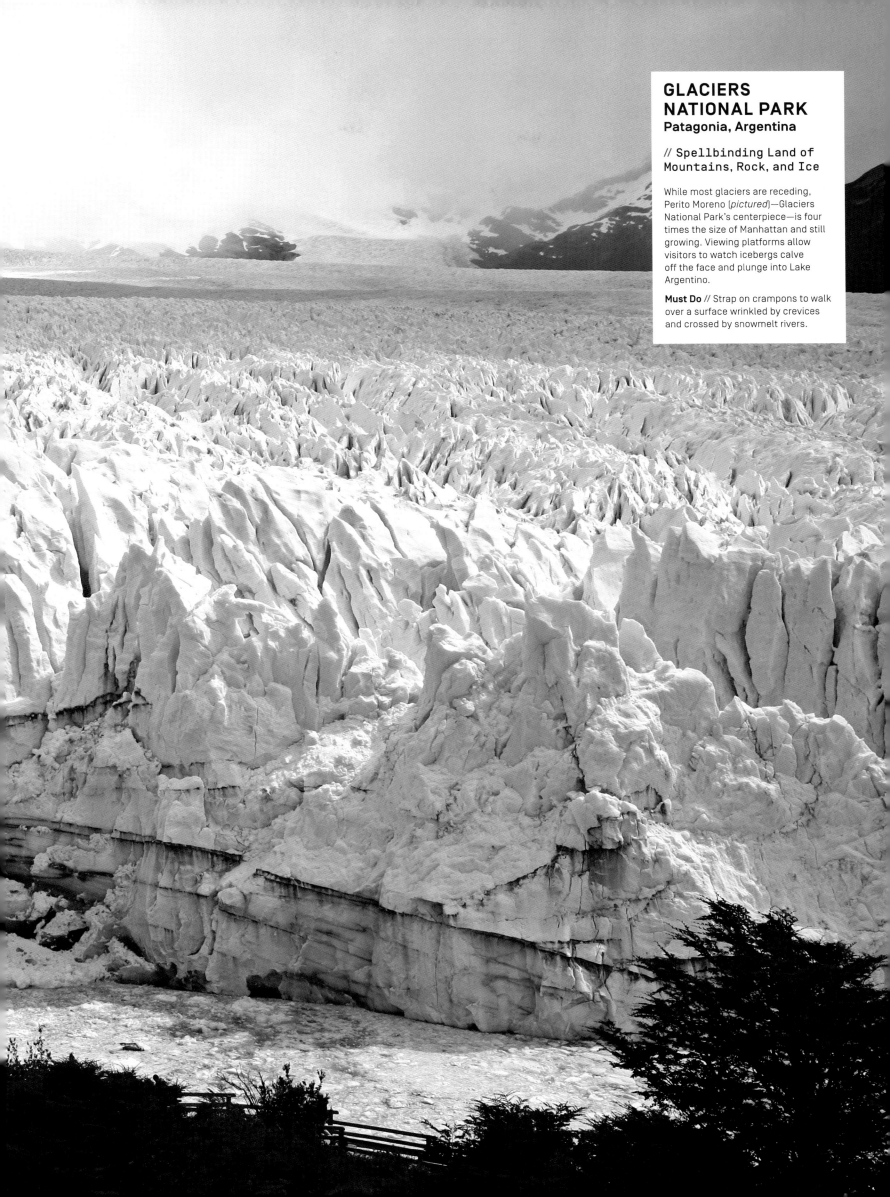

GLACIERS NATIONAL PARK
Patagonia, Argentina

// Spellbinding Land of Mountains, Rock, and Ice

While most glaciers are receding, Perito Moreno (*pictured*)—Glaciers National Park's centerpiece—is four times the size of Manhattan and still growing. Viewing platforms allow visitors to watch icebergs calve off the face and plunge into Lake Argentino.

Must Do // Strap on crampons to walk over a surface wrinkled by crevices and crossed by snowmelt rivers.

THE LAKE DISTRICT
Patagonia, Argentina

// The Switzerland
of South America

San Carlos de Bariloche stands on the
shores of Lake Nahuel Huapi near rivers
and lakes that offer some of the world's
best fly-fishing. But many come here to ski
from June through October, and the place
to do it is Cerro Catedral's 50-plus trails
(*right*).

Must Do // Take the scenic drive 50 miles
north from Bariloche to the lakeside town
of Villa La Angostura // Stay at a working
estancia, or cattle ranch, for a real cowboy
experience.

CAFAYATE
Salta, Argentina

// Argentina's Tuscany

The layered red rock terrain called the
Quebrada de Cafayate (*left*) is a paradise
for hikers, drivers, and horseback riders.
The region's other true star is the dry
and aromatic white wine produced from
torrontés grapes, which flourish in the
sandy hills of the area.

Must Do // Drive north along the highly
scenic Ruta 40 through the Calchaquíes
Valley to Cachi to visit one of the region's
finest archaeological museums // Tour
the James Turrell Museum at the nearby
Colomé winery and estancia to view works
by the celebrated California-born artist.

SALTA AND JUJUY
Salta, Argentina

// Romantic Respite and
a Breathtaking Train Ride

The country's most northwesterly provinces of Salta and Jujuy (*above*) promise stunning countryside dotted with pre-Columbian ruins, vineyards that produce well-known wines, and artisan villages. Both are characterized by their deep, mineral-streaked, polychromatic *quebradas* (gorges) carved by rivers running down the nearby snow-draped Andes.

Must Do // Board the seasonal El Tren a las Nubes (Train to the Clouds) for unforgettable views of Salta's terrain // Stroll the colonial town of Salta's Plaza de Nueve de Julio, flanked by the Salta Cathedral and the former Cabildo (City Hall) // Visit the Museo de Arqueología de Alta Montaña (Museum of High-Altitude Archaeology) to see three mummified, 500-year-old Inca children // Spend time at *peñas folkloricos*, or folk clubs, where the zamba (Salta's answer to the samba) is contagious.

USHUAIA AND TIERRA DEL FUEGO
Argentina

// Southernmost City
in the World

The final stop on the Pan-American Highway, Ushuaia is the starting point for most Antarctic expeditions and the base to explore the archipelago of islands that make up the province of Tierra del Fuego. Situated at a latitude of 55 degrees south, this city is also a marvelous underexplored destination in its own right with nature being the star attraction.

Must Do // Try to spot the rare Andean condor, black-browed albatrosses, Magellanic penguins, and cormorants (*left*) // Visit the Museo Maritimo, housed in the former jail for the country's most hardened prisoners // Ride the Tren del Fin del Mundo (Train of the End of the World), for a picturesque 40-minute ride into the Parque Nacional Tierra del Fuego.

FALKLAND ISLANDS
British Overseas Territory

// Subantarctic Galápagos

Home to more sheep than people, the Falkland Islands are famous for their biological diversity—they're known as the cold Galápagos—and in particular for their five species of friendly penguins.

Must Do // Visit Leopard Beach on Carcass Island to see gentoo and Magellanic penguins (*right*) // Explore the small capital city of Stanley, located on East Falkland, and its Victorian stone church and gilded whalebone arch // Drive 2 hours from Stanley to Volunteer Beach to see gold-throated king penguins // Travel to Sea Lion Island, where elephant seals and sea lions swim ashore while killer whales circle in pursuit.

COPACABANA AND LAKE TITICACA
Bolivia

// A Pilgrimage City on the Banks of a Sacred Lake

One of South America's most important Roman Catholic pilgrimage sites, Copacabana is set on the southern shores of Lake Titicaca in the Andes and is best known for its 400-year-old Moorish-style basilica, which houses the shrine of the Dark Virgin of the Lake, Bolivia's beloved patron saint. Among the town's annual feast days in her honor is the Fiesta de la Virgen de la Candelaria (*left*), celebrated the first 2 days of February.

Must Do // Hike to the replica of Calvary Hill at sunset for the best views of the lake and some of its 36 islands // Take a boat to Isla del Sol and Isla de la Luna to see Inca temples and ruins // Plan an excursion to one of the lake's reed islands created by the Aymara Indians // Travel to the City of the Gods, the ancient capital of a pre-Incan civilization believed to date back to 500 BC.

WITCHCRAFT MARKET
La Paz, Bolivia

// Fascinating and Peculiar Finds

La Paz's daily Witchcraft Market (Mercado de las Brujas) brims with herbal tea infusions, homeopathic folk cures, dried toucan beaks, snake skins, and amulets guaranteeing a long and happy sex life.

Must Do // Try the traditional tea made from coca leaves for altitude sickness // Visit booths selling colorful alpaca sweaters and woven textiles // Hear the ancient languages of Aymara and Quechua spoken here by the indigenous women known as *cholas*.

MADIDI NATIONAL PARK
Bolivia

// Overlooked and Untrammeled in the Amazon Rain Forest

One of the best places to experience the Bolivian jungle is in Parque Nacional Madidi, an enormous protected ecosystem that is accessible via the town of Rurrenabaque, a 1-hour flight from La Paz. Nearly 44 percent of all American mammal species, 38 percent of all known tropical amphibian species, and 10 percent of all known bird species (including the cormorant—*left*) live here.

Must Do // Try to spot jaguars and howler monkeys on the banks of the Beni River // Keep an eye out for the pink river dolphins that often follow alongside small tour boats.

SUCRE
Bolivia

// A White City and Former Capital

Sucre is Bolivia's original capital and the country's prettiest city. By government decree, all buildings in its historical heart must be whitewashed every year, hence its name, White City.

Must Visit // La Catedral Metropolitan and its small museum, located near Plaza 25 de Mayo, one of South America's loveliest city squares // The Museo de Arte Indígena, for insights into the region's ancient crafts and culture // The Tarabuco Sunday market (30 miles east), where indigenous women wearing coin-festooned hats sell their wares

UYUNI SALT FLAT
Bolivia

// An Eerie Sea of Salt
in the Altiplano

The Salar de Uyuni, the world's highest and largest salt flat, lying 11,975 feet above sea level, is the only remnant of a prehistoric salt lake that once covered much of Bolivia. The white expanse is punctuated by freshwater lakes that glow like emeralds and sapphires. Just as brilliant are the flocks of pink flamingos that feast on red algae in the Laguna Colorada.

Must Do // Hire an experienced tour operator as salt-flat crossings are rough and there are no real roads in the area // See the Sol de la Mañana, an area of geysers, fumaroles, and boiling mud, in the light of sunrise.

BRAZILIAN AMAZON
Amazonas, Brazil

// The Mother of
All Rain Forests

The vast kingdom of the Amazon, known as Amazonia, stretches across nine American nations and is roughly the size of the contiguous United States. The area claimed by Brazil comprises 60 percent of this region. Manaus, in the heart of Amazonia and accessible only by air, is one of the popular starting points for exploring the Amazon, home to 1,000 bird species, 300-plus mammal species, and roughly 45,000 species of plants.

Must Do // Tour Manaus's Teatro Amazonas, a Belle Époque opera house built during the rubber boom // Walk the corridors of the century-old Mercado Adolfo Lisboa, a replica of the now-defunct Les Halles, a market hall in Paris // Take a boat to Encontro de Águas, where the two tributaries Rio Negro and Rio Solimões meet to form the Amazon // Explore the river to watch for pink dolphins, fish for piranha, and canoe into the lesser tributaries.

CIDADE ALTA
Salvador da Bahia, Brazil

// Proud Heart and Soul
of an Afro-Brazilian City

After a restoration that began in 1992, the landmark buildings n the Pelourinho district in Salvador da Bahi's hilltop Cidade Alta (Upper City—*left*) ncw form the cultural heart of this city famous for its rich Afro-Brazilian heritage.

Must Do // Stroll around Largo do Pelourinho, a square that boasts lovely Colonial architecture and nightly music // Tour Terreiro de Jesus, the historic main square surrounded by four polychrome churches // Explore the Museu Afro-Brasileiro da Bahia, which documents the evolution of Afro-Brazilian culture // Visit the São Francisco complex on Tuesday, when a street party follows the 6 p.m. mass // Watch performances of Brazil's martial art at Mestre Bimba, a local capoeira school.

THE FESTIVALS OF SALVADOR
Salvador da Bahia, Brazil

// Bahia's Special Heritage

Rio's Carnaval attracts all the notoriety, but those who head north to Salvador da Bahia will find an authentic and more participatory pre-Lenten blowout, where Rio's samba is replaced by African-based *axé* music blasted from motorized floats.

Must Do // Attend Ilê Aiyê's public music rehearsals, which start as early as November // Watch Salvador's most innovative percussion group practice at Casa do Olodum // Visit in mid-January for Lavagem da Igreja do Bonfim, an 8-day celebration that brings African hymns to the 18th-century church Nosso Senhor do Bonfim // Be in Salvador on February 2 when the Afro-Brazilian goddess of the sea is honored with the Festa de Iemanjá.

TRANCOSO
Bahia, Brazil

// A Seaside Town Where
Simplicity Rules

The heart of Trancosco, a laid-back village
and gateway to southern Bahia's untouched
beaches, is the bluff-top Quadrado de
Trancoso (right), an expansive, grassy
town square, which overlooks the Praia
dos Nativos, a 2-mile stretch of beach
where visitors sip beer and passion-fruit
caipirinhas while listening to reggae and
world music.

Must Do // Head north to Arraial d'Ajuda to
enjoy Pitinga and Taípe beaches // Travel
half an hour south to stroll peaceful Praia
do Espelho (Mirror Beach).

BRASÍLIA
Distrito Federal, Brazil

// Capital City and
Oasis of Modernism

Oscar Niemeyer has been called the Pablo
Picasso of architecture and a legend of
modernism. The biggest concentration
of his work, including the Catedral
Metropolitana (right), is in Brazil's capital
of Brasília, the world's first master-planned
20th-century capital. The city's poetic and
surprising public buildings designed by the
Brazilian architect are open to visitors.

Must Do // Grab a window seat on a
Brasília-bound flight to get the best
glimpse of the city's eye-catching shape
// Climb to the TV tower's observation deck
to view the gentle curves of the Palácio do
Planalto or the Catedral Metropolitana.

PANTANAL
Mato Grosso do Sul, Brazil

// A Wildlife-Watching
Wonderland

The largest freshwater wetland in the
world, a place where 100 rivers meet,
the Pantanal supports the greatest
concentration of fauna in the western
hemisphere, including jabirus (large
storks), coatis (relatives of the racoon),
capybaras (the world's largest rodents),
and the elusive jaguar (left).

Must Do // Watch for monkeys, giant river
otters, tapirs, giant anteaters, marsh
deer, caimans, and anacondas // Visit the
Caiman Ecological Refuge, a sustainable
operation located about 150 miles
from Campo Grande that offers guided
excursions throughout the 131,000-acre
ranch // Enjoy nature's spectacle at night,
when millions of fireflies twinkle like
Christmas lights and the eerie sounds of
predators fill the air.

GOLD TOWNS OF MINAS GERAIS
Minas Gerais, Brazil

// Baroque Splendor
in the Mountains

In 1690, huge deposits of gold were discovered in what is now the state of Minas Gerais, home to more UNESCO World Heritage Sites than any state in Brazil. With trade enriching the region like never before, towns showcasing stunning Baroque architecture, such as the church of São Francisco de Assis (left) in Ouro Preto, and unprecedented wealth proliferated.

Must Do // Visit Ouro Preto, an 18th-century town 2 hours east of Belo Horizonte, to see one of Brazil's greatest enclaves of Baroque architecture // Travel south to Tiradentes, to see seven impressive Baroque churches.

BELÉM'S OLD CITY
Belém, Pará, Brazil

// Color and Culture
at the Mouth of the Amazon

Boats have sailed down the Amazon for centuries to unload their goods at the market in Belém on the Atlantic coast, where visitors can sample piranha, armadillo, and ice cream made from rain-forest fruits before exploring Cidade Velha, Belém's oldest neighborhood. Belém is especially known for October's unique Cirio de Nazaré (above). More than 1 million people join the 5-hour procession honoring the Virgin of Nazareth, who is said to be responsible for many miracles here.

Must Do // Savor *pato no tucupi*, duck in an aromatic herb sauce, the city's premier dish // Take the 3-hour boat ride to Ilha de Marajó, home to water buffalo, caimans, monkeys, and flocks of colorful birds.

FERNANDO DE NORONHA
Pernambuco, Brazil

// Island Paradise
of Dolphin Ballets and
Spectacular Beaches

One of the last little-visited ecotourist destinations, the archipelago of Fernando de Noronha promises a Galápagos-like experience in a national marine park that hosts hundreds of species of wildlife. Its highest point, Morro do Pico (right, background), can be seen from almost anywhere on the island.

Must Do // Watch whitebelly spinner dolphins frolic in the Baía dos Golfinhos (Dolphin Bay) // Rent a dune buggy to tour the hilly main island, Ilha Fernando de Noronha // Surf at Cacimba do Padre, a beach that boasts waves up to 12 feet between December and March // Brave the iron ladders scaling the 100-foot red rock cliffs to Baía do Sancho.

RECIFE AND OLINDA
Pernambuco, Brazil

// The Rich Musical
Traditions of the Northeast

Recife and Olinda (*left*), the waterfront
city's more tranquil colonial neighbor, are
home to some of Brazil's most fascinating
music and dance traditions, best seen
during festivals that are held throughout
the year.

Must Do // Stroll Recife's 4-mile-long
Boa Viagem beach, the location of some of
the city's best eating and drinking spots
// Head to Recife Antigo, a historic
neighborhood with bars and nightclubs,
to hear live music // Visit Oficina Cerâmica
Francisco Brennand, the workshop of
Brazil's most famous ceramic artist // Tour
Olinda's 1582 Mosteiro de São Bento to
see the monastery's gilded Baroque altar
// Come for Carnaval, a celebration as
heartfelt as the more commercial version
in Rio.

CARNAVAL!
Rio de Janeiro, Brazil

// The World's
Most Decadent Party

The centerpiece of Rio's Carnaval are
the samba parades (*above*) of lavishly
costumed troupes, over-the-top floats,
and drum corps that compete on the
Sunday and Monday before Ash Wednesday
in the filled-to-capacity 75,000-seat
Sambódromo.

Must Do // Visit one of the samba
schools that open to visitors beginning
in September // Tag along with the
bands that snake through the beachside
neighborhoods of Copacabana, Ipanema,
Leblon, and the hilltop district of Santa
Teresa.

COPACABANA AND IPANEMA
Rio de Janeiro, Brazil

// Surf, Sand, and Samba in the Cidade Maravilhosa

Hectic, democratic, and glorious, Copacabana is lined with hotels, high-rise apartment buildings, and open-air restaurants while Ipanema [left] is Rio's most sophisticated beach, a showcase for gorgeous bodies wearing dental-floss swimwear.

Must Do // Take the passenger train to the summit of Corcovado Mountain to put Rio's beauty at your feet and for up-close views of the city's legendary symbol, a 124-foot-high soapstone figure of Christ with outstretched arms // Board the aerial tram to Pão de Açúcar (Sugarloaf Mountain) across the bay, for a superb panorama 1,299 feet above the sea // Copacabana is the site for a Carnaval-like celebration on New Year's Eve.

MARACANÃ STADIUM
Rio de Janeiro, Brazil

// Goal!

Experience one of Brazil's biggest passions firsthand in Maracanã Stadium [right], Rio de Janeiro's enormous shrine to soccer, where Pelé scored his 1,000th goal in 1969.

Must Do // Visit the stadium when Flamengo, Fluminense, Botafogo, or Vasco da Gama continue their local rivalry // Take a guided tour of the stadium and the on-site sports museum, which exhibits Pelé's number 10 shirt.

BÚZIOS
Rio de Janeiro State, Brazil

// Barefoot Chic in One of Brazil's Glamorous Beach Towns

Búzios was launched to stardom when Brigitte Bardot and her Brazilian boyfriend-of-the-moment basked in the sun here in the 1960s. Now soccer players and telenovela stars mingle with well-heeled foreign visitors in stylish oceanfront restaurants.

Must Visit // Azeda beach [left] for its warm, gentle tides // Ferradura beach, perfect for snorkeling // Geriba beach, the best pick for surfing // Rua das Pedras, for chic boutiques and casual but excellent restaurants

ILHA GRANDE
Angra dos Reis, Rio de Janeiro State, Brazil

// A Magical, Verdant Island

A pirate hideout during the colonial era, Ilha Grande (*left*) is the largest in a constellation of 360 islands that dot the beautiful Angra dos Reis (Bay of Kings). It has become a favorite destination for Brazilian sun seekers and a handful of foreign beach cognoscenti drawn by the untamed island's empty beaches and do-nothing vibe.

Must Do // Take the ferry from mainland Angra dos Reis to the village of Vila do Abraão, the gateway to Ilha Grande's tropical seclusion // Hike the island's miles of trails through a rain forest full of birds, sloths, and howler monkeys // Tour ruins from the island's dark past of slavery // Catch a boat to the untouched beaches of Caxadaço and Saco do Céu // Snorkel among sea life and nearby shipwrecks in the Green and Blue lagoons.

PARATY
Rio de Janeiro State, Brazil

// Colonial and Charismatic on the Lush Costa Verde

Paraty's location is stunning, with jungle-clad mountains rising behind the town and white sand beaches a short drive or boat ride away. Its cobblestone streets are lined with colorful remnants of its colonial past. In the historic, car-free center, admire fine houses and elaborate churches built by wealthy merchants, and the Church of Santa Rita (*right*), built by and for slaves.

Must Do // Visit the Casa da Cultura, for a multimedia explanation of Paraty's past and present // Take a guided boat trip to the deserted beaches on the outlying islands // Sample a caipirinha, the mint-infused drink once called a Paraty.

SÃO PAULO'S FOOD SCENE
São Paulo, Brazil

// Groundbreaking Cuisine from Brazil and Beyond

Food is a serious pastime for *paulistas*, and visitors who explore the Mercado Municipal (*above*) will find more than 300 stalls overflowing with fresh fruits, vegetables, meat, fish, and other goods. Sample the *caju* (cashew fruit), *maracuja* (passion fruit), or *pitaya* (dragon fruit). Then join the crowd at Hocca Bar for *bolinhos de bacalhau* (cod-filled croquettes).

Must Visit // D.O.M., for classic French elements with exotic Amazonian ingredients // Brasil a Gosto, for a creative take on traditional comfort food from Brazil's backwaters // Mocctó, to sample cow's-foot soup and other specialties from northeastern Brazil // Maní, to savor panethnic creations // Figueira Rubaiyat, for selections from the owner's ranch // Fasano, serving the best Italian cuisine in the city // Carlota, to try the crispy shrimp risotto with ham and sweet pepper chutney

SÃO PAULO'S ART SCENE
São Paulo, Brazil

// Creativity on a Grand Scale

São Paulo is a sprawling concrete metropolis in some respects, but its reputation for artistry and design shines through in everything from galleries and museums to cuisine and hotels.

Must Visit // The Monument to Latin America complex, home to Oscar Niemeyer's sculpture of a giant hand stained with a bloodred map of Latin America (*above*) // The Museu de Arte de São Paulo (MASP), to view works by Raphael, Matisse, Dalí, and Brazilian artists // The Pinacoteca do Estado and the surrounding gardens of Jardim da Luz // The Museu de Arte Contemporânea (MAC) and the Museu de Arte Moderna (MAM), which display international contemporary art

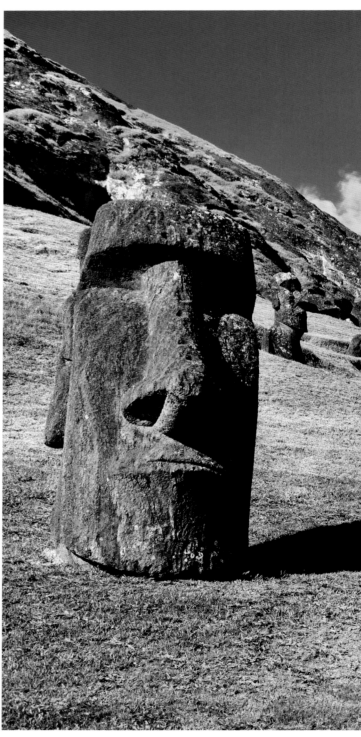

THE WINE ROADS OF CHILE
Central Valley, Chile

// At Home with Internationally Acclaimed Vintners

Having escaped the plagues that once blighted France's vines, Chile is the only country besides Australia with its original rootstock, French cuttings that were planted in the mid-19th century.

Must Visit // The traditional wineries of Cousiño Macul (*right*), Errazuriz, and Concha y Toro // Maipo, Chile's oldest wine valley, located on the outskirts of Santiago, for its cabernet sauvignons // Colchagua, home to some of the best wineries in Chile // Santa Cruz's Colchagua Museum, the largest private museum in Chile

EASTER ISLAND
Chile

// The Thousand Mysteries of Rapa Nui

Rapa Nui, aka Easter Island, is the world's most remote inhabited island and the site of more than 800 *moai* (*left*), elongated stone figures. This tiny windswept speck of land continues to captivate a curious world long after its "discovery" by the Dutch West India Company on Easter Sunday 1722.

Must Visit // Ahu Tongariki, the largest excavated and restored series of *moai* on the island // The nearby Museo Antropológico Sebastián Englert, which presents possible clues as to the purpose and history of the statues // Ovahe beach, which features pink-tinged sand and dramatic rock formations

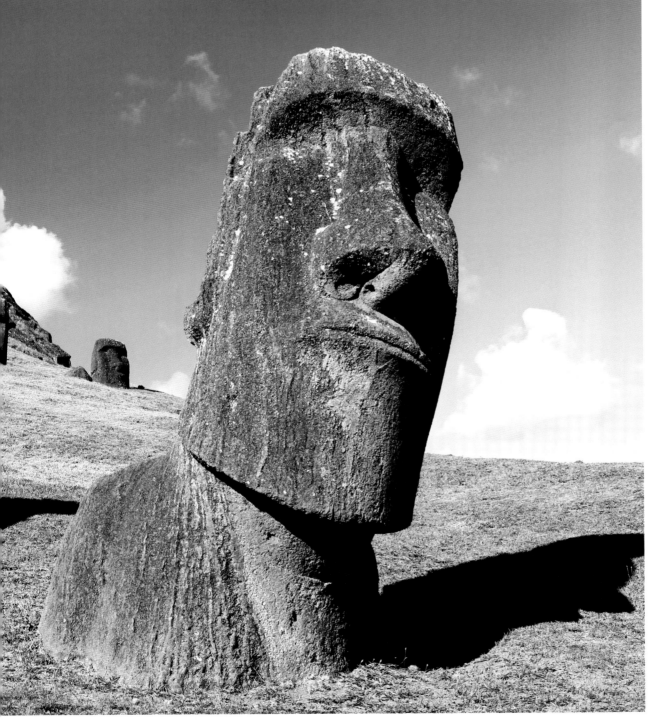

CRUISING CHILE'S FJORDS
Patagonia, Chile

// Filigreed Channels
at the End of the World

Beyond Puerto Montt, Chile's coastline crumples into thousands of islets that slowly give way to eerie ice fields. Best appreciated by ship, this spectacularly filigreed coast is home to icy channels opened by seismic and glacial activity millions of years ago, and its waters are full of elephant seals, sea lions, humpback whales, and dolphins.

Must Do // Sail from Puerto Natales to see Glaciar Amalia and Glaciar Bernal // Travel from Puerto Montt to see ice spires calve off Glaciar San Rafael // Visit the island of Chiloé for its wooden churches that date back to the 18th and 19th centuries // Fly to the southernmost reaches of Chilean Patagonia and Tierra del Fuego and beyond and explore the wild scenery and isolated glaciers.

PORTILLO AND VALLE NEVADO
Chile

// Skiing the
Formidable Andes

When the slopes north of the equator are snow-free, the western hemisphere's highest peaks are covered in deep-powder snow, and Chile's resorts offer breathtaking scenery with no lift lines or slope traffic.

Must Visit // Portillo, the site of the 1966 World Alpine Ski Championships, with 14 lifts accessing 2,200 acres of snowy diversion, is ideal for advanced skiers // Valle Nevado, which boasts dramatic Andean scenery, the continent's most modern lift system, and more than 2,000 acres of terrain suitable for every skill level

TORRES DEL PAINE NATIONAL PARK
Patagonia, Chile

// Wilderness and
Civilization on the
Continent's Tip

This remote outpost in the heart of Chilean Patagonia is one of nature's last virtually untrammeled wildernesses. At its heart stand the distinctive Cuernos del Paine, spectacular 10,000-foot towers of rose-colored granite.

Must Do // Try to spot the orange-and-white guanaco, a cousin of the llama, and the ever-elusive mountain puma // Hike the "W," a 35-mile trail that starts at Laguna Amarga and takes 4 to 5 days to complete // Test yourself on the demanding 37-mile "Circuit" that requires between 4 and 11 days to cover // Enjoy easy hikes, kayaking, and horseback riding in the park // Visit picturesque Puerto Natales, 150 miles northwest of Punta Arenas.

CHILE'S LAKE DISTRICT
Pucón, Chile

// Outdoor Adventures amid Picture-Perfect Scenery

Bordered by Lake Villarrica on one side and the Villarrica Volcano [*right*] on the other, Pucón is the gateway to the pristine Región de los Lagos, a major destination for boaters, water-sports enthusiasts, and sport fishermen.

Must Do // Sign up for an excursion to Lake Caburga, Coñaripe, or Lican Ray // Raft, kayak, or fish the Río Trancura // Trek or join canopy tours in Huerquehue National Park // Visit Termas Geométricas, 40 minutes outside of Pucón, to soak in slate-tiled pools of various temperatures.

THE ATACAMA DESERT
San Pedro de Atacama, Chile

// Surreal Odyssey to the Driest Place on Earth

Stretching over nearly one-third of Chile's surface, the Atacama Desert is so otherworldly that NASA has conducted experiments here, and travelers now come for adventure and natural wonders.

Must Visit // The Geysers del Tatio [*left*] come to life in the early morning // San Pedro de Atacama, for convenient access to hiking, mountain biking, horseback riding, and sand-boarding // The Museo Arqueológico Padre Le Paige, to see pre-Columbian artifacts and take guided excursions // The Termas de Puritama, to unwind in 8 warm pools descending a narrow gorge // Salar de Atacama, part of a national flamingo reserve // The eerie landscape of the Valle de la Luna

VIÑA DEL MAR AND VALPARAÍSO
Valparaíso, Chile

// Irresistible Contrasts in Chile's Twin Cities

Few cities are so close geographically but so different in looks and personality as Valparaíso [*right*] and Viña del Mar. Visitors to Chile's central coast can travel from the wonderfully quirky, Victorian-era ambience of Valparaíso to the upscale beachfront pleasures of Viña del Mar in just a few minutes.

Must Do // Visit La Sebastiana in Valparaíso, one of the late poet Pablo Neruda's three homes // Stroll through Valparaíso's 19th-century cemeteries to see Baroque mausoleums // Ride one of the Valparaíso's funiculars [the city was built on 45 hills] // Visit Viña del Mar's Casino Municipal, a throwback to when gamblers dressed to the nines // Tour the Museo Palacio Rioja in Viña del Mar, an opulently furnished 1910 Belle Époque mansion.

CANDELARIA AND GOLD MUSEUM
Bogotá, Colombia

// A Reborn City and
Its Treasures

Once known primarily for drug cartel-driven crime, Colombia's capital has cleaned up its bad-boy image, and La Candelaria leads this renaissance with its pedestrian-only cobblestone streets lined with Colonial mansions, churches, and a dozen museums.

Must Visit // The Museo del Oro (*left*), the world's largest and finest gold museum that also displays the world's largest uncut emerald // The nearby Donación Botero, to see works by Fernando Botero, Chagall, and Picasso

OLD CARTAGENA
Colombia

// A Riot of Color,
a Caribbean Vibe

Old Cartagena's elaborate *murallas*—nearly 7 miles of walls up to 25 feet thick and 83 feet high—enclose stately and vividly painted mansions housing hotels and fine restaurants that have made this Caribbean port of call a global destination once again.

Must Do // Tour the outer forts of San Sebastián de Pastelillo and San Felipe de Barajas, which protected the city from pirates // Listen to *cumbia*, *vallenato*, *champeta*, and other Afro-Caribbean rhythms // Linger in Plaza Santo Domingo, home to the voluptuous reclining nude by Colombian artist Fernando Botero.

EJE CAFETERO
Colombia

// The Coffee Triangle

One of the most beautiful areas in all of Colombia is the one that produces coffee, the country's most famous product. The regional hub of the Coffee Triangle is Armenia, the capital of Quindío.

Must Do // Join the locals who enjoy the Parque Nacional del Café, for its train, mechanical rides, and vignettes about coffee cultivation // Immerse yourself in the Andean beauty of the Parque Nacional Natural Los Nevados near Pereira.

CUENCA
Ecuador

// Highland Colonial Charm

The historical center of Cuenca, Ecuador's third-largest city, oozes colonial charm, with cobblestone streets, balconies, and buildings no higher than a church steeple per zoning regulations. The best days to visit are Thursdays and Sundays, when the central plaza becomes a marketplace filled with local women in *polleras*, colorful woolen dresses. Many stalls overflow with Panama hats, which are actually made here and not in Panama.

Must Do // Visit the Iglesia El Sagrario and the Catedral de la Inmaculada Concepción, modeled on the Italian Baptistry in Florence // Explore the Museo del Monasterio de la Concepción, a 16th-century Colonial structure filled with religious art.

GALÁPAGOS ISLANDS
Ecuador

// Evolutionary Miracles Above and Under Water

It was here that Charles Darwin first developed his theory of evolution, using as evidence an amazing roster of wildlife. Each of the "Enchanted Islands" is remarkably individual in its topography, flora, and fauna, and all of them are as stunning underwater as above.

Must Do // View 400-pound land tortoises, marine iguanas (*left*), blue-footed boobies, and 13 species of finches // Scuba dive to see penguins, sea lions, fur seals, dolphins, and even the odd migrating whale // Sign up for a fully equipped live-aboard to dive among hammerheads and manta rays off Wolf and Darwin islands // Visit the Darwin Research Station in Santa Cruz, which many giant tortoises call home.

EL ORIENTE, ECUADOR'S AMAZON
Ecuador

// Exuberant World of Biodiversity

Among the world's most biodiverse regions, El Oriente is a vast, wild region of tropical Amazon forest in eastern Ecuador where visitors can glimpse monkeys, birds, caimans, and pink freshwater dolphins.

Must Visit // Sacha Lodge, to view treetop bromeliads and exotic birds from an observation tower // The Napo Wildlife Center, a birder's paradise set in Yasuní National Park // Kapawi Ecolodge and Reserve, among the area's most remote lodges

OTAVALO
Ecuador

// The Continent's Most Famous Indigenous Market

Otavalo awakens every Saturday at dawn to trade in hemp, saddles, vegetables, grain, and textiles as well as pottery, weavings, jewelry, and carved wooden animals—but most visitors come for the authentic local atmosphere.

Must Do // Arrive before the animal market ends at around 8 a.m., or before day-trippers from Quito arrive at around 10 a.m. // Take a guided horseback tour through ancient Indian towns and unspoiled high country to the shores of a volcanic lake // Stop at the Middle of the World monument midway between Quito and Otavalo, to straddle the line of the equator for a photo op.

QUITO
Ecuador

// Latin America's Best-Preserved Center

Ringed by mountains and volcanoes, Quito is among the world's highest capitals. The historic heart of the city is rich with Colonial buildings and Baroque churches built on Incan foundations.

Must Do // Visit the 1535 Iglesia de San Francisco, which rises over Plaza San Francisco // Tour the Iglesia de la Compañia de Jesús, a late-18th-century masterpiece // Take in spectacular views of the city from the towers of the Basílica del Sagrado Voto Nacional [right] // Drop by Olga Fisch Folklore, a museum and crafts store // Drive an hour southeast to view Cotopaxi, the world's highest continuously active volcano.

PERUVIAN AMAZON
Amazonas, Peru

// Where the Mighty River
Begins

The confluence of the Ucayali and
Marañón rivers in Loreto, Peru, forms
the legendary head of the mighty Amazon,
2,400 miles from where it flows into the
Atlantic. Though Brazil garners most of
the fame as the home of the Amazon,
Peru is one of the best places to see it.
Iquitos, a flourishing rubber plantation hub
in the late 1800s, is a good launchpad for
exploring the headwaters of the longest
river in the Americas and the 5-million-acre
biodiversity-rich Pacaya-Samiria National
Reserve (*left*).

Must Do // Travel aboard a weeklong
expedition to visit the local shaman or
one-classroom schools // Take guided
hikes through the dense Amazon jungle
// Visit the Amazon Center for Environmental
Education and Research, to explore the
rain forest via an ingenious multilevel
system of aerial platforms and suspended
pathways.

COLCA CANYON
Arequipa, Peru

// A Little-Known Valley
of Wonders

Colca is home to 14 villages founded in
colonial times that are now home to the
descendants of pre-Inca ethnic groups.
Outdoor enthusiasts enjoy hiking and
rafting amid soaring mountains scored by
agricultural terraces (*right*).

Must Do // Head to the lookout point Cruz
del Cóndor in the morning to marvel at
Andean condors // Study the constellations
at Casa Andina's observatory in Chivay, the
canyon's largest town.

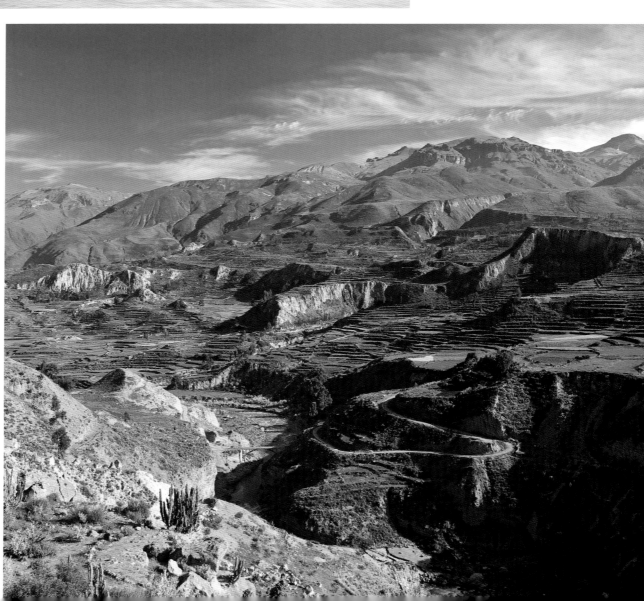

MONASTERIO DE SANTA CATALINA
Arequipa, Peru

// An Island of Serenity in
Peru's White City

Known as La Ciudad Blanca for the pearly
volcanic stone used to build its 16th- and
17th-century buildings, Arequipa is a lovely
city with a secret: the cloistered world of
the Monasterio de Santa Catalina (*below*).

Must Do // Meander along twisting streets
to admire the brightly painted buildings in
this miniature city within a city // Relax in
tiny fruit tree–shaded plazas // Explore the
Plaza de Armas in the center of Arequipa.

CUZCO AND THE SACRED VALLEY
Peru

// At the Center
of the Inca Universe

Cuzco, the birthplace and center of the
Inca empire, is sometimes overlooked as a
unique destination unto itself. Founded in
the 12th century, it is the oldest continuously
inhabited city in the Americas.

Must Do // Explore the Old City, Plaza de
Armas, and its centerpiece, an ornate
Baroque cathedral, La Compañia de Jesús
(*right*) // Visit the ruins of Sacsayhuamán, a
fortress complex of enormous interlocking
stones // Tour the Urubamba (aka Sacred)
Valley // Head to Ollantaytambo, one of the
most popular starting points for the Inca
Trail hike // Hike or drive up to Pisac's ruins
and market above the town // Be sure to
visit the salt pans of Maras; the enigmatic
Inca crop circles of Moray; and Chinchero's
Sunday market.

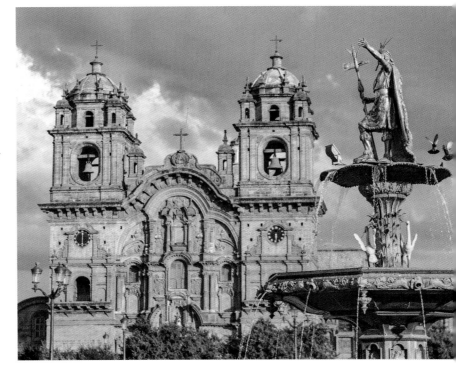

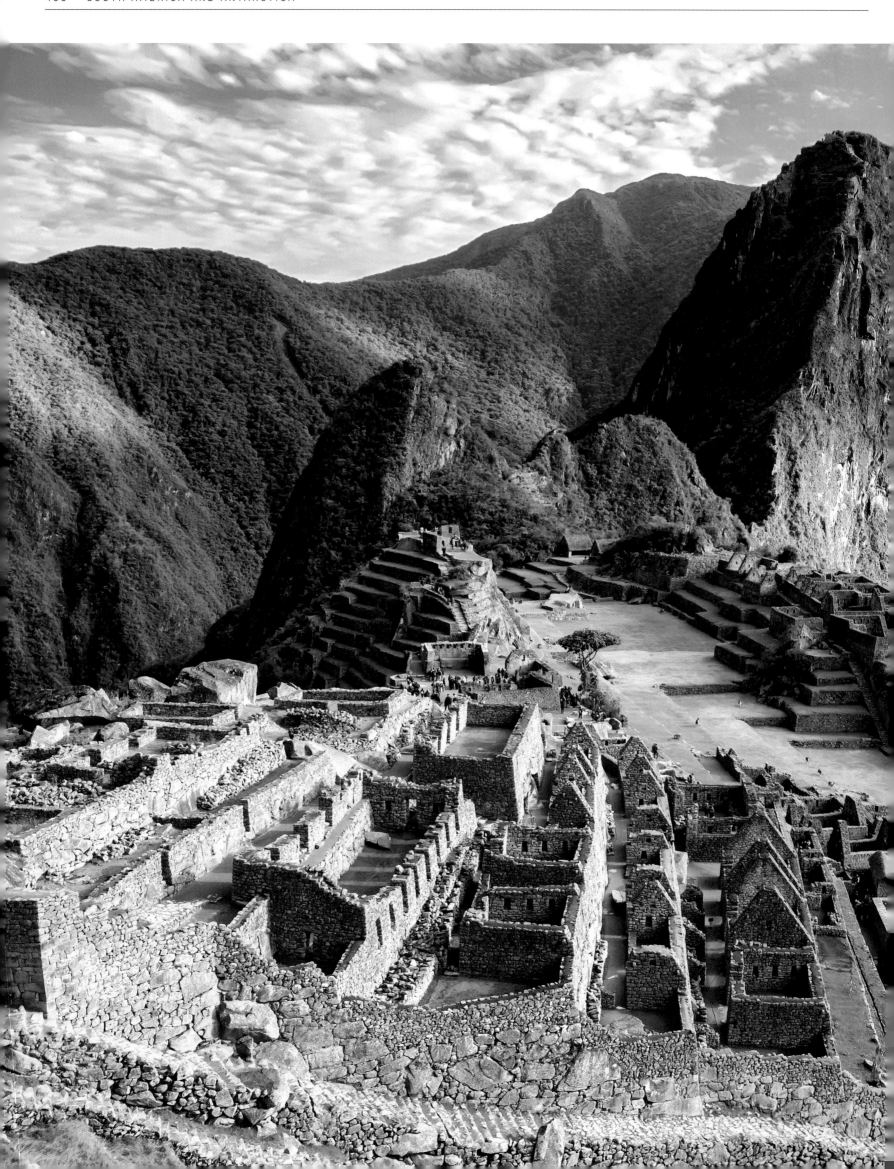

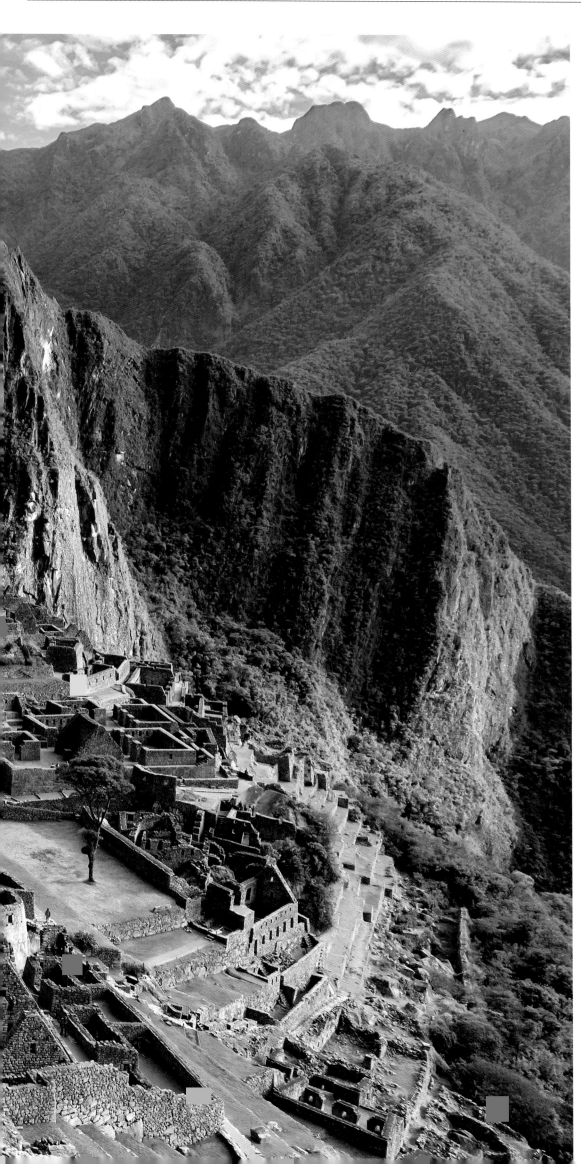

MACHU PICCHU
**Urubamba Valley,
Cuzco Region, Peru**

// The Lost City of the Incas

On a continent endowed with magnificent pre-Columbian archaeological sites, this "lost city of the Incas" is the supreme showpiece. Machu Picchu's strategic and isolated setting more than 7,800 feet above sea level, coupled with its mysterious significance in the Inca universe, make this remote site one of the world's most beautiful and haunting destinations. Abandoned by the Inca and reclaimed by the jungle, the 100-acre complex of temples, warehouses, homes, irrigation terraces, and stairs cascades down the mountain.

Must Do // Make the near-vertical 1-hour scramble to the summit of Huayna Picchu for breathtaking views // Arrive at sunset at the 500-year-old Gate of the Sun after a 4- or 5-day trek along the Inca Trail // Take the train (there is no direct road) from Cuzco to Machu Picchu Pueblo and the shuttle buses that bring you up to the site.

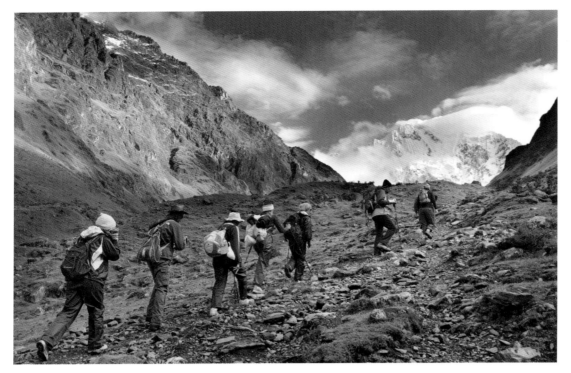

THE INCA TRAILS
Peru

// The Andes' Sacred Highways

The Inca built a complex and extensive network of mountain trails through their empire, which centered on the Andean mountain range from Colombia to Chile. Though many of them have been reclaimed by the jungle, a number of ancient paths still wind through the fertile valleys and mountain passes from outside the former capital of Cuzco to Machu Picchu.

Must Do // Hike the 26-mile Inca Trail from Cuzco to Machu Picchu, a trophy approach that requires endurance and tolerance to thin air // Book your permits to hike the trail well ahead of time, as they sell out months in advance // Take the alternative Salcantay trail to Machu Picchu, a 5-day, approximately 35-mile journey that begins in Mollepata // Trek to the much less visited—and much less excavated—sister site of Choquequirao, a 5-day hike that begins and ends in the town of Cachora, 4 hours from Cuzco by road.

LIMA'S FOOD SCENE
Lima, Peru

// Gastronomic Revolution

As cosmopolitan as its population, Lima's cuisine is founded on indigenous cooking, enriched with European traditions, emboldened with Asian flavors courtesy of Chinese and Japanese immigrants, then set to simmer with Creole spices brought by Caribbean workers.

Must Do // Visit Astrid y Gastón [right], considered Peru's top dining spot, whose owner has been a passionate trailblazer at home and abroad // Get a table at a *cebichería*, where the Peruvian national dish ceviche is served in various interpretations // Try spicy dim sum at a *chifa* (slang for Chinese-Peruvian restaurant).

MANU NATIONAL PARK
Peru

// A Bird- and Wildlife-Watcher's Utopia

Unrivaled for its biodiversity, Manu National Park in the southeastern corner of Peru encompasses Andean peaks, cloud forests, and lowland Amazon rain forests that rest below 1,000 feet. Here you'll find an estimated 15,000 plant species, 1,000-plus species of birds, 13 species of monkeys, and 200 mammal species that include the elusive jaguar. The trade-off is that Manu is difficult to get to.

Must Do // Arrange a visit with a tour operator.

THE NAZCA LINES
Nazca, Peru

// Age-Old Mysteries Etched
into the Desert Floor

Peru's desert coast is the setting for the
mysterious, ancient Nazca lines, a vast
series of furrows in the earth that depict
stylized human and animal forms—such
as monkeys, hummingbirds (right), spiders,
and whales—as well as geometric lines and
shapes. The full impact of their 193-square-
mile expanse sets in only when they are
seen from the air, which is how they were
discovered in the 1920s.

Must Visit // The Museo Antonini, to see
trophy skulls, textiles, and artifacts that
have been found in the area // The tiny
museum in Pascana, where German-
born Maria Reiche dedicated her life to
researching the lines and the Nazca culture

LAKE TITICACA
Puno, Peru

// Mythical Birthplace
of the Incas

Set in the Andes at 12,500 feet above
sea level, legendary Lake Titicaca is the
highest navigable lake in the world and,
at 3,200 square miles, it is the continent's
largest. The Inca believe that Manco Cápac
and his sister-consort emerged from the
lake to found Cuzco and the Inca empire.
The Uros people have been living on
floating islands made of reeds for centuries
to escape conflicts with the Inca who had
demanded their lands.

Must Do // Visit the markets on the islands
of Taquile and Amanti for handwoven
textiles made by inhabitants of the islands
(above) // Visit Puno in early February for
the festival of the Virgen de la Candelaria to
see the flamboyant Suits of Lights dances
// Attend November's Puno Week festivities
to see costumes, masks, and dancing
rooted in Inca culture // Take PeruRail's
Titicaca train for a 10-hour scenic trip along
Lake Titicaca from Cuzco to Puno.

COLONIA DEL SACRAMENTO
Uruguay

// A Little-Known Getaway

An easy ferry ride from Buenos Aires, tiny Colonia is the unappreciated gem of underrated Uruguay even though the town's cobblestoned Barrio Histórico is among the continent's most carefully restored urban areas.

Must Visit // Iglesia Matriz, Uruguay's oldest church (*left*, background) // The Sunday market in Plaza Mayor // The Bodega Bouza winery, on the road from Colonia to Montevideo

JOSÉ IGNACIO
Uruguay

// Like Bohemian Summer Camp with Celebrities and Soccer Stars

A 40-minute drive east of Punta del Este is the small peninsula of José Ignacio and the stylish Playa Brava beach. The town's most prominent landmark is Faro José Ignacio (*right*), a century-old lighthouse where surfers catch waves at sunset.

Must Do // Enjoy the laid-back vibe and boho-chic crowd that gathers here // Dine in restaurants tucked into beachside pine groves, feast on the day's catch, and sip wines from nearby vineyards.

PUNTA DEL ESTE
Uruguay

// South America's St-Tropez

Punta del Este has reigned for decades as the continent's premier jet-set mecca although this former fishing village is now full of high-rise hotels and condominiums, and has lost some of its exclusive air.

Must Do // See *The Hand* by Mario Irarrázabal (*left*) peeking out from the sands on Brava Beach // Try neighboring Punta Ballena or Barra de Maldonado to escape some of the crowds // Take a day trip to Isla Gorriti or Isla de Lobos to glimpse sea lions instead of beautiful people.

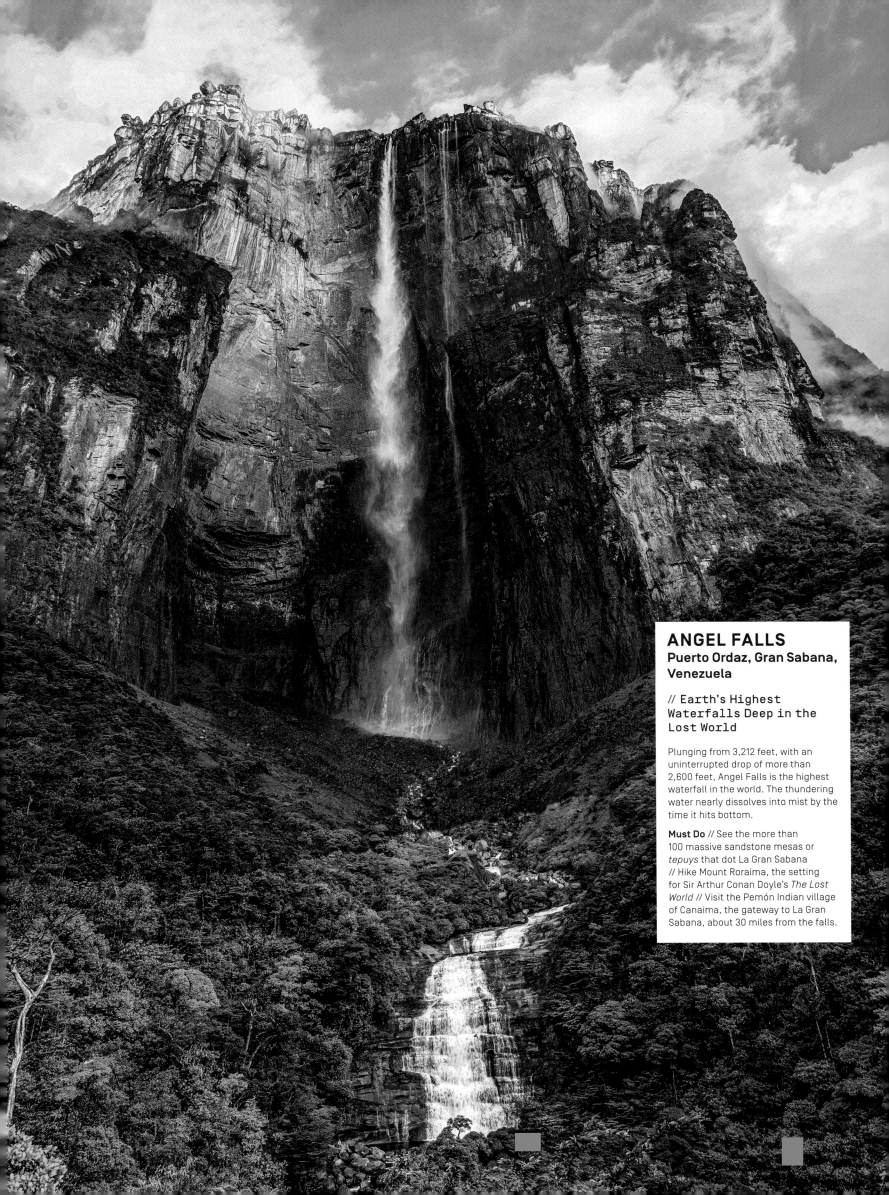

ANGEL FALLS
Puerto Ordaz, Gran Sabana, Venezuela

// Earth's Highest
Waterfalls Deep in the
Lost World

Plunging from 3,212 feet, with an
uninterrupted drop of more than
2,600 feet, Angel Falls is the highest
waterfall in the world. The thundering
water nearly dissolves into mist by the
time it hits bottom.

Must Do // See the more than
100 massive sandstone mesas or
tepuys that dot La Gran Sabana
// Hike Mount Roraima, the setting
for Sir Arthur Conan Doyle's *The Lost
World* // Visit the Pemón Indian village
of Canaima, the gateway to La Gran
Sabana, about 30 miles from the falls.

THE WHITE CONTINENT
Antarctica

// Terra Australis Incognita

Antarctica—"the unknown land of the south"—is the surreal seventh continent at the bottom of the world, a place of ethereal beauty and unequivocal grandeur that inspired the great explorers of old and captures the hearts of adventurers today. The limitless landscape of ice, sea, and sky comes in a million shades of blue, and jagged, snowy mountain peaks and glistening glaciers dwarf anything ever made by man. It is the ultimate, end-of-the-earth expedition, the world's most inaccessible continent.

Must Do // Look for orca, humpback, fin, and right whales, and Weddell and leopard seals // Stand inside a rookery of Adélie or emperor penguins // Choose a tour that offers a high number of Zodiac shore landings to optimize wildlife encounters // Learn from a veteran expedition crew of geologists, zoologists, polar explorers, historians, ecologists, and oceanographers.

SOUTH GEORGIA ISLAND
South Georgia and the Sandwich Islands (British Overseas Territory)

// South Atlantic
Bird Paradise

Windswept, largely unknown, and utterly isolated, South Georgia nevertheless delights intrepid visitors with impossibly high sea cliffs, dazzling fjords, and snowy Alpine peaks sloping down to wave-whipped beaches of fine-grained salt-and-pepper sand. Vestiges of the area's whaling days remain at the "capital" of Grytviken, home to fewer than 20 seasonal souls. These seemingly desolate shorelines harbor one of the world's largest and most important penguin colonies: more than a half million breeding pairs of king penguins and their fluffy brown chicks (*above*).

Must Do // Watch for 81 rare and wonderful bird species, including a million-plus macaroni penguins // Visit during the summer when fur seals and elephant seals breed on the shores of South Georgia // Tour the cozy museum and ring the bell of the wooden church in Grytviken, built in 1913 // Pause at the simple grave of legendary explorer Sir Ernest Shackleton.

The Caribbean, the Bahamas, and Bermuda

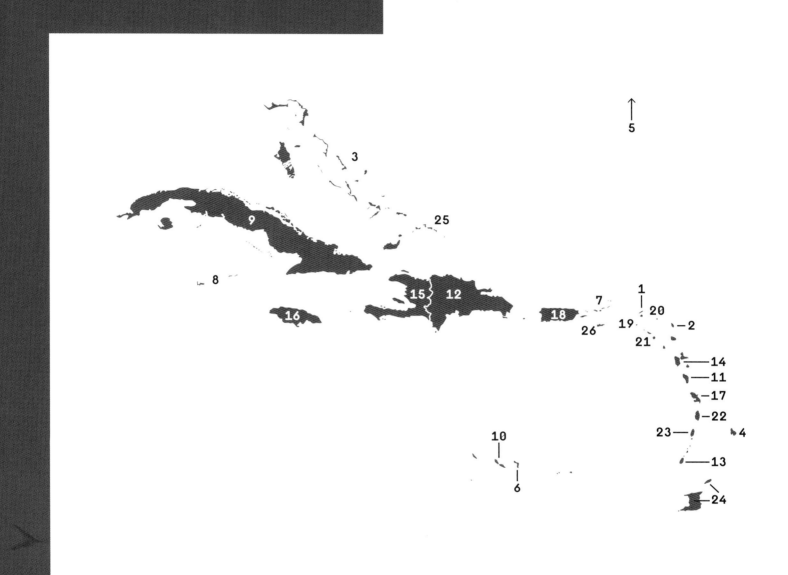

A hawksbill sea turtle swims in the calm waters off Barbados (see page 499).

The Caribbean, the Bahamas, and Bermuda

1 Anguilla
2 Antigua
3 The Bahamas
4 Barbados
5 Bermuda
6 Bonaire
7 British Virgin Islands
8 Cayman Islands
9 Cuba
10 Curaçao
11 Dominica
12 Dominican Republic
13 Grenada
14 Guadeloupe

15 Haiti
16 Jamaica
17 Martinique
18 Puerto Rico
19 Saba
20 St. Barths
21 St. Kitts and Nevis
22 St. Lucia
23 St. Vincent and the Grenadines
24 Trinidad and Tobago
25 Turks and Caicos
26 The U.S. Virgin Islands

ANGUILLA
Lesser Antilles

// 33 Spectacular Beaches

Anguilla is a flat, scrubby island that's light on interior scenery, but it has some of the most picture-perfect white sand beaches and crystal-clear waters you'll find anywhere.

Must Do // Explore the island's friendly towns undisturbed by cruise ships, casinos, or strip malls // Visit Shoal Bay on the northeast coast, known for its beautiful beach and food shacks // Visit in March for Moonsplash, a music festival cofounded by Bankie Banx.

ANTIGUA
Lesser Antilles

// A Nautical Kentucky Derby and Stellar Beaches

Antigua boasts one of the few British Georgian-style naval dockyards left in the world, now a national park named for Admiral Horatio Nelson, who arrived on the island in 1784.

Must Do // Visit in April for Antigua Sailing Week (*above*), one of the top regattas in the world // Snorkel at Dickenson Bay in the northwest or Half-Moon Bay on the eastern coast // Sail to Barbuda, Antigua's sister island to the north, to view a rookery of frigate birds.

THE ISLANDS OF THE BAHAMAS
The Bahamas

// A Vast Archipelago

The Bahamas comprise 750 sun-soaked islands with 2,500 cays, stretching over 100,000 square miles of green and cobalt-blue seas. Some of the best sea kayaking and snorkeling can be found on the Exuma Cays (*left*). The Abacos are known as the "sailing capital of the world" and promise a fine collection of 25 cays off the eastern coast of the long, thin, boomerang-shaped Great Abaco Island. Andros Island offers excellent bonefishing and the chance to explore the blue holes first made famous by Jacques Cousteau. Harbour Island is best known for its 3-mile pink sand beach.

Must Do // Sail the Abacos Cays, one to the next, dropping anchor for snorkeling, swimming, fishing, diving, or island exploration // Visit the 1838 lighthouse in Hope Town on Elbow Cay in the Abacos // Scuba through the Tongue of the Ocean, a narrow underwater canyon off Andros Island // Dive the Current Cut Dive, an exciting underwater gully off Harbour Island // Explore Exuma Cays for their swimming pigs and Land and Sea Park, to see coral gardens, conch, grouper, and lobster.

BARBADOS
Lesser Antilles

// The Caribbean's "Little England"

After more than 300 years of British rule, afternoon tea is a tradition and cricket is the national sport on Barbados, home to the Platinum Coast, named for the ritzy resorts and stylish condos found along the island's western shoreline.

Must Do // Visit Harrison's Cave (*right*), to view well-lit stalactites and stalagmites // Stroll to the Andromeda Botanic Garden, to see heliconia, orchids, and a bearded fig tree.

BERMUDA

// So Much More Than Shorts and Triangles

Considerably cooler than the Caribbean islands to its south, Bermuda is best known for its stunning pink sand beaches, Bermuda shorts, and the Bermuda Triangle. When the *Sea Venture* wrecked here in 1609, a few stalwarts stayed on to claim it, making it England's oldest colony.

Must Do // Visit postcard-perfect Horseshoe Bay [*right*] on the south shore // Set off by scooter (there are no car rentals in Bermuda) to serene Warwick Long Bay // Dive among the island's many historic wrecks // Play golf at any of the island's clubs and enjoy the spectacular scenery and challenging courses.

BONAIRE
Lesser Antilles

// Underwater Forests of Coral Reefs and Round-the-Clock Diving

Bonaire is one big dive site, thanks to its 86 marked diving spots and the Bonaire National Marine Park, where some of the world's healthiest coral reefs harbor doctorfish, sergeant majors, trumpet fish, and four-eye butterfly fish.

Must Do // Windsurf and kayak in Lac Bay // Visit between December and March to see pink flamingos in Washington-Slagbaai National Park.

BRITISH VIRGIN ISLANDS
Lesser Antilles

// Premier Sailing and Gigantic Boulders

The volcanic archipelago of the British Virgin Islands comprises four main islands and some 60 smaller islets and unspoiled keys scattered across miles of incomparably blue sea. These waters have long been held as prime cruising grounds, and those who don't arrive with their own private boat can charter one in Tortola, the largest of the BVIs, with or without a crew.

Must Do // On Virgin Gorda, troll the less trafficked coastline on either side of the Baths [*below*], where the massive boulders continue // Visit Jost Van Dyke's White Bay, a beach with great snorkeling and beach bars, including Ivan's Stress-Free Bar [*right*] // Explore the RMS *Rhone* near Salt Island, one of the great wreck-diving sites of the Caribbean // Head to Guana, a private wildlife sanctuary, to experience untrammeled nature // Search for pirate treasure on uninhabited Norman Island, said to be the inspiration for *Treasure Island* // Sail to Anegada's Horseshoe Reef, for some of the best snorkeling in all of the Virgin Islands.

CAYMAN ISLANDS
Greater Antilles

// Bloody Bay Wall, Iguanas, and Stingrays

Swimmers and sun lovers consider Grand Cayman's Seven Mile Beach near perfect. But for the finest dive site in the Caymans, head to the 6,000-foot plunging Bloody Bay Wall off the north shore of Little Cayman, an island where iguanas and red-footed boobies far outnumber humans. Grand Cayman is home to Stingray City, where throngs of the large-winged marine creatures [*left*] eat from visitors' hands.

Must Do // Visit in January for Cayman Cookout, a celebration of Cayman and global cuisine on the beach.

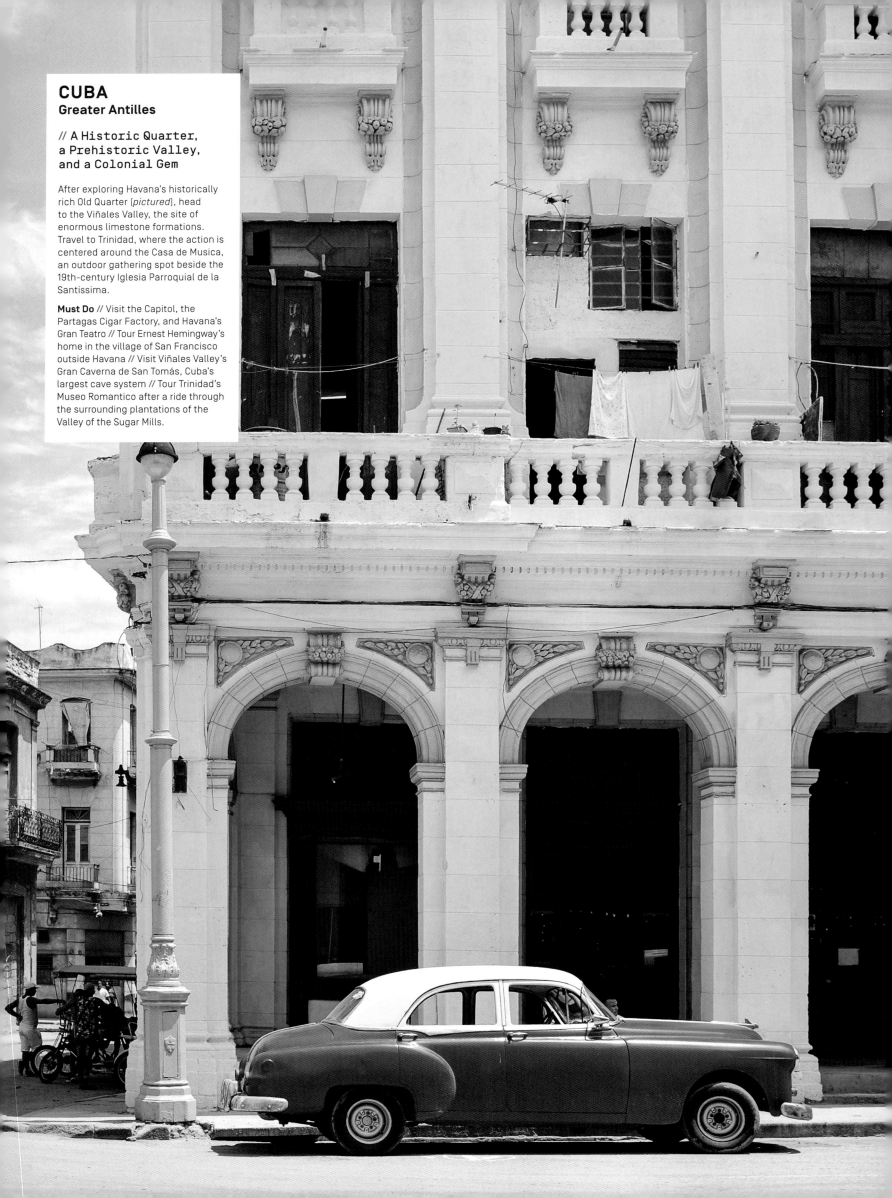

CUBA
Greater Antilles

// A Historic Quarter,
a Prehistoric Valley,
and a Colonial Gem

After exploring Havana's historically
rich Old Quarter (*pictured*), head
to the Viñales Valley, the site of
enormous limestone formations.
Travel to Trinidad, where the action is
centered around the Casa de Musica,
an outdoor gathering spot beside the
19th-century Iglesia Parroquial de la
Santissima.

Must Do // Visit the Capitol, the
Partagas Cigar Factory, and Havana's
Gran Teatro // Tour Ernest Hemingway's
home in the village of San Francisco
outside Havana // Visit Viñales Valley's
Gran Caverna de San Tomás, Cuba's
largest cave system // Tour Trinidad's
Museo Romantico after a ride through
the surrounding plantations of the
Valley of the Sugar Mills.

CURAÇAO
Lesser Antilles

// An Enclave of Culture in the ABC Islands

Of the three tiny islands sharing a common Dutch heritage known as the ABCs (Aruba, Bonaire, Curaçao), Curaçao is the largest, with a sophisticated cultural enclave, a prosperous financial center, and a trading port—a long way from the island's less-than-sunny history as the Caribbean's largest slave-trade depot in the 17th and 18th centuries.

Must Visit // Willemstad's Museum Kura Hulanda, to learn about the slave trade; and on the opposite end of the spectrum, take in the vibrant colors of the city's architecture (*left*) and walk along the Handelskade, one of the most photographed waterfronts in the Caribbean // The Curaçao Underwater Marine Park, for excellent snorkeling // The oldest active Jewish synagogue in the western hemisphere (the congregation has been here since 1651, the synagogue since 1732)

DOMINICA
Lesser Antilles

// A Lush Oasis for Eco-Adventurers

Untrammeled and with few beaches to tout, wild and primeval Dominica draws naturalists and ecotourists to explore Morne Trois Pitons National Park (*left*)—an ungovernable refuge of huge ferns, ancient trees, wild orchids, and bright anthuriums—named for the three-pronged mountain at its center.

Must Do // Make the strenuous 8-hour trek to Boiling Lake through the Valley of Desolation's steaming vents and boiling mud // Cool off at Trafalgar Falls, a 200-foot twin cataract // Dive and snorkel Champagne Reef near Roseau.

DOMINICAN REPUBLIC
Greater Antilles

// Golf and Whales in Spain's First Foothold

Many of the New World's "firsts"—the first cathedral, fort, hospital, monastery, nunnery, customhouse, university, paved road, even the first sewer system—can be seen in Santo Domingo's Zona Colonial year-round. Many come for the island's reputation as the finest golfing destination in the region, but nature lovers visit the Samaná Peninsula, home to one of the world's top breeding grounds for humpback whales.

Must Do // In Santa Domingo, visit the Tower of Homage, Catedral Santa María la Menor, Alcazar de Colón, the Museo del Hombre Dominicano, and Parque Colon, with its statue of Christopher Columbus (*above*) overlooking the leafy square // Golfers should book Teeth of the Dog, La Cana, the Corales Course, and the Playa Grande // Whale-watch in Samaná and Cayo Levantado

GRENADA
Lesser Antilles

// A Fragrant Spice Island
with Scenic Allure

This postcard-perfect port—the crater of
an inactive volcano—is one of the most
scenic in all the Caribbean, flanked by
early-18th-century forts and hugged by the
raffishly charming port town of St. George's
(*right*). Beach lovers need look no further
than Grand Anse, south of town, a 2-mile
curve of perfect sand.

Must Do // Stop by the daily open-air
market to listen to turbaned ladies sell
their fragrant nutmeg, cloves, bay leaves,
and cinnamon // Visit Grand Etang National
Park, a trekker's paradise, with wild
spices, long-tailed monkeys, and powerful
waterfalls // Snorkel and dive at the
Underwater Sculpture Park—65 works of
art installed in Molinere Bay off the island's
west coast.

GUADELOUPE
Lesser Antilles

// Creole Cuisine and
Tropical Adventures

Guadeloupe is one of the Caribbean's most
interesting culinary destinations, and
Grande-Terre's variety of restaurants serve
a marriage of African, French, and West
Indian cuisine that rivals that of St. Martin
and Martinique.

Must Do // Drive the transcoastal Route
de la Traversée, one of the most scenic
highways in the Caribbean // Trek to the
three waterfalls known as Chutes du Carbet
in Basse-Terre (*left*) // Visit in August for the
annual Fête des Cuisinières to see a parade
of costumed women bearing the island's
bounty on their heads.

HAITI
Greater Antilles

// Where African Spirits
Come to Earth

Despite the country's being rocked
by earthquakes, political turmoil, and
persistent poverty, visitors can get a taste
of the strong Haitian spirit every Thursday
at the Hotel Oloffson (*right*), a ramshackle
Victorian gingerbread in the capital city of
Port-au-Prince, where Mick Jagger, Ann-
Margret, and Graham Greene have stayed.

Must Do // Dance all night to *musique
racine*, a blend of rock 'n' roll and
traditional music performed on the rara
horn and petwo drums // Escape the
commotiion of Port-au-Prince to small and
charming Jacmel, long known for its arts
and crafts scene.

JAMAICA
Greater Antilles

// Great Reggae,
a Wild Beach, and the
Birthplace of Jerk

Montego Bay draws music fans to Reggae Sumfest in mid-July, and the fun continues year-round on Negril's Seven Mile Beach. For an authentic sense of Old Jamaica, head to Port Antonio, the birthplace of jerk, or Ocho Rios where Ian Fleming wrote his 14 thrillers and Noël Coward lived up the hill.

Must Do // Tour Montego Bay's allegedly haunted Rose Hall (*left*), built in the 1700s in the heyday of the sugar-plantation era // Hike the Blue Mountains' trails, which lead to staggering views, or bike down from 5,600 feet // Take a day trip from Ocho Rios to Nine Mile, Bob Marley's final resting place // Visit the Blue Lagoon—a 180-foot-deep indigo hole near Port Antonio // Ride on a poled bamboo raft once used to transport bananas in nearby Rio Grande.

MARTINIQUE
Lesser Antilles

// Island Cuisine—
C'est Magnifique

Martinique is the most French of the Caribbean islands, and the local gastronomy—a mélange of classic French and Creole ingredients—is a major part of the island's allure, as a stroll through the local spice market in Fort-de-France will confirm. Martinique is famous for its rums, which have been awarded the prestigious French designation Appellation d'Origine Contrôlée (AOC) and have long been the foundation of many traditional island recipes.

Must Do // Travel the Route de Rhum to visit 12 of the island's best distilleries, including the historic Habitation Clément in Le François (*above*) // Drive north along the Route de Trace from Fort-de-France to Le Jardin de Balata to learn about its plant species // Hike and bird-watch around Mont Pelée, which last erupted in 1902 // For stellar beaches, head south to Les Salines and Diamant Beach.

PUERTO RICO
Greater Antilles

// Spanish Colonial
Architecture, a Beautiful
Back Road, and Off-the-Radar
Islands

Walk back through history in Old San Juan, a showcase of pastel-colored landmarks. Surfers from around the globe gravitate to Rincón, while nonsurfers explore La Ruta Panoramica. Visitors should head to Vieques to do nothing while surrounded by natural beauty. For even less of a scene, travel to tiny Culebra, home to Playa Flamenco, one of the region's most beautiful beaches.

Must Do // Tour Old San Juan's El Morro (*right*), a 16th-century fortress that rises 150 feet above the sea // Boat at night in Mosquito Bay on Vieques to experience one of the brightest bioluminescent bays in the world.

SABA
Lesser Antilles

// Underwater Alps Draw Divers In-the-Know

With just 1,200 friendly inhabitants, Saba has no beaches or nightlife to speak of, but those with a thing for mountains consider it heaven on earth. Saba's 5 square miles are mostly vertical, with 12 great trekking trails, just one paved road, and the shortest commercial runway in the world (*right*).

Must Do // Trekkers take to Mount Scenery, an extinct volcano, while experienced divers head for the spectacular pinnacles rising from the ocean floor // Snorkel or dive around Saba Marine Mark, perfect for novices and experts alike // Explore the Bottom, a Dutch village of gabled roofs and the island's capital where the dive boats anchor.

ST. BARTHS
Lesser Antilles

// The Caribbean's Star-Studded Riviera

Chic St. Barths has amazing views of the sea and surrounding islands and a quiet French flair. For the 2 weeks around Christmas and New Year's Eve, it is the destination of choice for le beau monde from France, Hollywood, and New York.

Must Do // Explore the storybook-quaint harbor of Gustavia (*above*), St. Barths's only town and seaport // Swim and celebrity-spot at St. Jean Beach on the northern side of the island.

ST. KITTS AND NEVIS
Lesser Antilles

// Where Sugar Was King

Both islands were once wealthy British sugar colonies, but while St. Kitts is busy with casinos, golf and big expansion plans, lush and unhurried Nevis (*left*) offers simple pleasures without a single traffic light.

Must Do // Hike into verdant rain forests to Nevis Peak, the island's ultimate destination // Catch the sunset on Pinney's Beach on Nevis // Take in the panoramic views from Brimstone Hill, an 18th-century stone fortress on St. Kitts // Hit the Thursday-night beach party at Frigate Bay on St. Kitts to see the blazing Fire Man // Check out Reggae Beach, a kayaking, snorkeling, and sailing paradise on St. Kitts.

THE PITONS
St. Lucia, Lesser Antilles

// Views Beyond Extraordinary

These towering twin peaks (*left*), known as the Pitons, rise side by side out of the sea, lending an exotic South Pacific air to St. Lucia. The silhouettes of these volcanic remnants have appeared on everything from the national flag and postcards to local currency and the label of the locally brewed beer.

Must Do // Enjoy some of the Caribbean's best snorkeling and diving along the Anse Chastanet Reef // Take a guided hike to the top of Gros Piton—at 2,619 feet, it is the Kilimanjaro of the Caribbean // Learn more about St. Lucia's volcanic origins and ongoing activity at La Soufrière, a lunar landscape with bubbling sulfur mud baths.

ST. VINCENT AND THE GRENADINES
Lesser Antilles

// Idyllic Sailing and Private Islands

The ideal way to explore one of the world's best sailing grounds is to charter a self-skippered bareboat at the Moorings in Canouan or book a cabin aboard a luxury catamaran. Visit Bequia [*BECK-way*], hilly, green, and just 7 square miles in size, the largest and northernmost of the 32 Grenadine Islands. Daily boat service from St. Vincent allows visitors to join the rich and famous on the privately owned island of Mustique.

Must Do // Stroll to Bequia's beach at Spring Bay, where the snorkeling is excellent // Visit Mustique's beautiful Macaroni Beach, then toast the sunset at Basil's Bar // Arrange for a deep-sea-fishing, scuba-diving, or sailing trip to Tobago Cays Marine Park.

TRINIDAD AND TOBAGO
Lesser Antilles

// A Riotous Celebration, Bird-Watching, and Drift Diving

To understand Trinidad, come for Carnival [*left*], or mas [for masquerade], as it's locally known. With Port of Spain at its heart, it's the wildest and loudest Carnival in the Caribbean, but Tobago, Trinidad's sleepy country cousin, offers quieter pursuits: world-class bird-watching and the best drift driving in the Caribbean.

Must Do // Book a boat trip through Trinidad's Caroni Swamp at sunset to see thousands of scarlet ibises return to their roosts // Head to Tobago's Pigeon Point Beach to board a boat to Buccoo, a natural aquarium // Sign up for the Tobago Dive Experience in Speyside to drift dive past manta rays, southern stingrays, nurse sharks, and turtles // Visit the Tobago Forest Reserve for avian sightings and to view Argyll Waterfall // Travel from Speyside to Little Tobago Island, one of the most important seabird sanctuaries in the Caribbean.

TURKS AND CAICOS
// Miles of Pristine Beach

Grace Bay (*left*)—the jewel in the crown of Turks and Caicos—is located on the northern shore of the main island of Providenciales. Considered one of the most beautiful beaches in the world, it boasts a 12-mile arc of powdery white sand lapped by turquoise waters teeming with marine life.

Must Do // Head to Salt Cay to dive among forests of elkhorn coral past a British frigate that wrecked in 1790 // Spot—and swim with—migrating humpback whales in winter.

THE U.S. VIRGIN ISLANDS
Lesser Antilles

// Magens Bay, Buck Island, and a Virgin Island

St. Thomas is the most developed of the three major U.S. Virgin Islands, and the sweeping views from Paradise Point give you the lay of the land, including a glimpse at Magens Bay Beach (*above*), a prime contender on any short list of the world's most beautiful beaches. Snorkeling is legendary off Buck Island, accessible from Christiansted on St. Croix's northern coast. And St. John puts the "virgin" back in the Virgin Islands. Reachable only by ferry, more than half the island is a national park.

Must Do // Hang out at Hull Bay Beach, St. Thomas's most popular surfing beach // Dive at St. Croix's Salt River Canyon and Cane Bay, where coral gardens lead to a 2,000-foot-deep wall // Visit St. John's Trunk Bay, a picture-perfect beach with a snorkeling trail with labeled underwater features.

ACKNOWLEDGMENTS

I could not begin this list of those to whom I am profoundly grateful without first acknowledging Workman Publishing, who published the original *1,000 Places to See Before You Die* in 2003. They helped spread my love of travel to those here and abroad: there is no more intense way to learn and grow. I am a better person for it.

To Artisan, I want to give a big—no, huge—heartfelt thank-you for this opportunity to create something novel and visually beautiful, something very important to me that has long lived in my mind: a complete and total reimagination of *1,000 Places*, with the lush illustrations missing from the original.

The Artisan team is small, but they are mighty, and their enthusiasm is endless. From the start, I knew that even though this challenge would be as daunting as the first in some ways, it was in the right hands.

It was more rewarding than I could have imagined to learn the mechanics and appreciate the vision that go into a book of this kind—I have a newfound appreciation for the deluxe and handsome tomes that grace the coffee tables of this world.

Thank you all for your endless patience as I asked to see yet another photo of a Maya ruin or attempted to capture the magic of being surrounded by a million penguins on the island of South Georgia. No one ever questioned my requests or persistence and everyone always went the extra mile: we all understood the potential of this project, and strove to create its finest interpretation.

Overseeing the multiple-year endeavor with unwavering confidence was Artisan's publisher, Lia Ronnen—as intuitive and wise as she is keenly insightful—supported by my tireless editor, Shoshana Gutmajer, committed and reassuring at every turn of the book's evolution. A warm thank-you to Elise Ramsbottom as well, for the many efforts and ready smiles. The impressive creative and design talents of Michelle Ishay-Cohen and Jane Treuhaft steered the book steadfastly forward—it was both fun and exciting to work with them and watch the book's progress and growth under their direction and unerring eyes.

More thanks yet to Zach Greenwald, managing editor; Nancy Murray, production director; and Hanh Le, production and design manager. And thanks to those I never saw but whose involvement was invaluable: copy editor David Hough, designer Erica Heitman-Ford, and photo researchers Michelle Wolfe and Kate Osba.

It is exciting to see the work being done now by Allison McGeehon, associate publisher, and her marketing and publicity team, especially Theresa Collier and Amy Michelson. They've picked up the *1,000 Places* torch, creating partnerships and collaborations so that the world may embrace and help us celebrate this new and intoxicating mix of our planet's many wonders, reborn in this photographically inspiring edition.

GENERAL INDEX

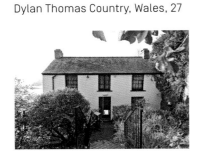

H

I

J

K

W

Wachau Valley, Austria, 39
Wadi Rum, Jordan, 210, 216
Wales, 26–28
Walking the Nakasendo, Japan, 244
Walt Disney World, Orlando, Florida, 362
Warwick Castle, England, 17
Wasatch Range, Utah, 412
Washington, D.C., 420–23
Washington State, U.S.A., 402, 424
Waterways of the Czars, 152
Wawel Hill, Kraków, Poland, 146
Wells Cathedral, England, 16
West, South, and Central Asia, 252–80
West Africa, 188–89
West Bank, Palestine, 214
Western Europe, 38–133
West Jerusalem, Israel, 213
West Lake, Hangzhou, China, 237
West Virginia, U.S.A., 424
West Virginia's White-Water Rafting, 424
Wexford Opera Festival, Ireland, 36
Whirling Dervishes of Konya, Turkey, 278
Whistler Blackcomb Ski Resort, British Columbia, 433
White City of Tel Aviv, Israel, 215
White Continent, Antarctica, 494
White Mountains, New Hampshire, 388

White Nights Festival, St. Petersburg, Russia, 153
Wilamette Valley, Oregon, 403
Winchester Cathedral, England, 7
Wine Roads of Chile, 479
Winterlude and Rideau Canal, Ottawa, Canada, 438
Winter Palace and Hermitage, St. Petersburg, Russia, 153
Wisconsin, U.S.A., 425
Witchcraft Market, La Paz, Bolivia, 469
Woodstock, Vermont, 416
World of Alvar Aalto, Helsinki, Finland, 164
Wye Valley, Wales, 28
Wyoming, U.S.A., 425–27

X

Xi'an and Terra-Cotta Warriors, China, 234

Y

Yap, Micronesia, 327
Yasawa Islands, Fiji, 329
Yeats Country, Ireland, 35
Yellowstone National Park, Wyoming, 427
Yogyakarta, Java, Indonesia, 284
Yoho National Park, Canada, 428
York Minster, England, 20
Yosemite National Park, California, 352
Yukon River, Canada, 443
Yunnan, China, 237
Yurt Stay at Lake Song Köl, Kyrgyzstan, 264

Z

Zakopane, Poland, 147
Zambia, 205–6
Zanzibar, Tanzania, 203
Zeeland, Netherlands, 112
Zermatt, Switzerland, 132
Zimbabwe, 206
Zion and Bryce National Parks, Utah, 416
Zürich, Switzerland, 133

THEMATIC INDEXES

ADVENTURE TRAVEL

ART, ARCHITECTURE, DESIGN

BEACHES, ISLANDS, SEACOASTS

CASTLES AND PALACES

CITIES AND TOWNS

MOUNTAINS AND LANDSCAPES

MUSIC, DANCE, THEATER

NATURAL WONDERS

PYRAMIDS, RUINS, LOST CITIES

RAILWAYS, ROADWAYS, BRIDGES

SACRED PLACES

WILDLIFE,
ZOOS,
AQUARIUMS

WINERIES,
BREWERIES,
DISTILLERIES

PHOTO CREDITS

Names in *italics* indicate images that also appear on the back cover.

pp. iv–v: Sarawut Aiemsinsuk/Shutterstock; **pp. vi–vii:** Brown W. Cannon III/Intersection Photos; **p. viii:** Natapong Paopijit/Getty Images; **p. ix:** PjrTravel/Alamy Stock Photo [*left*], Robert Haasmann/imageBROKER/Alamy Stock Photo [*right*]

EUROPE

pp. x–1: Panther Media GmbH/Alamy Stock Photo; **p. 2:** Evikka/Shutterstock (Cambridge), Dave Bolton/Getty Images (Chester); **p. 3:** Mike Charles/Shutterstock (Land's End), Gallery Stock (Padstow); **p. 4:** Raul Belinchon/Gallery Stock; **p. 5:** Peter Adams/AWL Images Ltd/Cavan Images (Dartmoor), Adam Burton/Alamy Stock Photo (Exmoor); **p. 6:** Nigel Norrington/ArenaPAL (Glyndebourne Festival), Gordon Bell/Alamy Stock Photo (Cotswolds); **p. 7:** Philip Bird LRPS CPAGB/Shutterstock (Winchester Cathedral), © Historic England Archive (Osborne House); **p. 8:** Gallery Stock (Canterbury Cathedral), ptaxa/Getty Images (Leeds Castle); **p. 9:** Paul Cox/Alamy Stock Photo (Sissinghurst Castle Garden), Ben M. Thomas (Lake District); **pp. 10–11:** *Panther Media GmbH/Alamy Stock Photo*; **p. 12:** Slawek Staszczuk Photo/Alamy Stock Photo (National Gallery), Justin Pumfrey/Getty Images (British Museum), David Steele/Shutterstock (Buckingham Palace), *iolya/Shutterstock* (Hyde Park); **p. 13:** Emad Aljumah/Getty Images (Westminster Abbey), Alexander Spatari/Getty Images (St. Paul's Cathedral), Alison Wright/Getty Images (London Eye), Peter Phipp/Travelshots.com/Alamy Stock Photo (Tower of London), Scott E. Barbour/Getty Images (Tate Modern); **p. 14:** Loop Images Ltd/Alamy Stock Photo; **p. 15:** David Jones/PA Images/Getty Images (International Antiques), Imagno/Hulton Archive/Getty Images (Blenheim Palace), The Foto Factory/Alamy Stock Photo (Ludlow); **p. 16:** MY Stock/Shutterstock (Bath), Manor Photography/Alamy Stock Photo (Wells Cathedral); **p. 17:** Steve Vidler/SuperStock (Stratford-Upon-Avon), Dan Breckwoldt/Shutterstock (Warwick Castle), Julian Elliott/Shutterstock (Salisbury Cathedral); **pp. 18–19:** Gallery Stock; **p. 20:** The National Trust Photolibrary/Alamy Stock Photo (Stourhead Garden), Raul Belinchon/Gallery Stock (Castle Howard), Mark Sunderland/robertharding/Getty Images (York Minster); **p. 21:** John P. Kelly/Getty Images (Royal Scotsman), Steven Scott Taylor/TSPL/Camera Press/Redux (Edinburgh Castle); **p. 22:** Tom Till/Alamy Stock Photo (Castle Trail), Gallery Stock (Hebrides); **p. 23:** travellinglight/Alamy Stock Photo (Argyll Highlands), Gannet77/Getty Images (Highland Games), Cultura Creative (RF)/Alamy Stock Photo (Malt Whisky Trail); **p. 24:** Chris Sargent/Shutterstock (Trossachs National Park), *John Braid/Shutterstock* (Orkney Islands); **pp. 24–25:** CStringer/Shutterstock; **p. 26:** *funkyfood London—Paul Williams/Alamy Stock Photo* (Castles of North Wales), Barrie Potter Photography/Courtesy Llangollen International Musical Eisteddfod (International Musical Eisteddfod), tirc83/Getty Images (Llŷn Peninsula); **p. 27:** Graham M. Lawrence/Alamy Stock Photo (Snowdonia National Park), John Norman/Alamy Stock Photo (Dylan Thomas Country); **p. 28:** Billy Stock/robertharding/Getty Images (Wye Valley), *Ian G Dagnall/Alamy Stock Photo* (St. Davids Cathedral); **p. 29:** George Karbus Photography/Alamy Stock Photo (Coast of Clare), Courtesy Evan Schiller/Ballybunion Golf Club (Ireland's Temples of Golf), Ye Choh Wah/Shutterstock (Cork Jazz Festival); **p. 30:** Courtesy Ballymaloe House (Culinary Cork), George Karbus Photography /Cultura/Cavan Images (Wild Donegal); **p. 31:** ©Michael St. Maur Sheil/Corbis/VCG/Getty Images; **p. 32:** Courtesy Guinness Storehouse (Pubs and St. Patrick's Festival), *Ryan Donnell/Cavan Images* (Aran Islands), Look Foto/Cavan Images (Connemara); **p. 33:** Cody Glenn/Sportsfile/Getty Images (Galway), Dennis Frates/Alamy Stock Photo (Dingle Peninsula), Walter Bibikow/Getty Images (Ring of Kerry); **p. 34:** Barbara McCarthy/www.barbaramccarthyphotos.com (Horse Country), *Patryk Kosmider/Shutterstock* (Adare); **p. 35:** *Stephen Barnes/Ireland/Alamy Stock Photo* (Ashford Castle), Sean Caffrey/Lonely Planet Images/Getty Images (Boyne Valley), Alain Le Garsmeur W.B.Yeats Book/Alamy Stock Photo (Yeats Country); **p. 36:** Clive Barda/ArenaPAL (Wexford Opera Festival), David Lyons/Alamy Stock Photo (Gardens of Wicklow); **p. 37:** Paul J Martin/Shutterstock (Belfast's Moment), Martin Siepmann/imageBROKER/Cavan Images (Causeway Coast), Kevin Wells/Alamy Stock Photo (Kingdom of Mourne); **p. 38:** *Henry Georgi/Cavan Images* (Arlberg Region), Schubertiade GmbH, Peter Mathis (Austria's Music Festivals), Zoom Team/Shutterstock (Grossglockner Road); **p. 39:** LianeM/Alamy Stock Photo (Old Graz), Nido Huebl/Shutterstock (Salzburg), imageBROKER/Alamy Stock Photo (Wachau Valley); **p. 40:** blickwinkel/Alamy Stock Photo; **p. 41:** Ian Dagnall/Alamy Stock Photo (Kunsthistorisches Museum), Boris Karpinski/Alamy Stock Photo (Schloss Schönbrunn), JOHN KELLERMAN/Alamy Stock Photo (Belvedere Palace), George Papapostolou Photographer/Getty Images (St. Stephen's Cathedral); **pp. 42–43:** Werner Dieterich/Westend61/SuperStock (Rubens Trail); **p. 42:** Arterra Picture Library/Alamy Stock Photo; **p. 43:** Westend61/Getty Images (Bruges), Courtesy Chocolaterie Mary (Belgian Chocolate); **p. 44:** Robert Landau/Alamy Stock Photo (Belgian Frites), pbombaert/Getty Images (La Grand Place); **p. 45:** © Alan John Ainsworth 2015 (Showcase of Art Nouveau), Paul Maguire/Alamy Stock Photo (Ghent), Christian Michel-VIEW/Alamy Stock Photo (Liège); **p. 46:** Hiroshi Higuchi/Getty Images (Strasbourg), Dutourdumonde/Alamy Stock Photo (Biarritz), shapencolour/Alamy Stock Photo (Bordeaux); **p. 47:** duchy/Shutterstock; **p. 48:** Trevor Wood/Getty Images (Brittany's Emerald Coast), Christian Musat/Alamy Stock Photo (Belle-Île); **p. 49:** Brown W. Cannon III/Intersection Photos; **p. 50:** Travel Library Limited/SuperStock (Champagne), Marie Hennechart (Champagne, Moët et Chandon), John Zada/Alamy Stock Photo (Les Calanches); **p. 51:** Rosemary Calvert /robertharding/SuperStock (Impressionist Normandy), Ventura Carmona/Getty Images (Mont St-Michel), Russ Bishop/age fotostock/SuperStock (Normandy's D-Day Beaches); **pp. 52–53:** juan moyano/Alamy Stock Photo; **p. 54:** BABAK TAFRESHI /NG Image Collection (Louvre), PETIT Philippe/Paris Match Archive/Getty Images (Musée Picasso), Prasit Rodphan/Alamy Stock Photo (Arc de Triomphe), Hercules Milas/Alamy Stock Photo (Museum of the Middle Ages); **p. 55:** Kirk Fisher/Alamy Stock Photo (Ste-Chapelle), Inge Johnsson/Alamy Stock Photo (Basilique Du Sacré-Coeur), Alan Wilson/Alamy Stock Photo (Musée d'Orsay), JOHN KELLERMAN/Alamy Stock Photo (Cimetière du Père-Lachaise); **p. 56:** JOHN KELLERMAN/Alamy Stock Photo (Albi), Zoonar GmbH/Alamy Stock Photo (Carcassonne), Museimage/Getty Images (Nancy); **p. 57:** Mikel Bilbao/age fotostock/SuperStock (Lourdes), JeniFoto/Shutterstock (Loire Valley), Dreamer Company/Shutterstock (Aix-en-Provence); **p. 58:** Klaus Neuner/Mauritius/SuperStock, robertharding/Alamy Stock Photo (Arles), Nadia Isakova/AWL Images Ltd/Cavan Images (Avignon); **p. 59:** Andrey Khrobostov/Alamy Stock Photo (Cannes), *David Madison/The Image Bank/Getty Images* (French Riviera); **p. 60:** *Stock Connection/SuperStock* (Luberon), ZM_Photo/Shutterstock (Old Marseilles); **p. 61:** MANIN Richard/Hemis/SuperStock (Moustiers), Brian Jannsen/age fotostock/SuperStock (St-Paul-de-Vence); **p. 62:** © Ken Scicluna/John Warburton-Lee Photography Ltd/Cavan Images (Vieux Nice), Doug Pearson/JAI/Cavan Images (Beaujolais), Menno Boermans/Cavan Images (French Alps); **p. 63:** CALLE MONTES/Getty Images (Lac d'Annecy), Andia/Universal Images Group/Getty Images (Lyon's Food Scene); **p. 64:** Hackenberg-Photo-Cologne/Alamy Stock Photo (Baden-Baden), Sergey Borisov/Alamy Stock Photo (Heidelberg Castle); **p. 65:** manfredxy/Shutterstock (Bamberg), Ilene Perlman (Christkindlmarkt), Travel Pix Collection/Jon Arnold Images/SuperStock (Germany's Beer Culture); **p. 66:** *Westend61/Getty Images*; **p. 67:** Jan Greune/LOOK-foto/Getty Images (Munich's Pinakotheks), Mauritius/SuperStock (Regensburg); **pp. 68–69:** Aaron Choi/Getty Images; **p. 70:** Album/Alamy Stock Photo (Berlin's Museum Scene), Wolfgang Kaehler (Berlin's Architecture); **p. 71:** RICOWde/Getty Images (Mitte), PjrTravel/Alamy Stock Photo (Sanssouci), H & D Zielske/Gallery Stock (Cologne's Cathedral); **p. 72:** Wolfgang Kaehler (Rhine Valley), phoelixDE/Shutterstock (Dresden's Altstadt); **p. 73:** *Roman Sigaev/Shutterstock* (Quedlinburg), Tupungato/Shutterstock (Lübeck), Michael Thaler/Shutterstock (Sylt); **p. 74:** Wolfgang Kaehler (Acropolis), Lonely Planet/Getty Images (Athen's Museum), f8grapher/Tandem Stock (Hydra); **p. 75:** Anastasios71/Shutterstock (Delphi), Hugh Olliff/Alamy Stock Photo (Crete), ZGPhotography/Shutterstock (Mykonos); **p. 76:** Marinos Karafyllidis/Alamy Stock Photo; **pp. 76–77:** leoks/Shutterstock; **p. 77:** *Jason Knott/Alamy Stock Photo* (Sifnos); **p. 78:** Panos Karas/Shutterstock (Patmos), Victoria/Adobe Stock (Rhodes); **p. 79:** robertharding/Alamy Stock Photo (Mount Athos), anjokan/Adobe Stock (Mani Peninsula); **p. 80:** Hercules Milas/Alamy Stock Photo (Monemvassia), Greece/Alamy Stock Photo (Nafplion); **p. 81:** *PANAGIOTIS KARAPANAGIOTIS/Alamy Stock Photo*; **p. 82:** frans lemmens/Alamy Stock Photo (Cyprus's Painted Churches), Martin Jung/imageBROKER/SuperStock (Alberobello), Jason Michael Lang (Sassi of Matera); **p. 83:** funkyfood London—Paul Williams/Alamy Stock Photo; **pp. 84–85:** S-F/Shutterstock; **p. 85:** DaveLongMedia/Getty Images (Naples), Konrad Wothe/LOOK-foto/Getty Images (Naple's Antiquities); **p. 86:** GoneWithTheWind/Alamy Stock Photo, Adobe Stock (Piazza del Duomo) ; **p. 87:** Konstantin Kalishko/Alamy Stock Photo (Ravenna), *LianeM/Shutterstock* (Friuli); **pp. 88–89:** ©Pascal Boegli/Getty Images; **p. 90:** Grant Kaye/Cavan Images (Coliseum), JOHN KELLERMAN/Alamy Stock Photo (Basilica di Santa Maria Maggiore), Dmytro Sidashev/Alamy Stock Photo (Borghese Gallery), Cahir Davitt/JWL/Cavan Image (Piazza del Campidoglio), Pajor Pawel/Shutterstock (Pantheon); **p. 91:** Angelo Ferraris/Getty Images (Roman and Imperial Forums), Catarina Belova/Shutterstock (Spanish Steps), Claude LeTien/Getty Images (Campo de' Fiori), Pablo Cersosimo/robertharding/Getty Images (Trevi Fountain); **p. 92:** *Marco Saracco/Shutterstock* (Cinque Terre), Taiga/Shutterstock (Italian Riviera); **p. 93:** zilber42/Shutterstock (Italian Lakes), Danita Delimont/Getty Images (Palazzo Ducale), Oronoz/Album/SuperStock (The Last Supper); **p. 94:** Joel Micah Miller/Gallery Stock (On and Around), Ppictures/Shutterstock (Urbino); **p. 95:** Marco Saracco/Alamy Stock Photo; **p. 96:** MONTICO Lionel/Hemis.fr/Getty Images (Sardinia), Olaf Krüger/imageBROKER/Cavan Images (Aeolian Islands), banepetkovic/Adobe Stock (Gems of Palermo); **p. 97:** Grant Kaye/Cavan Images (Sicily's Greek Temples), Arts Illustrated Studios/Shutterstock (Taormina), Michael DeYoung/Tandem Stock (Dolomite Drive); **pp. 98–99:** *Ruslan Gilmanshin/Alamy Stock Photo*; **p. 100:** Sylvain Sonnet/Getty Images (Uffizi Galleries), Isogood_patrick/Shutterstock (Basilica of Santa Maria Novella), Givaga/Adobe Stock (Palazzo Vecchio), JOHN KELLERMAN / Alamy Stock Photo (Museo San Marco); **p. 101:** da-kuk/Getty Images (Il Duomo), Terry Vamvakinos/Alamy Stock Photo (Basilica of Santa Croce), JOHN KELLERMAN/Alamy Stock Photo (Bargello National Museum), GoneWithTheWind/Shutterstock (Pitti Palace); **p. 102:** funkyfood London—Paul Williams/Alamy Stock Photo (Hill Towns), Samuele Gallini/Adobe Stock (Lucca), Martin Westlake/Gallery Stock (Maremma); **p. 103:** Sivan Askayo, Panther Media GmbH/Alamy Stock Photo (Siena), Bruce Shippee/EyeEm/Getty Images (Assisi); **p. 104:** Unlisted Images, Inc./Alamy Stock Photo (Il Duomo); **p. 105:** Henryk Sadura/Shutterstock (Perugia), Nataliya Nazarova/Alamy Stock Photo (Courmayeur); **p. 106:** Ricardo Ribas/Alamy Stock Photo; **p. 107:** Hercules Milas/Alamy Stock Photo (Gallerie dell'Accademia), Chuck Pefley/Alamy Stock Photo (Peggy Guggenheim Collection), Anton Petrus/Getty Images (Piazza San Marco), Stefano Politi Markovina/Alamy Stock Photo (Ca' d'Oro), Fabio Nodari / Alamy Stock Photo (Grand Canal); **p. 108:** Rupert Sagar-Musgrave/Alamy Stock Photo; **p. 109:** Scirocco340/Shutterstock (Luxembourg City), Richard Wright/Tandem Stock (Valletta), Jiri Vondrous/Alamy Stock Photo (Monaco); **p. 110:** Chris Sorensen/Gallery Stock (Rijksmuseum), RooM the Agency Mobile/Alamy Stock Photo (Red Light District), Stephen Barnes/Netherlands/Alamy Stock Photo (Flower Market), Eye Ubiquitous/Alamy Stock Photo (Anne Frank House), JOHN KELLERMAN/Alamy Stock Photo (Van Gogh Museum); **p. 111:** Javier Larrea/age fotostock/Alamy Stock Photo (De Hoge Veluwe), Peter van Evert/Alamy Stock Photo (Delft), Look/Alamy Stock Photo (Delft, blue

porcelain); p. 112: Michel Porro/Getty Images (Het Mauritshuis), Westend61/Getty Images (Zeeland); p. 113: Tobias Weber/Alamy Stock Photo (Estremoz), GUIZIOU Franck/hemis.fr/Alamy Stock Photo (Évora); p. 114: Michele Falzone/Alamy Stock Photo (Bussaco Forest), Novarc Images/Alamy Stock Photo (Óbidos), Emmanuel LATTES/Alamy Stock Photo (Bairro Alfama); p. 115: Angel Manzano/Alamy Stock Photo (Two Great Museums), Taiga/Shutterstock (Sintra); p. 116: © Cahir Davitt/ John Warburton-Lee Photography Ltd/Cavan Images (Madeira), Mikehoward 1/Alamy Stock Photo (Porto); p. 117: *Wiliam Perry/Alamy Stock Photo* (La Mezquita Cathedral), lotsostock/Shutterstock (Alhambra); p. 118: Julian Kumar/Getty Images (Jerez de la Frontera), Sebastian Wasek/Alamy Stock Photo (Ruta de los Pueblos Blancos), DEA/C. SAPPA /Getty Images (Seville); p. 119: Gonzalo Azumendi/Getty Images (Balearic Islands), Bernard/imageBROKER/Cavan Images (Guggenheim Museum Bilbao); p. 120: Renato Granieri/Alamy Stock Photo (Rioja), Simon Bajada (San Sebastián), Biosphoto/SuperStock (Caves of Altamira); p. 121: robertharding/Alamy Stock Photo (Picos de Europa), Igor Plotnikov/Shutterstock (Cuenca), Maremagnum/Getty Images (Ávila); p. 122: Ivan Vdovin/Alamy Stock Photo (León), Arturo Rosas/VWPics/ Alamy Stock Photo (Salamanca's Plaza Mayor), Fotokon/Shutterstock (Ciutat Vella); p. 123: Gallery Stock; p. 124: Alberto Masnovo/Shutterstock (Parc de Montjuïc), Byelikova Oksana/Shutterstock (Costa Brava), Alvaro German Vilela/Shutterstock (Cáceres), @Michi B./Moment/Getty Images (El Camino de Santiago); p. 126: Sylvain Sonnet/Photolibrary/Getty Images; p. 127: Ingolf Pompe 85/Alamy Stock Photo (Centro de Arte Reina Sofia), ©MATTES RenÃ/hemis.fr/Getty Images (Thyssen-Bornemisza Museum), Stefano Politi Markovina/Alamy Stock Photo (Plaza Mayor), Adam Eastland/Alamy Stock Photo (Mercado de San Miguel); p. 128: imageBROKER/ *Alamy Stock Photo* (Valencia), *Chris Parker/Axiom/Cavan Images* (Alps' Most Scenic Train Trips); p. 129: SEBASTIEN BOZON/AFP/Getty Images (Basel), © Gstaad Saanenland Tourismus/Christof Sonderegger (Gstaad); p. 130: PatitucciPhoto/Cavan Images (High-Country Hiking), Travel Pictures Ltd/SuperStock; (Davos-Klosters); p. 131: Olaf Protze/McPhoto/ullstein bild/Getty Images (St. Moritz), © Christian Kober/John Warburton-Lee Photography Ltd/Cavan Images (Lucerne Riviera), Alessandro Storniolo/Shutterstock (Lugano); p. 132: ©Grant Gunderson Photography, Inc. (Verbier), *sodapix/F1 Online/Cavan Images* (Zermatt); p. 133: FABRICE COFFRINI/AFP/Getty Images (Montreux Jazz Festival), © Kunsthaus Zürich, Franca Candrian (Zürich's Art Beat); p. 134: S-F/Shutterstock (Dubrovnik), imageBROKER/ Superstock (Istria); p. 135: Elisabeth Schmidbauer/imageBROKER/Cavan Images (Plitvice Lakes); p. 136: *Pavaris Khaosaman/EyeEm/Getty Images* (Český Krumlov), Swedishnomad.com—Alex W/Shutterstock (Karlovy Vary); p. 137: Radim Beznoska/age fotostock/Superstock (Kutná Hora), Cum Okolo/Alamy Stock Photo (Czech Beer), ROBERT HARDING PICTURE LIBRARY/NG IMAGE COLLECTION (Old Town Square); p. 138: Martin Child/Cavan Images (Prague's Castle District), Radim Beznoska/age fotostock/Superstock (Borderlands of Southern Moravia), Profimedia.CZ a.s./Alamy Stock Photo (Olomouc); p. 139: Alexander Spatari/Moment Open/Getty Images (Old Tallinn), *Anilah/Shutterstock* (Saaremaa Island); p. 140: age fotostock/SuperStock (Vardzia), saiko3p/Adobe Stock (Old Tbilisi); p. 141: Gallery Stock (Budapest's Traditional Thermal Baths), Cultura Exclusive/Ben Pipe Photography/Getty Images (Chain Bridge); p. 142: Ivan Vasylyev/Shutterstock (Danube Bend), LeicherOliver/ Shutterstock (Lake Balaton); p. 143: Sinuswelle/Adobe Stock (Pécs), Chamille White/Shutterstock (Old Riga); p. 144: Virginija/Shutterstock (Curonian Spit), Cezary Wojtkowski/Adobe Stock (Old Vilnius); p. 145: Elena_Sistaliuk/Getty Images (Bay of Kotor), Garsya/Shutterstock (Budva Riviera), Alex Robinson/AWL Images Ltd/Cavan Images (Auschwitz); p. 146: Sopotnicki/Shutterstock (Rynek Główny), Ben M. Thomas (Wawel Hill); p. 147: Hideo Kurihara/Alamy Stock Photo (Showcases on Chopin), Ben M. Thomas (Zakopane); p. 148: Amana Images Inc/Getty Images (Maramureş), Dennis Cox/Alamy Stock Photo (Painted Monasteries); p. 149: maryd/Adobe Stock; pp. 150–151: Tanatat pongphiboo1, Thailand/Getty Images; p. 151: David Leventi/Gallery Stock (Bolshoi Theater), Lars Ruecker/Getty Images, Grigory Bruev/Adobe Stock (Tretyakov); p. 152: Ken Scicluna/JWL/Cavan Images (Waterways of the Czars), Andrey Pozharskiy/Shutterstock (Novgorod); p. 153: ITAR-TASS News Agency / Alamy Stock Photo (White Nights Festival), David Lyons/Alamy Stock Photo (Winter Palace); pp. 154–155: Michael Nolan/Getty Images (Catherine Palace); p. 154: Nataliya Dvukhimenna/Adobe Stock; p. 155: ALEKSANDR RIUTIN/Shutterstock (The Trans-Siberian Express), *joyfull/Shutterstock* (Bratislava's Old Town); p. 156: Ken Scicluna/ John Warburton-Lee Photography Ltd/Cavan Images (Lake Bled), Matej Kastelic/Shutterstock (Ljubljana's Old Town); p. 157: JURE MAKOVEC/AFP/Getty Images (Caves of the Karst Plateau), finwal/Getty Images (Kiev Caves Monastery), vicsa/Getty Images (Historic Center); p. 158: Christian Mueringer/Alamy Stock Photo (Bornholm), Alan Kraft/Shutterstock (Danish Design); p. 159: Ditte Isager (Denmark's Culinary Revolution), Yadid Levy/Alamy Stock Photo (Tivoli Gardens); p. 160: Andrey Shcherbukhin/Shutterstock (Kronborg Slot), Pep Roig/Alamy Stock Photo (Louisiana Museum), De Agostiri/S. Vannini/Getty Images (Århus); p. 161: Look/Alamy Stock Photo (Skagen), Mikhail Markovskiy/Shutterstock (Roskilde), ALLTRAVEL/Alamy Stock Photo (Ærø); p. 162: Rick Strange/Alamy Stock Photo (Funen), David Harding/ Alamy Stock Photo (Ribe); pp. 162–163: Johnathan Ampersand Esper/Cavan Images (Faroe Islands); p. 163: *blickwinkel/Alamy Stock Photo* (Disko Bay); p. 164: Ilja Dubovskis/Alamy Stock Photo (Åland Archipelago), Ivan Vdovin / Alamy Stock Photo (Design District), V&A Images/Alamy Stock Photo (World of Alvar Aalto); p. 165: age fotostock/Alamy Stock Photo (Finnish Lapland), Prisma by Dukas Presseagentur GmbH/Alamy Stock Photo (Lakeland), Salawin/Getty Images (Turku); p. 166: Curdin Wuethrich/Getty Images (Lake Mývatn), *Thomas Janisch/Getty Images* (Ring Road); p. 167: Ben M. Thomas (Bergen), Douglas Pearson/The Image Bank/Getty Images (Geirangerfjord); p. 168: Andrea Pistolesi/Getty Images (Lofoten Islands), Jenna Lois Chamberlain/Shutterstock (North Pole), *Anibal Trejo/Shutterstock* (Norway's Coast); p. 169: Hemis/Alamy Stock Photo (Munch Museum), Ilene Perlman (Viking Ship Museum); pp. 170–171: *Pe3k/Shutterstock*; p. 172: Matthias Scholz/ Alamy Stock Photo (Göta Canal), Niar/Shutterstock (Gotland); p. 173: Asaf Kliger, ICEHOTEL (Ice Hotel), Jchnér/Offset (Stockholm Archipelago); p. 174: *Adisa/ Shutterstock* (Gamla Stan), Yadid Levy/robertharding/Alamy Stock Photo (Vasa Museum), Anna Yu/Getty Images (Drottningholm Palace); p. 175: Courtesy Lisa Raihle Rehbäck/Kungligaslotten.se (Gripsholm Castle), Utterström Photography/Alamy Stock Photo (Midsummer Eve in Dalarna)

AFRICA

pp. 176–177: *Shawn Dechant/Alamy Stock Photo*; p. 178: Philip Game/Alamy Stock Photo (Alexandria), MelindaChan/Getty Images (Islamic Cairo); p. 179: *B.O'Kane/ Alamy Stock Photo* (Museum of Egyptian Antiquities), Jochen Schlenker/robertharding/Getty Images (Pyramids of Egypt), Sarawut Aiemsinsuk/Shutterstock (Mount Sinai); pp. 180–181: Doug Pearson/Jon Arnold Images/SuperStock; p. 182: oversnap/Getty images (Luxcr), John Wreford/Alamy Stock Photo (Siwa Oasis); p. 183: Wolfgang Kaehler (Essaouira, Fès el Bali), Cultura RM Exclusive/Philip Lee Harvey/Getty Images (Dining in Marrakech); p. 184: Pavliha/Getty Images (Place Djemaa El-Fna), Chris Cross/Caiaimage/Getty Images (Place Djemaa El-Fna, detail); p. 185: *Frank Lukasseck/The Image Bank/Getty Images* (Great Sahara), *David Santiago Garcia/Cavan Images* (Tangier's Medina); p. 186: Neil Farrin/AWL Images/Getty Images (Taroudannt), Ben M. Thomas (Trekking); p. 187: Max Shen/Getty Images (Sidi Bou Said), age fotostock/SuperStock (Bardo Museum), Dan Shugar/Cavan Images (El Djem); p. 188: Anthony Pappone/Moment/Getty Images (Akwasidae Festival), Danita Delimont/Gallo Images/Getty Images (Elmina Castle); p. 189: Yoshio Tomii/SuperStock (Great Mosque of Djenné, Timbuktu); p. 190: Mint Images/Cavan Images (Chobe National Park), Wolfgang Kaehler (Kalahari Desert); p. 191: Courtesy Great Plains Conservation (Selinda Reserve), Hemis/Alamy Stock Photo (Okavango Delta); p. 192: Juan Carlos Muñoz/age fotostock/SuperStock (Gonder), ©Santiago Urquijo/Getty Images (Lalibela); p. 193: John Dambik/Alamy Stock Photo (Omo River Valley), Eric Baccega/age fotostock/SuperStock (Omo River Valley, detail), Olivier Cirendini/Lonely Planet Images/Getty Images (Simien Mountains National Park); p. 194: Joseph Sohm/Corbis NX/Getty Images (Lewa Wildlife Conservancy), Lapof/iStock/Getty Images (Climbing Mount Kenya), Nigel Pavitt/JWL/Cavan Images (Island of Lamu); p. 195: Winfried Wisniewski/Photodisc/Getty Images; p. 196: Ian Cumming/Axiom/Cavan Images (Lake Malawi), Eric Nathan/Alamy Stock Photo (Archipelagos of Mozambique), Blaine Harrington III/Alamy Stock Photo (Etosha National Park); p. 197: ©Jamie Larb—elusive-images.co.uk/Getty Images (Skeleton Coast), David Santiago Garcia/Cavan Images (Sossusvlei Dunes); p. 198: Ann and Steve Toon/Alamy Stock Photo (Bo-Kaap), Sergi Reboredo/Alamy Stock Photo (Robben Island), hpbfotos/Alamy Stock Photo (Table Mountain), Lingbeek/Getty Images (Boulders Beach); p. 199: Albie Venter/Shutterstock (Drakensberg Mountains), Alys Tomlinson/ Cultura/Getty Images (Greater Kruger Park Area); p. 200: Courtesy Rovos Rail Tours, South Africa (Rovos Rail), Jonathan Kingston/Cavan Images (Cape Winelands), Peter Unger/Lonely Planet Images/Getty Images (Garden Route); p. 201: Volodymyr Burdiak/Alamy Stock Photo (Mount Kilimanjaro), *Konrad Wothe/imageBROKER/ Alamy Stock Photo* (Mahale Mountains); p. 202: Jamie Friedland/Getty Images; pp. 202–203: Adrian Bailey/Aurora/Getty Images; p. 203: Duncan Vere Green/Alamy Stock Photo; p. 204: Robert Haasmann/imageBROKER/Alamy Stock Photo (Tracking the Mountain Gorilla), Alberto Loyo/Shutterstock (Murchison Falls); p. 205: ©MINT *Images/Art Wolfe/Cavan Images*; p. 206: Anton_Ivanov/Shutterstock (Victoria Falls), De Agostini/G. Sioen/De Agostini Picture Library/Getty Images (Matobo National Park); p. 207: Panther Media GmbH / Alamy Stock Photo (Expedition Into the Eighth Continent), *Reinhard Dirscherl/Cavan Images* (Maldive Islands); p. 208: Ellen Rooney/robertharding/Getty Images (Mauritius), Tom Walmsley/SpecialistStock/Cavan Images (Bird Island); pp. 208–209: Michael Runkel/robertharding/Alamy Stock Photo

THE MIDDLE EAST

pp. 210–211: Design Pics Inc/NG Image Collection; p. 212: David Orcea/Shutterstock (Acre), Karol Kozlowski/Shutterstock (Caesarea), Blaze986/Shutterstock (Galilee); p. 213: Jason Langley/Getty Images (Historic Jerusalem), Russell Kord/Alamy Stock Photo (West Jerusalem); p. 214: Christian Kober/robertharding/Getty Images (West Bank), RIEGER Bertrand/hemis.fr/Alamy Stock Photo (Masada); p. 215: Anton Petrus/Shutterstock (Old Jaffa), ChameleonsEye/Shutterstock (White City of Tel Aviv), Nickolay Vinokurov/Shutterstock (Dead Sea); p. 216: Peter Adams Photography Ltd/Alamy Stock Photo (Aqaba), Anton_Ivanov/Shutterstock (Jerash), Kevin Button/Getty Images (King's Highway); p. 217: *klempa/Shutterstock*; p. 218: Anton_Ivanov/Shutterstock (Baalbek), diak/Shutterstock (Beirut's Corniche); p. 219: Styve Reineck/Shutterstock (Nizwa), ajansen/iStock/Getty Images (Museum of Islamic Art), Tom Till/Alamy Stock Photo (Old Jeddah); p. 220: David Kirkland/Design Pics/ Getty Images (Mada'in Saleh), Zou Zou/Shutterstock (Mecca), Jereme Thaxton/Cavan Images (Empty Quarter); p. 221: Enjoytheworld/Alamy Stock Photo

ASIA

pp. 222–223: Yimei Sun/Getty Images; pp. 224–225: Gallery Stock; pp. 226–227: Sean Pavone/Alamy Stock Photo; p. 228: Joshua Davenport/Alamy Stock Photo (Temple of Heaven), WojtekZet/Getty Images (Lama Temple), Bjanka Kadic/Alamy Stock Photo (798 Art Zone), *aphotostory/iStock/Getty Images* (Great Wall of China); p. 229: zhangshuang/Getty Images (Forbidden City), Askolds Berovskis/Shutterstock (hutongs), Waitforlight/Getty Images (Summer Palace); p. 230: Henry Westheim Photography/Alamy Stock Photo (Grotto Caves of China, Mogao Caves), Greatstock/Alamy Stock Photo (Grotto Caves of China, Longmen Grottoes); p. 231: Vadim Petrakov/Shutterstock; p. 232: CHUNYIP WONG/Getty Images (Victoria Harbour), David Davis Photoproductions RF/Alamy Stock Photo (Ten Thousand Buddhas), *Shaun Jeffers/Shutterstock* (Chi Lin Nunnery), Sean Gallagher/National Geographic Image Collection/Alamy Stock Photo (Hong Kong Museum of History), Jake Wyman/Corbis NX/Getty Images (Three Gorges), *Robert Paul van Beets/Alamy Stock Photo* (Gardens of Suzhou); p. 234: Keren Su/China Span/Alamy Stock Photo (Giant Panda Tracking), Jonathan Look, Jr./Cavan Images (Xi'an), M&G Therin-Weise/age fotostock/Super Stock (Xi'an, detail); p. 235: Grant Faint/The Image Bank/Getty Images (Bund), Atlantide Phototravel/Getty Images (Shanghai Museum), Sino Images/Getty Images (Potala Palace); p. 236: Thomas L. Kelly/Getty Images (Mount Kailash), Eric Lafforgue/Art in All of Us/Corbis/Getty Images (Sunday Market); p. 237: Mario Weigt/Anzenberger/Redux (Road to Yunnan), Andreas Brandl/Cavan Images (West Lake), Godong/robertharding/Alamy Stock Photo (National Palace Museum); p. 238: Menno Boermans/Cavan Images (Niseko), The Asahi Shimbun/Getty Images (Sapporo Snow Festival), Michele Falzone/JAI/Cavan Images (Shiretoko Peninsula); p. 239: Guy Nesher/Alamy Stock Photo (Takayama), Ben M. Thomas (Hiroshima), Judy Bellah/Lonely Planet Images/Getty Images (Kanazawa); pp. 240–241: EQRoy/Alamy Stock Photo; p. 242: Hemis/Alamy Stock Photo (Sanjusangendo), Daniela Constantinescu/Shutterstock (Kiyomizu-dera), r.nagy/Shutterstock (Ginkakuji), Photo Amitabha/Shutterstock (Ryoan-ji); p. 243: Kyodo News/Getty Images (Geisha), Xavier Portela/Gallery Stock (Fumari Inari shrine), Charles Mann/Alamy Stock Photo (Saiho-ji), Patrick Wallace/Alamy Stock Photo (Nijo Castle), tera.ken/Shutterstock (Tenryu-ji); p. 244: Milosz Maslanka/Shutterstock (Walking the Nakasendo), Ian Shive/Tandem Stock (Cherry Blossom

AUSTRALIA, NEW ZEALAND, AND THE PACIFIC ISLANDS

THE UNITED STATES OF AMERICA AND CANADA

LATIN AMERICA

THE CARIBBEAN, THE BAHAMAS, AND BERMUDA

Patricia Schultz is one of the 25 most
influential women in travel today [*Forbes*].
When not exploring destinations both
remote and in her backyard, she regularly
travels across the United States as a
keynote speaker at all the annual travel
shows [in New York City, Chicago, Los
Angeles, and more] as well as to speak
at bookstores, libraries, museums, and
private events. She also appears as a
guest speaker on river and cruise ships,
and hosts small groups on special
adventures and remote expeditions. A
veteran travel journalist with over 35 years
of experience, she's written for Frommer's
and Berlitz, as well as the *Wall Street
Journal, Condé Nast Traveler,* and *Travel
Weekly,* where she is a contributing editor.
Her home base is in New York City, but good
luck finding her there.

Library of Congress Cataloging-in-Publication Data is on file.
ISBN 978-1-57965-788-8

Design by Erica Heitman-Ford
Creative direction by Michelle Ishay-Cohen
Author photograph by Laura Barisonzi
For other photography credits, see page 529.

All details in this book are based on information available at the time of publication; however,
readers should be sure to call or e-mail ahead for confirmation of information when making travel
plans. The author and publisher shall not be responsible for any travel conditions experienced by
readers resulting from changes in information provided in this book.

Artisan books are available at special discounts when purchased in bulk for premiums and sales
promotions as well as for fund-raising or educational use. Special editions or book excerpts also
can be created to specification. For details, contact the Special Sales Director at the address
below, or send an e-mail to specialmarkets@workman.com.

For speaking engagements, contact speakersbureau@workman.com.

Published by Artisan
A division of Workman Publishing Co., Inc.
225 Varick Street
New York, NY 10014-4381
artisanbooks.com

Artisan is a registered trademark of Workman Publishing Co., Inc.

1,000 PLACES TO SEE BEFORE YOU DIE is a registered trademark of Workman Publishing Co., Inc.,
and Patricia Schultz.

Published simultaneously in Canada by Thomas Allen & Son, Limited

Printed in Hong Kong
First printing, September 2019

10 9 8 7 6 5 4 3 2 1